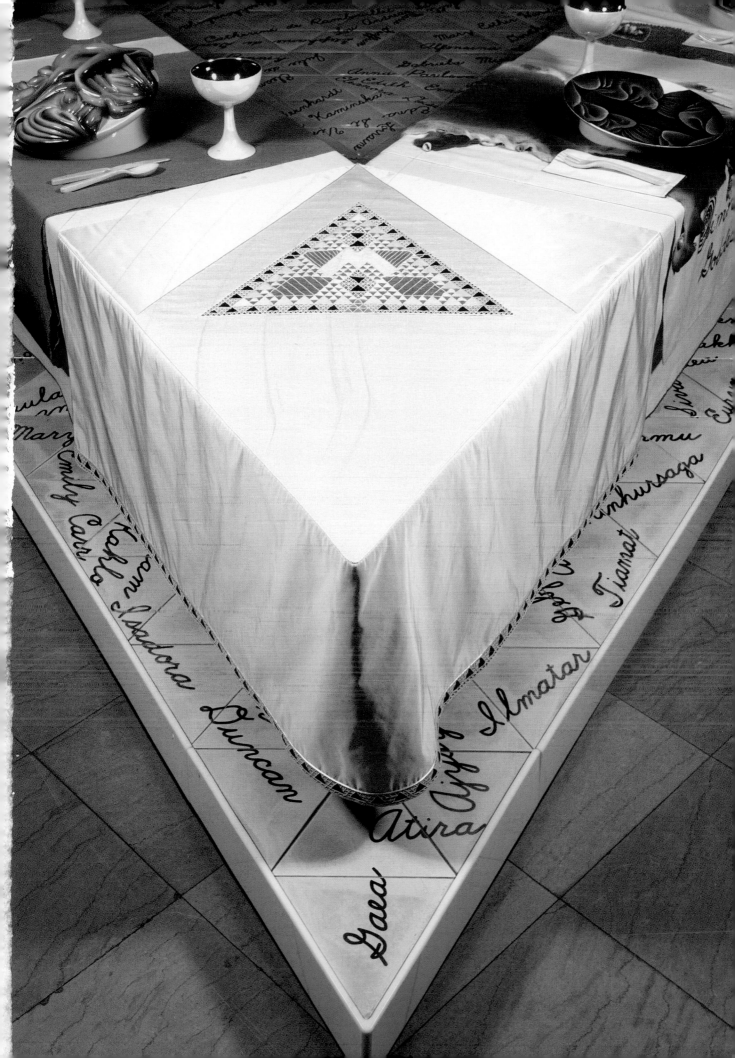

THE DINNER PARTY

Judy Chicago

Restoring Women to History

FOREWORD BY ARNOLD L. LEHMAN, DIRECTOR, BROOKLYN MUSEUM

ESSAYS BY JUDY CHICAGO, FRANCES BORZELLO, AND JANE F. GERHARD

THE MONACELLI PRESS

ISBN 978-1-58093-389-6

Library of Congress Control Number: 2013957235

Design: Gina Rossi

Printed in China

www.monacellipress.com

CONTENTS

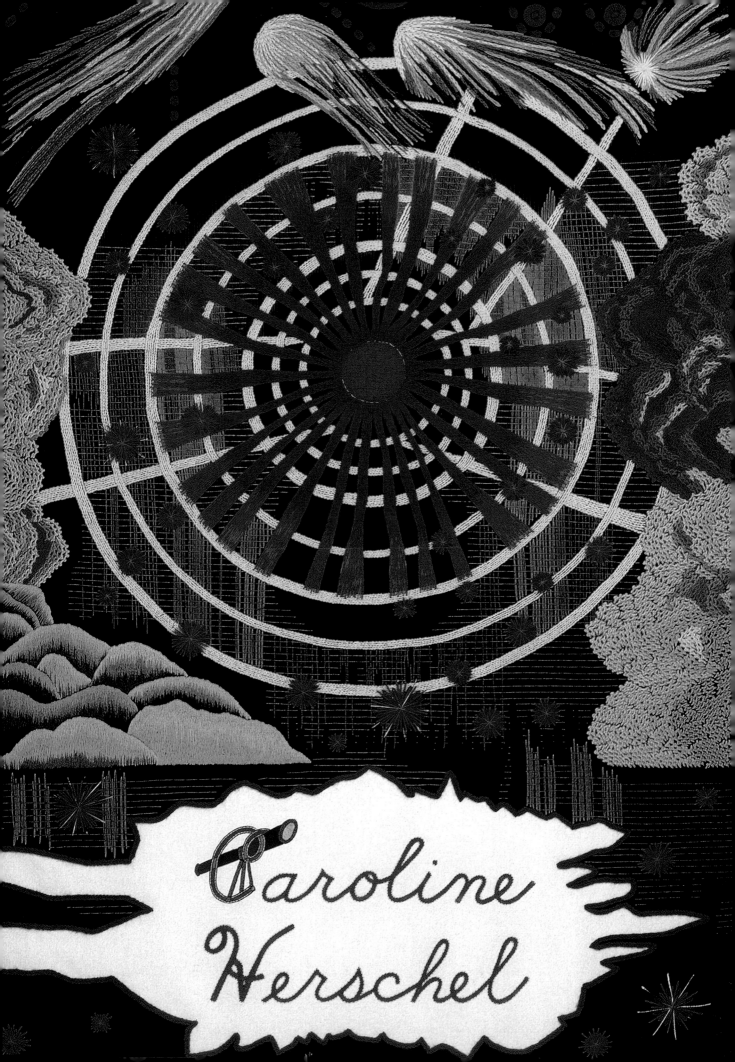

FOREWORD
THE BROOKLYN MUSEUM
AND THE DINNER PARTY

One day, more than a decade ago, Elizabeth A. Sackler, public historian, progressive philanthropist, now a Trustee of the Brooklyn Museum, and extraordinary friend of longstanding, met with me carrying a copy of a book on *The Dinner Party* under her arm. Placing it before me, she asked if I would like to have it. "Certainly," I replied, not understanding for several minutes that what she meant was not the book, but the iconic work of art itself. The extraordinary ensuing conversation was the start of what we have been referring to as "our great adventure," and the gift of that book—the power of that book—was the founding gesture of the Elizabeth A. Sackler Center for Feminist Art, which houses as its exceptional centerpiece *The Dinner Party*.

My enthusiasm for Elizabeth's idea was based not only on my own interest in developing a unique exhibition model for an innovative institution such as ours, but also in recalling that the Brooklyn Museum had, at that point, already played a significant role in the history of *The Dinner Party*. The symmetry of the Museum's early advocacy of the work and its final disposition here as a permanent installation was impossible to resist.

That joint history began in the early 1980s. The Brooklyn Museum was the second major museum venue to exhibit *The Dinner Party*, after its debut at the San Francisco Museum of Modern Art on March 14, 1979. As other museums and institutions shied away from presenting the then-controversial work of art, Brooklyn and San Francisco were in fact the only two large institutions to participate in the travel schedule. *The Dinner Party* arrived on the East Coast, opening at the Brooklyn Museum on October 17, 1981. The reception was attended by 4,500 guests, the largest number to attend an opening in the Museum's history. One hundred thousand visitors waited patiently in long lines to see *The Dinner Party* during its two-month run (I

The Dinner Party, Caroline Herschel runner, detail

was one of them). As at most of its other venues, funds to make the presentation possible were raised by a number of local and national women's groups, including the Women's Fund Joint Foundation; *Ms.* magazine; the National Women's Political Caucus; and the firm Arts, Letters and Politics. Collectively, these groups raised over forty thousand dollars for the Brooklyn showing, more than half the cost of mounting the exhibition.

According to Michael Botwinick, who directed the Brooklyn Museum from 1974 to 1982 and championed the Museum's presentation of the piece, visitors "ranged widely over a far broader spectrum of age, background, and origin than we usually saw. And most exciting, they were energized. No parades of bored visitors, eyes glazed over, walking down the middle of the galleries simply because this was the show to see. They came early, they stayed late, they returned again and again, and even when they were profoundly challenged and disturbed by the piece, they told us they felt it was important that they had seen it." More than thirty years later, we continue to see that strong legacy of viewer engagement and loyalty every day in the galleries of the Elizabeth A. Sackler Center for Feminist Art.

Building on this history was part of our strategy as we began planning the Sackler Center. In 2002, five years before the grand unveiling of its newly designed home, *The Dinner Party* was presented in its second special temporary exhibition at the Brooklyn Museum. And once again, the public came, with over eighty thousand visitors seeing the work during its run from September 20, 2002, through February 9, 2003.

During this time we were hard at work conceptualizing, designing, and building the Elizabeth A. Sackler Center for Feminist Art. A very large and extremely talented team came together with founding curator Maura Riley to make this happen. Knowing the importance of a flexible exhibition gallery and a functioning space for the Center's activities, and the critical role of a spectacular

showplace for *The Dinner Party* itself, we initiated an architectural competition and ultimately selected the proposal of Susan Rodriguez to pursue for realization. Rodriguez, then Design Partner at the office of Polshek Partnership Architects (and now Founding Partner and Design Principal at Ennead Architects), worked closely with us to visualize a center that is called upon to accommodate a multitude of demands: the unique and dramatic *Dinner Party* Gallery; the changing-exhibition spaces that surround it, including the Herstory Gallery, devoted to smaller exhibitions inspired by the 1,038 names that appear on *The Dinner Party*; and the Forum, which is at once a gathering place and educational site that also houses research resources developed by the Center and documents its activities and accomplishments.

At its core, the Sackler Center is not simply a venue but a dynamic exhibition and education environment, dedicated to feminism in art—its past, present, and future. As one of the most ambitious, influential, and enduring intellectual legacies of the late twentieth century, feminism has played a vital role in the art world over the last fifty years, and the Elizabeth A. Sackler Center for Feminist Art participates in the new thinking and vibrant activity which keep that legacy current. Toward that end, we have presented nineteen special exhibitions in the Sackler Center since it opened in 2007. In 2013, four generations of Sackler family members estab-lished an endowment for the Sackler Family Curator, ensuring for perpetuity a curatorial voice within the Museum devoted exclusively to developing exhibitions and programs focusing on current thinking about feminism in the visual arts; Catherine Morris is the first curator to hold the title. Programming is an integral part of what we do; presenting dozens of events annually, from tours for children to academic conferences and artist performances, we seek out projects and ideas that supplement our exhibitions, as well as other opportunities to bring significant dialogue into the Sackler Center that we might not have the chance to address directly in our general exhibition calendar.

The easiest part of the early planning stages was knowing where we wanted to put *The Dinner Party:* in the center of the Center, of course. But what grew up around *The Dinner Party* was complex in that it needed to be in dialogue with, in support of—yet also ultimately stand apart from—*The Dinner Party* per se. I am proud to say that I believe we have accomplished all those goals. The Sackler Center preserves for posterity the monumental work of art that Judy Chicago created specifically "to end the ongoing cycle of omission in which women were written out of the historical record." At the same time, it adds constantly to that historical record, by both revising the historical canon and participating in the contemporary development of new voices for feminist thought.

ARNOLD L. LEHMAN
Director, Brooklyn Museum

INTRODUCTION
RESTORING WOMEN TO HISTORY

JUDY CHICAGO

Over the years, I have often been asked about what inspired me to create *The Dinner Party*. I usually cite as the original impetus an experience in an undergraduate course that I took at UCLA, "Intellectual History of Europe." The teacher, a respected historian, promised that in the last class he would discuss women's contributions to Western thought. As I was an incredibly ambitious young woman intent upon making a mark on art history, I was keenly interested in learning about what women before me had accomplished. I waited eagerly all semester. At the final meeting, the instructor strode in and announced: "Women's contributions to European intellectual history? They made none."

His pronouncement was quite distressing; if no woman before me had managed to achieve anything important, how could I have the audacity to think that I might be able to do so? Nevertheless, I persevered. Almost a decade later, despite my professor's assessment, I decided to look back at history to see if there were any women who had encountered obstacles similar to those that I had been facing in the Los Angeles art world of the 1960s where sexism was rampant. The self-guided study tour upon which I embarked demonstrated that my professor had been entirely wrong; women had a rich though largely unknown heritage. The information that I uncovered became the basis of *The Dinner Party*, which—as most readers know—is a symbolic history of women in Western Civilization and a tribute to the many achievements of women even in the face of difficult circumstances.

A few years after I began my research, I started work on a series of paintings titled *Great Ladies*. These employed the visual language that I had developed in my early years of professional practice to create abstract portraits of women. The images were done with sprayed acrylic on canvas; after a stint in auto body school right after receiving my Master's degree, I had become adept with an airbrush. Even though I was happy with the paintings, I wanted to make them more detailed, something that required using a paint brush. However, I had always disliked oil paint because it sat on top of the surface and I wanted the color and surface to be fused as they were with spray-painting.

Quite by accident, during a trip up the northwest coast of California, I saw a china-painted plate in an antique store that intrigued me. Because the color was literally vitrified into the glaze, it produced exactly the look I was after. While continuing my studio work and research, I undertook a two-year apprenticeship in china painting, which at that time was mainly a hobbyist technique mostly practiced by women. One did not learn to paint china, however, but rather to paint a particular motif such as a baby rose. My challenge was to find a teacher who would help me extract the basic technique from the instructional approach in which it was embedded.

During this time, I also worked on my iconography because—like many university-educated artists—I had learned to "talk in tongues," that is, to make art whose content was indecipherable to most viewers. This was brought home to me during a lecture tour in the early 1970s in Great Falls, Montana (by then, I was lecturing widely about my art). During the question and answer period, I decided to ask the audience, more than two hundred people, their opinions of my work. Several people stated that they loved the images, especially the *Great Ladies*, but would not be able to understand what they were about without my explanation. This interaction stimulated me to figure out how to make my content more accessible to audiences while also strengthening the imagery so that it was more openly female-centered, something that ran entirely counter to my earlier efforts to excise any hint of gender from my art in order to be taken seriously as an artist.

By 1974, my research, my two-year study of china painting, and my efforts to clarify my iconography combined in my decision to undertake a series of one hundred hand-painted china plates representing important women in history. My initial plan involved hanging these on the wall because, I thought, that's where paintings belong.

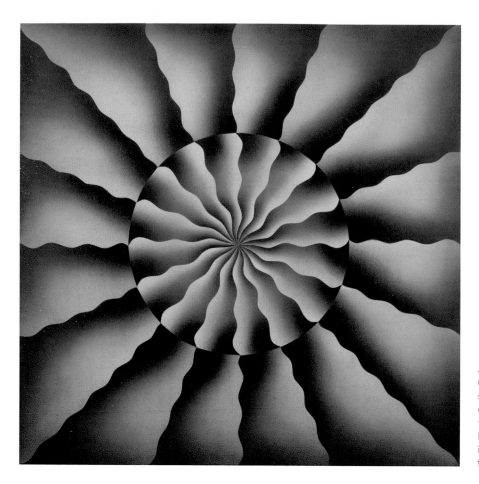

JUDY CHICAGO, *Queen Victoria* (from The Great Ladies series), 1972. Acrylic on canvas, 40 × 40 in. (101.6 × 101.6 cm). On loan to the National Museum of Women in the Arts, Washington, DC, from Dr. Elizabeth A. Sackler

At some point during my two-year apprenticeship, I had seen an entire set of dishware that had been painted and placed on an artist's dining room table as a display. Suddenly it occurred to me that plates belong on a table. This epiphany made me think about Leonardo's *Last Supper* because it was essentially a dinner party or, more specifically, a Seder, though I didn't give much thought to its latent Jewish theme. By this time, I was hard at work on a series of fourteen-inch Japanese porcelain plates whose sturdy composition and gorgeous surfaces allowed for multiple firings, which were necessary for the nuanced color fades that I have always favored.

I spent a considerable amount of time considering the format of the table; at first, I imagined duplicating the number of persons represented in Leonardo's work, that is, thirteen. It occurred to me that this was the number of witches that make a coven, which seemed particularly interesting because, while the men were considered holy, witches were perceived as the embodiment of

female evil. Then I decided that I wanted my table setting to convey the history of Western Civilization but from the distaff side, which is when I first coined the description of *The Dinner Party* as "a reinterpretation of the Last Supper from the point of view of those who've done the cooking throughout history."

As I pondered how to convey this alternate history, I realized that I had learned about Western Civilization through a series of male heroes, each symbolizing a particular period of time. If women appeared at all, they were on the periphery. Moreover, people of color entered the story very late; native Americans as a result of European colonization and African-Americans when their ancestors were brought over in chains on slave ships. Obviously, this long-accepted narrative was Eurocentric, sexist, and racist, as well as narrow in terms of inclusion. Perhaps I could demonstrate how easily the same story could be told in a comparably exclusive manner by substituting female figures for each of the various heroic men.

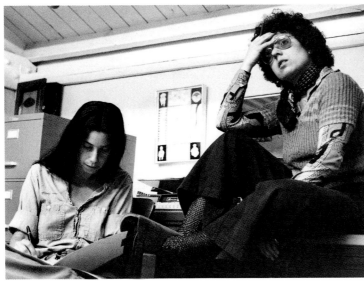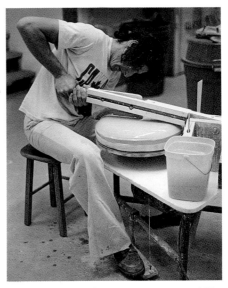

Left, Diane Gelon, *The Dinner Party* administrative and tour coordinator, and Judy Chicago; right, ceramicist Leonard Skuro, who helped solve technical problems of making dimensional plates.

For instance, a female Pharaoh could stand for Egypt, as I had learned that there were several, including Hatshepsut, who had a glorious reign (as demonstrated by the 2006 show about her at the Metropolitan Museum in New York). Also, I had uncovered many distortions in the way women were customarily treated by history, notably Theodora of Byzantium, who was often presented in a negative light even though she had instituted many positive reforms for women including the death penalty for rape. Moreover, she had ruled jointly with her husband, Justinian.

In order to cover all the periods of history, how many women would I have to include? I had already decided to stick with the number thirteen, though a set of thirteen women would clearly not be enough. I tried out twenty-six but still couldn't cover all the historical eras, and finally decided that thirty-nine women would be presented on three open tables, each with thirteen plates. By this time, I had realized that these women's singular achievements had not occurred in a vacuum; rather, each of them had enjoyed some form of support, be it from their families, a convent, or a group of like-minded women. I wanted to emphasize this by placing the tables on a floor that would include the names of other women, finally arriving at the number 999, which sounded almost Biblical. These names would be divided into groupings, each in relation to one of the plates, to represent the long

tradition of achievement each plate symbolized.

I had already begun to assemble a file on important historic women and needed some help in expanding this compendium. Fortunately, a graduate art history student named Diane Gelon agreed to take on this task though she greatly underestimated the amount of time it would take. By the end of *The Dinner Party* project, there was a whole team of researchers who put together a file of 3,000 names from which the 999 listings were selected for what I called the *Heritage Floor*. Unfortunately, no trained historian was interested in working on this project. Admittedly, the researchers were a rather rag-tag group, but they made up in dedication what they lacked in skill. The downside was that there were a number of errors in the information they compiled, which has slowly been corrected by me and the various editors who have gone through this material.

After painting the first group of porcelain plates (which took a year and a half of solo work), I decided that I wanted the images to rise up as a metaphor for women's intensifying struggle for liberation. Although I had made a number of clay pieces in college, I had avoided the ceramics department because the technique was viewed as craft in the painting and sculpture departments. This meant that I did not know how to make a plate, so I turned to the new head of ceramics at UCLA who introduced me to Leonard Skuro, a

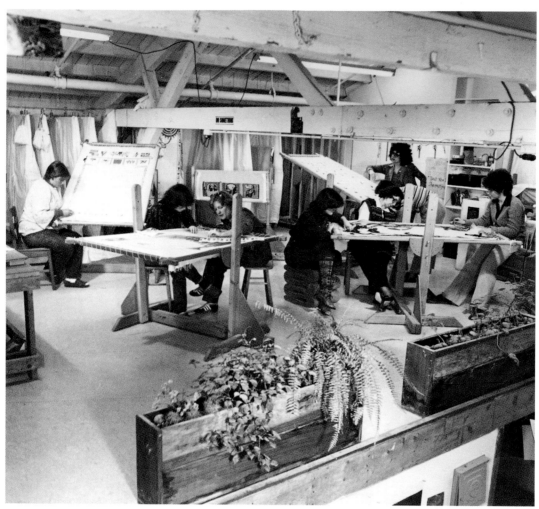

The needlework loft, where *The Dinner Party* runners were executed.

graduate student. He came to work with me on the grueling task of producing dimensional plates that could withstand repeated firings and whose surfaces matched the beauty of the Japanese ware. As it turned out, this was a formidable undertaking that eventually required a number of ceramicists with different skills.

The other problem I encountered had to do with the tablecloths, as any proper table would have to be covered with linens. I definitely wanted to identify each of the thirty-nine women. My initial idea about how to accomplish this was based on a series of small porcelains that I had created as part of my effort to develop the vaginal or vulval form as a symbol of female agency. This iconography included a butterfly motif in a series titled "Butterfly Goddesses and Other Specimens," small, velvet-lined boxes enclosing china-painted porcelain

plaques from which tiny spheres extended. Each image was elucidated by a line of writing that surrounded the circular forms.

At first, I thought that I could embroider identifying texts on the tablecloths around each plate. Sometime later, when *The Dinner Party* studio was full of devoted volunteers, it would be an ongoing source of amusement—especially to the needlework gang—that I had ever imagined this as possible. By the time Susan Hill offered to work with me, I had bought an embroidery machine and was (as she put it) trying to figure out how to turn linens that were forty-eight feet in length around in circles thirteen times. Because Susan had some background with needlework (which is more than I had; as I often say, I can neither sew nor stitch), I designated her the head of that effort though I had no idea at the time how large a team the stitching would require.

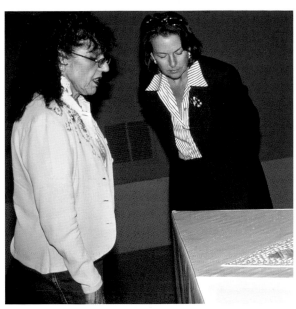

Judy Chicago and Dr. Elizabeth A. Sackler, founder of the Sackler Center for Feminist Art at the Brooklyn Museum.

To supplement her knowledge, Susan enrolled in an ecclesiastical embroidery class and she took me to their exhibition where I was blown away. Not only was the needlework exquisite, the altar cloths suggested a solution to the problem with which I was struggling: how to make a series of "runners" that would be presented underneath the plates and drop over the front and back of the table. In addition to allowing for the identification of each woman, these would provide sufficient space to expand upon the plate designs and symbolize the particular circumstances of each woman's life. As I studied the history of needlework, I realized that the same story that I was piecing together about women's history could be conveyed through the needle and textile arts. Thus the runners became another method of visually recounting that history.

As the project developed, my need for help expanded dramatically. Much has been written about The Dinner Party studio, a lot of it untrue. The best description of both the empowering environment and the experiences of the people who worked there can be found in The Dinner Party: Judy Chicago and the Power of Popular Feminism (University of Georgia Press, 2013) by the historian Jane Gerhard, who has contributed an essay to this volume. The important point is that I brought the same organizational principles that I had used in

my earlier teaching projects (which I discuss in my essay beginning on page 248); the studio became a center of education, consciousness raising, and art production.

From the time I first conceived of The Dinner Party, I envisioned that it would be permanently housed. I was convinced that only through permanent housing could the piece accomplish its goal, which was helping to end the cycle of repetition that it recounts. As the pioneering women's historian Gerda Lerner writes in The Creation of Feminist Consciousness: "Men develop ideas and systems of explanation by absorbing past knowledge and critiquing and superseding it. Women, ignorant of their own history [do] not know what women before them thought and taught. So generation after generation, they [struggle] for insights others had already had before them, [resulting in] the constant reinventing of the wheel." This insight is the same one that I had previously come to from my own study of women's history, which is why I was so intent upon permanent housing as the only way to overcome the repeated erasure of women's achievements.

At the time I set this goal, I had absolutely no idea what a long struggle it would entail. Finally, after more than twenty-five years of effort and many false starts, permanent housing was attained through the vision of Dr. Elizabeth A. Sackler, who acquired The Dinner Party and donated it to the Brooklyn Museum as the centerpiece of the Elizabeth A. Sackler Center for Feminist Art, which opened in 2007, the only center for feminist art in the world. In a personal communication, Elizabeth described its impact: "In the first five years after it was installed, over half a million visitors have circled The Dinner Party in awe. To some it is an education; to others, a beacon; for another, a magnet; for tourists, a destination; to women who remember it well, it is a shrine." She continued, "Within a couple of years after the opening of the Center, nationwide statistics bore out an increase in planned solo shows for women and feminist artists. Though parity in the art world has not yet been reached, there has been a seismic shift. I am grateful to Elizabeth whose pioneering efforts demonstrate that one woman can alter the course of history, and I derive considerable satisfaction from the fact that my work is playing a part in this change.

Entrance to *The Dinner Party* installation at the Brooklyn Museum; on following pages, the banners seen hanging in the entryway.

Welcome to

The
Dinner
Party

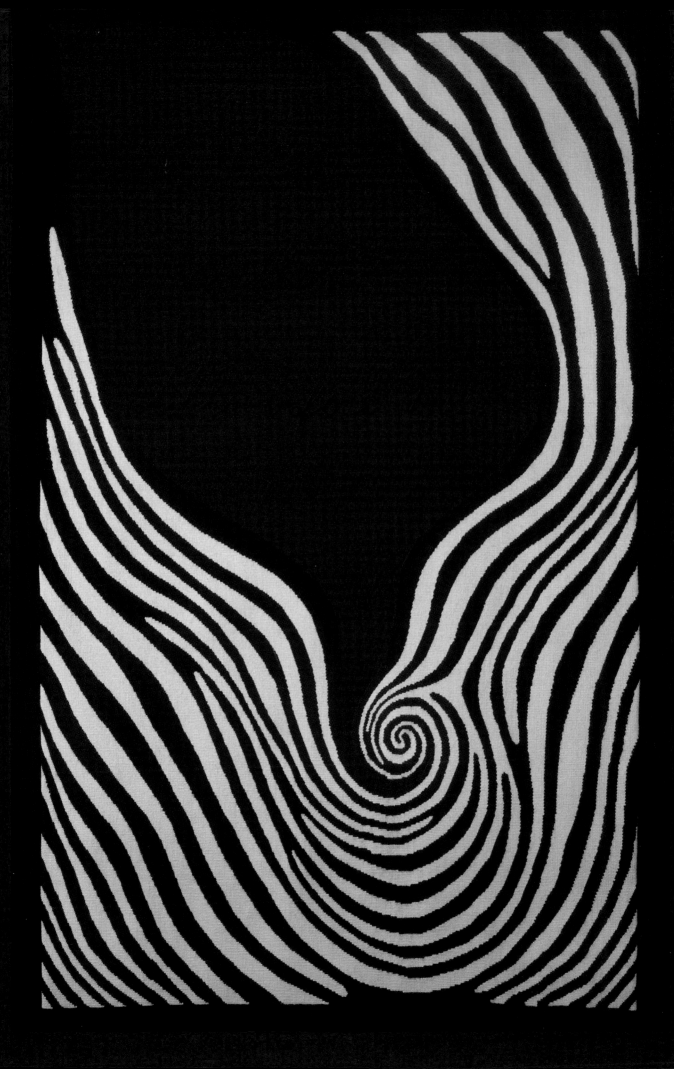

And lo
They saw
a Vision

From
this day
forth

Like to like
in
All things

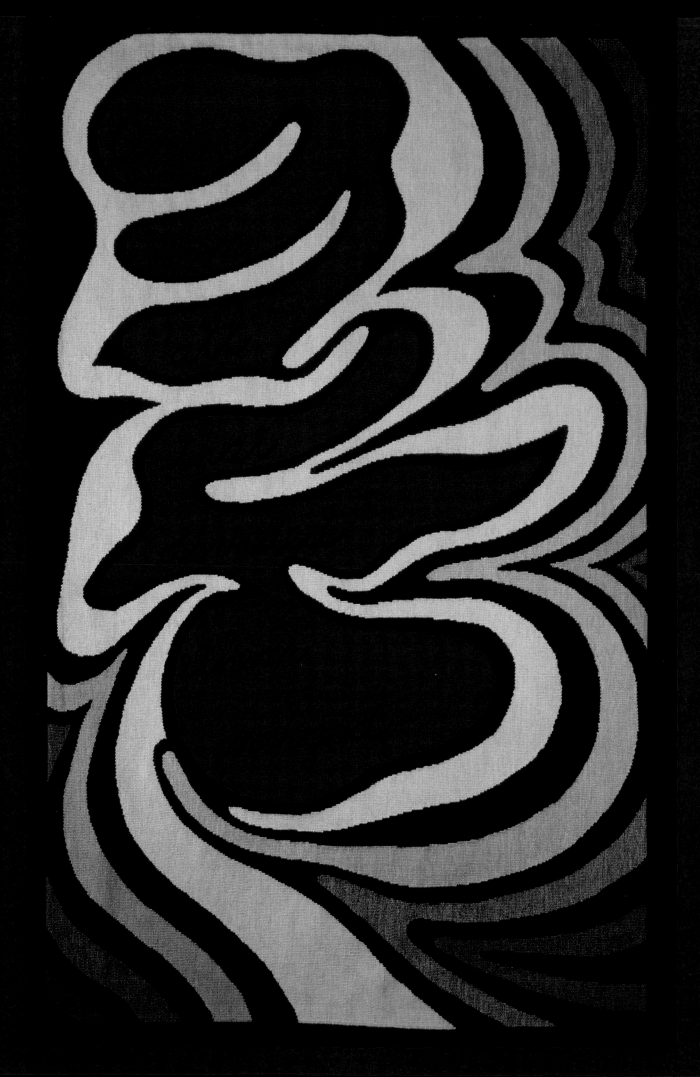

And then
Everywhere

was

Eden

Once

again

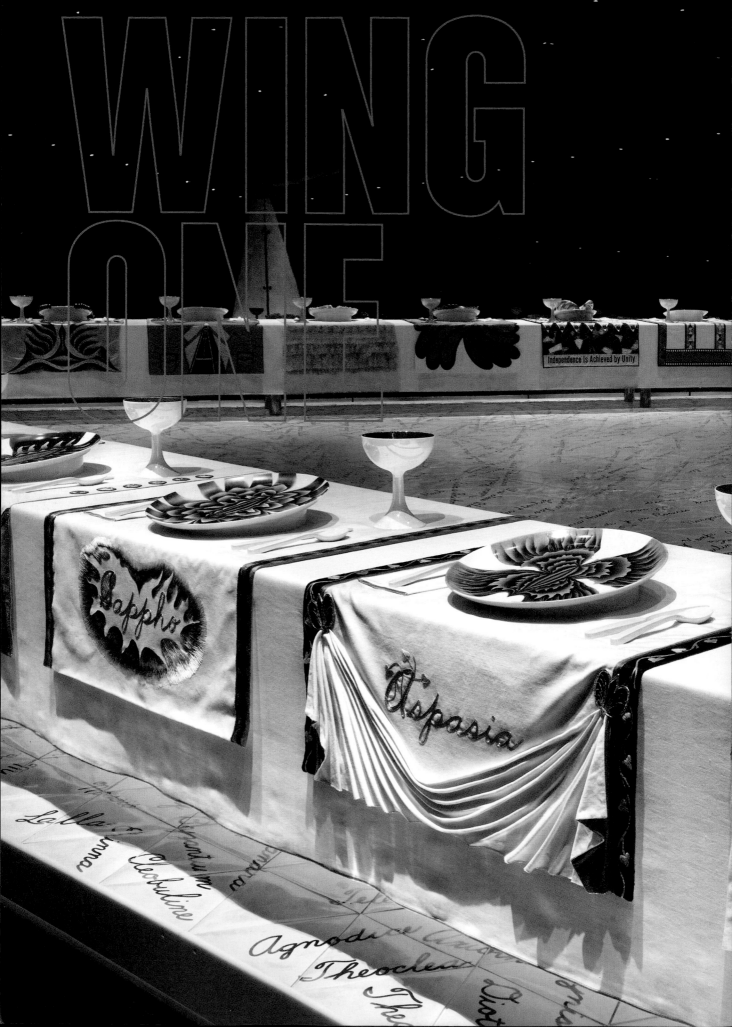

FROM PREHISTORY TO ROME

The first wing of the table begins with prehistory, which is represented by an initial seven place settings depicting mythic or legendary figures. These settings are intended to symbolize pre-patriarchal societies, which were typified by the widespread worship of the Goddess. The plates rest on runners that incorporate simple textile techniques and design motifs emphasizing the importance of the Goddess to the development of needlework, as attested to by a variety of myths and legends. The invention of weaving and spinning was attributed to various female deities, who were described as having both taught these skills to women and sanctified their work.

As men gained control of civilization, the power of the Goddess was diminished or altogether destroyed, and with this change, women's status gradually waned. Although it is difficult for many people to imagine a world in which male dominance is not all-pervasive, *The Dinner Party* presents a vision of history that suggests that there was once such a time and, by implication, there could be such a time again.

Women's intensifying resistance to the constriction of their liberties and rights—brought about by the rise and spread of patriarchal societies—is connoted by the gradual reliefing of the plate surface, a visual metaphor that appears for the first time in the eighth plate setting honoring *HATSHEPSUT*, one of the four female pharaohs of Egypt, and becomes more apparent in later plates. Hatshepsut's place setting is meant to straddle the mythological and real worlds, much like pharaohs, who were thought to be deities incarnate. The next sequence of place settings chronicles the development of Judaism, early Greek societies, and the emergence of Rome as the center of the so-called civilized world.

The decline of the Roman Empire, while marking the end of the classical world, also brought about some significant alterations in women's circumstances. Earlier societies which had continued to provide women with a degree of social and political power gradually gave way to cultures that imposed ever more stringent legal restrictions, increasing disenfranchisement, and in some cases, sequestering within the domestic sphere. These changes are epitomized in the final place setting—that of *HYPATIA*—and particularly in the runner back, which symbolizes the terrible punishment inflicted upon her, in part because of her effort to maintain the ancient traditions of reverence for both women and the Goddess.

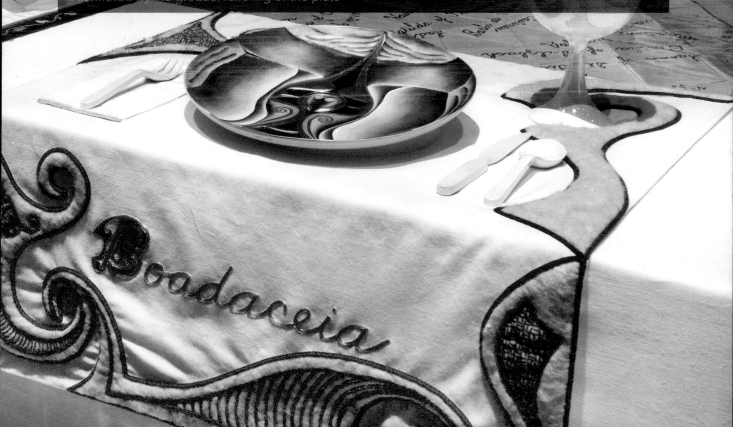

Primordial Goddess

In the beginning, the feminine principle was seen as the fundamental cosmic force. Many ancient peoples believed that the world was created by a female deity who brought the universe into being either alone or in conjunction with a male consort—usually her son—whom the Goddess created parthenogenetically. Perhaps because procreation was not yet understood to be connected with coitus, some thought that women, like the Goddess, alone brought forth life.

Awe of the universal Goddess was expressed as reverence for women, and the female body was repeatedly represented in art as a powerful symbol of birth and rebirth. Long before there was written language, holes in sacred stones were thought to denote this mysterious female power, which was later personified through primitive markings and pictographs, spiral forms carved and painted on rocks, or incised triangles that stood for the vulva.

It is this female creative energy that is embodied in the first plate on the table, that of the *PRIMORDIAL GODDESS*. Her plate symbolizes the original feminine being from whom all life emerged; for there was a time when there seemed to be no distinction between this Primordial Goddess, the Earth, and Earth's daughter, Woman.

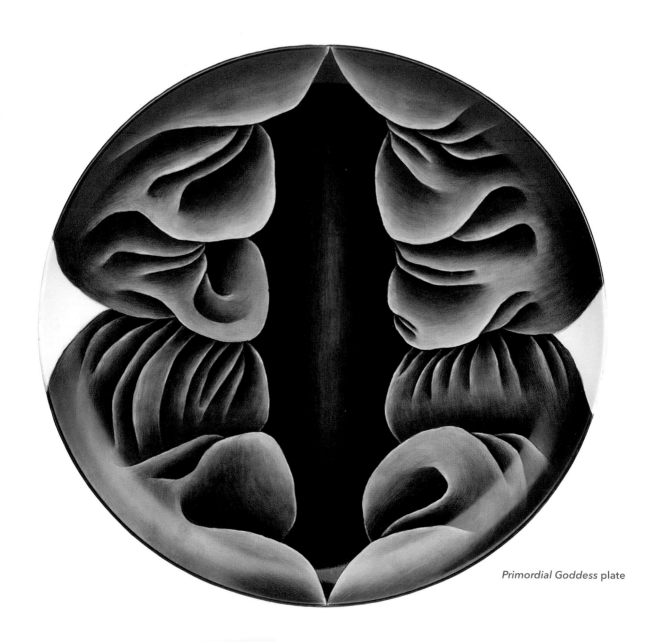

Primordial Goddess plate

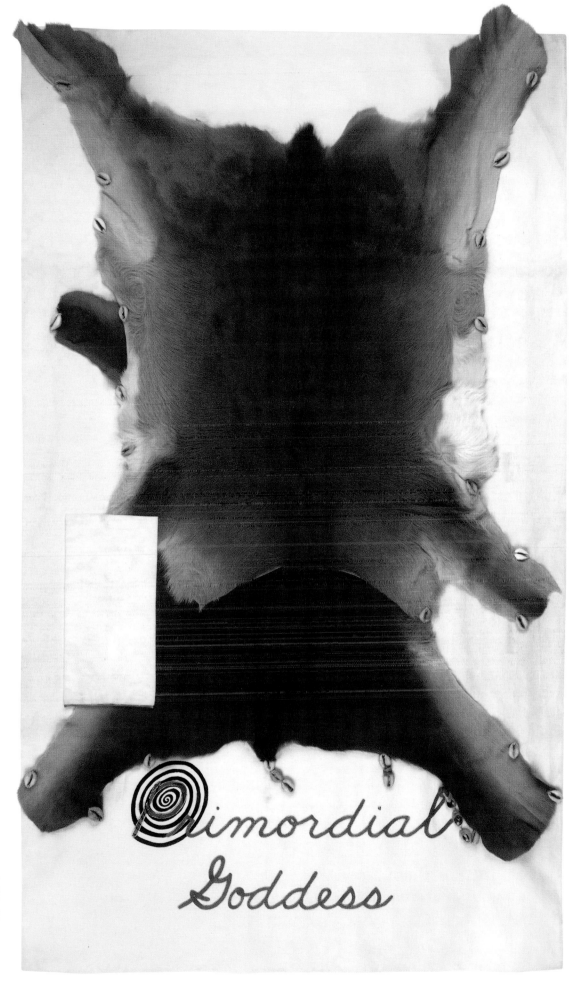

Primordial Goddess runner

Primordial Goddess place setting

Grouped around the place setting for the PRIMORDIAL GODDESS are the names of other early Goddess figures. Goddesses of one culture sometimes reappeared under different names in later societies; eventually, female deities were overshadowed by male gods who assumed their attributes and were finally eclipsed by the ascendance of the single male deity who dominates the Judeo-Christian tradition.

Ajysyt
MYTHIC; SIBERIA

Ajysyt, whose name means "birth giver," was the Siberian Goddess of Birth. She also appeared in many prayers as the "Milk Lake Mother," an apparent reference to the mythical divine lake, the life source that has been said to exist beside the Tree of Life in the center of the earth.

Aruru
MYTHIC; BABYLONIA

The Earth Goddess Aruru was known as "The Potter" and "The Shaper" in Babylonian mythology. When the god Marduk wanted to create the earth, he called on Aruru to help him form the human race out of clay.

Atira
MYTHIC; NORTH AMERICA

Atira, specific to the Pawnee, is one of the many "Mother Earth" or "Universal Mother" figures venerated by the native peoples of North America. It was she who was thought to have brought forth all life and into whose body all life would return at the end of its appointed time. Her symbol was the ear of corn.

Eurynome
MYTHIC; GREECE

Eurynome, "Goddess of All Things" and the most ancient Greek goddess, is described in the creation myth of the Pelasgians, an agricultural people who populated Greece before 1900 BCE. Eurynome rose naked out of chaos, divided the sea from the sky, began to dance on the waters, and by her ecstatic movement created the North Wind. Grabbing the wind, she rubbed it between her hands, thus producing the great serpent Ophion, who coupled with her. Then the goddess assumed the form of a dove and laid the universal egg, from which all creation hatched.

Gaia
MYTHIC; GREECE

Gaia, a Greek version of the mythic Earth Mother, sent up fruits from the soil to nourish the human race and was said to descend from the deities of ancient religions, which viewed the feminine earth as the source of all life and the home of the dead. According to Greek creation myths, Gaia originally emerged from chaos and gave birth to her husband, Uranus (or Heaven), the mountains, and the sea. Every aspect of the natural world was thus part of her being.

Gebjon
MYTHIC; SWEDEN

A fertility goddess, Gebjon or Gefion was identified as "The Giver," who provided the king so much pleasure through her knowledge of magical arts that he offered her as much land as she could mark out in a day and a night. She dug the plowshare so deeply that it tore away the entire crust of the earth, leaving a lake and an island.

Ilmatar (also known as Luonnotar)
MYTHIC; FINLAND

The Virgin Daughter of the Air, Ilmatar was considered responsible for all creation. Myths say that because she became tired of floating alone in space, Ilmatar threw herself into the ocean, where she remained for 700 years. Submerged just beneath the waves, she saw a duck, and allowed her knee to break the water's surface. There the duck made a nest, and from its seven eggs she created heaven and earth.

Nammu
MYTHIC; SUMERIA

Known as the "Controller of the Primeval Waters," Nammu existed at a time when the Sumerians conceived of all life as having arisen from the union of the Goddesses of Water, Air, and Earth. Nammu was said to have given birth to all the other gods and goddesses and, with their help, created human beings from the cosmic clay which supposedly hung over the abyss.

Neith
MYTHIC; EGYPT

Neith (also called Nit, Net, and Neit) was a local divinity of Sais, the capital city of Egypt in the seventh century BCE. A virgin goddess, she was described as self-created and self-sustaining, playing a primary role in creation by causing all matter to come into existence and flourish. In another incarnation, Neith was called the "Great Weaver," who wove the world on her loom as a woman weaves cloth. She was often represented as a goddess of hunting whose attributes were the bow, shield, and arrows.

Ninhursaga
MYTHIC; SUMERIA

Ninhursaga (Ninhursag), the ancient Earth Goddess of Sumeria, was originally called "Mother of the Land." Her life-giving powers were symbolized by twigs sprouting from a "horn-crown" (ears of corn over her shoulders) and a cluster of dates from the Tree of Life symbol held in her hand. With her son/lover, she was thought to have produced all plant and animal life on earth.

Nut
MYTHIC; EGYPT

The Pyramid Texts (a collection of Egyptian mortuary prayers intended to protect a pharaoh in the hereafter) contain a beautiful description of Nut (Nuit) as a woman whose elongated body is arched to vault the earth from her fingertips to her toes. Referred to as "The Goddess of the Sky," she was depicted as a woman along

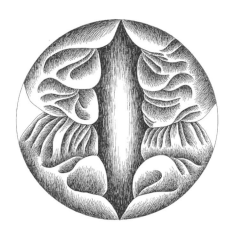

whose body the sun traveled, her star-studded belly holding all the constellations and forming the curved dome of heaven. It was said that Nut gave birth each morning to the sun and every evening to the stars, and she was believed to have been present at the creation of the universe.

Omeciuatl

MYTHIC; MESOAMERICA

Omeciuatl or Omecihuatl, the Lady of Our Subsistence, was originally considered the direct creator of the spirit of human life and the source of all nourishment. The most ancient Mexican creation myth states that the original Goddess Omeciuatl gave birth to a sacrificial knife made of obsidian; this knife fell upon the northern plains, from which sprang sixteen hundred goddesses and gods.

Siva

MYTHIC; RUSSIA

Siva, worshiped as the "Great Goddess of Life," was represented seated, with an ornamental headdress suggestive of the sun's rays. Shoulders and chest bared and wearing flowing skirts, Siva held a sheaf of wheat in her left hand and a pomegranate in her right, both symbols of the fertility of the earth as embodied in the female.

Tefnut

MYTHIC; EGYPT

Tefnut was one of the nine deities who formed the divine pantheon in Egypt. She was worshiped in the form of a lioness or as a woman with the head of a lioness. Tefnut was described as the "Goddess of Dew and Rain," and she was also considered to be the left

Primordial Goddess
illuminated capital letter

eye of the sun or its reflective aspect, as represented by the moon. She and her brother/husband Shu, the "Dry Atmosphere," symbolized the opposite forces which, according to Egyptian beliefs, had to unite to produce life.

Tiamat

MYTHIC; BABYLONIA

Like her Sumerian predecessor Nammu, Tiamat held a primary place in Babylonian creation myths, for all the later principal gods were said to have issued from her. Moreover, her story aptly demonstrates the takeover of female-centered creation tales by male gods. In the beginning, there existed only Tiamat, who represented the blind forces of primitive chaos against which male gods struggled but could not overcome. She was eventually killed in a great cosmic battle by one of her descendants, the god Marduk. Although he would claim to be the sole creator of heaven and earth, he actually dismembered Tiamat's body in the creation process, a graphic symbol of the destruction of the Goddess that predated the rise of patriarchal religions.

Fertile Goddess

From a generalized concept of the universe as an amorphous, feminine being with all creatures merged into one force, humans gradually became able to recognize themselves as distinct beings. However, because people did not yet fully understand the biological processes of reproduction, it seemed as if all that sustained human life emanated from women. Awe of the universe, which had once informed most human actions, was transferred to woman herself, whose body was seen as the symbol of birth and rebirth as well as the source of nourishment and protection.

Women's generative power was embodied in a multitude of female figurines that emphasized breasts, belly, hips, and vulva. Images of this "fertile woman" or "fertile goddess" have been discovered underneath the remains of civilizations the world over. Called "Venuses," these small, faceless icons were worshiped by women and men alike as the expression of a Mother Goddess religion that was spread by migrating peoples. These evocative female representations and all they suggest in terms of reverence for women were the source for the image of the *FERTILE GODDESS*.

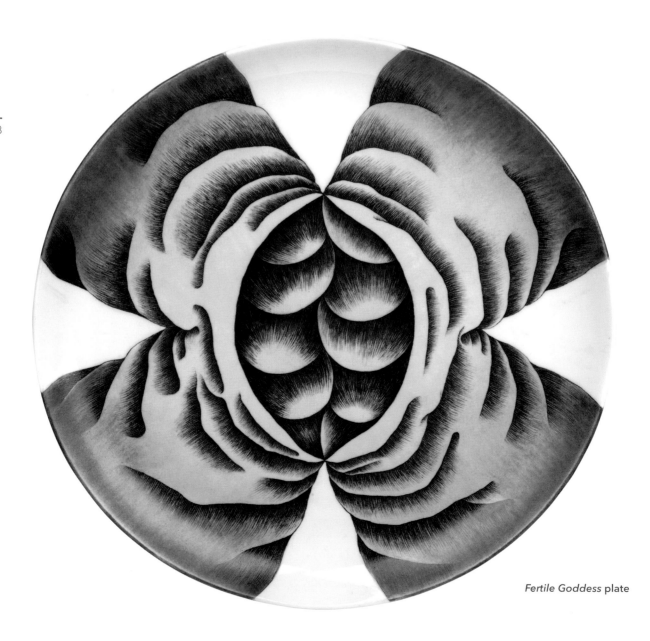

Fertile Goddess **plate**

Fertile Goddess runner

Assembled around the FERTILE GODDESS are the names of other Goddess figures that embody the worship of women's procreative functions, often projected onto the magical properties of various goddesses. The gradual loss of status of the Goddess can be seen in the myths associated with these various deities.

Bona Dea
MYTHIC; ROME

Bona Dea, the "Good Goddess," was an agricultural divinity who originally represented the procreative principle in nature. A festival to ensure prosperity was held in her honor every December, from which men were excluded. Also considered a healing goddess, she was portrayed sitting on a throne holding a cornucopia. Bona Dea's stature was diminished by later Roman society, which referred to her merely as Fauna, the daughter of the Roman god Faunus.

Brigid
MYTHIC; CELTIC IRELAND

The "Goddess of Plenty," Brigid was an ancient Irish fertility goddess associated with the fruits of the earth as well as with the fire and the hearth. Although reverence for the Mother Goddess never entirely died out in Celtic Ireland, with the advent of Christianity many of this particular Goddess's attributes became associated with St. Bridget, the patron saint of culture, skills, and learning, who is represented on *The Dinner Party* table.

Cardea
MYTHIC; ROME

Originally described as the "Goddess of the Changing Seasons," Cardea was thought to rule over the "celestial hinge" at the back of the North Wind, where the universe was said to revolve. Also known as the "Queen of the Circling Universe," she held the keys to the Underworld. Later legends say that Cardea was captured by the Latin god Janus (an early form of Jupiter) and forced to become his mistress—then his wife. Janus gradually assumed her characteristics until Cardea was relegated to a subordinate position and assigned the menial task of keeping witches away from the nursery door.

Danu
MYTHIC; CELTIC IRELAND

Danu, the "Goddess of Plenty," was originally considered the universal mother who represented the earth and was also associated with the moon. Thought to watch over crops and cattle, she was described as having given birth to the Irish deities who presided over the Tuatha de Danaan, a confederacy of tribes in which kingship descended through matrilineal succession. Later, the gender of this Goddess was transformed, along with her name, which became Don. In Roman records, Don became Donnus, the divine father of a sacred king.

Freya
MYTHIC; NORWAY

Freya, the Goddess of love, marriage, and fecundity, was originally said to be the daughter of the Earth Mother, Nerthus. At some point in the development of Norwegian mythology, Nerthus was replaced by the god Niord, who came to be considered the sole creator of Freya and her brother Frey. Later, Freya would be identified with the Goddess Frig, losing her original status, but retaining a limited role as the "Goddess of the Atmosphere and Clouds" and the wife of the sky god Odin.

Frija
MYTHIC; GERMANY

Although goddesses did not appear to play as primary a role in Teutonic mythology as they did in other cultures, Frija (also called Friia or Frea) is the one Goddess who seems to have been revered by all the Germanic tribes.

Described as the "Goddess of Marriage, Love, and the Home," she was considered omniscient and in control of nature.

Hera
MYTHIC; GREECE

Hera, the Greek Goddess who presided over all aspects of feminine existence, was originally thought of as the "Queen of Heaven" and the "Celestial Virgin." After her marriage to Zeus, she was worshiped as the chief feminine deity of Olympus. At some point she was stripped of her cosmic attributes, viewed primarily in relation to marriage and maternity, and thereafter considered the protectress of women in childbirth. Later, in classical Rome, she was known as Juno.

Juno
MYTHIC; ROME

Etruscan, Sabine, and Umbrian tribes venerated Juno as a moon Goddess. Her attributes were associated with childbirth, though in time she came to be identified with all aspects of women's lives. Regarded as a female guardian angel, her worship carried on until after the time of Christ, although in reduced form. She became a symbol of the Roman matron and the sister and consort of Jupiter (the Roman counterpart of Zeus).

Macha
MYTHIC; CELTIC IRELAND

According to legend, Macha—fertility Goddess, fearful warrior queen, and the patron of the capital city of Ulster (then known as Emhain Macha)—was forced to race against a team of horses, despite being pregnant. Although she won, she died soon after giving birth to twins. On her deathbed, she imposed a curse on the warriors of Ulster: for nine generations whenever they attempted to fight, they would be stricken with childbirth pains, so they would experience the same agony Macha had suffered before she died.

Madderakka
MYTHIC; LAPLAND

It was said that the three daughters of Madderakka, the "Goddess of Childbirth," assisted her in creation. Although she was originally regarded as the mother of all deities, Madderakka, like many other goddesses, was accorded less power as time passed.

Fertile Goddess **place setting**

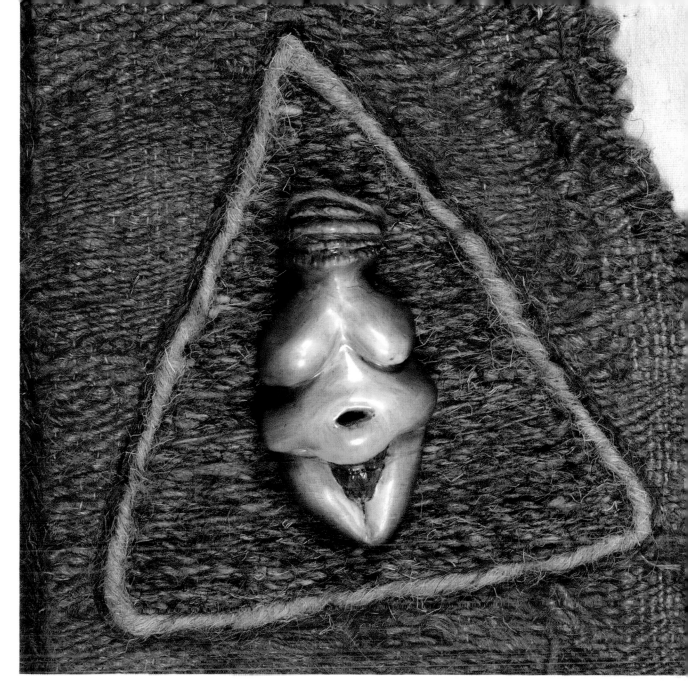

Detail, *Fertile Goddess* runner top

Nerthus

MYTHIC; OLD ENGLAND, GERMANY

Veneration of the Earth Mother Nerthus spread from the Near East and the eastern Mediterranean to old England, southern Denmark, and northern Germany where, in the late first century CE, she was referred to as "Terra Mater." She was represented as a woman with a gold collar around her neck, flanked by two oxen. In an annual ritual thought to ensure good crops, her image was taken around the countryside in a wagon pulled by oxen, which stopped frequently to allow prayers and feasting. Nerthus was eventually transformed into the god Niord and some of her attributes were taken over by his son, Frey.

Ninti

MYTHIC; SUMERIA

According to legend, the goddess Ninhursaga allowed eight lovely plants to sprout in Paradise. Though it was forbidden to eat these, Enki, the water god, did so. Ninhursaga, angry at Enki's defiance, condemned him to death and he fell ill. The goddess decided to take pity on him, creating eight special healing deities, one for each of his afflicted organs. Ninti was to cure his rib. This myth was later transformed into the story of Eve's birth from Adam's rib.

Tellus Mater

MYTHIC; ROME

In ancient times, Tellus Mater or Terra Mater was a goddess of fecundity, similar to the Greek Gaia. She was seen as Mother Earth, presiding over the common grave of all living things, and representing the presumed parallel between the fruitfulness of woman and the earth. Tellus Mater eventually became associated with Jupiter, the principal male deity of the Roman Empire.

Ishtar

The Great Goddess Ishtar was worshiped for thousands of years in Mesopotamia as the supreme giver and taker of life; the women who served as her priestesses were considered her incarnation. Each year, the priest or king mated with these priestesses in the "sacred marriage." If the male partner pleased the Goddess through this union, he maintained his authority; this would also ensure the fecundity of the land, the prosperity of the community, and the continuation of the cosmos. Some of the cultures that venerated Ishtar were highly developed civilizations. But as these societies perfected the art of weaponry, they became increasingly male-dominated, and the identity of the Goddess began to undergo a transformation, as she came to be viewed as responsible for the victories of the warrior-king. This newfound association was dubious; traditionally, the Goddess had represented a benevolent force. With this change, women's position was steadily more circumscribed, as reflected in the Code of Hammurabi (the first written code of laws in human history) crafted at this same time.

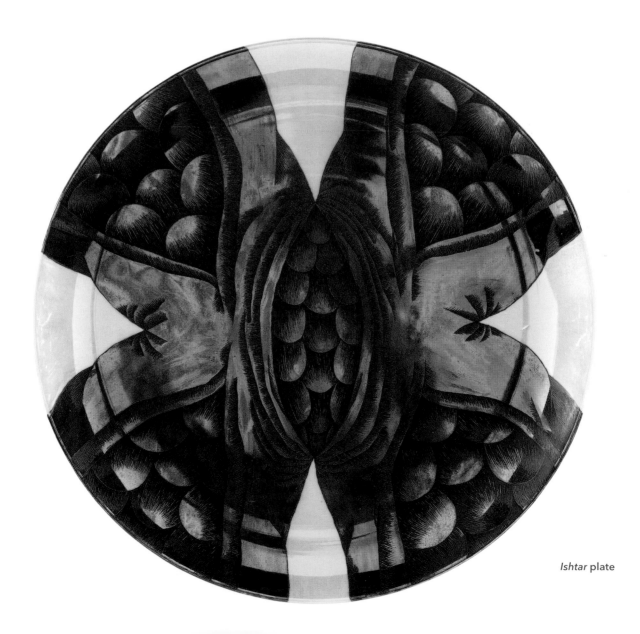

Ishtar plate

Ishtar place setting

In addition to commemorating other female deities whose power was comparable to that of Ishtar, the names that appear in relation to her place setting reflect the ways that the concept of the Goddess was changing. Historical figures are also included, some of whom served as priestesses or remained devoted to Goddess worship.

Amat-Mamu

CIRCA 1750 BCE; BABYLONIA

It has long been known that the earliest writing system in the world was Sumerian script, but there has been little acknowledgment that women as well as men participated in record-keeping. Amat-Mamu was an official scribe who lived in a community of 140 priestesses at Sippar. Her name shows up repeatedly in their documents, which attests to her importance as a scribe and to the prominent role she played at this religious institution.

Anahita

MYTHIC; PERSIA

Anahita was closely identified with Ishtar in that she had a fearful as well as a beneficent aspect. She was sometimes associated with the planet Venus and described as the "Goddess of Springs and Rivers," whose life-giving waters were thought to ensure fertility. Iranian texts from as late as the fourth century CE state that she was in charge of the universe, referring to her as the "Queen of Heaven."

Anath

MYTHIC; CANAAN

Anath or Anat, a Goddess of fertility and love as well as of war, was said to have shared her position with Asherah, the Goddess of sexuality and procreation. Both goddesses played important roles in the resurrection myths that chronicle the struggles of the rain god Baal against his adversary Mot, the god of sterility and drought.

Aphrodite

MYTHIC; GREECE

Aphrodite, the Greek Goddess of love and beauty, originally ruled over nature like her predecessors Ishtar and Astarte. According to myth, Aphrodite gave her son Adonis to Persephone, the Goddess of the Underworld, for protection. Because she was enamored of Adonis, Persephone refused to return him until Zeus decreed that Adonis could spend half the year on earth and the other half with her. Gradually, Aphrodite's identity as a love Goddess became fragmented. As Aphrodite Urania, she represented what was considered the "highest" form of love, particularly wedded love and fruitfulness. As Aphrodite Paudemus, she was considered a Goddess of "lust" and the patron saint of courtesans (who might actually have been descendants of the hereditary priestess class, once considered the representatives of the Goddess but later described as temple prostitutes).

Arinitti

MYTHIC; ANATOLIA

After Indo-European tribes established the Hittite Empire (circa 1900 BCE), Arinitti (Arinnitti) came to be seen as their principal deity, worshiped along with her two daughters and granddaughters. The center of her cult was only 125 miles south of Catal Huyuk in Turkey, site of a matriarchal, agrarian society and home to the earliest Goddess-worshiping society uncovered to date (circa 7th millennium BCE), which has led scholars to believe that the veneration of Arinitti might have been related to the practices of that culture.

Asherah

MYTHIC; CANAAN

Asherah, Goddess of sexuality and procreation, was one of the two principal Earth Goddesses described in the ancient myths of Canaan. Known as the "Mother of the Deities," she was said to rule jointly with her male consort El, with whom she had a son—the weather god Baal, whose power gradually expanded until it eclipsed that of his parents. In vain, Asherah tried to retain her position, and in later myths she attempted to become Baal's consort. But it was Anath—sometimes described as an aspect of Asherah and at other times as her daughter—who became Baal's lover. Although the worship of Asherah was eventually forbidden, she continued to be revered as late as the sixth century BCE.

Ashtoreth

MYTHIC; HEBREW

When the Hebrew tribes invaded Canaan around 1250 BCE, they borrowed the worship of Asherah, renaming her Ashtoreth. The Hebrew counterpart of Ishtar and Astarte, she was considered the "Goddess of Fertility and Reproduction." The widespread worship of Ashtoreth from 1150 to 586 BCE is attested to by archeological and literary evidence; originally, temples to Yahweh (the Hebrew male God) and Ashtoreth existed side by side. This goddess was apparently venerated in the royal household of Solomon and became part of the temple worship during the time of Jezebel. It could be argued that this was one reason why the biblical Levite prophets maligned Jezebel; as part of their patriarchal, monotheistic beliefs they denounced the worship of the Goddess. They also attacked what they called "temple prostitution," perhaps a reference to the continued practice of sacred marriage.

Astarte

MYTHIC; PHOENICIA

Astarte, the Phoenician version of Ishtar, was a powerful fertility Goddess associated with the planet Venus, often represented standing naked on a lion. In connection with her worship, the sacred marriage ceremony was practiced extensively, and she was one of three goddesses mentioned in the texts of biblical Canaan. It has been suggested that these goddesses symbolized three aspects of womanhood: Asherah, mother and protector; Astarte, mistress and lover; and Anath, virgin daughter and warrior. Astarte is

often associated with her lover, Adonis. Every year the Phoenicians celebrated his death and resurrection at a natural woodland sanctuary dedicated to Astarte. This myth was borrowed by the Greeks as the basis for their account of the similar relationship between Aphrodite and Adonis.

Baranamtarra
CIRCA 2500 BCE; SUMERIA

Baranamtarra, who ruled the city of Lagash with her husband, was known by the honorific title "The Woman." Lagash and other important cities such as Ur and Mari were temple and palace communities that evolved during the early dynasties in Sumeria. One of the earliest known female philanthropists, Baranamtarra is said to have donated money to religious groups that worshiped the Mother Goddess.

Blodeuwedd
MYTHIC; WALES

Because she was often imaged as a fragrant, seductive blossom being pollinated by a bee, Blodeuwedd was known as the "Goddess of the White Flower." A moon and love Goddess, she was part of a transmuting trinity of Goddesses which also included Cerridwen and Arianrhod, the Underworld Goddess, who is said to have conceived the sun god Llew Llaw Gyffes. According to legend, Arianrhod then adopted the form of Blodeuwedd and persuaded the sun god to be her partner in a sacred marriage. After consummating this union, Llew Llaw Gyffes was sacrificed in honor of the summer harvest; his soul took the form of an eagle and he was restored to life. Arianrhod then assumed her original identity while a new child developed In what was described as her dark womb. In this classic resurrection myth, the son issues from the Goddess, reaches maturity, unites with her then dies, only to be reborn.

Cerridwen
MYTHIC; WALES

Cerridwen was considered a barley and moon Goddess who symbolized the continuous cycle of life and death in the progression of the seasons. She was also called the "White Sow" because pigs, which have crescent moon-shaped tusks, were generally associated with her and frequently sacrificed in her honor. She and her sister deities, Arianrhod and Blodeuwedd, were thought to possess a magic liquid that gave the gift of inspiration to anyone who drank it.

Cybele
MYTHIC; PHRYGIA

Referred to as the "Mountain Mother," Cybele was said to personify the earth in its primitive state. She was often depicted in a turreted crown, seated on a throne flanked by lions. By 1000 BCE, worship of Cybele and her son/consort Attis had become widespread. Religious rites involved an annual vegetation-resurrection festival that became associated with a group of eunuch priests, who considered themselves the servants of Attis. Their goal was to attain immortality through mystical identification with the Goddess, which was accomplished in an altered state of consciousness through ecstatic dancing, which supposedly resulted

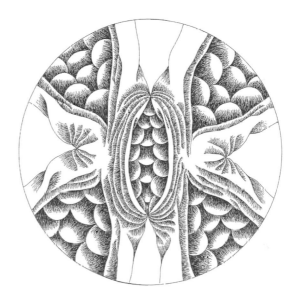

in voluntary castration. If this legend is true, it would have been a perversion of traditional Goddess worship, which was generally life-affirming rather than destructive.

Encheduanna
CIRCA 2050 BCE; SUMERIA

Encheduanna or Enheduanna, the earliest recorded poet, was both a high priestess and a member of the ruling class. Presumably, Encheduanna performed ritual sacrifices in the temple and fulfilled the role of the bride in the sacred marriage rites. As was customary, she would prepare for the sexual ceremony by writing hymns to the Goddess, taking a luxurious bath, applying fragrant oils, and adorning herself with jewelry. Unfortunately, none of her poetry is extant.

Hannahanna
MYTHIC; HITTITE EMPIRE

Hittite mythology recounts that Hannahanna (Hannahannas), known as "The Grandmother," played an important role in one of the religious ceremonies of the people of Hatti. A young fertility god became angry with the queen and stormed off, causing the crops to die and the life process to stop. Hannahanna sent a bee to recover him. Upon the god's return, she used magic spells to ensure his reconciliation with the queen, whereupon life was regenerated. Thus, Hannahanna was thought to have protected the fertility of the earth and secured the perpetuation of the human race.

Hathor
MYTHIC; EGYPT

As a primary Goddess in the Egyptian pantheon, Hathor was considered the mother of the sun god, whose human incarnation as the pharaoh she suckled and protected, thereby symbolically passing to him the hereditary right of kingship as her son. Hathor, one of the oldest deities of Egypt, was worshiped as a cow, an animal with great fertility significance dating back to prehistoric times. Hathor also came to be regarded as a protector of the dead, supposedly giving sustenance to whoever appealed to her for a happy life in the hereafter.

Iltani

CIRCA 1685 BCE; BABYLONIA

Iltani, a wealthy priestess from a royal family, enjoyed an influential position during the First Dynasty of Babylon. She belonged to a special class of priestess known as "nadiatum," most of whom did not marry. Many were connected with a religious community such as the one at Sippar, where the Babylonian scribe Amat-Mamu lived.

Inanna

MYTHIC; SUMERIA

Described as "The Queen of Heaven" in the Sumerian pantheon, Inanna was an earlier version of the Babylonian Ishtar. As "Goddess of Love and Fertility," she represented the life-producing mother who extended her reproductive power to all the plants and animals on the earth. This Goddess was thought to play a dominant role in the life process, while her son/consort was of secondary importance. It was only after he proved himself in her bed that the Goddess allowed him to become king. As late as 2040 BCE, kingship continued to be bestowed by priestesses of Inanna through the sacred marriage ceremony.

Isis

MYTHIC; EGYPT

In early Egypt, the royal family's lineage was matrilineal. Consequently, the pharaoh gained his title through marriage to his sister, who was identified with the Goddess Isis, whose name means "the throne." The extent of her power was so vast that she was thought to rule heaven, earth, the sea, and the underworld. Isis was one of the most widely venerated deities of Egypt; as her earthly representative the queen symbolized the continuing female vitality inherent in the throne. She was often represented with her son Horus seated on her lap. In this maternal aspect, Isis became identified with the Cow Goddess (Hathor or Neith), and her worship spread to western Asia, Greece, and Rome.

Kubaba

CIRCA 2573 BCE; SUMERIA

Originally an innkeeper and beer seller, Kubaba (also Kug-Baba or Kubau) rose to power during a volatile political time and is said to have founded the Third Dynasty of the city-state of Kish, becoming one of the few independently reigning queens in the ancient Near East. Her dynasty retained power for nearly one hundred years and she became a legendary figure in Sumerian history.

Shibtu

CIRCA 1700 BCE; BABYLONIA

The official correspondence of Shibtu, queen of the kingdom of Mari, suggests that she played a significant administrative role in the affairs of state. The queen is known to have secured the release of a number of women from debtors' prison, and when the king was away on military campaigns or inspection tours, she conducted royal business and oversaw diplomatic relations.

Shub-Ad of Ur

CIRCA 2500 BCE; SUMERIA

Queen Shub-Ad (also known as Pu-Abu) lived during the First Dynasty of Ur, when city-states had replaced matrilineal kinship groups based upon communal ownership of land. Even though men were gradually gaining control over the temples, Sumerian queens still fulfilled the triple roles of queen, priestess, and musician. Queen Shub-Ad seemed to have had considerable power, suggested by the staggering wealth discovered in her royal tomb. Scholars believe that these assets were hers, primarily because her tomb bears an identifying inscription, while that of her consort/king's does not—a discrepancy which seems to imply her primacy.

Tanith

MYTHIC; CARTHAGE

A winged "Goddess of Heaven," Tanith (Tanit) was the primary Goddess worshiped at the Phoenician colony of Carthage in Africa. Depicted on numerous stelae, she was frequently shown standing beneath the vault of heaven and the zodiac. Tanith, who was associated with the male fertility god Ba'al-Hammon, was frequently referred to as the "face of Ba'al." Because the word Ba'al means "god" or "lord," it is possible that Tanith herself was regarded as a god (a term for which the word Goddess is not an adequate parallel) or that she ruled interchangeably with Ba'al-Hammon.

The Dinner Party, installation view, Wing One

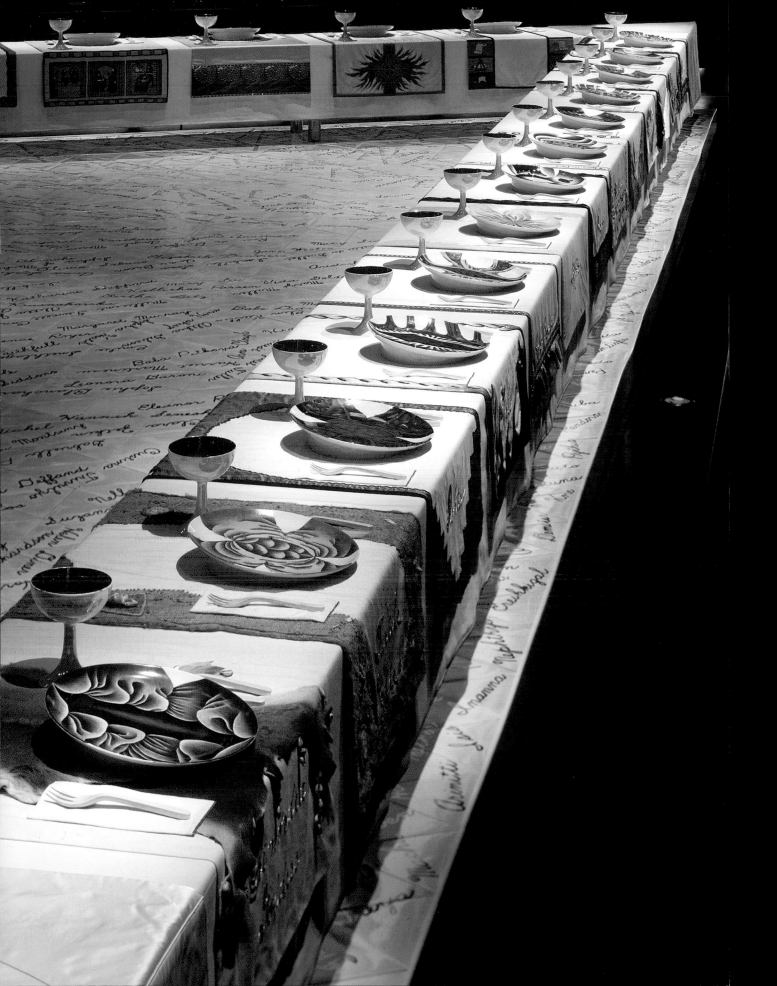

Kali

Although *The Dinner Party* was not intended to include women outside Western civilization, the Indian goddess Kali provides a dramatic representation of what has been considered the destructive aspect of the Mother Goddess, an idea that took hold as society became male-dominated. Because female power continues to be viewed negatively, it seemed important to represent it.

Despite the fact that the Kali figure has a number of counterparts in other cultures, rarely—except perhaps in South America—has she been so clearly depicted as a demonic figure as in Indian art, where she is usually presented as a fierce, hideous creature who rejoices in drinking the blood of those she destroys.

Kali began to be worshiped by the Hindu religion during the first millennium BCE, at a time when women's power was being assaulted. When Hinduism became established, so did a rigidly patriarchal family system. Women lost educational opportunities along with all rights and could look forward only to marriage and children.

In most ancient myths, the Goddess was thought to possess the power of both life and death, and even though it was considered awesome, it was seen as essentially positive. Gradually, the "death" aspect of the Mother Goddess became instead a separate and terrifying entity. It is this change that the *KALI* place setting symbolizes.

38

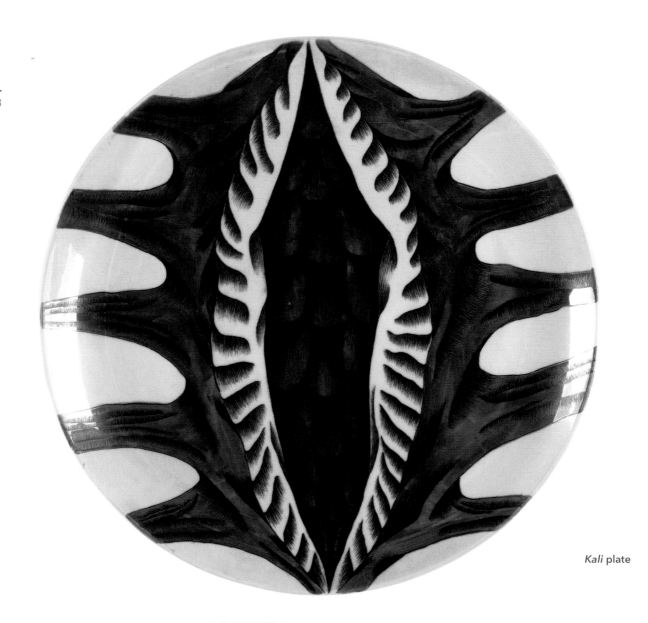

Kali plate

Kali runner

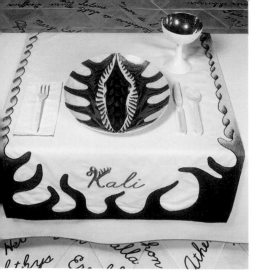

Kali place setting

Grouped around the place setting for KALI are other goddesses and female figures who have been depicted as harmful or have exemplified a so-called devouring female energy.

Alukah

MYTHIC; CANAAN

Alukah represented the darker side of the Mother Goddess in Canaan culture, which flourished between the Jordan, the Dead Sea, and the Mediterranean around 1400 BCE. Alukah was depicted as a succuba or vampire, and her two daughters were "Sheve" and "The Womb" (Death and Life).

Arianrhod

MYTHIC; WALES

Arianrhod had multiple incarnations as the destructive aspect of the Earth Mother Cerridwen and as another form of her sister Blodeuwedd. It was said that Arianrhod—who was symbolized by a curved sliver of both the new and the waning moon—ruled over the double spiral (representing the continuous cycle of death and rebirth) in the tomb beneath Cerridwen's castle-fortress. Because Arianrhod was also characterized as a virgin Mother Goddess who gave birth to new life as the great "Wheel of Heaven" revolved, the dead supposedly went to live in her castle with hopes of resurrection.

Coatlicue

MYTHIC; MESOAMERICA

Coatlicue, the Aztec Earth Goddess, was often depicted with a death's head, wearing a serpent-woven skirt, her hands raised in an awe-inspiring gesture. Her image reflected the way in which life and death were believed to be profoundly interconnected: She who gives life is also the life-taker.

Ereshkigal

MYTHIC; SUMERIA

According to Sumerian myths, Ereshkigal, the Goddess of death, originally reigned over the subterranean world and—with the exception of her sister Inanna—no one who entered her realm was ever allowed to leave it. Nergal, the god of war and hunting, failed to properly honor Ereshkigal at a banquet of the deities and then subsequently invaded her domain in response to the Goddess's demand for his death as retribution. With fourteen demons helping him, Nergal dragged Ereshkigal from her throne and threatened to cut off her head. In an effort to save her life and achieve peace, she offered to share her throne with him. This story was later transformed into the Greek myth that posits the male god Hades rather than Ereshkigal as the ruler of the netherworld.

The Furies

MYTHIC; GREECE

In their more benevolent Underworld aspect, The Furies—winged women with snakes entwining their bodies—were considered the forces that worked to generate life and send it upward. They figured prominently in the myth of Orestes, who killed his mother Clytemnestra in vengeance for her murder of his father Agamemnon. According to the laws of mother-right, Clytemnestra's act was not a crime because Agamemnon was not her direct blood relation, whereas The Furies pursued Orestes because they considered his deed of matricide unforgivable. His acquittal by the Goddess Athene enraged them, and they decided to hide in the subterranean depths in order to destroy the fertility of the earth should any further crimes be committed against women. This threat was considered to be serious because, when angered, The Furies had the power to inflict sterility, crop failure, and disease.

Hecate

MYTHIC; GREECE

Hecate was regarded as the invincible "Queen of the Underworld" who ruled with Persephone and Hades. As the triple-headed "Goddess of the Moon," she personified the new, full, and waning moon, which were thought to represent the three phases of a woman's life: young girl, mature woman, and old hag. In her incarnation as the "Old Hag of the Subterranean Depths," she was worshiped by witches, who in early times were simply women who practiced healing by means of medicinal herbs and incantations.

Hel

MYTHIC; NORWAY

Hel was the name applied to both the territory of the Underworld and its presiding goddess, who was thought of as a vague and shadowy figure, frequently represented by a face that was half human and half obscured by darkness. She was said to possess a vast palace where she received those heroes and deities who descended into the Netherworld.

Irkalla

MYTHIC; BABYLONIA

A "Goddess of the Underworld," Irkalla was sometimes said to be Ishtar's sister. Possessing the head of a lioness (Ishtar's sacred animal) and the body of a woman, she was often depicted grasping a serpent in her hands. Her kingdom was known as the "Land of No Return" where the dead existed by eating dust and mud. Ishtar and Irkalla were said to be the connecting links between life and death; the former was thought to possess the power over both life and death, while the darker side of female potency was embodied in the latter.

Morrigan

MYTHIC; CELTIC IRELAND

Morrigan, known as the "Great Queen," was actually a transmuting trinity of three warrior goddesses: Macha, who took the form of a raven; Badb Catha, "The Cauldron;" and Anu, the "Old Hag." Accompanied by her prophetic raven of death, Anu—who represented the supernatural power of Morrigan—stood eternal watch over a boiling kettle in which bubbled the ever-changing faces of life and death. Celtic warriors invoked the power of this triple god-

dess to watch over them by blowing on their war horns in imitation of a raven's croaking.

Nephthys
MYTHIC; EGYPT

The sister and companion of Isis, Nephthys was the "Goddess of the Dead" and one of the nine deities of the divine pantheon of Egypt. The daughter of the earth and the sky, she represented the twilight and, like Isis, was described as having occupied a place in the "Boat of the Sun" at the time of creation. Although a death Goddess, Nephthys was not viewed as a negative deity, perhaps because— even though the Egyptians dreaded the idea of decay—they did not fear death itself.

The Norns
MYTHIC; NORWAY

The Norns—Urda, Verdandi, and Skuld— were considered the three "Goddesses of Fate" who balanced the forces of life and death. Described as female giants who represented the past, present, and future, their job was to sew the web of fate and to water the sacred ash tree, whose roots reached down into the subterranean depths of the earth.

Rhiannon
MYTHIC; BRITAIN

Called the Great Queen, Rhiannon ruled the underworld jointly with her husband, the god Pwyll. Depicted as a mare-headed goddess who fed on raw flesh, her demonic appearance represented the terrifying aspect of the Great Goddess, who was sometimes symbolized as a horse.

Tuchulcha
MYTHIC; ETRURIA

Transposed from Etruscan mythology, Tuchulcha came to be considered the principal female demon of the Roman Underworld. She was usually depicted with ferocious eyes, a beak instead of a mouth, and the ears of a donkey. Two serpents wound around her head, and another snake encircled her arm.

The Valkyries
MYTHIC; GERMANY

The Valkyries included thirteen armored maidens who were like the German counterparts of the Amazons. Dispensers of destiny, they watched the progress of battles and chose the winners. In their benevolent function, they were thought to lead the souls of dead war heroes back to the kingdom of Valhalla. It is possible that the presence of female warriors in Teutonic mythology reflected the fact that early German women were reputed to have participated in warfare, something that was discovered only when their corpses were stripped of their armor by conquering soldiers.

41

Kali runner back

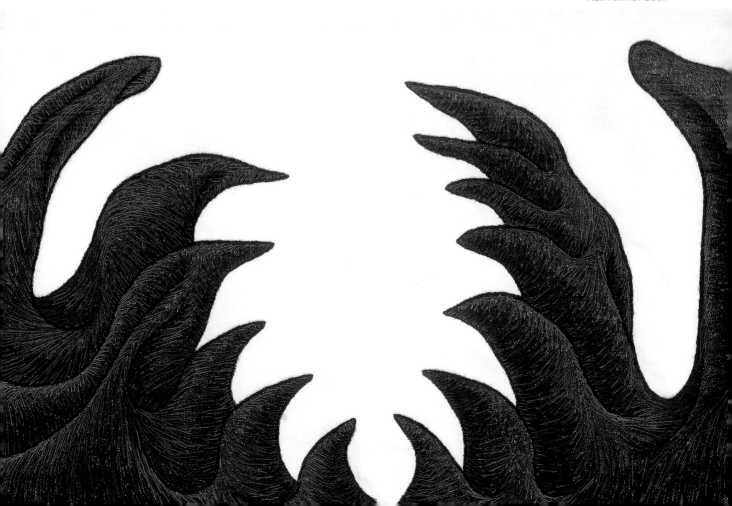

Snake Goddess

When I was studying art history, the Snake Goddess really spoke to me, probably because—as I would later learn—Crete was a matriarchal society and the relationship between women and snakes had its origins in the early Goddess religions. The snake was seen as the embodiment of psychic vision and oracular divination—traditionally considered to be part of women's magical powers—and was connected to a succession of Goddesses for thousands of years. The priestesses of the Goddesses served as advisors to their societies, solving the problems that were presented to them by entering trance states achieved by fasting and through snakebites or the administration of snake venom. In such altered states, the priestesses were considered to be in direct communication with the Goddess.

Until 1400 BCE Crete was organized around a female totem system of clans; here the snake aspect of Goddess-worshiping religious rituals reached its highest development. Venerated as a protector of the household, the snake represented the wisdom of the Goddess; was associated with life, death, and regeneration; and was considered the reincarnation of a dead family member. Once the male role in procreation was understood, the snake came to symbolize the male principle. But in Crete, the male consort/son was always subordinate to the Goddess; most sacred scenes depicted the Mother Goddess in conjunction with the Tree of Life.

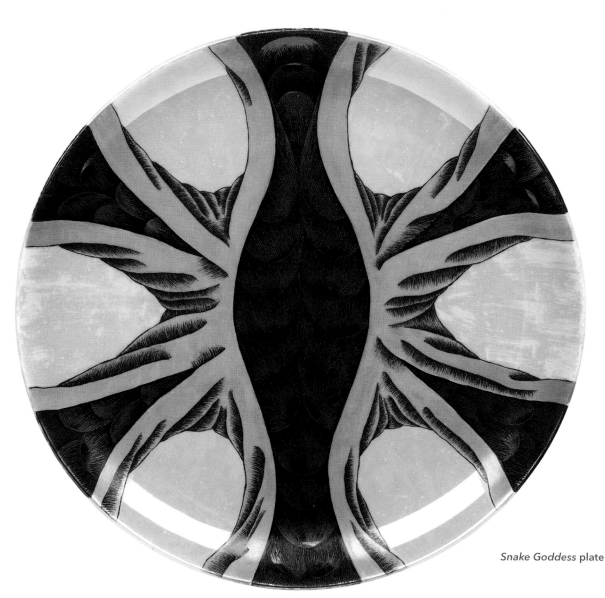

Snake Goddess **plate**

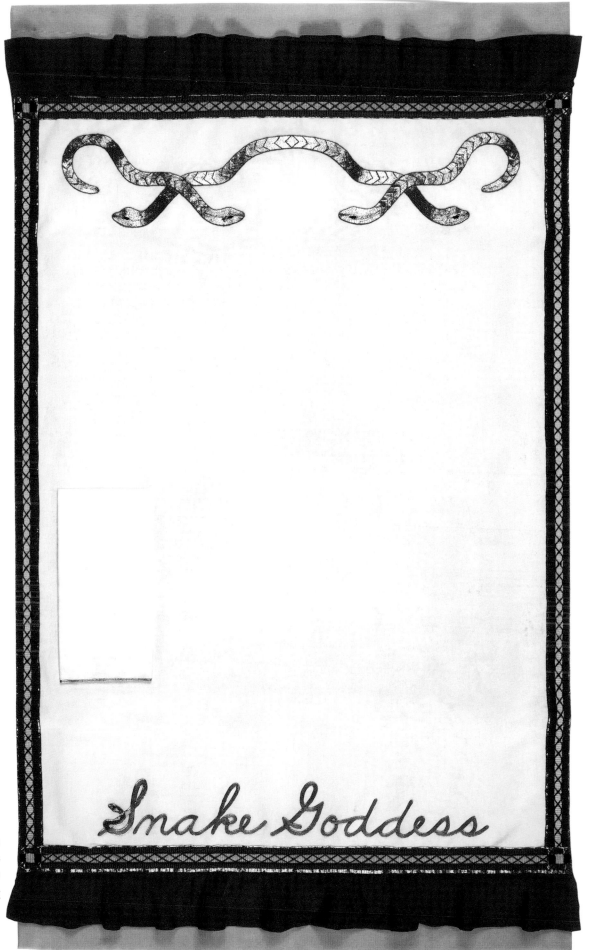

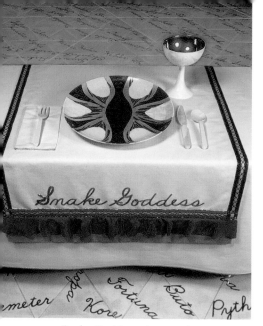

Snake Goddess place setting

Surrounding the place setting honoring the SNAKE GODDESS are the names of other Cretan Goddesses, many of whose legends were incorporated into later Greek myths. In addition, a number of mythological figures are included who were thought to possess characteristics of a snake.

Ariadne

MYTHIC; CRETE

Ancient legends described the worship of Ariadne as involving an orgiastic practice in which a young king was ritually sacrificed as part of a fertility and vegetation rite. The Greek Theseus was said to have volunteered to go to Crete to participate in this rite as a ruse; his real purpose was to overthrow the king. After Ariadne helped Theseus accomplish his goal, they were married. Theseus then wanted her to leave Crete, but she refused, hoping that by remaining she might be able to establish more peaceful relations between Crete and Greece. Theseus abandoned Ariadne on an island near her homeland, symbolically breaking Crete's matrilineal tradition and weakening the government. Eventually, the Dorians invaded Crete, whereupon Zeus was established as the supreme deity in lieu of the traditional Goddess religions.

Artemis

MYTHIC; GREECE

The continued transformation of Goddess figures from matriarchal Cretan to patriarchal Greek and Roman incarnations can be traced through such icons as Artemis. She was originally a widely venerated Mother Goddess figure whose religious rites followed in the Ishtar tradition. One early embodiment of this Goddess was the famous Artemis of Ephesus at the temple known as the Artemision, one of the seven wonders of the ancient world, in present-day Turkey. By the time Artemis appeared in the Greek pantheon of Olympus, she was viewed simply as an agricultural deity. She also became identified with the Roman Goddess Diana; both were connected with the Moon and the hunt and were seen as protective figures. The Goddess Diana was eventually incorporated into the Roman Vesta, whose limited role as a virgin priestess was a pale reflection of her powerful predecessors.

Athene

MYTHIC; GREECE

It is possible that the figure of Athene was derived from the Egyptian goddess Neith, whose attributes were somewhat similar. Athene, a virgin Goddess who was both a warrior and a patron of culture, was also the deity of architects, artists, and weavers, and the protector of the city of Athens. Traditionally associated with the snake—possibly in connection with her role as "Goddess of Wisdom"—numerous images of her contain serpents. By the time Athene became part of the Greek pantheon, she had been transformed from a warrior Goddess into the daughter of Zeus and described as springing full-grown from his head, an inversion of earlier notions of life originating from the Goddess, and her name became Athena after 500 BCE. When Athene acquits Orestes of matricide in Aeschylus's play *The Eumenides*, she symbolically rejects the tradition of mother-right which was gradually being replaced by the laws of patriarchy.

Britomartis

MYTHIC; CRETE

According to later Greek legends, Britomartis, often depicted as a huntress, was one of Crete's most ancient goddesses. She was associated with the moon, which in gynocracies was said to control planting, harvesting, festivals, and religious rituals.

Buto

MYTHIC; EGYPT

Buto was a snake Goddess usually represented in the form of a cobra, sometimes with the head of a woman. She was often associated with Nekhebet, the "Vulture Goddess" of the South. The early Neolithic cultures of Egypt venerated these two goddesses as supreme deities. Around 3000 BCE, with the beginning of the Egyptian dynasties, the Cobra Goddess and the Vulture Goddess both lost prominence; what remained were their symbols, which appeared in the center of the pharaoh's crown and on official documents.

Chicomecoatl

MYTHIC; MESOAMERICA

Traditionally represented by a double ear of corn, Chicomecoatl was also known as "Seven Snake." She was the agricultural personification of the Earth Mother, underscoring the complex rhythm of life, growth, and death in nature.

Demeter

MYTHIC; GREECE

Demeter, thought to be the daughter of Rhea, the ancient Cretan Goddess, personified fecundity and rebirth. As the "Goddess of Agriculture" she was responsible for the cultivation of the soil. In her primitive form, she was associated with snakes and also represented the underground, where seeds were planted and grew. This characteristic was later transferred to her daughter Persephone and played out in the Eleusinian mystery rites enacted annually at harvest time, which involved the symbolic separation and reunification of Demeter and Persephone in order to ensure the continued fruitfulness of the earth.

Europa
MYTHIC; CRETE

According to Greek mythology, Europa was the daughter of a Phoenician king. Her beauty inspired the love of the god Zeus, who approached her in the form of a white bull and carried her away to Crete. Some versions of the myth claim that Europa was raped by Zeus while others simply state that she bore Zeus three sons. Later, she married the king of Crete who adopted her children, one of whom, Minos, was the legendary founder of the Minoan dynasty.

Fortuna
MYTHIC; ROME

As the "Goddess of the Turning Wheel," Fortuna represented fate. Also considered an oracular goddess, she was connected with the sacred golden wheel of divination. Fortuna was often depicted bearing a cornucopia (as a fertility deity and the giver of abundance), with a rudder (as the controller of destinies), or standing on a ball (to indicate the uncertainty of fortune). Eventually, she was reduced to a good-luck charm, and small statues of her were placed in the Roman emperor's bedroom to protect him from misfortune.

Kore
MYTHIC; GREECE

There are various myths about Kore. One Greek version states that Hades, the brother of her father Zeus, abducted Kore while another suggests that her father raped her—rape having become a prominent theme in Greek mythology by then. After Kore disappeared, her bereft mother, Demeter, threatened to make the earth barren if her daughter were not returned to her. Kore was restored to her mother, though for only part of each year; during the rest of the time, she had to live with Hades, whom she had been tricked into marrying. Throughout the different narratives, Kore remains symbolically connected to the seasons. During the winter, when she is with Hades in the Underworld, the earth is said to sleep in sadness; the flowering of spring occurs only upon Kore's return to her mother.

Pasiphae
MYTHIC; CRETE

Described as a Moon Goddess, "She Who Shines for All," Pasiphae was said to be the daughter of Europa and the mother of Ariadne. According to the Greek myth, she married the Cretan king Minos; however, as Minos means "king" and does not necessarily refer to a particular man, she may have married the heir to the Minoan throne.

Python
MYTHIC; GREECE

According to legend, Python was a female serpent who lived near the temple of Delphi, a center of oracular divination. Originally established by Cretan priestesses, this temple was built in Mycenaean times in honor of the Goddess, and a real python was kept in one of its underground chambers to act as the guardian of the dead and as a symbol of resurrection.

Rhea
MYTHIC; CRETE

Rhea was initially considered the powerful Earth Mother of Crete, comparable to Gaia or Cybele. In later Greek myths, her status declined and she was described merely as the mother of Zeus. Then her former stature became further fragmented and incorporated into the figures of Demeter, Artemis, and Athene, each of whom assumed some of Rhea's attributes.

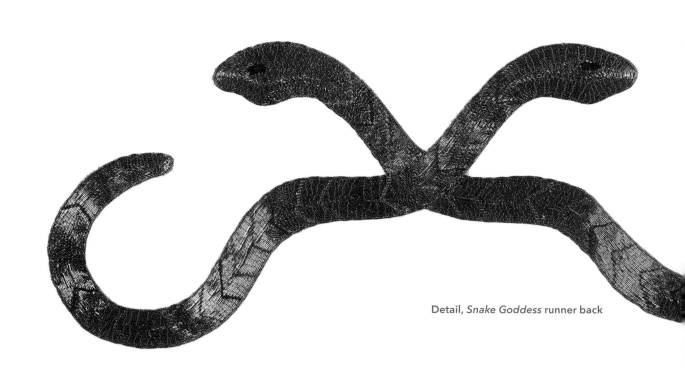

Detail, *Snake Goddess* runner back

Sophia

Early Gnostic religions, developed in the centuries after Christ, posited that the knowledge of transcendence was arrived at by way of personal religious experience, which lends itself to and is expressed through myth. A figure in Gnostic mythology, Sophia is an incorporeal entity—the active thought of God—who created the world. A pale outline of earlier, powerful Goddess figures can be perceived in descriptions of Sophia as the highest form of feminine wisdom. Her inclusion symbolizes the transformation of the original and mighty power of the Goddess into the insubstantiality of an abstract, spectral force.

Sophia was traditionally thought of as providing nourishment and transformation of the human spirit as individuals strove for greater understanding of the mystery of life. She was often portrayed as a single, delicate flower—imagery that inspired the flower/petal iconography of both the plate and the runner. The plate draws upon a beautiful illustration by Dante Alighieri (1265–1321) presenting Sophia as the supreme flower of light. During the Middle Ages, Sophia's identity often merged with that of the Virgin Mary; both were depicted as having nurturing and regenerative powers.

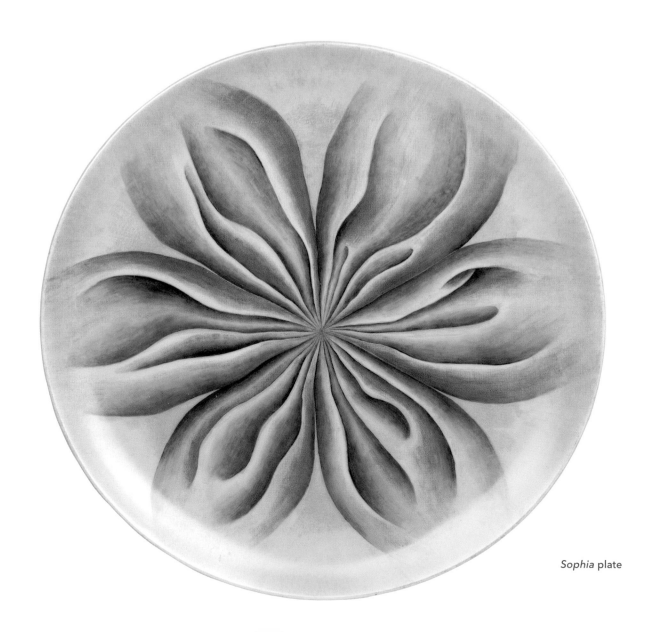

Sophia plate

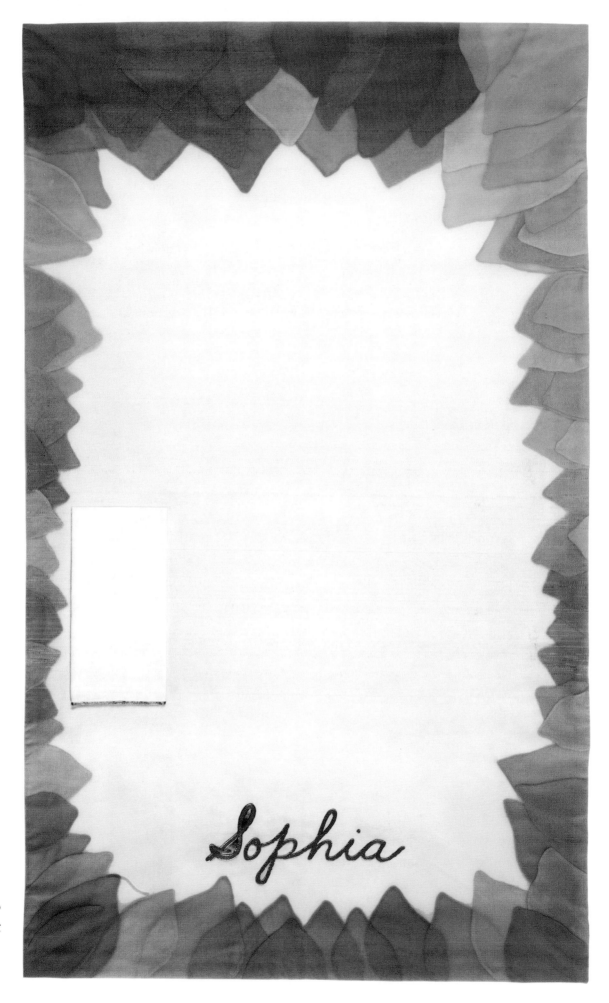

Sophia runner

Grouped around the place setting for SOPHIA are the names of legendary figures of the Greco-Roman period, along with a number of heroines of Greek tragedies. The inclusion of literary personages is intended to mark the transition from the powerful, mythical Goddesses of prehistory to the developing written record, which would emphasize the achievements of men at the expense of women.

Antigone
LEGENDARY; GREECE

Antigone, the leading character in a play by Sophocles (circa 496–406 BCE), represents the rebellious woman who flaunts masculine authority. She defied the king's edict denying her dead brother the right to a burial, arguing that she had a duty to honor the sibling relationship that was the basis of the traditional matriarchal kinship line. As punishment for her disobedience, the king had Antigone walled up in a cave. She committed suicide in order to circumvent the inevitability of a slow, painful death.

Arachne
LEGENDARY; GREECE

Greek mythology holds that Arachne's weaving was so perfect that she challenged the Goddess Athene to a contest. Intimidated by the perfection of Arachne's work, Athene destroyed it, whereupon the girl hanged herself. Athene, taking pity on her, brought her back to life but turned her into a spider and her noose into a web.

Atalanta
LEGENDARY; GREECE

Abandoned by her father, Atalanta was raised in the woods by a she-bear sent by the Goddess Artemis. She became a formidable hunter, warrior, and sportswoman. Although repeatedly warned against marriage by the Oracle at Delphi, Atalanta promised to wed whichever of her suitors won a footrace with her; anyone who lost would be killed. The Goddess Aphrodite gave Hippomenes three golden apples with which to tempt her. Because the girl stopped to retrieve the fruit, Hippomenes won the race and, presumably, Atalanta's hand.

Camilla
LEGENDARY; ROME

Camilla was the daughter of Metabus, king of the Volscians. When he was driven out of his kingdom, he took his infant daughter with him. After praying to the Goddess Diana for their safe passage (which was granted), the king dedicated Camilla to Diana's service. Raised in the woods, the girl became a skilled hunter and warrior. She was slain by an Etruscan, who was supposedly aided by the god Apollo. Diana avenged Camilla's death by sending a nymph to slay her killer.

Cassandra
LEGENDARY; GREECE

According to legend, Apollo fell in love with Cassandra and, in an effort to win her heart, taught her the art of prophecy. Even after acquiring this gift, she rejected Apollo. In revenge, he condemned her to always tell truthful prophecies, but never be believed. Because her prophecies were preceded by trances, Cassandra was thought to be mad. After the sack of Troy, she was awarded to the Greek commander Agamemnon as a concubine, but when they returned to Mycenae, she was murdered by his wife, Clytemnestra, after having foretold Agamemnon's imminent death. No one listened, and he too was killed by Clytemnestra. Cassandra's name has become synonymous with one whose wisdom remains ineffectual because it is unheeded until too late.

Circe
LEGENDARY; GREECE

Considered an enchantress, Circe was said to live alone on an island, transmuting anyone who tried to invade her territory into an animal. According to the *Odyssey*, written by the Greek poet Homer, when Odysseus's men attempted to land on her island, she turned them all into swine. When Odysseus arrived, he was able to convince Circe to return his men to human form. Enchanted by her, Odysseus remained on the island for three years, during which time Circe bore him three sons. Upon Odysseus's departure, she used her psychic powers to predict the trials that lay in store for him. By heeding her warnings, he was able to survive.

Clytemnestra
LEGENDARY; GREECE

A Greek queen, Clytemnestra was the sister of Helen of Troy and the wife of Agamemnon. At the outset of the Trojan War, Agamemnon cruelly sacrificed their daughter Iphigenia. Later, Clytemnestra asserted her mother-right to avenge her daughter's death by killing Agamemnon. She was then slain by her son Orestes and other daughter Electra. They were tried but acquitted because the crime was considered only matricide; this verdict underscores the shift from a matriarchal to a patriarchal form of justice.

Daphne
LEGENDARY; GREECE

Daphne, a nymph and hunter, was said to be the daughter of the River Peneus. Because she was determined to remain chaste, she rejected all suitors, including the aged god Apollo. Undeterred, he chased her to the river, where she entreated her father's aid; he saved her by turning her into a laurel tree. Apollo declared that, henceforth, laurel leaves would serve as wreaths for musicians and as symbolic signs of victory. In earlier legends, however, Daphne was considered a priestess of Mother Earth, and when Apollo pursued her, it was Mother Earth to whom she cried out. Mother Earth spirited her away to Crete, leaving a laurel tree in her place. From its leaves, Apollo made a wreath for consolation.

Sophia place setting

48

Hecuba

LEGENDARY; GREECE

In Homer's *Iliad*, Hecuba, the queen of Troy, was the second wife of Priam and the mother of nineteen children, including Hector, Paris, and Cassandra. Hecuba's husband and all her children were slain or enslaved by enemy soldiers, and she herself became the slave of Odysseus. She was said to have committed suicide, throwing herself into the Hellespont, a strait near the Aegean Sea.

Helen of Troy

LEGENDARY; GREECE

Helen, daughter of Zeus and the mortal Leda, is the prototypical heroine of male literature, the pivot around whom action takes place, but never the central actor herself. Considered the most beautiful woman of her time, Helen abandoned her husband Menelaus, fleeing to Troy with her lover Paris. Her husband's attempts to reclaim her were said to have resulted in the ten-year Trojan War, although Homer portrayed her as being idolized by Greeks and Trojans alike, and a helpless victim of the love goddess Aphrodite.

Hersilia

CIRCA 800 BCE; ROME

The Rape of the Sabine Women is a theme that has been glorified in both art and history. Hersilia was one of those abducted and raped by Roman soldiers. By the time the Sabine men arrived to free their wives, the women had supposedly established bonds with their new husbands and children and seemed reluctant to abandon their Roman families. In order to avert more bloodshed, Hersilia asked that the original Sabine families be rejoined but that newer kinship ties be recognized if the women so desired. Through her efforts a truce was declared and the Festival of the Matronalia came to be celebrated by Roman women to commemorate this somewhat dubious pact.

Lysistrata

LEGENDARY; GREECE

In a bawdy comedy by the ancient Greek playwright Aristophanes (circa 400 BCE), women take over the treasury and then refuse to have sex with their husbands until the men bring a halt to the Peloponnesian War. The play's heroine Lysistrata was supposedly based upon certain prominent women of Athens who were determined to alter the status of women in society by denying sex to their spouses as a means of achieving their goals.

Pandora

LEGENDARY; GREECE

Originally considered a benevolent force, Pandora later came to personify the jaundiced assumption that women were the greatest evil ever inflicted on men. According to the ancient Greek poet Hesiod (circa 700 BCE), Pandora was given a great jar as a dowry, which she was instructed never to open. (It was in such jars that the Greeks both stored their food and buried their dead.) When she disobeyed this injunction, she supposedly unleashed all of the evils into the world.

Praxagora

LEGENDARY; GREECE

In another play by Aristophanes, Praxagora was the leader of a group of women who disguised themselves as men, entered a public assembly, overturned the government by a majority vote, and proclaimed the supremacy of women.

Pythia

LEGENDARY; GREECE

For over a thousand years, the temple where Pythia was consulted was an oracular center at Delphi originally dedicated to the Cretan Earth Goddess. The priestesses of Pythia were considered to be in direct communication with the Great Goddess, embodied in the figure of Pythia, whose temple was considered the center of spiritual authority. Originally, the influence of the priestesses was considerable; by Homeric times, however, the site had been turned into a shrine to Apollo and the Pythian priestesses became mere instruments, transmitting Zeus's messages through their mouths.

Sibyl of Cumae (Amalthea)

CIRCA 500 BCE; ROME

Sibyls were prophetic women thought to possess knowledge of the future. The most celebrated of these figures was Amalthea, presumed author of the nine *Sibylline Books,* which are said to have predicted the Trojan War, the rise and fall of the Roman Empire, and the coming of Christ. Roman priests frequently consulted the *Sibylline Books* before they were destroyed by fire during Nero's reign.

Rhea Silva

LEGENDARY; ROME

A priestess of the Goddess Vesta, Rhea Silva or Rea Silvia was the mother of the legendary founders of Rome, the twin boys Romulus and Remus. She was thought to have conceived them in a sacred marriage festival of the Oak Queen and King when group couplings supposedly took place in the darkness of a sacred cave; Rhea Silva claimed that the God Mars had fathered her children in one such encounter. Her uncle had her imprisoned and ordered her sons drowned because, as the children of a Vestal Virgin, they would have had a claim to the throne since kinship still passed through the female line. However, the boys survived, going on to establish Rome.

Vesta

LEGENDARY; ROME

Vesta was similar to the Greek goddess Hestia, though held in much higher esteem. Young girls who entered into the service of the Goddess between the ages of six and ten kept a flame perpetually lit in her honor. Because these Vestal Virgins were greatly respected, they were free of the guardianship of male relatives to which all other Roman women were subject. The priestesses of Vesta participated in the festivals of the Oak Queen and King when a new heir to the throne was conceived through a sacred marriage ceremony. Later, the Vestals were stripped of their privileges and were no longer responsible for producing an heir; instead, they were required to take a vow of chastity, punishable by death if violated.

Virginia

LEGENDARY; ROME

Virginia (Verginia), a commoner of great beauty, was killed by her father so that she would not be taken as the slave of a Roman noble. Her tragic death is said to have inspired a political revolt in Rome.

Amazon

In the fifteenth century, Christine de Pisan wrote: "They have done so much . . . these women of Amazonia who were . . . feared and respected . . . these women did not cease invading and conquering lands . . . and . . . there was no force which could resist them." This legendary nation of female warriors, which was thought by the Greeks to have flourished during the time of their mythical heroes, is located by ancient authors either in a distant northeast region bordering Scythia, on the edge of the Black Sea, or in North Africa. The earliest indication of such a society dates back to about 1750 BCE. Myths characterize Amazons as living most of the year in all-female societies and mating with random men in the spring. Girls were taught to take pride in their sex, learning athletics and the martial arts in order to preserve their independence.

The Greeks left extensive information about the Amazons in their history, mythology, and visual art, but in our own time there is considerable debate about whether such female societies actually existed. Although the names of many warrior queens are known, I chose to depict a symbolic Amazon in order to better represent the concept of unfettered female power, something that might be said to have ended with the real or mythological defeat of the Amazons by the Greeks.

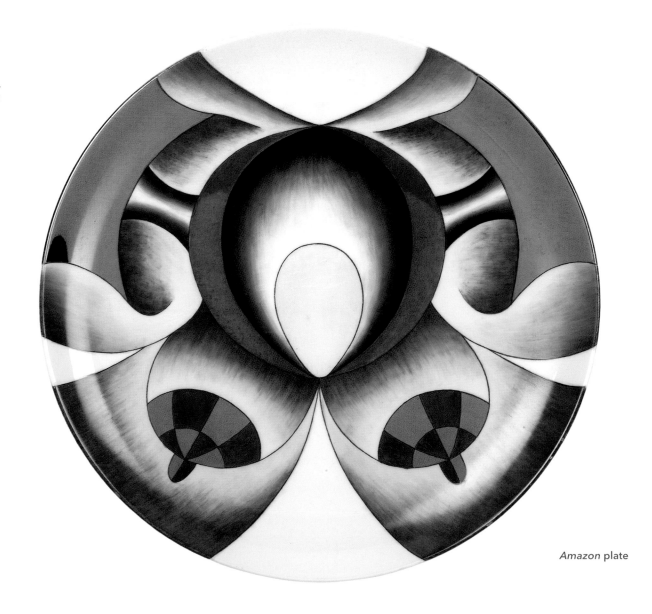

Amazon plate

The names of a number of Amazon queens are assembled around this place setting. Much of what we know of these warrior women comes from the Greeks, who commonly depicted them as either wounded or dying.

Antiope
THIRTEENTH CENTURY BCE; SCYTHIA

Supposedly one of a long line of Amazon warrior queens from the legendary capital of the Amazons, Themiscyra (at or near the modern town of Terme, Turkey), Antiope is said to have fought Hercules, the most popular of Greek heroes. Although she and her two sisters were taken prisoner, she succeeded in freeing herself and one sister, with whom she then jointly ruled.

Egee
TWELFTH CENTURY BCE; LIBYA

Egee is thought to have commanded a vast army of women who marched through Libya and Asia Minor to fight at Troy. After killing the city's king, she and her troops returned home, supposedly carrying a great booty with them.

Eurypyle
CIRCA 1760 BCE; NEAR EAST

It has been conjectured that Eurypyle, also known as Eurpyle, and her female troops vanquished the capital of an area inhabited by a Semitic people living west of Mesopotamia, who had invaded Babylonia several hundred years before finally being driven out by the Amazonian forces.

Hiera
CIRCA 1184 BCE; ASIA MINOR

Hiera was the general of an army of Mysian women who fought in the Trojan War. One of Greece's most famous warriors, she is mentioned in the *Heroicus* by the Greek biographer Philostratus (170–247 BC), who suggested that Homer chose to exclude her from the *Iliad* because she would have outshone Helen.

Hippolyte
THIRTEENTH CENTURY BCE; SCYTHIA

Hippolyte (Hippolyta), Antiope, and Orinthya were sister-rulers at the time of the Greek invasion of the Amazon capital of Themiscyra. Hippolyte was either killed or captured; in retaliation, the Amazons invaded Athens, which supposedly led to the eventual fall of the Amazonian empire.

Lampedo
THIRTEENTH CENTURY BCE; GREECE

Lampedo and her sister Martesia, who called themselves the "Daughters of Mars," were the queens of an Amazon society. Because the majority of their men were presumably killed by Scythian princes, the women decided to couple with men from neighboring communities. As soon as they became pregnant, the women returned home where, according to legend, their male offspring were killed at birth. The female children were educated in the military arts. The girls' right breasts were supposedly caused to wither so that they would not interfere with their use of bow and arrow, while the left breasts were left unharmed for the nurturing of future children.

Martesia
THIRTEENTH CENTURY BCE; GREECE

Martesia or Marpesia and her sister Lampedo ruled an Amazon nation in the region of Themiscyra. While her sister consolidated the empire and attended to domestic government, Martesia enlarged their lands through military conquest. After she was killed in battle, her daughters Antiope, Hippolyte, and Orinthya succeeded her and Lampedo as sister-queens.

Medusa
CIRCA 1290 BCE; GREECE

Perseus, king of Mycenae, killed Medusa, the leader of an Amazon society known as the Gorgons. After her death, his soldiers destroyed the main shrines of the Mother Goddess.

Myrine
THIRTEENTH CENTURY BCE; LIBYA

Although tales of Amazons fighting each other are rare, Myrine is said to have led 30,000 Libyan horsewomen in battle against the Gorgons, another Amazon tribe. Then she and her army conquered parts of Syria, Phrygia, and the islands of Samos, Lesbos, Patmos, and Samothrace, where Myrine died while fighting against the invading patriarchal Thracian and Scythian forces.

Orinthya
THIRTEENTH CENTURY BCE; SCYTHIA

Orinthya or Orithya, Martesia's daughter, ruled with her sisters Antiope and Hippolyte as virgin queens of Themiscyra. Together they brought great military honor to the Amazons. According to myth, the Athenian warriors Hercules and Theseus defeated them.

Penthesilea
D. 1187 BCE; NORTH AFRICA

According to legend, Penthesilea, the last in the dynasty of great Amazon queens, went to Troy with twelve of her warrior women to help defend the city against the Greeks. Although they fought bravely, Achilles, the hero of Homer's *Iliad*, eventually defeated them.

Thalestris
CIRCA 325 BCE; ASIA MINOR

Legend states that Thalestris, another famous Amazon queen, led an expedition of over three hundred female warriors across Asia in order to mate with the Greek conqueror Alexander the Great (356–323 BCE), whom she considered sufficiently brave and honorable to be the father of her child. The outcome of her voyage is unknown.

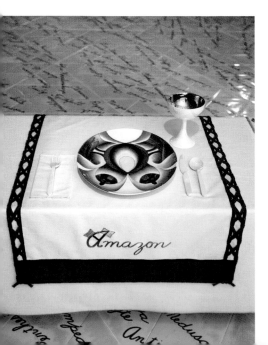

Amazon place setting

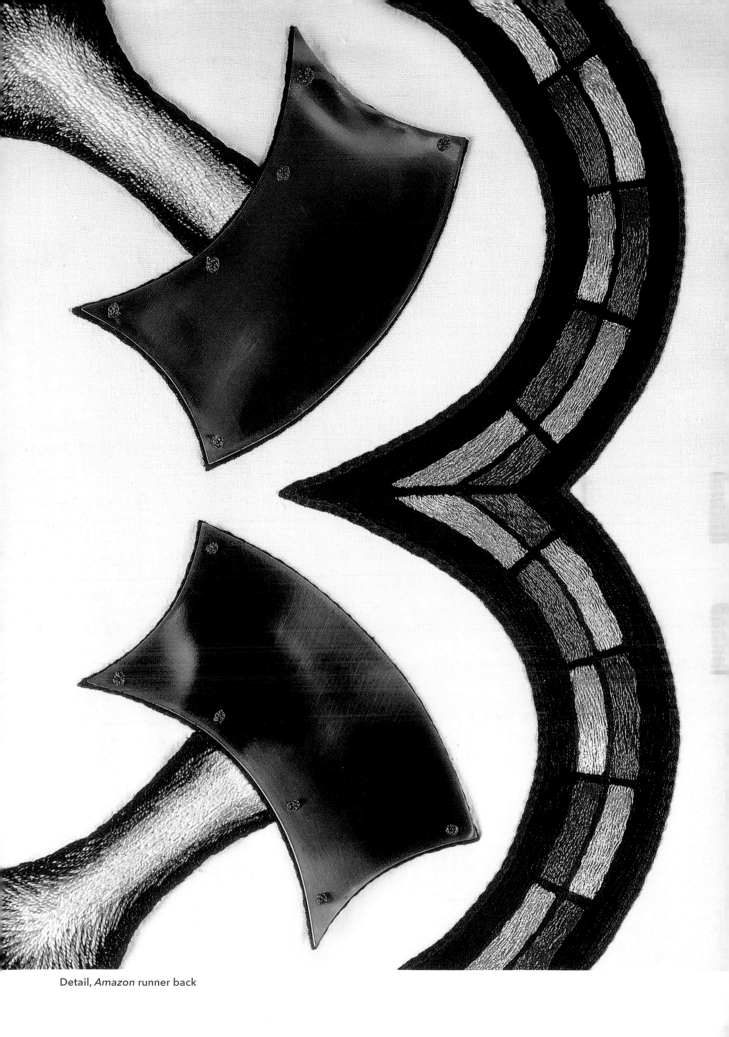

Detail, *Amazon* runner back

Hatshepsut

BORN 1503 BCE REIGNED 1473–1458 BCE

In ancient Egypt, women and men were considered equal under the law. They often worked side by side and were paid in proportion to their output. The same standard of dress applied to both genders; divorce was easily obtained; and affection and consideration for the women of the family are commonly shown in tomb art. New Kingdom pharaohs prided themselves on keeping such good order in their societies that women could travel anywhere without fear of being molested.

Although the position of women later underwent dramatic changes, certain features endured. The principles of matrilineal descent and matrimonial inheritance rights remained firmly established. Four women are known to have ruled as pharaohs, though little is known of any except Hatshepsut, ruler of the XVIII dynasty and daughter of a great warrior king, Tuthmose I.

Hatshepsut continued her father's policies of strengthening the country's defenses by leading many military expeditions. She initiated numerous construction projects including the building and refurbishing of temples and bolstered Egypt's economy through trade, achieving peace and prosperity during her reign. Her own words reveal the pride she felt in her accomplishments: "My command stands firm like the mountains and the sun's disk shines and spreads rays over the titulary of my august person, and my falcon rises high above the kingly banner unto all eternity."

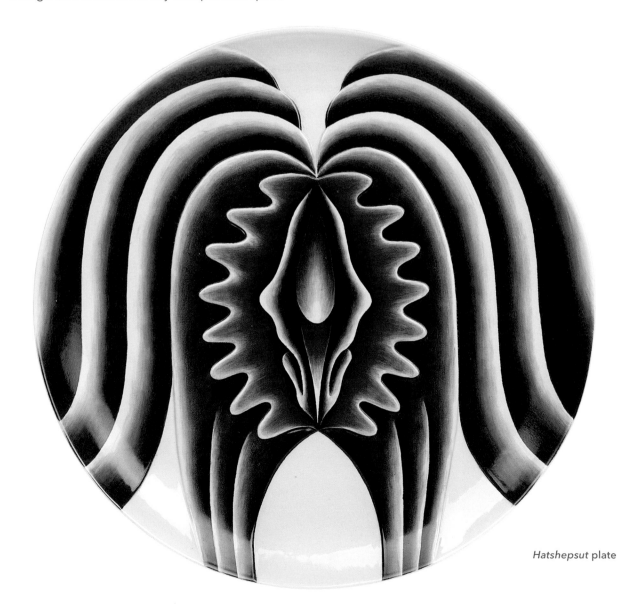

Hatshepsut plate

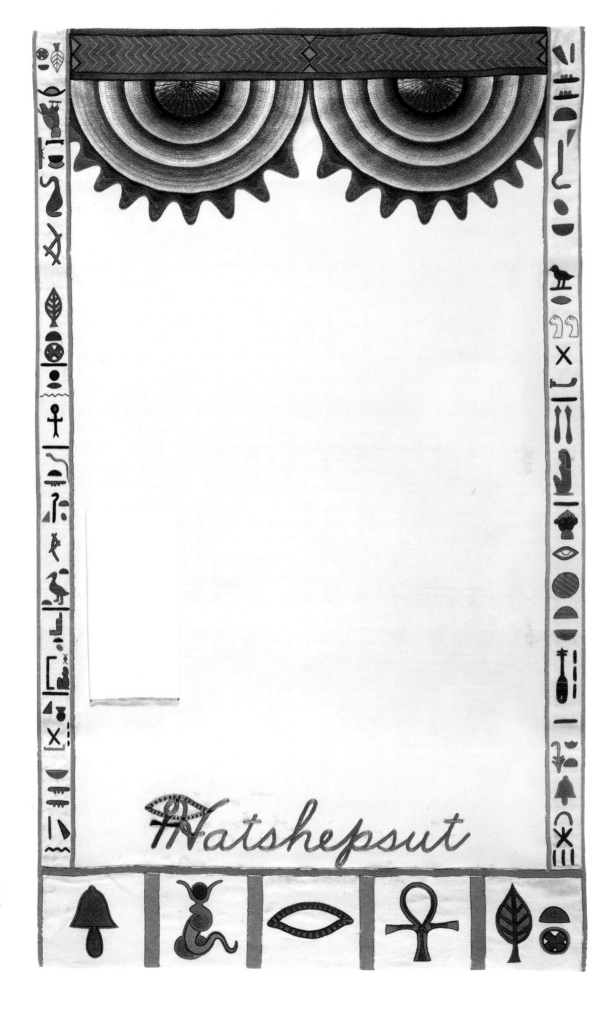

Hatshepsut place setting

The names arrayed around the HATSHEPSUT place setting are primarily those of other Egyptian queens or prominent women. A number of powerful queens from other cultures are also represented as an example of women's exalted stature throughout the ancient world.

Bel-Shalti-Narrar

CIRCA 540 BCE; BABYLONIA

Bel-Shalti-Narrar, also known as Bel-Shalti-Nanna, was dedicated by her father, the last king of Babylon, to the service of the Moon God at Ur. As a high priestess, she was revered as a wise woman and consulted in many political and military matters.

Dido

CIRCA 850 BCE; NORTH AFRICA

Dido was a Phoenician princess who fled her home when her brother murdered her husband. After long wanderings, she settled on the African coast of the Mediterranean, where she founded the great city of Carthage, which prospered for 600 years until it was destroyed by the Romans in 45 BCE. Dido committed suicide rather than submit to a forced marriage with a neighboring chief who had threatened war with the city if she refused to wed him.

Hashop

CIRCA 2420 BCE; EGYPT

Little is known of the Egyptian queen Hashop other than the fact that she made some type of long journey and, in addition to being a ruler, produced great architectural works.

Khuwyt

CIRCA 1950 BCE; EGYPT

Khuwyt, one of the first women musicians in recorded history, was a singer and harpist. She was portrayed in several paintings and was also depicted as a female effigy adorning the top of a harp.

Lucretia

CIRCA 600 BCE; ETRURIA

According to legend, a group of young nobles decided to test the character of the royal women by surprising them in their quarters. Lucretia was found chastely sitting with her handmaidens, weaving at her loom. Later that night, one of the king's sons returned and threatened to kill Lucretia along with one of her slaves if she didn't submit to his sexual advances. Realizing that she had little choice, she gave in. Afterward, she sent for her husband and father to explain what had happened. But fearing that her rapist would accuse her of adultery, Lucretia killed herself. When this story became known, the citizens—incensed by such an abuse of power—revolted against the king and his family.

Makeda, Queen of Sheba

BORN 1020 BCE; NORTH AFRICA

Makeda, the queen of Sheba, was a scholar as well as a ruler of a country believed to have been a matriarchy in which women and men were equally involved in all civil, religious, and military functions. In an effort to improve trade between her country and ancient Israel, the queen traveled twelve hundred miles to meet with King Solomon. The Old Testament recounts her visit to his court at the head of a huge caravan bearing vast treasures of gold, jewels, and spices. However, both her stature and her many accomplishments have been obscured by the historic focus on her relationship with Solomon and her conversion by him to Judaism.

Mama Oclo

CIRCA TWELFTH CENTURY; PERU

According to tradition, Mama Oclo or Ocllo was one of the two founders of the Inca Dynasty, which was originally established in Cuzco. It was said that Mama Oclo taught the Inca women how to weave cotton and wool, sew, and make clothing.

Mentuhetop

CIRCA 2300 BCE; EGYPT

Mentuhetop, more commonly known as Mentuhotep, was a queen of the XI dynasty at Thebes. In addition to being a ruler, she was a skilled doctor, as it was common in Egypt for the queen to be a leading authority on allopathic matters. Her medical bag, which has been preserved, is on exhibit at a museum in Berlin.

Naqi'a

CIRCA 704–626 BCE; ASSYRIA

Naqi'a was an energetic ruler who played an outstanding role in both the internal politics and general policies of the court. During the reigns of her son and grandson, she occupied the revered post of "King Mother" and was officially represented with her son on a bronze tablet, a sign of the high esteem in which she was held.

Nefertiti

CIRCA 1300 BCE; EGYPT

Nefertiti was the daughter of Queen Tiy and Amenhotep III and the wife of Akhenaten, who could be said to be the precursor of monotheism and humanism in that he abolished the priests as intermediaries to the divine and encouraged the worship of a single deity rather than the traditional pantheon of Egyptian gods and goddesses. Nefertiti was represented wearing a pharaoh's crown; religious texts of the period suggest that she shared the rule of Egypt equally with her pharaoh husband. He lost his life and the throne when the clergy reclaimed its power. Nefertiti's role in this religious revolution is unknown, though it is thought that she assumed the leadership of Egypt upon his death. But today she is remembered primarily through a sculpture that reveals her as a great beauty.

Nicaula

CIRCA 980 BCE; ETHIOPIA

A learned scholar and one of the wealthiest queens of the ancient world, Nicaula (also known as Makeda in Ethiopia) may have ruled over Arabia as well as Ethiopia and Egypt. She traveled widely in order to study with the greatest teachers of the time.

Nitocris

SIXTH CENTURY BCE; ASSYRIA

Nitocris, the second of two ruling queens, fortified the country's defenses and sustained the Babylonian Empire through her massive public works. She was responsible for building a bridge over the Euphrates to connect the two parts of Babylon, which led to a great increase in commerce and trade. She had her tomb constructed with an inscription intended to deceive possible thieves. Although the monument seemed to offer treasures, in fact, only her body lay within it, along with a writing which said: "Had you not been insatiate of money, and careless how you got it, you would not have broken open the sepulchers of the dead."

Nofret

CIRCA 1900 BCE; EGYPT

Nofret (Nefret), who reigned in conjunction with her husband Sesostris II, was called "the ruler of all women" because she was responsible for introducing progressive laws and practices concerning Egyptian women. Statues of her with her husband can be seen at the Egyptian Museum in Cairo.

Phantasia

TWELFTH CENTURY BCE; EGYPT

Phantasia, a skilled storyteller, musician, and poet, is said to have traveled to Greece from Egypt during pre-Homeric times. She and another poet were reputed to have invented the hexameter, one of several verse forms traditionally used in epic poetry.

Puduchepa

CIRCA 1280–1250 BCE; HITTITE EMPIRE

Queen Puduchepa, also known as Puduhepa, played an active role in the affairs of state, signing many of the royal documents of the time jointly with her husband Hattusilis III. She was also a priestess, carrying out her religious duties throughout her life and thereby maintaining the traditional role of the priestess/queen.

Rahonem

OLD KINGDOM; EGYPT

In Egypt, the queen was the head of an independent group of women, including a prophetess, a spiritual teacher, and a priestess/musician, along with choirs of dancing, singing attendants. Rahonem was the director of a group of female players and singers, a position equivalent to that of the priestess/musician.

Semiramis

NINTH CENTURY BCE; ASSYRIA

Semiramis, the queen of Assyria, was one of two women who ruled Babylon. She was responsible for making the city—which she also built—into one of the most magnificent in the world. In order to bring irrigation to its deserts and plains, she had mountains leveled, valleys filled, and dikes and aqueducts constructed. She also conquered nations in military campaigns that took her as far as India. She was the only female ruler represented in the row of stelae of the great Assyrian kings at Ashur. Her son may have killed her in order to assume the throne.

Tanaquil

CIRCA 570 BCE; ETRURIA

Tanaquil was a Roman queen, famed for her shrewdness and prophetic gifts. When the king died, she managed to preserve the crown for her daughter's husband. The Romans renamed her "Gaia Cyrilla," which means "the good spinner," in reference to her needlework and weaving. A law was passed that required newly married women to mention her Roman name (Gaia) upon first entering their homes in order to bring good fortune upon their households.

Tetisheri

CIRCA 1650 BCE; EGYPT

Tetisheri, called the "Mother of the New Kingdom" because of her influence over her son and grandsons who were its founders, was the first of six great queens of the XVII dynasty of Egypt. She was held in such high regard that decrees were issued regarding her service to the nation and she was granted a great estate along with a tomb with priests and servants to conduct mortuary rituals in her honor when she died. There is a statue of her in the British Museum.

Tiy

CIRCA 1400 BCE; EGYPT

Queen Tiy (Tiye), wife of Pharaoh Amenhotep III, was the mother of Akhenaten. The first Egyptian queen to have her name on official acts, she established an independent correspondence with many foreign rulers, which helped to maintain peace in Egypt. The pharaoh, who was extremely fond of his wife, issued a commemorative scarab in her honor in an effort to induce the people to accept her despite the fact that she was a commoner.

57

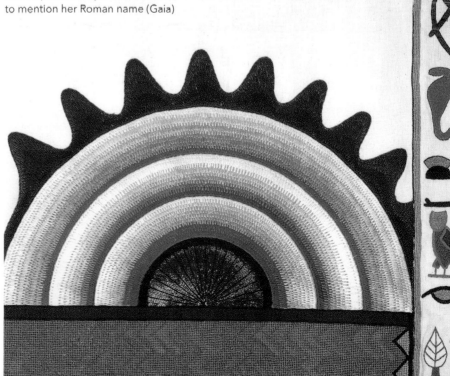

Detail, *Hatshepsut* runner back

Judith

Judith was a legendary Jewish heroine, whose story, which lies in the shadowy region between history and fiction, is told in the Book of Judith. A devout and learned woman, she lived in the city of Bethulia, which had been conquered by the Assyrian general Holofernes. Many Jews were forced into exile, taken into slavery, or persecuted for their refusal to pay tribute to the Assyrian king; women were sexually assaulted. As the men sank into a torpor of despair, Judith took matters into her own hands.

Clothed in festive attire and carrying a basket full of food and drink, Judith entered the enemy camp, easily passing by the soldiers who did not suspect that a woman could be a threat. Holofernes, beguiled by Judith's appearance, invited her into his tent. She had prepared the wine so that it would quickly put him to sleep. Then she crept up to his bedpost, and grasping Holofernes's sword, she caught the tyrant by the hair and cut off his head with two sharp strokes. She wrapped his severed head in a cloth and stole from the encampment. When she reached the gates of the city, she placed Holofernes's head on a gatepost for all to see. Emboldened by her bravery, the Jews rose up against their oppressors, who retreated. That evening, the women honored their savior and celebrated into the night.

58

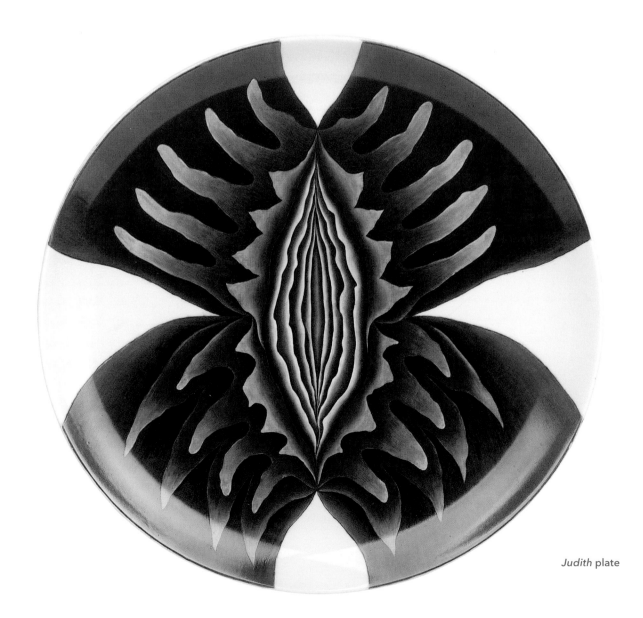

Judith plate

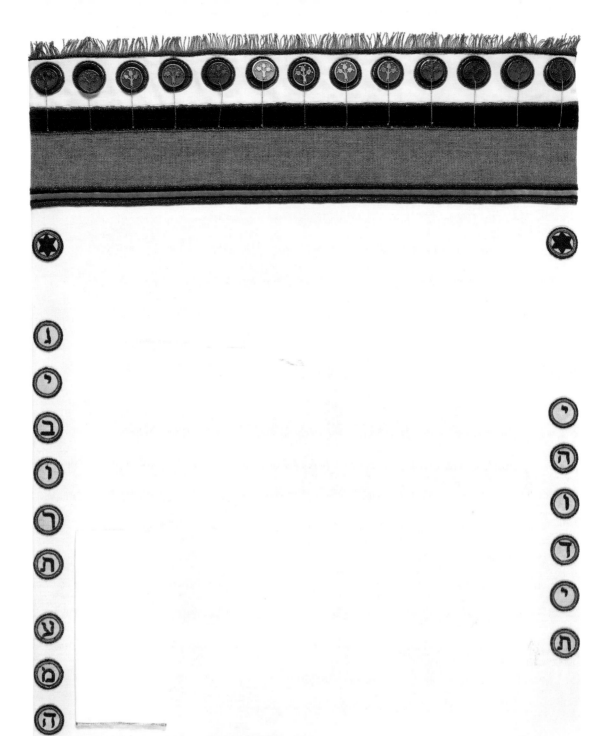
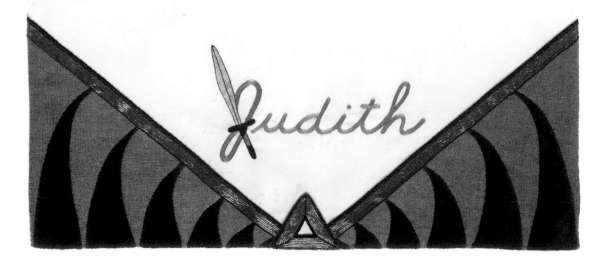

Judith was not the only important woman in Jewish history. The names aligned with her place setting include other Jewish heroines, along with women of the Bible whose stories helped to shape ideas about female identity and appropriate behavior. Also included are women, both mythical and real, who attempted to carry on matriarchal traditions, including the practice of prophesying.

Abigail
CIRCA 1060 BCE; HEBREW

Abigail has been called the earliest female pacifist on record and one of the wisest women in the Old Testament. As the story goes, David, the shepherd who would become king, asked Abigail's boorish husband Nabal, a wealthy landowner, for provisions. When he refused the request, David became irate. Realizing that Nabal's lack of generosity could precipitate warfare between the men and their tribes, Abigail defied her husband and prepared food for David and his men. When her husband died soon thereafter, she married David, her wise and gentle character supposedly moderating his tempestuous personality.

Athaliah
CIRCA 842 BCE; HEBREW

Athaliah, thought to be the daughter of Queen Jezebel, claimed the southern kingdom of Judah as her own despite the fact that Hebrew law forbade women to reign alone. Much to the distress of the biblical patriarchs, during her six-year reign she reinstated the ancient Mother Goddess religion. Athaliah became so popular that it required a violent revolution to dethrone her.

Beruriah
N.D.; HEBREW

A scholar and the only woman mentioned in the Talmud, Beruriah (Bruriah) was one of the few women in Jewish history to write commentaries on the law. Because she often contradicted the judgments of her rabbi husband, he tried to discredit her, even ordering one of his students to seduce her. After numerous attempts on her virtue, Beruriah finally succumbed, after which she was so mortified that she hanged herself.

Deborah
CIRCA 1351 BCE; HEBREW

Deborah was the only woman of her time to possess political power by common consent of the people and the sole female judge mentioned in the scriptures. Her accurate prediction of the outcome of a battle with the Canaanites is commemorated in the Bible's Song of Deborah, in which she is referred to as the "Mother of Israel." It is said that she governed the Hebrews in tranquility for forty years. In one of the most unusual passages spoken by a man to a woman in the Bible, Barak, a military man, responded to Judith's statement that God needed him to lead an army against the Canaanites by saying: "If thou will go with me, then I will go; but if thou will not go with me, then I will not go." Deborah agreed to accompany him, accurately prophesying that God would deliver the enemy into the hands of a woman.

Esther
CIRCA 475 BCE; HEBREW

When Ahasuerus, the king of Persia and Media, demanded that his wife Vashti display her beauty to his officials, she refused, whereupon he banished her. Not knowing that Esther was Jewish, the king selected her as his next wife. Then Haman, the king's advisor, connived to have all the Jews in the kingdom executed. When Esther discovered this, she confronted the king, cleverly managing to convince him to reverse Haman's order. The king had Haman executed instead and gave all of his property to Esther. Every year the holiday of Purim is celebrated in her honor.

Judith place setting

Eve
BIBLICAL

The biblical story of Eve depicts her as responsible for all the evil that befalls humankind. This now-familiar story transformed the ancient concept of a powerful Goddess giving life into the tale of Eve being created from the rib of Adam to be his submissive wife. Eve's punishment for eating the forbidden fruit of knowledge was to experience—along with all women—severe pain during childbirth.

Huldah
CIRCA 624 BCE; HEBREW

Toward the end of Israel's ancient history, King Josiah sent his men to see the prophetess Huldah, asking her to validate the discovery of a scroll in the temple that called for Israel to observe certain laws it had not been heeding. She verified its authenticity, adding a message to Josiah: "Your eyes will not see the evil which I am bringing on this place" (Kings 22:15–20), a divination that was borne out by Josiah's early death, before the doom that would descend on Israel.

Jezebel
NINTH CENTURY BCE; HEBREW

Stigmatized as evil in the Bible because she was a foreigner and a woman, Jezebel was the wife of Israel's King Ahab. As a result of their union, he began to worship her deities, including Baal and the Goddess Asherah. Jezebel, a strong woman, became locked in battle with the priests over religion. The House of Ahab began to unravel, and she met a gruesome end. To this day, her name is invoked to describe women who wear too much makeup, jewelry, or sexually provocative clothing.

Leah
CIRCA 1700 BCE; HEBREW

Niece of Rebekah and mother of Dinah, Leah was the first daughter to be named in the Bible. Her father duped her into having intercourse with Jacob, although he really desired her younger sister Rachel. Leah then married Jacob, bearing seven children. Seven years later, Jacob married Rachel as well. Leah's sons became major figures in Jewish history. Her story, though bleak, is meant to illustrate the importance of the mother in Jewish life.

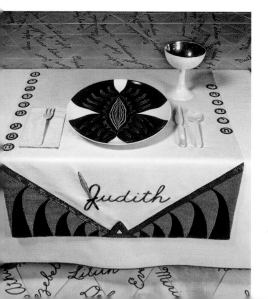

Lilith

APOCRYPHAL

Only alluded to in Genesis, Lilith was, according to legend, created by God at the same time and in the same manner as Adam. But they never found peace together because she refused to lie beneath him during sex, insisting that they had been created equal. She fled when Adam tried to compel her obedience. Yahweh then sent three angels to retrieve her. They threatened that if she did not return, she would—as the mother of the human race—lose a hundred of her children every day. When Lilith still refused to submit, the angels tried to drown her, but Lilith pleaded her cause so eloquently that she was allowed to live. However, she was then given to Satan as his wife and henceforth described as a heartless, tempting, and destructive force.

Maacah

CIRCA 915 BCE; HEBREW

Maacah (Maachah), daughter of the king of Geshur, probably came to her marriage with David before he became king of Israel with her own retinue of courtiers and attendants. They would have built a palace for her; perhaps it was there that she attempted to reinstate worship of the Goddess by erecting a statue of Asherah. This image was destroyed by her son Absalom, who deposed her and suppressed Goddess worship.

Miriam

CIRCA 1575 BCE; HEBREW

For many centuries, most historians saw Miriam—the sister who guarded Moses in the basket until pharaoh's daughter saved him—as a minor figure, but recent scholarship has revised that perception. The most famous reference to Miriam involves her having led the women to freedom during the Exodus: "Then the prophet Miriam . . . took a tambourine in her hand; and all the women went out after her with tambourines and with dancing" (Exodus 15:20-21).

Naomi

CIRCA 1000 BCE; HEBREW

During the famine of Judah, Naomi emigrated with her family to Moab, a fertile area east of the Dead Sea, where she lost her husband and both her sons. After ten years, she decided to return to Bethlehem. Both of her daughters-in-law offered to accompany her, but she urged them to leave her and find new husbands. Ruth refused; her fealty was rewarded by marriage to Boaz, a powerful relative of Naomi. This story suggests the deep love and loyalty that existed between women in biblical times.

Rachel

CIRCA 1753 BCE; HEBREW

Sister to and then cowife with Leah, Rachel, along with their two maids, mothered the sons destined to head the twelve tribes of Israel. Rachel also had the dubious distinction of being the first biblical woman to die in childbirth.

Rebekah

CIRCA 1860 BCE; HEBREW

The Bible traces Israel's development from Abraham and Sarah and then from Sarah's daughter-in-law, Rivka or Rebekah. After years of childlessness, Rebekah finally conceived, then learned that she would bear twins. She bore two sons: Esau and Jacob, the younger and her favorite. She convinced her husband Isaac to give his blessing to Jacob as his successor. When Esau threatened to kill his brother in revenge, Rebekah interceded, sending Jacob away even though it meant that she would never see him again.

Ruth

CIRCA 1000 BCE; HEBREW

Ruth was the daughter-in-law of Naomi and is the central figure in the Book of Ruth. She was living in her native land of Moab when Naomi and her family arrived seeking refuge from a famine in Judah. Ruth married one of Naomi's sons, but then he, his brother, and father died. When her mother-in-law decided to return home, Ruth chose to follow her.

Sarah

CIRCA 1900 BCE; HEBREW

The story of Sarah, the first matriarch, reveals the important role women played even in patriarchal Jewish families. Although the rabbinic tradition bestows upon Sarah much praise, it could be argued that her life was one continuous trial of her faith in God's promise in Genesis that she was to be the mother of nations, giving birth to Isaac when she was far beyond childbearing age.

Detail, *Judith* runner

Vashti

CIRCA 475 BCE; PERSIA

Queen Vashti, Esther's predecessor, was banished for disobeying her husband King Ahasuerus, when he insisted that she publicly display her beauty. When she refused and as an example to other disobedient wives, she lost her royal position. The king then issued an edict instructing all wives to obey their husbands, thereby reinforcing patriarchal authority.

Witch of Endor

CIRCA 1060 BCE; BIBLICAL

Described as having gnarled hands, coarse leathery skin, and dark hair falling over stooped shoulders, the wise old Witch of Endor supposedly told fortunes and practiced witchcraft. Many people, including King Saul, sought her counsel, for she had a reputation for making accurate prophecies. She represents the continued tradition of female witches, seers, and prophetesses who, by Hebraic times, were being denounced as evil.

Zipporah

CIRCA 1500 BCE; HEBREW

On his way back to Egypt, after his confrontation with the burning bush, Moses is attacked. Zipporah, his wife, circumcises their son with a piece of flint, saying: "For you are a bridegroom in blood to me" (Exodus 4:24-26), a statement that has been subject to multiple interpretations, one of which suggests that because the son was not yet circumcised, Moses was in danger. Although bizarre, this biblical story demonstrates the significance of the Midrashic commentary: "Because of the righteous women of that generation, Israel was redeemed from Egypt."

Sappho

Sappho, one of the finest lyric poets in Western civilization, was born in 612 BCE on the island of Lesbos. Here she founded a *thiasos*, a sacred society of women who were bound by special ties. Their presumed power over life and death was expressed at religious festivals through singing, dancing, and playing instruments, all considered divine arts belonging to women. In her time Sappho became a renowned teacher of poetry, music, and dance. Her fame spread throughout Greece; statues were erected in her honor; her likeness was imprinted on coins; and her poetry was thought to rival Homer's. In addition to developing new poetic structures, she was known for her poems expressing her love for women, often in openly erotic terms. Because Sappho came from the island of Lesbos, the word "lesbian" has come to mean a woman who loves women.

Although celebrated in her own time, she subsequently became the object of ridicule; the Greeks maligned her and the Romans considered her love of women perverse. The Christian Church branded her a criminal for her eroticism and homosexuality. Fanatical monks burned her poems; only a few hundred lines survive. In defiance of the effort to erase her memory, Sappho's place setting is intended to commemorate the last burst of unimpeded female creativity in the ancient world.

62

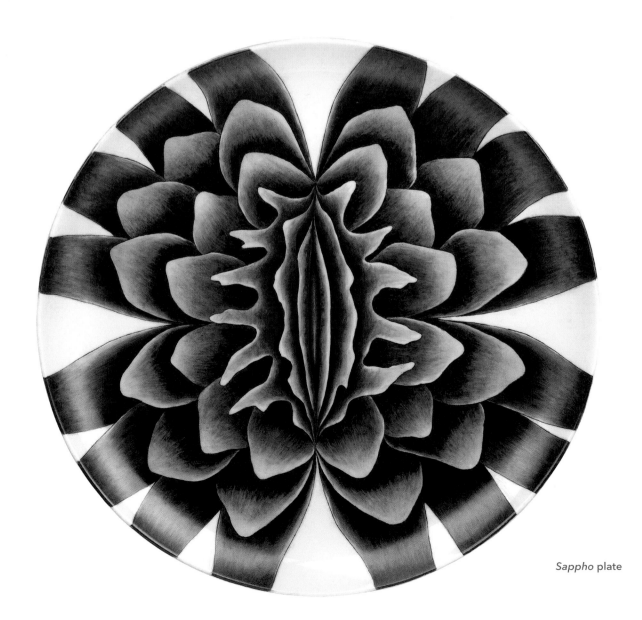

Sappho plate

Sappho runner

The island of Lesbos remained conducive to women's creativity even after the Greek mainland became repressive. But gradually, women writers there were excluded from competitions; then, men began to appropriate the healing arts, which had always been considered the province of women. However, no matter how difficult their circumstances, women continued to express themselves. The stream of names associated with SAPPHO includes other early poets, musicians, and women artists about whom, unfortunately, there is very little information.

Amyte
THIRD CENTURY BCE; GREECE

More is known about the poet Amyte, more commonly called Anyte, than any other ancient Greek woman writer. She is well-represented in the *Greek Anthology* (a collection of classical Greek and Byzantine poems, mostly epigrams, initiated about 60 BCE and surviving today in an early tenth-century edition), was one of the first Greek poets to make use of the epigram (a short poem or saying), and is credited with having introduced pastoral poetry.

Anasandra
FIFTH CENTURY BCE; GREECE

Anasandra, also known as Anaxandra, studied painting with her father, a well-known artist, and eventually became an eminent painter in her own right.

Carmenta
EIGHTH CENTURY BCE; ETRURIA

Revered as a poet, a prophetess, and a queen, Carmenta (Carmentis) led her people into the area that would later become Rome. After establishing her son as king, she built the first temple there and brought agriculture, music, and poetry to the region.

Cleobuline
FIFTH CENTURY BCE; GREECE

Cleobuline (Cleobulina), who often collaborated with her father, the philosopher and poet Cleobulus, was celebrated for her skill in writing riddles.

Corinna of Tanagra
CIRCA 490 BCE; GREECE

There is conflicting information about Corinna, sometimes called the "Lyric Muse." Although she has traditionally been considered a rival of the great lyric poet Pindar (circa 500 BCE), some scholars believed she lived as late as 200 BCE. Thought to be second only to Sappho in poetic ability, Corinna wrote lyrics in a simple style. Extant fragments of her poetry include a song cycle featuring two mountain gods who were prominent in the mythology of Boeotia, a region of ancient Greece.

Cresilla
CIRCA FIFTH CENTURY BCE; GREECE

All that is known about Cresilla, also called Kresilas, is that she took part in a competition to create seven images of Amazons for the ornamentation of the Temple of Artemis at Ephesus, placing third behind noted Greek sculptors Polyclitus and Phidias.

Erinna
SIXTH CENTURY BCE; GREECE

Erinna was known as Sappho's most gifted student. She composed a 300-verse poem, *The Distaff*, before her untimely death at age nineteen. Even though her verses were considered as good as Homer's, only fragments of her work still exist.

Sappho place setting

Helena
FIFTH CENTURY BCE; GREECE

A painter during the Hellenistic period in Greece, Helena's paintings were presented to a temple dedicated to Venus.

Kora
SEVENTH CENTURY BCE; GREECE

Kora is one of the earliest women artists of whom there are reliable records. She is credited with having created the first bas-relief.

Lalla
FOURTH CENTURY BCE; GREECE

Lalla's name has come down to us through her honorific title, "The Painter." Although she seems to have primarily painted portraits of women, she did execute at least one self-portrait, which was unusual at that time. Her name is also spelled Laia or Lala.

Manto
CIRCA 850 BCE; GREECE

According to Greek legend, Manto was the daughter of a seer from Thebes. After the city was conquered, she was brought to Delphi as a war prize and installed as a priestess of Apollo in Colophon, a city in Asia Minor. Despite this inauspicious beginning, she became famous for the wisdom of her prophecies. It was said that Homer incorporated many of her verses in his work.

Megalostrata
CIRCA 600 BCE; GREECE

Megalostrata achieved prominence as a poet, composer, singer, and leader of girls' choirs in Sparta at a time when female choirs were especially important in Greek life. Unfortunately, none of her compositions have been preserved.

Moero of Byzantium
THIRD CENTURY BCE; GREECE

Although only two known epigrams written by Moero (Myro) survive, there are also ten lines from a poem attributed to Athenaeus (a second-century Greek author) that are thought to be hers. The extant fragments suggest that she wrote lyric poems, hexameter verses, and epigrams. Some authors have described her poetry as "lilies" because of their delicacy.

Detail, *Sappho* runner

Myrtis of Anthedon
SIXTH CENTURY BCE; GREECE

Myrtis was a member of a group of women poets who were referred to as the "Nine Earthly Muses." The teacher of the lyric poet Pindar of Thebes (522 BCE), Myrtis also instructed Corinna, another of the nine famous poets.

Nanno
SIXTH CENTURY BCE; GREECE

Nanno was a flute player. Many elegies were addressed to her, suggesting that she was a prominent musician.

Neobule
EIGHTH CENTURY BCE; GREECE

Neobule was a poet whose own work has been obscured by the story of her engagement to the poet Archilochus, which was broken off either by her or her father. Enraged, her rejected lover blamed Neobule, attacking her in a poetic form that became the basis for the later creation of satiric verse.

Nossis
THIRD CENTURY BCE; GREECE

Sappho's influence can be seen in the work of many other poets, including that of Nossis. Well represented in the *Greek Anthology*, her writing often dealt with the subject of female desire. A number of her epigrams remain; in them, she traces her own poetic influences back two generations through a female line.

Penthelia
PRE-SIXTH CENTURY BCE; EGYPT

Like many other Egyptian women, Penthelia was a priestess/musician who trained for service in the temples. She described the events of the Trojan War in song and story, and her technique was said to have inspired Homer as well as other Greek poets.

Praxilla
CIRCA 450 BCE; GREECE

This lyric poet and composer came from the city-state of Sicyon, a place where for a long time women continued to play a leading role in religious and musical life. Her many well-known poems and songs were sung at banquets and festivals.

Timarete
CIRCA 800 BCE; GREECE

Timarete, an established artist also known as Thamyris, came from the town of Ur in Sumer. She produced a famous image of the Goddess Artemis, an ancient example of a painting by a woman, which was on view at her temple in Ephesus.

Aspasia

470–410 BCE

In Athens, women's lives were marked by near-total segregation, and they were rarely permitted outside. The fact that most women were virtually illiterate created a gap between the sexes, particularly in light of the enormous emphasis on intellect in Athenian culture. Aspasia, a scholar and philosopher, came from an area of Greece where women were still allowed some independence; as a foreigner, she was not subject to the same restrictions as the local women. She soon joined the ranks of the *hetaerae*, the only Athenian women allowed to participate in Greek culture. Although this term now refers to prostitutes, it originally connoted women who remained unmarried, literate, and free. Their popularity suggests that not all Athenian men were satisfied with uneducated women.

In 445 BCE Aspasia became the companion of the statesman Pericles. Soon, the most learned men of the day frequented their house, where Aspasia created the first known salon. She urged her male guests to bring their wives so that they might be exposed to the sophistication of Greek culture. Aspasia was eventually tried for "impiety"; only Pericles's intervention saved her life.

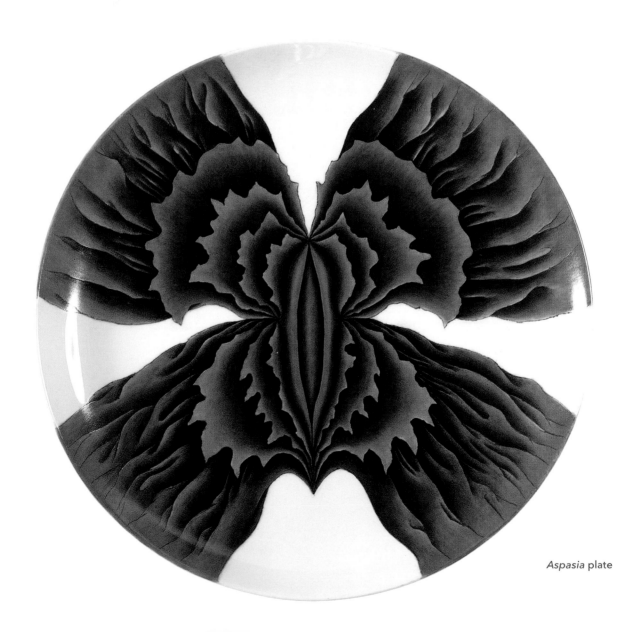

Aspasia plate

Aspasia was not the only Greek woman to make her voice heard in Athens, but her influence seems to have exceeded that of anyone else. There is evidence that, because of her example, Athenian women began to agitate for greater rights. Assembled around the ASPASIA place setting are the names of other independent women, some of whom had to disguise themselves as men in order to be educated.

Aglaonice
SECOND CENTURY BCE; GREECE

Aglaonice (Aganice), regarded as the first woman astronomer, always referred to her scientific skills as "her will," perhaps because her motivation to learn was strong. Although she was sometimes described as a sorceress, her observations of solar and lunar eclipses were grounded in expertise in both astrology and astronomy.

Agnodice
CIRCA 505 BCE; GREECE

In order to become a doctor, Agnodice disguised herself as a man; her goal was to become an expert in gynecology. After completing her studies, she revealed her true identity only to women patients, who were so pleased to have a female gynecologist that they flocked to her. Although male doctors did not realize that Agnodice was a woman, they were outraged that their female patients seemed to prefer her services. They brought her to trial for malpractice, and when she publicly revealed her gender, they tried to enforce the law prohibiting women from practicing medicine. When a number of prominent women protested, the law was changed, at least until the twelfth century.

Arete of Cyrene
CIRCA 370–340 BCE; GREECE

For thirty-five years, Arete taught in the academies of Attica in the north of Greece. After the death of her philosopher father Aristippus, who had educated her, Arete was unanimously elected to succeed him as the head of the school of philosophy. She held a passionate belief in equality and is quoted as saying: "I dream of a world where there are neither masters nor slaves."

Aristoclea
SIXTH CENTURY BCE; GREECE

Aristoclea (Aristocleia), an instructor of the mathematician and philosopher Pythagoras (c. 590–475 BCE) at the college at Delphi, was renowned for her wisdom. She is said to have been responsible for improving Pythagoras's attitudes toward women. Although it was generally considered unacceptable for Athenian women to be educated, both the Pythagorean and Epicurean philosophers allowed them to study. This resulted in many women becoming associated with these two schools of philosophy.

Aspasia of Athens
FIRST CENTURY CE; GRECO-ROMAN

Renowned as a surgeon, Aspasia wrote a text on gynecology that remained the standard work for nearly one thousand years. The titles of her other medical writings were later recorded by Aetius, a physician and writer of the fifth century CE.

Axiothea
FOURTH CENTURY BCE; GREECE

Axiothea was educated at home in Arcadia, which was outside of Athens and thus not subject to its practices. After studying some of Plato's *Republic*, she went to Athens to learn with him. As women were not admitted into his academy, she had to attend his lectures in male attire. Although it is not known whether Plato was aware of her gender, supposedly he refused to commence without her, saying that he would not begin "before the arrival of the mind bright enough to grasp his ideas."

Cynisca
THIRD CENTURY BCE; GREECE

In Sparta, part of the education of girls involved athletic instruction. Cynisca, the daughter of the king of Sparta, won several chariot races and paved the way for others as the first female to enter the Olympics. She was also the first woman horse breeder in recorded history.

Damo
CIRCA 500 BCE; GREECE

Daughter of Pythagoras and his philosopher wife Thano, Damo was privy to the secrets of Pythagorean philosophy and supposedly devoted much of her time to the education of women. When her father died, she was entrusted with his writings. Though poverty-stricken, she remained true to his wishes not to publish them, even though they would have brought her a considerable amount of money.

Diotima
FIFTH CENTURY BCE; GREECE

According to the writings of Plato, it was Diotima who was responsible for instructing Socrates in social philosophy. A prophet, priestess, and Pythagorean philosopher, her theories supposedly became the basis for many of Socrates's famous dialogues.

Elpinice
FIFTH CENTURY BCE; GREECE

In contrast to the women of Athens, women in Sparta were able to control two-fifths of its land and property. Though Athenian, Elpinice decided to model herself on the Spartan women, rejecting the domestic reclusiveness expected of women and attempting to fully participate in the intellectual life of the city.

Euryleon
THIRD CENTURY BCE; GREECE

In the tradition of the charioteer Cynisca, Euryleon, also known as Euryleonis, won an Olympic victory in the two-horse chariot race. In honor of her triumph, a statue of her was erected in Sparta.

Aspasia place setting

Hipparchia

BORN 346 BCE; GREECE

Hipparchia married a fellow philosopher of the Cynic school of thought, Crates, with whom she shared an equal partnership. She became widely respected as a consoler of those who were bereaved, ill, or troubled. Though self-educated, Hipparchia wrote several tragedies, philosophical treatises, and other works, none of which are extant.

Hippo

FIFTH CENTURY BCE; GREECE

When Hippo, who had taken a vow of chastity, became aware that a group of enemy sailors were planning to rape her, she killed herself rather than submit to either the sexual abuse or the violation of her commitment. When her body was found and the reasons for her suicide discovered, she was buried with veneration in a memorial built to celebrate her personal morality and her martyrdom.

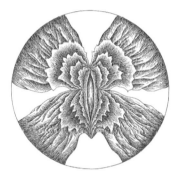

Lamia

FOURTH CENTURY BCE; GREECE

Lamia, a musical prodigy, was the most renowned flute player in antiquity. She lived as an independent woman, traveling extensively and performing wherever she went. Altars were erected to celebrate her, a festival and a temple were created in her honor, and she was worshiped as a goddess under the name "Aphrodite Lamia."

Leontium

THIRD CENTURY BCE; GREECE

Those Athenian women able to educate themselves by attending schools for the *hetaerae* often became associated with prominent, learned men. Leontium (Leontion), considered the most eloquent philosopher of her time,

Detail, *Aspasia* runner back

was the companion of the philosopher Epicurus, with whom she had studied. But she owed her singular fame to her own writings, none of which, unfortunately, have survived.

Nicobule

CIRCA 300 BCE; GREECE

While some important literature written by women in antiquity has survived, other work is known only through references or scraps. Among the work that has not survived is that of Nicobule (Nicobula), a celebrated author of the fourth century BCE who wrote a history of Alexander the Great and also composed many poems.

Perictyone

FIFTH CENTURY BCE; GREECE

Perictyone (Perictione) was a Pythagorean philosopher who may have been the mother or sister of Plato. One of her works, *On Wisdom*, was cited by Aristotle, and another, *On the Duties and Harmony of Women*, dealt with the relationship between body and spirit, thought and action. It is included in *The Pythagorean Sourcebook and Library*, an anthology of ancient writings compiled and translated by Kenneth Sylvan Guthrie.

Phile

FIRST CENTURY BCE; GREECE

Phile was elected to the post of magistrate, the highest municipal office in her city. In this capacity, she was responsible for the construction of reservoirs and aqueducts.

Salpe

FIRST CENTURY BCE; GREECE

Both a physician and a poet, Salpe wrote treatises on women's diseases and eye afflictions as well as poetry about the importance of athletics for women's health.

Telesilla

CIRCA 50 BCE; GREECE

Telesilla was a lyric poet who wrote verses to Artemis and Apollo. She is said to have saved her city during a battle with Sparta by arming all the women. A statue was erected in her honor at the temple of Aphrodite at Argos.

Theano

CIRCA 540–510 BCE; GREECE

A brilliant mathematician who was knowledgeable about medicine, hygiene, physics, and early psychology, Theano succeeded Pythagoras as head of his institute of philosophy. When he was quite aged, she married him. It was supposedly Theano who first articulated the idea of the Golden Mean, which has come to signify the classic proportion in art, architecture, and music.

Theoclea

SIXTH CENTURY BCE; GREECE

Theoclea, a student at the Pythagorean school of philosophy at Delphi, later became a high priestess at the temple of Apollo.

Boadaceia

During the time when the Roman Empire was spreading to the British Isles, women there retained many rights. Boadaceia, a member of the Iceni people who had been conquered by the Romans, was married to Prasutagus. Upon his death she had no difficulty in establishing her own right to rule. As was required of vanquished rulers, half of his property was given to the Roman emperor, and the other half was left to his wife and their two daughters. But his will was simply used as a pretext for Roman officials to ransack the kingdom.

Soldiers seized the estates of Boadaceia's relatives. Soon after that, she was cruelly forced to witness the rape of her daughters. Determined to avenge the wrongs done to her, her family, and her country, she called together the Iceni along with their neighboring communities, uniting them in one great army, declaring: "In this battle we must conquer or die. This is a woman's resolve. As for the men, they may live or be slaves." Led by their queen and with men and women fighting side by side, the British force attacked their oppressors. At first they seemed successful, but Boadaceia's apparent triumph was brief. More than 80,000 of her people were eventually slaughtered. Boadaceia made her way home, where she took poison rather than surrender to the Roman conquerors.

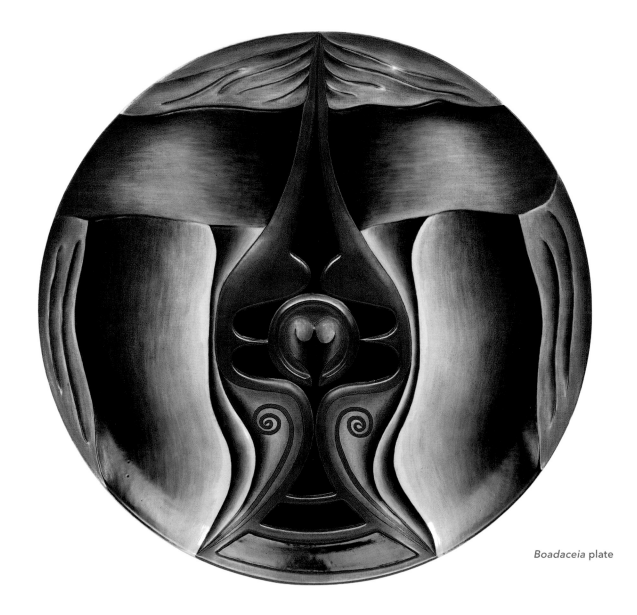

Boadaceia plate

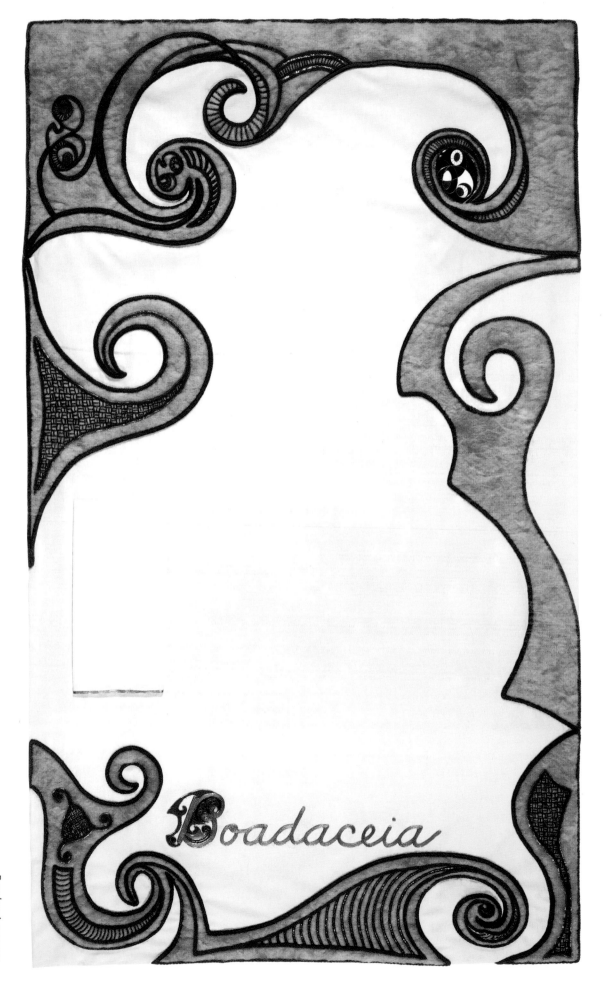

Boadaceia

Boadaceia runner

71

Boadaceia place setting

Boadaceia was not the only woman to have led armies or challenged the might of great powers. Aligned with her are the names of other warriors/queens as well as female rulers prominent in areas outside of Rome.

Alexandra of Jerusalem
D. 70 BCE; JUDEA

Alexandra, the widow and successor of the king of Judea, Alexander Jannaeus, was able to establish peace in the area after her husband's bloody reign. Unfortunately, the later years of her rule were disturbed by conflicts arising from her younger son's opposition to her policies, particularly her insistence upon religious tolerance.

Aretaphila of Cyrene
CIRCA 120 BCE; CYRENE

Widowed at the hands of a tyrant and then forced to marry the man who had murdered her husband, Aretaphila vowed to free herself and her country from his oppression. This goal was eventually fulfilled. According to Plutarch, she "displayed . . . a bravery and an achievement which may well rival the counsel of the heroines of olden times." The people asked Aretaphila to reign, but for unknown reasons she declined.

Arsinoe II
THIRD CENTURY BCE; EGYPT

Though Arsinoe II's first two marriages were tumultuous, eventually she fled to Alexandria, Egypt, where she married her brother Ptolemy II and shared all of his titles. Thanks to her foreign policy skills, he won his campaign against Syria; Arsinoe II was also responsible for the expansion of Egyptian sea power. For her contributions, he had her deified. They were both represented on Egyptian coinage, and even after she died, her husband continued to cite her name in connection with royal decrees.

Artemisia I
FIFTH CENTURY BCE; HALICARNASSUS

According to Herodotus's *Histories*, Artemisia, who was named after the Goddess Artemis, was one of the most distinguished women of antiquity and the only one to whom he attributed the virtue of courage or *andreia*, which literally means "manliness." Upon the death of her husband, she assumed the throne of Halicarnassus, near Turkey. In 480 BCE, she engaged in a military expedition against the Greeks, distinguishing herself as a strategist comparable to any of the Persian generals. In response, the Athenians offered a large reward for her capture because they could not believe a woman could have outmaneuvered them.

Artemisia II
FOURTH CENTURY BCE; HALICARNASSUS

Artemisia II erected a tomb for her dead husband Mausoleus, with whom she had ruled for twenty-four years. This "mausoleum" (from which all such subsequent monuments obtained their name) was considered one of the Seven Wonders of the Ancient World. For the two years she outlived her husband, Artemisia ruled the empire. When the Rhodians (from the Greek isle of Rhodes) attempted to dethrone her, she drove them back to the walls of their own city, which she and her troops besieged in the year 351 BCE.

Basilea
LEGENDARY; CELTIC

Queen Basilea, the first ruler of Atlantis and the legendary daughter of the Goddess Gaia, was said to have brought law and order to her people after the mythical war against the forces of evil and chaos.

Brynhild
LEGENDARY; GERMANY

Brynhild was the most famous of the Valkyries, a band of German horsewomen and warrior goddesses. Depicted as virgins with swans' plumage, these women would supposedly become the slaves of any man able to steal their feathers. Brynhild's were taken by King Agnar, whom she aided during his battle with King Hjalmgunnar. By helping Agnar, she had presumably defied the sky god Odin, who stripped her of her immortality, then secluded her in a flame-encircled castle. Despite her vow to virginity, she swore that she would marry any man who could rescue her. The German hero Sigurd, or Siegfried, rode through the fire that surrounded her dwelling and won her hand.

Cartismandua
FIRST CENTURY CE; BRITAIN

Cartismandua (Cartimandua) ruled the Brigantes, a loose federation of tribes whose name was derived from that of the Celtic Goddess Brigante. At the time of the Roman invasion in 43 CE, the queen was able to establish friendly relations between her people and the Romans. In 57 CE, her estranged husband Ventius attempted to overthrow her, but the Romans put down the rebellion. She and her husband then reconciled, reigning jointly for a number of years until Cartismandua apparently deserted Ventius for his arms bearer Vellocatus, after which she was never heard from again.

Chiomara
CIRCA 180 BCE; GAUL

When the Romans defeated the Gauls, Chiomara was one of the many women taken captive. After she resisted a Roman centurion's attempts to seduce her, he raped her and then offered to grant her freedom in exchange for a large quantity of gold. She managed to cut off his head, which she took to her husband as a symbol of her revenge.

Cleopatra
69–30 BCE; EGYPT

After the death of their father, Cleopatra and her brother Ptolemy XIII became joint rulers. Because her brother was weak, Cleopatra basically reigned alone, which galled Ptolemy's advisors. They conspired against her, driving the queen from the capital city of Alexandria. With Caesar's aid, she raised an army and recaptured the throne. In 47 BCE, Cleopatra joined Caesar in Rome, remaining with him until his assassination, after which she returned to Egypt. In the ensuing power struggle between Octavian

and Mark Antony, Cleopatra sided with Antony; soon they became lovers. Octavian declared war on Cleopatra, and they met in the Adriatic Sea in one of the most famous battles in history. Cleopatra was defeated, but Octavian waited a year before claiming Egypt as a Roman province. He arrived in Alexandria and easily defeated Antony, who committed suicide by falling on his own sword, dying in Cleopatra's arms. She then killed herself by allowing an asp to bite her. At the height of her powers, Cleopatra was considered the "New Isis" who would fulfill the prophecy that a woman would bring salvation to a world torn with strife, but it would be her tragic love affairs rather than her accomplishments that would claim history's attention.

Cynane
FOURTH CENTURY BCE; MACEDONIA

As was then customary, Cynane's father arranged a marriage between her and Anyntyas. When her husband was killed by Alexander the Great, she was left with their daughter Eurydice. Although it might seem odd that a mother would want her daughter to marry into the family of the man responsible for her husband's death, Cynane wished to ensure that their daughter would marry Alexander's heir. Therefore, she led an expedition following Alexander to Asia. Macedonian warriors were sent to kill Cynane, but Eurydice went on to marry a son of Alexander, eventually becoming the queen of Macedonia, thereby achieving her mother's goal.

Eachtach
FOURTH CENTURY; IRELAND

Eachtach was reputedly a warrior of such prowess that the men of Ireland gave her a distinguished burial, an unusual honor for a woman.

Macha of the Red Tresses
CIRCA 350 BCE; IRELAND

The warrior queen Macha, the sixty-seventh monarch of Ireland, is said to have disguised herself as a leper in order to manipulate her enemies. After capturing them, she brought them to Emhain Macha, in ancient Ulster. Instead of condemning the prisoners to death, a council ruled by women supposedly made them slaves of the queen. The men then built Macha a fortress that became the capital of the province, which she is

credited with establishing. She is also thought to have founded the first Irish hospital.

Meave
FIRST CENTURY CE; IRELAND

Though married to King Ailill, Meave or Maeve was the superior leader and is credited with saving the city of Ulster from falling to the enemy. *The Cattle Raid of Cooley*, considered the national epic of Ireland, purports to tell the story of Queen Meave's efforts to capture the famous Brown Bull of Cooley. Her tomb, visible for miles, is marked by a huge cairn of stones on the summit of Knocknaree Mountain.

Medb of Connacht
LEGENDARY; IRELAND

A mythical warrior queen and Earth Goddess, Medb was the legendary ancestor of such historic warrior queens as Boadaceia and Cartismandua. Her predecessor was Macha, the fertility and warrior Goddess who was worshiped in parts of pre-Celtic Ireland.

Muirgel
CIRCA 882 BCE; IRELAND

According to Irish folklore, the warrior Muirgel is said to have courageously slain the chieftain of the Vikings during an unexpected invasion of her country, thereby ridding Ireland of a longtime foe.

Olympias
CIRCA 350–320 BCE; MACEDONIA

Olympias was the most prominent woman in Macedonia during the stormy period when her husband Philip II ruled that country. Devoted to her son Alexander the Great, she worked to ensure his succession to the throne.

Tomyris
SIXTH CENTURY BCE; SCYTHIA

Tomyris, a Scythian warrior queen and founder of the city of Tamyris, assumed the throne upon the death of her husband. Cyrus of Persia, a neighboring ruler, invaded her country; she placed her son Spargapises at the head of the army. When Cyrus took him prisoner, Spargapises committed suicide. Distraught, Tomyris led her forces in a fierce battle with the king and was victorious. She then killed Cyrus, dipping his head in gore and proclaiming that she was giving the bloodthirsty man his fill of blood for murdering her beloved son.

Veleda
CIRCA 70 CE; GERMANIC

The word *Veleda* is either the name of a person or a title; it could be the Latin rendering of the Celtic word for prophetess. The Veleda that has come down through history predicted the success of the German Batavians when they revolted against the Roman Empire. It is not known whether she simply prophesied or actively incited the rebellion. It is certain, however, that this Veleda was an unmarried woman who enjoyed wide influence. Because she was venerated as a goddess, approaching her was forbidden. While living in seclusion in a tower, she is thought to have issued her directives through one of her relatives.

Zenobia
CIRCA 240–300; PALMYRA

Zenobia, one of the most famous women in history and legend, was a scholar, able warrior, and military strategist. After the death of her husband the king of Palmyra, she took over the large empire, ruling for many years and waging wars to conquer Egypt, Syria, and Asia Minor. Because Zenobia had rebelled against Roman imperialism, her power was seen as a threat, and two emperors besieged her land. She was able to repulse the first attack, but was captured during the second and taken to Rome as a valuable prisoner, where she lived to an old age as a well-respected matron in Roman high society.

73

Boadaceia illuminated capital letter

Hypatia

370–415 CE

A child prodigy, Hypatia was the daughter of the mathematician and philosopher Theon of Alexandria. She mastered mathematics, astronomy, and the natural sciences, becoming the first woman to make a substantial contribution to the development of mathematics. A charismatic philosopher, she was appointed head of the University of Alexandria. Because of her stature, government officials consulted with her about the widespread unrest in Rome. She advised them that Roman men abusing their women was the cause, leading to turmoil in the empire that could only be resolved by elevating women to their earlier status.

Hypatia attempted to bring about an intellectual reawakening of reverence for the Greek gods and goddesses. Her position in Alexandrian society incensed the bishop of Alexandria, no doubt in part because she had come to symbolize learning and science, which early Christians identified with paganism; moreover, silence and submission were what some Church fathers expected from women. Her prominence made it difficult for the bishop to openly attack her. Instead, he organized a group of fanatical monks who waylaid her as she traveled to her weekly lecture at the university. Dragging her from her carriage, they pulled her limbs from their sockets, plucked out her organs, hacked her remains into pieces, and then burned them. Years later, when the great library of Alexandria was sacked, Hypatia's writings—like her person—were extinguished by flames.

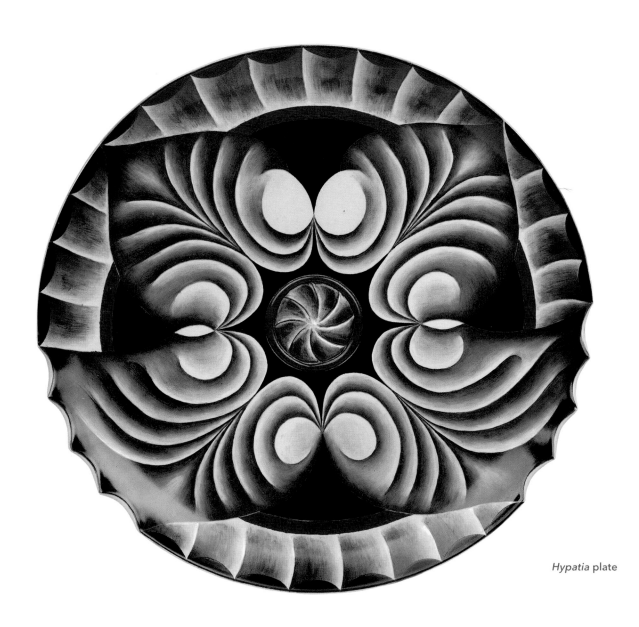

Hypatia plate

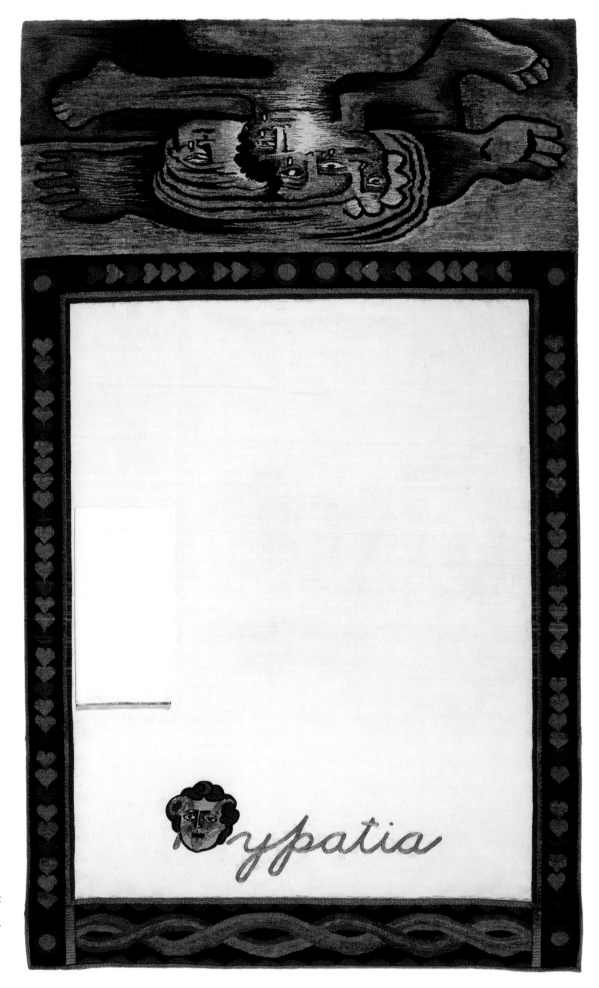

Hypatia runner

Hypatia place setting

Although upper-class Roman women were educated and able to participate in society, they exerted political influence largely through men. The names surrounding the *HYPATIA* place setting represent women's varying efforts to exercise intellectual, cultural, and political power. Also included are some early Christian women, many of whom became martyrs to this new faith. Although Christianity would eventually constrict women's freedom, initially it provided both hope and a haven to women.

Aemilia

FOURTH CENTURY; ROME

Because Roman women enjoyed considerably more rights than their Athenian sisters, Aemilia was able to become a physician, practice medicine, and write books on gynecology and obstetrics.

Agatha

D. 250; SICILY

Agatha, whose name means "good," was a noblewoman who became a Christian. When edicts were announced against the burgeoning religion, a magistrate named Quinctianus tried to blackmail Agatha into having sex with him in exchange for not imprisoning her for her beliefs. After she refused, he had her beaten and tortured, her breasts crushed and then cut off. She was rolled onto burning coals, then left to die in prison. Undeterred, she valiantly proclaimed: "My creator, you have protected me since I was in the cradle . . . and given me patience to suffer. Now receive my spirit."

Barbara

D. 306; NICODEMIA

Barbara, a wealthy, well-educated woman, converted to Christianity and took a vow of chastity. This so enraged her father that he exposed her as a Christian. Cruelly tortured, her wounds miraculously healed. Her father then beheaded her. Highly venerated, she became the patron saint of those in peril.

Blandina

D. 177; GAUL

Blandina was the slave of a Christian mistress and one of forty-eight martyrs to die in Lyons during the persecutions that took place there. Blandina was arrested and tortured in an amphitheater before a cheering crowd. Her body was mangled then thrown to wild beasts. She was finally burned at the stake without ever having recanted her faith.

Catherine

D. 305; ALEXANDRIA

Educated in the schools and libraries of Alexandria, Catherine was learned in science and oratory. She converted to Christianity after having a vision. When she was eighteen years old, she offered to debate the non-Christian scholars in the country, many of whom were swayed by her arguments. In response, the Emperor Maximus imprisoned her. Maximus's wife and the leader of his army visited her and were so moved by her oratory that they also converted. The emperor then ordered that Catherine's body be broken on a specially constructed machine, which had four wheels armed with points and saws that turned in opposite directions—a device that came to be called "the Catherine Wheel." But as soon as her body touched the wheel, it was miraculously destroyed. In the end, she was beheaded.

Clodia

FIRST CENTURY BCE; ROME

Clodia, a wealthy and independent woman, conducted a great salon in her house that included many of the outstanding thinkers and politicians of the era. But because she advocated and practiced sexual freedom, Catullus and Cicero, two of the most prominent writers of the time, characterized her as a loose woman. Consequently, she became a symbol of late Roman decadence and her story used as a cautionary tale for those subsequent women who wished to live freely.

Epicharis

FIRST CENTURY; ROME

A freed slave, Epicharis was involved in a conspiracy against the deranged emperor Nero. When the plot was uncovered, she was cruelly tortured but refused to divulge any information on her coconspirators. The following day, she was brought back to the tribunal in a chair because she could not stand or walk. In an act of open rebellion, Epicharis took off the girdle that bound her breasts, tied it to the canopy of the chair in a noose, and publicly hanged herself.

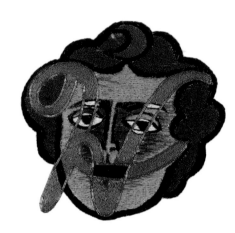

Hypatia Iluminated capital letter

Cornelia Gracchi

CIRCA 169 BCE; ROME

Cornelia Gracchi or Gracchus was considered one of the most remarkable women in Roman history. Her house was a social and intellectual center; extant fragments of her letters substantiate that she corresponded with some of the most distinguished philosophers and scientists of her time. She carefully educated her sons, known to history as the Gracchi; they became lightning rods of political reform in the late Republic. Their assassination is often referred to as the first major step toward the fall of the Roman Republic.

Hestiaea

SECOND CENTURY; ALEXANDRIA

Hestiaea, a Homeric scholar, was one of the first people to attempt a scientific exploration of the actual locations of places named in *The Iliad*, notably Troy, a site first settled in the third millennium BCE and a center of ancient civilization.

Hortensia

CIRCA 50 BCE; ROME

Hortensia, an eloquent orator, represented fourteen hundred wealthy women who felt they were being unfairly taxed to pay for a war they had no part in planning. An early advocate of "no taxation without representation," Hortensia confronted male lawmakers at the Roman Forum, asking: "Why should we pay taxes when we have no part in the honors, the commands, the policy making?" After her argument, the taxes levied on the women were reduced.

Laya

CIRCA 100 BCE; GRECO-ROME

Thought to be the inventor of miniature painting, Laya was renowned for her small images on ivory—particularly her portraits of women. Her work, which commanded large sums of money, is known to history through the writings of Pliny the Elder (23-79 CE), who praised her highly.

Metrodora

SECOND CENTURY; ROME

Metrodora, a physician, wrote a treatise on the diseases of women that is the oldest extant medical writing by a woman. A twelfth-century copy of *The Metrodora Text* is housed in the Laurentian Library in Florence. In addition to an alphabetical listing of cures, contraceptives, and aphrodisiacs, the manuscript contains valuable prescriptions for the treatment of diseases of the uterus, stomach, and kidneys.

Pamphile

CIRCA 20; GREECE

Pamphile (Pamphila), the daughter of a grammarian and the wife of a scholar, was a historian who supposedly wrote a thirty-three-volume work as well as many important shorter treatises.

Philotis

CIRCA 380 BCE; ROME

Philotis, a maidservant in Rome, led a group of female slaves in a plot against the invading Gauls, who had demanded that the women of the city be given to them. The female slaves dressed themselves as Roman matrons with clothes supplied by the upper-class women. They feasted with the Gauls, using potions to sedate the troops. Then Philotis lit a torch to signal the women, who—together with a group of Roman warriors—drove the invaders from their land.

Cornelia Scipio

FIRST CENTURY BCE; ROME

Cornelia Scipio was a mathematician, a philosopher, and a musician. She is known to have traveled widely but, unfortunately, her later career was lost to history.

Shalom

CIRCA 70; HEBREW

Shalom became a highly educated and respected woman despite the fact that her husband, a religious scholar, accepted the scriptural proscription that "Whoever teaches his daughter Torah, it is as though he taught her lechery."

Sulpicia

FIRST CENTURY; ROME

Sulpicia was the only female poet included in the corpus of classical Latin literature as well as the first woman to encourage other Roman women to believe that they could write poetry on the level of the greatest Greek poets. While some feminist critics have argued for a female-centered, erotic reading of her extant poetry, others have viewed her work in the context of Roman gender relationships, concluding that her poems give voice to an ancient woman's struggle to express herself within the confines of the language.

Detail, *Hypatia* runner back

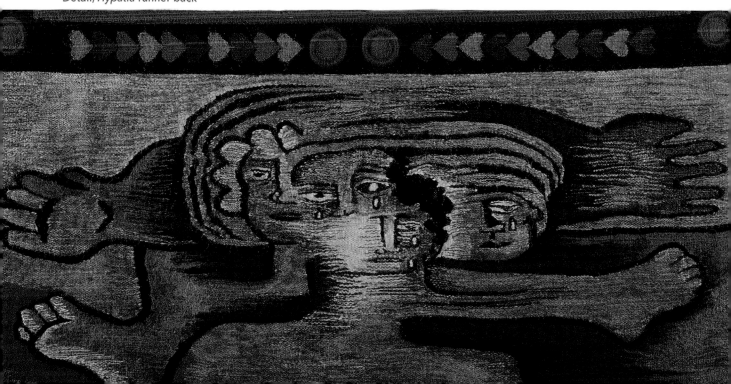

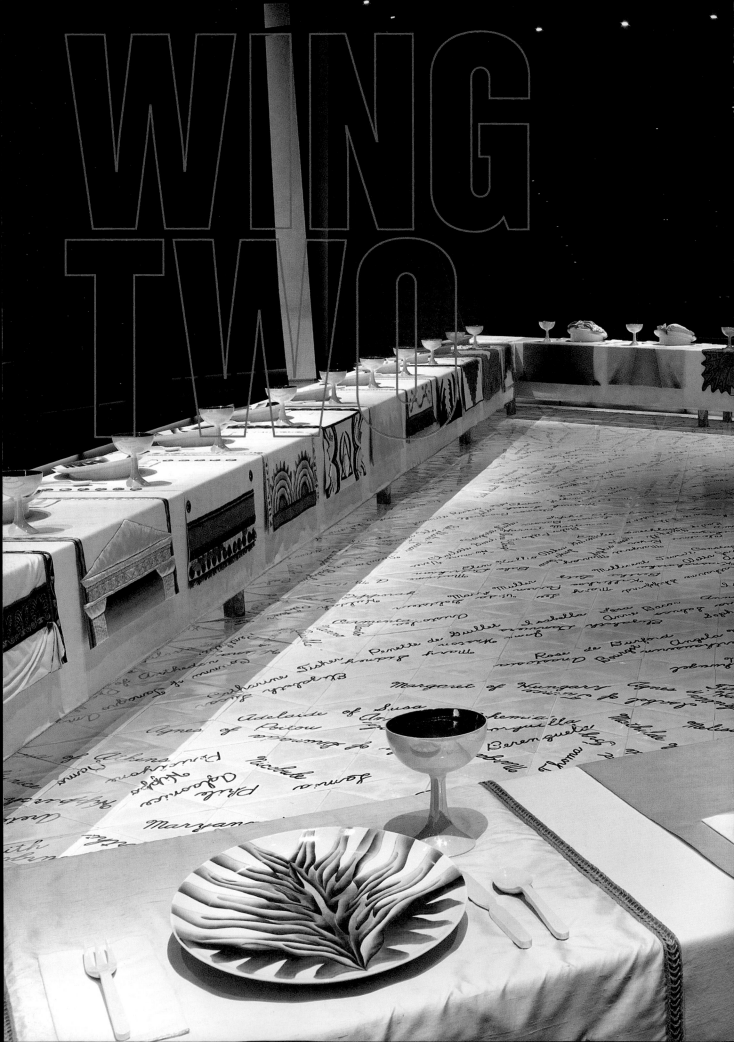

FROM CHRISTIANITY TO THE REFORMATION

The second wing of *The Dinner Party* visually chronicles the fluctuations in women's circumstances from the early days of Christianity when, in many religious communities, women enjoyed considerable freedom, to the advent of the Reformation, which brought about the dissolution of convents and with that the education and independence they had provided women for centuries. Previously, religious houses had served as both a refuge and support for the aspirations of many women, at least those from the ruling classes.

As feudal society gradually gave way to the Renaissance and the modern state, all classes of women were affected. With the rise of the guilds, women were gradually forced out of some of their traditional occupations, such as weaving and the healing arts. And in contrast to the monastic system, the new secular universities were essentially closed to women.

The new form of female education ushered in by the Reformation was limited to preparing women for marriage and domestic life. But, as access to education became more widespread, women were gradually able to develop the intellectual tools necessary to articulate arguments for obtaining more rights, arguments that would gain ascendancy as the centuries passed.

These developments are reflected in the iconography of the second wing, particularly in the runners, where the imagery moves up onto the runner tops and encroaches upon the plates as a metaphor for the increasing constriction of women's freedoms. Simultaneously, the plate edges begin to be more irregular, the forms assuming greater definition and the images becoming more active and dimensional, visually symbolizing women's struggle to transcend the confines of their historical circumstances.

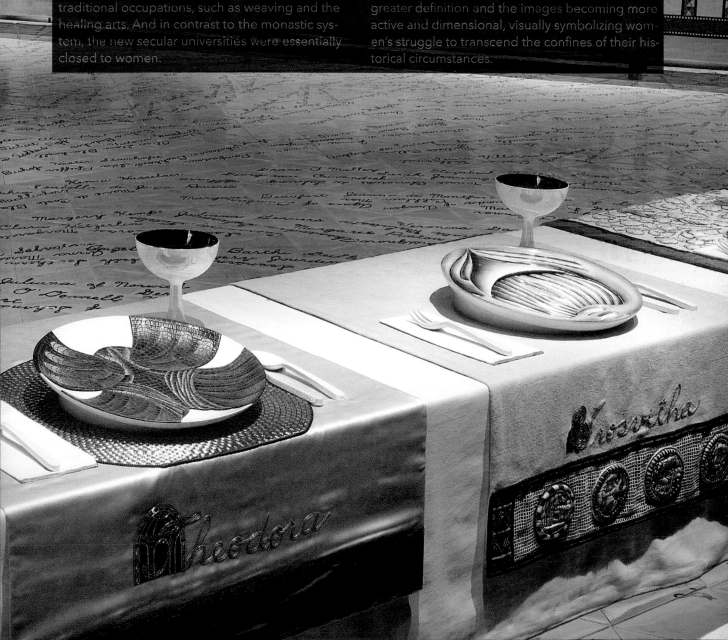

Marcella

325–410

Born to a noble family, Marcella lived in the Roman Empire during its disintegration. Although she was forced to marry at an early age, she was widowed young. She then dedicated herself to a religious life, transforming her palatial quarters into the "Little Church of the Household," a center for women who were interested in a simple life of purpose. Under her guidance, women studied Scriptures and were educated in a Christian way of life.

Marcella and her followers were attracted to Christianity in part because of the doctrine that "in Christ there is neither male nor female," a widespread ideal at the time. In addition to functioning as a place of study and prayer, Marcella's household became a center for deeds of Christian charity. Its members set up religious houses and schools for women and ministered to the sick and needy. As the Church became more organized, however, women began to be excluded from many of these activities, and the importance of their contributions was minimized.

In 410, during the Sack of Rome, Marcella was beaten by invading soldiers and she died soon after. But this remarkable woman helped to plant the seed that eventually flowered into the great monastic system of Christianity. Her modest convent was among the first of many female religious communities that would provide women with education, support, and a refuge from a world increasingly hostile to both their aspirations and their independence.

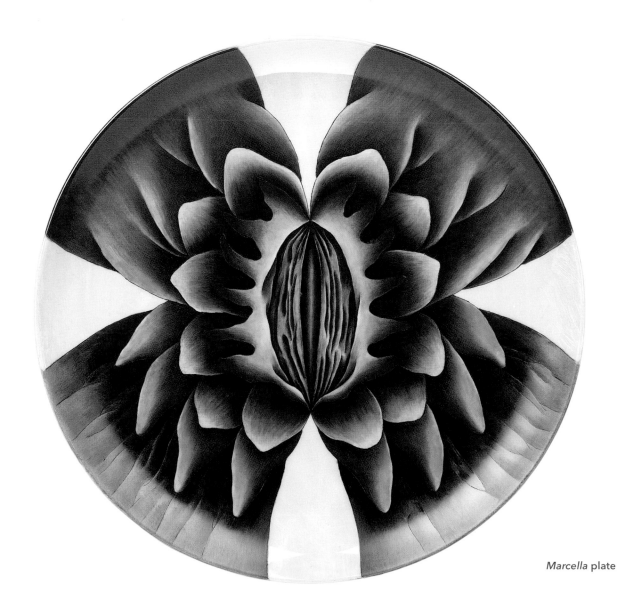

Marcella plate

Marcella place setting

Grouped around MARCELLA's place setting are the names of others who spread the gospel of Christianity, along with powerful Roman women. Although they could only exercise cultural or political power through men, they enjoyed considerably more independence than their sequestered Athenian sisters.

Agrippina I
13 BCE–36 CE; ROME

Agrippina I grew up as a member of Rome's first imperial family. Her father died when she was young, and her mother Julia was forced into an unhappy political marriage. In response, Julia took up with a series of lovers, causing her to be banished by the emperor. She eventually starved to death because her allowance had been stopped as a punishment for her infidelities. When her daughter Agrippina was eighteen or nineteen, she was married to Germanicus, an educated general. A loyal wife, she gave birth to a total of nine children. She also often accompanied her husband into battle. After his death (supposedly under suspicious circumstances), she returned to Rome with her children, carrying her husband's ashes. She became the rallying point for a political struggle that eventually led to her arrest; like her mother, she was sent into exile. Eventually she too died of starvation, either deliberately or by force.

Agrippina II
15–59 CE; ROME

Like her mother and grandmother, Agrippina II was also exiled—in her case, for taking part in a conspiracy against her brother, Emperor Gaius. After being allowed to return to Rome, she married Emperor Claudius and induced him to adopt her son from her first marriage, Nero, as his heir. There is some evidence that Claudius was an inept ruler and that it was actually Agrippina II who governed in his name for ten years. When Claudius died, Nero succeeded him. As he was only sixteen, his mother attempted to play the role of regent, but Nero gradually usurped her power. Enraged by Agrippina II's opposition to an affair he was having and her conviction that his worsening mental condition would bring chaos to the country, Nero ordered his mother put to death.

Anastasia
D. 303; ROME

Anastasia's father arranged her marriage to a wealthy Roman who, upon discovering her Christian faith, treated her harshly. After he died, Anastasia devoted herself to scriptural studies, spending her fortune on charity and building one of the first parish churches, which was named after her. She was eventually imprisoned and burned for her refusal to renounce her faith.

Caelia Macrina
SECOND CENTURY; ROME

Caelia Macrina, a philanthropic noblewoman, provided an enormous amount of money for the care of more than one hundred boys and girls.

Dorcas
FIRST CENTURY; JERUSALEM

An affluent woman whose name has become synonymous with charity, Dorcas made clothes for the needy. Out of her work grew the Dorcas Sewing Societies, which evolved into an international aid society that is still functioning. Upon her death, Dorcas was said to have been resurrected by St. Peter.

Eustochium
CIRCA 368–419; ROME

Eustochium and her mother Paula belonged to one of the first families of Rome and were disciples of Marcella. They both took a class with the Christian priest Jerome (377–404) when he visited the city. Eustochium soon mastered Latin and Greek, as well as the ability to read the Bible in Hebrew. She began teaching a circle of noble Roman widows, guiding them in their spiritual growth. She and Paula made a pilgrimage to the Holy Land, where they settled, founding three convents, a monastery, and a hospice in Bethlehem.

Fabiola
D. 399; ROME

Fabiola, a wealthy noblewoman, was also converted to Christianity by Marcella. As her husband was abusive, she divorced him and then married again while he was still alive, creating a controversy because divorce was viewed as a male prerogative. After being widowed, she made public penance for these supposedly sinful acts by founding the first public hospital in Rome, where she acted as nurse, physician, and surgeon. Later she traveled to Bethlehem where she lived at the hospice founded by Paula and Eustochium. Upon her return to Rome, she was important in the inception of a female order of Christian ministry. When she died, thousands of people paid homage to her for her good works.

Flavia Julia Helena
D. 330; ROME

It was at her father's inn that Flavia Julia Helena, a commoner, met and then married the Roman general Constantius. When he became emperor in 292, he was forced to divorce her in order to marry a noblewoman. Fourteen years later when Constantius died, with the support of his troops Helena ensured that her son Constantine was proclaimed emperor. In recompense for the public disgrace Helena had previously experienced, her son renamed the city of her birth after her, struck coins in her image, and bestowed upon her the title "Empress of the World." When Helena was sixty-three, she converted to Christianity, becoming known for her generous support of the Church. Shortly before Constantine died, he also converted and, under his mother's influence, established Christianity as the official state religion, an act that brought a monumental change to the Western world.

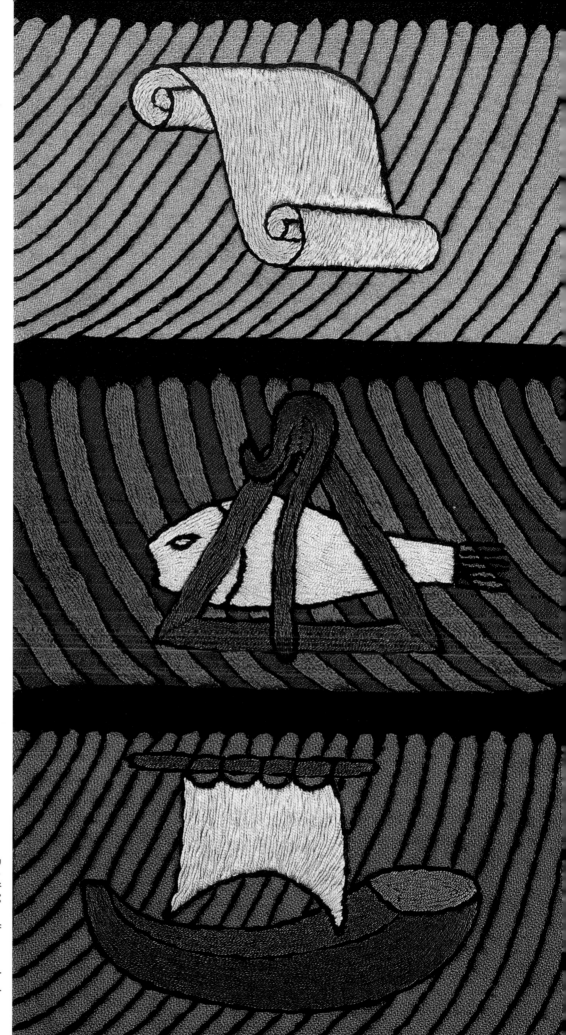

Detail, *Marcella* runner back

Galla Placidia

395–450; ROME

Galla Placidia was the daughter of Emperor Theodosius I and his second wife Galla. She received a classical education and was granted her own household by her family, which made her financially independent. Twice-widowed, she became regent when her young son Valentinian was named emperor in 425. Even after he reached his majority, she retained a position of influence until her death. A devout Christian, Galla Placidia was responsible for the building and restoration of several churches as well as for many city improvements.

Julia Domna

CIRCA 157–217; ROME

A well-educated Syrian, Julia Domna was the second wife of the Roman emperor Septimius Severus. Even after his death, she remained an important figure, gathering around her a group of intellectuals whose activities are known through the writings of Philostratus (170–247). After a power struggle in which her son Caracalla killed his brother Geta, the victor succeeded his father as emperor. He soon embarked on a five-year military campaign, leaving his mother in charge of the administration of Rome. In 217, he was murdered. Distraught, Julia Domna starved to death, either voluntarily or on the orders of the new emperor, Macrinus.

Julia Maesa

CIRCA 217; ROME

Julia Maesa acted as a military commander in the Roman army and was the sister-in-law of Emperor Septimius Severus. Her knowledge of the inner workings of the court enabled her to put her grandson Alexander on the throne. She then made a place for herself and her daughter Soemias in the Senate, becoming the leader of the Senaculum, a group of females who decided issues pertaining to women.

Julia Mamaea

D. 235; ROME

Julia Mamaea, trained in state affairs by her mother Julia Maesa, led troops in a battle that established her regency in the name of her young son Alexander. A level of peace and prosperity unprecedented in Roman history characterized her reign. When her son reached adulthood, he named her imperial consort. It was in this capacity that she accompanied him on his military campaigns. Although Julia Mamaea and Alexander spent money on public works and implemented many reforms, they failed to gain the loyalty of their soldiers. During a military expedition, the dissatisfied troops assassinated both Julia and her son.

Livia Drusilla

58 BCE–29 CE; ROME

The daughter of a Roman noble, Livia Drusilla was married off at a young age. When she was nineteen and pregnant with her second son, she caught the eye of Octavian, the Roman emperor, who arranged to have her marriage annulled so that he could take her as his bride. The haste of his actions and the fact that Livia relinquished her children to their father precipitated a scandal, one with which Octavian dealt by announcing an omen that he claimed justified the marriage. In the early days of Octavian's rule, his position was tenuous, and Livia's lineage and wealth afforded him the opportunity to consolidate support, which was one reason he had insisted upon marrying her. However, Octavian increasingly depended upon Livia's sage advice, and she became the first Roman woman to actively influence the major decisions of an emperor's reign, albeit from behind the scenes.

Lydia

FIRST CENTURY; MACEDONIA

A successful businesswoman in the city of Philippi, Lydia was engaged in the lucrative sale of the difficult to make purple dye and purple-dyed textiles used by royal families. (Roman senators and royalty were required to have a band of that imperial color around the edge of their togas.) Lydia is mentioned in the New Testament as an early convert to Christianity, perhaps the first in Europe. Her entire household subsequently converted, and her home became a haven for the disciple Paul and his followers.

Macrina

327–379; TURKEY

Macrina studied medicine in Athens, then went on to build a large hospital in Cappodocia, Turkey, that was revolutionary in that it provided separate pavilions for patients with different diseases along with living spaces for staff. Macrina also founded a women's community in Asia Minor where she taught and lived an exemplary life. Her family was influential in the early Church; she and her brothers, Bishops Gregory and Basil, were later canonized.

Marcellina

330–398; ROME

In the first known ceremonial recognition of a nun by the Church, Marcellina received the Virgin's Veil in 353 at St. Peter's Basilica from the hand of Pope Liberius. In honor of her piety and celibacy, her brother Ambrose wrote *De Virginibus*, a treatise setting forth the guidelines by which professed nuns were to live. When Ambrose became bishop, Marcellina devoted herself to assisting him in building a number of female religious orders.

Mary Magdalene

FIRST CENTURY; JERUSALEM

As a historical figure, Mary Magdalene's identity remains obscured by a variety of patriarchal interpretations of the gospels. Around 600, Pope Gregory decreed that these differing "Mary" identities be combined under the name Mary Magdalene, assigning her the character of the penitent prostitute, a notion that remains despite any textual evidence to support this belief. Subsequently, Mary Magdalene and Mary, mother of Jesus, came to symbolize the Church's polarized attitudes about woman as either a whore or a virgin. More recently, there have been a variety of other theories, including that she was a temple priestess in one of the Goddess-worshiping religions of the Middle East or that she and Jesus were married. What does seem certain is that Mary Magdalene was one of the early female followers of Jesus, was present at his crucifixion and burial, and the first to report the Resurrection.

Martha of Bethany

FIRST CENTURY; JERUSALEM

Martha was the sister of Lazarus, whom Jesus supposedly raised from the dead, and Mary of Bethany. Martha was an early follower of Jesus and prepared meals for him and his flock when they visited her home. While she worked in the kitchen, her sister Mary sat at Jesus's feet, which Martha resented. When she complained to Jesus, he told her that she, Martha, had indeed chosen the better role, which later writers interpreted to mean that she represented action and good works. After Lazarus's resurrection, Jesus visited the two sisters again. This time, it was Martha who went out to greet him; it was to her that Jesus said; "I am the Resurrection and the Life" (John 11:1–44).

Mary of Bethany

FIRST CENTURY; JERUSALEM

Like her two siblings, Martha and Lazarus, Mary of Bethany was an early disciple of Jesus. Although she has been most frequently described as the sinner who anointed Jesus with oil and whom he forgave before his death, her story, like that of her sister's, has also been used to stress the importance of contemplation, prayer, and devotion.

Octavia

CIRCA 69–11 BCE; ROME

Octavia became a political pawn in the ambitious plans of her brother, Emperor Octavian. After he and Mark Antony arrived at a pact in which they would rule together, the agreement was sealed by an arranged marriage between Antony and Octavia. Because she had only recently been widowed, the marriage required a special resolution by the Senate to allow her to remarry before the end of the official mourning period. The couple lived in Athens and had two daughters. However, Antony's desire to extend his power through a marriage alliance with Cleopatra led him to divorce Octavia and to give the queen of Egypt many of Rome's eastern territories. Incensed, the Roman Senate censured Antony and declared war on Cleopatra. After Antony and Cleopatra were defeated, he committed suicide; Cleopatra followed suit. Octavia dutifully took responsibility for the welfare of Antony's children, both Cleopatra's and her own.

Paula

347–404; ROME

After Paula, a wealthy Roman noblewoman and scholar, was widowed, she was converted to Christianity by Marcella. She became a philanthropist and ascetic. In 382, Paula met the disciple Jerome, who inspired her to travel with him to the East to take up the monastic life. Along with her daughter Eustochium, she collaborated on his translations of the Bible, many of which are dedicated to her. Her correspondence with Jerome serves as a historic record of her life and work.

Phoebe

FIRST CENTURY; ROME

Phoebe was perhaps the first deaconess of the Church and one of a vast array of women who would render loyal services to the Church and help build its power. Phoebe was also a close friend of the disciple Paul and delivered an epistle from him to his followers in Rome, an important document in which he explains his reasons for believing in Jesus.

Plotina

D. 120; ROME

Plotina, empress and wife of Trajan, was highly regarded for her political judgment. In addition to helping reduce governmental corruption, she constructed harbors, highways, and buildings, fed orphans, improved the lot of slaves, and expanded the public education system. As a woman, Plotina was, of course, unable to rule in her own name when Trajan died. Instead, she managed to secure the throne for her favorite son Hadrian, extending her influence through him until her death.

Porcia

FIRST CENTURY BCE; ROME

Porcia was devoted to her husband Brutus; when she realized that he was planning a coup as well as the assassination of Caesar, she inflicted wounds upon herself in order to demonstrate how much pain she could bear without divulging her knowledge of the plot. After learning that Brutus had committed suicide, she followed suit, killing herself by swallowing burning coals.

Priscilla

FIRST CENTURY CE; ROME

Priscilla was one of the most influential women in the early Church. She and her husband Aguila, early Roman converts, traveled with Paul to Ephesus, where they preached and held services. Priscilla edited Paul's letters and was instrumental in having them copied and dispersed throughout the empire.

Saint Bridget

450–525

When the first Christian evangelists arrived in Ireland, Goddess worship was still prevalent there. As a strategy for conversion, missionaries encouraged the populace to bring their deities, rituals, and holidays into the Christian faith. This process of cultural and religious amalgamation is demonstrated in the story of Saint Bridget. Born in 450, Bridget was the daughter of an Irish chieftain and a slave woman who had converted to Christianity. As a young girl, Bridget heard the missionary St. Patrick preach, which made such an impression on her that she resolved to consecrate her life to religion. Since there were no nunneries in Ireland, she established a cell under a giant oak tree that had been traditionally used as a shrine of the Mother Goddess Brigid (with whose characteristics Bridget became identified). There she founded a sisterhood devoted to teaching and charity and built the first convent in Ireland, which grew to be a great monastery and center of learning.

She traveled extensively, founding convents all over the country. Under her inspiration, the arts flourished; she established a school of art whose metalwork and illuminated manuscripts became famous for their exquisite workmanship. Bridget has had countless churches, monasteries, and villages named after her, and she is a patron saint of Ireland. To this day, travelers hoping to be healed and wishing to pay tribute to this remarkable woman visit a well named after her at the location of her original convent.

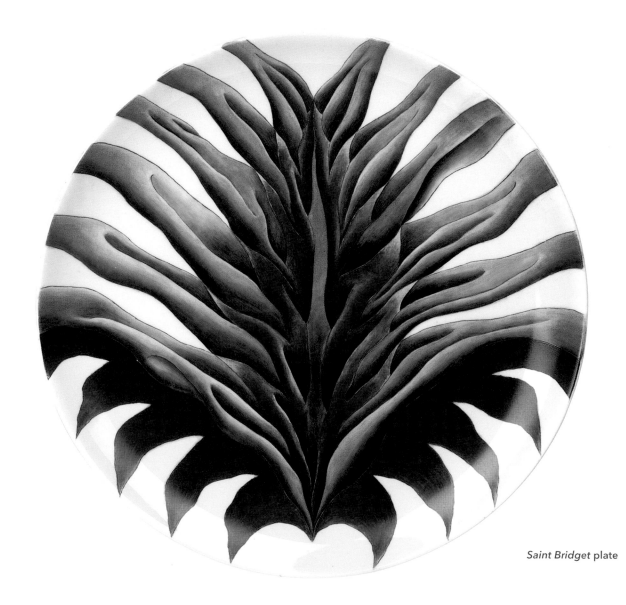

Saint Bridget plate

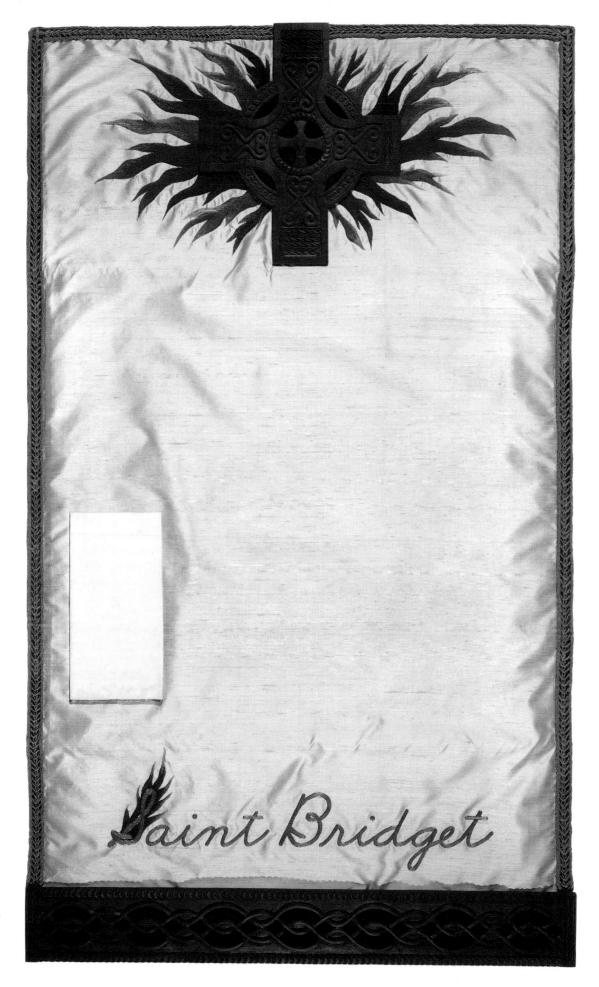

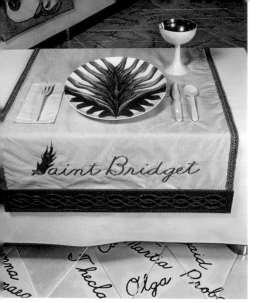

Saint Bridget place setting

The names aligned with the place setting for SAINT BRIDGET represent some of the other women who dedicated themselves to spreading the new Christian faith. They had no way of knowing the degree to which the Church would eventually become oppressive toward women.

Basine

FIFTH CENTURY; FRANCE

During the fourth and fifth centuries, the group of Germanic tribes known as the Franks began settling in the Roman region of Gaul, which included what is now France. In the sixth century, Merovech, king of the Franks, founded the royal Merovingian dynasty. His son Childeric was exiled and took refuge at the court of King Basinus and his wife, Queen Basine (Basin), with whom he had an affair. After eight years, he returned home with Basine, who divorced her husband and married him. Their son Clovis united the Frankish kingdom under Christianity (he converted under the influence of his wife Clothilde), moved the capital to Paris, and become known as the founder of France. Thought to be a prophet, Basine had predicted that her son would possess the strength of a lion, but not so later generations, who would squabble like dogs—a prophecy that proved true. The Merovingian rulers who succeeded Clovis weakened France through ongoing feudal wars.

Brigh Brigaid

70 CE; IRELAND

Brigaid (Briugaid, Brughaidh) was a lawyer who rose to the position of judge, or *brehan*, and was responsible for many precedent-setting laws, particularly in the area of women's rights. For many centuries, Irish women were entitled to inherit property, to retain the wealth they brought to marriage, to divorce, and to take part in military and political activities.

Cambra

N.D.; BRITAIN

Cambra, a scholar, mathematician, and daughter of an early British king, may have invented the method of building and fortifying citadels. Her father was said to have respected her extensive knowledge so much that he consulted her on all important matters of state.

Eugenia

D. 262; EGYPT

Eugenia was a well-educated Roman noblewoman. Because her father Philip had been appointed governor of Egypt, they lived in Alexandria. Determined to devote her life to Christianity, she disguised herself and entered a monastery as the monk Eugene. There she lived humbly until she was elected abbot, an office she reluctantly accepted. At one point, a rich young woman tried to seduce Eugenia and, when she was turned away, accused "Eugene" of rape. Eugenia was thus forced to reveal her gender, subsequently retiring to her mother's estates near Rome. There, she continued with her monastic life until the Emperor Gallienus began a new persecution of Christians and Eugenia was arrested and then beheaded for her faith.

Genevieve

B. 419; FRANCE

Genevieve, who became the patron saint of Paris, was twice credited with saving the city. The first time was when Attila the Hun threatened to besiege it. Genevieve persuaded the women to pray for protection; miraculously, they remained untouched by the destruction suffered by the nearby town of Orleans. Later, she managed to avert a terrible famine by securing large quantities of grain. She is buried in a church whose construction she is said to have planned.

Lucy

283-304; SICILY

At a young age, even before her father's untimely death, Lucy decided to commit herself to a religious life, a decision which her mother Eutychia opposed. Lucy convinced her mother, who had suffered from vaginal bleeding, to make a pilgrimage to Catania, where the relics of St. Agatha were attracting those hoping to be healed. Eutychia was cured, and in gratitude she agreed to support Lucy in her desire to take religious vows. But when Lucy refused a marriage proposal, the rejected suitor denounced her as a Christian and a tribunal condemned her to a house of prostitution. In response, she refused to move from the spot of the trial where—to her mind—such an unfair judgment had been rendered. She was then tortured and, when she wouldn't recant her faith, murdered. She is one of the few female saints whose name appears in the canon of St. Gregory, the first body of codified Church law. There are special prayers for her in some of his writings.

Martia Proba

FOURTH CENTURY; BRITAIN

Martia Proba (*Proba* means just) was the learned wife of King Guithelon. After his death, she ruled Britain for five years. She was responsible for writing the Martian Statutes, which provided the basis for English Common Law, upon which the Western legal system is modeled. They also introduced the idea of trial by jury, a concept unknown to earlier Roman Law. Later, Alfred the Great translated this code, called the Lex Martiana, as the Mercian Laws, having assumed that they had been named after the much later Saxon kingdom of Mercia, rather than their true author.

Maximilla

THIRD CENTURY; ROME

Maximilla was one of the founders of Montanism, an ascetic, apocalyptic movement that was a reaction to what its members believed was the increasing worldliness and ecclesiasticism of the Church. Its proponents advocated religious equality between the sexes, including the rights of women to prophesy, which enraged churchmen. A popular spiritual movement, Montanism posed a threat to the emerging Church hierarchy. Despite continued clerical opposition, the movement existed until the sixth century.

Scholastica

480–543; ITALY

According to the *Dialogues of St. Gregory*, which chronicles the life of Benedict, Scholastica's twin brother, she consecrated herself to God at an early age. When Benedict established his monastery at Monte Cassino, she founded a convent nearby; since it was under the protection of his monastery, it can be viewed as part of the first Benedictine order. Under Scholastica's leadership, greater dignity was accorded to female monasticism. The nuns devoted their time to worship, study, and manual labor; their spinning, weaving, and manufacturing of cloth led to the development of the textile industry that became one of the triumphs of the Middle Ages.

Sylvia

CIRCA 398; FRANCE

Sylvia of Aquitaine was a noblewoman who traveled to the Holy Land with Paula, the friend of Jerome and mother of Eustochium. She left an extensive record of their journey in the form of a series of letters to a group of nuns in a French convent and was later sainted.

Thecla

FIRST CENTURY; TURKEY

Thecla was closely associated with the Apostle Paul and, like him, became a symbol for the ideals of the early Christian ascetic movement. Sometime between 160 and 190, a devout Christian woman penned what was originally called *The Acts of Thecla*. Later versions seem to have added Paul's name as coauthor and deemphasized his strong support of women's leadership roles perhaps because, by the second century, the women's ascetic movement was becoming too powerful for some of the male leadership. They began to emphasize that women would be saved not through chaste lives but by bearing children. Despite the Church's efforts to minimize Thecla's importance, her influence has persisted. She is especially revered in the Eastern Church, where she is referred to as the "Equal of the Apostles." In the early 1980s, interest in *The Acts of Thecla* revived among Christian scholars, particularly among women.

Detail, *St. Bridget* **runner back**

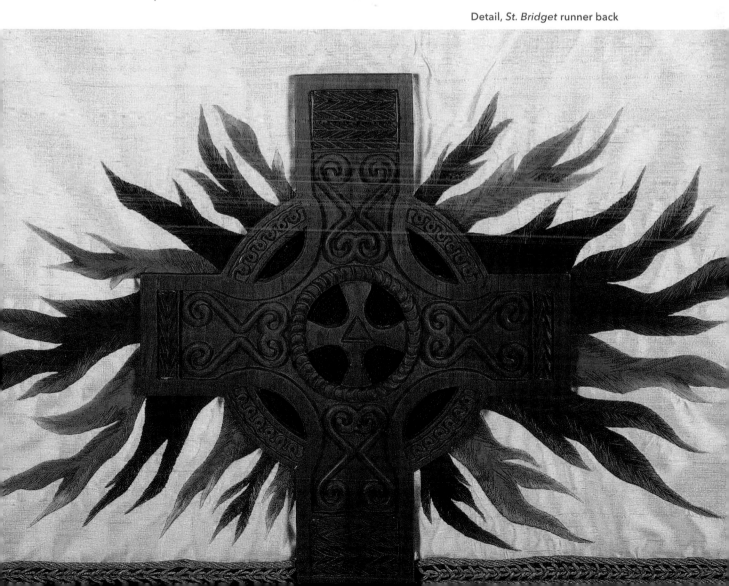

Theodora

Most of what we know of the famed Byzantine empress Theodora derives from the misogynist writings of Procopius (circa 490/507–560s). According to him, she lived a dissolute life as an actress, a despised profession in Byzantine society. At some point, however, she became religious, establishing a simple life in Constantinople and supporting herself by spinning. Shortly thereafter she met Justinian, the Emperor Justin's nephew. They were married as soon as Justinian was able to convince his uncle to change the laws prohibiting marriage between a royal and a commoner.

After Justinian inherited the throne, he and Theodora reigned jointly. She passed laws to improve the lives of actresses and issued an imperial decree making it punishable by death to entice a woman into prostitution, turning one of her palaces into an institution where ex-prostitutes could go to start new lives. She helped raise the low status of women in marriage, improved divorce laws in their favor, saw to it that women could inherit property, and instituted the death penalty for rape. Moreover, Theodora's insistence that all these legal changes be enforced created a legacy that benefited the lives of Byzantine women for centuries.

90

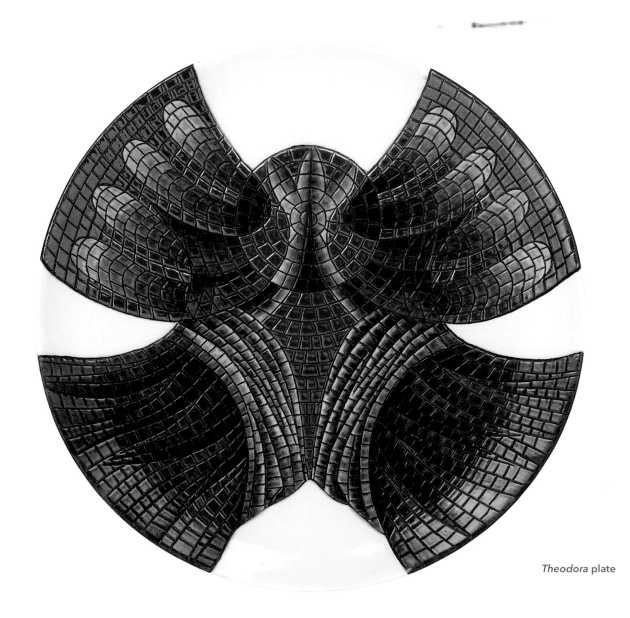

Theodora plate

Theodora runner

Assembled around the place setting for THEODORA are the names of other prominent Byzantine women. As a result of the empress's reforms, the position of women in Byzantium was higher than almost anywhere else in the West. Though the status of women in other countries was less favorable, there were still some who were able to leave their mark; their names are also included here.

Adelaide
931–999; BURGUNDY

Adelaide, queen of Burgundy and empress of the Holy Roman Empire, was the daughter of King Rudolf of Lorraine. After an early marriage and the untimely death of her husband Duke Lothar of Burgundy, she married Otto I of Germany, uniting her lands with his and achieving what appeared to be a happy marriage. When Otto died, she became regent for their son Otto II, who married Theophano but died while still a young man. Adelaide and Theophano then aligned themselves to ensure that Otto III, the three-year-old son of Theophano and Otto II, would inherit the throne. Together, they ruled in the child's name until Theophano died, at which time Adelaide became sole regent of Germany. When Otto III reached his majority, he said that he no longer wished to be ruled by a woman. Adelaide retired to a nunnery, spending her final years doing good works. She died in 999 on the eve of the next millennium.

Aethelburg
CIRCA 673–740; ENGLAND

Aethelburg was the wife of Ine, king of Wessex. Together, they reigned long and prosperously. In 728, Aethelburg, a devout Christian, convinced her husband to relinquish the crown to her brother Aethelhard. The couple traveled to Rome, where they lived among the poor, supporting themselves by manual labor. After Ine's death, the queen took her children and went to Kent, which was ruled by another brother, King Eadbald, founding a monastery at nearby Liming, where she is buried.

Aethelflaed
869–918; ENGLAND

Aethelflaed was the eldest child of Alfred the Great (871–900). He married her to the earl of Mercia in a political alliance; after her husband's death, Aethelflaed was essentially given sovereignty over the region. When she died, by law the throne should have passed to her daughter Elfwynn. (Contrary to the practices of many other nations, sovereign authority among the Anglo-Saxons could still descend to a female, a tradition described as "falling to the spindle side.") Instead, Elfwynn was taken captive by her uncle Edward, who declared himself king.

Balthilde
SEVENTH CENTURY; FRANCE

Born in England, Balthilde was a princess who was captured, sold into slavery, taken to France, and forced into marriage with Clovis II, the Frankish king. At his death in 657, she became ruler, using her position to liberalize many laws including restoring the rights of individuals, abolishing the slave trade in France, and establishing equalized taxation.

Bertha of England
D. 612; ENGLAND

In order to create a political alliance between England and France, Bertha, a Frankish princess, was married to the king of Kent. Because she was a Christian and her husband was not, she insisted that their marriage contract stipulate her right to practice Christianity. It was through Bertha's influence that Christianity was introduced into England, specifically through her

Theodora place setting

establishment of the first Christian church at Canterbury. She was also primarily responsible for codifying the first body of written law in England, which was based upon the Martian Statutes.

Brunhilde
CIRCA 545–613; AUSTRASIA

Brunhilde (Brunhild), daughter of the Visigoth king Athanagild, married King Sigebert of Austrasia (today's northeastern France and western Germany). Because his country was less developed than her own, she attempted to introduce a number of legal reforms. She also supervised the construction of buildings and infrastructure and provided patronage for the arts. Her sister Galswintha, who was married to Chilperic, Sigebert's half-brother and king of the neighboring kingdom of Neustria, was killed by Chilperic's mistress Fredegund, who subsequently married him. Brunhilde convinced her husband to avenge Galswintha's murder by declaring war on Neustria, a conflict that continued for forty years. In 575, Chilperic had Sigebert assassinated then claimed Austrasia as his own. Brunhilde left the country but returned later in order to maneuver her grandsons onto the throne. When she was eighty, she perished at the hands of Clothaire II, the son of an old political rival. He had her paraded before the army on the back of a camel and kicked to death by a wild horse.

Clotilda
475–545; FRANCE

Clotilda, queen of the Franks, is known primarily for converting her husband Clovis I and three thousand of their subjects to Christianity, an act that would establish the Frankish kingdom as a Catholic nation and create a significant alliance with the Papacy. As a result, historians often refer to Clotilda as the "Mother of France." After her husband's death, she became known for her piety and charitable work. She was buried beside Clovis in Sainte-Genevieve, the church they cofounded in Paris.

Anna Comnena

1083–1148; BYZANTIUM

Anna Comnena, considered the world's first female historian, wrote *The Alexiad*, a fifteen-volume work chronicling the achievements of her father Alexius I, whose empire stretched from Italy to Armenia. She grew up expecting to inherit her father's throne, but the birth of her brother put an end to her hopes. Disappointed, she declared that nature had "made a pretty mess of things, clothing her masculine spirit with a woman's body." In 1097, Anna Comnena married a historian and, with her mother's encouragement, attempted to seize the throne in his name. When her efforts failed, she was forced to retire from court life. After her husband died, she entered a monastery, where she wrote her historic work.

Anna Dalassena

ELEVENTH CENTURY; BYZANTIUM

Anna Dalassena, the grandmother of Anna Comnena, established her family upon the Byzantine throne. Her granddaughter wrote admiringly of her in *The Alexiad*, stating that whenever her father was away, he entrusted his mother with the administration of state affairs and the fiscal management of the empire.

Damelis

NINTH CENTURY; BYZANTIUM

Damelis, who was a benefactor of the emperor and a major landowner in the Peloponnesus, established and administered a chain of factories where women wove fine linens, magnificent silks, and exquisite carpets.

Engleberga

832–876; GERMANY

Queen Engleberga or Engelberga, the wife of King Louis II of Italy, was the first German woman of the Middle Ages to rule equally with her husband.

Eudocia

CIRCA 400–460; BYZANTIUM

Educated by her father, the Athenian philosopher Leontius, and raised in privilege, Eudocia was devastated by his death and by the fact that he had left her no inheritance. She traveled to Constantinople to contest the will; while there, she met and married Theodosius (401–450), the emperor of Byzantium. In addition to her royal position, Eudocia was a scholar and a patron of education, founding the University at Constantinople. She was also a poet and writer, although many of her works are lost. Later exiled to Jerusalem, Eudocia—as a devoted convert to Christianity—founded churches, medical schools, and a hospital where she personally tended the sick.

Eudoxia

D. 404; BYZANTIUM

Eudoxia, the daughter of a Frankish chieftain and Roman consul named Bauto, married Emperor Arcadius II (reigned 383–408). In 400, she was crowned Augusta, empress of Byzantium, and her portrait was sent throughout the Eastern Empire, a rare honor. She was known to be an independent woman with considerable influence over her husband. But her life and reign were cut short by a painful miscarriage.

Fredegund

CIRCA 550–597; FRANCE

Fredegund was a servant who became the mistress and then the wife of Chilperic, ruler of the Frankish kingdom of Neustria. She is thought to have murdered her husband's first wife Galswintha and to have arranged for Chilperic's murder, after which she fled with her son Chlotar, returning only when he was declared heir to the throne. She ruled as regent for thirteen years, her reign characterized by ongoing wars and political rivalries.

Irene

752–803; BYZANTIUM

An Athenian by birth, Irene married Leo IV, the heir of Emperor Constantine V, who was known for his iconoclasm—the opposition to the worship of icons and statues. When Constantine died in 775, the sickly Leo ascended the throne but only lived for five more years, leaving his ten-year-old son Constantine VI to succeed him. Irene acted as regent, immediately reversing the iconoclastic policies that had been put into place by her father-in-law. She maintained her power through political intrigue. When her son reached his majority, Irene imprisoned him and later had him killed. She then ruled as emperor—something no woman had ever done previously. Because there was a female head of state, the Pope severed all ties with Byzantium. In 802, Irene was ousted in a coup and exiled to Lesbos, where she was forced to support herself by spinning wool.

Theodora illuminated capital letter

Leoparda

FOURTH CENTURY; BYZANTIUM

Historically, lower-class women generally delivered their children at home while upper-class women were aided by midwives and, in some cases, widely renowned gynecologists like Leoparda, who practiced medicine at the Byzantine court.

Maude

895–968; GERMANY

Convent-educated, Queen Maude, also known as Mathilda, continued to lead a pious life even after marrying Henry I of Germany. She favored her second son as the successor to the crown, but after Henry's death, it was the elder Otto who became king. Angry at his mother's preference, he stripped her of her inheritance and exiled her. Maude took refuge in a convent while Edith, Otto's wife, worked to accomplish a reconciliation between mother and son. Through Edith's efforts, Maude's wealth was restored, which she used for philanthropic work.

Olga

890–969; RUSSIA

Olga, a princess of Kiev, was married to Igor, the second monarch of Russia. After his assassination, she acted as regent for their son, improving the system of government, regulating the amount of taxes to be paid by different provinces, and establishing courts of justice. Her conversion to Christianity in 959 paved the way for the general conversion of the Russian people some thirty years later, which took place under her grandson Vladimir. Olga and Vladimir are regarded as the founders of Russian Christianity.

Olympia

368–408; BYZANTIUM

Olympia or Olympias was the daughter of rich aristocrats who died when she was young. At age eighteen, she was married to Nevridios, treasurer at the court of Emperor Theodosius. Within a year, she was left a wealthy widow. The emperor tried to force Olympia to marry one of his Spanish relatives, but she refused, as she was determined to devote herself to a religious life. She brought together a community of Christian women in her mansion near Hagia Sophia and donated most of her wealth to charity. After she was ordained a deaconess, her community grew from fifty women to over two hundred. When she died, her female followers accompanied her coffin to its final resting place, known as the Convent of St. Olympia, which flourished for centuries.

Pulcheria

399–453; BYZANTIUM

Pulcheria, the eldest sister of Emperor Theodosius, was the de facto ruler of Byzantium during her brother's minority. At this time—due in part to Pulcheria's wisdom—the empire enjoyed an era of peace and prosperity.

Radegund

518–587; GERMANY

Radegund (Radegunda) was the daughter of the king of Thuringia, in Germany. She grew up in the household of her uncle, who had killed her father in battle. In 531, Clothar, king of the Franks, conquered Thuringia and took Radegund and her brother as booty. She was to be raised as Clothar's future wife as a way of legitimizing his claim to the region. After their marriage in 538, they lived together

Detail, *Theodora* runner back

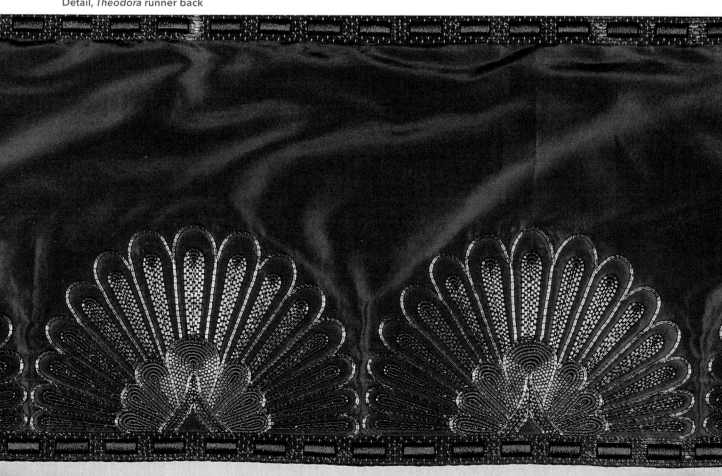

for fifteen years. Unbeknownst to her husband, she had taken up Christianity and was using her revenues as queen to found hospitals and do other charitable work. In 550, Clothar had Radegund's brother killed. Distraught after learning of his death, she later took sanctuary in the church at Noyon under the care of Bishop Medard. She asked him to consecrate her as a nun; eventually, he agreed to ordain her as a deaconess, after which she founded a convent in the city of Poitiers. There Radegund lived as its guiding spirit, writing a number of poignant poems describing the loss of her family and homeland and the loneliness that had shadowed her life.

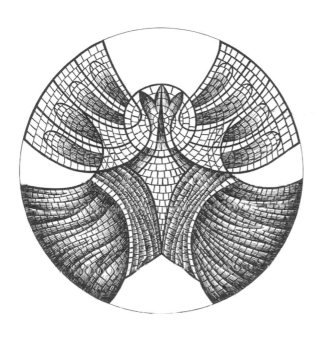

Theodelinda
580–628; LOMBARDY

Theodelinda was the Christian wife of two successive Lombard rulers and took an active part in establishing peace between the Pope, the Eastern Empire, and the secular powers of northern Italy. She endowed charitable foundations, built monasteries, reduced taxes, and attempted to improve conditions for the lower classes.

Theodora II
D. CIRCA 867; BYZANTIUM

Theodora II, who was the wife of Emperor Theophilus II, possessed a natural talent for governing. After her husband died in 842, she acted as regent for her son Michael III, preserving the tranquility of the empire and enhancing its prestige. However, when Theodora II's son reached his majority, he pressured her to retire to a monastery. When she resisted, he had her forcibly removed from the throne.

Theodora III and Zoe
981–1056, 978–1050; BYZANTIUM

Theodora and Zoe were the daughters of Constantine VIII, who reigned for only three years. Before his death in 1028, the emperor tried to convince Theodora to marry his chosen heir, Romanus III, but she refused. He nevertheless arranged a marriage between Zoe and Romanus, who proved to be an unfaithful husband and an ineffective ruler. In 1034, Romanus was found murdered in his bathtub. Zoe immediately remarried, this time to Michael IV, who reigned with her until his death, at which point she adopted her nephew Michael V in order to maintain her power, but their reign lasted less than a year because he also died. For a few months, Zoe and Theodora ruled the Byzantine Empire jointly until Zoe forced her sister into religious retirement and married a third time, to Constantine IX, who outlived her by four years. When he died in 1055, Theodora finally ruled on her own at age seventy. She presided over Cabinet and Senate meetings and heard appeals as Supreme Court judge. A year later, she died suddenly. The person she had chosen as her successor, adopted son Michael VI, was not considered to be a rightful emperor as he was not related to the dynasty that had ruled Byzantium for almost two hundred years. This situation resulted in a series of struggles for the throne that continued for twenty-five years.

Wanda
EIGHTH CENTURY; POLAND

Wanda inherited the throne when her father Krakus, the ruler of Poland, died. She refused many marriage proposals because she felt that none of her admirers were suitable to rule with her. Legends about her beauty, valor, and wisdom abounded, spreading even as far as Germany, where a prince named Rytigier became intrigued by both Wanda and the idea that Poland might be easy pickings from an unmarried queen. He sent her a letter, asking for her hand in marriage and suggesting that as her dowry she bring him her lands, implying that if she refused he would invade the country. Wanda knew that Rytigler's army was powerful, but the queen refused to surrender herself or her country. Instead, she retired to her apartments and prayed that the gods would grant freedom to the Polish people in return for her life. She then threw herself into the Vistula River, an act that has caused her to be revered ever since.

Hrosvitha

935–1002

Gandersheim, the convent that Hrosvitha entered when she was young, was a free abbey, which meant that visitors were allowed. Consequently, Hrosvitha had the opportunity to associate with the scholars, churchmen, and royalty who came to pay their respects to the well-connected abbess. Like most girls who were convent trained, Hrosvitha was educated in Latin, Greek, astronomy, and music. She proved a gifted student and began to write, at first surreptitiously: "Unknown to others and secretly, I wrote by myself. Sometimes I composed, sometimes I destroyed what I had written." Her work was dis-

covered by her abbess, who encouraged her. Her early poems were so well received that Hrosvitha expanded her writing to include, among other things, sacred legends in verse and a history of the Ottonian dynasty.

But her most important works were her plays, where she found inspiration of a sort in the Roman playwright Terence, whose work trumpeted the frailty of the female sex. Hrosvitha's work celebrated women and challenged Terence's misogyny; in her plays, men embodied paganism and lust, while strong, steadfast women represented the purity and gentleness of Christianity.

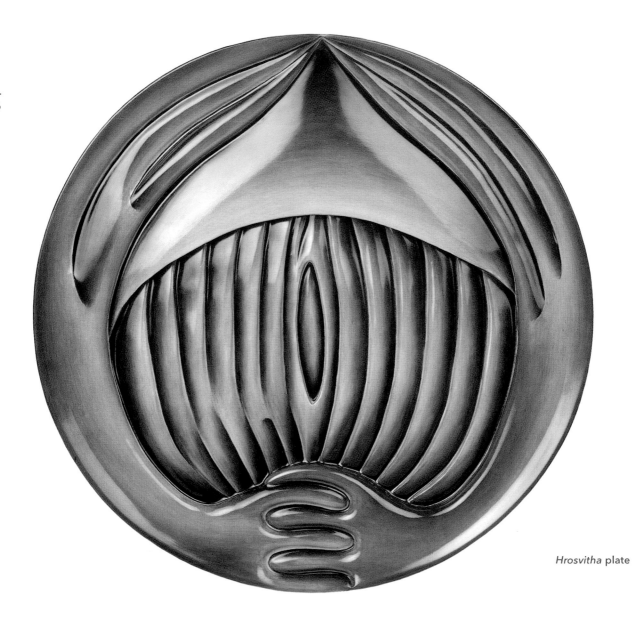

Hrosvitha plate

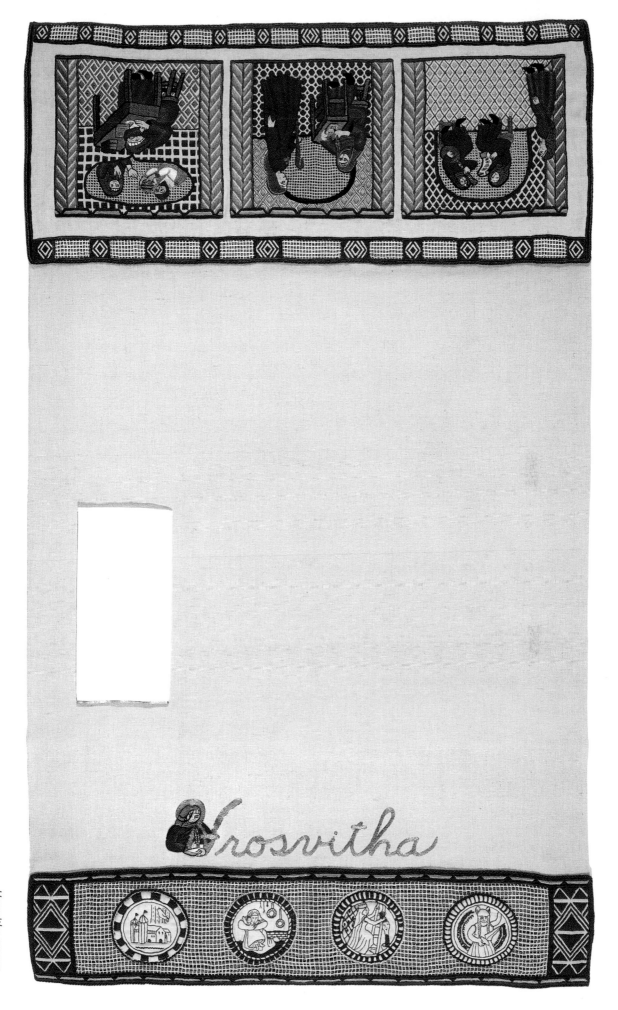

Hrosvitha runner

Hrosvitha place setting

Medieval nunneries recruited largely from the upper classes because, for noblewomen, the only alternative to marriage was the convent. In contrast to the direct authority of ruling abbesses, other ruling-class women wielded power primarily through their roles as mothers, daughters, sisters, or wives. The stream of names associated with the HROSVITHA place setting represents women who availed themselves of the opportunities afforded by a religious life, along with medieval rulers and a number of poets, writers, and scholars from Spain. During this period, Moorish Spain was experiencing a great intellectual awakening, the result of an unusual merging of Arab, Jewish, and Christian cultures. Women had access to education and enjoyed considerable freedom, which resulted in a flowering of female creativity.

Agnes
CIRCA 1184–1203; GERMANY

Agnes was the abbess at the Monastery of St. Mary's in Quedlinburg, a prosperous trading and political center of the Ottonian Empire. As abbess, Agnes encouraged art industry, collaborating with her nuns on ecclesiastical embroideries and supervising the manufacture of large wall hangings. Her cloister was also known for its manuscript illuminations.

Aisha
TWELFTH CENTURY; SPAIN

Aisha (Ayisha, 'A 'ishah, Ayesha), a distinguished poet, left a large body of work, a well-selected library, and a reputation for having frequently presented her verses and orations at the Royal Academy of Cordova.

Maria Alphaizuli
TENTH CENTURY; SPAIN

Alphaizuli, a renowned poet also called Miriam Bint Abu Ya'qub, was often referred to as the "Arabian Sappho." (Women from one period have been frequently likened to previous women, as if there were certain immutable categories of female achievement.) Some examples of Alphaizuli's compositions are preserved in the library of the Escorial, a remarkable group of Spanish buildings considered a treasure-house of art and learning.

Athanarsa
D. 860; GREECE

Athanarsa or Athanasia wished to dedicate herself to a religious life but, at that time, vows of celibacy were forbidden in Greece. Her parents forced her into an arranged marriage, but then her husband chose to become a monk. She inherited all of his possessions, which allowed her to found a great convent, which she administered.

Frau Ava
D. 1127; GERMANY

Frau Ava was an established singer of sacred songs; she was also the first woman known to have composed biblical and evangelical stories in the German language. As most religious writings were in Latin, Ava's work made Christian ideas available to the common people.

Baudonivia
SIXTH CENTURY; FRANCE

Baudonivia was educated at and lived in the monastery of St. Croix at Poitiers, which had been founded by the devout Radegund. After the abbess's death, Baudonivia was chosen by the nuns of the convent to write a study of her life, which was included in the first volume of *The Acts of the Saints of St. Benoit*, an early listing of the Latin saints.

Begga
D. 698; BELGIUM

Begga was the daughter of a powerful nobleman from Austrasia, part of the Frankish Empire. She married Ansegilius and their son Pepin became the founder of the Carolingian dynasty of rulers in France. Upon the death of her husband in 691, she built a church and convent where she spent the rest of her life as abbess.

Bertha
720–783; FRANKISH EMPIRE

During the reign of her husband Pippin the Short (751–768), Bertha performed many administrative duties and established a court of women that made laws concerning those of her gender. Bertha was also responsible for the education of her son Charlemagne. Many of his later religious policies can be directly attributed to her influence.

Bertha of France
BORN 777; FRANKISH EMPIRE

Bertha of France, one of Charlemagne's daughters, was a scholar particularly known for her abilities as a poet and musician. Supposedly, her father forbade her and her sisters to wed because he couldn't bear to part with them. However, his real agenda might have been to control the number of alliances that would have been created by his daughters' marriages, which could have threatened his reign. After his death, his daughters were forced to enter convents, which was particularly distressing to Bertha because she had been having an intimate relationship with one of her father's courtiers.

Berthildis or Bathilde
D. 680; FRANCE

Bathilde was originally a slave who came to the attention of Clovis II, the king of France, who was so impressed by her unusual qualities that he freed and then married her. Seven years later, Clovis died, leaving Bathilde with three sons. An assembly of leading nobles declared one of them, Clothaire III, the king. As he was only five, his mother served as his regent, instituting numerous reforms, including the abolition of slavery. She also founded a number of hospitals and monasteries, including the Abbey of Chelles.

Bertille or Berthilde
652–702; FRANCE

Bertille (Bertilla), the daughter of a propertied family near Soisson, became a nun. At the request of Queen Bathilde of France, she became the abbess of the Abbey of Chelles, near Paris, remaining in that position for forty-six years.

Carcas
EIGHTH CENTURY; FRANCE

According to legend, to save a walled city from conquest by Charlemagne and his army, the widow Carcas devised a scheme. She ordered a well-fattened pig to be thrown from the ramparts in order to give the impression that the city had enough provisions to be able to withstand a long assault. The attackers were deceived and departed. To announce the good news, Carcas had the town bells rung—in French, *sonner*—hence the town's name of Carcassonne. A bust honoring her is situated at the east entrance of the ancient fortress.

Claricia
CIRCA 1200; GERMANY

Claricia was an illustrator in Augsburg, Germany. Known for both manuscript illumination and bookmaking, she painted herself as the tail of the letter "Q," a signed self-portrait unusual for its time when most artists worked anonymously (and particularly early for a woman's self-portrait). Judging by her clothing, Claricia was probably not an ordained nun but a lay member of the convent where she worked. It is only in medieval Germany, where the Ottonian Empire supported female intellectual and artistic aspirations, that the work of individual women of this period can be traced.

Dhuoda
NINTH CENTURY; FRANCE

Dhuoda was the wife of Bernard, the duke of Septimania, an area in southwestern France. She is known primarily through her *Liber Manualis* (*The Manual*), completed in 841 after two years of work. This seventy-two chapter treatise on Christian virtues, written for the education of her son William, reveals Dhuoda's fine mind and affection for her family and includes numerous quotations from the Bible and references to classical writers. Dhuoda did not live long after completing this work, which contains several allusions to her ill health, suggesting that she was aware that she would probably not see her son reach adulthood.

Diemud
1057–1130; GERMANY

Diemud, a nun in the Cloister of Wessobrun in Bavaria, was a calligrapher and manuscript illustrator whose work was distinguished by its ornate letters and small elegant writing. She is reputed to have been responsible for the production of over forty-five highly prized manuscripts, one of which, a Bible, was so valued that it was exchanged for an estate. An illumination by her with a self-portrait embedded in the letter "S" is another early example of female authorship in medieval art.

Eadburga
D. 751; ENGLAND

Eadburga (Eadburh) was the only daughter of King Centwine and Queen Engyth of Wessex, the royal family of Kent, England. A Benedictine nun, skilled scribe, and calligrapher, Eadburga became the abbess of Minster-in-Thanet Abbey in 716. After meeting the priest Boniface (circa 675-754), she established a lengthy correspondence with him. Though her letters have not survived, it is known that she aided him in his missionary work and also copied manuscripts for his use.

Eanswith
CIRCA 630; ENGLAND

Because the early Church paid great honor to the celibate life and allowed royal women to participate in a variety of activities, many women like Eanswith (Eanswythe, Eanswide) wanted to take up the veil. Her father, Eadhald of Kent, gave her a piece of land upon which in 630 she founded what is considered the first religious settlement for women in Anglo-Saxon England. She took up residence there, subsequently serving as the institution's abbess. A fifteenth-century Augustinian monk left an account of her life in which he described how a king of Northumbria had wished to marry her. Because he was not a Christian, Eanswith insisted that his gods manifest their power by miraculously lengthening a beam, a condition they apparently could not meet, for her suitor soon departed and she remained both single and chaste.

Ebba
SEVENTH CENTURY; SCOTLAND

In the late 630s, a Northumbrian princess named Ebba was shipwrecked on a promontory in Scotland now called St. Abbs (the name by which St. Ebba is known today). She was taken in as a nun in a nearby convent, where she later became abbess. Convents were vulnerable to capture because of their wealth; both laywomen and nuns were sometimes raped and tortured by invaders. During one such assault, Ebba persuaded the nuns of her monastery to disfigure their faces in order to render themselves less attractive, hoping that would save them. Instead, the soldiers were so enraged that the women had mutilated themselves that they set fire to the convent, killing the nuns.

Ende
TENTH CENTURY; SPAIN

Ende assisted in the paintings for a manuscript containing the *Commentary on the Apocalypse* compiled by the Spanish monk Beatus of Liébana. In the Beatus manuscript now kept in the Girona Cathedral, known as the *Gerona Apocalypse*, completed in 975, she identifies herself as one of the two illuminators (the other being a monk, Emeterius): "Ende pintrix et dei aiutrix"–"Ende, woman painter and servant of God."

Ethelberga
CIRCA 616; ENGLAND

Daughter of King Ethelbert of Kent, Ethelberga (Ethelburga, Aethelberga) was a devout Christian who married King Edwin of Northumbria (circa 625) and was urged by the Pope to convert him, which she did. After he died, Ethelberga established the first Benedictine nunnery in England, where she taught medicine to women and tended the sick.

Detail, *Hrosvitha* runner back

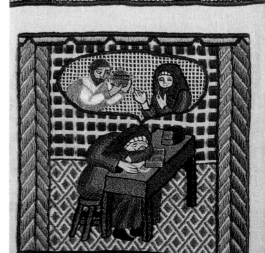

Ethylwyn
ELEVENTH CENTURY; ENGLAND

Ethylwyn, whose needlework was renowned throughout England, worked under the patronage of Queen Edith (910–946), who, like many royal women, collaborated with needleworkers and the archbishop in the design and fabrication of ecclesiastical vestments and hangings, which were often created in special workshops in royal palaces as well as in convents and monasteries.

Gertrude of Nivelles
626–659; BELGIUM

Gertrude, the younger daughter of Pepin I of Landen and his wife Ida of Nivelles, became devoted to Christianity at an early age, refusing a noble marriage. When her father died, Gertrude's mother founded a double monastery (with houses for both monks and nuns), retiring there with her daughter, whom she appointed as abbess. Gertrude became known for her generosity, providing land for monasteries and aid to missionaries. She was revered as a visionary, and after her death, a cult devoted to her adulation spread throughout Belgium, Germany, and neighboring countries.

Gisela
D. 807; GERMANY

Gisela, the sister of Charlemagne, founded a Benedictine abbey where she took up residence, first as a nun and later as the abbess. She directed the first major convent scriptorium, a special room set aside for the use of scribes and illustrators. Under Gisela's direction, nine female scribes created thirteen signed manuscripts, among them a three-volume commentary on the Psalms.

Gisela of Kerzenbroeck
D. 1300; GERMANY

Women who worked as scribes or illustrators were generally nuns who had access to education, training, and materials in the convents or royal women who were literate and wealthy enough to have sufficient leisure to perfect their skills. No information exists about how Gisela (Gisle) of Kerzenbroeck achieved her position as a manuscript illuminator other than the fact that she worked independently in the town of Rulle in Westphalia until her death.

Gormlaith
983–1064; IRELAND

Gormlaith (Gormflaith) was the third wife of Brian Boru, who rose from obscurity to become the first king of Ireland. After he repudiated her in favor of another woman, Gormlaith, in alliance with her son Sitric from an earlier marriage, organized the Battle of Clantarf in 1014, which overthrew Brian Boru and drove the Danes out of Ireland. In addition to being an Irish heroine, she is considered one of Ireland's first female historians, having written a body of verse that helped to preserve many Irish traditions.

Details (above and opposite),
Hrosvitha runner front

Guda
TWELFTH CENTURY; GERMANY

Guda, also known as Guta, was a nun and illuminator known to have worked on the *Homilary of Saint Bartholomew*. The manuscript proclaims in Latin that "Guda, woman and sinner, wrote and painted this book," and her self-portrait is embedded in the letter "D."

Harlind and Reinhild
CIRCA 850–880; GERMANY

While still young, Harlind (Harlinde, Herlind) and her sister Reinhild (Relind, Relinde) were sent by their parents to the convent in Valenciennes, in the north of France. There, they were trained in reading, singing, writing, and painting, as well as in the needle and fiber arts. When they returned home, the sisters found no outlets for their talents. Their family agreed to found a religious settlement for them at Maaseyck in what is now Belgium. According to a ninth-century chronicler, the two sisters transcribed many gospels and psalms and created altar cloths, vestments, and ornate embroideries, examples of which can still be seen in the small church at Maaseyck.

Hilda of Whitby
614–680; ENGLAND

From a royal family, Hilda used her wealth to found several monasteries after becoming a Benedictine nun, the most prominent of which was at Whitby, which she administered as abbess for thirty years. A celebrated religious and coeducational center, it trained future bishops, abbesses, and priests. Hilda was also the patron of Caedmon, the first religious poet to write in English. Considered one of the most distinguished churchwomen of Anglo-Saxon times, she greatly influenced the political and religious affairs of the era.

Hygeburg
CIRCA 778–786; ENGLAND

Hygeburg's (Higeburc) relatives, Willibald (701–786) and Wynnebald (702–761), founded a Benedictine double monastery. Originally, Wynnebald directed the men's house while their sister Walpurgis was abbess to the women. After Wynnebald's death, Walpurgis took over the administration of both houses. Hygeburg began her convent life during Walpurgis's tenure, soon commencing work on the two books for which she is known, both chronicles of her kinsmen's lives: *Vita Willibaldi episcopi Eischstetensis* (the *Life of Willibald*) and *Vita Wynnebaldi abbatis Heidenheimensis* (the *Life of Wynnebald*).

Joanna
CIRCA 1200; GERMANY

Throughout the twelfth and thirteenth centuries, Germany was caught up in political rivalries between two noble families. Because of the close relationship between the royal women who entered religious orders and the ruling families, convents were often involved in these struggles. With the help of several nuns, Joanna, the prioress of Lothen in Germany, created a series of tapestries telling the tumultuous history of their order as well as the historical and political struggles of the country.

Leela of Granada
THIRTEENTH CENTURY; SPAIN

For centuries, Spanish culture was influenced by the Moors. Even after the breakup of the Moorish leadership in the twelfth century, the Moors retained some of their smaller kingdoms, par-

ticularly Granada, which possessed a cultured environment that was also conducive to women's achievements. Leela of Granada was celebrated there for her erudition and scholarship.

Liadain
SEVENTH CENTURY; IRELAND

A renowned poet of Ireland, Liadain fell in love with another poet Cothair, and their tragic story became the basis for a good deal of poetry, music, and legend. While Cothair was away making preparations for their marriage, Liadain, for an unexplained reason, decided to take vows as a nun. In despair, Cothair became a monk. At first, they continued to see each other, but when this led to the breaking of their commitments to celibacy, Cothair left Liadain for a life of penance in order to save his soul.

Libana
D. 975; SPAIN

As soon as written Arabic became widespread in the eighth century, literary production blossomed all over the Islamic Empire, including that of Libana, a Moorish Spaniard of noble parentage, who became an established poet as well as a philosopher and musician.

Lioba
700–780; GERMANY

When the priest Boniface called upon women to help convert Germany to Christianity, one of the women who responded was his distant relative Lioba. Because she was thoroughly acquainted with religious writings, theology, and ecclesiastical law, he placed her in charge of all the nunneries then under Benedictine rule. Lioba and Boniface had a lengthy correspondence, and many of her letters have survived, as has some of her devotional poetry. She is considered one of the most important churchwomen in Germany.

Mabel
THIRTEENTH CENTURY; ENGLAND

From early medieval times, English-women were known for their skill with the needle; by the seventh century, a rudimentary form of *opus anglicanum*—the type of needlework for which England became famous—was being developed, particularly in the religious houses. This technique is characterized

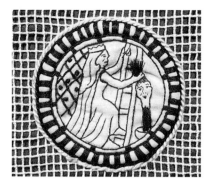

by highly refined stitching in colored silk floss combined with gold and silver thread, pearls, and gems. Needlework production gradually moved out of the monasteries and began to be done in secular workshops or by professional needlewomen like Mabel, who was commissioned by Henry III of England to execute an intricate gold and ruby banner for Westminster Abbey.

Maryann
NINTH CENTURY; SPAIN

Medieval Spain prospered under Arab rule, and Spanish cities became centers of science, where both boys and girls studied. Maryann or Mariam founded a school for girls, providing them with instruction in science as well as mathematics and history.

Mathilda
D. 999; GERMANY

Mathilda was the abbess of the monastery at Quedlinburg, which had been established by her father Otto I. In 983, Mathilda raised an army to help him battle the invading Wends, a group of Slavic tribes that had occupied much of Europe. When the king died, her brother Otto II inherited the throne. He often entrusted Mathilda with the control of state affairs during his absences. Because of her family connections, Mathilda was able to provide her cousin Hrosvitha with excellent information for her chronicle of the Ottonian dynasty.

Elizabeth Stagel
CIRCA 1300–1360; GERMAN EMPIRE

Though probably not an ordained nun, Elizabeth (Elsbeth) Stagel resided in a Dominican order. A historian and writer, Stagel was associated with an informal religious group known as the "Friends of God" and was largely responsible for recording much of their history and philosophy. This group of both ecclesiastical and laypeople united to

counteract what they saw as many of the evil influences of their time. Their efforts gave rise to the great school of German mystics in the thirteenth and fourteenth centuries, in which women played a prominent role.

Thoma
D. 1127; SPAIN

Spain's location caused it to be somewhat removed from European trends, which reached it long after other areas of the continent. It was precisely this isolation that allowed the country to develop its own distinctive literary voice as part of the flowering of Moorish Spanish culture. The twelfth century also saw the achievements of many women, among them Thoma, a distinguished scholar who wrote highly celebrated books on grammar and jurisprudence.

Lady Uallach
CIRCA 932; IRELAND

Because Celtic matriarchal traditions continued for many centuries in Ireland, a number of women living there during the early Middle Ages became prominent, including Lady Uallach. Considered one of the great poets of Ireland, she was a learned woman in the tradition of the eminent St. Bridget.

Valada
1011–1091; SPAIN

Born into a powerful family, Valada (or Wallada bint al-Mustakfi) was celebrated for her scholarship and debating skills. When she turned thirty, she inherited a great deal of money, which allowed her a degree of independence unusual for women of her time. She opened a salon for writers, soon becoming the lover of Ibn Zaydun, one of the most renowned of the literary group. They had a long and stormy relationship, during which time she became known both for her verse and for her liberated ways, which set an example and helped to raise the status of women. When Ibn Rushd, the great Moorish philosopher and supreme judge of the city, accused her of being a harlot, she responded by having one of her own poems embroidered on her gown, so that everyone could read the words she had written: "For the sake of Allah. I deserve nothing less than glory. I hold my head high and go my way. I will give my cheek to my lover and my kisses to anyone I choose."

Trotula

In most of southern Italy, Byzantine influence remained strong for centuries. Thanks in part to the progressive laws of Theodora, women were able to study in Salerno, which housed the greatest medical center in medieval Europe. Trotula di Ruggerio, known as Trotula, trained there as a physician, becoming a professor of medicine; in Chaucer's *The Canterbury Tales* she is referred to as "Dame Trot."

While other countries were still relying on saints' relics and the like for curing sickness, Salerno's doctors were employing more advanced forms of medicine. Since doctors were forbidden by the Church to dissect the human body, diagnosis was dependent on analyzing the symptoms of disease, a practice at which Trotula excelled.

Trotula wrote prolifically on gynecology and obstetrics, and her books were the authoritative texts for centuries. Her contemporaries referred to her as "*magistra mulier sapiens*" (wise woman teacher), and she was the first doctor to give advice on pediatrics. She stressed the importance of hygiene and exercise at a time when many people thought diseases were cured magically. Contrary to the Church's teaching—that women must suffer in childbirth because of Eve's transgressions—Trotula urged the use of opiates to alleviate what she considered unnecessary pain. When she died, the procession of mourners was two miles long. Unfortunately, the writings of Trotula were lost or attributed to male authors.

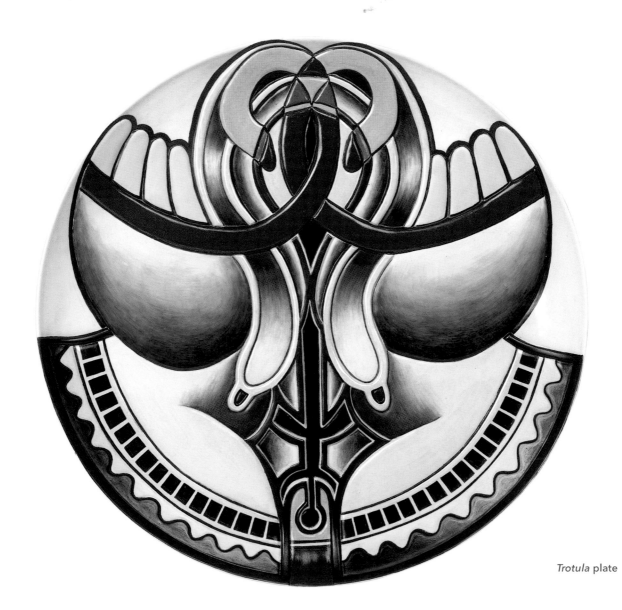

Trotula plate

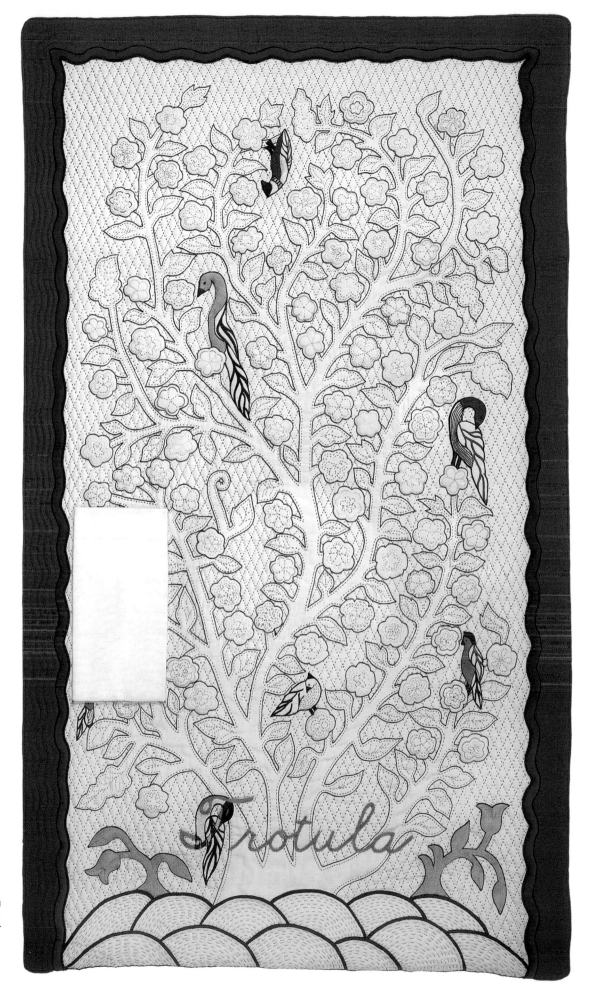

Trotula runner

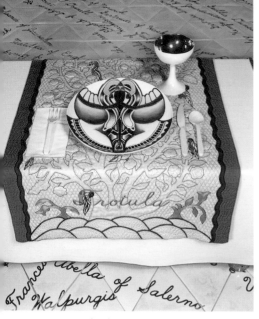

Trotula place setting

The names aligned with TROTULA include other women who practiced medicine, along with female rulers of the period who enjoyed a level of freedom unimaginable to most women. Also included are medieval women who, like some of their predecessors, had to disguise themselves as men in order to pursue their ambitions.

Abella of Salerno
FOURTEENTH CENTURY; ITALY

Abella was another female physician in Salerno. She wrote highly esteemed medical treatises and lectured on the nature of women at a time when the Christian moral system, with its emphasis upon women as the heirs of Eve's faults, greatly shaped male attitudes toward the female body.

Adelberger
EIGHTH CENTURY; ITALY

During the Middle Ages, when it was common for female practitioners to treat women patients, Adelberger was a member of the guild of lay healers in northern Italy.

Aloara
D. 992; ITALY

After her husband Pandolf's death, Aloara ruled the principality of Capua until she died. She also founded a religious house there. Some historians assert that she was a wise and courageous leader, while others claim that she was as despotic as her husband had been.

Angelberga
CIRCA 835–896/901; ITALY

Known for her astute abilities, the Empress Angelberga or Engelberga, wife of Louis II, was responsible for building one of the most famous monasteries in Italy. Later, her daughter Ermengarda had her kidnapped and brought to Germany. Ermengarda was planning to overthrow the French king and hoped her mother would help her; only the Pope's intervention achieved Angelberga's release.

Ageltrude Benevento
NINTH CENTURY; ITALY

Ageltrude (Agiltrude) was the daughter of Adelchis of Benevento (853–878) and the wife of Wido II of Spoleto. When her husband died, Ageltrude was left to defend her property against both invasions and intrigues by political and religious leaders. At a time when women were often forcibly married for their holdings, she was able to ensure that her rights were respected. She also founded the Benedictine abbey of Rambona, which helped to spread the Benedictine order throughout Italy.

Bertha of Sulzbach
1125–1161; GERMANY

The marriage of Bertha, sister-in-law of the German emperor Conrad III, to Manuel, heir to the throne of Byzantium (ruled 1143–1180), sealed a political alliance between the two countries. The common goal of these two powers was to eliminate the Norman presence in southern Italy, an objective that Bertha actively supported.

Constantia
1154–1198; ITALY

Constantia, or Constance, the queen of Sicily, became German empress as the wife of Emperor Henry IV. Because she was not married until she was thirty—unusual for a princess when marriages provided bargaining chips in terms of political alliances—there was considerable speculation that she had become a nun. Though false, Dante incorporated the rumor into his works, placing her in Paradise in *Paradiso*, canto III, lines 109-20. When Henry died, Constantia returned to Sicily to support the rebellion against German rule. She had her three-year-old son Frederick crowned king and, in his name, formally dissolved the ties between Sicily and the German Empire.

Etheldreda
CIRCA 630–679; ENGLAND

Etheldreda (Aethelthryth, Audrey), wife and queen of Ecgfrid, king of Northumbria, founded the church and convent at Ely in 673, later becoming abbess. Under her tutelage she and the nuns treated diseases and cared for the poor.

Francesca of Salerno
CIRCA 1321; ITALY

Francesca studied medicine at the School of Salerno. But in order to receive her degree in surgery, she had to publicly prove her expertise to a panel of male judges. Even then, she was allowed to practice medicine only after obtaining permission from the duke who governed the area.

Bettisia Gozzadini
CIRCA 1296; ITALY

Born of a noble family in Bologna, Bettisia Gozzadini so desired a university education that she attended classes disguised as a man. She became a doctor of civil and canon law and later obtained a professor's chair, devoting her life to teaching and writing about law. However, once her gender became known, she was required to lecture from behind a curtain.

Pope Joan
D. 855; ITALY

Modern scholars have been unable to resolve the historicity of Pope Joan, who was supposed to have ruled as Pope John VII from 853 to 855. She remained recognized as a pope until 1601, when Pope Clement VIII tried to destroy what was viewed as an embarrassing historical record, officially declaring her to be mythical. According to legend, Joan disguised herself as a man to study in Athens, obtaining a degree in philosophy. Garbed in the attire of a monk, she went to Rome where Pope Leo IV made her a cardinal. Upon his death in 853, her fellow cardinals elected her pope. Roughly two years later, she gave birth to a baby. Some accounts state that once her gender was revealed, she and her child were stoned to death, while others suggest that she was sent to a convent and that her son grew up to become a bishop. The most intriguing tale regards what is known as the "chair exam." After Joan, each newly elected

pope was required to sit on the "*sella stercoraria*" (literally, "dung seat"), which was pierced in the middle so that the genitals could be examined to provide proof of the pope's manhood.

Stephanie de Montaneis
THIRTEENTH CENTURY; FRANCE

By the thirteenth century, the developing guilds of physicians and surgeons had begun to exclude women. Soon, only those women whose fathers or husbands were willing to train them would be able to gain access to medical knowledge. Stephanie de Montaneis was fortunate to have been taught the art of healing by her father, a doctor in Lyons. She became a practicing physician.

Odilla
EIGHTH CENTURY; GERMANY

In the Middle Ages, the only medical remedies sanctioned by the Church were not based on medical knowledge. In 720, Odilla or Odilia built and ran a monastery and a hospital that introduced more scientifically sound practices and became famous for its treatment of eye diseases. She was sainted, and afterward people prayed to her for a cure for eye problems.

Rachel
TWELFTH CENTURY; HEBREW

Rachel was one of the daughters of Rabbi Shlomo ben Isaac, also known as Rashi, a preeminent scholar. One text quotes Rashi as saying that because of his infirmities, Rachel acted as his secretary. This would have required her to possess knowledge of Hebrew, which would have been unusual for a woman of that time and suggests that she must have been trained by her father, as that would have been the only way for her to have acquired such an education.

Sarah of St. Gilles
CIRCA 1326; FRANCE

Maimonides, one of the great rationalistic thinkers and doctors of the Middle Ages, said: "Oh, God, thou hast appointed me to watch over the life and death of Thy creatures; here I am ready for my vocation," which indicates that, for Jews, the practice of medicine constituted a form of religious worship. Sarah (Sara), a Jewish physician in St.

Gilles, practiced and taught at a large medical school. There is a document, dated August 28, 1326, sanctioning her to teach medicine to her husband.

Theodora the Senatrix
901–964; ITALY

Never has a woman gained such ascendancy over papal affairs as Theodora, mistress of Pope John X, who owed his position to her. Her daughter Marozia followed in her footsteps, entering into an affair with Pope Sergius III. Marozia had a son with Sergius, who would also become pope. In fact, between the years 901 and 964, mother and daughter virtually controlled the election of pontiffs, managing to have their lovers, sons, and grandsons selected.

Urraca
1150–1188; PORTUGAL

Urraca was the queen of Portugal and sister to Blanche of Castile, who ruled France as regent for her son Louis IX after the death of her husband Louis VIII. In addition to her royal duties, Urraca became famous for her hospital work and support of advanced medical practices.

Trotula illuminated capital letter

Walpurgis
710–779; ENGLAND

Walpurgis (Walpurga) was the sister of Willibald and Wynnebald, whose lives were memorialized by their relative, Hygeburg (who lived in the abbey run by Walpurgis). She was also the daughter of the king of Kent and his wife Winna, sister of the priest and missionary Boniface. At the request of Boniface and Willibald, Walpurgis went with a group of nuns to found religious houses in Germany, where she became the abbess of a Benedictine nunnery. Upon Wynnebald's death in 760, she succeeded him as administrator of his monastery, which remained in her charge until her death. She was laid to rest in a hollow rock from which exuded a type of oil that came to be known as "Walpurgis oil," thought to miraculously cure disease. This site became a place of pilgrimage upon which a church was built.

Detail, *Trotula* runner

Eleanor of Aquitaine

1122–1204

Eleanor of Aquitaine was one of the wealthiest and most powerful women of the Middle Ages. Born to a noble family of southern France, she inherited her father's lands at his early death, and brought her rich properties—along with rather liberal ideas regarding women—to the French court of Louis VII, to whom she was married when she was fifteen. When the king informed Eleanor of his intentions to leave for the Crusades, she insisted on going with him. Louis opposed her, capitulating only because the nobles of southern France would not support him unless their queen led them. Her decision to launch the Second Crusade from Vézelay, the supposed site of Mary Magdalene's grave, was meant to underline the role of women in the campaign. But the Crusade was a disaster, and the marriage was eventually annulled.

Soon afterward, Eleanor married Henry of England, hoping that her support in his effort to gain the crown would bring her an expanded role. In an effort to regain her ancestral lands and her freedom, the queen encouraged her sons Richard and John to revolt against their father. In response, the king imprisoned her and seized her property. Although the king and the princes eventually reconciled, the queen was kept sequestered for sixteen years.

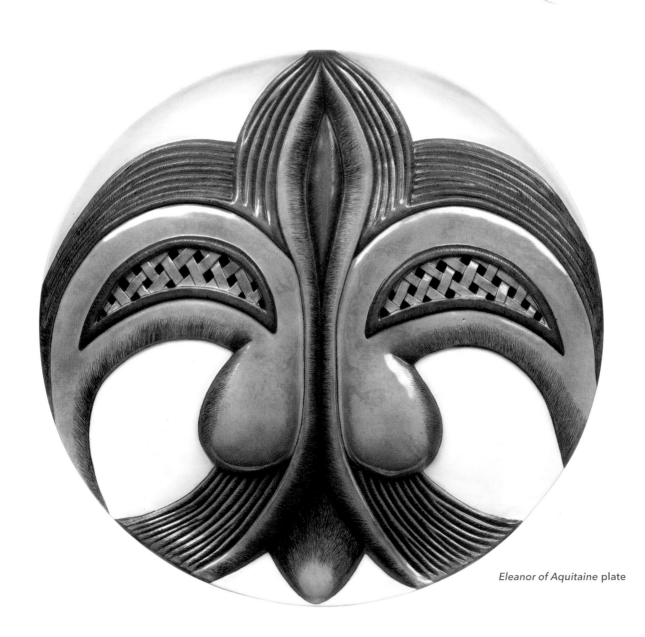

Eleanor of Aquitaine **plate**

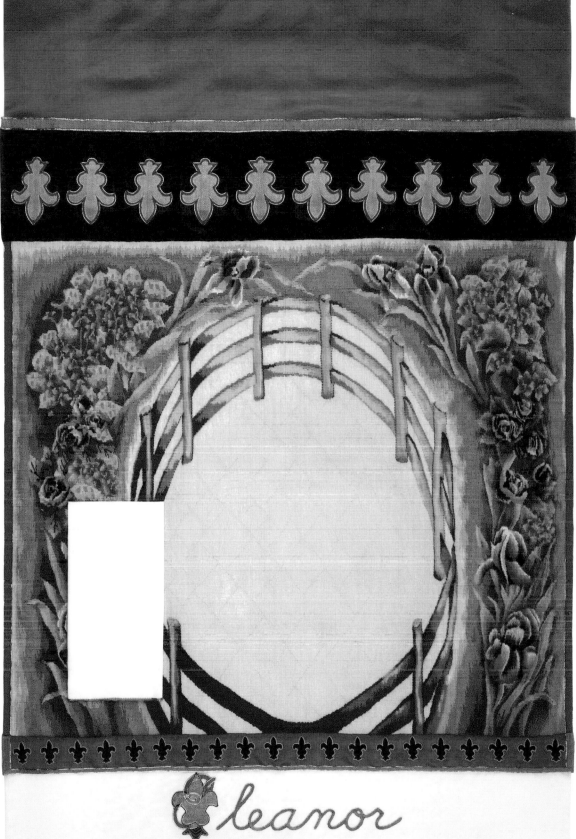

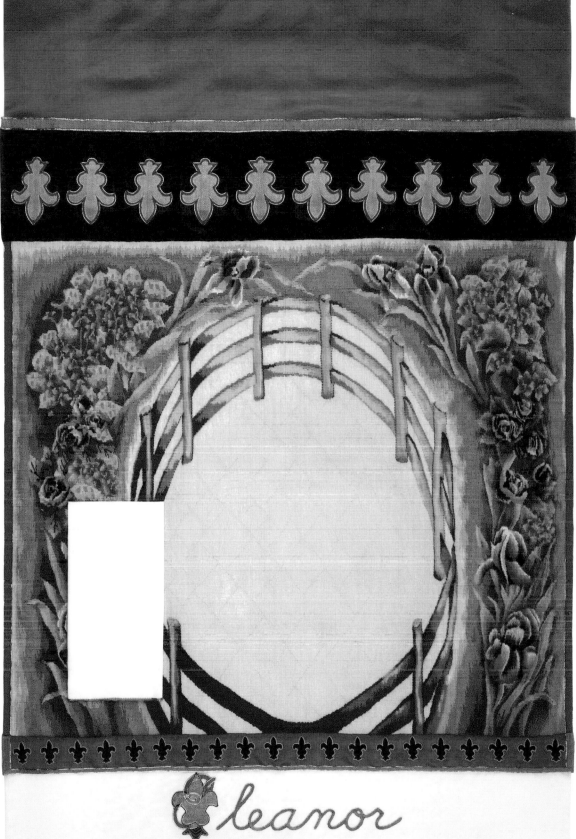

The body of doctrine associated with chivalry was profoundly influenced by the adoration of the Virgin Mary, who was venerated by the troubadours. Her importance cannot be ignored, particularly during medieval times when it was said, "God changed sex." The stream of names associated with ELEANOR includes other prominent women of the period, along with patrons and minstrels of the Courts of Love, which Eleanor is said to have established in Poitiers between 1168 and 1173. There, graced by the troubadour poetry first introduced by her grandfather William IX, women heard cases concerning relationships between the sexes, and their judgments were then communicated by the minstrels, who spread reverence for women through poetry and song. She made this "religion of the gentle heart" the foundation for courtly love, which helped to shape the values and mores of the time.

Adela of Blois
1062–1137; FRANCE

Adela was the youngest daughter of William the Conqueror and Queen Matilda of Flanders. After marrying Stephen, the count of Blois, she ruled as countess of Blois, Chartres, and Meaux. In 1096, her husband went on the First Crusade, and in his absence Adela acted as an exceedingly able regent. When he deserted and returned home, she convinced him to go back to the Holy Land, where he was killed the following year. Adela continued to rule until 1107, when she passed the reins of power to her son Theobald. Another of her sons, Stephen of Blois, became king of England, while the third became the bishop of Winchester.

Adelaide of Susa
CIRCA 1034–1091; ITALY

Adelaide led an army in defense of Turin, a territory she inherited from her father Ulric Manfred II. She married Otto of Savoy, ruling jointly with him until his death. She then governed more freely and became a patron of the arts, supporting and protecting poets and troubadours.

Agnes of Poitou
ELEVENTH CENTURY; FRANCE

Agnes of Poitou was the second wife of Henry III, who ruled the Holy Roman Empire. After his death, she acted as regent 1056–1068, though she continued to exert considerable influence even after her son Henry IV assumed the throne. This was a turbulent period during which the ambitious designs of her son and the growing independence of the papacy came into conflict, in part because Henry III had strengthened the papacy during his rule, which proved disadvantageous for his son. Agnes acted as an intermediary between Pope Gregory VII and her son in their struggle for power, helping to affect a truce.

Lady Beatrix
ELEVENTH CENTURY; ENGLAND

Beatrix was the daughter and heir of Yvo de Vescey who began building the famed Alnwick Castle in Northumberland, near the Scottish border. When her father died, Beatrix and her husband Eustace Fitzjohn completed the castle. She was also known as a daring swordswoman, whose prowess earned her the name "La Belle Cavaliere."

Berenguela
1180–1248; SPAIN

Berenguela, the granddaughter of Eleanor of Aquitaine, astonished all of Europe by challenging the authority of a king and a pope. She refused to submit to a marriage arranged by her father, the king of Castile. She then chose her own husband, Alfonso IX of Leon. Even after the Pope had annulled their marriage, Berenguela continued to live with him for seven years. When her parents died, she returned to Castile, becoming regent for her younger brother. When he unexpectedly died, the crown passed to her. Described as the "fittest ruler in all Spain," she successfully arranged for her son to become king of both Castile and Leon, thereby reuniting the two provinces under a single ruler.

Blanche of Castille
1188–1252; FRANCE

Blanche was another granddaughter of Eleanor of Aquitaine. At the age of twelve, she became a political pawn in an arranged marriage to Louis VIII of France, which was one of the conditions of a truce between England and France. In 1216, Louis invaded England in an effort to gain the English throne. Blanche supported his efforts by organizing two fleets, but their troops were repelled. After the death of her husband, she became regent for her son Louis IX. Both the French nobility and the king of England organized against her rule, but she was able to repress the insurrection and conclude another peace treaty with England.

Almucs de Castenau
CIRCA 1140; FRANCE

De Castenau (or Castelnau), who was from a town near Provence, was a *trobairitz* (as female troubadours were called). She was probably also a patron of the troubadours as was her son Raimbaut D'Agoult. Recent scholarship suggests that the trobairitz were not wandering minstrels (as the troubadours have often been described), but rather, court poets. If this is true, it would help explain why so many women could have been involved in the troubadour movement, as women couldn't move about freely on their own. Also, unlike the male writers who focused on fictional characters, the trobairitz wrote about their own experiences. De Castenau was particularly known for a work describing a dialogue between a male and female poet.

Dervorguilla
1213–1290; SCOTLAND

Dervorguilla, daughter of Roland, lord of Galloway, was an heiress and the mother of John Baillo, who through her lineage became the king of Scotland (1292–1296). She was married to John de Balliol, who founded Balliol College at Oxford University. After his death she continued to be involved with the college, expanding its property, stabilizing its finances, and drawing up a code of conduct for scholars.

Eleanor of Aquitaine place setting

Beatrice de Die
TWELFTH CENTURY; FRANCE

Countess De Die was another of the trobairitz whose material was derived from personal experience, such as her work *Of Deceived Love*, which is one of the few medieval compositions actually accredited. Only four of her poems are known, but they all openly express emotion and desire, revealing a degree of independence that seems unexpected in light of the restrictions on medieval women.

Edith
CIRCA 1020/1030–1075; ENGLAND

Edith was the only daughter of Earl Godwin of Wessex, the most powerful nobleman in England. She inherited vast lands, which she brought to her marriage to Edward the Confessor (1003–1066). She often took part in debates at court, which was unusual for the time. In addition, she became noted for her skill with the needle at a time when it was common for noble-women to have needlework workshops in their quarters and to oversee the production of Church vestments and furnishings.

Failge
THIRTEENTH CENTURY; IRELAND

An intellectual noblewoman, Failge, also known as Máirgréag Ni Chear-bhaill or Margaret O'Carroll, opened her home to those who wished to worship according to the old Celtic ways. She thus helped to transmit traditional Irish culture and matriarchal ideas.

Fibors
TWELFTH CENTURY; FRANCE

Fibors (or Tibors) is the earliest known of the trobairitz. The sister of the famous troubador Raimbaut d'Orange, she was the wife of Bertrand de Baux, the head of a powerful family in Provence and an important patron of troubadours.

Isabella de Forz
1233–1293; ENGLAND

Married at twelve and widowed at twenty-three, de Forz acquired so much property that King Edward I, who regarded her holdings as being too great for any subject (particularly a woman), tried to pressure her into selling them to him. He did not suc-ceed until she was on her deathbed; even then he was able to obtain only a portion of it.

Marie de France
TWELFTH CENTURY; FRANCE

Marie de France, the first professional woman writer in the country, was most likely connected to the court of Eleanor of Aquitaine. In addition to collecting legends and songs from the oral tradi-tions of Europe, she composed poems and stories, including a rhymed col-lection of *Aesops' Fables*. De France's writing, which was widely read during her lifetime, evidenced a woman's perspective, standing in sharp stylistic contrast to the masculine genre of the *chanson de geste*, or heroic epic.

Lady Godiva
CIRCA 1040–L080; ENGLAND

Godiva (Godgifu) was married to Leof-ric, earl of Mercia, who had earned his fortune and his title through success in business. They moved to Coven-try, founding an abbey that became a social focus for the town. Leofric assumed a growing role in its gover-nance, using his position to impose what Godiva viewed as excessive taxes. She attempted to convince him to lower the taxes; he claimed he would do so only if she rode naked through the town. To his surprise, she agreed. Accompanied by two female aides also on horseback, Godiva made her historic journey, one that was partic-ularly shocking because at that time the only images of unclothed people appeared in the church. As the story goes, in respect for Godiva's modesty, the townspeople stayed inside their houses during her ride, except for one man known as Tom, hence the term "peeping tom." As for the taxes, most of them were reduced and the tale has become part of the lore of Coventry, which celebrates an annual Godiva festival.

Hawisa
CIRCA 1160–1195; ENGLAND

Before the codified legal code of the Magna Carta (1215) ended the prac-tice, English kings had the right to sell off widows and their property to the highest bidder if the couple had no children. This must have been particu-larly vexing to Hawisa (Halwisa, Hawise) because she had been considered one of the great ladies of the time and her

JUDY CHICAGO, detail, drawing for *Eleanor of Aquitaine* runner top

1180 wedding to the earl of Essex had been considered the social event of the year. But when he died leaving no heir, she was forced by King Richard I to marry a man of lower status, and her land and stock were seized on behalf of the crown.

Jeanne of Navarre
1271–1305; FRANCE

Despite her marriage to Phillip IV of France who by law could have taken her property from her, Jeanne (Joan, Johanna), the heiress of Navarre and Champagne, retained title to both of her kingdoms. When Champagne was attacked, she personally defended her lands as head of the army. She is, how-ever, best known for having founded the college of Navarre (a school for the French nobility) and for her patronage of intellectuals and writers.

Margaret

1045–1093; SCOTLAND

Margaret was an Anglo-Saxon princess who was forced to take refuge in Scotland after the Norman Conquest. An educated woman, she brought culture to the country, particularly after marrying Malcolm, the king of Scotland, whom she taught to read. In addition to instigating many reforms within the church, she played an important role in the political affairs of the state. She was canonized in 1250 and later declared a Patroness of Scotland.

Margaret of Lincoln

THIRTEENTH CENTURY; ENGLAND

Though the Church considered women to be inferior, medieval women often had considerable responsibility that carried with it a degree of power. Particularly after the establishment of the Magna Carta, the death of a husband meant that a woman could keep her property and enjoy other freedoms. After being widowed, Margaret took over the management of the family estate as well as the farm and dairy.

Marie of Champagne

1174–1204; FRANCE

Marie of Champagne was the daughter of Eleanor of Aquitaine and Louis VII. It had long been thought that she worked with her mother to develop the code of chivalric manners used in the Courts of Love, though now historians disagree on whether Marie and her mother had much contact. Also contested is the long-held notion that Christien de Troies, author of *Lancelot* or *Le Conte de la Carette,* was directly inspired by Marie. What is known, however, is that, like her mother, Marie was an important patron of the troubadours.

Detail, *Eleanor of Aquitaine* runner

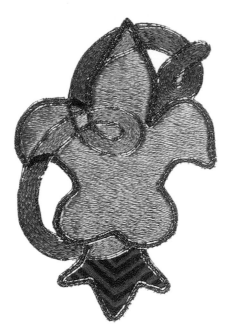

Eleanor of Aquitaine illuminated capital letter

Mathilde of Tuscany
1046–1115; ITALY

Mathilde (Matilda) was the daughter of Boniface of Tuscany, the most powerful nobleman of the period. After her father was murdered in 1053, she inherited his vast estates. When Henry III invaded Italy, he took Mathilde and her mother prisoner. After she was freed, Mathilde used her wealth to establish churches, convents, and the like, while also promoting the guilds of Florence. In 1087, Mathilde organized a successful military expedition to Rome in support of Pope Victor III, subsequently marrying the duke of Bavaria in order to obtain a powerful ally. She further attempted to solidify the power of the papacy by willing all her land to the Holy See. Although Italy was united largely through her effort, it did not remain so after she died.

Matilda
1102–1167; ENGLAND

Matilda (also known as Maud) was married to Henry IV. She influenced him to grant the important legal charter that became the model and precedent for the Magna Carta. Considered the first queen of England, she was known for her good works. She enacted a welfare program to provide for underprivileged pregnant women, endowed religious institutions, and built and improved bridges. She also protected the civil rights of the Saxons, paving the way for peace between them and their Norman conquerors.

Matilda of Flanders
D. 1083; ENGLAND

Queen Matilda is thought to have designed and supervised the execution of the Bayeux Tapestry. This monumental work, over two hundred feet long, took years to produce and depicts events related to the Norman Conquest of England in which Matilda's husband, William the Conqueror, figured prominently. It is believed that Matilda and the women of her court completed the work; it was then brought to France, where it was displayed in the Bayeux Cathedral. Although called a tapestry, the piece is actually elaborately stitched in worsted wool on linen and is probably the world's most famous embroidery.

Melisande
D. 1161; JERUSALEM

Melisande (Melisende) was the eldest daughter of King Baldwin II of Jerusalem. Upon his death she reigned for roughly seventeen years, relinquishing power only after her son came of age and his army laid siege to the citadel of Jerusalem, in which she had barricaded herself. Despite their struggles, the two reconciled, and she spent the remainder of her life advising him and devoting herself to the Church. She was also a great patron of the arts, undertaking many building projects, the crowning achievement of which was her renovation of the Church of the Holy Sepulcher.

Sobeya
TENTH CENTURY; SPAIN

Sobeya (also known as Aurora or Subh) became regent for her twelve-year-old son Heschem II in 976. Before long, their power was challenged by Mansur, who despite her efforts managed to wrest political control from them. Once the most powerful of Muslim sultanas, she was forced into seclusion for the rest of her life.

Maria de Ventadorn
1165–1221; FRANCE

De Ventadorn (also called Marie de Turenne), a noblewoman and innovative writer, was an important patron of the troubadours and trobairitz, playing a crucial role in the development and spread of the courtly culture.

Barbe de Verrue
THIRTEENTH CENTURY; FRANCE

Another of the trobairitz, De Verrue earned a fortune traveling and performing her own compositions. She lived to an advanced age and was much admired by her contemporaries.

Violante
1236–1301/02; SPAIN

Married to John I, Violante, also known as Yolande, recreated the elegant atmosphere of the French Courts of Love, attracting poets and knights from all over her realm. Violante herself left an extraordinary (and yet unpublished) literary will, which is unusually revealing of her private feelings. She also interceded on behalf of the Jews, who were being persecuted and heavily taxed.

Virgin Mary
BIBLICAL; NEW TESTAMENT

The ancient reverence for a nurturing female deity could be said to have found its Christian expression in the veneration of Mary. She is grouped with Eleanor of Aquitaine because in the high Middle Ages the adulation of a female deity reflected the enhanced status of women brought about in part by the Courts of Love. Although many women both in and out of the cloister blossomed under Mary's beneficent gaze, she both reflected and reinforced the diminishment of the Goddess as well as the steady contraction of female power.

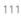

Hildegarde of Bingen

1098–1179

The twelfth century was not only a high point for women at court but also in the cloister. The ruling abbess of a monastic center often enjoyed the rights and privileges of a feudal baron. One such abbess, Hildegarde of Bingen, was also a significant political and religious figure, as a scholar, scientist, artist, and mystic. Hildegarde spent almost her entire life in the convent, where she received a rudimentary education from the anchoress Jutta. A series of visions instructed her to move her convent to Bingen. She did this in the face of opposition from churchmen, who attempted to denounce the authenticity of her revelations.

In her popular writings, Hildegarde described her visions, explained their allegorical meanings, and wrote commentaries on religious issues. Of particular importance were her books on medicine. Her remedies for disease reveal a wide knowledge of drugs and herbs, and her medical treatments—in spite of their emphasis on magic—were progressive. Surprisingly, given her godly vows, she was one of the first people to accurately describe female orgasm. In her later years, she concentrated on developing a theory of the universe that stressed the relationship between the human and the divine. Like Dante, Hildegarde conceived the universe holistically, emphasizing the inseparability of the physical and the spiritual.

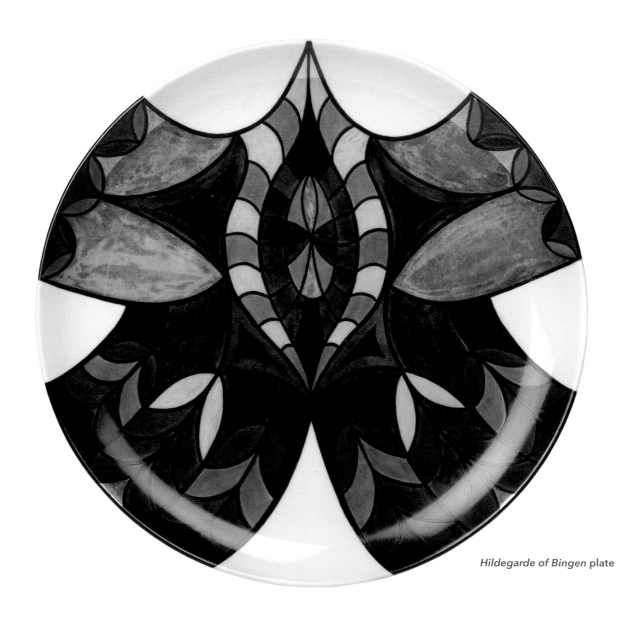

Hildegarde of Bingen **plate**

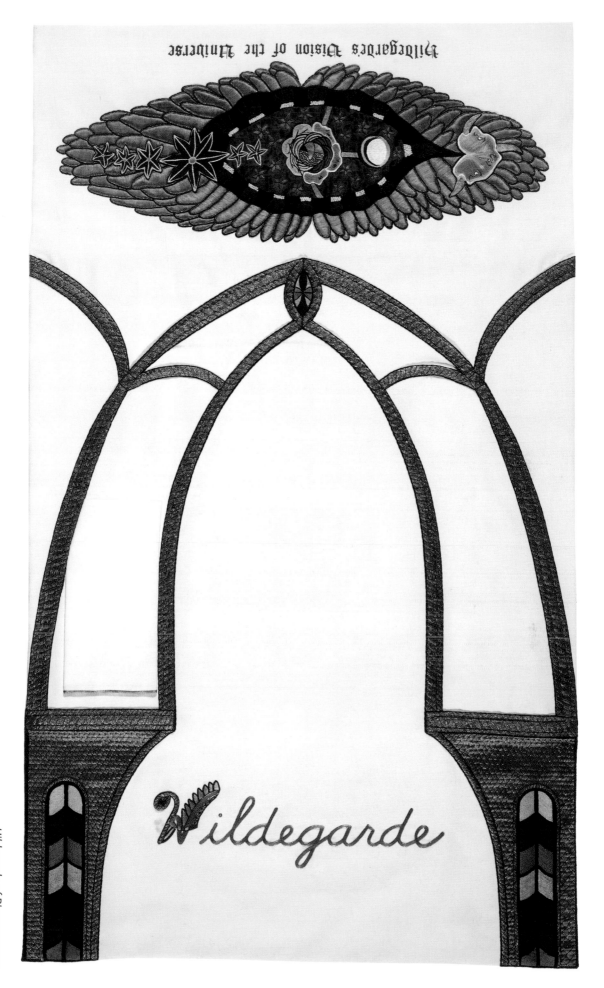

Hildegarde of Bingen place setting

Women played an important role in the medieval Church, but as the institution developed, they were increasingly placed under male control and the rights of abbesses were gradually curtailed. As a result, many women turned toward spirituality as an avenue of personal expression that was unrestricted by Church fathers. The thirteenth-century mystic movement emphasized the breaking down of barriers between the Church and the laity, along with the reform of the Church. Assembled around the place setting for HILDEGARDE OF BINGEN are the names of other women mystics and religious women, as well as noblewomen who were involved in medical work or who used their wealth to found and administer hospitals.

Agnes
1205–1282; BOHEMIA

When Constance of Hungary was pregnant with Agnes, she had a dream in which she saw a woman in the garb of the Sisters of Saint Clare (a community of contemplative women). A voice said: "The child whom you carry in your womb will one day wear this garment, and she will be a light onto the kingdom of Bohemia." From the time she was a child, Agnes wanted to devote herself to religious work but her father, King Ottokar I, wanted to marry his daughter for political purposes. After his death she followed her calling, founding a hospital on land donated by her brother King Wenceslaus I and later building a Franciscan friary and a

Poor Clare convent, where she became the abbess and spent fifty years. The convent, the first Gothic building in Prague, became an influential spiritual center.

Anna
CIRCA 1253; BOHEMIA

Our original research indicated that Anna (Anne), sister to Agnes, was trained in medicine, specializing in the treatment of children, and founded nunneries and hospitals. But recent scholarship suggests that she had been married to the duke of Silesia in a politically advantageous marriage, the type of union her sister Agnes had avoided.

Phillipe Auguste
1164–1225; FRANCE

Phillipe Auguste was a prominent member of the Order of St. Augustine, the oldest nursing order in existence. She worked at a hospital in Paris that had been open since 650 CE.

Berengaria
1165/70–1230; SPAIN

Described as the "only English queen never to step foot in the country," Berengaria or Berenguela, daughter of Sancho VI of Navarre, married Richard I of England, son of Eleanor of Aquitaine. Although Berengaria accompanied Richard on a Crusade, their marriage may never have been consummated; they had no children and Richard was widely believed to have been homosexual. They never lived together, and after Richard's death, Berengaria founded a monastery, entered convent life, and attended to the sick and needy.

Birgitta
1303–1373; SWEDEN

Birgitta was married at thirteen to the son of the governor of a province in western Sweden. In 1341, he died, and she began to experience revelations that inspired her to form a new religious order, the Bridgettines, which encouraged the contemplative life. She became dedicated to church reform, traveled extensively, and became a favorite of the people and an advisor to rulers. She is still honored at an annual retreat in Finland. Respected

as a prophet, her *Revelations* (meditations on the Passion of Christ) were widely read and translated into several languages, markedly influencing the literary history of Sweden.

Catherine of Siena
1347–1380; ITALY

Catherine, one of the greatest mystics of the Western world, tried to restore the Church to its original purity through the establishment of a spiritual community. She traveled, preached, and advised many of the rulers in Europe, reconciling enemy factions and attracting numerous disciples. Her book *The Dialogue of St. Catherine* and her four hundred *Letters* comprise a great treasury of spiritual writing. She was one of the first women to be named a Doctor of the Church.

Clare of Assisi
1194–1253; ITALY

From a noble family, Clare was a follower of Francis of Assisi, who intervened on her behalf to allow her to organize the Poor Clares according to "the privilege of poverty." After he died, the Church attempted to interfere with her ministry, at which point she wrote her own "Rule," one of the earliest religious texts known to have been written by a woman. Although her order spread throughout Europe, within ten years after her death, all her religious houses were forbidden to practice the institutional poverty that Clare believed to be essential to the purity of the Church.

Alpis de Cudot
TWELFTH CENTURY; FRANCE

Two centuries before Copernicus introduced the heliocentric theory of the universe, Alpis (Alpaïs) de Cudot argued that the earth was a round globe and a solid mass and that the sun was larger than the earth.

Cunegund
1224–1292; POLAND

The daughter of the king of Hungary, Cunegund, also called Kinga, was married at sixteen to the king of Poland, although she insisted on retaining her chastity because she was determined to devote herself to a religious life. Living austerely, Cunegund spent her time caring for the poor and the sick. When the king died, she refused the

wish of the nobles that she assume the throne, preferring to become a Poor Clare at a convent she founded. She spent the rest of her life building churches and hospitals. When the Tartars invaded Poland in 1287, she was able to save the nuns in her convent.

Douceline de Digne
D. 1274; GERMANY

Douceline was the founding member of the Ladies of Roubaud, a Beguine community in Marseilles. The Beguines (originally, communities of uncloistered women devoted to chastity and charity) were not bound by vows or subject to papal enclosure. Some Beguines preached, outraging the Church, and a few were accused of heresy. Nevertheless, Beguine communities were still in existence as recently as the late 1960s.

Elizabeth
1207–1231; HUNGARY

In a political alliance, Elizabeth, daughter of King Andrew of Hungary, was betrothed at four and married at thirteen to Prince Ludwig of Thuringa. After Ludwig became king, Elizabeth acted as regent while he was away, distributing alms, building a hospital and home for lepers, and nursing the ill. During a terrible famine, she fed thousands, causing the king's treasurers to accuse her of squandering money. In 1227 Ludwig died, leaving her with several children. Historians disagree if she then left the court voluntarily or was driven away by the brutal treatment of her brothers-in-law. Regardless, the following year she built another hospital and devoted herself to the care of the sick until her death.

Elizabeth of Schonau
CIRCA 1129–1165; GERMANY

Hildegarde of Bingen's contemporary, Elizabeth of Schonau also experienced visions. At the age of twelve she entered the convent at Schonau, becoming its superior in 1157. She recorded her mystical experiences on wax tablets. Her writings became extremely popular, and many people regarded her as a divinely inspired messenger of God.

Gertrude the Great
1256–1301; GERMANY

A great mystic and healer, Gertrude was one of the most eminent religious figures of the Middle Ages. Brought to the convent of Helfta at age five, she was a brilliant student, but a vision in 1281 caused her to focus only on religious studies. Thereafter, she spent her time studying and writing, recording her revelations, prophecies, and personal experiences in a series of books that are still in use.

Gertrude of Hackeborn
CIRCA 1232–1292; GERMANY

Gertrude, a mystic and writer, was an enlightened abbess at the convent of Helfta, which became a center of the thirteenth-century mystical movement in which women played a central role.

Agnes D'Harcourt
THIRTEENTH CENTURY; FRANCE

D'Harcourt was the abbess of Longchamp, a religious house founded by Isabel of France. A little-known though important author, D'Harcourt wrote a chronicle of Isabel's life. Probably the first French biography of one woman by another, it is also one of the only books of the period containing a female perspective.

Hedwig
1174–1243; POLAND

Hedwig was educated at a convent ruled by her sister. At age twelve, she married Henry I, the future king of Poland, with whom she had seven children. Queen Hedwig founded hospitals and was famous for her medical skill. After Henry died she returned to the religious life, giving away her fortune and devoting herself to educating the nuns at the convent and caring for the sick.

Heloise
1101–1164; FRANCE

The tragic story of Heloise and Abelard is well known. A brilliant student, Heloise was educated in a convent and then lived in Paris with her uncle Fulbert. Abelard, a renowned theologian, moved into Fulbert's home and became Heloise's tutor. They fell in love and had an affair; Abelard proposed marriage, but despite her love for him, Heloise refused. She was concerned that, because Abelard was master of the cathedral school at Notre Dame and expected to be celibate, his career would be destroyed if they wed. When Heloise became pregnant, her uncle insisted that she and Abelard marry, which they did secretly. When rumors began to spread, she publicly denied the marriage in order to protect Abelard's career. Abelard spirited Heloise away for the birth of

115

Detail, *Hildegarde of Bingen* runner back

𝕳ildegarde's 𝖁ision of the 𝖀niverse

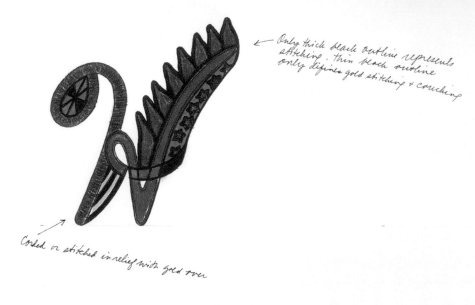

Only thick black outline represents stitching. thin black outline only defines gold stitching + couching

Corded or stitched in relief with gold over

Study for Hildegarde's letter *jc 1977*

JUDY CHICAGO, drawing for *Hildegarde of Bingen* Illuminated capital letter

the baby. Robbed of his niece and the family's honor, Fulbert arranged to have Abelard castrated. Desolate, Abelard took refuge in a monastery. Although Heloise could have had the marriage annulled and gone back to the city, she chose convent life instead, eventually becoming an abbess. She elevated the intellectual level of her order, established a school of theology, and became one of the most learned doctors of her era. But the love story between Heloise and Abelard has overshadowed her personal accomplishments. And their relationship continued, as evidenced in a series of letters, some only recently discovered. When Heloise died, she was buried next to Abelard.

Herrad of Lansberg
1130–1195; GERMANY

Herrad, abbess of the convent of Hohenberg, created the encyclopedic work *Hortus Delicarum* (Garden of Delights), which contained over 340 illuminations. Its purpose was the education and spiritual nourishment of her nuns. Although the book was destroyed, what we know of its contents is derived from tracings made in the nineteenth century.

Hersend
CIRCA 1249; FRANCE

As physician to Louis IX, Hersend accompanied him on his first Crusade to the Holy Land. The king rewarded her service with a lifelong pension.

Las Huelgas
TWELFTH CENTURY; SPAIN

Las Huelgas was the abbess of a prominent monastery that produced *Las Huelgas Codex*, one of the most important manuscripts in the history of Western liturgical music. The monastery was also famous because its abbesses heard confessions, said Mass, preached, traveled freely, and enjoyed full ecclesiastical jurisdiction.

Isabel of France
1225–1270; FRANCE

Daughter of Blanche of Castile and sister to Louis IX, Isabel chose a life dedicated to religious observance and scholarship. Although she never entered the cloister, she founded the abbey of Longchamp and, while living nearby, followed the regulations she had drawn up for the nuns. Having refused many offers of marriage, including one that would have made her Holy Roman Empress, she preferred to be "last in the ranks of the Lord's virgins to being the greatest empress in the world."

Juliana of Norwich
CIRCA 1342–1413; ENGLAND

In or around 1393, Juliana of Norwich, a recluse and mystic, wrote the *Revelations of Divine Love*, one of the first spiritual works penned by an Englishwoman. A rare reflection of the spirit of the Middle Ages, it enjoyed a popular revival when it was reprinted in 1902.

Jutta
TWELFTH CENTURY; GERMANY

Although Jutta was born into a wealthy and prominent family, she chose to become an anchoress cut off from the world. Jutta's devotion brought her a group of female disciples who were only able to access her through a door to her cell, which was adjacent to a church. She became the first ruling abbess of the Benedictine abbey where Hildegarde of Bingen was educated and personally supervised her studies.

Loretta
CIRCA 1207; ENGLAND

Many women chose a religious life rather than marriage because the latter often meant they would lose control not only of their property but also over their bodies. Loretta is another example of a woman who, after her family died, gave away all her inherited property to live simply as an anchoress, attended by a few servants in a modest house.

Margaret
1242–1271; HUNGARY

When Margaret, the daughter of Bela IV, king of Hungary, was born, her parents promised her to God in the hope that this would bring an end to the continued invasions of their country. Educated by the Dominican Sisters of Hare Island (now Margaret Island), Margaret became the spiritual advisor of her order.

Marguerite of Bourgogne
CIRCA 1293; FRANCE

Marguerite, daughter of the duke of Burgundy, married Charles I of Anjou. She used her wealth to finance a hospital complex that was a vast improvement over most institutions of the period. Its long wards were well ventilated, and its comfortable beds were screened, affording privacy.

Mechthild of Hackeborn
1241–1299; GERMANY

Sister to Gertrude of Hackeborn, Mechthild was also a Benedictine nun at the convent of Helfta. Her widely read *Book of Special Grace* described her visions and inspired other religious women to record their own revelations. Mechthild presided over the convent choir and possessed a talent for sacred music.

Mechthild of Magdeburg
1210–1297; GERMANY

A member of the Beguines, Mechthild was a writer at the center of the German literary and mystic movement. She wrote *The Flowing Light of God*, a collection of visions, parables, and dialogues that influenced Dante's *Paradiso*. Her work is the first mystical writing that is not based upon an earlier Latin prototype but is rather an independent composition. Appalled by the widespread decadence of the Church, Mechthild, like many Beguines, attempted to instigate reform but was charged with being "unlearned, lay, and worst of all, a woman!" She was helped by the influential Gertrude the Great, who admired her writing, courage, and visionary powers.

Finola O'Donnel
D. 1528; IRELAND

A nun for twenty-two years and cofounder in 1474 of a Franciscan monastery, Finola O'Donnel (Fionnghuala) is noteworthy because references to Irish nuns during this period are so rare, despite the fact that they played a pivotal role in the creation of a devout Catholic Church in Ireland.

Rosalia of Palermo
CIRCA 1130–1166; ITALY

Another woman who turned her back on her family's wealth to become an anchoress, Rosalia took up residence in a cave and devoted herself to a life of contemplation. Her prayers are thought to have delivered the town of Palermo from the Plague in 1150, for which she was canonized.

Theresa of Avila
1515–1582; SPAIN

"The very thought that I am a woman is enough to make my wings droop," wrote Theresa, a monastic reformer and visionary. She challenged the apostolic precept that forbade women to teach; one of her books, *The Way of Perfection*, has been described as an early feminist work. Her objective was to restore the purity of the Carmelite order and thereby bring about the regeneration of the Church. Although continually harassed by Church officials, she established numerous religious houses for men and women. She urged her nuns to live purposeful lives, stressing that, although convent life was difficult, it was "better than being a wife." Theresa is memorialized by a famous sculpture by Bernini. In 1970, she was elevated to Doctor of the Church by Pope Paul VI, the first woman to be so honored in the modern era.

Yvette
1158–1228; HUNGARY

Like many women of her time, Yvette was married against her will. At the age of eighteen, she was left a widow with two sons. Rather than remarry, she spent the next ten years nursing lepers and thirty more as an anchoress in a walled cell.

Detail, *Hildegarde of Bingen* **runner**

Petronilla de Meath

DIED 1324

Despite the spread of Christianity throughout Europe, populations clung to traditional forms of worship of the Mother Goddess, sometimes incorporating these into their veneration of the Virgin Mary, practices which—like various forms of magic—came to be viewed as either heretical or witchcraft. One of the first documented witchcraft trials took place in Ireland in 1324. Lady Alice Kyteler, a wealthy noblewoman, was accused of heresy, and her maid, Petronilla de Meath, was tortured to force her to accuse her mistress of witchcraft. A bishop, inspired by his desire to confiscate Lady Kyteler's property, pursued this, along with other charges. Lady Kyteler, Petronilla, and a number of their friends were accused of being heretics, of having nocturnal meetings with the devil, and of making animal sacrifices. The noblewoman was also charged with having sexual relations with a man who could supposedly appear as both a black male and a cat. Lady Kyteler was able to escape to England, where she raised Petronilla's child. Not so fortunate was Petronilla, who was imprisoned, tortured, and then burned alive.

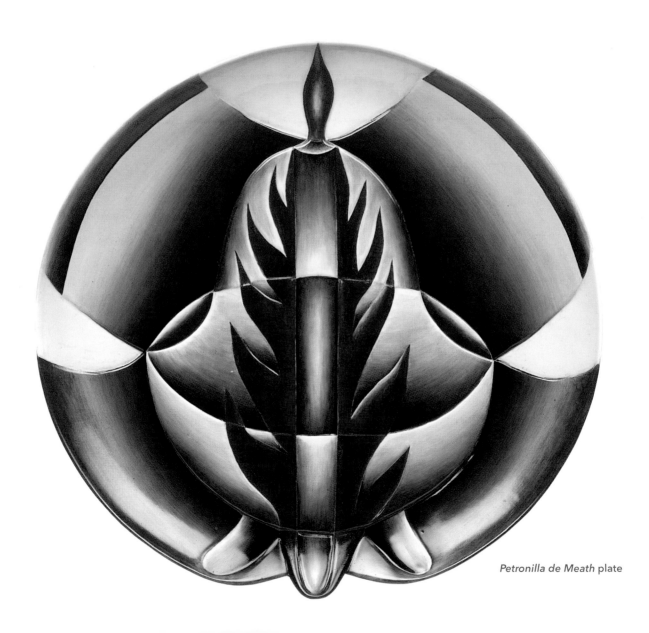

Petronilla de Meath plate

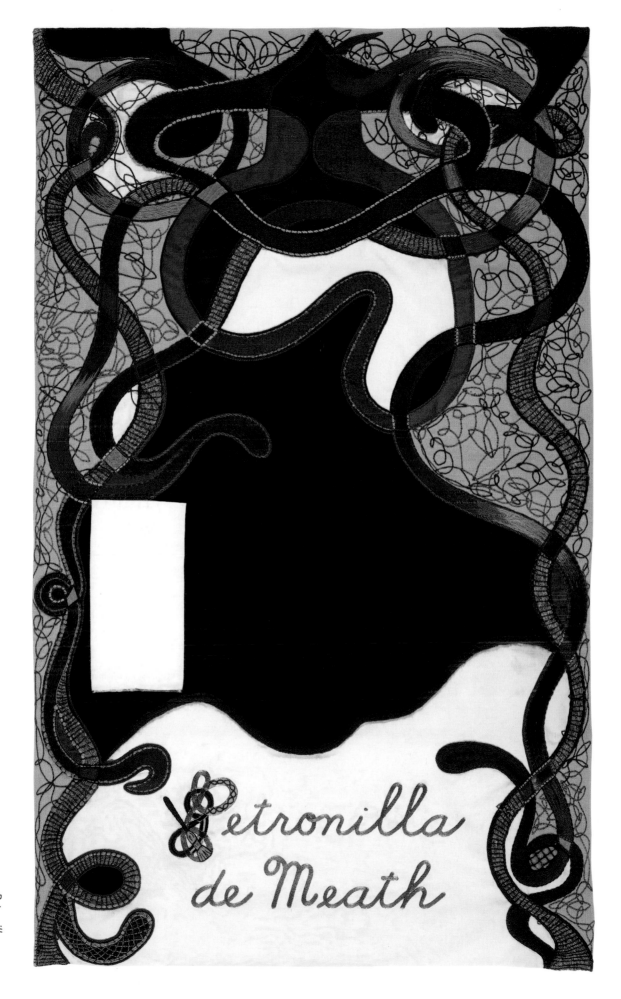

Petronilla de Meath

Petronilla runner

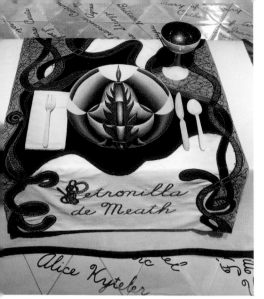

Petronilla de Meath place setting

The witch hunts occurred during a period in European history in which women's status was undergoing a profound transformation. Where previously there had been a rough equality between the genders, particularly when the family was still an economic unit in which parents and children worked together, there was an increasing emphasis on male control. Also, men steadily usurped the traditional occupations of women, such as lay healing and textile production. Women in these professions, along with those who resisted the intensifying domination of men, were often accused of witchcraft. The extent of the witch-hunting craze was much wider than is commonly thought. Women (who comprised 85 percent of those accused) were tried and burned on countless pretexts; their real crimes were their ongoing practice of magic, their devotion to non-Christian or radical Christian beliefs, or their independence. Grouped around the place setting commemorating PETRONILLA DE MEATH are the names of other women targeted in the witch-hunting frenzy.

Angele de la Barthe

D. 1275; FRANCE

In the first witchcraft trial in France, De La Barthe was accused of copulating with the devil, found guilty, and executed. As in many other such trials, the real reasons for her persecution are unknown.

Madeleine de Demandolx

1593–1670; FRANCE

At the age of fourteen, Demandolx became a novice in a convent in Marseilles, where she confessed to having had intercourse with her family's priest. She then experienced hallucinations, which were thought to have been caused by the devil. When a local priest was summoned to exorcise her, her hysteria became even more uncontrollable. She was put in jail, presumably to protect her from Satan. The guilty priest denied the relationship but was tried by the Inquisition and executed for witchcraft. Several years later, she was charged with the same crime, for which she served a lengthy prison sentence.

Catherine Deshayes

D. 1679; FRANCE

Deshayes, a fortune-teller and sorcerer, was charged with witchcraft for her involvement with a scandal involving the nobility. Supposedly, several members of the ruling class sought her out to obtain poisons and spells to kill their spouses. When the plot was exposed, only Deshayes was arrested, accused not only of providing potions, but also of killing two thousand infants with her "demonic powers." She was tortured and executed.

Geillis Duncan

D. 1590; SCOTLAND

Duncan, a lay healer, was one of the women tried in the famous North Berwick witch trials, in which a group of women were accused of causing a storm that delayed a ship carrying the Scottish king James VI and his bride Anne of Denmark. Duncan worked as a servant in the home of a town official who believed that Satan gave her the power to heal the sick. She was tortured into saying that she and the others had been told by the devil to induce the storm by throwing a cat into the ocean. She was tortured again in an effort to force her to name her accomplices.

Jacobe Felicie

BORN 1292; FRANCE

Jacobe (Jacoba) Felicie was a Jewish empiric (a doctor who relies on practical experience) who was brought to trial by the University of Paris Medical Faculty in 1322. Her competency was not the issue—six cured patients testified on her behalf—but rather, that she was practicing without a degree (as a woman, she was unable to attend the university). The institutionally trained physicians insisted that medicine had to be learned from books. Felicie argued for the need for women doctors, especially for treating female patients. Though she was repeatedly fined and even threatened, she refused to give up her practice.

Goody Glover

D. 1688; MASSACHUSETTS BAY COLONY

Irish-born Glover, a Catholic, was sent as a slave to Barbados in the 1650s. She married there, and after her husband died, she and her daughters became housekeepers in Boston. When the children of the family for whom she worked fell ill, Glover was accused of having bewitched them. The evidence used against her included her inability to recite the Lord's Prayer in English and the existence of dolls found in her home. On November 16, 1688, she was hanged. Three hundred years later, on the anniversary of her death, the Boston City Council declared her execution an injustice and proclaimed that day "Goody Glover Day."

Guillemine

THIRTEENTH CENTURY; BOHEMIA

Guillemine or Guglielma was the founder of a religious sect for women and a reformer who questioned the prevailing Church doctrine on the inherently evil nature of woman. She argued for women's right to prophesize, to interpret the scriptures, and to commune directly with God. Because of her challenge to the clergy's authority, the Inquisition denounced her sect.

Joan of Arc

1412–1431; FRANCE

When Joan was twelve, she began to hear voices that told her that it was her divine mission to free her country from the English (which had invaded France) and to obtain the crown for the exiled dauphin, Charles VII. At the age of seventeen she obtained an audience with Charles, convincing him that she was destined to be his savior. Wearing a suit of armor and carrying a banner covered with gold fleurs-de-lis, Joan led the French army to victory at the Battle of Orleans in May 1429. In July,

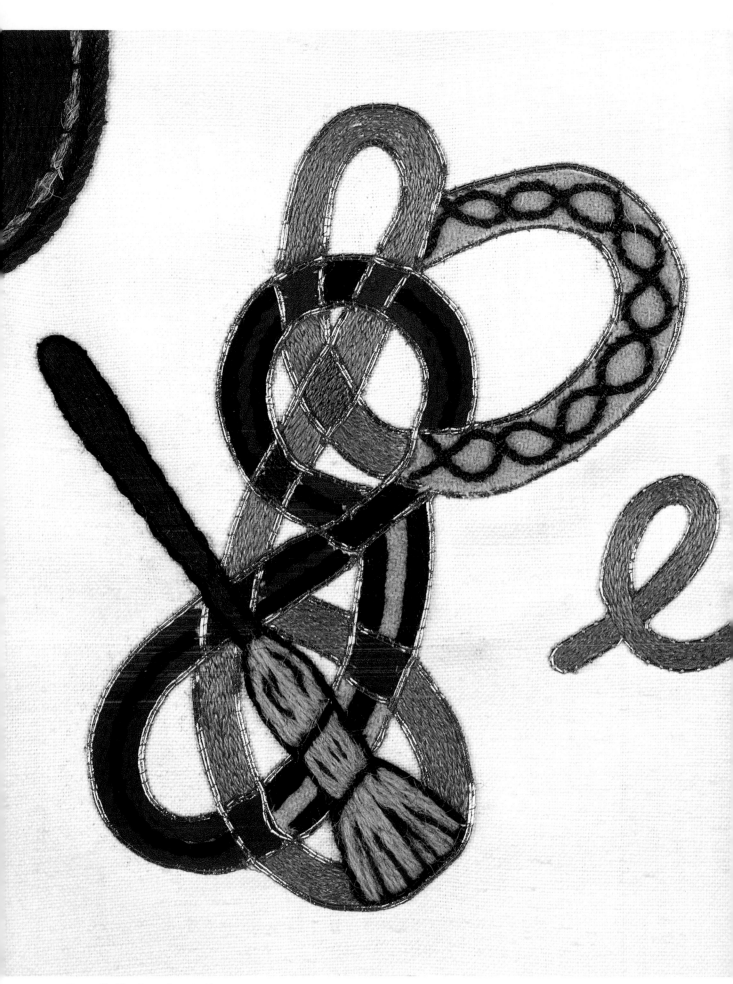

Petronilla illuminated capital letter

Charles VII was crowned king of France, and at the coronation, Joan was given a place of honor. The next year she was captured and handed over to the English, who in revenge turned her over to the Inquisition. After fourteen months of torture, the only charge against her that could be proven was cross-dressing. On May 30, 1431, she was burned at the stake. Twenty-four years after her death, she was acquitted of all charges. In 1909, she was beatified; in 1920, she was canonized as a saint. Today, many historians view her as an innovative military genius.

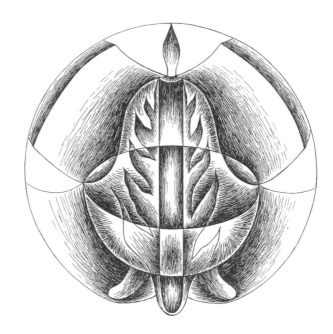

Margaret Jones
D. 1648; MASSACHUSETTS BAY COLONY

In the seventeenth-century colonies, childbirth was the exclusive province of midwives. Although midwives eventually became licensed, the association between women and the supernatural, particularly in relation to birth and healing, came to be seen as possession by the devil. Consequently, both the Church and the medical profession took a keen interest in a midwife's activities out of concern that she might be a witch; a child born with a deformity often provoked such a suspicion. Jones was a midwife who for unknown reasons so aroused the distrust of the male physicians that she was accused of witchcraft, brought to trial, and hanged, the first person executed as a witch in America.

Margery Jourdemain
D. 1441; ENGLAND

Jourdemain was a noted diviner. She allegedly used her supernatural powers to help the duchess of Gloucester in her plot to secure the crown for her husband by killing King Henry VI. The king discovered their intentions and had them all arrested. The duchess and her cohorts were banished while Jourdemain was burned at the stake for treason.

Ursley Kempe
D. 1582; ENGLAND

A lay healer, midwife, and wet nurse, Ursley (Ursula) Kempe was an independent woman who bore several children out of wedlock. Consequently, even though the community used her services, she was considered a loose woman. When a neighbor's son became ill, Kempe allegedly engaged in a series of rituals that healed the boy. Later, when the neighbor's granddaughter fell and broke her neck, the woman blamed Kempe, accusing her of witchcraft. After another woman from the village insisted that Kempe had bewitched her child, the magistrate questioned Kempe's eight-year-old son, who testified against his mother, a common occurrence in witchcraft trials when children were terrified into cooperating with the Inquisitors. The magistrate trying Kempe promised her clemency if she confessed, but even after she implicated others, she was hanged.

Alice Kyteler
CIRCA 1324; IRELAND

Although Kyteler was accused of hastening the deaths of her first three spouses through sorcery, she was able to escape the country. Her maid, Petronilla de Meath, was not so lucky.

Margaret of Porete
D. 1310; GERMANY

A mystic and perhaps a Beguine, Margaret of Porete's writing suggests that she was well-educated in courtly literature and in religious texts. Her book *Mirror of Simple Souls,* which was read for many centuries, espouses a form of mystical pantheism. Passages of her book were deemed heretical by a group of male theologians, and she was publicly burned at the stake. She is also known as Marguerite Porete.

Pierrone
D. 1430; FRANCE

Pierrone (Pierronne) was a companion of Joan of Arc, rumored to have served with her in the French army. Like Joan, she believed that she was divinely directed, asserting that God had appeared to her in human form. She was also accused of witchcraft and burned at the stake.

Anne Redfearne
D. 1612; ENGLAND

Although little is known of the circumstances surrounding the trial of Anne Redfearne, we do know that there was a general distrust of women, particularly unmarried women like her. She was accused by the local magistrate of "witchcraft by common complaint" and charged with causing the death of Robert Nutter, a man who had tried to rape her. Because the jury found the evidence against her inconclusive, she was acquitted. Later she was accused of murdering Nutter's father, who had died twenty years earlier, a crime for which she was executed in 1612.

Maria Salvatori
D. 1646; ITALY

Old women were particularly vulnerable to accusations of witchcraft because they were often poor and alone or were seen as eccentric. One such woman, Maria Salvatori, was brought to trial as a witch on the grounds that she had used communion wafers to cast spells. The Inqui-

sition was so zealous in its torture of her that she died in prison before she could be executed.

Agnes Sampson
D. 1591; SCOTLAND

Sampson, a lay healer, was one of the chief witnesses in the North Berwick witch trials. Under torture, she confessed to a series of acts with a group of other women, including Geillis Duncan. She was found guilty and executed in 1591.

Alice Samuel
D. 1593; ENGLAND

Alice Samuel lived next door to a family with five daughters, one of whom suffered terrible fits. When Samuel visited the household, the girl accused her of having caused the fits through witchcraft. Soon, the girl's sisters also began having fits, and their parents, who believed that such fits could be cured if the victim scratched their supposed bewitcher, encouraged the girls to violently scratch poor Samuel. Finally, the mother, who had also started having fits, died. By then, everyone in the town believed that she and her daughters were the victims of witchcraft. The girls' father insisted that Samuel and her daughter move into their home so that his daughters could cure themselves by scratching both of them. By the time this ordeal was over, Samuel, her husband, and their daughter had been accused of witchcraft and hanged, after which the girls supposedly had no more fits.

Anna Maria Schwagel
D. 1775; GERMANY

Schwagel was the last woman to be tried and executed for witchcraft in Germany, site of the most brutal of these trials. She fell in love with another servant who worked for the same family employing her. When Schwagel discovered that he was married, she ran away and was later found half-demented. When she was arrested, she accused her lover of being a Satanist who had convinced her to renounce Christianity. The authorities found her guilty, though of what remains unclear.

Elizabeth Southern
D. 1613; ENGLAND

Southern was one of the main defendants in England's first mass witchcraft trial. For several years, her family had apparently attempted to use witchcraft in a long-standing feud with another family. Under torture Southern supposedly provided the magistrate with the details. She died in prison while awaiting trial.

Gertrude Svensen
D. 1669; SWEDEN

Gertrude Svensen was the first victim of the mass trials that swept Sweden in the late seventeenth century. She was accused of kidnapping children in order to hand them over to the devil. Under torture, she implicated others; seventy people were charged with witchcraft, including fifteen children. The spectacular trial attracted three thousand people. Despite an absence of any evidence, all seventy were found guilty and burned to death.

Tituba
CIRCA 1697; MASSACHUSETTS BAY COLONY

Tituba was an Indian woman from South America who was sold into slavery in Barbados. It was there that she was probably purchased by a merchant who took her along when he moved to the Massachusetts Bay Colony. The children of her master's household blamed her for invoking spells that caused them to exhibit strange behavior. Although only guilty of practicing traditional herbal medicine, she confessed after being savagely beaten, telling a story of orgies and witches' Sabbaths that led to the famous Salem witchcraft trials. Eventually, Tituba was released for lack of evidence, sold to another owner, and taken away from the area.

Agnes Waterhouse
D. 1566; ENGLAND

In the witchcraft trials in Essex, 95 percent of those accused were women who were generally poor, old, widowed, or spinsters. Witchcraft was sometimes thought to be hereditary, which explains why some mothers and daughters were implicated, including Agnes Waterhouse and her daughter Joan. Agnes was brought to trial at the age of sixty-four, accused of employing her cat in acts of violence. In an effort

to save herself, Joan testified against her mother. Despite a lack of any real evidence, Agnes was hanged while her daughter was found not guilty.

Jane Weir
D. 1670; SCOTLAND

The Witchcraft Act in Scotland was in force between 1563 and 1736, during which time Jane (Jean) Weir was charged with practicing witchcraft, committing incest with her brother (who was said to be a god of the witches), and keeping a "familiar." Weir and her brother seemed to have freely confessed a devotion to witchcraft and refused to recant. The two appear to have been followers of the religion now called Wicca, which suggests that the rituals of ancient doctrines continued despite widespread persecution.

Maria De Zozoya
D. 1610; BASQUE

De Zozoya (Zozaya) was an elderly Basque woman who was accused of mating with the devil, casting evil spells, vampirism, and cannibalism. She was considered the principal member of a large group of witches who were tried for heresy and burned alive.

Christine de Pisan

In the late fourteenth century, one outstanding woman emerged to take up the task of defending her gender. Christine de Pisan, or Pizan, was educated by her father, an Italian doctor who served as personal physician to Charles V of France. At fifteen she was happily married to a man who was also sympathetic to female scholarship. Within ten years, both her father and husband had died. Christine turned to writing to support her family, becoming the first professional female author in France. She initially received attention when she criticized a popular book, *Le Roman de la Rose*, because of its attack on women. As one of the few females accepted in the world of letters, her advocation of equality for women carried considerable weight, and her response initiated what has been called the *querelle des femmes* (the argument about women), often cited as the beginning of modern feminism.

Christine then wrote *The Book of the City of Ladies*, an impassioned defense of women, followed by a sequel that chronicled hundreds of important and historical women. Five hundred years later, many of these same women are celebrated in *The Dinner Party*.

124

Christine de Pisan plate

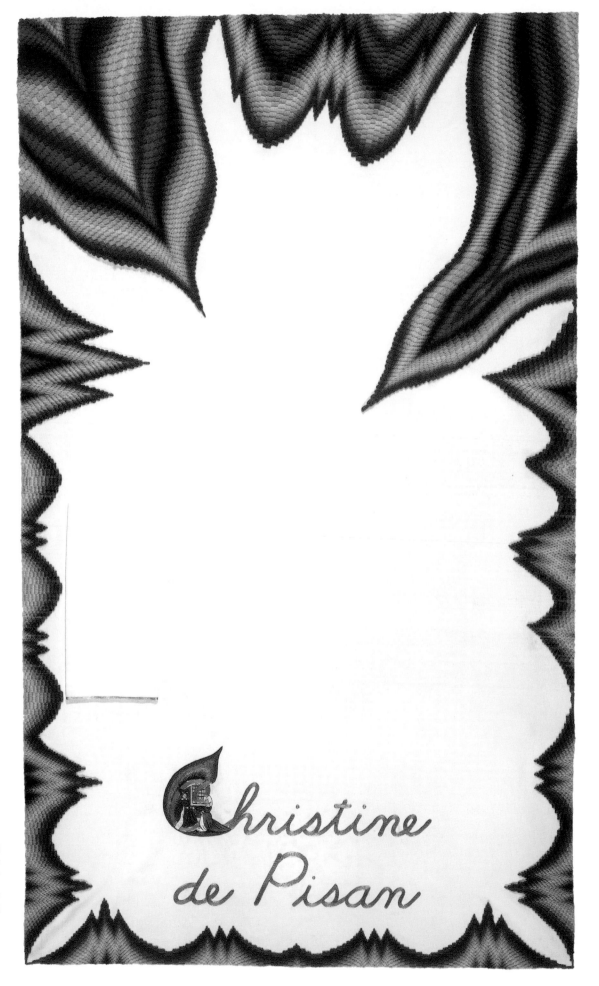

During the Renaissance, the concept of female inferiority, a theme certainly present in medieval thought, took on a new dimension. Throughout the Middle Ages, misogynist thinking was somewhat moderated by the early Christian belief in spiritual equality between women and men; the increasing secularization of society undermined this perspective and reinforced women's second-class status. Nevertheless—and despite the terror induced by the witchcraft trials—women continued striving to transcend increasingly severe social limits. The collection of names aligned with the place setting for CHRISTINE DE PISAN includes a number of scholars and artists who, like Christine, put forth feminist arguments. Their achievements are all the more remarkable in light of the obstacles they faced.

Agnes of Dunbar
1312–1369; SCOTLAND

The story of the countess of Dunbar—"Black Agnes"—symbolizes the spirit of Scottish resistance to English domination. In 1337, while her husband was away at war, Agnes successfully defended their castle against one of the most memorable sieges in Scottish history. During five months of heroic resistance, Agnes plotted the defense, walked the battlements, and nearly killed the earl of Salisbury, who led the English attack. The countess caused a huge rock to be launched against her enemy, whereupon the soldiers scattered, the blockade of the harbor was lifted, and a cessation of hostilities was concluded.

Christine de Pisan place seting

Anastasia
FOURTEENTH CENTURY; FRANCE

Described in *The Book of the City of Ladies*, Anastasia was an artist who may have executed some of the illuminations in the manuscripts of Christine de Pisan. Although it was extremely difficult for women artists to obtain training during the Renaissance, some managed, either through their fathers or brothers or in the convents.

Jane Anger
CIRCA 1589; ENGLAND

Anger's works include *Protection for Women*, an early feminist tract. Written under a pseudonym, this straightforward defense advocates female sexual autonomy and criticizes men for their deceptive dealings with women. Anger also chastised women for spending too much time catering to men, with the result that "Our good toward them is the destruction of ourselves; we being well-formed, are by them foully deformed."

Martha Baretskaya
CIRCA 1471; RUSSIA

Martha Baretskaya or Marfa Boretskaya, the mayor of the ancient northern republic of Novgorod, was the leader of a movement to resist Moscow's subjugation of the region. In 1471, a group under her direction offered their allegiance to the king of Poland if he would support their autonomy. As this alliance represented a direct threat to the control of Ivan III, the Russian king sent an army to sever the new ties. Baretskaya was captured and sent to a convent.

Margaret Beaufort
1443–1509; ENGLAND

Beaufort's great-aunts are thought to have been among the first women in England to learn to write. She herself wrote books on theology, lectured at Oxford and Cambridge, founded several grammar schools, built and endowed Christ College and founded St. John's College at Cambridge. She also instigated the Lady Margaret professorships of divinity at both schools. The mother of Henry VII, Beaufort gained the right to hold property and to sue, which gave her a unique legal status. She also studied medicine,

founded hospitals where she attended patients, and provided refuge for the indigent in her own home.

Juliana Bernes
CIRCA 1388; ENGLAND

A well-educated noblewoman and the prioress of a nunnery, Bernes (Barnes, Berners) displayed her vast technical knowledge in a book titled *Julyan Bernes, Her Gentleman's Academy of Hawking, Hunting, Fishing and Armorie*, published in 1486. This book, the first by an Englishwoman to appear in print, is noteworthy because Bernes's expertise was in areas that were regarded as male provinces.

Bourgot
FOURTEENTH CENTURY; FRANCE

Bourgot was a famous manuscript illuminator who learned the art from her father. She is best known for her work on the *Psalter and Hours of Bonne de Luxembourg*, commissioned by the Bonne of Luxembourg, wife of Jean, duke of Normandy (later, king of France). The Bonne of Luxembourg was a member of the Valois family, known for its patronage of the arts. Her family insignia appears in the lower borders throughout the manuscript.

Maddalena Buonsignori
FOURTEENTH CENTURY; ITALY

Although little is known about how she was able to establish herself as a scholar, Buonsignori wrote a Latin treatise that provided a detailed study of the legal status of women.

Rose De Burford
FOURTEENTH CENTURY; ENGLAND

De Burford, from a wealthy London family, worked with her husband as a wool merchant, and after his death, she carried on the business. While her husband had been alive, he had been an officer of the court and had lent money to King Edward II, which had not been repaid. De Burford cleverly arranged to receive the money through export duties on her wool, which greatly enhanced her financial position and social status.

Detail, *Christine de Pisan* **runner back**

Teresa De Cartagena
FIFTEENTH CENTURY; SPAIN

A mystic, writer, and nun, De Cartagena was born into a family of conversos (Jews who converted to Catholicism, usually to escape the Inquisition). While still young, she lost her hearing; twenty years later, she produced her major work, *Arboleda de los Enfermos* (*Grove of the Infirm*), a reflection upon the spirituality of illness. Some readers were surprised that a deaf person could write such a book (there was considerable ignorance concerning physical disabilities) while others assumed that, since the book was well written, someone else—probably a man—must have crafted it. In her next treatise, *Admiracion operum Dey* (*Wonder at the Works of God*), De Cartagena defended her authorship and argued on behalf of women's capacities.

Beatrix Galindo
1473–1535; SPAIN

During the reign of Isabella of Spain (1451–1504), women's scholarship was encouraged, which might explain how Galindo became a professor of philosophy, rhetoric, and medicine at the University of Salamanca. Known as "La Latina" because of her extensive knowledge of Latin, she was appointed the queen's instructor.

Clara Hatzerlin
1430–1476; GERMANY

A scholar who worked as a professional scribe, Hatzerlin or Hätzlerin assembled a collection of folk songs and poems documenting major trends in German literature. Containing 219 entries (many of an erotic nature), this volume represents the transition from the medieval to the modern style.

Ingrida
1303–1373; SWEDEN

The most celebrated religious woman in Sweden, Ingrida was a nun at the convent of St. Birgitta and a distinguished literary stylist. An epistle that she wrote to her lover is considered to be a classic example of the use of the Swedish language.

Margareta Karthauserin
FIFTEENTH CENTURY; GERMANY

From a convent in Nuremberg, Karthauserin (Cartheurserin) was an artist and scribe at a time when there was a widespread mystical movement among German Dominican nuns. A number of written and illustrated manuscripts from 1455 to 1470 are signed by her.

Margery Kempe
1373–1440; ENGLAND

Kempe, the daughter of a respected public official, was married to a merchant with whom she had fourteen children. In her twenties, she began to experience religious ecstasies and spent years struggling with Church authorities over the authenticity of her visions. She also had the "gift of tears," meaning that she was unable to attend Mass without crying profusely, so moved was she by her passionate experiences of Jesus Christ and the Virgin Mary. Despite her domestic situation, she lived an adventurous life, making a series of pilgrimages. At age sixty, she dictated her spiritual autobiography, the *Book of Margery Kempe*, the first known autobiography in English. Her book, lost to history for centuries, was found and published in 1936.

Francisca De Lebrija
FIFTEENTH CENTURY; SPAIN

Privately educated by her father, a humanist scholar, De Lebrija (Lebrixa) became a lecturer in rhetoric at the University of Alcala.

Angela Merici
1474–1540; ITALY

Angela Merici founded the Ursuline order in 1494, the first female teaching order of the Catholic Church and the first group of religious women to work outside the cloister. Even though nuns were able to be educated at this time, they were not allowed to leave their convents, a situation Merici changed so that they could teach poor girls, who would otherwise have had no access to education.

Cobhlair Mor
CIRCA 1395; IRELAND

A forerunner of the French salonists, Mor gathered people in her home to practice Gaelic cultural traditions, which in 1367 had been declared illegal by the Statute of Kilkenny.

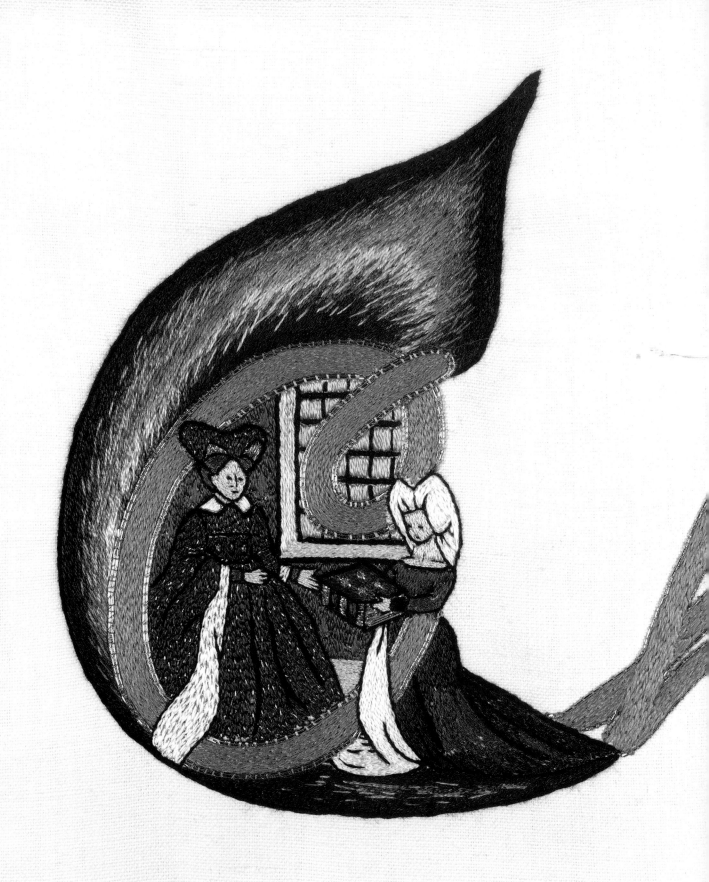

Isotta Nogarola
1418–1466; ITALY

Isotta Nogarola's life followed a pattern that would be repeated many times in history, in that she argued against the notion of women's inferiority without reference to, or knowledge of, earlier women's work. She was fortunate to be tutored by some of the best scholars of the day. By the time she reached the age of eighteen, her eloquence had been recognized by many prominent humanists. But when she attempted to pursue an intellectual career, her efforts were thwarted. Despite this, Nogarola refused to either marry or enter a religious order. Instead, she retreated to her family home and a life of private study and contemplation which allowed her to carve out a place for herself in the world of letters. An ardent feminist, she became known for her lively correspondence with noted humanist Ludovico Foscarini regarding the relative guilt of Adam and Eve concerning their expulsion from Paradise. Their exchanges became one of the most important debates on the woman question in fifteenth-century Italy and copies of their correspondence circulated throughout Europe for centuries.

Margaret O'Connor
FIFTEENTH CENTURY; IRELAND

O'Connor, another name for Máirgréag Ni Chearbhaill, was a wealthy woman who supervised the construction and adornment of many churches. Also known for her devotion to social and artistic causes, she was a patron of poets and *brehons* (official lawgivers). In 1433, a year of great famine in Ireland, she organized two large public assemblies where she personally provided food for thousands of starving people.

Margaret Paston
1423–1484; ENGLAND

Daughter of a wealthy farmer, Paston married a lawyer and large landowner. While he was away on business, she supervised the family estates, staying in contact with him by letters, over a hundred of which have survived. Their contents provide important information about English social history and the role of women.

Christine de Pisan illuminated capital letter

Alienor De Poitiers
CIRCA 1430–1480; FRANCE

De Poitiers, the daughter of a lady-in-waiting in the court of Isabelle (wife of King Philip), is best known for *Les Honneurs de la Cour* (*The Honors of the Court*). This record of famous women in the French court from 1380 to 1480 provides an invaluable account of court etiquette, tradition, and style with an emphasis on women who broke with tradition in order to realize their ambitions.

Modesta Pozzo
1555–1592; ITALY

In 1600, under the pseudonym of Moderato Fonte, Modesta Pozzo's daughter posthumously published her mother's feminist broadside *The Worth of Women: Wherein Is Clearly Revealed Their Nobility and Their Superiority to Men*. Pozzo had been an anomaly, a married woman who produced literature in genres that were considered masculine. *The Worth of Women,* a witty and ambitious work, takes the form of a dialogue between seven Venetian noblewomen over the course of two days. Through their debate, Pozzo explores many aspects of female experience, including a frank discussion of marriage and men. She also argues for gender equality, insisting that women have the same innate abilities as men and, if similarly educated, would prove their equals.

Margaret Roper
1505–1544; ENGLAND

Roper, considered the greatest pre-Elizabethan Tudor woman of learning, was the favorite child of Sir Thomas More, author of *Utopia*. Because her father believed that women should be given the same education as men, she was taught Greek, Latin, philosophy, astronomy, physics, mathematics, logic, and music. One of the activities thought proper for literate women was the translation of devotional literature. This may explain her translation of a work by Erasmus, a great humanist and family friend. His *Treatise on the Lord's Prayer* was printed with an introduction that cited Roper's accomplishments as an argument for university education for women. In 1535, More was tried for treason and beheaded by King Henry VIII because he refused to sanction the king's divorce from Catherine. His head was put on London Bridge, and Roper defied the king by rescuing it, for which she was arrested and imprisoned. Her eloquence before the judges won her release.

Isabella d'Este

Isabella d'Este was born into one of the ruling families of Ferra, an important duchy during the height of the Italian Renaissance. Because her father believed in the equality of men and women, both she and her sister Beatrice were well educated. Isabella became a serious scholar, reading voraciously and studying the classics as well as literature, theology, and languages. She was skilled at debate, fluent in both Greek and Latin, and also adept in music, dance, and the needle arts.

At the age of sixteen, Isabella married Francesco Gonzaga in a political alliance that was fortunately graced with love. She turned the city of Mantua where they lived and ruled into a cultural center, assembling an art collection that included portraits she commissioned by leading Renaissance artists. Whenever Francesco was away, Isabella governed on her own. In 1509, when her husband was captured during a war, she took control of the troops, saving Mantua and negotiating Francesco's release. In 1519, her husband died, leaving the management of the city-state in her capable hands. Like other Renaissance women of her class, she also devoted a considerable amount of time to consolidating her family's position and ensuring the success of her sons' careers.

130

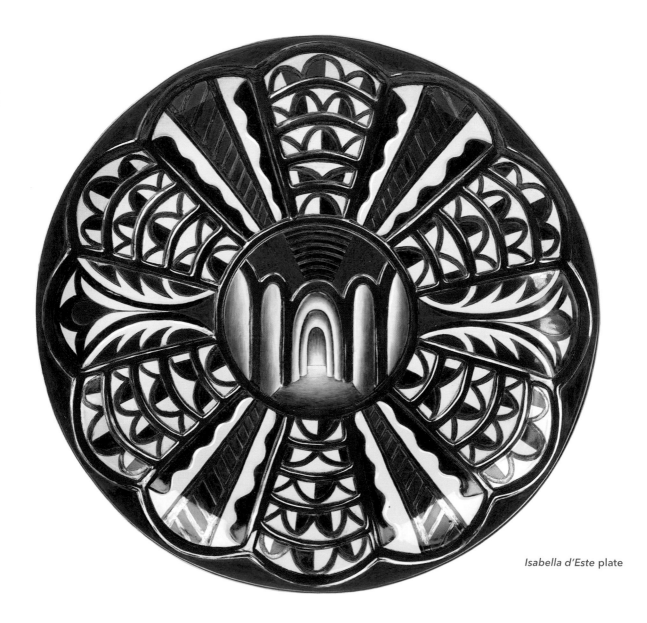

Isabella d'Este plate

Isabella d'Este runner

Isabella d'Este place setting

Isabella d'Este's situation mirrored that of many Renaissance women. As members of the upper classes, they exercised a provisional degree of authority; in most cases, however, women were expected to be charming and docile. Associated with the ISABELLA D'ESTE place setting are the names of other prominent Renaissance figures who strove to overcome the limitations of their circumstances, including a number of female musicians who were popular in the Renaissance courts.

Catherine Adorni
1447–1510; ITALY

Born into one of the noble families of Italy, Adorni or Adorno expressed a desire at a young age to devote herself to a religious life. However, when she was sixteen, her family married her to the son of another prominent family. When she was twenty-seven, she experienced a religious conversion, after which she devoted herself to a life of prayer and penance, convincing her husband to respect her decision. Some years later, she became the superintendent of a large hospital in Genoa, where she also led a group of religious disciples. When the Plague broke out, she saved many lives by organizing the first open-air wards. Two mystical works are associated with her, *Purgatory* and *A Dialogue between the Soul and the Body,* though it is now thought that the latter book, which chronicles her spiritual life, might have been written by one of her disciples.

Laura Battiferri Ammanati
1513–1589; ITALY

Considered one of the finest poets of the sixteenth century, Ammanati was married to Bartolomeo Ammanati (1511–1592), a sculptor and architect who designed many buildings in Rome. Both of them were associated with a group of artists and intellectuals, among whom was the Mannerist painter Bronzino, who painted Ammanati's portrait now hanging in the Uffizi Gallery. She was depicted as holding an open book, pointing to two sonnets by Petrarch (1300–1374), an image intended to suggest that her poetry was equal to his. Ammanati was also a scholar in philosophy and literature and a member of the Academy at Siena.

Novella d'Andrea
FOURTEENTH CENTURY; ITALY

D'Andrea, a scholar in law and literature, was educated by her father, whose assistant she became when he was professor of canonical law at the University of Bologna. It was reported that, because she was so beautiful, she was required to present lectures from behind a curtain so as not to distract the male students.

Isabella Andreini
1562–1604; ITALY

Andreini was the most famous actress of the Commedia Dell'Arte. In 1603, at the court of Henry IV, she became the first woman to perform on a French stage. Andreini was also a musician, a poet, and a playwright. A book of her work was published posthumously by her husband, the actor Francesco Andreini.

Anne of Beaujeu
CIRCA 1460–1522; FRANCE

Anne was the eldest daughter of the French king Louis XI; after his death, she acted as regent during the minority of her brother Charles VIII. The duke of Orleans disputed her position, provoking a civil war. She defeated the duke, holding him captive for several years. Known as an astute stateswoman, she weathered diplomatic storms and many challenges to her authority during her reign.

Anne of Brittany
1477–1514; FRANCE

Anne was the daughter of the duke of Brittany and heiress to his duchy, a desirable property. At age fifteen, Anne was wed to Charles VIII of France. Unhappy about her politically arranged marriage, she supposedly arrived for the wedding with an entourage carrying two beds. While Charles VIII fought in the Italian Wars, she took over the administration of the country. After his death, she married his successor Louis XII, and was the first queen to give women an important place at court. A patron of the arts, she won many privileges for the office of queen, such as her own guard. However, despite her efforts to protect the independence of her duchy, Brittany was eventually incorporated into France.

Tullia d'Aragona
CIRCA 1510–1556; ITALY

The sixteenth century brought about a dramatic increase in the discussions about gender initiated by Christine de Pisan. Among those who took up the defense of women was Tullia d'Aragona, celebrated courtesan and poet. Sexually liberated and financially independent, d'Aragona caused a scandal with her book *Dell Infinita d'Amor (Dialogue on the Infinity of Love),* in which she linked issues of love and sex to the broader treatment of women. No other woman had dared to write on the topic of love or sex, and none would do so for centuries to come.

Lucrezia Borgia
1480–1519; ITALY

Lucrezia Borgia was an innocent young woman who was used as a political pawn by her father Pope Alexander VI. He manipulated his daughter's beauty to further his own ambitions, betrothing her to a succession of men before she reached the age of twenty-two. Perhaps because of the family's close relationships and the secretive nature of their maneuverings, claims were made about incest between her and both her father and brother, but these seem not to have been based in fact. Finally, Alexander decided that Lucrezia should marry the prince and heir to the duchy of Ferrara, to whom she became devoted. As duchess of Ferrara, she made her court a lively center of intellectual activity. She also founded hospitals and convents,

pawned her jewels to aid famine victims, and proclaimed a special edict to protect Jews from persecution. Despite her good works, history would not treat her kindly, casting her as the very image of feminine evil.

Dorotea Bucca
D. 1436; ITALY

The daughter of a physician and philosopher, Bucca (Bocchi) received a doctorate from the University of Bologna, one of the few schools that admitted women. She succeeded her father as a professor of medicine and moral philosophy, teaching for forty years and attracting students from all over Europe.

Francesca Caccini
1587-1645; ITALY

Often called "La Cecchina" ("The Songbird"), Francesca Caccini was the daughter of a well-respected composer and his wife, a singer. Caccini's musical training began early, and she became a singer as well as a player of the harp, guitar, and harpsichord in the court of the Medicis. She composed both sacred and secular songs, published as Il Prima Libro, one of the largest collections of solo songs to appear in print. In the 1620s, she received a commission to compose what is believed to be the first opera written by a woman.

Laura Cereta
1469-1499; ITALY

Laura Cereta was sent to a convent for her early education. At age eleven, she was ordered home to help care for her younger siblings. She continued studying at night, after the household was asleep. Though she married Pietro Serina, he died eighteen months later. She neither remarried nor entered religious life; instead, she attempted to support herself by circulating in manuscript form a volume of letters. These dealt with the oppression of women in marriage, their right to education, and their contributions to history and culture. Facing harsh criticism, Cereta never again attempted to make her writing public, and how she earned her keep is unknown. Her letters remained unpublished until the seventeenth century.

Vittoria Colonna
1490-1547; ITALY

Vittoria Colonna was born into one of the major families of Rome. When she was three years old, she was betrothed to the marquis of Pescara, to whom she was married when she was seventeen. Her husband soon left for a war that continued for fifteen years; in 1525, he succumbed to wounds he received on the battlefield. After his death, Colonna took up residence in a series of convents. Her first collection of poems was published in 1538 and then another in 1546, though no complete translation of her work has yet been published. Her voluminous writings dealt with nature, religion, patriotism, and the human condition. Though she was considered the most influential woman of the Italian Renaissance and Italy's greatest woman writer, it is her close friendship with Michelangelo that has been the primary focus of history. About her, he wrote: "Without wings, I fly with your wings; by your genius I am raised to the skies; in your soul my thought is born."

Caterina Cornaro
1454-1510; ITALY

The Doge (chief magistrate of Venice) arranged for Caterina Cornaro, a member of Venetian nobility, to be married to the king of Cyprus in order to secure an alliance. She had only been there a year when her husband was killed. As soon as the Venetian government was able to gain control of Cyprus through her regency for their unborn child, she was sent back to Venice. She was eventually given an estate in the Alps, where she founded hospitals, institutions for the poor, and a salon that became an international retreat.

Isabella Cortese
D. 1561; ITALY

Cortese is thought to have written books on chemistry, alchemy, and medicine. Her most significant volume was I Secreti (Secrets), the first printed work by a woman on cosmetics. Soap was not widely used in those days, and her book dealt with face creams and perfumes, which were used to cover body odors.

Annabella Drummond
1350-1401; SCOTLAND

Drummond married Prince John Stuart, the heir to the Scottish throne. Because her husband was often ill, Annabella largely assumed the responsibility of governing once they were crowned. During her reign, Scotland enjoyed a period of relative tranquility.

Cassandra Fidelis
1465-1558; ITALY

After educating Fidelis (Fedele) in Greek and Latin, her father sent her at age twelve to be tutored by a monk. At twenty-two Fidelis delivered a speech in Latin praising the arts and sciences, achieving instant success. Her talk was published in several countries, and she gave lectures in Padua and exchanged letters with prominent humanists and nobles throughout Europe. In 1499, she married and seems to have abandoned intellectual pursuits, probably because she was burdened with the management of a large household. Her letters and orations were published in 1636. In one of her speeches (translated by Diana Robin and published in 2000), she reflected upon the situation of women at that time: "When I meditate on the idea of marching forth in life with the lowly and execrable weapons of the little woman—the needle and the distaff—even if the study of literature offers no rewards or honors, I believe women must nonetheless pursue and embrace such studies alone for the pleasure and enjoyment they contain."

Veronica Gambara
1485-1550; ITALY

As the daughter of a forward-thinking nobleman, Gambara enjoyed an unusually broad education. She began writing poetry while young and, by the time she was seventeen, was corresponding with leading scholars, which was one of the only modes of intellectual discourse for women of her time. At twenty-four, she married the lord of a small state near Parma. Their court became a meeting place for artistic figures. Although there is no complete published English translation of her writing, many of her poems, often about love and religious devotion, are available online.

Alessandra Giliani
1307–1326; ITALY

Giliani devised a means of drawing blood from the veins and arteries of cadavers, then filling them with different colored liquids to render them more visible. She was an assistant to the surgeon Mondino (considered the father of modern anatomy) and her work was featured in his medical text.

Elizabetta Gonzaga
FIFTEENTH CENTURY; ITALY

Elizabetta Gonzaga was the wife of the duke of Urbino and sister-in-law to Isabella d'Este. Like her, she was a patron of the arts, and her court was the heart of the cultural life of the city. A portrait of her, thought to have been painted by Raphael, hangs in the Uffizi Gallery in Florence. She was also the patron of Baldassare Castiglione (1478–1529), whose book *The Courtier* was based on conversations in her chambers, where the court would retire after dinner. His book, one of the most influential prose works of the period, dealt with what should be expected of a member of a royal entourage and helped to spread Italian humanism into England and France.

Isabella of Lorraine
1410–1453; FRANCE

Isabella or Isabelle, who was married to Rene I d'Anjou, was one of the most illustrious women of the fifteenth century. She was the patron of Agnes Sorel, the future mistress of Charles VII. When Isabella's husband was taken prisoner in 1429, she assembled an army to rescue him. But even before he was freed, he inherited another kingdom that Isabella successfully claimed, thereby widening her realm.

Mahaut of Artois
1270–1329; FRANCE

Mahaut was a powerful landowner, arts patron, and collector of manuscripts. She inherited her father's estate of Artois and then, after her husband's death, his lands in Burgundy. She governed these two domains for many years, surviving scandal and insurrection, proving herself to be an able administrator. In addition, she practiced medicine, leaving many illustrated manuscripts on the treatment of disease, and built many hospitals.

Baptista Malatesta
D. 1460; ITALY

Malatesta was the younger daughter of the count of Urbino. Even before her marriage in 1405 to Galeazzo Malatesta, heir to the lordship of Pesaro, she had developed an interest in literature, philosophy, and poetry. That same year, Leonardo Bruni, an early humanist, dedicated a tract to her that is the first such letter expressly consecrated to a woman. Malatesta's concern with women's study of the classics established her as a forerunner of the later important female scholars of Italy.

Mathilda of Germany
CIRCA 1470; GERMANY

Humanism was brought to Germany by scholars who studied in Italy and also through the efforts of women like Mathilda (Mechthild or Mathilde). She had some of the early humanist writings translated into German and provided patronage for the humanist Nicholas von Wyle, who composed a eulogy praising the many blessings women had brought into the world, part of the growing discourse about women that was sweeping Europe.

Marie de Medici
1573–1642; FRANCE

Marie was the daughter of Francesco de Medici, grand duke of Tuscany. After she married Henry IV of France, she became involved in art patronage, like her family. In 1610, when Henry was assassinated, she was named regent for her son Louis XIII, remaining in power for three years after he reached his majority. In 1617, Marie was exiled by her son, in part because of her role in various political intrigues. When she was allowed to return to Paris, she continued to be an influential art patron—arranging for eight statues of famous women to surround the entrance to her residence, building the Luxembourg Palace and Gardens, and commissioning Rubens to paint a series of works depicting events from her life. However, she never stopped

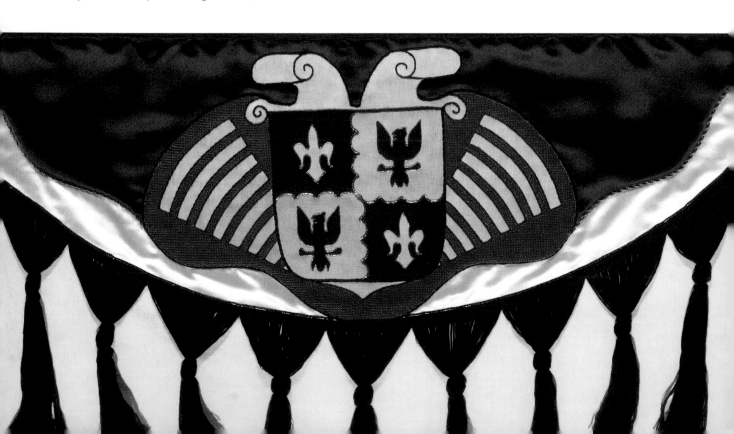

trying to regain the influence she had exerted during her regency. In 1631, fed up with his mother's constant political maneuvering, Louis exiled her again. She settled in the Netherlands, where she remained for the rest of her life.

Jeanne de Montfort
CIRCA 1341; FRANCE

De Montfort, a good military strategist and fearless leader, played a key role in the Hundred Years' War between England and France. She was determined to support her husband in his claims to the duchy of Brittany. Together, they took certain towns and fortresses and garrisoned them. When her husband was captured, De Montfort obtained the aid of the English armies and thereby achieved victory for her family.

Tarquinia Molza
1542–1617; ITALY

Molza was a poet, singer, composer, and the conductor of an orchestra of women at the d'Este court in Ferrara and one of the few women known to have been a named member of a humanist academy. Until the late fifteenth century, it was extremely difficult for female composers and singers to acquire adequate training or support because of the ecclesiastical view of women's voices as lewd and lascivious. As the hold of the Church began to weaken, professional female musicians began to appear, inspired in part by the tradition of the Courts of Love, where women had both written and played music. This tradition continued into the Renaissance when female musicians like Molza enjoyed great popularity.

Olympia Morata
1526–1555; ITALY

Morata was educated by her father, a well-known tutor of the younger sons of Alfonso d'Este, the duke of Ferrara. She proved to be such a fine student that, when she was twelve, she was invited to the court of Ferrara as a study companion to one of the d'Este daughters. In 1548, she was called home to care for her ill father. Although she wanted to return to the

court after he died, her invitation was not renewed, and her options for a scholarly career came to an end. In 1549, she married Andreas Grunthler, a young German follower of Luther. They moved to Germany, where Morata continued her studies. Unfortunately, the German town in which she and her husband were living came under siege, and Morata became ill with malaria. After her death, her writings were published, thereby leaving some record of another nearly forgotten feminist voice.

Caterina Sforzia
1463–1509; ITALY

In the fifteenth century, Italy was not a unified country; instead, it was composed of warring city-states. Caterina was the illegitimate daughter of the duke of Milan, a member of the ambitious Sforzia or Sforza family. She married Girolamo Riario, the nephew of Pope Sixtus IV, who gave them title to the cities of Forli and Imola, located northeast of Rome. In 1484, the Pope died, and the couple's fortunes changed as numerous enemies attempted to take their lands. In 1488, Girolamo was murdered, and Caterina and her children were captured. She managed to escape and then took back the two cities through political skill and military strength. Though she was finally overthrown by Cesare Borgia, she was one of the few Renaissance women to seize power so directly.

Agnes Sorel
1409–1450; FRANCE

Agnes Sorel was the first king's mistress to be publicly acknowledged, establishing a precedent for subsequent royal mistresses to wield considerable influence. Sorel acted as advisor to her lover King Charles VII, using her position to strengthen the French kingdom.

Gaspara Stampa
CIRCA 1523–1554; ITALY

The home of Gaspara Stampa became a salon for the Venetian literati where she and her sister presented musical performances to an audience of both women and men. At some point she became involved with a count who apparently abandoned her. This unfortunate affair became the subject of 311 poems, which were circulated among friends during her lifetime and pub-

lished after she died. At the time, it was considered shameful for a woman to perform in front of mixed audiences or to write openly about love or sex, which makes both her life and her work unusual.

Barbara Strozzi
1619–1667; ITALY

Strozzi was one of the most important composers of Italian cantatas of the seventeenth century. She was also known as a singer who performed her own compositions. Between 1644 and 1664—at a time when many composers didn't even publish their work—she published eight books of music, including one hundred compositions for the solo voice. Though neglected for centuries, there now seems to be an effort among musicologists and performers to revive Strozzi's music.

Lucrezia Tournabuoni
CIRCA 1425–1482; ITALY

Lucrezia Tournabuoni or Tornabuoni was from a highly respected Florentine family. In 1444 she married Piero de Medici, who inherited the family fortune and political position. Before he died he assigned to his wife the right to distribute as charity some of the income from Medici properties, which she gave to the more powerless members of the society, particularly women. She also invested her own capital in real estate projects and financed small traders and artisans. Tournabuoni left behind a number of hymns, narrative poems, and letters that reveal the private side of this influential woman.

Yolanda of Aragon
FIFTEENTH CENTURY; FRANCE

Yolanda or Yolande sought to bolster the interests of France against the English during the Hundred Years' War. Married to a French nobleman, she supported Joan of Arc's army financially and introduced Agnes Sorel to King Charles VII. Together, Sorel and Yolanda exerted pressure on the king to favor Joan's plans. When Joan was tried, Yolanda testified on her behalf. She also engineered an alliance between the provinces of Navarre and Brittany, greatly strengthening the French crown.

Detail, *Isabella d'Este* **runner back**

Elizabeth R

1533–1603

Elizabeth—whose birth had been cursed by her father Henry VIII because he wanted a male heir—ascended to the throne of England in 1558. She inherited a tattered realm with dissension between Catholics and Protestants. In order to eliminate religious unrest, she had to order the execution of her own Catholic cousin Mary Queen of Scots. Among the most erudite women of the sixteenth century, Elizabeth continued the tradition of female scholarship first introduced by her stepmother Catherine of Aragon. Nonetheless, government was considered an exclusively masculine affair, and Elizabeth was constantly urged to find a husband and thereby give England a king. She remained determined to rule England herself, sometimes manipulating her marital status to forge alliances under the pretense of an engagement, then forestalling the marriage while she maneuvered to obtain her political goals.

During the forty-five years Elizabeth reigned, England saw a vast increase in national power and economic wealth as well as a cultural renaissance that made it a global intellectual and artistic center. Elizabeth built a popular base of support, establishing the right to a fair trial and organizing governmental relief for those in need. She was a humane ruler who introduced religious tolerance, maintained relative peace throughout her reign, modernized the Royal Navy, and made diplomacy an art. She virtually eliminated England's witchcraft trials by insisting that a woman could not be executed without evidence.

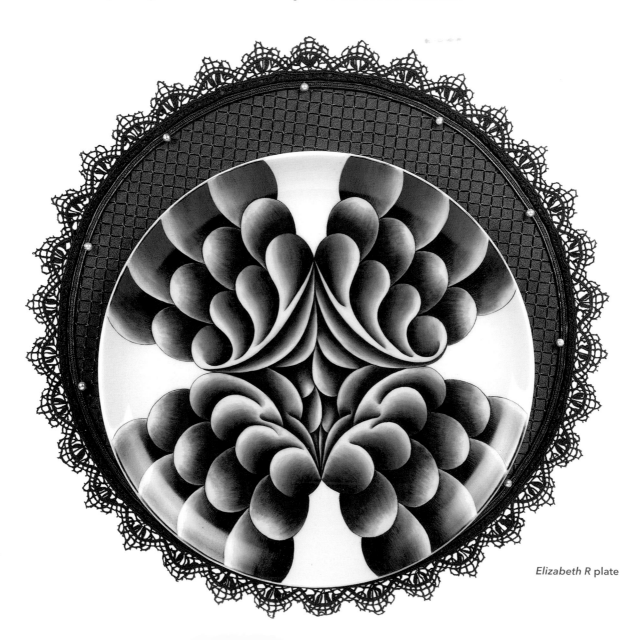

Elizabeth R plate

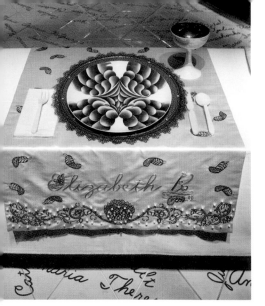

Elizabeth R place setting

The humanist philosophy of the Renaissance influenced many ruling queens to support female education in their courts, which produced numerous women of achievement and a startling number of exceptional monarchs. The names of these women are aligned with the place setting for ELIZABETH.

Anna Sophia
1531–1585; DENMARK

Sixteenth-century Denmark was marked by civil war as the Reformation swept through the country. By 1536, the hold of Catholicism had been broken and the Danish Lutheran Church established. Local languages replaced Latin in sermons, and Bibles were translated into Danish, encouraging the development of both a national language and literature. Anna Sophia, the daughter of Frederick I of Denmark and wife of August I of Savoy and also known as Anna of Saxony, played an important role in this transformation. Known as the "Mother of Her Country," she built schools and churches, established botanical gardens, and founded an apothecary that remained in existence for three hundred years.

Anne Bacon
1528–1610; ENGLAND

Anne Bacon was the daughter of Sir Anthony Cooke, tutor to Queen Elizabeth's half-brother Edward VI, and the wife of Sir Nicholas Bacon. In 1550, she translated and published a number of religious tracts and sermons by Bernardine Ochine, a celebrated religious figure. She also translated *An Apology for the Church of England* by John Jewel, the bishop of Salisbury. This defense of Anglicanism was an important and controversial document, and her translation made it widely accessible. Bacon and her husband were the guardians of the Elizabethan author Sir Francis Bacon (1561–1626), and she was an important influence on his life and thought.

Catherine of Aragon
1485–1536; ENGLAND

Catherine's classical training was supervised by her mother Isabella of Castile, who, as an advocate of education for women, had brought a number of female scholars to her court. Even after marrying Henry VIII of England, Catherine maintained her intellectual pursuits. Many treatises on the education of women were written under her auspices; her policies benefited women's education for the next hundred years. However, she is most widely known for her steadfast refusal to grant an annulment to Henry VIII so that he could marry Anne Boleyn. His subsequent break with the Catholic Church helped bring about the Reformation.

Catherine II (The Great)
1729–1796; RUSSIA

Born in Germany, Catherine married Peter III, heir to the Russian throne, who turned out to be an ineffectual ruler. In 1762, Catherine took over the country. Intelligent and strong willed, she was a voracious reader of historical and philosophical works and corresponded with some of the greatest thinkers of Europe, including Voltaire. Catherine began to make changes based upon her study of Western thought. For example, she introduced improved animal breeding techniques and crop rotation, broke up monopolies, and further developed the manufacturing and mining industries. She also established the first schools for girls and built educational institutions and hospitals. Her commitment to medical progress was underscored by her willingness to be the first in Russia to receive a smallpox inoculation. A patron of the arts, she established the Hermitage Museum whose collections remain the delight of the world. She also attempted to free the serfs, but the nobility resisted her intended reforms. Upon her death, she left Russia stronger and more prosperous.

Georgiana Cavendish
1757–1806; ENGLAND

Georgiana Cavendish married the duke of Devonshire, and her home became the center of Whig politics in England. She played an active role, becoming the first woman to campaign for a candidate in an election. Although she was also a writer, she is best known for her part in a ménage à trois in which she, her husband, and his mistress, also her close friend, carried on a relationship for many years.

Christina of Sweden
1626–1689; SWEDEN

Christina of Sweden was the daughter of King Gustave II, who insisted that she receive the same type of education as would a male heir. Her father died in 1632, and when she reached the age of eighteen, she was crowned as king and later helped to end the devastating Thirty Years' War, which involved most of Europe. During her ten-year reign, she established the first Swedish newspaper and tried to raise the standards of Swedish culture, attracting leading intellectuals and artists to her court, including Descartes and Scarlatti. Some historians believe that she suffered a nervous breakdown in 1652 (after which she abdicated), either as a result of illness or because she could not abide the idea of having to marry, which was being urged upon her by her advisors. She left Sweden in men's clothing, riding a white charger in a tour around Europe. She eventually settled in Rome, where she converted to Catholicism, continued her studies, founded an academy for philosophy and literature, acted as a patron of music, and began an autobiography that was published posthumously.

Maria de Christine de Lalaing
1545–1582; BELGIUM

During the sixteenth century, Belgium was occupied by Spain. De Lalaing organized a military defense of her city. Even after being wounded, she continued to fight, thereby providing a valiant model for her soldiers, who surrendered only when their food and ammunition ran out.

Maria de Coste Blanche
CIRCA 1566; FRANCE

The sixteenth century brought a surge in new scientific thinking, in which a number of women participated. In 1543, Copernicus published *On the Revolution of the Celestial Spheres*, which challenged the long-held idea that the sun revolved around the earth. A little over twenty years later, De Coste Blanche, an instructor of mathematics and physics in Paris, published *The Nature of the Sun and the Earth*. She is also known as Marie de Cotteblanche.

Jeanne d'Albret
1528–1572; FRANCE

Jeanne d'Albret was the daughter of Henry d'Albret and Margaret of Navarre, king and queen of a small but significant buffer state between France and Spain. At thirteen, the girl was forced into a political marriage that was annulled four years later. She then married Antoine de Bourbon, and they soon became joint rulers of Navarre and Bearn, with authority over much of southwest France, which had become a refuge for the Huguenots. She and her husband became alienated over religion, with d'Albret supporting Protestantism in the face of her husband's Catholicism. Their own breach was reflected in the violent religious wars that erupted, putting her under constant attack and in danger

of excommunication. In 1572, d'Albret died of tuberculosis only a few months before the massacre of the Huguenots. Her published writings span most of her active political career.

Elizabeth Danviers
SIXTEENTH CENTURY; ENGLAND

Married to a cousin of Queen Elizabeth, Danviers, more commonly known as Danvers and one of the most learned women of the Elizabethan era, was an authority on Chaucer, the author of such English classics as *The Canterbury Tales*.

Catharine Fisher
D. 1579; GERMANY

Catharine Fisher, also known as Catherine Tishem, was one of the most precise linguists in a period when dictionaries became particularly important. She was also responsible for the education of her son James, who became a celebrated philosopher.

Penette de Guillet
1520–1564; FRANCE

Fluent in numerous languages, Penette or Pernette de Guillet was an accomplished musician and part of the Lyons school of poetry, the first group to bring the influence of the Italian literary renaissance to France. She left behind a collection of poems that were subsequently published by her husband.

Kenau Hasselaer
1526–1589; HOLLAND

Hasselaer's father was the mayor of Haarlem. In 1561 she was left widowed with four children when her shipbuilder husband died. After registering as an independent shipwright, she successfully carried on the family business. When the Spanish besieged the city, she led three hundred women in its defense in what were called the Wars of Liberation. She supposedly died at the hands of pirates, but her name lives on in colloquial Dutch as "*kenau*," the word for a bossy woman who is disliked (an example of the ways in which women's achievements are denigrated by history).

Elizabeth Hoby
1528–1609; ENGLAND

Sir Anthony Cooke and his wife Anne were celebrated for their erudition, which they passed on to their four daughters. Elizabeth, who married Sir Thomas Hoby, was a close friend of Queen Elizabeth and often at court. She acquired a reputation for both musical and linguistic achievements and was a patron of composers and a prominent translator. After her death, a legend surfaced that her ghost wandered the home she had shared with her husband and children. Supposedly she had beaten her youngest son William so badly that he had died, the result being her repentant ghost. How-

139

Detail, *Elizabeth R* runner front

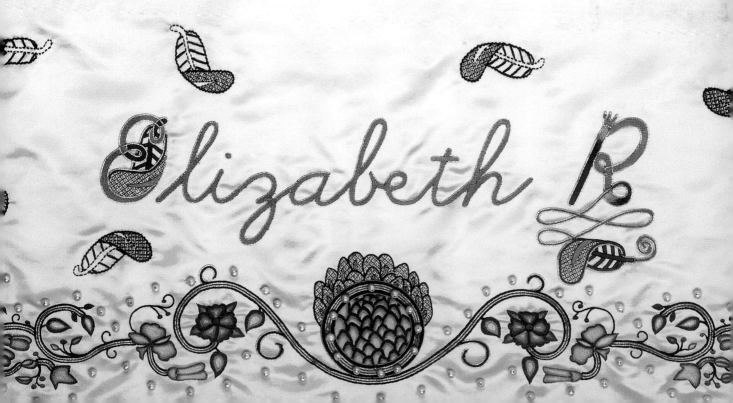

ever, because historic records reveal no son named William, one cannot help but wonder about the veracity of this story.

Isabella of Castille
1451–1504; SPAIN

Isabella was the daughter of John II of Castile and Leon and Isabella of Portugal. Upon the death of her brother Henry IV, she and her husband Ferdinand of Aragon jointly succeeded to the throne of Castile and Leon. Three years later, Ferdinand inherited the throne of Aragon, thereby uniting two major Spanish kingdoms and contributing to the future influence of Spain. Although her legacy is mixed, Isabella created many opportunities for women, assigning them to teaching posts and supporting female scholars in her court. She also founded many universities and subsidized scholars in the sciences and the arts. However, she and Ferdinand (known together as the "Catholic kings") initiated the Inquisition in 1478, which led to the ruthless expulsion of the Jews from Spain in 1492, the conquest of Granada, and the forced conversion of the Moors. They also showed foresight in their patronage of Christopher Columbus, though his "discovery" of the Americas contributed to untold suffering for the native peoples there.

Jadwiga
1371–1399; POLAND

In default of a male heir, Jadwiga ascended to the throne in 1382 to become the first Christian queen to rule Poland. Although she wished to marry the son of the duke of Austria, she was convinced that Poland would benefit if she were to wed Jagiello, the ruler of Lithuania, who was willing to convert to Christianity (at which time his name became Ladislaus). The marriage united their two countries and ushered in the heroic age of Poland, which lasted for two hundred years. Jadwiga tried to bring religion and learning to all her people, reestablishing the University of Krakow, supporting and improving church music, and raising the cultural level of her country.

Detail, *Elizabeth R* runner front

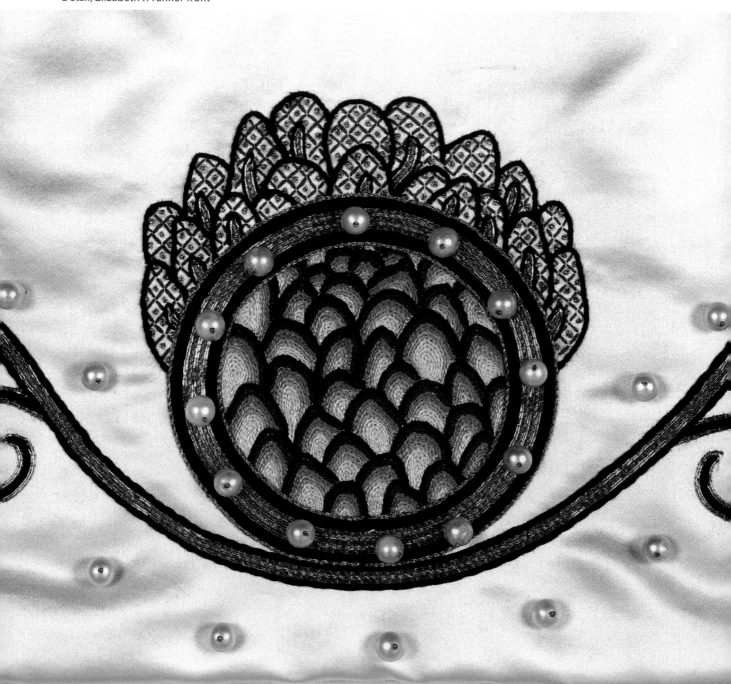

Jane of Sutherland
1545–1629; SCOTLAND

A pragmatic yet visionary business-woman, Jane, a Catholic, was responsible for turning the small harbor town of Brora into an industrial center. She oversaw the working of a new coal mine and established a saltworks, both of which became mainstays of the town. She was often embattled because when the Reformation reached Scotland in the mid-sixteenth century, persecution of Catholics became widespread. She is also known as Jean Gordon.

Sarah Jennings
1660–1744; ENGLAND

Married to John Churchill, the first duke of Marlborough, Jennings was for many years a confidante of Queen Anne. She ultimately disagreed with royal policies, leading the opposition Whig Party. Known as "Queen Sarah" because of her influence, Jennings was a shrewd businesswoman and eventually one of the richest peeresses in England. When she became too old to leave her rooms, she worked from her bed. She left a record of her life and times in her memoirs, which she published herself.

Isabella de Joya Roseres
SIXTEENTH CENTURY; SPAIN

Because the Catholic Church retained its power in the region, Spain was spared the violent religious conflicts that shook Europe as a result of the Protestant Reformation. Given the Church's opposition to female authority, it is surprising that De Joya Roseres was able to address the congregation in a Catholic church, much less preach in the cathedral at Barcelona. She later went to Rome where she was a member of the papal court of Paul III. There, she discoursed on theological problems before the College of Cardinals. She is also known as Isabel de Josa.

Helene Kottauer
1410–1471; AUSTRIA

Kottauer or Kottanner was a court lady to Elizabeth of Austria, wife of Albrecht II (who was crowned in 1438 but died within two years, leaving an unborn son). Kottauer kept a modest record of the queen's struggles to retain her power and ensure that her child

was crowned king. Austria treasures her memoirs as the first written by a woman.

Lilliard
D. 1545; SCOTLAND

Lilliard is thought to have fought in the Battle of Ancrum in 1545 between the Scottish and the English. Her participation is believed to have been an act of retaliation for a raid by English soldiers in which her parents and lover were murdered. Wearing a suit of armor, she killed the English commander. Though the Scots won, she died during the fighting. A memorial erected at her grave states: "Fair maiden Lilliard lies under this stane. Little was her stature, but muckle was her fame; Upon the English loons she laid many thumps. And when her legs were cuttid off, she fought upon her stumps."

Isabella Losa
1473–1546; SPAIN

In the sixteenth century, the influence of Isabella of Castile on female education was still being felt, and Spanish art and culture entered their greatest period. Losa was illustrious for her knowledge of Greek, Latin, and Hebrew, which she pursued while married. After she was widowed, she entered the Order of St. Clair and went to Italy, where she founded a hospital.

Elizabeth Lucar
FL. 1510–1537; ENGLAND

A skilled needleworker and an excellent calligrapher, Lucar wrote the first English essay on calligraphy in 1525. She was also an accomplished musician, proficient in mathematics, and fluent in Latin, Italian, and Spanish.

Margaret of Austria
1480–1530; AUSTRIA

In 1507, Margaret, mother of King Francis I of France, became regent of the Netherlands and guardian of her nephew Charles (later, Holy Roman Emperor Charles V). She negotiated important trade agreements with western Europe and played a role in the formation of the League of Cambrai, an alliance which helped to end the Franco-Spanish war. In 1529, Margaret and Louise of Savoy negotiated "The Ladies' Peace," one of the first recorded instances of women of power deciding to compromise rather than go to war—the standard method used by kings to settle disputes. Margaret was also a prominent patron of music; her coat of arms has been found on music books sent to the Pope, which indicates that her political and musical influence was widespread.

Margaret of Desmond
CIRCA FOURTEENTH CENTURY; IRELAND

Margaret of Desmond, also known as Margaret Butler, led her own band of female warriors. She was also a

stateswoman, jointly governing her estates with her husband. As a patron of the arts and education, she invited weavers from Flanders, founding a school where they could teach tapestry-making.

Margaret of Navarre
1492-1549; FRANCE

Margaret of Navarre, the daughter of Louise of Savoy and sister of King Francis I of France, was a supporter of religious liberty and church reform as well as a patron of the arts. She was also the author of poems, plays, and stories. After being ridiculed by the Italian poet and storyteller Boccaccio in his *Decameron,* Margaret responded in the *Heptameron,* a collection of seventy-two medieval tales written in the style of Boccaccio.

Margaret of Scandinavia
1353-1412; DENMARK

Margaret, daughter of the king of Denmark and wife of the king of Norway, became regent of Denmark in her infant son Olaf's name in 1375, after the death of her father. Five years later her husband died, and again Margaret acted as regent, this time of Norway. After Olaf's premature death in 1387, Margaret was unanimously elected queen of Denmark and Norway, though there was no precedent in either country for a ruling queen. At that time, Sweden had an extremely unpopular king and a group of mutinous nobles were attempting to overthrow him. After succeeding, they elected Margaret "Sovereign Lady and Ruler." In order to end the constant warfare between Denmark, Norway, and Sweden, she tried to unite the three countries, appointing as king her infant cousin Eric of Pomerania and ruling as regent in his name. To this day, a special bell is rung twice daily in Copenhagen to commemorate her many contributions.

Maria Theresa
1717-1780; AUSTRIA

Maria Theresa was the daughter of Charles VI, who changed the law so that she could inherit his throne. However, he assumed that her husband, Francis Stephen of Lorraine, would actually wield power, so he failed to properly prepare Maria Theresa for what would become a forty-year reign. Nevertheless, in those decades she suppressed the Inquisition, strengthened the army, reorganized the tax structure, eased the life of peasants, and fueled prosperity through economic reforms. In time the arts flourished, and Vienna became the musical capital of Europe, fostering the talents of Mozart, Haydn, and Gluck. Maria Theresa engaged the support of Hungary in the Seven Years' War against Prussia and established alliances with Holland, Denmark, and Russia, all of which helped to expand Austria's territories and strengthen the queen's position. In 1763, her husband Francis died. From that time on, she dressed in mourning. Though she recognized her eldest son as emperor, she never abdicated.

Mary of Hungary
1505-1558; SPAIN

Mary (Maria), the daughter of Philip of Spain, was a member of the Habsburg dynasty, which ruled Austria from 1278 until World War I—and for some period, Hungary as well. She married Louis II, king of Hungary, but upon his death in 1531, she returned to the Habsburg court in Vienna. That same year she became regent of the Netherlands, representing her brother Charles V, who as Holy Roman Emperor had inherited a vast empire. Little is known about her twenty-five year reign over the Netherlands except that she was a patron of the arts and friend to the Protestants. In 1555, both she and her brother abdicated their positions.

Gracia Mendesa (Beatrice de Luna)
1510-1569; PORTUGAL

Gracia Mendesa or Mendes was born thirteen years after the Inquisition expelled all Jews from Portugal. She was raised as Beatrice de Luna by a prosperous family of conversos. In 1528, she married Francisco Mendes, a wealthy businessman and another converted Jew. They moved to Antwerp. When he died, she took over his affairs, proving to be a shrewd businesswoman. She used her fortune to save Jews who had been expelled from Spain and Portugal. In 1550, she moved to Ferrara, Italy, under the protection of its liberal governors. There, she began to live openly as a Jew. She later settled outside Istanbul, where she influenced Jewish life throughout the Ottoman Empire with her charity, which included the printing of thousands of Jewish manuscripts, the founding of a yeshiva (study center) and a synagogue, and her generous support of schools and hospitals. She attempted to establish a Jewish autonomous area in Tiberius (in the Holy Land), but her death cut short that plan.

Grace O'Malley
1530-1603; IRELAND

Daughter of a well-known sea captain and clan chieftain, O'Malley came from a family famous for their sea prowess. From an early age, she wanted to follow in her father's footsteps and often sailed with him on trading missions. In 1546, she married Donal O'Flaherity, the son of another clan chieftain. When he died, she returned to her family home with her two children. Because she was denied an inheritance by her husband's relatives, she had to earn a living. Recruiting a crew of two hundred men, she charged for protection against pirates, hired out navigators, and raided ships. She soon had a thriving piracy empire, ruling the sea for years, as well as controlling five castles. In 1577, O'Malley was captured and

imprisoned in Dublin Castle. Somehow, she managed to escape, but at the age of fifty-six, she and other members of her clan were captured again, imprisoned, and scheduled for execution. She was saved by her son-in-law, who had offered to take her place. O'Malley appealed to Queen Elizabeth, asking for the release of the rest of her family. No one has been able to explain why the queen agreed to meet with the female pirate, but in September, 1593, she did. Elizabeth accepted O'Malley's offer of service to the crown in exchange for her family's freedom. O'Malley died in her early seventies, leaving behind a legendary life of courage, style, and adventure.

Catherine Pavlovna
1788–1819; RUSSIA

In the sixteenth century, a Christian monk named Sylvester, published a domestic guide, the *Domostoi*, with the imprimatur of the Russian Orthodox Church and the support of Tsar Ivan IV. The book justified the brutal treatment of women that had been the norm in Russia for centuries. It was against this background that Pavlovna (Pawlowna), a grand duchess, formed social and political associations for women and promoted education for both sexes. She also established agricultural societies and provided food for her subjects during a terrible famine.

Elizabeth Petrovna
1709–1762; RUSSIA

Elizabeth Petrovna was the youngest daughter of Catherine I and Peter the Great. In 1741, she overthrew the infant emperor Ivan VI and his acting regent mother. Petrovna ruled single-handedly as empress for twenty years, preferring "love affairs and absolute sovereignty." Greatly influenced by Western ideas, she founded Moscow State University and the Academy of Arts at St. Petersburg. In addition, she tried to eradicate the extensive corruption in the Russian government, forged alliances with France and Austria, ended the long-standing dispute between Sweden and Russia, introduced a better system of taxation, established banks, opened mines, and encouraged pioneer settlements in eastern Russia.

Philippa of Hainault
1311–1369; ENGLAND

Wife of Edward III, Queen Philippa led an army of twelve thousand soldiers against the Scots, capturing their king and becoming a heroine to the English people. Recognized throughout Europe for her innovations in social welfare and her concern for the poor (especially women), she established the wool industry at Norwich and the coal industry at Tynedale, enterprises that became the backbone of the English economy.

Oliva Sabuco
BORN 1562; SPAIN

In 1587, Sabuco published a comprehensive work titled: *New Philosophy of Human Nature not Known and not Reached by the Ancient Philosophers that Improves Human Life and Health*, which presented a scientific description of the ways in which emotions can impair health. She urged doctors to treat the whole person—body, mind, and soul. Her ideas faced considerable skepticism from the medical profession and the Church, both of which believed women to be unfit to tackle such topics. Nevertheless, recognition of her work grew, first in Spain and then throughout Europe, causing the Inquisition to target her books. Her reputation declined; only recently has there been a revival of interest in her theories.

Mary Sidney
1561–1621; ENGLAND

Mary Sidney was the daughter of Sir Henry Sidney, lord deputy of Ireland, and sister to the poet Sir Philip Sidney (1554–1586). Well-educated, she married Henry Herbert, second earl of Pembroke, and soon gathered around her some of the most illustrious people of the period. Her own literary works include an edition of her brother's *Arcadia* along with an elegy to him, a number of translations, and several poems. After Philip's death, she completed the verse translations of the psalms he had begun, contributing 107 of the 150 psalms herself. This manuscript was widely circulated and influenced many seventeenth-century poets, including John Donne.

Sophia of Mechlenberg
SIXTEENTH CENTURY; SCANDINAVIA

After the death of her husband, Sophia of Mechlenberg ruled Norway and Denmark until her son Christian IV came of age. During her reign, she tried to alleviate the suffering women endured as a result of the "baby a year" custom. She put a stop to the killing of illegitimate babies, promoted the teaching of birth control, encouraged mothers to nurse their young, and insisted on the proper training of midwives. Her influence can still be seen in the fact that Scandinavia leads the world in low infant and maternal mortality rates.

Elizabeth Talbot
1520–1608; ENGLAND

Talbot, an English noblewoman, was also known as Bess of Hardwicke. She inherited several large estates from two husbands who died. A shrewd businesswoman, she designed and built a number of houses, including the historic Hardwicke Hall in Derbyshire, which is now a hotel.

Jane Weston
D. 1612; ENGLAND

Weston was one of only two Elizabethan Englishwomen known to have published collections of their poems. Considered one of the leading neo-Latin poets of the sixteenth century, she appears in Thomas Farnaby's *Index Poeticus* (published in 1634), the only woman in the work and one of only seven English authors.

Artemisia Gentileschi

1593–1652

rtemisia Gentileschi was trained as an artist by her father Orazio, a painter who recognized his daughter's talent when she was young. Unfortunately, she was raped by the artist her father had hired to teach her perspective skills, which almost ruined her life. The rapist was brought to trial, but it was she who was questioned and tortured. Although the man was finally imprisoned, he served only eight months, and she became the object of endless gossip. In an effort to protect his daughter, her father arranged for her to be married; but it did not last and she began to move from town to town, creating works that exhibit the dramatic use of lights and darks and the sensuous movement characteristic of the Italian Baroque.

She was admitted to the Accademia del Disegno (Academy of Design) in Florence, a rare honor for a woman. But although she was successful in her own time, her art was later obscured, some canvases even being attributed to male artists. Only recently has her historical importance been recognized. She was the first female artist to paint large-scale historic and religious subjects, and she created vividly naturalistic portrayals of strong women. One of her favorite themes was the biblical heroine Judith. In her treatment Gentileschi seems to articulate her outrage at the violence she herself had experienced. Today, she is considered the most important woman artist of the premodern period and a major figure of the Italian Baroque.

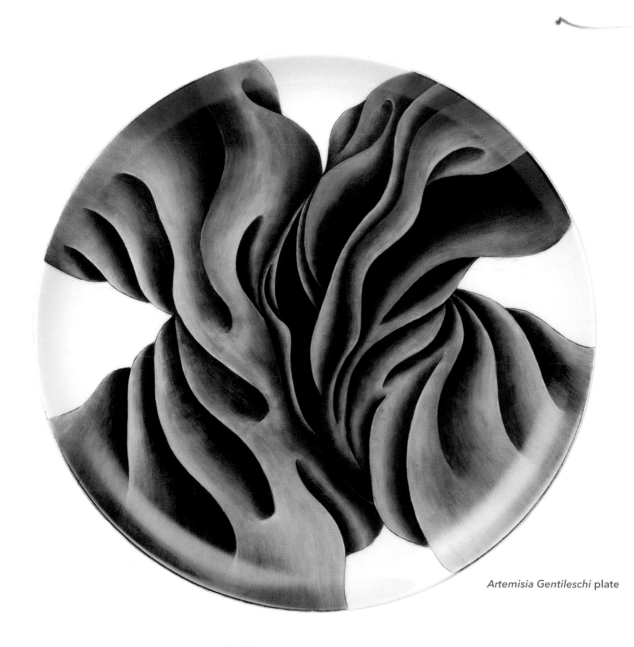

Artemisia Gentileschi plate

Artemisia Gentileschi runner

Artemisia Gentileschi place setting

Even if women could obtain basic art training, they encountered such obstacles as a lack of support and few opportunities; most daunting of all was the fact that, after the Renaissance, artists were expected to have a liberal arts education and to have studied the human body, both of which were impossible for most women. Nevertheless, a number of determined female artists were able to forge successful careers, often by limiting themselves to artmaking that did not require extensive knowledge of anatomy. Their names, along with others in the arts, are grouped with the place setting honoring ARTEMISIA GENTILESCHI.

Maria de Abarca
D. 1656; SPAIN

With her humanist education and private art training, Maria de Abarca became a celebrated portrait painter. She was a contemporary of Rubens and Velasquez, both of whom held her in high esteem.

Sophonisba Anguissola
1527–1624; ITALY

Sophonisba Anguissola's father encouraged her artistic and musical talents. In 1560 she was invited to join the court of Philip II in Madrid, where she spent ten years painting portraits of the royal family, becoming the first Italian woman to achieve international celebrity as an artist. Her best works are fine examples of late Renaissance portraiture, and her numerous self-portraits, unusual for an artist of that period, display considerable inventiveness.

Leonora Baroni
SEVENTEENTH CENTURY; ITALY

After centuries of prohibitions against the female voice, in seventeenth-century Italy solo vocals became a new vehicle for expressing emotion. The combination of several solo voices was particularly in demand. Leonora Baroni, who was also a published poet, was known for her extraordinary musical talents. Along with her sister Caterina and their mother Andreana Baroni Basile, she became exceedingly popular; they were known as the "three singing ladies of Rome" and their many patrons and admirers included the English poet John Milton (1608–1674).

Rosalba Carriera
1675–1757; ITALY

Rosalba Carriera first made a name for herself painting portrait miniatures on ivory for the inside of snuffbox lids, going on to develop pastel as a medium for the idealized style of portraiture typical of the sixteenth and seventeenth centuries. A superb colorist, she was one of the originators of the Rococo style of painting that developed in the eighteenth century in France and Italy, and she inspired a generation of amateur artists to work in pastel. One of the few female artists elected to the French Academy (which had a limit on the number of women allowed), her skills as a portrait artist were so respected that it became common practice to call other women artists a Dutch, English, or German "Rosalba," whether their work had any similarity to Carriera's or not. Tragically, she began to go blind in 1746, which so depressed her that she is said to have ended her life in a state of complete mental collapse.

Marie Champmesle
1642–1698; FRANCE

Marie was married to the actor and playwright Charles Chevillet Champmesle. They played at the Theatre du Marais and later at the Comedie Francaise in Paris. She achieved fame for her portrayals of Iphigenia and Phaedre in the dramas by the French playwright Racine (1639–1699), who wrote some of his finest tragedies for her.

Elizabeth Cheron
1648–1711; FRANCE

From a noble family, Cheron was trained by her father, a miniature painter. Her historical paintings and portraits won her admission to the French Academy and were so respected that Louis XIV gave her an annual pension.

Elizabeth Farren
1759–1829; IRELAND

Farren made her London debut in Oliver Goldsmith's *She Stoops to Conquer,* later becoming a leading English actress. She attempted to expand the available repertoire by playing male parts, but her efforts were not well received. She also performed in the plays of Elizabeth Inchbald (1753–1821), one of the most famous women writers of the day.

Lavinia Fontana
1558–1614; ITALY

Trained by her artist father, Fontana created the largest body of work of any woman artist prior to the eighteenth century, producing small devotional paintings, large-scale altarpieces, portraits, and mythological works. She was the first female painter to practice professionally, not in a court or convent but as a peer among male artists. She married another painter, G.B. Zappi of Imola, who gave up his career to assist Fontana in her work. The first woman to portray male and female nudes, she usually signed and dated her painting (which women didn't always do). Her work is included in many public and private collections and churches in Bologna, Cento, and Rome.

Fede Galizia
1578–1630; ITALY

Fede Galizia's artistic talent was written about by the time she was twelve years old; she was a recognized portrait painter by her late teens. She helped pioneer the establishment of the formal and iconographic conventions of still-life painting. Even an artist who was successful in this genre, though, would not be accorded the same respect as one working in what were considered higher aesthetic forms. Nevertheless, Galizia had a rewarding career. Some of her work can still be seen in churches in Milan, and her painting of the biblical Judith hangs in the Ringling Museum in Sarasota, Florida.

Marguerite Gerard
1761–1837; FRANCE

Marguerite Gerard was the first French female genre painter to achieve professional success (genre paintings depict people in everyday surroundings). After her sister married the painter Fragonard's brother, she went to live with them, training in the family atelier while she was still young. Gerard availed herself of the artistic community that surrounded Fragonard and saw some of the outstanding private art collections of the time. Her brother-in-law helped to launch her career. Once established, her professional life flourished for nearly fifty years, but despite her success, she resented the limited educational opportunities available to women.

Nell Gwyn
1650–1687; ENGLAND

One of England's leading comic actresses, Gwyn, who started out selling oranges at the theater, made her stage debut in 1665. A favorite in London for nearly twenty years, she was extremely popular even after she became mistress to Charles II. Well known for her generosity, she influenced Charles to build Chelsea Hospital and, upon her death, willed to the poor most of the money left to her by the king, to whom she remained loyal until he died.

Angelica Kauffman
1741–1807; SWITZERLAND

Kauffman (yet another daughter of a painter) was one of the major artists of the eighteenth century. While traveling in Italy, she became involved in the emerging style of Neoclassicism and was subsequently elected to the prestigious Academia di San Luca (the Italian Art Academy). Kauffman received numerous commissions from European nobility. Unlike many women artists, she refused to accept a career limited to portrait painting. Instead, she became a history painter (a field generally considered unsuitable for women), achieving an international repute for her historical and allegorical works. One of the original founding members of the British Royal Academy of Art, she was also one of only two women admitted at the time (the other was Mary Moser, a flower painter). Until 1922, no other women were allowed membership there.

Joanna Koerton
1650–1715; HOLLAND

Koerton or Koerten began cutting tiny scenes and portraits from paper and mounting them on dark backgrounds a century before Etienne de Silhouette (1709–1767), a French finance minister whose name came to be associated with stark dark and light images. She also excelled in drawing, painting, and embroidery.

Adelaide Labille-Guiard
1749–1803; FRANCE

From a low social class and with no family artistic tradition, Labille-Guiard became one of the most influential artists of the eighteenth century. Working primarily as a portrait painter, she was admitted to the French Academie Royale in 1783 and actively campaigned to make the privileges of the Academie available to her sex. A supporter of the French Revolution, she built up a clientele among the leaders of the new regime, embarking on a monumental work that would have opened up options for her as a history painter. Unfortunately, after two and a half years of work, she was forced to destroy the painting because the revolutionary government thought it glorified the monarchy. After that, her productivity declined steadily until her death some years later.

Judith Leyster
1609–1660; HOLLAND

Judith Leyster was a major Dutch artist of the seventeenth century who painted genre scenes and portraits as well as still lives. One of only two female members of the painters' guild in her native Haarlem, her career was unusual because, like Labille-Guiard, there was no artistic tradition in her family. Though she achieved considerable fame during her lifetime, her career was eclipsed after her death, and many of her works were attributed to Frans Hals (1582–1666). In 1893, the Louvre acquired a painting thought to be by him, but it turned out to have been painted by Leyster. This led to the recognition of her distinct artistic versatility as well as her historical importance.

Maria Sibylla Merian
1647–1717; SWITZERLAND

The first person to record observations of plant and animal species, Merian kept a journal of what she saw for fifty-three years. She wrote and illustrated *The New Flower Book*, a three-part catalog of flower engravings, and published a three-volume set of insect paintings that provided the basis for the later classification of biological species. In 1699, she and her two daughters undertook a two-year scientific expedition to the Dutch colony of Surinam in South America, sponsored by the city of Amsterdam. Upon returning, Merian began work on *Metamorphosis insectorum Surinamsium*, which consisted of plates engraved from her detailed watercolors of some of the plant and insect specimens they had brought back. Peter the Great, the tsar of Russia, bought three hundred of her paintings and in 1717 opened the first art museum in Russia in order to display them. Nevertheless, that same year, she died penniless.

Honorata Rodiana
D. 1472; ITALY

Legend holds that Honorata Rodiana was the only woman fresco painter in fifteenth-century Italy. She either worked in the court of the duke of Cremona (a small agricultural town near Milan) or the duke was her patron until one of his courtiers attempted to (or actually did) rape her. Rodiana is thought to have fatally stabbed her rapist, then fled. Disguised as a man, she joined a band of professional soldiers, dividing her time between painting and fighting. She is said to have died defending her birthplace of Castelleone near Lombardy, Italy.

Luisa Roldan
1652–1706; SPAIN

Luisa Roldan was the daughter of Pedro Roldan, a well-known Spanish sculptor. Although she trained in his workshop, after her 1671 marriage to the sculptor Louis Antonio de los Arcos she began to establish her own style. In 1689, Roldan, her husband, and children moved to Madrid, where she became a sculptor in the court of Charles II. Extremely prolific, she produced both oversize wooden figures and more intimate terra-cottas. Most of her work deals with religious themes and features delicate workmanship

Artemisia Gentileschi illuminated capital letter

and elaborate details. Her terra-cotta sculptures incorporate a subtle harmony of colors that predate the eighteenth-century establishment of Spanish porcelain factories.

Properzia De Rossi
1490–1530; ITALY

Properzia De Rossi was a sculptor who worked in several media, the most unique of which were miniature sculptures created from apricot, peach, or cherry stones. She went on to produce portrait busts, which helped establish her reputation as a serious artist.

Supposedly, she spent her last years working in engraving, though no works in this medium have been attributed to her.

Rachel Ruysch
1664–1750; NETHERLANDS

Ruysch was one of the greatest still-life painters Holland ever produced. Her specialty was flower painting, an art form that came into its own during the seventeenth and eighteenth centuries. Born into an educated family, her talent was evident early on, and at age fifteen she was apprenticed to one of Holland's finest flower painters; she

was still painting at age eighty-five. Though married to the portrait painter Juriaen Pool (with whom she had ten children), she continued to sign her work in her maiden name. Between 1708 and 1713, they were court painters in Dusseldorf to the Elector Palatine (the prince who ruled a region in the name of the Holy Roman Emperor). By the time of her death, Ruysch's career had been celebrated in published biographies and poems, and her work sold for prices equaled by only half a dozen other Dutch painters.

Sarah Siddons
1755–1831; ENGLAND

Sarah Siddons, whose parents led a traveling theater company, debuted on the London stage in 1782. By that time, she had married William Siddons, an actor in her parent's company. She was thought by many to be the greatest tragic actress of her time, reigning as queen of the theater for thirty years.

Elizabetta Sirani
1638–1665; ITALY

As a young girl, Sirani was apprenticed to her father at the insistence of a critic who noticed her precocious drawing talent. Considered a master by the time she was nineteen, she ran the Sirani workshop, which included her sisters and supported the family when her father was no longer able to paint. She also established an art school for young girls. Though she never traveled, her reputation spread far beyond her hometown of Bologna. She produced at least 150 paintings on subject matter ranging from portraits to religious, allegorical, and mythological scenes. Unfortunately, her life was cut short, some said by poison. At her funeral, a life-size effigy was displayed depicting the artist at work before her easel.

Levina Teerling
CIRCA 1515–1576; FLANDERS

Teerling or Teerlinc was the eldest of the five daughters of Simon Benninck, a book illuminator and miniature painter. In 1545, she married George Teerling, and soon they moved to England where her career flourished as court painter to four successive monarchs. In 1559, Queen Elizabeth gave her a substantial annuity for life; later, she and her husband became English citizens. She is primarily known as a miniature painter though it is difficult to ascertain if she created other forms of art because of the absence of works signed by her.

Luiza Todi
1753–1833; PORTUGAL

Todi, a soprano, performed throughout Europe during the latter part of the eighteenth century and was one of the major figures in the history of music in Portugal.

Caterina van Hemessen
1527–CIRCA 1587; FLANDERS

Ego Caterina de Hemessen me pinxi 1548 (I, Caterina van Hemessen, painted myself in 1548) reads the inscription on a poignant self-portrait by one of the earliest recorded female artists in northern Europe. She was the daughter of the Antwerp painter Jan Sanders van Hemessen and probably collaborated with him on some of his works. In 1554, she married Chretien de Morien, a prominent organist. Though van Hemessen was best known for her small, elegant portraits, mostly of women, she also executed at least two elaborate religious paintings, receiving commissions not only from the upper-class families of Flanders, but also from Queen Mary of Hungary, whom she accompanied to the court of Philip II of Spain after the queen abdicated her regency. Upon her death, the queen left a generous pension to van Hemessen and her husband, which allowed them to return to Antwerp, where they stayed for the remainder of their lives.

Marie Venier
1590–1619; FRANCE

France's position as the most powerful nation in seventeenth-century Europe was reflected in its theater, which reached its pinnacle at this time. Prior to this period, women were not allowed to appear on the European stage; female roles were played by men and boys. Venier or Vernier, the first French actress recorded by name, became famous for her portrayal of tragic heroines.

Elizabeth Vigee-Lebrun
1755–1842; FRANCE

History doesn't usually work on the side of women artists—except perhaps in eighteenth-century France when, according to the memoirs of Elizabeth Vigee-Lebrun: "The women reigned . . . the Revolution dethroned them." This helps to explain both the number of women artists working during that period and the enormous success many of them enjoyed, particularly Vigee-Lebrun. The sheer quantity of her production greatly exceeded that of almost any previous woman artist—over eight hundred portraits and landscapes. However, with no reliable modern catalog of her enormous oeuvre, an estimation of her achievement is almost impossible. Vigee-Lebrun's training began with her father, an artist. By the time she was fifteen, her father had died, and she was supporting the family by painting oil portraits. She soon began receiving commissions from the aristocracy, eventually becoming a favorite at Versailles and court painter to Marie Antoinette, with whom she grew close. On the eve of the Revolution, Vigee-Lebrun fled to Italy. She spent twelve years in exile, painting in the courts of Europe and becoming a member of the Academies of Rome, Florence, Bologna, St. Petersburg, and Berlin before returning to France. She was buried beneath a gravestone with a relief carving of a palette and two brushes, a fitting end to one of the most celebrated women artists of her time.

Sabina von Steinbach
CIRCA 1318; GERMANY

By the early thirteenth century, German sculptors and masons began visiting northern France. Within a century, German sculptors' guilds were producing vast quantities of carvings for the many cathedrals under construction. Families often worked together, which might explain why Sabina von Steinbach was credited with sculpting the stone figures on the south portal of Strasbourg Cathedral. It is known that after the master builder died, she received the contract to complete the work, though it is not clear if she was related to him. Although a dispute exists as to the validity of this attribution, there is an inscription on one of the sculptures that bears her name.

Anna van Schurman

1607–1678

One of the most famous women of the Reformation period, Anna van Schurman was given a humanist education and, because her parents were of the nobility, she had sufficient income so that she was not forced to marry. At first she devoted herself to art, particularly to those techniques she could teach herself. She was also proficient in numerous ancient and modern languages and soon began corresponding with prominent scholars. When she was twenty-nine, a university was established in Utrecht, and she was invited to attend lectures on theology, though she had to be concealed behind the curtains of a box. This injustice stimulated her to write *Whether the Study of Letters is Fitting for a Christian Woman*, in which she argued that women's abilities were not being recognized.

Throughout the 1640s, van Schurman was considered "the star of Utrecht" and was one of the mandatory "sights" for visitors to the city. In 1648, she compiled all of her published works into a book titled *Little Works in Hebrew, Greek, Latin & French, Prose and Poetry*. In the mid-1660s, she left Utrecht permanently to become part of a religious community in which women had equal rights. Although the community was often persecuted, she preferred it to the injustice of secular life, as she explained in *The Good Choice; or Choosing the Better Part*, in which she described the community's religious beliefs and expressed the joy she found in her chosen path.

Anna van Schurman plate

WOMAN HAS THE SAME WISH FOR SELF-DEVELOPMENT AS MAN, THE SAME IDEALS, YET SHE IS TO BE IMPRISONED IN AN EMPTY SOUL OF WHICH THE VERY WINDOWS ARE SHUTTERED.

Anna van Schurman

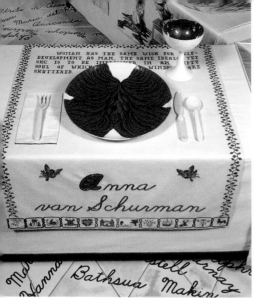

Anna van Schurman place setting

The Reformation brought with it the idea that women's work should be confined to the domestic sphere; consequently, marriage became the only acceptable option for most Protestant women. Grouped around the place setting for ANNA VAN SCHURMAN are the names of women who challenged prevailing ideas about their place, many arguing for women's right to education, others articulating early feminist ideas about the equality of the sexes, usually with little or no knowledge of previous women's arguments.

Maria Agnesi
1718–1799; ITALY

Maria Agnesi was the daughter of Pietro Agnesi, a wealthy nobleman who was interested in mathematics. Because all three of his wives died young, Maria was expected to assume some of the care for his twenty other children. She herself was a child prodigy who spoke fluent French by the time she was five and, at nine, spoke publicly for an hour in Latin on the rights of women to study science. In her teens, she seems to have taken up the study of mathematics primarily to please her father, who insisted that she enter into public debates as a way of demonstrating her erudition. When she was twenty, she embarked on the *Analytic Institutions for the Use of Italian Youth*, a two-volume treatise on calculus to which she devoted ten years of uninterrupted labor. When the work was published in 1748, it caused a huge sensation as it demonstrated that women could aspire to the high-

est eminence in science. The French Academy of Science sent Agnesi a letter congratulating her while apologizing for not being able to offer her membership, as this would have been against their rules. She was offered an appointment in mathematics at the University of Bologna at a time when women weren't allowed to study there. She turned down the position and, after the death of her father, stopped doing scientific work altogether. In 1759, Agnesi established a home for the poor, and later became the director of a residence for the elderly, where she lived until her death. Having given away all her wealth to charity, she was buried in a pauper's grave.

Maria de Agreda
1602–1665; SPAIN

De Agreda was born into a wealthy family whose assets were donated to the Franciscan order. All the family members took vows, and their castle was turned into the Convent of the Immaculate Conception, where she became a nun and then the ruling abbess, retaining this position until her death. In 1620, she began experiencing visions of the Virgin Mary, who presumably appeared to De Agreda and requested that she write her biography. This four-volume work, the *Mystical City of God*, was alternately embraced and condemned by the Inquisition. Eventually, her work would become a valued mystical treatise, and she would be viewed as one of the most influential women in Spanish history.

Marianna Alcoforado
1640–1723; PORTUGAL

Alcoforado entered a Franciscan convent when she was sixteen years old. At that time, Portuguese nunneries were open, which meant that visitors were permissible. When Alcoforado was twenty-five, she met a French officer with whom she became involved. Before long, their affair was discovered and caused a scandal, whereupon the soldier abandoned her. She wrote about her situation in *Letters of a Portuguese Nun*, a major piece of self-analytical writing as well as an important record of the life of seventeenth-century Portuguese religious women.

**Detail, *Anna van Schurman*
runner back**

Anna Amalia
1739–1807; GERMANY/PRUSSIA

Anna Amalia was the sister of Frederick the Great, king of Prussia (1712–1786), and regent for her son Frederick Wilhelm II, who inherited the throne. Although she is best remembered as a music collector and patron, she was also a skilled performer and composer, fashioning music to accompany the words of her close friend, the writer Goethe (1749–1832). Many distinguished artists and literati were drawn to her court. In 1775, she retired from social affairs to devote herself to the study of music and the arts.

Anne Askew
1521–1546; ENGLAND

When Anne Askew was fifteen, her family forced her to marry her dead sister's husband, a man named Thomas Kyme. In rebellion, she refused to adopt his surname. The couple argued frequently about religion; he was Catholic while she was an ardent supporter of the Reformation. She left Kyme and went to London where she attempted to get a divorce. Although unsuccessful, she found her calling: giving sermons, distributing Martin Luther's writings, and arguing for a reformed Church. She was arrested and ordered back to her husband's house. But she escaped and was arrested once more. Despite being tortured on the rack, she refused to recant. Found guilty of heresy, she was burned at the stake. The published account of her martyrdom helped to strengthen the Protestant cause.

Mary Astell
1668–1731; ENGLAND

Mary Astell was one of the most important writers of her generation and one of the few women to earn at least part of her living as a writer. Her numerous works include two great feminist treatises: *A Serious Proposal to the Ladies* (1694), which dealt with the defects of the educational system for women, and *Some Reflections on Marriage* (1700), which analyzes marriage from a woman's perspective and includes her most famous line: "If all men are born free, how is it that women are born slaves?" Throughout her life she seems to have been supported by wealthy female friends, an early example of what the pioneering women's historian Gerda Lerner called "female affinity groups," which have often been a critical component of female achievement. One of her goals was to establish a new type of institution for women where they could live and study; this would not be attained until the late nineteenth century when feminists would create women's institutions.

Laura Bassi
1711–1778; ITALY

Able to acquire a wide-ranging education, in 1731 Bassi was appointed professor of anatomy at the University of Bologna; soon she was elected to the Academy of the Institute for Sciences and then became a professor of philosophy. Five years later, she married her colleague Giuseppe Veratti, with whom she had twelve children. While they were young, she lectured from home and continued to explore her lifelong interest in science. Once the children were grown, she returned to the university as a professor of experimental physics, working in her own lab (no other woman would work in this field again for almost two hundred years). She published a number of technical papers and, in addition to achieving professional renown, became a popular teacher, drawing students from all over Europe.

Anne Baynard
1672–1697; ENGLAND

After the reign of Elizabeth I, women's education suffered serious setbacks. James I, Elizabeth's successor, is quoted in Antonia Fraser's book, *The Weaker Vessel*, as saying, "To make women learned and foxes tame has the same effect – to make them more cunning." Fortunately, Anne (Ann) Baynard's father provided her with a solid classical education. As a result, even in her short life, she became widely respected for her scholarship.

Aphra Behn
1640–1689; ENGLAND

Aphra Behn, born Aphra Johnson, was the first woman to be accepted as a playwright in the male-dominated English theater; her fiction was important to the development of the English novel. As a child, she went with her family to the West Indies. After returning to England, she married, but after three years, her husband died. Then King Charles II employed her as a spy in Antwerp in his war against the Dutch, but she was paid very little for her work. In fact, upon her return to England, she was briefly imprisoned for debt. In order to support herself, she began to write poetry, novels, and plays. Today, she is best known for her novel *Oroonoko* (1688), a vivid portrayal of a noble black prince enslaved by cruel white men.

Luisa de Carvajal
1568–1614; SPAIN

De Carvajal wrote during what is considered the golden age of Spanish literature. Her lyric poetry, written in Castilian as the official language of Spain, is considered the most illustrious of this type of work. An outspoken Catholic, De Carvajal took an active part in defending the Church against the Reformation. She went so far as to publicly destroy paintings and writings that offended her faith. Later, she founded an uncloistered community for pious women in England.

Bernarda de la Cerda
1595–1644; PORTUGAL

De la Cerda (or de Lacerda) was a scholar whose poems and prose (*Volume of Comedies* and *Political Selections*) were so well known throughout Spain and Portugal that she received recognition from the academies of both countries.

Helen Cornaro
1646–1684; ITALY

Cornaro, also known as Elena Cornaro Piscopia, challenged the practice of excluding women from academia by making formal application to the University of Padua to stand for the doctor of philosophy degree. Six years later, before an immense audience of male scholars, ecclesiastics, and foreign dignitaries, Cornaro defended her dissertation and was unanimously approved, the first woman in the world to be accorded a doctorate in philosophy.

153

Detail, *Anna van Schurman* **runner front**

Isabela Czartoryska
1746–1835; POLAND

As a young woman, Isabela (Izabela) Czartoryska, a countess, journeyed throughout Europe, becoming a travel writer and friend to other artists, politicians, and scientists. When Poland was partitioned at the end of the eighteenth century, Czartoryska returned there in order to help preserve Polish cultural life. She made her Pulway Park estate a literary and political center and, later, the first museum in Poland where she displayed her extensive collection of Polish art and artifacts. She was also a knowledgeable gardener, compiling a catalog of trees as well as a book on the creation of gardens, one example of which would be her own garden at Pulway Park.

Anne Dacier
1651–1720; FRANCE

When Dacier was a young woman, her father discovered that she was studying secretly and supplying her brother with answers for his lessons. At that point, he began educating her as well. She became a scholar supposedly unequaled in her knowledge of classical literature. Invited by Queen Christina to join the Swedish court, she instead went to the French court, then the intellectual center of Europe, where she distinguished herself.

Luise Gottsched
1713–1762; GERMANY

Luise Gottsched, a writer of both letters and plays, put aside her own literary efforts to help her husband compile the *Dictionary of the German Language and Model Grammar.* She devoted almost thirty years to this undertaking, which helped to reestablish German as the primary language of the country at a time when French had almost completely replaced it. Though she did most of the work on the dictionary, her husband got the credit.

154

Anna van Schurman runner back

Jeanne Marie Guyon
1648–1717; FRANCE

Educated in a convent, Jeanne Marie Guyon desired to enter a religious order. Her mother opposed this plan, insisting that she marry a man twenty years her elder. After twelve unhappy years of marriage, her husband died, leaving Guyon a wealthy widow. She soon became involved in Quietism, a form of mysticism that emphasizes the inner religious experience as the way to attain spiritual perfection. Through her efforts, this philosophy was introduced into France, attracting many adherents in the French court. She wrote extensively; her most widely read book, *A Short and Easy Method of Prayer,* brought her philosophy to scores of believers since its first publication in 1685. Persecuted for heresy and imprisoned for seven years, she was finally released on the condition that she withdraw from public life. She spent her last years performing charitable deeds and living according to the philosophy she had promoted, one whose influence continues today.

Glueckel von Hameln
1646–1724; GERMANY

From a wealthy Jewish family, Glueckel von Hameln married Chaim Segal when she was fourteen. The couple, who had twelve children, worked together; he sold precious jewels while she did most of the paperwork. In 1689, after almost thirty happy years, Chaim died and Glueckel took over the family business, which she successfully ran for many years. In 1690, she began work on a memoir that would become an invaluable document. Unpublished until 1896, the seven-volume set is now viewed as a classic, providing information about the customs and lifestyle of Jewish-German life at that time.

Maria le Jars de Gournay
1565–1645; FRANCE

In 1622, Maria le Jars de Gournay, an early feminist, wrote *L'Égalité des Hommes et des Femmes,* which extended earlier arguments by Christine de Pisan and others about equality between the sexes. She believed that the gulf between men and women was due largely to the limited educational opportunities available to women, the subject of her 1626 book *The Ladies' Grievances,* which included these words; "Lucky are you, reader, if you happen not to be of that sex to whom is forbidden all good things . . . lucky are you if you are one of those who can be wise without its being a crime." De Gournay supported herself through her prodigious writing, which also included a number of translations from Latin; essays on a wide range of subjects including French language and translation, poetry, education, and morality; as well as critical analyses of contemporary writers.

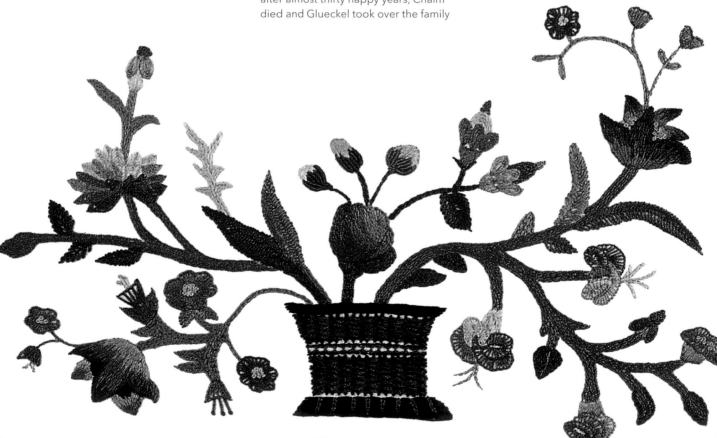

Susanna Lorantffy
1600–1660; HUNGARY

Lorantffy managed the estates of her wealthy family, was influential in securing her husband's 1636 appointment as prince of Transylvania, and during the 1644–1645 uprising, helped to run military operations. However, her most important contribution was founding the Reformed College of Sarospatak. The Reformation precipitated a new type of school, one in which needy but talented students were able to study; the college that Lorantffy founded was one such school. She also established scholarships for the students and endowment funds to maintain the institution.

Bathsua Makin
1600–1675; ENGLAND

In 1673, Bathsua Makin wrote one of the earliest English treatises on women's right to education: *An Essay To Revive the Ancient Education of Gentlewomen in Religion, Manners, Arts and Tongues*. Daughter of a London schoolmaster, Makin was fluent in seven classical and modern languages, many of which she taught in his school. Although married with six children, she continued to teach throughout her lifetime and in the 1640s became tutor to the young princess who would become Elizabeth I. She and Anna van Schurman provided each other support for their shared feminist philosophy.

Lucretia Marinelli
1571–1653, ITALY

Marinelli was best known for her eight-volume work *The Excellence of Women and the Defects of Men* (1610), another publication in the growing body of writing defending women. Her literary output also included poetry and two religious works—*The Life of St. Francis* and *The Life of the Virgin Mary*.

Marie de Miramion
1629–1696; FRANCE

Marie de Miramion inherited a fortune and, after a short marriage, was widowed. Deciding not to remarry, she devoted her life to helping the poor, founding a school for young women, training teachers and nurses, establishing a dispensary, and instructing women in the preparation of medical salves and plasters. She also opened a home for former prostitutes where they could forge alternative means of support.

Hortensia von Moos
1659–1715; SWITZERLAND

Von Moos was one of the most remarkable women of the Reformation, a self-taught scholar who corresponded with the foremost thinkers of her time as well as the author of a number of important theological texts. An early feminist, she was ahead of her time in how she dealt with female depression. She became particularly known for her advocation of women's right to both education and freedom of expression, using strong biblical women as examples to buttress her arguments.

Charitas Pirckheimer
1467–1537; GERMANY

Charitas Pirckheimer, abbess of the Convent of St. Clare in Nuremberg, was the sister of the celebrated writer and humanist Willibald Pirckheimer (1470–1530). They came from a noble family that produced some of the most learned German scholars. Pirckheimer presided over the convent during a period of extreme Lutheran agitation. She strongly opposed the Reformation and wrote a memoir expressing her beliefs.

Bridget Tott
SEVENTEENTH CENTURY; DENMARK

Bridget Tott (better known as Birgitte Thott) translated into Danish the works of some of the most celebrated authors of antiquity, contributing to the beginnings of an authentic Danish literature.

Barbara Uttman
1514–1575; GERMANY

Although netting dates back to ancient Egypt, true lace (an openwork fabric made by tatting, crochet, or the like) was of European origin. Its development began in fifteenth-century Italy and reached its height a century later, in part due to the 1567 invention of bobbin lace by Barbara Uttman or Uttmann. (Bobbin lace is an extremely delicate type of lace made over a pattern attached to a pillow.) She learned the then little-known technique in Nuremberg, starting a school in her home in Annaburg, Saxony, that grew

Anna van Schurman illuminated capital letter

into a profitable industry for the impoverished town. Through her efforts, schools were opened throughout Germany, and by 1561 lace making was an active trade employing thirty thousand people, primarily women.

Maria Antonia Walpurgis
1724–1780; GERMANY

As a member of the highest ranks of the aristocracy, Walpurgis was taught music by some of the leading opera composers of the period. In addition to being a patron of music (an expected role for women of her class), she was a singer, harpsichordist, and composer. She became a member of the Arcadian Academy in Rome under a pseudonym (the only way a woman could participate). Her most important compositions were her operas, which were highly praised by many of her contemporaries, but have yet to be recorded.

Hannah Woolley
BORN 1623; ENGLAND

Woolley, a professional educator, was active in the early stages of English feminism. Her numerous publications included the *Gentlewoman's Companion* (1675), a compendium of recipes, housekeeping hints, medical advice, and autobiographical writing. She believed that if women could obtain the same education as men, their "brains would be as fruitful as their bodies!"

WING THREE

The last wing of the table begins with the place setting for the American religious leader Anne Hutchinson. Painted in somber tones, her plate is presented on a runner modeled upon traditional eighteenth-century mourning pictures. The imagery is intended to "mourn" the constrictions of women's options set in motion by the Renaissance, reinforced by the Reformation, and firmly locked into place by the laws and attitudes of the early nineteenth century.

The advent of the Enlightenment and the French Revolution would have important implications for women, particularly after the pioneering eighteenth-century writer and philosopher Mary Wollstonecraft applied modern principles of democracy to her arguments for the equality of women. Her work helped kindle the feminist revolution that erupted in the mid-nineteenth century, making it possible for women to finally gain access to education, speak publicly, achieve significant political reforms, enter previously restricted professions, and begin forging organizations, philosophies, and then creative forms through which their experiences and perspectives could be articulated. As a visual metaphor for this enlarged sphere of opportunity, the plates become increasingly dimensional, and the rigid, rectilinear form of the runners begins to break open at the edges.

Finally, the butterfly—as a symbol of liberation—becomes more prominent in both the plate and the runner designs, representing women's ever-intensifying struggle to achieve both greater independence and fuller creative powers. But even though the images on the plates become more powerful, they remain firmly anchored on the banquet table, a symbol for the tragic cycle of repetition in which women will remain trapped until they can build upon the rich history and important lessons embodied by the 1,038 women represented in *The Dinner Party*.

Anne Hutchinson

1591–1643

In 1634, Anne Hutchinson arrived in the Massachusetts Bay Colony with her husband and family. Trained in theology by her minister father, she became involved with the religious issues of the day, arguing for what was known as the covenant of grace, the idea that *faith* was more important than *actions* (the covenant of works). Before long, Hutchinson began to organize theological discussions in her home; her ability as a speaker began to draw men as well as the women who were not allowed to attend the regular after-sermon debates.

Hutchinson's arguments contradicted the Church, which required as blind a submission to its doctrine as was then demanded of a wife by her husband. Her followers grew bold, even walking out of services when ordered by the clergy to "be silent and remember [their] place." Brought to trial for heresy, accused of being a "husband rather than a wife, a preacher rather than a hearer, and a magistrate rather than a subject," she was excommunicated and banished from the colony. She continued her work in Rhode Island, and after her husband died in 1642, she tried to find safety in a Dutch colony near New York. But the director of the colony had alienated the nearby Indians, and it was not long before Hutchinson and five of her children were killed in a native uprising.

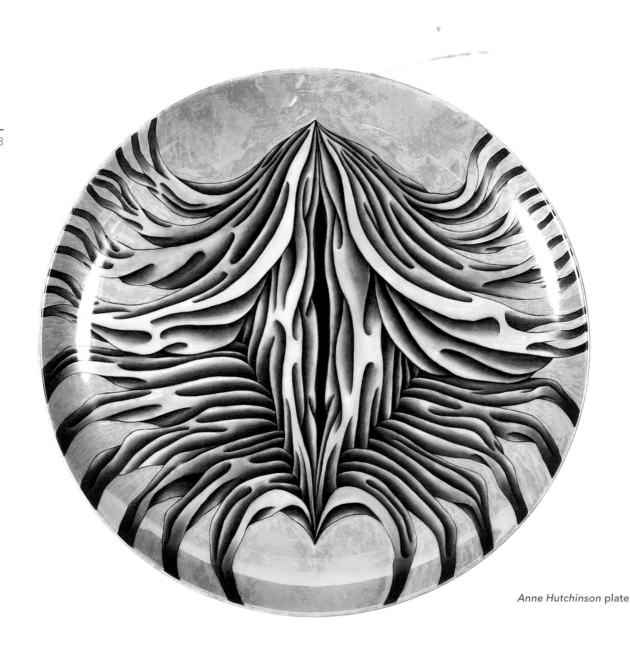

Anne Hutchinson **plate**

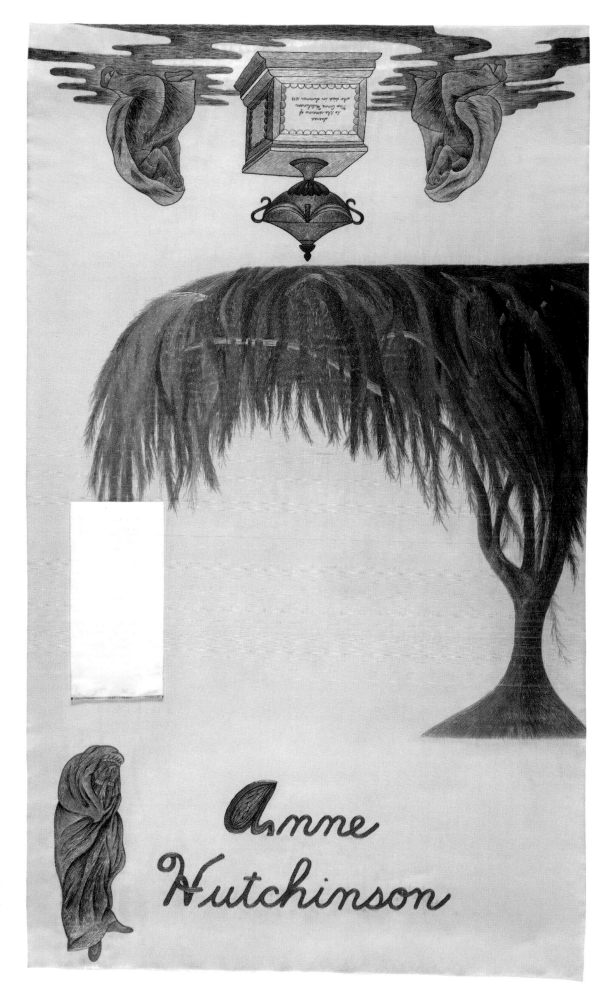

Anne Hutchinson runner

Anne Hutchinson place setting

Those who looked to the colonies for religious tolerance and political freedom discovered that women enjoyed a good deal more liberty than in Europe. Puritans emphasized the dignity of women within the family structure—as long as they accepted ultimate male authority. If a woman challenged this, as Hutchinson did, she paid a high price. Nevertheless, women continued to be active in reform movements, only to find themselves excluded as soon as the institutions they had helped to build became more established.

Abigail Adams
1744–1818; UNITED STATES

Despite being self-educated, Adams managed all the business affairs for her family and served as a valued advisor to her husband John (the second president of the United States). Her views are known primarily through her letters, which provide a vivid chronicle of revolutionary times. She spoke out against slavery and argued for a woman's rights clause in the Declaration of Independence. In a letter to her husband, she wrote: "Remember the ladies and be more generous and favorable to them than your ancestors. Remember all men would be tyrants if they could."

Hannah Adams
1755–1831; UNITED STATES

Hannah Adams was an early American historian, a pioneer in the field of comparative religion and the first author in the United States to make a living from writing. After reading Thomas Broughton's *An Historical Dictionary of All Religions from the Creation of the World to This Perfect Time* (1742), she realized that most texts on religion treated faiths other than Christianity with prejudice. To remedy this, Adams developed a radically dissimilar approach in *An Alphabetical Compendium of the Various Sects Which Have Appeared from the Beginning of the Christian Era to the Present Day* (1784), the first book to discuss different religions evenhandedly.

Mary Alexander
1694–1760; UNITED STATES

Although it was uncommon, women ran mills, distilleries, and even slaughterhouses. Alexander invested her inheritance in trading ventures, developing an extremely prosperous business. It was said that hardly a ship docked in New York harbor without a consignment of goods for her, which, together with colony products, she sold in her own store.

Penelope Barker
1728–1796; UNITED STATES

Most history textbooks overlook women's roles in the American Revolution, even though women were active in the independence movement in a variety of ways. Barker, the leader of a women's group that opposed taxes levied by the British Parliament on the colonies, single-handedly drove off British soldiers when she discovered them stealing horses from her stables.

Helen Blavatsky
1831–1891; UKRAINE

Blavatsky arrived in New York in 1873, bringing with her the philosophy that formed the basis of the Theosophical Society, which she founded in 1875 and now has branches in seventy countries. Blavatsky's thinking might be best summed up by one of her maxims: "Compassion is the law of laws." She believed that the problems faced by humanity, including war, prejudice, oppression, greed, and hate, were symptoms of a widespread disease: an inability to recognize that we are all one with each other and with all life in the universe.

Mary Bonaventure
CIRCA 1610–CIRCA 1694; IRELAND

Bonaventure was one of the founders of the historic community of the Poor Clares in Galway, an enclosed, contemplative order and the oldest existing order of nuns in Ireland. She left a record of the struggles of the sisters during the anti-Catholic reform movement led by Oliver Cromwell (1599–1658). Bonaventure was forced into exile in Spain after her religious house was burned in 1652.

Anne Bradstreet
1612–1672; UNITED STATES

Bradstreet, celebrated as America's first poet, was both the daughter and wife of governors of the Massachusetts colony. Though she appreciated their love and protection, she complained that "any woman who sought to use her wit, charm or intelligence in the community at large found herself ridiculed, banished, or executed by the Colony's powerful group of male leaders." The 1658 publication in the colonies of a book of Bradstreet's poems, *The Tenth Muse Lately Sprung Up in America,* which had appeared in England in 1650, made her the first female writer published in the British North American colonies.

Margaret Brent
1601–1671; NORTH AMERICA

In 1648 Brent appeared before the Maryland assembly to request the right to vote as a landowner; she was the first woman in North America to make such a demand. Though she was denied, her effort marks the beginning of the long struggle for female suffrage.

Hannah Crocker
1752–1829; UNITED STATES

Crocker, the granddaughter of American Puritan clergyman Cotton Mather (1663–1728), was a passionate advocate of women's education. In 1818, she wrote *Observations on the Real Rights of Women,* arguing that "The wise author of nature has endowed the female mind with equal powers . . . and given them the same right of . . . acting for themselves as (he) gave to the male sex." Crocker believed that Christian doctrine advocated that the sexes shared equally in divine grace and thus marriage should be a state of mutual

trust, with all responsibilities shared by both partners, including earning the family income.

Mary Dyer
CIRCA 1611–1660; UNITED STATES

Dyer, an advocate of religious freedom, was a follower of Anne Hutchinson. Despite the threat of punishment for associating with her, Dyer publicly supported Hutchinson during her trial for heresy. When Hutchinson was excommunicated, so were Dyer and her family. In 1652, she made a trip to England where she became acquainted with George Fox, the founder of the Quakers. Attracted to his teachings, in 1657 she returned to Boston a committed Quaker. The next year, religious intolerance in that city escalated, and a law was passed banishing Quakers "on pain of death." Despite warnings, Dyer continued to visit Boston to gain the repeal of what she considered an evil law. In 1660, she was hanged.

Mary Baker Eddy
1821–1910; UNITED STATES

Mary Baker Eddy, the founder of Christian Science, was born and raised in New Hampshire. Because of restrictions on women's education and her continual bouts of ill health, she was educated at home. She began to experiment with conventional medicine, alternative therapies, and homeopathy, seeking to understand the relationship between the mind, the body, and disease. In 1866, after a life-threatening accident, she was healed, she believed, through insights

gained from the Bible. Over the next few years, she studied the scriptures, searching for a spiritual belief system that she could use as a method of healing. In 1875, she published *Science and Health with Key to the Scriptures*, her major work on the theology and healing system of Christian Science, and in 1879, she founded the first Christian Science Church in Boston, serving as its minister for ten years, thus becoming the first woman to found a major religion.

Margaret Fell Fox
1614–1702; ENGLAND

Often referred to as "the mother of Quakerism," Fell along with her husband George Fox and William Penn were the founders of the religious movement. She married Fox in 1669, two years after she wrote *Women's Speaking Justified, Proved and Allowed by the Scriptures*, in which she argues for the spiritual equality of men and women and supports the ministry of women—ideas that became incorporated into the Quaker denomination. She also established women's meetings that provided training in midwifery along with guidelines for aid to the poor. Her lobbying efforts helped bring about King James II's Declaration of Indulgence of 1687 and the Toleration Act in 1689, which signaled an end to the persecution of the Quakers in England.

Mary Goddard
1738–1816; UNITED STATES

Goddard, America's first female postmaster, published in 1777 the first edition of the Declaration of Independence to include the typeset names of the signers, which is known as the Goddard Broadside. A founder of the *Providence Gazette*, she moved from Rhode Island to Philadelphia in 1768 to help her brother publish the *Pennsylvania Chronicle*, and she was subsequently editor and publisher of the *Maryland Journal* and *Baltimore Advertiser* in Baltimore, where she became postmaster in 1775.

Catherine Greene
1755–1814; UNITED STATES

Greene invented a method for separating cotton from its seed, entrusting the fabrication of the machine she had designed to her boarder Eli Whitney. He nearly abandoned the project sev-

Detail, *Anne Hutchinson* runner front

eral times, but she encouraged and supported him while he completed the job. Social norms inhibited women from applying for patents, so Whitney applied and thereby received credit for the invention of the cotton gin.

Selina Hastings
1707–1791; ENGLAND

In 1739, Hastings became a fervent supporter of John Wesley (1703–1791), founder of the Methodists, and her home became a center of religious activity. She built over sixty Methodist chapels, founded a religious school, and helped establish missions throughout the British Isles that contributed to the spread of the Methodist faith.

Marie de l'Incarnation
1599–1672; CANADA

L'Incarnation, an Ursuline nun, spent thirty-two years working among the Algonquin people in what is now Quebec, taking many Native American girls into her personal care and tutelage. She mastered several native dialects, writing a number of dictionaries as well as a series of letters that are valuable sources of French Canadian history.

Henrietta Johnston
1670–1729; UNITED STATES

Johnston, who was born in Ireland and emigrated to North America in 1701 with her husband, is the earliest recorded female artist and the first known pastelist working in the English colonies in the New World. She produced forty known portraits that depict public officials, clergy, and members of prominent families.

Ann Lee
1736–1784; UNITED STATES

Also known as "Mother Wisdom," Lee was the founder of the United Society of Believers in Christ's Second Coming. Known as the Shakers because of their frenzied dancing, the sect grew to include a number of communities that believed in common possession of property, codes for dress and daily life, celibacy, and the absolute equality of the sexes.

Judith Murray
1751–1820; UNITED STATES

Poet, essayist, playwright, and novelist Murray was an early American advocate for women's rights. Her short 1790 essay, "On the Equality of the Sexes," predated Mary Wollstonecraft's *A Vindication of the Rights of Woman* by several years. In her first published piece, "Desultory Thoughts upon a Degree of Self Complacency Especially in Female Bosoms" (1784), she agreed with Wollstonecraft's ideas about the importance of education for women, further advocating that they should be equipped to make their own living. A major theme of her work was that an understanding of history is particularly crucial for young women because knowledge of their foremothers' achievements is an essential tool of empowerment.

Sarah Peale
1800–1885; UNITED STATES

Peale is considered to be the United States' foremost woman painter in the nineteenth century. She studied with her father James, a miniaturist, and her famous uncle, the artist and naturalist Charles Willson Peale. She was commissioned to paint more than one hundred portraits, becoming one of the country's first professional female artists able to earn her living through her work.

Margaret Philipse
D. 1690; UNITED STATES

Philipse began her career as a business agent, representing Dutch merchants trading with the early North American communities. Like many Dutch women, even after she married, she carried on her business in her maiden name. When her husband died, she took over his trading interests, soon becoming a shipowner and naming her new fleet ship *Margaret*. After 1664, when the English pushed the Dutch out of the New Netherlands (now the Hudson River Valley and New York City), the legal structure changed; though her business was not affected, she was forced to take her new husband's name (she had remarried), and she could no longer own property—including her boat—in her own right.

Eliza Lucas Pinckney
1722–1793; UNITED STATES

The color indigo, often associated with political power or religious ritual, has held a significant place in many cultures for thousands of years. By the seventeenth century, indigo supplies from India were not sufficient to meet the European demand, and the plant's cultivation was taken up in the Americas. Eliza Lucas Pinckney was sixteen when her father left for military service in the Caribbean and entrusted his three plantations to her. She helped introduce the plant in South Carolina, where it became an important cash crop and sustained the state's economy for three decades (albeit through slave labor). Pinckney's correspondence is one of the largest surviving collections of letters by a colonial woman, published in 1850 as *The Journal and Letters of Eliza Lucas*.

Molly Pitcher
1754–1832; UNITED STATES

Pitcher's real name seems to have been Mary Hays; she was married to a young soldier in the Continental army and accompanied him to the Battle of Monmouth on June 28, 1778. In addition to tending to the wounded, she carried water to the thirsty soldiers, one of whom dubbed her "Molly Pitcher," which is how she has gone down in history. When her husband was shot, she took his place as a gunner and is said to have fired the last shot against the British. She is also reputed to have carried a wounded soldier two miles to safety and nursed him back to health. Some records claim that she was honored by George Washington while others state that in 1822 she was accorded a lifelong annuity in honor of her service to the country.

Deborah Sampson
1760–1827; UNITED STATES

Dressed in men's clothing, Sampson enlisted in the Continental army in 1782, apparently the first known American woman to impersonate a man in order to take part in combat. She fought in a number of battles and was repeatedly injured before her true gender was discovered, at which point she was honorably discharged. In 1802, she began to travel throughout New England dressed in her uniform, giving lectures on her military experiences. When she became ill as a result of old army wounds, Congress granted her a pension.

Mercy Otis Warren
1728–1814; UNITED STATES

Though her brothers attended Harvard University, Warren was able to acquire only such education as she picked up for herself, like most women of her era. When the colonies rebelled against English rule, Warren anonymously published a series of satires and plays attacking specific public officials who, in her opinion, were insufficiently supportive of America's claims to freedom. In addition, Warren maintained a cor-

respondence with important figures of the Revolution, many of whom consulted her on political questions. Over the subsequent centuries, hundreds of her letters were published, providing historians insight on the founding of the United States. In 1805, she published the three-volume *The Rise, Progress and Termination of the American Revolution.*

Susanna Wesley
1669–1742; ENGLAND

Wesley had nineteen children in twenty years and educated all ten of those who survived, conducting a "household school" that provided the same education to boys and girls. Neighbors began to send their children; soon there were two hundred pupils. Because she also wrote religious textbooks and conducted services for the children, she met opposition from the local curate, as women were forbidden to preach. Among her most distinguished students was her son John, who founded Methodism, which, it has been suggested, had its origins in his mother's teachings.

Phillis Wheatley
1753–1784; UNITED STATES

Bought directly off a slave ship in Boston, Phillis was only eight when she was purchased by John Wheatley to be his wife's personal maid. The Wheatleys encouraged her to study theology and the classics and to write poetry. One of her works, "An Elegiac Poem," published locally in 1770, was then reprinted in newspapers throughout the colonies and England, bringing her international attention. In 1774, she was freed from slavery; four years later, she married a free black man named John Peters. After bearing three children and being forced by her husband to work as a scullery maid, she died at the age of thirty-one, leaving one of the first bodies of writing by an African American, including this poignant poem:

I, young in life, by seeming cruel fate
Was snatch'd from Afric's fancy'd
happy seat;
What pangs excruciating must molest,
What sorrows labor in my parent's
breast?

**Left, detail, *Anne Hutchinson*
runner back**
Right, detail, *Anne Hutchinson* runner

Sacajawea

CIRCA 1788–1812 (OR 1884)

Sacajawea (Sacagawea), the daughter of a Shoshone chief, was kidnapped by the Hidatsa (or Minitari) when she was about ten. At about thirteen, she married Jean Baptiste Charbonneau, a French-Canadian trapper later hired by Meriwether Lewis and William Clark as interpreter for their Corps of Discovery when they had reached North Dakota. When the expedition resumed in the spring of 1805, Sacajawea was only about seventeen with a baby less than two months old. While in Shoshone country, she helped secure the horses to cross the Rocky Mountains, thanks to the fact that the tribe's chief proved to be her brother.

While on the Missouri River, the expedition encountered a sudden storm and its boat nearly capsized. Sacajawea's quick thinking and calm demeanor saved the valuable books and instruments upon which they depended. Her very presence protected the men by assuring the native tribes they encountered that their mission was peaceful (a war party never traveled with a woman). There are conflicting accounts as to her fate. Historians generally believe she died in 1812 (William Clark became her orphaned children's guardian in 1813), but some Native American oral traditions, and romanticized biographies, have her living until 1884.

164

Sacajawea plate

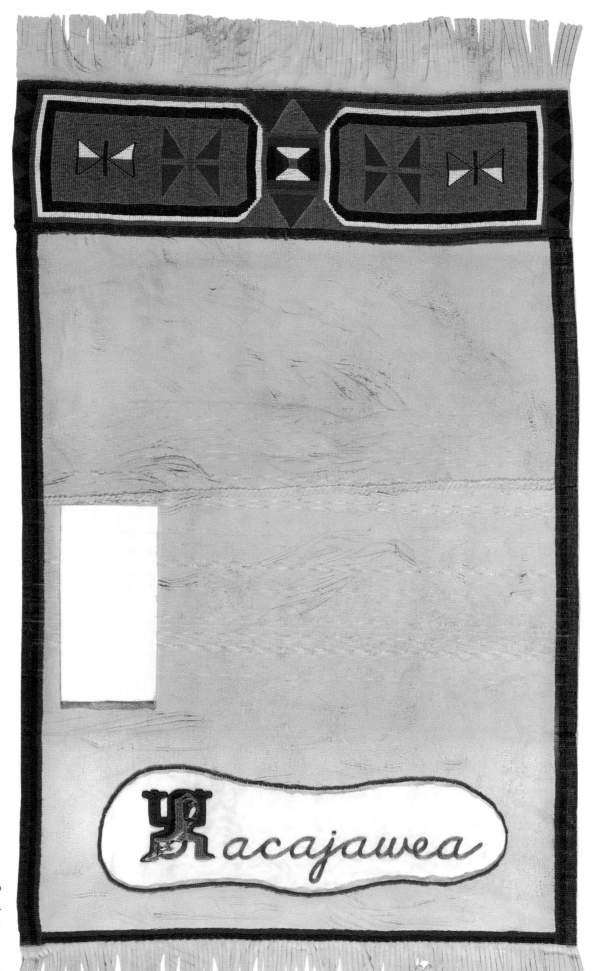

Sacajawea runner

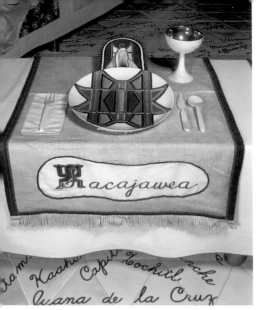
Sacajawea place setting

Despite her importance to Lewis and Clark, Sacajawea's name was almost lost to history; she could not have known that her help in opening up the Northwest Territory would lead to wholesale slaughter of Native American tribes and the near-destruction of Indian cultures. Aligned with the place setting for *SACAJAWEA* are the names of other women who experienced the trauma of European colonization. Sexual relations—both forced and voluntary—between native women and their conquerors produced interracial, intercultural societies with strong ethnic and class distinctions. Social conditions also gave rise to the independence movements that stimulated the growth of both political and feminist consciousness. Some of the important members of these movements are included in this stream of names.

Ojelia Uribe de Acosta
1900–1988; COLOMBIA

De Acosta attributed her early feminist consciousness to her childhood experiences when she saw the preferential treatment accorded to her father and five brothers. She became involved in radical politics in the hope of improving the position of women in Colombia. In 1926, Ojelia (more commonly known as Ofelia) Uribe married Guillermo Acosta, and when he became a judge, she assisted him in his work, acquiring considerable legal knowledge which she used to change the laws that enforced women's second-class citizenship. In addition to raising female consciousness, she argued that women

had to be educated to overcome internalized myths about their inferiority. She also worked on behalf of working and middle-class women, writing many articles in *Feminine Agitation,* a women's rights magazine she helped to found.

Anaconda
D. CIRCA 1503; NORTH AMERICA

In some Native American communities, concepts of gender were more fluid than those in Europe, which made it possible for "Two Spirit" Indian women to be warriors. This might explain the fact that Anaconda, better known as Anacaona, is recorded as having led a war party to destroy a Spanish settlement. The Spanish retaliated by sending troops to reestablish the enclave, capturing Anaconda and executing her.

Awashonks
CIRCA 1671; NORTH AMERICA

Awashonks was the leader of the Sakonnet Indians, who inhabited what is now Rhode Island. She led many battles against the encroaching English settlers. Her name was inscribed on a peace treaty at Plymouth Colony in 1671, but she was drawn into King Philip's War (1675–76)—the last major effort (and one of the bloodiest) by the Indians of southern New England to drive out the settlers. She eventually sided with the English in the belief that this was the best path to peace.

Maria Bartola
SIXTEENTH CENTURY; MEXICO

In 1519, Hernán Cortés set his sights on the highly developed Aztec Empire. Although the Spanish burned many of their documents, some records survived. Bartola left an account of the conquest of Mexico from the point of view of an Aztec experiencing the destruction of her world.

Ana Betancourt
1832–1901; CUBA

A feminist, Betancourt was actively involved in Cuba's struggle for independence from Spain. Her house was at the center of the independence movement, and she was active in the public debates about the new Constitution, speaking up to demand equal rights for women.

Capillana
D. 1549; PERU

In 1533 the Spaniard Francisco Pizarro conquered the Incan Empire. Capillana became his lover and advisor. After he was assassinated, she lived a secluded life. Perhaps it was then that she created her famous manuscript, which described many of the old monuments and plants of Peru, thereby preserving their history.

Rosa Chouteau
CIRCA 1875; NORTH AMERICA

In 1875, after the death of her uncle, Chouteau was elected chief of the Osage Beaver Band (in what is now western Missouri)—an unusual event because the Osage was a patrilineal tribe. About this, Chouteau said: "I am the first one [female chief] and expect to be the last one. I think my band obeys me better than they would a man."

Sor Juana de la Cruz
1648–1695; MEXICO

By the time Sor Juana was six, she could read all the books in her grandfather's extensive library. Eleven years later, she was paraded before forty university professors and made to "defend herself" in an examination of her intellectual merits. Eventually, she joined a convent where she was allowed visitors. She soon became famous for both her poetry and erudition, turning her quarters into a salon where she could engage in discourse with some of the most learned people of her day. In the decade during which England's Mary Astell argued for the education of women in *A Serious Proposal to the Ladies,* Sor Juana made a similar case in *La Respueta,* the first woman on the North American continent to pen such an argument. Unfortunately, she became a target of the Inquisition and had no choice but to give up her scholarly life and spend her time caring for the poor. After her death, a carefully hidden, unfinished poem was found in her quarters, a sign that, despite the intense pressures placed upon her, she never completely surrendered.

Josefa de Dominguez
1768–1829; MEXICO

Dominguez was a heroine of the 1820s Mexican independence movement from Spain. As wife of the mayor of the city of Queretaro, she had access to information about the Spanish troops which she passed on to the revolutionaries, allowing them to avoid arrest. Her actions became known to the Spaniards, and she was imprisoned. Later, she was offered compensation for her services to the Revolution but she refused, stating that she needed no reward for doing what was right. A statue honoring her as a symbol of Mexican emancipation stands in a plaza bearing her name in Mexico City.

Ehyophsta
D. 1915; NORTH AMERICA

Ehyophsta, called "Yellow-Haired Woman," was the daughter of the Cheyenne chief Stands-in-Timber. She belonged to a select group of female warriors and fought in the 1867 Battle of Beecher's Island in Kansas, led by the famous Cheyenne war chief Roman Nose. During an invasion by the Shoshone the following year, she saved a tribesman by courageously stabbing his opponent.

Candelaria Figueredo
1852–1924; CUBA

In 1868, Cuba was on the threshold of the Ten Years' War following the "Grito de Yara," the declaration of independence from Spain. Revolutionaries attacked the capital city of Bayamo, among them Figueredo, wearing a white dress, astride a horse, and bearing a flag made by her sister Eulalia. For three months the revolutionaries held the city, until Spain sent a major force to recapture it. Figueredo was imprisoned and then released. She fled to Florida but returned in time to celebrate Cuban independence in 1902. She was buried with full military honors, her coffin covered by the flag she had carried forty-five years earlier.

Maria del Refugio Garcia
CIRCA 1895–1973; MEXICO

Garcia, the secretary of the United Front for Women's Rights, was a delegate to the Women's National Congress in 1931, where she publicly accused the provisional president of Mexico of reneging on his promised support of women's suffrage. In retaliation, he had her imprisoned, but a huge women's demonstration forced her release. Garcia was then elected to federal office but was denied her seat because the constitution did not allow women to hold office. She appealed to the Supreme Court and won. She then used her position to improve working conditions and legal protections for women.

Isabel de Guevara
CIRCA 1515–AFTER 1556; SPAIN

The Spanish crown encouraged women to join colonizing missions to the New World. Isabel de Guevara was one of the few European women to accept the offer in the first wave of conquest and settlement. She sailed in 1534 with a group of 1,500 colonists—including twenty women—bound for the Río de la Plata region of what is now Argentina. The hardships they endured are revealed in Isabel's correspondence. Within three months of arrival, at the newly founded settlement of Buenos Aires, the combined effects of deficient supplies, famine, disease, and hostile Indians had killed two-thirds of the original party. In a letter she wrote in 1556 to Princess Juana of Spain, who was the head of the Council on the Indies, Isabel de Guevara wrote that her labors entitled her to a parcel of land, explaining that because hunger had caused the male colonists to "fade into weakness," "all of the work was left to the women." Her request was granted.

Jovita Idar
1885–1946; MEXICO/UNITED STATES

In 1903, Idar, who lived in Laredo, Texas, obtained a teaching certificate but became frustrated by the poor conditions in the schools. She resigned and went to work for *La Cronica*, a Spanish language newspaper founded by her father, writing weekly articles exposing the discrimination against Mexican children in the public schools along with the racism and brutality suffered by Mexicans in south Texas. She cofounded La Cruz Blanca (the White Cross), modeled on the Red Cross, and in 1911 helped organize the first Mexican Congress, one outcome of which was the formation of the League of Mexican Women. Idar became the first president of the group, whose primary focus was to provide education for poor children. She also established a free bilingual kindergarten and worked as a writer and educator until her death.

Marie Iowa
1786–1850; NORTH AMERICA

Marie Iowa, better known as Marie Dorion, was an Indian guide whose knowledge of the terrain and expertise in wilderness survival techniques also contributed to the opening up of the Pacific Northwest. Like Sacajawea, she had no way of knowing that her help would be repaid in a manner that would be catastrophic for native people.

Kaahumanu
1772–1832; HAWAII

Kaahumanu's father served as counselor to Kamehameha I, the head of a dynasty that governed Hawaii for more than a century. She was betrothed and then married to the king. In 1819 the king died and the throne passed to Liholiho, the son of one of his other wives (Kaahumanu had no children). Dressed in warrior's clothing, she challenged his succession, announcing that the king had appointed her coruler. She used her position to enact many reforms, establishing educational rights and schools for women and passing laws to rid the islands of the social disruption and sexual exploitation of women that had been introduced by European traders.

La Malinche
SIXTEENTH CENTURY; MEXICO

One of the most controversial female figures in Mexican history is Dona Marina or La Malinche. The daughter of a noble Aztec family, after her father's death Malinche was turned over by her mother to a passing trader, who then offered her to Cortés. By this time, Malinche had learned various languages and dialects, and she became Cortés's interpreter and then his lover. Because of her relationship with him, Malinche is still viewed by many as a traitor, when, in reality, she probably saved the lives of thousands of Indians by making it possible for Cortés to negotiate with rather than slaughter them.

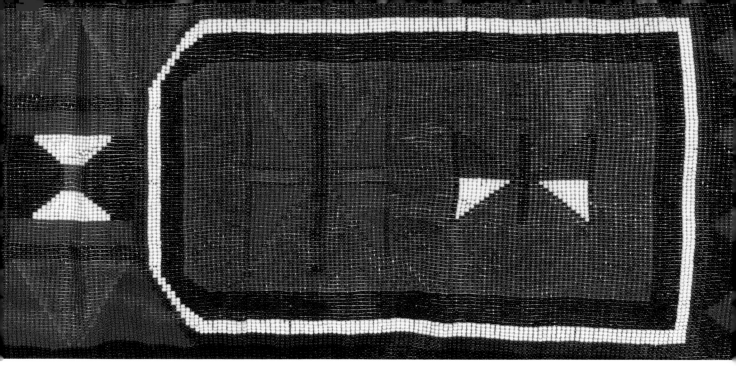

Detail, *Sacajawea* runner back

Maria Montoya Martinez

LATE 1880S-1980; NORTH AMERICA

Martinez, a Tewa Indian from the pueblo of San Ildefonso, now part of New Mexico, became an acclaimed craftswoman, perfecting black on black pottery, a technique that had been lost for almost seven hundred years. Not long after her marriage to Julian Martinez, Maria—who already had a reputation as an excellent ceramicist—was asked to replicate some prehistoric pottery styles that had been discovered in an archeological excavation near her home. Martinez and her husband began to collaborate. At first only Maria signed her name, even though Julian did the painting, because pottery was considered women's work. Soon their entire family learned the process, and in the 1920s they began teaching their techniques to others. The industry they built benefited their entire pueblo and continues to flourish.

Carlota Matienzo

1881-1926; PUERTO RICO

After attending the University of Puerto Rico and Columbia University in New York, Matienzo returned to her native Puerto Rico, in part because she wanted to become involved with some of the organizations working there to achieve female suffrage. (Literate women were granted the right to vote in 1929, and universal suffrage was achieved in 1936.) Matienzo was particularly interested in transforming the public school system and was post-

humously honored by the female students at the University of Puerto Rico, who named a hall after her.

Luisa Moreno

1907-1992; UNITED STATES

Born into an upper-class Guatemalan family, Moreno attended schools in both the United States and Guatemala. With the onset of the Depression, she founded a Latina garment worker's union, and in 1935 she became a professional labor organizer for the American Federation of Labor (AFL) and then for the Congress of Industrial Organizations (CIO). Thanks to her efforts, thousands of cannery workers were unionized, 75 percent of whom were women. In 1939, she organized the Congress of Spanish Speaking Peoples, the first Latino civil rights assembly, to discuss labor conditions and police brutality. As a result of her activities, Moreno was deported to Mexico in 1950 on the grounds that she had once been a Communist Party member.

Mary Musgrove

CIRCA 1700-1763; NORTH AMERICA

Prior to the early eighteenth century, most of Georgia was home to a southeastern alliance of Indians known as the Creek Confederacy. Mary Musgrove was the daughter of a European trader and a woman from an influential Creek family. She and her first husband, John Musgrove, established a fur trade with the Creeks. When the first settlers arrived, she served as interpreter and cultural liaison, acting to protect Indian

interests, to maintain peace, and also to expand her trading business. Later, she helped to avoid a war between the English and the Creeks through her skillful negotiations.

Isabel Pinochet

CIRCA 1870S; CHILE

Isabel Pinochet was active in bringing higher education to a broad cross section of women in her country. She also worked to open up professions, founding a women's college in 1875. Two of her graduates became the first female physicians in South America.

Pocahontas

1595-1617; NORTH AMERICA

Pocahontas was the daughter of Powhatan, the powerful chief of the Algonquin Indians of Virginia. When the English landed at Jamestown in 1607, the ship's captain John Smith was supposedly taken captive and brought before Powhatan, who welcomed him and ordered a feast. Then Smith was stretched out on two flat stones and threatened with death, at which point Pocahontas rushed in and rescued him. The girl's actions were actually part of an "execution and salvation" ritual that was traditional among Indians. Pocahontas has gone down in history primarily as the Indian princess who saved Smith's life, but it would seem more appropriate to honor her for her lifelong efforts to bring about peaceful relations between the colonists and the Indians.

Magda Portal
1901–1989; PERU

Portal was founder of a revolutionary political party that was against women's suffrage on the grounds that women would be influenced by both the Church and their husbands to vote conservatively. Like many Latin American women, Portal believed that the socialist revolution must take precedence over feminism and that once socialism was achieved, gender equity would follow, a belief that has proven untrue in most left-wing revolutionary movements around the world.

Maria Luisa Sanchez
1910–1980; BOLIVIA

Sanchez, a writer and translator, was the founder of the Women's Athenaeum, which worked for the continuation of the culture and education of women. The group's first president, she continued as head of the organization for twenty-eight years. After women gained the right to vote in Bolivia, Sanchez organized the first all-women's political conference in 1929 in La Paz. She tried to bridge the gap between liberal and radical women and stressed the importance of women working together to achieve equality with men.

Laura Torres
CIRCA 1900S; MEXICO

Torres, a labor organizer, was employed at a cigar factory where the women were forced to work seventeen hours a day for extremely low wages. One of the women tried to get food for her sick child from the company store and was refused because she had no money. When the child died, the women became outraged and went on strike. The local police were called in, but when Torres confronted them with the question, "Men of Mexico, will you shoot your sisters?" they retreated. The army was called in; they slaughtered the police and arrested the thousands of strikers. For their part in what came to be called the "Rio Bravo Massacre," the workers were sent to labor camps where most of them died.

Saaredra Villanueva
CIRCA 1916; BOLIVIA

Villanueva founded the Women's Legion for Popular Education, which investigated women's issues and commissioned articles that advocated rights for women and children. As an official in the Ministry of Defense, she helped establish the Intra-American Organization for Women, which expanded their educational opportunities throughout the region. In addition, she was a poet, teacher, and feminist who edited an anthology of women poets while pursuing her own writing, which focused on a range of female experiences.

Andrea Villarreal and Teresa Villarreal
CIRCA 1910; MEXICO

The Villarreal sisters were feminists and anarchists who were associated with the *Partido Liberal Mexicano* (Mexican Liberal Party), the radical political organization of the Mexican Revolution. They worked for the independence of Mexico and the liberation of women, founding a feminist club for political action and an influential feminist newspaper, *La Mujer Modern* (The Modern Woman).

Nancy Ward
1738–1822; NORTH AMERICA

Because of her bravery on the battlefield, Nancy Ward was named "*Aqi-qa-u-e*" or "Beloved Woman," a position that carried considerable weight in the Cherokee tribal government. She headed the Women's Council and sat on the Council of Chiefs. In 1781, she spoke during the settlement talks that occurred after a series of attacks on Cherokee towns. It was unprecedented for a woman to do so and surprised the commissioners. Her arguments for peace on behalf of European-born and Indian women contributed to one of the few treaties in which settlers took no Indian land. In 1923, the Nancy Ward Chapter of the Daughters of the American Revolution erected a monument on her grave.

Wetamoo
1640–1676; NORTH AMERICA

Wetamoo or Weetamoo was the daughter of the chief (or "Sachem") of the Pocasset tribe, located around present-day Rhode Island. When her father died, she became the "Squaw Sachem" or female chief. Wetamoo joined forces against the English with the leader of the Wampanoag Indians, dubbed "King Philip" by the settlers (thus, this war became known as King Philip's War). She led attacks on fifty-two of the ninety existing English towns, twelve of which were completely destroyed. By 1676, however, her forces had all been dispersed, and she drowned while trying to escape. The colonists cut off her head and displayed it on a pike in a nearby town.

Sara Winnemuca
1844–L891; NORTH AMERICA

Sarah Winnemuca or Winnemucca, a scout who became a translator and arbitrator for her tribe, was the daughter of the chief of the Paiute tribe of Nevada. Like many other Indian women, she attempted to achieve peace with the European settlers. One seminomadic tribe, the Bannock, kidnapped Winnemuca's father, her brother, and others from her village, hoping to force the Paiutes into a fight with the settlers. Winnemuca traveled over two hundred miles on horseback in order to rescue her family. In her book *Life Among the Piutes*, she described how the women of her tribe customarily took part in war, using her sister-in-law as an example: "One splendid woman that my brother had married . . . went out into the battlefield . . . and went into the front ranks . . . and she stood . . . as brave as any man."

Xochitl
CIRCA 900; MESOAMERICA

Xochitl was the wife of Tecpancaltzin, king of the Toltecs, a pre-Columbian society that flourished from the eighth to the twelfth centuries. They were accomplished temple builders, and their influence spread throughout Mesoamerica. Legend has it that Xochitl led female soldiers in a battle in which she was killed; the blood that flowed from her wounds foretold the destruction of Toltec culture.

Caroline Herschel

1750–1848

Born in Hanover, Germany, Caroline Herschel was secretly tutored by her father because her mother was opposed to female education. After he died, she moved to England to keep house for her brother William and became obsessed with his hobby of astronomy. She began as her brother's apprentice, grinding and polishing mirrors for his burgeoning telescope business. Her newfound passion developed into a career, and she soon became an astronomer in her own right. William gave Herschel her first Newtonian telescope, which she used to discover three new nebulae in 1783. She went on to identify eight new comets between the years of 1786 and 1797, her first being Comet Herschel (C/1786 P1). She was the first woman to discover a comet, and until the 1980s she held the record for the most comets discovered by a woman. In 1798 the Royal Astronomical Society published two catalogs of stars she had compiled, and she later completed her own (and her brother's) work by presenting a star catalog of 2,500 nebulae and clusters to the Royal Society, of which she became an honorary member. When Herschel was 32, King George III appointed her brother William as his personal astronomer, with an annual pension of two hundred pounds. Herschel received fifty pounds annually to be her brother's assistant, making her the first woman in science to receive recognition for her academic work and research.

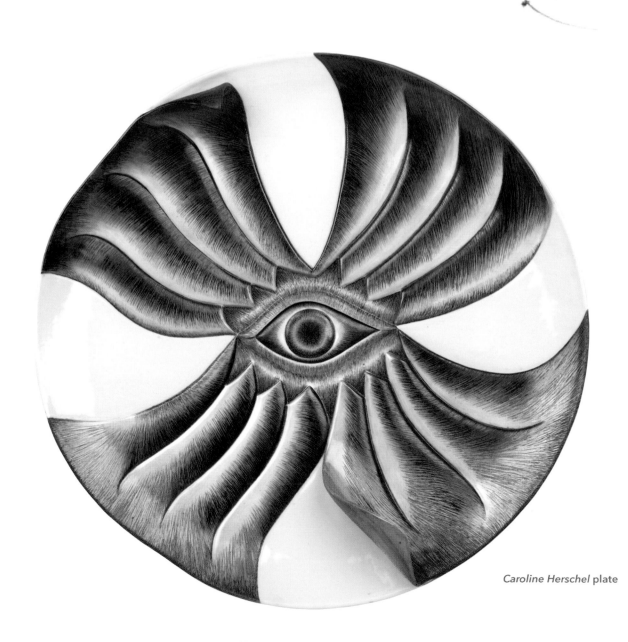

Caroline Herschel **plate**

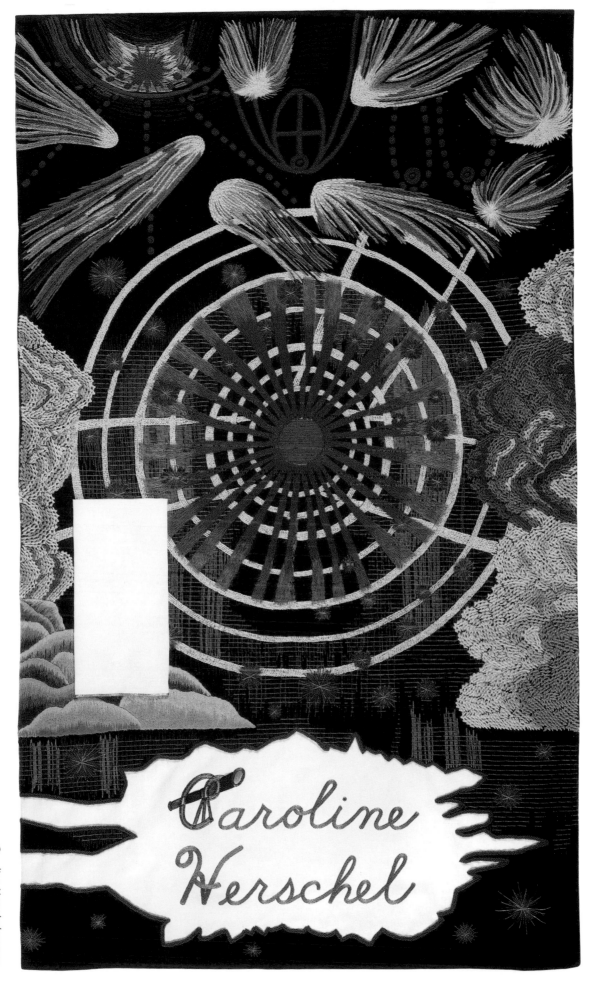

Caroline Herschel runner

Although many women became amateur scientists in the seventeenth century, in order for them to become professionals, they had to overcome limited educational opportunities, discrimination, and deeply entrenched ideas about women's intellectual inferiority. Associated with *CAROLINE HERSCHEL'S* place setting are the names of other women who attempted to work in science, medicine, and related fields, many in the shadow of male relatives.

Genevieve d'Arconville
1720–1805; FRANCE

D'Arconville wrote on chemistry, medicine, natural history, and philosophy, though it is unclear whether she did this as an amateur or a professional. She also undertook work in osteology (a branch of anatomy dealing with the bones), translating a major text on the subject and supervising illustrations drawn directly from cadavers.

Baroness de Beausoleil (Martine de Bertereau)
FL. 1600–1630; FRANCE

An expert douser from a mining family, Martine de Bertereau married the mining engineer Jean du Chatelat, the baron of Beausoleil. (Although used for locating water, dousing was originally employed to search for minerals and was associated with the occult.) Between 1610 and 1626, she and her husband visited mines throughout Europe; they had been commissioned to prospect for new mineral deposits and give advice on established mines. In 1642, they were arrested and accused of witchcraft. He died in the

Bastille prison in 1645; it is unclear whether she was sent to another prison or executed.

Katherine Bethlen
1700–1759; HUNGARY

In 1710, Katherine or Kata Bethlen's husband Prince Michael Apafi II died, leaving her a prosperous landowner. She used her wealth to support a wide variety of scientific activities; she also wrote about scientific developments.

Louyse Bourgeois
1563–1638; FRANCE

For twenty-six years, Louyse (Louise) Bourgeois acted as midwife to the French court, becoming known as the "mother of obstetrics" after she delivered Marie de Medici's first child before an audience of two hundred people. Her 1609 book *Observations* was instrumental in the advancement of midwifery as a science. In 1635, a group of midwives petitioned the king to allow Bourgeois to teach a public course in obstetrics, but their request was denied.

Annie Jump Cannon
1863–1941; UNITED STATES

Cannon studied astronomy at Wellesley and was later hired to work at the Harvard College Observatory. The many women on the staff there were referred to as "computers" because they handled star classification and complex data reduction. Cannon was the most famous, becoming curator in 1911. The world's leading expert on star classification, she received many honorary degrees; was appointed to numerous learned societies (including the Royal Astronomical Society in 1914); and won many prizes, including the Draper Medal of the National Academy of Science, the first woman to be so honored. As an ardent supporter of female scientists, Cannon would probably be pleased to know that the American Association of University Women presents an annual award in her name to a woman starting out in the field of astronomy.

Margaret Cavendish
1623–1673; ENGLAND

Cavendish, the duchess of Newcastle, wrote fourteen books on various subjects that are relevant to feminist theorists today. The first woman to write extensively about science, she experimented with microscopes and telescopes and published her findings under her own name, thereby shocking English society. In 1655, she penned these poignant words in *Philosophical and Physical Opinions*, written as an open letter to the most famous English universities: "We are shut out of all power and authority . . . our counsels are despised . . . the best of our actions are trodden down with scorn, by the over-weening conceit men have of themselves . . ."

Elizabeth Cellier
CIRCA 1662; ENGLAND

Cellier was a midwife and Catholic convert. The 1680 publication of her pamphlet, "Malice Defeated," so outraged Protestant authorities that she was fined one thousand pounds and pilloried for several days at sites where copies of her manuscript were burned. But with the accession to the throne of the Catholic king James II, her fortunes changed. In 1687 she presented him with a plan (which he accepted) for the establishment of a foundling hospital along with suggestions about how to reverse the high mother and infant mortality rates through the education and organization of professional midwives.

Emilie du Chatelet
1706–1749; FRANCE

Chatelet was a unique scholar of mathematics, the sciences, philosophy, and metaphysics. Her most noted achievement was the first (and only) translation into French of Newton's *Principia*. Along with her commentary and synthesis, this contributed to the development of Newtonian science, as her book made his ideas available to French mathematicians and scholars. Despite her many accomplishments, Chatelet is remembered primarily as Voltaire's companion. During the fifteen years they were lovers, they lived at her country estate, assembling a library equal to what would be housed in an eighteenth-century university.

Caroline Herschel place setting

Marie Colinet
CIRCA 1560–1649; SWITZERLAND

Colinet learned medicine by assisting her husband, a famous surgeon named Wilhelm Fabry. He recorded a spectacular case in which Colinet cured a man whose ribs were so severely injured that she had to wire them in place. She also devised a method of using hot bags to dilate the uterus during childbirth, and in 1627 she was the first to employ a magnet for extracting steel from the eye, a method that historians have wrongly attributed to her husband.

Angelique de Coudray
1712–1789; FRANCE

The author of a textbook on gynecology, Coudray, a midwife, was one of the first people to bring a scientific approach to the discipline and popularized the use of mannequins in midwifery education. She made it her mission to educate other European midwives, traveling to the Austrian low countries to teach her skills there.

Frau Cramer
1655–1746; HOLLAND

Because Dutch midwives were members of the guild of surgeons and worked under municipal ordinances, Cramer was able to study medicine with doctors whose expertise was in obstetrics. For fifty-two years she kept a journal of all the deliveries she made, which was given to the Medical Association of Holland and finally published in 1926.

Maria Cunitz
1610–1664; GERMANY

Cunitz's abilities in astronomy were so outstanding that she was called "Urania Propitia," "she who is closest to the stars." In 1627, the *Rudolphine Tables* were published: the first laws of planetary motion, based on Kepler's model of elliptical orbits. In 1650, Cunitz translated and simplified Kepler's works, making them accessible to scholars. For several centuries, her translations were the only ones available. Sadly, in 1656 her home, library, and equipment were destroyed in a fire, as were her letters to and from scholars all over Europe.

Caroline Herschel illuminated capital letter

Justine Dietrich
1636–1705; GERMANY

Whether Dietrich, also known as Justina Siegemund, was a physician or a midwife is not known, but she published and illustrated a textbook on midwifery, which demonstrated the most advanced techniques of the time. Her book helped rural midwives, who had little access to sophisticated training, to become more highly skilled.

Jeanne Dumee
EIGHTEENTH CENTURY; FRANCE

A mathematician and astronomer, Dumee wrote books that brought scientific information to the public, including a defense of Copernicus's findings. She also championed the right of women to study science, challenging the prevailing notion that a woman's brain was smaller in size (and therefore inferior) to that of a man.

Sophie Germain
1776–1831; FRANCE

At the age of thirteen, Germain read about Archimedes (287–212 BCE), considered one of the greatest mathematicians of all times. Although her parents considered mathematics unsuitable for a girl, she was determined to study on her own. When the Ecole Polytechnique opened in 1795, she obtained lecture notes from male students, since women could not attend. She then submitted a paper under a male student's name to a renowned mathematician; he saw talent in the effort and, despite her sex, became Germain's sponsor. In 1816, she won the Grand Prix of the French Academy of Sciences for her work on the vibration of elastic surfaces, a theory that made possible the construction of the Eiffel Tower. Her importance is also attested to by the "Sophie Germain prime," which is based upon her theories about prime numbers.

Louise le Gras
1591–1660; FRANCE

In 1623, as her husband was wasting away from illness, Le Gras had a vision while praying in which she saw herself serving the poor and living in a community of religious women. She inscribed this vision on a parchment that she carried with her to remind her that God was guiding her life. Ten years later she founded the Daughters of Charity, the first order of non-cloistered nuns, whose 25,000 members now serve around the world.

Anne Halkett
1623–1699; ENGLAND

Halkett grew up near the center of court life under James VI. Her mother arranged for her to be tutored in a range of subjects deemed suitable for an upper-class girl, including religious studies. She was a witness to many important events, which she recorded in her *Memoirs*; she also wrote a twenty-one-volume series of *Meditations*. Her work, like that of many women, has been critically marginalized despite the fact that her involvement in the social, political, and religious changes taking place during her lifetime make her manuscripts a rich repository of information.

Detail, *Caroline Herschel* runner back

Maria Kirch
1670–1720; GERMANY

Maria Winkelman Kirch was an astronomer who worked with her husband Gottfried in making tables showing the positions of the sun. In 1702 she discovered a comet; eight years later she published *A Discourse on the Approaching Conjunction of Jupiter, Saturn, Etc.* Her daughters also became astronomers, working for the Berlin Academy of Sciences.

Mary Lamb
1764–1847; ENGLAND

Born into a poor family, Lamb was educated along with her brothers Charles and John but was forced to give up her schooling and work as a needlewoman to help support her brothers while they completed their studies. She was also expected to care for their invalid mother. In 1796, Lamb killed her mother with a kitchen knife. She was declared temporarily insane and placed under the guardianship of Charles. Despite her mental condition she was able to write and, in 1807, she and Charles published *Tales of Shakespeare*, a series of prose adaptations of Shakespeare's plays, intended for children. Though they each contributed, only Charles's name appeared on the title page, and the highly successful book established his literary reputation. Lamb and her brother published two more collaborative works for children. At some point, she wrote a fascinating but little-known essay on needlework in which she put forth the then-radical proposition that women should be paid for the work they do in the home, an argument that is still not heeded today.

Mother Hutton
EIGHTEENTH CENTURY; ENGLAND

The therapeutic properties of the foxglove plant (digitalis) have been known since the days of the Roman Empire, but it was Mother Hutton (as she was called), a biologist and pharmacist, who first used digitalis extract as a treatment for heart conditions. In 1785, Dr. William Withering bought a prescription from her, analyzed its content, then arranged for the inclusion of digitalis in the new London Pharmacopoeia. Ever since, the product has been associated with his name rather than hers.

Josephine Kablick
1787–1863; CZECHOSLOVAKIA

As a result of the Enlightenment, many authors began writing scientific books for women. Kablick, a botanist and naturalist, began her career by collecting specimens for her own herbarium as well as for schools in Czechoslovakia and other parts of Europe. Many fossil animals and plants are named in her honor. But after 1830, when botany became a modern science, women's participation declined as they were forced out of the field by university-trained scientists.

Marie Lavoisier
1758–1836; FRANCE

When she was only thirteen, Marie Anne Paulze married Antoine Lavoisier, known as the father of modern chemistry, becoming his laboratory assistant and then his collaborator. She learned Latin and English in order to translate books that might be useful to him, wrote descriptions of his experiments, and studied engraving in order to execute the illustrations for his textbook—the first on modern chemistry. After his death, she edited his memoirs and distributed them to prominent scientists and organized a scientific

salon that allowed her to maintain relationships with the leading intellectuals of the time.

Hortense Lepaut
1723–1788; FRANCE

An important astronomer, Lepaut, better known as Lepaute, investigated the oscillation of pendulums, studied Halley's comet, charted the path of eclipses, and edited the astronomical annual of the Academy of Sciences, among other accomplishments.

Dorothea Leporin-Erxleben
1715–1762; GERMANY

Leporin-Erxleben was initially trained in medicine by her physician father. She demonstrated such talent for the subject that Frederick the Great permitted her to attend the university. But her studies were interrupted, first by illness and then by marriage and the birth of four children. After her husband died, she resumed her studies, becoming the first woman to graduate from a medical school in Germany. She successfully practiced medicine for a number of years, but despite her example, medical schools refused to admit any other women for over 150 years.

Jeanne Mance
1606–1673; CANADA

In 1641, Mance crossed the Atlantic from France to Canada, ending in Montreal, which she helped to found. Mance built the first hospital there, subsequently acting as its primary physician, nurse, administrator, and fundraiser. She returned to France to recruit nurses, persuading the women of Louis XIII's court to support her institution. In 1902, the Jeanne Mance School of Nursing was founded in Montreal.

Anna Manzolini
1716–1774; ITALY

Manzolini held the chair of anatomy at the University of Bologna for many years. The wax anatomical models that she created were known throughout Europe, particularly those of the sense organs and the urogenital and cardiovascular systems. These became the prototypes for all subsequent models; after her death, they were viewed as among the most prized possessions of the university.

Martha Mears
CIRCA 1797; ENGLAND

In 1797, Mears wrote *Candid Advice to the Fair Sex on the Subject of Pregnancy*, a practical book on gynecology and obstetrics in which she stressed the importance of hygiene during pregnancy and the naturalness of childbirth. This was an attempt on her part to dispel certain unscientific beliefs concerning pregnancy, including the notion that it was a pathological state.

Giustina Renier Michiel
1755–1832; ITALY

Salons became an important vehicle by which women were able to participate in intellectual discourse, create networks of professional and personal relationships, and influence history albeit through men. Renier Michiel established a famous salon in Venice; she also wrote a six-volume historiography (writing *about* rather than *of* history, usually in a narrative form) of Venice and participated in debates about the new Italian constitution.

Maria Mitchell
1818–1889; UNITED STATES

Maria was the daughter of William Mitchell, a dedicated astronomer and teacher who delighted in his daughter's talent for science. Although her father provided her with a basic education, she had to continue her training on her own, as women were not yet welcome in universities. Nevertheless, in 1848, she became the first female member of the American Academy of Arts and Sciences and later became one of its "fellows." When Vassar opened in 1865, she was offered the chair of astronomy, which she held for twenty-three years. An innovative and inspiring educator, she refused to give grades because she believed the work, not the reward, was important. Through her achievements, her tutelage, and her pioneering efforts, Mitchell opened up an exclusively male field to American women.

Mary Somerville
1780–1872; SCOTLAND

In 1825, Somerville began a series of experiments on magnetism, presenting a paper on the subject to the Royal Society, which received considerable attention. With the exception of the astronomical observations of Caroline Herschel, this was the first paper by a woman to be read to the Royal Society and printed in its journal. In 1831, she published *The Mechanism of the Heavens*, which brought current mathematical thinking to a broad audience. At Cambridge, the book became a required text for higher mathematics students. In addition to becoming one of the leading scientific writers of her day, she was also an ardent supporter of women's education. The philosopher John Stuart Mill (1806–1873) requested that she be the first to sign the petition for women's suffrage drawn up by him and his wife, the radical thinker Harriet Taylor (1807–1858).

Dorothy Wordsworth
1771–1855; ENGLAND

Known primarily as the devoted muse of her brother, renowned poet William, Dorothy Wordsworth is entitled to an independent place in English literature as one of the earliest authors on the beauties of nature. In 1931, Beatrix Potter, author of *Peter Rabbit* and other children's books, bought the house where Dorothy and William had lived. In the barn, Potter discovered Dorothy's journals, published in 1933 as *The Grasmere Journal*. The journal and Wordsworth's other works revealed how much her brother relied on her detailed observations and borrowed freely from her writing. In her journal, she also wrote of her endless chores as William's housekeeper, noting, "William, of course, never does anything."

Mary Wollstonecraft

1759–1797

Mary Wollstonecraft became acutely aware of women's oppression by watching her violent father constantly bully her mother. As soon as possible, she left home, opening a small girls' school. She drew on these experiences to argue for women's right to education in *Thoughts on the Education of Daughters*, published in 1786. Soon, she obtained a job as a translator and literary advisor to Joseph Johnson, a London publisher of radical texts. Through him she became acquainted with some of the most prominent thinkers of the day.

Like many women of her era, she looked to the events of the French Revolution to bring about the emancipation of women. But she was soon disillusioned, particularly by the contrast between the heady talk about the "rights of man" and the grim realities of the lives of many women. In late eighteenth-century England, women and children were the property of their husbands. In a rage, she wrote *A Vindication of the Rights of Woman*, which made her famous overnight.

In this book, Wollstonecraft took a radical philosophical step in arguing that the democratic principles that defined the French and American revolutions must be extended to women; if women failed to become men's equals, the progress of human knowledge would be halted. And if women were to contribute to the development of the human race, their education would have to prepare them to do so, something that could only happen if men and women were similarly taught.

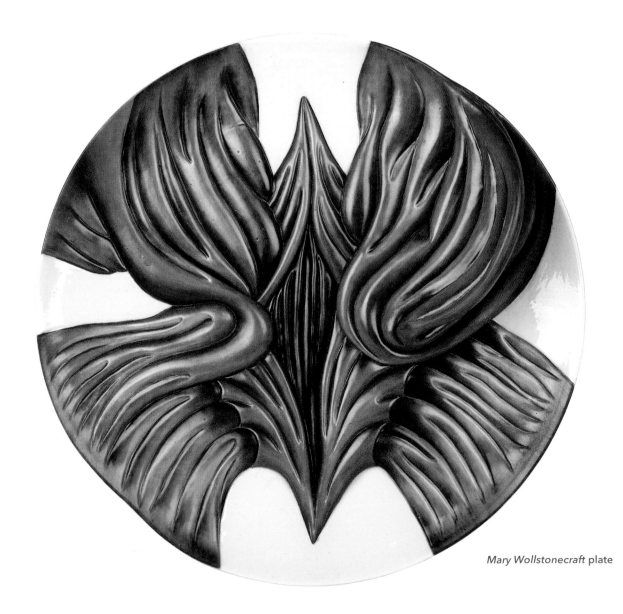

Mary Wollstonecraft plate

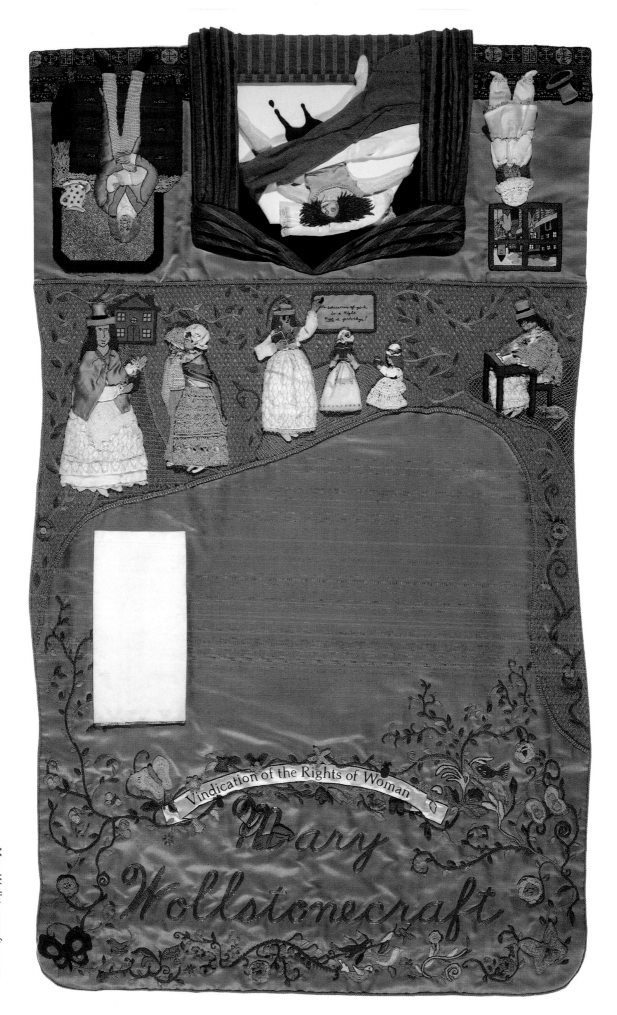

The education of girls is a Right Not a privilege!

Vindication of the Rights of Woman

Mary Wollstonecraft

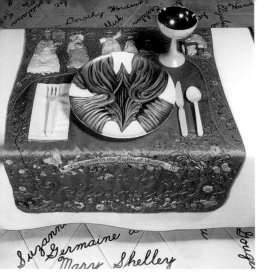

Mary Wollstonecraft place setting

The names grouped with the *MARY WOLLSTONECRAFT* place setting include women associated with the French Revolution, writers, explorers, and women who influenced society through their salons. These were often the breeding ground for feminist ideas because women not only presided over the intellectual discourse but also actively participated. Many of the salonists supported the French Revolution, only to discover that some of the freedoms for women ushered in during its early fervor were quickly swept away by the Napoleonic Codes.

Leonor d'Almeida
1750–1839; PORTUGAL

The self-educated d'Almeida created a salon that introduced the works of English, French, and German writers, thereby influencing the development of Portuguese literature.

Josefa Amar
1749–1833; SPAIN

The educated daughter of a physician, Amar wrote two treatises aimed at trying to improve women's lives through moral, social, and intellectual education. Some of her notions about motherhood were quite revolutionary in a conservative Catholic country where Enlightenment ideas were slow to arrive. Amar translated a number of English and Italian writers in an effort to make their liberal thinking more widely available in Spain.

Bridget Bevan
1698–1779; WALES

Bevan, the daughter of a philanthropist, was an important force for education in Wales, where until the mid-eighteenth century education was essentially nonexistent. In 1734, a preacher names Griffith Jones devised a scheme for establishing temporary schools that would educate both children and adults. Thanks to the financial support of Bevan (or Mother Bevan, as she was called), a network of schools was established. After Jones's death in 1761, she managed the schools herself until she died. As a result, by the end of the eighteenth century, Wales was one of the few countries with a literate majority.

Isabella Bird Bishop
1831–1904; ENGLAND

Bishop broke out of the circumscribed life of a middle-class woman in Victorian England through adventurous travels, begun when her father, a semiretired minister, sent her to North America to do research about the state of Christianity there. For the rest of her life she preferred a nomadic existence, saying; "I always feel dull and inactive when I am stationary . . . but that is why I can never stay anywhere." She published nine popular books about her adventures and was the first woman elected to the Royal Geographical Society.

Jeanne Campan
1752–1822; FRANCE

Campan was a friend of Marie Antoinette (1755–1793) and also served as tutor to the royal children. In 1792, she founded a school for girls and directed it until she was appointed the principal of an academy established by Napoleon. She also wrote a number of books, most of which were published posthumously, including a memoir about her relationship with the ill-fated queen.

Elizabeth Carter
1717–1806; ENGLAND

Carter was educated by her father, a clergyman and accomplished linguist. She made a conscious decision not to marry in order to preserve her freedom to study and write. Among her most celebrated works was the translation of the writings of the Stoic philosopher Epictetus (55–135 CE), who promoted the idea that human beings are free to control their lives. She belonged to the "Bluestocking Society," a salon known for its support of women's rights and the first of its kind in England. The term "bluestocking" dates back to fifteenth-century Venetian salons, when the aristocrats who gathered were labeled "*Della Calza*," literally translated as elaborately embroidered leg coverings, which is what the men and women often wore. By the late sixteenth century, the fashion had spread to the salons of Paris, becoming the rage among literary women. In the English salons, women wore blue worsted stockings, casual dress that would be the equivalent of blue jeans today. To "wear your blues" became a metaphor for evenings of intellectual discourse; over the years, the term "bluestocking" came to represent a learned and ambitious woman.

Charlotte Corday
1768–1793; FRANCE

From an aristocratic but impoverished family, Corday supported the French Revolution but was opposed to the "Terror," the mass killings condoned by its radical faction, particularly Jean-Paul Marat (1743–1793), who made up the death lists from which both the guilty and innocent were executed. After killing him in his bathtub (a scene memorialized in the 1793 painting by Jacques-Louis David), she was arrested, tried, and guillotined. In her "Speech to the French who are Friends of Law and Peace," she explained: "I have killed one man to save 100,000." Although her act was condemned at the time, history eventually saw her as having given her life to rid the country of a monster.

Yekaterina Dashkova
1744–1810; RUSSIA

One of the best educated women of her time, Dashkova played a major role in the coup that brought Catherine II to power, and the empress appointed her as director of the Russian Academy of Arts and Sciences. She was also named president of the Russian Academy of Language and Literature. During her tenure, she established public lectures and organized a translator's department that made available the best foreign literature. She was instrumental in the writing of a six-volume dictionary of the Russian language, which she viewed as critical to the nation's development. She also published and wrote for several periodicals, translated foreign works, wrote poetry and plays, and was a prominent patron of the literary arts.

Celia Fiennes
1662–1741; ENGLAND

Fiennes traveled extensively around England, Scotland, and Wales, riding sidesaddle and in a "spirit of pure curiosity" according to her journals, which were lost for 140 years and finally republished in 1888. Her remarkable writings, which encouraged women in the "study of those things which tend to improve the mind," provide valuable insights into the social and domestic attitudes of seventeenth-century England.

Olympe de Gouges
1748–1793; FRANCE

In response to the 1789 *Declaration of the Rights of Man* (the preamble to France's new constitution), Gouges, a playwright and journalist, wrote the *Declaration of the Rights of Woman*. In this work, she demanded equal rights for women in all aspects of public and private life. Although she had greeted the outbreak of the Revolution with hope, she became disenchanted because the male revolutionaries were proving themselves enemies of the emancipation of women. She covered the walls of Paris with signed bulletins exposing the ways in which the new government was betraying the women who had helped put it in power. She was arrested, and at her trial, she cried out to the women in the crowd, "What are the advantages you have derived from the Revolution? Slights and contempt more plainly displayed." Gouges was sentenced to death and guillotined.

Elizabeth Hamilton
1756–1816; SCOTLAND

Hamilton's first novel, *Translations of the Letter of a Hindoo Rajah* (1796), was in part a tribute to her deceased brother Charles, who had spent some years in India. She also wrote on the subject of female education in her most ambitious work, *Memoirs of the Life of Agrippina* (1804), intended to interest young women in some of the issues of morality raised by classical history. At this same time, she moved from London back to Scotland, where she became an active participant in the cultural life of the country.

Mary Hays
1760–1843; ENGLAND

Although Hays is primarily remembered for having introduced Mary Wollstonecraft to her future husband William Godwin (1756–1836), she was an important figure in her own right. In 1803, she published the six-volume *Female Biography; or Memoirs of Illustrious and Celebrated Women, of all Ages and Countries*, a compilation of entries highlighting women of influence or intellectual achievement (like Christine de Pisan's). Her last known publication was *Memoirs of Queens, Illustrious and Celebrated* (1821), another effort to recognize the important contributions of women, in this case those of female rulers.

Marie de Lafayette
1634–1693; FRANCE

Lafayette's salon was the most aristocratic and learned in Paris, and she was an insider to the intrigues of the court, which provided her with material for her memoirs and novels. Several of the latter were written with others, something that was common at the time; also, because women didn't usually publish under their own names, their work was often attributed to the men with whom they'd collaborated. Such was the case for two of Lafayette's novels—*Zaide* (1670) and *La Princesse de Cleves* (1678)—though she was probably the principal author. These two works are considered precursors of the psychological novel.

Francoise de Maintenon
1635–1719; FRANCE

Born Francoise d'Aubigne, Maintenon started out as tutor to the children of Louis XIV, then became his mistress, and later, secretly, his wife. For forty years, she influenced French government and education. She was responsible for the passage of laws that greatly improved the quality of life for the French people, and she established educational institutions for poor young women, including the Royale Maison de Saint-Louis, to which she retired after Louis's death. Historians value Maintenon's letters for what they reveal about the king and his policies. There are also a number of extant dialogues that she developed for the students at the Royale Maison. As yet, there is no complete edition of her writings available.

Mary Manley
1672–1724; ENGLAND

Journalist, novelist, and playwright Manley published more than ten works. After the 1709 publication of *Secret Memories*, which challenged the ideas of the ruling Whig Party, she was arrested and charged with libel, but later released. She was also a member of the group known as the "Fair Triumvirate of Wit," which included the popular and controversial figure, feminist writer Aphra Behn (1640–1689). In 1711, Manley became an influential newspaper editor.

Theroigne de Mericourt
1762–1817; FRANCE

Mericourt, who cut a dashing figure in a man's riding habit and red jacket, advocated the abolition of male privileges, insisting that women should be allowed to vote. She also urged women to arm themselves and join men on the battlefront. However, the French Revolution did not treat feminists kindly, even those like Mericourt who had worked for it. She was imprisoned twice and savagely beaten by working women who did not like her ideas or her defiance of traditional roles. She never recovered from the beating and suffered from headaches and depression for the rest of her life.

Mary Monckton
1746–1840; IRELAND

One of London's leading socialites and a member of the Bluestocking Society, Monckton drew a wide range of celebrities to her salon. Later, she attracted the attention of Charles Dickens (1821–1870), who used her as a model for Mrs. Leon Hunter, the famous hostess in his first novel, *The Pickwick Papers*. She also was painted by the English Rococo artist Joshua Reynolds (1723–1790).

Elizabeth Montagu
1720–1800; ENGLAND

For fifty years, Montagu was the pre-eminent intellectual hostess in London; it was at her home that the group known as the Bluestockings assembled, facilitating female intellectual visibility and introducing the notion that women's lives were worthy of consideration. Her "conversation parties" were elaborate evening affairs at which literature was frequently discussed.

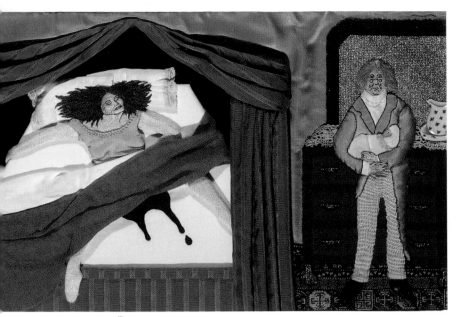

Detail, *Mary Wollstonecraft* runner

Mary Wortley Montague

1689–1762; ENGLAND

Though from a noble and wealthy family, whatever learning Montague, or Montagu, eventually possessed was acquired through her own efforts. She first began to travel when her husband Edward Wortley Montague was appointed ambassador to Turkey, recording her experiences in *Turkish Embassy Letters* (1763), one of the finest examples of the epistolary genre. When the Montagues returned to England, Mary introduced the Turkish practice of inoculating children against smallpox with a weakened strain of the disease in order to induce immunity. Although the physician Edward Jenner (1749–1823) would eventually be credited for the vaccine, it was Montague who pioneered this approach. A gifted linguist, she was also a prolific writer of diaries, essays, and poems and a translator of many plays from French and Latin.

Hannah More

1745–1833; ENGLAND

More and her sisters were educated by their village schoolmaster father. In 1738, her eldest sister Mary had opened a girls' school; Hannah continued her studies there and subsequently became a teacher at the school. She then moved to London, engaging in the Bluestocking circle; her poem, "The Bas Blue; or Conversation," was a witty celebration of that group. In

1788, to coincide with the first parliamentary debate on the slave trade, she published the poem "Slavery," one of the most important antislavery documents of the abolition period. She then turned her attention to the issue of female education, publishing the proto-feminist *Strictures on the Modern System of Female Education* in 1799, followed in a few years by an ambitious book on deportment called *Hints Towards Forming the Character of a Young Princess*. In later life, she devoted much of her time to religious writing; her commentaries were among the most widely read books of the day.

Suzanne Necker

1739–1794; SWITZERLAND

After the death of her parents, Necker went to Paris and married a wealthy banker who became the finance minister under Louis XVI (1754–1793). She began to devote herself to prison and hospital reform. As her husband's position provided her access to important figures and sufficient funds, she opened an influential salon that marked the transition between the two phases of such gatherings, from the more literary to the political. As the Revolution approached, the radical opinions of her daughter, writer Germaine de Staël, gave Necker's salon a semi-revolutionary character, which exerted considerable influence on contemporary affairs.

Ida Pfieffer

1797–1858; AUSTRIA

"When I was but a little child, I already had a strong desire to see the world," wrote Pfieffer (more commonly known as Pfeiffer) in *A Visit to Iceland and the Scandinavian North*, published in 1853. Although marriage and family prevented her from traveling until she was forty-five years old, she made up for it by journeying nearly two hundred thousand miles, recording her observations nightly and collecting artifacts wherever she went. Her travel books became so popular that whenever she announced an upcoming trip, railroad and steamship companies would offer her free transportation. After she died, her collection was distributed among British and European museums.

Karoline Pichler

1769–1843; AUSTRIA

Pichler published sixty romances and plays whose productions she supervised. Like many women writers, her work has not been widely translated. As a result, she is known more for her outstanding salon, visited by the likes of Wolfgang Amadeus Mozart, than for her literary oeuvre.

Jeanne de Pompadour

1721–1764; FRANCE

As the mistress of Louis XV, Pompadour wielded greater power than any other royal mistress. In addition to influencing government policy and the king's choice of ministers, she was an important patron of the arts, constructing a theater at the palace of Versailles and supporting both the Gobelin tapestry workshop (which produced magnificent hangings in an ornate, Baroque style) and the Sevres porcelain factory (celebrated for its glazes and background colors, including "rose Pompadour," a hue named after the royal mistress).

Mary Radcliff

1746–AFTER 1810; ENGLAND

Although she had inherited a fortune from her father, Radcliffe found herself penniless after her alcoholic husband squandered her wealth. She eventually found a position as a governess to an aristocratic Scottish family. Motivated by the constraints placed on the women around her as well as her own experiences, Radcliffe wrote *The Female Advocate, or An Attempt to Recover the Rights of*

Women from Male Usurpation (1799), a groundbreaking analysis of women's oppression and the close relationship between economic exploitation and patriarchal power.

Jeanne Manon Roland
1754–1793; FRANCE

Jeanne Manon or Jeanne-Marie Roland, enamored of revolutionary ideals, was at the center of the Girondists, a group of moderates who desired a constitutional government. The discussions in her salon centered on transforming France from a monarchy to a republic and Roland became increasingly outspoken. Her husband Jean rose to prominence in the Revolution largely as a result of her political connections. When the Girondist party was overthrown by the more radical Jacobins, Roland was arrested. While in prison, she wrote a letter protesting her incarceration, then began work on her life story. Given a mockery of a trial, Roland was taken to the guillotine, pronouncing the now immortal words, "O Liberty, what crimes are committed in thy name!"

Alison Rutherford
1713–1794; SCOTLAND

Arriving in Edinburgh in 1731, Rutherford established a literary salon patterned on those in Paris, attracting leading artists and political figures and making her the "queen" of Edinburgh society. She became known for character studies of her contemporaries, satirical poems about government officials, and songs and serious poetry. Throughout her lifetime, she supported and encouraged numerous women and their work.

Caroline Schlegel
1763–1809; GERMANY

Schlegel grew up in the university atmosphere of Gottingen where her father was a professor. With her husband, the philosopher August Wilhelm von Schlegel (1772–1829), she became involved in the German Romantic movement, which was at the center of a renewal that influenced national literatures all over the Western world. Schlegel played an important role, translating manuscripts and essays and exchanging letters with many of the movement's leading figures. After her divorce from her first husband, she

married another important member of this group, the philosopher Friederich Wilhelm Joseph von Schelling (1775–1854).

Mary Shelley
1797–1851; ENGLAND

Shelley, the daughter of Mary Wollstonecraft, was never able to forget that her infamous mother died of complications resulting from her birth. When she was seventeen, she ran away with the then unknown poet Percy Shelley (who was married at the time), thereby provoking her father to disown her. By the time she was twenty-two, she had borne four children (three of whom died), and then in 1822 her husband drowned. Fortunately, she had already published *Frankenstein*, a popular book that would remain a best seller in England for thirty years, which allowed her to support herself and her remaining child. Although best known for this book, Shelley wrote numerous other works. By the time she died, she had established a literary reputation entirely independent of her famous husband.

Germaine de Staël
1766–1817; SWITZERLAND

Germaine de Staël was virtually raised in the salon of her mother Suzanne Necker, which exposed her to progressive ideas. In 1794 she established her own salon, which became a powerful center for political opposition to Napoleon, whom she had originally supported. By then, she had authored a number of works, including the successful novel *Delphine*. She took up residence at her estate in Switzerland after Napoleon exiled her for her outspoken resistance to his policies. Her principal work, *De L'Allemagne* (1810), the result of her tour of Germany, deeply influenced European thought. Threatened by Napoleon's police, de Staël fled to England and Russia, finally returning to France in 1815 after the emperor's downfall. Though she was in bad health, she continued to write, to advocate for her political beliefs, and to work for the abolition of the slave trade, which she considered an abomination.

Hester Stanhope
1776–1839; ENGLAND

Famed for her beauty and wit, Stanhope was the niece of the English prime minister William Pitt, for whom she acted as secretary and hostess until his death in 1806. She was awarded a lifelong pension, which she used to travel around the Middle East. She settled among the Druze in Lebanon in an abandoned convent that she rebuilt. The indigenous population regarded her as a prophetess, a view that she accepted as it was in accord with her own sense of destiny. She turned her home into a refuge for the persecuted and distressed. She published volumes of memoirs and ones about her travels that present a lively picture of an extraordinary woman.

Rachel Varnhagen
1771–1833; GERMANY

Beginning in the late eighteenth century in Berlin, Jewish women led salons that allowed both women and Jews (whose participation in public life was restricted) to play a prominent role in the development of the arts, philosophy, and politics. Rachel or Rahel Varnhagen, one of the first such hosts, was a leading intellectual and champion of Enlightenment values. She advocated complete equality of the sexes, argued for the education of women, and insisted that women, as citizens, had a right to work. In a statement that reflected how she thought women should regard themselves, she proclaimed: "I am at one with myself and consider myself a good, beautiful gift."

Elizabeth Vesey
1715–1791; ENGLAND

The dominance of women in the salons provided them considerable freedom, prestige, and a level of authority not seen since the Courts of Love. Differences existed among salons of various regions. English salons tended to be largely female affairs, though the salon of Vesey attracted many powerful people, both men and women. As a result, she was able to exert a great deal of political influence.

Sojourner Truth

1797–1883

"Look at me!" demanded Sojourner Truth at the 1851 Women's Rights Convention in Akron, Ohio. The audience gasped at the sight of this imposing black woman. "Look at my arm," she continued. "It's plowed and planted and gathered into barns, and no man could head me—and ain't I a woman?" The woman known as Sojourner Truth was born into slavery in New York as Isabella Baumfree (named after her father's owner), sold several times, mistreated, and raped. In 1827, she escaped, making her way to New York City where she became involved with a commune devoted to Perfectionism, an offshoot of Methodism. In 1843, she discarded her slave name, selecting "Sojourner" because to sojourn meant "to dwell temporarily," which she thought an apt description of one's tenure in this life, and "Truth" as the message that she intended to carry to the world.

She was keenly aware of the double oppression of race and gender, and her antislavery lectures soon became infused with arguments for women's rights. In 1850, she published *The Narrative of Sojourner Truth: A Northern Slave*. During the Civil War, she sang and preached to raise money and food donations for the black regiments. After the war, she resumed her speaking career and worked to find jobs for the newly freed slaves. An inspiration to all who encountered her, she remains a proud symbol of black women's heroic struggle for freedom.

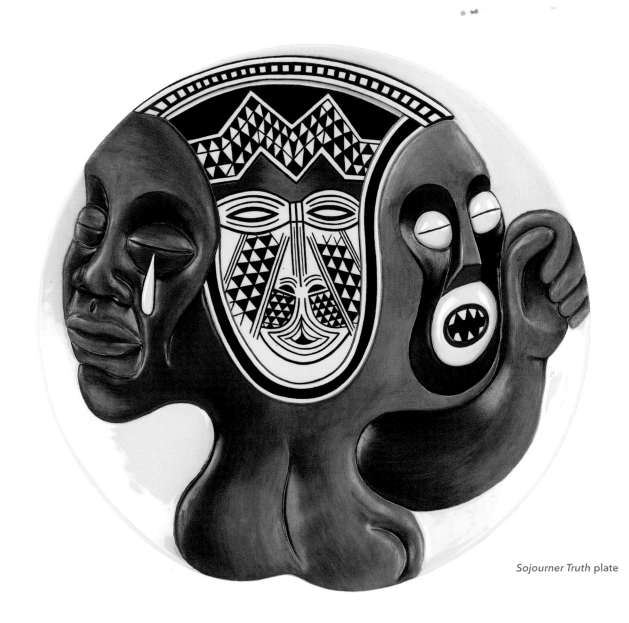

Sojourner Truth plate

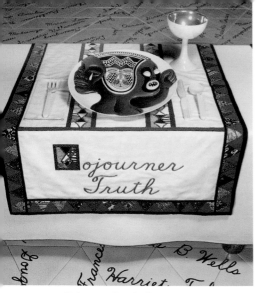

Sojourner Truth place setting

Like Sojourner Truth, many black women made the connection between racism and sexism and struggled to overcome this double bind. Others focused on trying to bring education and aid to their people and to achieve professional standing, which was even more difficult for them than for white women. Arranged around *SOJOURNER TRUTH'S* place setting are women of both races who used their resources to break through barriers or who participated in the antislavery societies that developed in the decades before the Civil War.

Marian Anderson
1897–1993; UNITED STATES

After numerous musical triumphs, Anderson performed at Carnegie Hall in 1930 and was then given a Rosenwald Scholarship to study in Europe, where, like many other black American performers, she found it easier to establish herself. On Easter Sunday, 1939, Anderson was scheduled to sing at Constitution Hall in Washington, DC, but the Daughters of the American Revolution—who owned the hall—refused to allow her to perform. In protest, First Lady Eleanor Roosevelt promptly resigned her membership in the DAR and arranged for a free concert to take place on the steps of the Lincoln Memorial, which was attended by 75,000 people and heard on the radio by millions more, a momentous event that helped to shatter the color barrier. In 1955, Anderson became the first black person to sing at the Metropolitan Opera, also performing at the White House and at Eisenhower's presidential inauguration. Her many awards include the American Medal of Free-

dom in 1963. She was the recipient of twenty-three honorary doctorates and was a delegate to the United Nations as well as a United States goodwill ambassador.

Josephine Baker
1906–1975; UNITED STATES

In 1925, Baker went to Paris, becoming an instant success as well as the most photographed woman in the world. Soon she was earning more than any other performer in Europe. Epitomizing the Jazz Age with her exuberant singing and dancing, Baker appeared in films, operettas, and extravagant revues during a career that spanned fifty years. U.S. writer Ernest Hemingway described her as "the most sensational woman anyone ever saw." Her own view was slightly less effusive: "The Eiffel Tower looked very different from the Statue of Liberty, but what did that matter? What was the good of the statue without the liberty?" During World War II, she was active in the French Resistance, receiving numerous awards from the French government. Afterward, she campaigned for civil rights in the United States and began to adopt children from around the world, whom she called her "rainbow tribe." Upon her death, 20,000 people gathered on the streets of Paris to pay their respects.

Mary McLeod Bethune
1875–1955; UNITED STATES

Born of slave parents, Bethune was one of seventeen children. She graduated from the Moody Bible Institute in Chicago and founded a school for African-American girls in 1904. In time she was able to interest James Gamble (of the Proctor and Gamble Company) in supporting the school financially and becoming the chairman of the board. In 1823, the institution, which had expanded to a high school, then a junior college, merged with a boy's school to become the Bethune-Cookman College. She served as its president until her retirement in 1942. Bethune also founded the National Council of Negro Women in 1932, becoming its president, and was appointed by President Franklin Roosevelt to be the director of African-American affairs in the National Youth Administration and a special advisor on minority affairs, serving for eight years. Bethune, who worked as

special assistant to the secretary of war during World War II, received many awards and honors during her distinguished career.

Anna Ella Carroll
1815–1894; UNITED STATES

Educated by her father Thomas King Carroll, a two-time governor of Maryland, Anna grew up in the world of politics. When the Civil War broke out, she wrote articles and letters in an effort to keep Maryland in the Union. She was also involved in espionage, which attracted the attention of President Lincoln, who sent her on a mission to evaluate the Union's war policy. Her suggestions for a plan of attack were adopted, which resulted in the defeat of the Confederacy. However, the president and his cabinet kept her participation secret because they did not want it known that their plans had been devised by a woman. Indirect recognition came in an 1864 painting of Lincoln and his advisors at the signing of the Emancipation Proclamation. The picture includes an empty chair with a folder of maps and notes similar to those Carroll had carried, supposedly an acknowledgment of her crucial role. About her, Lincoln's secretary of war Edwin Stanton said: "Her course was the most remarkable in the war. She got no pay and did the great work that made others famous."

Mary Ann Shad Cary
1823–1893; UNITED STATES

Although Mary Ann Shad, or Shadd, Cary was born free, the education of blacks was prohibited in Delaware where her family lived. She was sent to a Quaker school, an experience that—along with her exposure to slavery (Cary's father was a key figure in the Underground Railroad)—shaped her lifelong commitment to justice. In 1850, the Fugitive Slave Act was passed, which allowed free northern blacks to be sold into slavery if they helped southern slaves escape. The following year, Cary and her brother fled to Canada, followed by the rest of their family. She earned a teaching certificate, took a position as a teacher, and then opened an integrated school. She also founded a weekly newspaper, *The Provincial Freeman*, making her the first black woman in North America to establish and edit a paper. When

the Civil War began, she returned to the United States to help recruit black volunteers. After the war, she moved to Washington, DC, enrolled at Howard University, and became only the second woman of color to earn a law degree. She then worked for suffrage, organizing the Colored Women's Progressive Franchise in 1880.

Prudence Crandall

1803–1890; UNITED STATES

Born into a Quaker family, Crandall opened a school for girls in Connecticut in 1831, which thrived until she admitted a black servant girl who had asked to attend. When outraged parents began withdrawing their children, Crandall closed the institution and, with the support of prominent abolitionists, reopened it as a school for black girls. But the students faced daily harassment. Then, in 1834, Connecticut passed a law making it illegal to provide a free education to blacks (her school charged no tuition). Crandall was prosecuted and convicted. When news of her successful appeal reached the town, a white mob attacked the school. Fearful for the safety of the girls, she closed the school, spending the rest of her life in Illinois where she homesteaded, taught, and agitated for women's rights and temperance.

Milla Granson

1816–1880; UNITED STATES

Born into slavery, Granson (reidentified by contemporary research as Lily Ann Granderson) learned to read and write from the children of her owner. When her master died, she was sold to a Mississippi slaveholder. Although it was illegal to educate slaves, she organized a clandestine school that operated from midnight until 2 a.m.

One reason for the prohibition against educating slaves was that southern slaveholders were afraid their slaves would learn about abolitionism and try to escape to the North. Many of the hundreds of slaves taught by Granson did exactly that, writing their own "freedom passes" and fleeing. After the Emancipation Proclamation, Granson worked as a teacher with the American Missionary Association and became involved in building other institutions in the black community.

Angelina Grimke

1805–1879; UNITED STATES

Sarah Grimke

1792–1873; UNITED STATES

When Sarah Grimke was five years old, she saw a slave being whipped on the family plantation in South Carolina. She ran away in an attempt to "go to a place where there was no slavery." When she was twenty-six, Grimke took her father, a strong advocate of both slavery and the subordination of women, to Philadelphia for medical care. While there, she became involved with the Quaker movement; three years later, when her father died, she settled there. Shortly thereafter, she converted her sister Angelina to Quakerism and, in 1829, brought her to live with her. Both sisters became active in the abolitionist movement, writing and speaking publicly about the horrors of slavery, which elicited violent criticism both because of the subject matter and the fact that it was considered improper for women to speak out on political issues. In time, the Grimkes began to address feminist issues along with denouncing racial prejudice. Soon a severe split developed in the antislavery movement, with some abolitionists arguing that it was the "Negro's hour and women would have to wait." While Angelina continued to focus primarily on abolition, Sarah became a major theoretician of the women's rights movement. Concerning men, she stated: "All I ask of our brethren is, that they will take their feet from off our necks."

Frances Harper

1825–1911; UNITED STATES

Born free, Harper was raised by her aunt and uncle, an abolitionist. At the age of fourteen, she went to work as a domestic in a Quaker household, where she was given access to their library and encouraged in her literary aspirations. Her novel about the Reconstructed South, *Iola Leroy, or Shadows Uplifted* (1892), was the first book published by a black American. When the schism developed between abolitionists and feminists, Harper sided with those who argued that the issue of race had to take priority over that of gender. Nevertheless, throughout her life, she worked on behalf of women's rights. She was particularly active in advocating for black women, founding the National Association of Colored Women and serving as its vice president until her death.

185

Zora Neale Hurston

1891–1960; UNITED STATES

Hurston headed to New York in 1925, when the Harlem Renaissance was at its height. Dedicated to the preservation of black culture and tradition, she traveled throughout the South collecting folklore and mythology. During the thirties, she received WPA grants and a Guggenheim Fellowship to pursue her work. She published several collections of stories, an autobiography, and

Detail, *Sojourner Truth* runner back

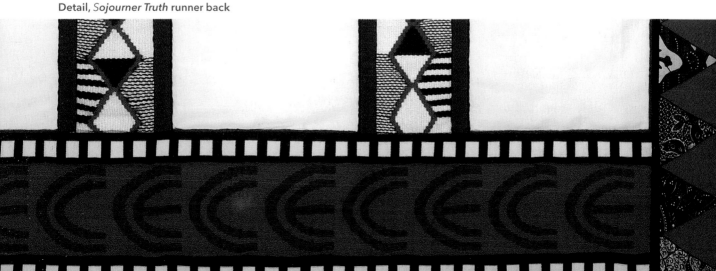

her most famous work, *Their Eyes Were Watching God*. By the 1950s, no longer able to find support for her writing, she worked as a maid, a librarian, and a teacher. She suffered a stroke in 1959 and died the following year, a patient in a county welfare home. Thirteen years later, the writer Alice Walker and Hurston scholar Charlotte Hunt placed a tombstone on her previously unmarked grave, which read: "Zora Neale Hurston, A Genius of the South, Novelist, Folklorist, Anthropologist."

Edmonia Lewis
CIRCA 1845–CIRCA 1911; UNITED STATES

Lewis, the first professional American sculptor of color, was born to a free black father and Chippewa Indian mother. After studying in Boston with the neoclassical sculptor Edward Brackett (1818–1908), she lived in Rome and worked among a group of women. How necessary this type of supportive environment was can be surmised

by the patronizing writing about her milieu by the famous American author Henry James (1843–1916): "One of the sisterhood, if I am not mistaken, was a negress, whose colour, picturesquely contrasting with that of her plaster material, was the pleading agent of her fame." Although she initially gained attention with portrait busts of abolitionist leaders, her finest works depict important Native American figures, manifest her concern with her black heritage, and celebrate heroic women.

Mary Livermore
1820–1905; UNITED STATES

Livermore, an editor, author, and journalist, was a vocal opponent of slavery. She worked in Lincoln's presidential campaign and was the only female reporter at his inauguration. During the Civil War, she joined the U.S. Sanitary Commission, for which she raised a considerable amount of money. After the war, she turned her attention to

women's rights, organizing the Chicago Women's Suffrage Convention in 1868, editing the feminist journal *The Agitator*, and becoming a founding member of the American Woman Suffrage Association. An effective speaker, she presented more than 150 lectures a year for more than a decade on a variety of topics.

Bessie Smith
1894–1937; UNITED STATES

Born in Chattanooga, Tennessee, Smith, "Empress of the Blues," started out as a street musician. In 1912, she appeared with Gertrude ("Ma") Rainey's minstrel show on the black vaudeville circuit. Rainey (one of the first of the great blues singers) became her mentor, but Smith soon developed her own style which blended classical blues, country blues, and jazz. By the early 1920s, she was the highest paid black entertainer in the country. Her congruence of words, delivery, and style has influenced countless musicians, and she remains an important figure in American music.

Maria Stewart
1803–1879; UNITED STATES

In 1831, Stewart published an essay in the abolitionist newspaper *The Liberator*, the first political manifesto written by an African-American woman. From the beginning, her ideas were controversial. In an 1833 speech in

Sojourner Truth illuminated capital letter

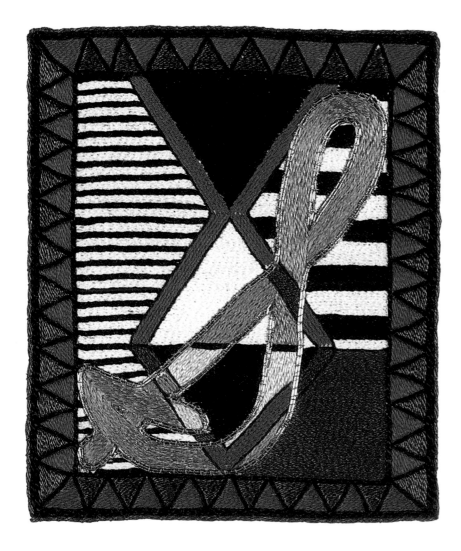

Boston, she admonished black men for not doing enough for their families or communities; many in the black community were outraged. The uproar caused her to move to New York, where she became a public school-teacher and participated in antislavery and women's rights activities. In 1875, she self-published her lectures, leaving a legacy that paved the way for other female activists, both black and white.

Harriet Beecher Stowe

1811–1896; UNITED STATES

Stowe's *Uncle Tom's Cabin* (1831) is often cited as one of the causes of the Civil War. In fact, when she met President Lincoln in 1862, legend states that he greeted her by saying: "Here's the little lady who started the big war." Stowe was familiar with slavery, the Underground Railroad, and the abolitionist movement because the slave state of Kentucky was just across the river from where her family lived in Ohio. First published in serial form in an abolitionist newspaper, her novel exposed the evils of the institution of slavery and became an immediate sensation. The popularity of the book has drawn attention away from Stowe's other published writings, which included a number of novels along with essays and poetry. Stowe was also an ardent supporter of women's rights.

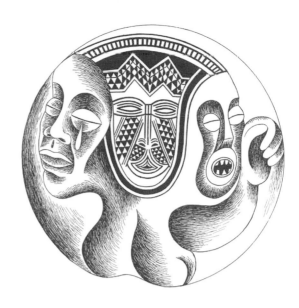

Harriet Tubman

1826–1913; UNITED STATES

Born into slavery, Tubman escaped to Philadelphia in 1849. Not long afterward, she became involved with the Underground Railroad and, as she proudly stated, "never lost a single passenger," leading more than three hundred people out of the slave states in the course of nineteen dangerous trips. Called the "Moses of her people," she became a legendary figure, and a reward of forty thousand dollars was offered for her capture. During the Civil War, she worked as a spy, a scout, and a nurse while continuing to help southern slaves. After the war, she lived in Auburn, New York, where she founded the Harriet Tubman Home for Aged Negroes and worked for voting rights for blacks. Later, she participated in women's suffrage conventions and helped organize the National Federation of Afro-American Women (1895).

Margaret Murray Washington

1861/65–1925; UNITED STATES

Mary Murray enrolled in Fisk University in 1881. Two years later she married leading educator Booker T. Washington (1856–1915) and worked with him to build Tuskegee Institute, an important institution for black education. She was also the dean of women at Tuskegee and the first president of the National Federation of Colored Women's Clubs. In addition, she founded various schools; worked for the improvement of prisons; and in 1896, became vice president of the National Federation of Afro-American Women and president of the Alabama Association of Women's Clubs.

Ida B. Wells

1862–1931; UNITED STATES

The child of slaves, Wells was a teacher who then became part owner of a black newspaper, the *Memphis Free Speech*. In 1892, three African-American men were lynched on false charges, and she wrote scathing editorials. Undeterred by the 1895 destruction of her office by mobs incensed by her writing, Wells began a one-woman campaign against lynching, publishing the exposé *A Red Record*. She founded antilynching societies and traveled throughout the United States and Britain to speak out on the issue, working with both the African-American community and leaders of the women's suffrage movement. In 1913, she and a white colleague formed the Alpha Suffrage Club, the largest black women's suffrage club in Illinois, which was crucial in helping black women develop strategies for political empowerment. That same year, the National American Woman Suffrage Association organized a parade in Washington, DC. Although Illinois suffragists had always embraced African-American women, the southern members of this organization practiced segregation. When the Illinois contingent asked its black members not to march with them, Wells allied herself with two white members of the group who dissented from that decision, marching in disregard of the biased stance of the organization. In so doing, she openly challenged the racism of white feminists.

Susan B. Anthony

1820–1906

Susan B. Anthony was brought up in a Quaker family with a long activist tradition. After teaching for fifteen years, she became involved in the temperance movement, which developed in response to the abuse of women and children by alcoholic husbands. When Anthony realized that she would not be allowed to speak at temperance rallies, she turned her attention to the women's rights movement. A landmark 1848 conference in Seneca Falls, New York, spearheaded in part by Elizabeth Cady Stanton (see below), adopted a list of eighteen demands including the right of women to vote, be educated, manage their own earnings, and administer their own property. A few years after this historic gathering, Anthony and

Stanton embarked on one of the most productive working partnerships in U.S. history. In 1868 they founded *The Revolution*, a newspaper whose masthead proclaimed: "Men, their rights, and nothing more; women, their rights, and nothing less." In the 1870s, Anthony campaigned vigorously for women's suffrage while Stanton, who had family responsibilities, stayed at home to write. Together, they drafted the text for the Nineteenth Amendment to the Constitution, guaranteeing women the right to vote. It was introduced in 1878, but not passed by Congress and submitted to the states for ratification until 1919, when it was colloquially known as the "Anthony Amendment."

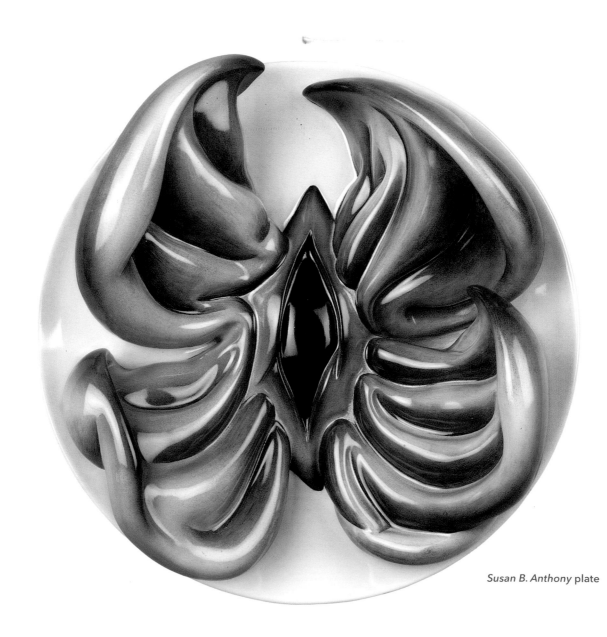

Susan B. Anthony plate

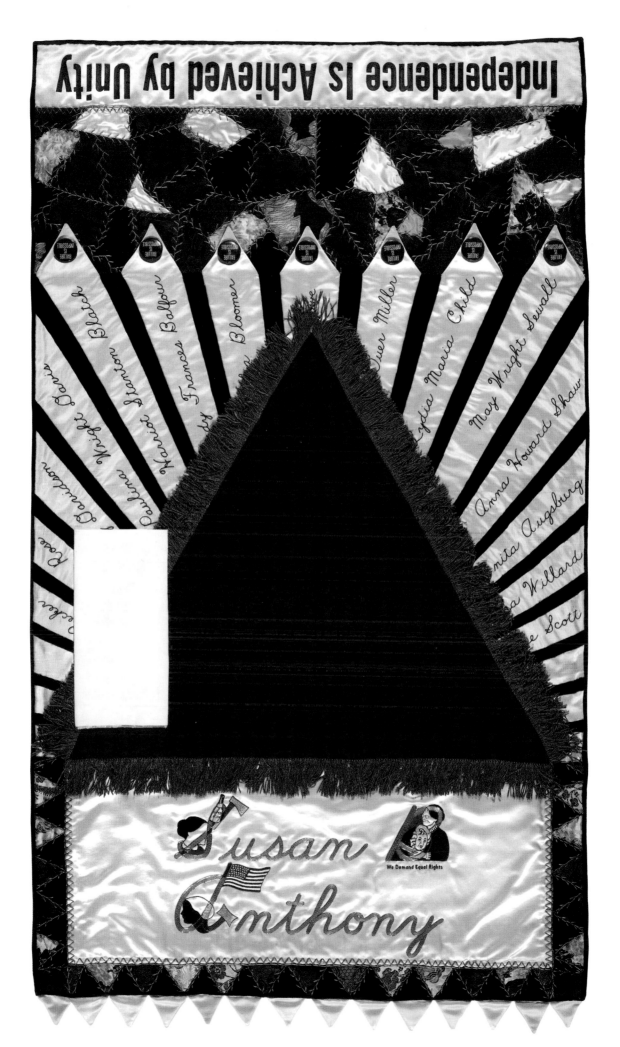

Susan B. Anthony runner

The names surrounding the *SUSAN B. ANTHONY* place setting represent some of the major leaders of the international women's rights movement. They comprise the largest grouping on the floor and are meant to remind viewers (particularly young women) of the enormous effort required to achieve the reforms that present generations of women take for granted. As Anthony herself once said: "I really believe that I shall explode if some of you young women don't wake up . . . and raise your voice in protest . . . and work to save us from any more barbaric male governments."

Sophie Adlersparre
1823–1895; SWEDEN

In 1859, Adlersparre began introducing feminist ideas to Sweden through her magazine *For the Home*. She had been deeply influenced by Frederika Bremer, who had traveled to the United States just as the women's movement was gaining steam. Adlersparre later founded the Frederika Bremer League, which promoted the establishment of women's peace societies. Many of the late nineteenth-century women's rights activists made a connection between the need for an international peace-keeping system and the movement for women's equality, believing that women were more innately inclined toward pacifism than men, a stance that has been challenged by contemporary feminists.

Susan B. Anthony place setting

Gunda Beeg
1858–1913; GERMANY

During the middle and late Victorian period (1837–1901), various reformers focused on attire that was more comfortable than the restrictive styles then popular. This "rational dress" movement was especially concerned with the tightly laced corset, which was both constricting of movement and potentially damaging to women's health. Beeg, a founder of the dress reform movement in Germany, designed a loose-fitting dress that did not require that a woman's body be deformed by corseting.

Annie Wood Besant
1847–1933; ENGLAND

Besant worked as a union organizer, was an early advocate of birth control, founded a newspaper, fought for better working conditions and higher wages for women, and wrote numerous texts on women's rights along with an autobiography and various works on theosophy, which are still considered among the best on the subject. Besant was the international president of the Theosophical Society from 1907 until her death and helped to spread theosophical ideas around the world, notably in India, where she eventually moved, soon becoming involved in the struggle for Indian Home Rule (the movement for independence from Britain founded by Gandhi). In 1918, she was elected president of the Indian National Congress, the political party that successfully led the independence movement.

Alice Stone Blackwell
1857–1950; UNITED STATES

Blackwell was the daughter of Lucy Stone (1818–1892), a pioneer in the women's rights movement, and the niece of Elizabeth Blackwell (1821–1910), the first woman doctor in America. After graduating from Boston University, she worked as a reporter at *The Women's Journal,* which was owned by her mother and father Henry Blackwell, and then as editor for thirty-five years. As a reporter, she covered the 1891 convention of the Women's Christian Temperance Union, where she recognized the link between liquor-related violence against women and children and women's lack of political rights. As the early temperance assaults on bars gave way to more sophisticated analy-

ses of this connection, strong ties were forged between the temperance and suffrage movements. Blackwell was instrumental in reuniting the two major factions of the suffrage movement in the United States, which had split over strategy in 1869. In 1890, she helped to form the National American Woman Suffrage Association (NAWSA), the organization that finally secured passage of the Susan B. Anthony Amendment granting women the vote.

Barbara Bodichon
1827–1891; ENGLAND

Born into a wealthy, well-known radical family, Bodichon became a painter and social reformer. Inspired by an 1854 meeting in London with Elizabeth Cady Stanton and other American feminists, Bodichon published "A Brief Summary, in Plain Language, of the Most Important Laws concerning Women." The widely read pamphlet eventually helped to change the fabric of English law through the Married Women's Property Act, which allowed women to retain ownership of their property after marriage. In 1857, she published "Women and Work," an even more radical pamphlet in which she called for equality of education and work opportunities. Bodichon formed the first women's employment bureau in Britain and purchased the *Englishwomen's Journal*, which became the national voice of the suffrage movement. In 1869, after Parliament's defeat of yet another women's suffrage petition, she published the influential text, *Reasons for and against the Enfranchisement of Women.* Through her writings, her activism, and her philanthropy (she helped to found the first women's college), Bodichon should be credited with almost single-handedly founding the women's rights movement in England. As for her art production, its aesthetic worth remains unexamined and therefore unknown.

Frederika Bremer
1801–1865; SWEDEN

The early nineteenth century brought a shift from an agrarian to an industrial capitalist economy. Women were deprived of the economic role they had previously played because work increasingly took place outside of the home and the domestic sphere was denigrated. Women like Frederika (or Fredrika) Bremer began to argue that

women should form social welfare organizations and pursue tasks that would be recognized as valuable to society. As a result, an array of women's associations came into existence that at first pursued general objectives such as charity. Gradually, however, promoting the welfare of others made women aware of the necessity for political influence and expanded rights for themselves. After Bremer visited the United States and met some of the suffrage leaders, she began to focus on women's rights and peace. Her writings launched the Swedish women's rights movement, and her 1856 book *Herha* became its textbook.

Minna Canth
1844–1897; FINLAND

When Canth was thirty-five, she was widowed and left with seven children. By taking over her father's textile shop, she was able to support her family while pursuing her writing. She created a salon that was a center of literary and philosophical debates for many years. One of the early authors to write in Finnish, Canth produced prose, fiction, short stories, and newspaper articles that dealt with temperance, workers' rights, and women's rights. In 1885 she published *The Worker's Wife*, an early feminist novel that shocked the community because of its sharp criticism of the Church's attitude toward women. She continues to hold a prominent place in Finnish literature.

Carrie Chapman Catt
1859–1947; UNITED STATES

In 1900, Catt succeeded Susan B. Anthony as president of the National Woman Suffrage Association, a role in which she was highly effective, training women for public speaking and direct action. Buoyed by a million-dollar bequest and legions of volunteers, she mounted the successful drive that finally helped women win the vote. She then reorganized the two million members of the Suffrage Association into the League of Women Voters, aimed at educating women in the intelligent use of their newly won voting rights. She helped to found the International Woman Suffrage Alliance, which brought together women activists from eight countries to work on suffrage in their respective societies. During World War I, she helped establish the Woman's Peace Party, believing that

Detail, *Susan B. Anthony* runner

women would use their newfound political power to bring about a more peaceful world. After World War II, she used her influence to see that qualified women were placed on crucial United Nations committees.

Minna Cauer
1841–1922; GERMANY

Influenced by Susan B. Anthony, Cauer began advocating for women's rights in Germany at a time when public attitudes toward women's suffrage were exceedingly hostile. She lectured, wrote, and started the feminist magazine *The Women's Movement*, which brought feminist ideas to a wide audience. In 1902, she helped to found the German Association for Women's Suffrage and participated in the founding of the International Woman Suffrage Association, spearheaded by Carrie Chapman Catt.

Frances Power Cobbe
1822–1904; IRELAND

Cobbe, a member of a prominent Anglo-English family, was an important feminist theorist and a tireless campaigner for women's rights. She wrote on a variety of subjects including women's suffrage, higher education for women, morality, and theology and produced a steady stream of pamphlets on the plight of the poor, particularly women and children. In her later years, she focused on the ill-treatment of animals, founding organizations to

abolish the practice of vivisection and introducing the broader issue of ethics into discussions about the relationship between human beings and animals.

Millicent Garrett Fawcett
1847–1929; ENGLAND

191

When Fawcett was twelve, her elder sister Elizabeth Garrett went to London with a determination to become a doctor (she succeeded and was England's first woman physician). Through Elizabeth, Fawcett met such women's rights advocates as John Stuart Mill (1806–1873) and his wife, Harriet Taylor (1807–1858). In 1868, Fawcett joined the London Suffrage Committee. Though not a charismatic public speaker, she was a superb organizer and by the early 1880s was one of the leaders of the suffrage movement. Perhaps because she was married to Henry Fawcett, a member of Parliament and supporter of his wife's activities, Fawcett was always moderate in her views and strategies, believing that reason and petitions would finally win women the vote. After the vote was attained in England, Fawcett published a number of books, including a chronicle of the English struggle for suffrage as well as an autobiography.

Augusta Fickert
1855–1910; AUSTRIA

In both Germany and Austria, there was an emphasis upon women's rights as part of a broader campaign for social change. However, as in many progressive movements, somehow women's issues ended up taking second place. Thus, it was not until the late nineteenth century that a separate women's movement developed in Austria. As part of this movement, educator and feminist Augusta or Auguste Fickert edited a women's magazine, worked for higher education and employment opportunities for women, initiated free legal aid for women, set up community kitchens to serve families with working mothers, and organized the General Women's Club of Austria, which sought to improve women's wages.

Henriette "Henni" Forchhammer
1863–1955; DENMARK

In 1899 Henni Forchhammer founded the Danish National Council of Women; within two decades, a suffrage bill was passed. When the vote was granted, Forchhammer led a procession of twenty thousand women in celebration and later became the first woman to address the Danish Parliament. In 1920, the International Council of Women convened a conference with nine countries participating. (The organization, which was cofounded by Forchhammer and Susan B. Anthony in 1888, now has seventy member countries.) The conference passed a resolution asking that women be included in all delegations sent to represent governments at the League of Nations, which was formed after World War I. Only Norway, Sweden, and Denmark appointed any women, Forchhammer among them; the other countries sent men.

Charlotte Perkins Gilman
1860–1935; UNITED STATES

In 1898, Gilman published *Women and Economics*, a radical declaration of women's economic independence from men. Although this book brought her acclaim, Gilman's most famous work is her 1892 story *The Yellow Wallpaper*, which depicts a depressed woman who slowly descends into madness while her well-meaning husband is often away due to work. The story is based upon Gilman's own experience of severe postpartum depression for which she was treated by a doctor who advocated that Gilman live a domestic life and never to write again. (She chose to divorce rather than follow his advice.) Her enormous body of work, much of it unavailable to the modern reader, is comprised of over two hundred short stories and ten novels, including the visionary *Herland* (not published until 1979). In 1932, she was diagnosed with incurable breast cancer. An advocate for the right to die, Gilman committed suicide, choosing "chloroform over cancer," as she put it in both her suicide note and her posthumously published autobiography.

Vida Goldstein
1869–1949; AUSTRALIA

A leader of the Australian women's movement, Goldstein devoted herself to the suffrage cause, speaking, lobbying at Parliament, and publishing *The Australian Women's Sphere*, a feminist journal. In Australia, women received the right to vote in federal elections in 1902; the following year, Goldstein became the first woman in the British Empire nominated for Parliament. She ran for that office five times and, though never elected, used her campaigns as opportunities to educate the public on women's issues. She was also an ardent pacifist, becoming head of the Peace Alliance (now an international organization) and, in 1915, founding the Women's Peace Army, which attempted to mobilize women who opposed war into a "fighting body to destroy militarism."

Aasta Hansteen
1824–1908; NORWAY

Norwegian women acquired inheritance rights in 1854, but it would not be until 1890 that married women were allowed to retain control of their own property; there was no real possibility for independence until 1882, when they were first given access to higher education. Then, in 1913, women won the vote after a hard-fought battle, thanks to the work of people like the writer Aasta Hansteen, an early feminist.

Amelia Holst
1758–1829; GERMANY

Amelia or Amalia Holst was the first German woman to write a book advocating for women's educational opportunities, providing an early impetus for the German women's movement. Later feminists used her work as a theoretical foundation for their political activities.

Aletta Jacobs
1854–1929; HOLLAND

The first woman to graduate from a Dutch university and the first female physician there, Jacobs was a staunch advocate of women's rights. She translated Charlotte Perkins Gilman's groundbreaking book *Women and Economics* into Dutch. It was through such actions that feminist ideas traveled across national boundaries. Jacobs joined Carrie Chapman Catt in a world tour to organize women to fight for both suffrage and broader rights. During World War I, she created the Women's International League for Peace and Freedom, considered the most important women's peace organization in the twentieth century.

Annie Kenney
1879–1953; ENGLAND

From a working-class family, Kenney began employment in a mill at age ten. The deplorable conditions there led to her involvement in the textile unions. In 1905, she heard Christabel Pankhurst (a member of the radical family of women's rights activists) and soon after joined the recently formed suffrage organization founded by the Pankhursts, the Women's Social and Political Union (WSPU). Later that year, Kenney and Pankhurst attended a meeting in London where a British government minister was speaking. Throughout his talk, the two women repeatedly shouted out: "Will the . . . Government give votes to women?" The police were called, and when the women refused to leave, they were found guilty of assault (they had spit at the police) and fined. When they refused to pay the fine, they were arrested. The case shocked the nation. For the first time, women had used violent tactics in an attempt to win the vote, a strategy that would escalate in the ensuing years. Although Kenney became a full-time activist, World War

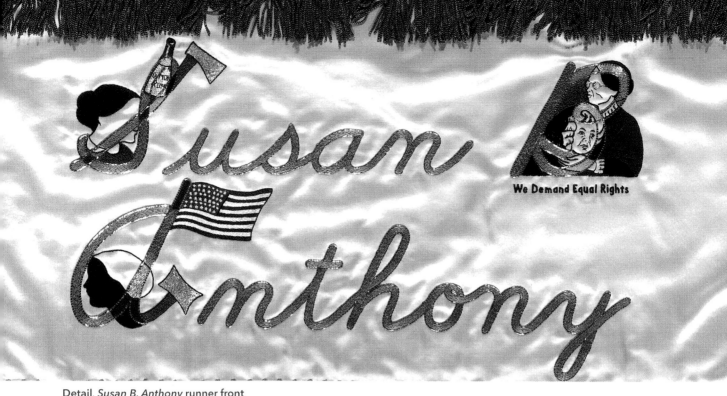

We Demand Equal Rights

Detail, *Susan B. Anthony* runner front

I ended her involvement in suffrage. Thereafter, she was active in labor issues and then in theosophy.

Eliska Krasnohorska
1847–1926; CZECHOSLOVAKIA

Krasnohorska founded the *Women's Journal*, the first women's rights publication in Czechoslovakia. She helped to establish the first girl's high school and became the leader of the Women's Industry Society, which opened educational opportunities in technical work and the arts. In addition, she founded the Minerva Society, whose goal was to secure higher education for women. Although she also produced many operatic librettos and a number of feminist commentaries, she is best remembered for her children's literature and translations of English, Polish, Russian, and German works.

Mary Lee
1821–1909; AUSTRALIA

Born in Ireland, Lee emigrated to Australia when she was fifty-eight years old, becoming involved in the Working Women's Trade Union. In addition, she helped to establish the Women's Suffrage League of South Australia, where women won the right to vote in state elections in 1894. But it would be another seven years before Parliament granted them voting rights in federal elections and fifty years before a woman was elected to Parliament.

Bertha Lutz
1894–1976; BRAZIL

The daughter of a well-known scientist, Lutz was educated at the Sorbonne and became a biologist at the National Museum of Rio de Janeiro. She was a pioneer in the Latin American feminist movement, organizing the Brazilian Federation for the Progress of Women. In 1923, Lutz was a delegate to the Pan-American Association for the Advancement of Women. In 1933, Brazilian women achieved the vote; four years later, Lutz was elected to Parliament, where she continued her activism. In recognition of her many achievements, the Bertha Lutz Prize is presented annually by the Brazilian government to women who contribute to gender equality.

Constance Lytton
1869–1923; ENGLAND

Lytton was from a wealthy family. At some point, she was taken on a tour of Holloway prison where some of the suffragettes were being held. (The term "suffragette" first appeared in 1906 to distinguish the women who used direct action, in contrast to the "suffragists," who employed constitutional methods.) Appalled by their treatment, Lytton joined the WSPU. A year later, she herself was imprisoned for throwing rocks at the car of a member of Parliament. When the authorities realized her social position, they treated her carefully. To protest her

special treatment, she carved a "V" for "votes" on her chest with a hairpin and continued to participate in demonstrations. She was repeatedly arrested, and because she went on hunger strikes while in jail, she was force-fed. As she was always of somewhat frail health, the strain of imprisonment took its toll on her. In 1910, she suffered a heart attack and, two years later, a stroke that left her paralyzed on her right side. She then taught herself to write with her left hand and published an account of her prison experiences. She died an invalid.

Lucretia Mott
1793–1880; UNITED STATES

Mott, a Quaker teacher and minister, was a leading abolitionist, founding the first integrated antislavery society in the United States. In 1840, she attended the World Anti-Slavery Convention in London, where the women delegates were denied seating by the men. In response, Mott became resolved to hold a convention to advocate for the rights of women. Finally, in 1848, at the historic gathering at Seneca Falls, she was able to see her plan realized. Addressing the audience, she stated that "it is the sacred duty of the women of this country to secure for themselves their sacred right to the elective franchise," a right that would be withheld for seventy-two years.

193

Mary Mueller
1820–1901; NEW ZEALAND

In 1869, under the pseudonym "Femina," Mueller published the pamphlet "An Appeal to the Men of New Zealand," which argued for women's rights. (Her true identity was not revealed until after her husband died). Under this same name, she also wrote a number of newspaper articles advocating for suffrage. Her writings helped influence passage of the Married Woman's Property Act, which became law in 1884. In 1893, New Zealand became the first country in the world to grant women the vote.

Carrie Nation
1846–1911; UNITED STATES

At the age of twenty-one, Nation married Dr. Charles Gloyd, an alcoholic who died soon thereafter. Until 1877, she taught school and then married David Nation, a minister and lawyer. They settled in Kansas where Nation responded to what she considered a divine calling to protect women and children from the violence of drunken men, which she had experienced personally in her first marriage. Between 1900 and 1910, Nation was arrested some thirty times after leading her followers (called "Home Defenders") in the destruction of one watering hole after another with cries of "Smash, ladies, smash!" The liquor interests massed against the temperance movement and, later, women's rights (fearing that if women gained political power, they would use it to limit the consumption of liquor). Nation has been maligned by history and dis-

missed as an eccentric. However, while she was certainly among their most colorful members, the Women's Christian Temperance Union (founded in 1874) left more in its wake than strewn glass. Once the largest women's organization in the country, the WCTU focused on such issues as health and hygiene, prison reform, women's rights, and world peace.

Caroline Norton
1808–1877; ENGLAND

After an unfortunate marriage, Norton finally separated from her violent husband George. By then, she had become a prominent writer and magazine editor. She could not sue for divorce, however, because only men had this right. Then her husband sued *her* for the earnings from her books, as well as custody of their children. Outraged, she launched a campaign to change the laws. In 1857, thanks largely to her efforts, the Marriage and Divorce Act was passed, which gave women the right to initiate divorce and to own their own property. In Victorian England, these were great victories.

Louise Otto-Peters
1819–1895, GERMANY

For centuries, a woman's role in German society was summed up by the words *Kinder* (children), *Küche* (kitchen), *Kirche* (church). An early feminist, Otto-Peters began advocating for women's emancipation in 1848, primarily through the newspaper she established, which would be suppressed by the government. Not to be stopped, she founded the General German Women's Association in 1865.

Its aims, like those of many other women's organizations, were better educational and work opportunities, equal pay for equal work, self-determination, and of course, suffrage. German women made rapid gains; by 1918, not only were they allowed to vote, but they were also allowed to stand for Parliament.

Christabel Pankhurst
1880–1958; ENGLAND

In 1897, the various English suffragist groups united into one organization, but within a few years, Christabel Pankhurst and her mother Emmeline became frustrated at the slow pace of change. In 1902, Emmeline met Susan B. Anthony, who had traveled to England to support the suffrage movement there. The result of their meeting was far-reaching. The following year, Christabel and her mother organized the Women's Social and Political Union (WSPU), which marked the birth of the British militant movement. Christabel was an able administrator, inspiring leader, and brilliant theoretician. When the government attempted to subvert the women's efforts by imprisoning WSPU leaders, Pankhurst escaped to Paris, where she continued to direct the organization's activities, which became increasingly violent. The women disrupted meetings of Parliament, chained themselves to railings, rioted, and, at one point, firebombed the prime minister's country house. Finally, in 1918, women over thirty were granted the vote, but it was not until 1921 that universal suffrage was achieved.

Detail, *Susan B. Anthony* **runner back**

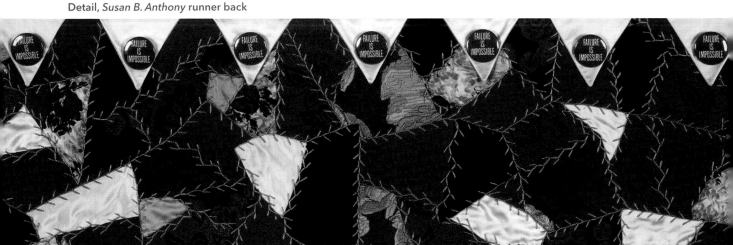

Emmeline Pankhurst
1858–1928; ENGLAND

Emmeline Pankhurst's mother, a passionate feminist, began taking her daughter to women's suffrage meetings in the early 1870s. In 1878, Emmeline met and married Richard Pankhurst, a socialist who helped draft legislation improving women's legal status. Later, Pankhurst became involved in a social welfare program that involved regular visits to the local workhouse (where employment was provided for the destitute). Shocked by the squalid conditions, she was particularly distressed by the misery of the women. Deciding that only through suffrage could these problems be solved, she became involved in the women's rights movement. Gradually, she became disillusioned with the conservatism of existing women's organizations. She and her daughter Christabel created the WSPU; their goal and motto: "Deeds, not words!" At the outbreak of World War I, Pankhurst, like many other women, directed her energy toward the war effort. After the war, she and Christabel founded the Women's Party, which supported, among other things, equal pay for equal work, equal marriage and divorce laws, and a system of maternity benefits.

Sylvia Pankhurst
1882–1960; ENGLAND

Sylvia Pankhurst was an artist who put aside her own work for the causes to which she was committed. At first she worked closely with her mother and sister in the suffrage movement, but her involvement with women in London's East End slums led her to the conclusion that only socialism could bring about the needed reforms. In addition to building the East London Federation of Suffragettes (a strong working-class women's organization), she founded and edited four newspapers; published twenty-two books and countless articles; organized clinics, nurseries, and communal restaurants; and worked to improve factory conditions. She painted whenever she had time. In 2002, one of her drawings, given as a gift to a supporter, was saved from the trash and purchased by the Women's Library in London, which houses a major collection of women's history. The library organized a small exhibit tracing Pankhurst's efforts to balance her life as an artist with her political activism.

Kallirhoe Parren
1859/61–1940; GREECE

Parren was a feminist, a writer, and for eighteen years the editor of a women's magazine. In 1896, she organized the Federation of Greek Women, which worked for women's political and social freedom and was part of the International Council of Women. In 1910, she founded the Lyceum Club, which emphasized the advancement of Greek women's rights. The club also collected Greek costumes and related accessories. Later, the collection became part of the Museum of the History of the Greek Costume, an affiliate of the Lyceum Club.

Alice Paul
1885–1977; UNITED STATES

In 1908, Paul, who was studying in England after receiving an MA at the University of Pennsylvania, heard Christabel Pankhurst speak. Inspired by her words, Paul joined the WSPU and was arrested and imprisoned three times. In 1910, she returned to the United States, where she became involved in the suffrage struggle while continuing her studies, receiving a PhD in political science and another degree in law. Paul recognized that a change in strategy was necessary in order to accomplish passage of an amendment granting suffrage to women. In 1912, she went to Washington, DC, where she staged a spectacle in relation to Woodrow Wilson's presidential inauguration. Eight thousand costumed women strode past the White House. When this failed to convince Congress to pass the amendment, she mounted a campaign that included demonstrations, hunger strikes, and media blitzes. Suffragettes who had been released from jail donned their prison garb and rode a train called the Prison Special that took them on a speaking tour across the country where they gathered hundreds of thousands of signatures on suffrage petitions that were then delivered to Congress. During the 1916 presidential campaign, Paul organized suffrage pickets, known as "Silent Sentinels," in which women holding banners waged the first nonviolent civil disobedience action in the United States. Many were arrested and sent to jail, where they were held in appalling conditions and brutalized. The resulting scandal helped push Congress to finally pass the Nineteenth Amendment.

Annie Smith Peck
1850–1935; UNITED STATES

"I decided in my teens that I would do what one woman could to show that women had as much brains as men," stated Peck, a feminist who at the age of forty-four took up mountain climbing. At age sixty-one she climbed Peru's Mount Coropu (21,083 feet) and planted a "Votes for Women" sign at the summit. She was also the first person to scale another Peruvian peak, Mount Huascaran (22,205 feet), which at the time was believed to be the highest in the Western Hemisphere. In addition to the difficulties of the ascent, she had to contend with the ridicule of the male climbers along with inadequate funding and ungainly clothing that had been designed without any thought to women's anatomy.

Emmeline Pethick-Lawrence
1867–1954; ENGLAND

In 1891, Emmeline Pethick started out as a volunteer social worker, organizing a club for young working-class girls. Shocked by the poverty she encountered, she became a socialist. In 1899, she met Frederick Lawrence, a wealthy lawyer. Emmeline refused his marriage proposal until she convinced him of the validity of socialist principles, at which time he adopted a joint name, Pethick-Lawrence. By 1905, they had both become involved in the suffrage struggle, and Emmeline had been imprisoned six times. They soon founded the journal *Votes for Women*, for which she wrote for many years. Their home became the office of the WSPU as well as an informal hospital for suffragettes made ill by their prison experiences. During World War I, Emmeline was prominent in the Women's International League for Peace and Freedom and also became involved in the campaign to provide birth control information to working-class women.

Adelheid Popp
1869–1939; AUSTRIA

In *Autobiography of a Working Woman* (1912), Popp explained how she came to be a socialist, using her miserable proletarian youth to argue for the need for radical political and social change. In time, though, she concentrated on women's issues, including suffrage, equal pay, divorce reform, and child care. She edited a socialist women's

paper and founded a group to encourage women to discuss political issues; in addition, she led one of the earliest strikes by women. Popp eventually became the leader of the Austrian Socialist Women's Movement. Before the Nazis came to power and forced her out, she served in the Austrian government.

Kathe Schirmacher
1859–1930; GERMANY

Schirmacher was a suffrage leader. In *Women's Charter of Rights and Liberties,* she proposed that women be paid for housework, an idea first put forth by Mary Lamb. In 1911, she published *The Riddle Woman,* in which she argued that women needed not only equal rights and opportunities but that they also had to forge their own plans for the future. In *The Modern Woman's Rights Movement* she documented the history of the suffrage movement and also examined the status of feminism internationally. She and her partner, Klara Schleker, were the only known lesbian couple in the early German women's movement.

Auguste Schmidt
1833–1902; GERMANY

In the spring of 1865, the first meeting of the National Association of German Women convened in Leipzig under the leadership of Auguste Schmidt, among others. As a member of the executive committee and associate editor of the official paper *New Paths,* she helped to develop the organization's activities, which involved supporting suffrage, women's right to education, options for work, and full participation in public life. In order to understand how daring these demands were, consider that in 1850 a law had been passed—and enforced in Germany until 1908—forbidding women from belonging to organizations that espoused any kind of political opposition.

Katherine Sheppard
1847–1934; NEW ZEALAND

Born in England and raised in Scotland, Sheppard emigrated to New Zealand in 1868. In the 1880s, New Zealand suffered a depression that brought about an increase in alcoholism and violence against women and children. In 1885, Sheppard helped to found the New Zealand Christian Temperance Union and, like her compatriots,

soon made the connection between women's powerlessness in the face of drunken husbands and their lack of political rights. Through her writings and speeches she spearheaded the movement for women's suffrage. Three times Sheppard submitted petitions to the House of Representatives, but they were all defeated. She continued the drive, finally submitting a petition in 1893 that had been signed by one-third of New Zealand's adult females, which led to passage of the first bill in the world granting women the right to vote. In 1919, women were granted the right to stand for Parliament, and in 1934, just prior to Sheppard's death, she had the satisfaction of seeing the first woman member enter Parliament.

Elizabeth Cady Stanton
1815–1902; UNITED STATES

The long-standing friend of Susan B. Anthony and one of the giants of the women's movement, Stanton devoted her life to the struggle for equal rights. Initially an abolitionist, she came to realize that women were treated as second-class citizens even in that movement. She then turned her attention to gaining educational opportunities for women, property and divorce law reform, and suffrage. Neither she nor Anthony ever imagined that obtaining the vote would be so difficult or require the effort of so many people. Rather, they saw suffrage as one small step in the struggle for complete equality, one in which "the united thought of man and woman will inaugurate . . . a civilization . . . in which ignorance, poverty, and crime will exist no more."

Lucy Stone
1818–1893; UNITED STATES

When Stone married Henry Blackwell, their wedding vows included a pledge that both partners would have equal rights. Declaring that "my name is my identity and must not be lost," Stone insisted upon retaining her own name after marriage. (For many years, women who refused to take their husbands' names were called "Lucy Stoners.") She had been one of the first women to attend Oberlin College when it opened its doors to women and blacks. Although she graduated as

valedictorian in 1841, she was required to sit in the audience while a male student read her speech, which turned her into a feminist. In 1869, she cofounded the American Woman Suffrage Association, which was less radical than the organization headed by Anthony and then Catt in that it focused exclusively on the vote. Stone, who had been inspired by the writings of the Grimke sisters, devoted most of her life to the suffrage movement. To those contemporary women who bemoan young women's lack of respect for the contributions of their foremothers, I recommend her 1893 comment that: "I think, with never-ending gratitude, that the young women of today do not and can never know at what price their free speech and to speak at all in public has been earned."

Mary Church Terrell
1863–1954; UNITED STATES

Terrell's parents had been born into slavery, but they became wealthy through hard work, which allowed her to attend Oberlin College. In 1884 she became one of the first black women to obtain a college degree. Despite the dual obstacles she faced due to her race and gender, Terrell became a high school teacher and principal. She was appointed to the District of Columbia Board of Education in 1895, the first African-American woman in the United States to hold such a position. A charter member and first president of the National Association of Colored Women, Terrell was nationally known for her outspoken opposition to racial segregation and her support of women's rights. She was part of the American delegation to the 1904 International Congress of Women in Berlin and one of the founders of the National Association for the Advancement of Colored People (NAACP). In 1940, she published her autobiography, *A Colored Woman in a White World,* and at age eighty-nine she marched at the head of a picket line. She died shortly after the Supreme Court decision on Brown v. Board of Education, the culmination of the fight to end legalized segregation.

Alexandra van Grippenberg
1857–1911; FINLAND

At the end of the nineteenth century, Finland was an autonomous duchy of the Russian Empire. The nobility continued to hold considerable political power and three-quarters of the population did not have the right to vote. Therefore, women's suffrage became part of a larger social and political movement to establish universal suffrage. By the mid-1890s, a workers' movement, together with a worker-led temperance movement, had begun agitating for the reform of voting rights. By 1905, faced with a possible revolution, the Russian tsar mandated universal suffrage, bringing Finnish women the earliest voting rights in Europe. In her writings, van Grippenberg was an early advocate for both temperance and women's rights. In 1888, she attended the Women's Congress in Washington, DC, organized by Anthony, after which she established a branch of the International Council of Women in Finland. She also wrote a history of the international feminist movement.

Frances Willard
1839–1898; UNITED STATES

In 1859, Willard graduated from the North Western Female College and taught school for a number of years. In 1871, she was named president of the new Evanston College of Ladies and two years later, when the college was absorbed into Northwestern University, became professor of aesthetics and the dean of women. In 1879 she was elected president of the national Women's Christian Temperance Union. Under her leadership, membership was boosted to two hundred thousand, and she expanded the organization's focus to include women's suffrage, arguing that women needed the vote to protect their homes and children against alcoholic husbands. In 1892, she moved to England where she was influenced by socialism to change her views, deciding that it was poverty rather than intemperance that was the cause of social ills.

Victoria Woodhull
1838–1927; UNITED STATES

Woodhull's career was as varied as it was controversial. With her sister Tennessee Claflin, she formed the first woman-owned brokerage firm on Wall Street. They made a significant amount of money, which allowed them to start their own journal, *Woodhull and Claflin's Weekly*. The two promoted radical causes, including women's suffrage, a graduated income tax, and expanded civil rights. In 1872, they published the first edition in the United States of *The Communist Manifesto* by Karl Marx and Friedrich Engels. Also in 1872, Woodhull was nominated as the presidential candidate of the Equal Rights Party, which had been established in 1836. (Oddly enough, though laws prohibited women from voting, there was nothing to stop them from running for office.) Friends of President Ulysses S. Grant, who was running for reelection, attacked her and she ended up spending election day in jail due to their smear campaign and a story she published. She had publicly accused Henry Ward Beecher (1813–1887), a highly respected clergyman and reformer, of being a hypocrite because he was carrying on an extramarital affair with a female member of his congregation. Over the next seven months, Woodhull was arrested eight times and endured several trials for libel. She was eventually acquitted of all charges, but the legal fees forced her into bankruptcy. As a consequence of the scandal, she had to move to England. She continued to fight for women's rights, suggesting that women should declare their independence from the United States and set up a government of their own.

Frances Wright
1795–1852; UNITED STATES

When Wright was two, her parents died, leaving her and her sister with a fortune. In 1818, the sisters sailed from Scotland to the United States for a two-year visit, after which she published a laudatory account of her trip, *Views of Society and Manners in America* (1821).

In 1824, she returned, but this time she traveled down the Mississippi and was appalled by the practice of slavery. She then published *A Plan for the Gradual Abolition of Slavery in the United States Without Danger of Loss to the Citizens of the South*, which urged Congress to set aside tracts of land to be given to freed slaves. As a way of demonstrating her plan, she invested a large part of her inheritance in 2,000 acres of Tennessee woodland where she created a community called Nashoba. She purchased slaves, freed them, and settled them on the land. Though well-intentioned, the colony got off to a poor start, from which it never recovered. A few years later, Wright joined Robert Dale Owen's utopian community in New Harmony, Indiana. In 1829, she and Owen settled in New York City, where she published *Course of Popular Lectures* and (with Owen) a radical journal, the *Free Enquirer*, in which she advocated for the abolition of slavery, universal suffrage, free secular education, birth control, and changes in the marriage and divorce laws. Her tombstone in Cincinnati was inscribed with the words: "I have wedded the cause of human improvement, staked on it my fortune, my reputation and my life."

Elizabeth Blackwell

Elizabeth Blackwell was the first woman to receive a medical degree in the United States and become a licensed physician. Challenging the restrictions barring women from becoming doctors, she applied to twenty-nine medical schools, all of which rejected her. Finally, she was admitted to Geneva Medical College in upstate New York. The dean had asked the male students to decide whether to admit her, and, primarily as a joke, they had agreed to let her attend. The students treated her badly, and members of the Geneva community ostracized her, but nevertheless in 1849 she graduated with honors.

Blackwell set up her practice in New York City, but she was denied work at hospitals and went months without any patients. In 1851 she wrote dejectedly, "I stand alone." Determined to educate women on sex, birth, and health, she began to lecture publicly at a time when such topics were not considered fit for open discourse. As a result, people sent her vile anonymous letters and followed her down the streets shouting insults.

Eventually, Blackwell was able to establish a practice with her sister Emily and their colleague Marie Zakrzewska, both of whom had become doctors with her help. They opened the New York Infirmary for Women and Children, the first hospital where female doctors could get training as well as clinical experience. In 1869, Blackwell moved to England where she pioneered preventive medicine and became a professor of gynecology at the London School of Medicine for Women.

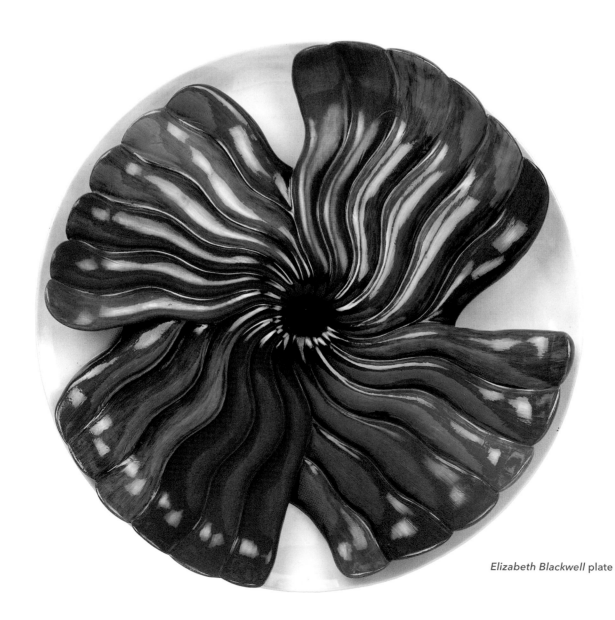

Elizabeth Blackwell plate

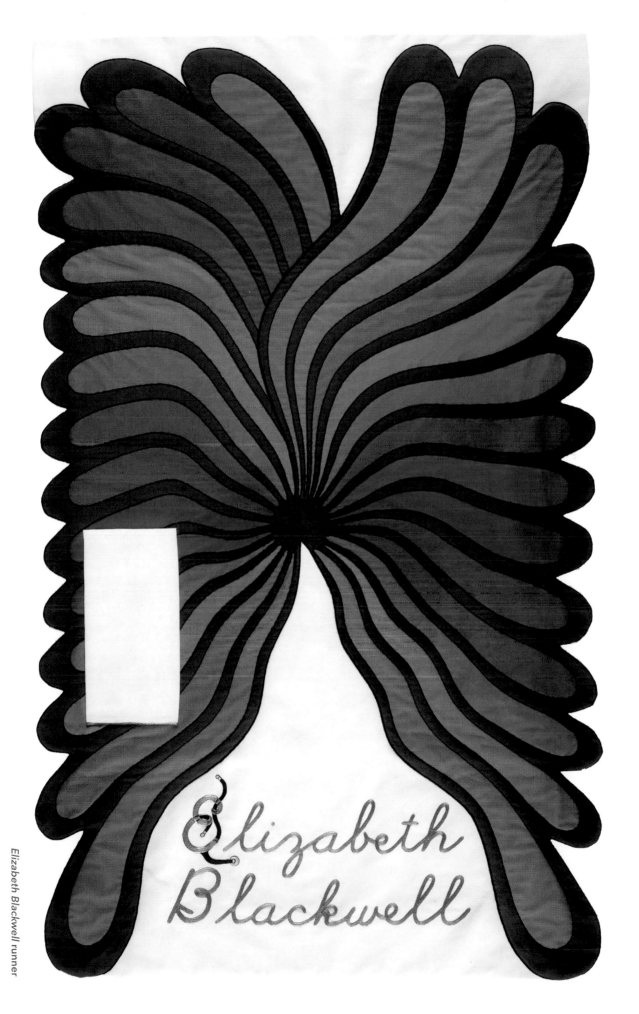

Elizabeth Blackwell

Elizabeth Blackwell runner

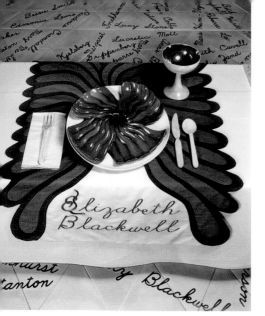

Elizabeth Blackwell place setting

The difficulties faced by women in medicine epitomized what many women encountered as they struggled to open previously closed professions. There was a pattern; a few women would win entry into a field, then they would have to establish training schools for other women in order to counteract the continued resistance of male-dominated institutions. Blackwell's words about the difficulties encountered by female doctors seem to apply to the experiences of many other women listed here: "A blank wall of social and professional antagonism . . . forms a situation of singular and painful loneliness, leaving her without support, respect, or professional council."

Elizabeth Garrett Anderson
1836–1917; ENGLAND

When Elizabeth Blackwell visited England in 1859 she met Garrett Anderson; inspired by Blackwell, the younger woman decided that she also wanted a career in medicine. When her efforts to enter medical school were unsuccessful, she became a nurse. Then she discovered that the Society of Apothecaries (Pharmacists) did not specifically ban women from taking examinations, so she sat for the test, which she passed. As soon as Garrett Anderson was granted the certificate enabling her to practice medicine, the society changed its rules in order to prevent any other woman from entering the medical profession through a

comparable process. In 1866, Garrett Anderson established a dispensary for women in London that was later renamed the Elizabeth Garrett Anderson Hospital. In 1872, she opened the New Hospital for Women, which was staffed entirely by women, including Blackwell, who became a professor of gynecology there. Garrett Anderson was also instrumental in helping to establish the London School of Medicine for Women, of which she became dean. Later in life, she was elected the first female mayor in England and was an active suffragist.

Clara Barton
1821–1912; UNITED STATES

In 1861, while Barton was working as a schoolteacher in Washington, DC, a military regiment arrived after the Baltimore Riots, which marked the beginning of the Civil War. Barton organized a relief program for the soldiers, raising money for medical supplies and establishing an organization to distribute them to the army. She was granted a pass to travel with army ambulances, and for three years she cared for the wounded, working without pay. Her nursing methods attracted national attention, and she was soon appointed as a superintendent of nurses. In 1870, she went to Europe to work with the International Red Cross, establishing military hospitals during the Franco-Prussian War. Barton returned to the United States determined to organize a branch of the Red Cross, which she did in 1881. She served as its president until 1904, extending Red Cross services to deal with disasters other than war.

Marianne Beth
1889–1984; AUSTRIA

The first Austrian woman to receive a doctorate of law, Beth specialized in international law and wrote influential papers on the rights of women and children. At first she was allowed only to study the history of Church law, earning a PhD. Later, after it became possible for women to earn law degrees, she went back to school and became a successful lawyer. When the Nazis invaded Austria, she disappeared, presumably murdered for her feminist and liberal beliefs.

Emily Blackwell
1826–1910; UNITED STATES

Following her sister Elizabeth's example, Emily decided to study medicine. She was rejected by several schools, including the Geneva Medical College, which had accepted Elizabeth. Finally, after six years of effort, she was admitted to the Rush Medical College in Chicago in 1852, only to be turned away the next year as a result of pressure applied by the (all-male) Illinois Medical Society. She was finally accepted to the medical school at Case Western Reserve in Cleveland and, after graduating in 1854, traveled to Britain for postgraduate work in obstetrics. She joined her sister and Marie Zakrzewska in establishing the first U.S. hospital for women entirely staffed by women. By 1868, they had turned their Infirmary for Women and Children into a first-rate hospital and medical school for women. Blackwell eventually assumed full responsibility for the institution, and for the next thirty years she served as dean and professor of obstetrics and the diseases of women. Although she closed the school when Cornell University began admitting women to their medical program, the infirmary still exists today as Beth Israel Medical Center.

Sophie Blanchard
1778–1819; FRANCE

In 1809, Blanchard's husband Jean-Pierre lost his life in a hot-air balloon accident. She carried on what was a family occupation, becoming the first woman in the world to earn her living as a professional balloonist. In 1810, she became the Chief of Air Services to Napoleon, performing at royal functions, including the celebration of his marriage to Marie-Louise of Austria. In 1819, her balloon caught fire, and though she successfully landed the balloon on a rooftop, a gust of wind blew her off the structure. She broke her neck and died in front of a horrified crowd.

Marie Boivin
1773–1841; FRANCE

Denied admission to medical school, Boivin was entirely self-taught. She was eventually awarded an honorary degree of Doctor of Medicine for her important work in gynecology.

Edith Cavell
1865–1915; ENGLAND

After training as a nurse, Cavell was appointed supervisor of nursing at the Birkendall Medical Institute in Brussels, where she raised the standard of care. With the outbreak of WWI and the subsequent German occupation of Belgium, her institution was converted into a Red Cross hospital for wounded soldiers of all nationalities. She was allowed to continue as supervisor and used her position to help many French and British soldiers escape to Holland. Discovered by the Germans, Cavell was arrested, tried, and found guilty. On October 12, 1915, she was shot by a firing squad. A statue of her, paying tribute to her courage, stands in St. Martin's Place, just off London's Trafalgar Square.

Marie la Chapelle
1769–1821; FRANCE

Trained in obstetrics by her mother, midwife Marie Duges, La Chapelle took over her hospital position as head of maternity and midwifery. Later, a separate teaching institute was established with La Chapelle In charge of education. She trained hundreds of midwives and wrote a three-volume work that remained the major text on midwifery for many years.

Marie Curie
1867–1934; POLAND

From childhood, Curie harbored the dream of a scientific career, a concept almost inconceivable to girls of her era. In 1891, she went to the Sorbonne, where she met and married Pierre Curie, a physics professor. The discovery of radioactivity in 1896 inspired the Curies to study the properties of radiation. The couple's work resulted in a scientific breakthrough—the isolation of radium. She and Pierre received many joint awards for their discoveries, among them the Nobel Prize for Physics and the French Legion of Honor. But because the latter award was presented only to men, Pierre declined it. The Curies' fame spread, but their joy was cut short by Pierre's premature death in 1906. Marie was appointed Pierre's successor as special lecturer at the Sorbonne, the first time a woman had obtained a full professorship. She continued her scientific research, sharing another Nobel Prize in 1903 for her discovery of radioactivity and radioactive elements. In 1911, she herself won the Nobel Prize in Chemistry.

Babe Didrikson
1911–1956; UNITED STATES

Sports have remained a key arena for male domination, which helps to explain the fierce battle that has marked women's efforts to gain equity in athletics. Reared in poverty in south Texas, Didrikson played basketball in high school but soon switched to track and field, setting world records in the 1932 Olympics and winning gold medals in the javelin throw and the eighty meter hurdles. In the late thirties and forties, she concentrated on golf, winning seventeen consecutive professional tournaments and every important title for women golfers. In addition, she swam, boxed, and played tennis, billiards, football, and baseball. She was said to have once struck out Joe DiMaggio. While trying to recover from a major operation for cancer, she won the National Women's Open Golf Tournament in 1954, but died of the disease two years later at the age of forty-two.

Marie Duges
1730–1797; FRANCE

Duges was trained in medicine by her husband. She became chief of midwives at the Hotel Dieu, a hospital in Paris, reorganizing its maternity department and greatly improving the quality of care. She also wrote several books on midwifery and passed on her vast knowledge as well as her position at the hospital to her daughter, Marie La Chapelle.

Marie Durocher
1809–1893; BRAZIL

Durocher, one of the first female doctors in Latin America, was born in France and raised in Brazil, where she studied obstetrics. In 1834, she became the first recipient of a medical degree at the new school in Rio de Janeiro. She conducted a successful practice for sixty years.

Amelia Earhart
1898–1937; UNITED STATES

Earhart's pioneering efforts in aviation were intended to improve the industry as well as to create opportunities for women in this new field. In 1928, she became the first woman to fly across the Atlantic; she was also the first woman to fly solo across the United States, setting the women's nonstop transcontinental speed record which she then broke the following year. In 1937, she embarked on an around-the-world flight on which she documented the effects of prolonged air travel on the human body, conducted mechanical tests on the aircraft, and recorded her observations of the lives of women in the countries where she stopped. It

Elizabeth Blackwell illuminated capital letter

is believed that her plane went down in the Pacific Ocean, and no trace of her has ever been found. Before she left on what would be her last voyage, she wrote: "Women must try to do the things men have tried. When they fail, their failure must be but a challenge to others."

Emily Faithfull
1835–1895; ENGLAND

In 1859, Faithfull established the Society for Promoting the Employment of Women. The following year, she founded *The Victoria Magazine*, which explored the problems of working women and was a forerunner in demanding equal pay for equal work. Faithfull printed the magazine on her own press, which employed only women compositors. The mixed shop enraged the printer's union, supposedly on moral grounds. Presses were sabotaged, and ink was poured on the chairs that Faithfull had specially built to alleviate some of the fatigue of standing at the presses for long hours. Nonetheless, the press continued for twenty years. In 1862, Faithfull was appointed "Printer and Publisher in Ordinary to Her Majesty, the Queen." She also lectured and wrote travel books and novels.

Althea Gibson
1927–2003; UNITED STATES

Gibson, whose ambition was to be "the best woman tennis player who ever lived," was born on a cotton farm in South Carolina (where her parents were sharecroppers) and raised in Harlem during the Harlem Renaissance. She began to play tennis seriously at age thirteen and soon quit school, doing menial labor to support herself while pursuing her dream. A prominent southern black family became her "foster" family, allowing her to concentrate on her game while also finishing high school. She went on to college, graduating with a degree in physical education. Between 1944 and 1950, she won the New York state championship six times, becoming the number one player in the American Tennis Association, the nation's oldest African-American sports organization. In 1950, she broke the color barrier when she was invited to play in the U.S. Open, and in 1957 she became the first black to win at Wimbledon. That same year, she became the first African-American woman to receive the Associated Press Award as female athlete of the year.

Charlotte Guest
1812–1895; WALES

Originally from Lincolnshire, Guest moved to Wales with her husband John, owner of the Dowlais Iron Company. Here she became involved in modernizing the local schools and also in the Romantic revival, which was producing a new interest in Celtic history among scholars. She and her husband helped to found the Society of Welsh Scholars, and she translated *The Mabinogion*, ancient Welsh tales exemplifying the idealistic world of Celtic literature. These were not well-known until Guest translated them; her work became the standard for more than ninety years. In 1852, John Guest died, and she took over the helm of the Iron Works. Under her administration, the business flourished. In 1855, she fell in love with Charles Schreiber, a young academic who was tutoring one of her ten children. She soon turned over the running of the company to others and concentrated on traveling with Schreiber and building a major ceramics collection, which would be donated to the Victoria and Albert Museum. After Schreiber died in 1884 Guest completed the cataloguing of what was called the Schreiber Collection and then concentrated on collecting fans, producing two books and eventually presenting her collection to the British Museum. She spent the last years of her life campaigning for various political causes.

Salome Halpir
1718–1760; POLAND

Halpir (more widely known as Regina Salomea Rusiecka), who received training from her oculist husband, became a renowned specialist in cataract surgery.

Jane Harrison
1850–1928; ENGLAND

Harrison studied classics at Newnham College at Cambridge (the women's school where Virginia Woolf later delivered her famous lecture on women and fiction, published as *A Room of One's Own* in 1929). Harrison then studied archeology at the British Museum, becoming the assistant director of the British School of Archaeology in Rome. The most famous female classicist in history, she was awarded more honorary degrees than any other woman in the world. In 1922, Harrison retired and moved to Bloomsbury, where she often saw Woolf, who wrote about Harrison and her partner Hope Mirrlees: "we like seeing her and Jane Harrison billing and cooing together."

Sophia Heath
1896–1939; ENGLAND

Heath set the women's world record in the high jump and became the British javelin champion. In 1922, she founded the Women's Amateur Athletic Association and then challenged the Olympic Committee's policies banning women from many of the competitions. Three years later, she was the only woman to speak before the committee in Prague when they debated the issue. Largely as a result of her efforts, women were able to participate in gymnastics for the first time at the 1928 Olympics.

Marie Heim-Voegtlin
1846–1934; SWITZERLAND

One of the first professional female physicians in modern Europe, Heim-Voegtlin received her degree in 1873 from the Zurich Medical School. She then established her own practice, specializing in gynecology and obstetrics, and later helped to found a hospital and training school for nurses, which treated women and children and was run by an all-female staff.

Sonja Henie
1912–1969; NORWAY

Henie started skating when she was six years old. At age ten, she won the Norwegian national figure-skating championship. In 1928, she won her first Olympic gold medal, repeating her victory in 1932 and 1936 and dominating women's figure skating for ten years. In 1941, she became a citizen of the United States, where she performed in popular ice shows and made a number of films that featured her skating. Her stated goal was to rival the success the dancer Fred Astaire had achieved in the movies, only on skates. To date, no female skater has ever equaled her accomplishments.

Kate Campbell Hurd-Mead
1867–1941; UNITED STATES

In 1888, Hurd-Mead graduated from the Women's Medical College of Pennsylvania to become a specialist in the diseases of women and children. She established an important nurse's organization along with the Baltimore Dispensary for Working Women and Girls and the Medical Women's International Association. But her preoccupation was the history of women in medicine, and she spent years compiling information on the topic. She published two books, *Medical Women of America* (1933) and *A History of Women in Medicine From the Earliest Times to the Beginning of the Nineteenth Century* (1938), the first comprehensive chronicles of women's contributions to medicine.

Irene Joliot-Curie
1897–1956; FRANCE

An ardent antifascist and feminist, Joliot-Curie became a leading scientist in the field of radioactivity, no doubt strongly influenced by her mother Marie Curie. She and her husband Frederic Joliot discovered the neutron, a fundamental subatomic particle, for which they received the Nobel Prize for Chemistry. She and her husband worked on nuclear fission and, following World War II, helped develop nuclear reactors. They also established the French Atomic Energy Commission.

Elin Kallio
1859–1927; FINLAND

At age seventeen, Kallio began teaching gymnastics, training other teachers, publishing books, and helping to popularize the sport. In 1896, she helped to found the Finnish Women's Gymnastics Federation, the first of its kind in northern Europe. Although she didn't live to see it, in 1928 women gymnasts participated for the first time in the Olympics.

Betsy Kjelsberg
1866–1950; NORWAY

Betsy or Betzy Kjelsberg was the first woman elected to the Norwegian Legislature. She founded a businesswomen's union and worked for legislation to protect factory workers. She was vice president of the International Council of Women (created by Susan B. Anthony), which even today works with agencies around the world to promote health, equality, and education for women. She also served as an officer of the International Congress of Working Women, set up in 1919 to promote fair labor standards for women.

Sofia Kovalevskaya
1850–1891; RUSSIA

At fourteen, Kovalevskaya taught herself trigonometry, which impressed a mathematics professor neighbor, who convinced her father to let her go to school in St. Petersburg. After graduating, Kovalevskaya was determined to go to college, but the closest universities open to women were in Switzerland, and young, unmarried girls could not travel alone. She entered into a marriage of convenience and went with her husband to Heidelburg, Germany, where she was tutored by a renowned mathematician (the university did not admit women). In 1874, she received a PhD from the University of Gottingen. Even with help from her esteemed tutor, she was unable to find employment. She and her husband returned to Russia, where she eventually published ten papers in mathematics and mathematical physics, many of which contained groundbreaking theories or were the impetus for future discoveries. In 1884, she was finally able to gain a tenured position at the University of Stockholm, becoming the first woman outside of Italy to hold a university chair.

Rebecca Lee
BORN 1833; UNITED STATES

The first African-American woman to earn a medical degree in the United States, Lee started her career as a nurse in 1852, almost two decades before the opening of any formal school for nursing. In 1860, she was admitted to the New England Female Medical College. Lee (or Crumpler, as she was known after her marriage to Arthur) practiced in Boston and then moved to Richmond, Virginia, after the Civil War. There, she joined other black physicians caring for freed slaves who would not have had access to medical care otherwise. She later returned to Massachusetts and in 1883 published her *Book of Medical Discourses*, based on notes she had kept during her years of practice. It was one of the very first medical publications by an African American.

Belva Lockwood
1830–1917; UNITED STATES

Lockwood had to fight first for admission to Columbia Law School and then to actually receive her diploma. Although she was admitted to the bar in 1873, when one of her cases went to the Supreme Court, she was not allowed to plead the case, which incensed her. For the next three years, she single-handedly lobbied legislation through Congress. In 1879, she became the first woman to argue a case before the high court. She gained national prominence as a lecturer on women's rights, was active in the affairs of various suffrage organizations, and ran for the presidency in 1884 and 1888 on the ticket of the National Equal Rights Party. When the statehood bills for Oklahoma, New Mexico, and Arizona came before Congress in 1903, she prepared amendments granting suffrage to women in the proposed new states.

Alice Milliat
1884–1957; FRANCE

An advocate for women's athletics, Milliat was active in the Federation of Feminine Societies in Sports, the first national women's sports club. Because women were still being denied the right to take part in many of the Olympic Games, Milliat organized a Women's Olympics, held in Paris in 1922. Eighteen female athletes broke world records before 20,000 spectators. The success infuriated the Olympic committee; they feared the competition but were unwilling to fully open the games to women. (By then women participated in such sports as tennis and figure skating but track and field—the most prestigious sport—was strictly taboo.) To counter this, Milliat continued her female Olympics; it was the pressure from the growing prestige of her efforts that forced the Olympic committee to gradually change the rules. But it was not until 1976 that there was a clearly marked increase in women's Olympic events.

Margaret Murray
1863–1963; ENGLAND

After graduating from University College in London, where she became an ardent suffragist, Murray was named a fellow of the college and became a specialist in Egyptology. In 1915, she fell ill during an excavation; during her

convalescence, she became interested in witchcraft and in 1921 published *The Witch Cult in Western Europe*. She was the first person to promulgate the theory that the witches of western Europe were adherents of an earlier woman-centered religion that was displaced by Christianity, which caused considerable controversy among her peers. Undaunted, Murray continued to study witchcraft while pursuing other research. In 1931, she published *The God of the Witches*, which traced the Horned God of witchcraft back to Paleolithic times. The book was almost totally ignored until the 1951 repeal of the Witchcraft Laws. The following year, the work was reissued, becoming a best seller and eventually stimulating a flood of new research. Murray continued to work until she died at age one hundred, after completing her autobiography, *My First Hundred Years*.

Florence Nightingale
1820–1910; ENGLAND

After battling her parents' opposition to nursing (which at the time was considered menial labor) and studying for two years, Nightingale was appointed superintendent of a hospital for invalid women in London. In 1854, the Crimean War broke out; Nightingale's offer to volunteer was initially refused. After the *London Times* noted that a large number of British soldiers were dying of disease, she was given permission to take thirty-eight nurses—whom she trained—to the Crimea. Nightingale was horrified at the filthy conditions in which the wounded soldiers were being kept. She was put in charge of all the hospitals in the war zone and within a few months had dramatically reduced the death rate, in part by improving hygiene. When she returned to England, she established the Nightingale School and Home for Nurses with the money she had received in recognition of her war work. Through Nightingale's efforts, nursing was revolutionized; the standards and programs that she developed laid the foundation for the entire system of modern nursing.

Emmy Noether
1882–1935; GERMANY

When Noether died, Albert Einstein noted that she "was the most significant creative mathematical genius thus far produced since the higher education of women began." At eighteen, Noether decided to study math at the University of Erlangen, where her mathematician father taught. Because she was a woman, she was not allowed to enroll, but his position made it possible for her to audit classes. Eventually, she became the second woman granted a doctorate in her field, but she could not get a teaching position. Instead, she taught her father's classes when he was sick and pursued her own research. After the end of WWI, she was invited to work at the University of Gottingen but was paid no salary for three years. While there, she built a following of students who traveled from all over Europe to study with her. In 1933, the Nazis came to power, and Noether, as a Jew, had to leave the country, settling in the United States where she taught at Bryn Mawr College until her death two years later.

Susan la Flesche Piccotte
1865–1915; NORTH AMERICA

Piccotte or Picotte, the first Native American woman to study Western medicine, was the daughter of the chief of the Omaha tribe. While still a young woman, she graduated from the Women's Medical College of Pennsylvania in 1889, returning to her homeland to practice medicine among her people.

Marie Popelin
1846–1913; BELGIUM

Female students were not allowed into Belgian universities until the 1880s; even then, after graduation they were not permitted to work in their chosen professions. In 1888, Popelin was the first woman to earn a law degree, but because of her gender, she was denied admission to the bar. In response, she became the driving force behind the first Belgian feminist organization, the Belgian League for the Rights of Women, established in 1892. Five years later, Popelin organized an International Feminist Congress in Brussels, which helped to build a feminist movement that eventually changed many of the discriminatory laws and customs in Europe and the United States.

Clemence Royer
1830–1902; FRANCE

The importance of translation in the spread of knowledge has been insufficiently acknowledged, particularly the work of female translators like Royer. Although self-taught, she became an expert in anthropology and prehistoric archeology, receiving acclaim for her 1862 French translation of Darwin's *Origin of the Species*. She later published her own treatise on evolution, which challenged the gender biases embedded in nineteenth-century science.

Anna Schabanoff
1848–1932; RUSSIA

Russian women were among the first university-trained female physicians and the first women to receive doctorates in chemistry, physiology, and mathematics. Schabanoff or Shabanova was the first woman to graduate from the Academy of Medicine in St. Petersburg. In addition to establishing a child welfare association, she became a beloved pediatrician.

Emilie Snethlage
1868–1929; BRAZIL

Although Snethlage was born in Germany, her life work was done in Brazil, where she specialized in the study of birds, traveling on foot, by canoe, and on horseback to collect specimens. Besides writing many essays about her research, she was the director of the Zoological Museum and Gardens at Porto Velho, Brazil, in the Amazon.

Miranda Stuart
1795–1865; ENGLAND

Stuart became the first English-speaking woman to obtain a medical degree from an established school, albeit in the guise of a man. In 1812, under the name James Barry, she became a doctor and joined the British army as a medical officer, developing considerable skill in the management of infectious diseases in a career that would span forty years. In 1840, Stuart was promoted to medical inspector, working in Malta and then on the Greek island of Corfu. Only after "his" death was it discovered that Barry was a woman.

Amelia Villa

1899?–1942; BOLIVIA

In a country where women continue to struggle against a traditional misogynist culture, Villa's achievement as the nation's first woman doctor (1926) marked an important step in the battle for gender equity. She was honored by the Bolivian government for her work in pediatrics; a children's ward bears her name at the hospital in Oruro, near La Paz.

Dorothea von Rodde

1770–1825; GERMANY

August Ludwig von Schlozer, a Protestant minister, educated his daughter only to prove that women were capable. A brilliant student, she knew numerous languages by the time she was eleven. When she was seventeen, her father paraded her before a group of professors who tested her, then awarded her a "doctorate." In 1792 she married a wealthy Lübeck merchant, Senator Mattheus Rodde, by whom she had three children. She wrote under the name of Rodde-Schlözer, the first use of the double surname in German. Their home became a center for social and intellectual life, attracting visitors from all over Germany and France. She later studied art in Paris and attained a high level of skill, being commissioned to paint a portrait of Francis II of Austria. She became involved romantically with the French writer Charles Villers in 1794, and she lived with him and her husband in a ménage à trois until 1810, when her husband declared bankruptcy. Soon after Villers and two of her children died. She died at Avignon of pneumonia in 1825, at age fifty-five.

Mary Walker

1832–1919; UNITED STATES

In 1855, Walker joined the tiny number of women doctors in the country when she graduated from Syracuse Medical College, which accepted men and women on an equal basis. When the Civil War broke out, after a few attempts she joined the Union army, becoming the first female surgeon in the military. It is thought that she also served as a spy. In 1865, President Andrew Johnson presented Walker with the Congressional Medal of Honor for her heroic work on the battlefield, the only woman to be so honored. After the war she wrote, lectured, and toured on behalf of women's rights, dress reform (she called the corset "a coffin of iron bands"), health, and temperance. In 1917, a review board revoked her medal, saying that it had been awarded by mistake. Walker refused to give up the medal and wore it until she died. Her great-grandniece successfully campaigned to have it officially restored in 1977.

Nathalie Zand

1883/84–1942; POLAND

Zand, a physician who embraced feminism and advocated for women's rights, specialized in the pathology of the central nervous system. Her papers were published in Poland, England, and France; unfortunately, she disappeared during World War II.

Detail, *Elizabeth Blackwell* runner back

Emily Dickinson

1830–1886

Born in Amherst, Massachusetts, Dickinson attended the Amherst Academy, which was founded by her grandfather, and then completed a year at the newly founded women's college Mount Holyoke, where she studied with the ardent feminist Mary Lyon.

As a young woman, Dickinson apparently enjoyed an active social life. But increasingly, she withdrew into her room whenever visitors arrived, although she corresponded with a large circle of friends and relatives and read widely. Throughout her life, her father treated her as a child; she had to beg him to buy postage stamps and books. By making her room a sanctuary, though, she was able to have time to read, think, and write.

Dickinson felt that her intense creativity was hopelessly at odds with the prevailing ideas of what a woman was supposed to be, and that her poetry was dangerous, for it revealed feelings that society had taught women to repress. Calling her work "A letter to the world," she wrote 1,775 poems about grief, love, death, loss of affection, and longing, 833 of which she bound with a darning needle into forty individual packets known as the fascicles. These were carefully placed in trunks to be found, read, and published after her death.

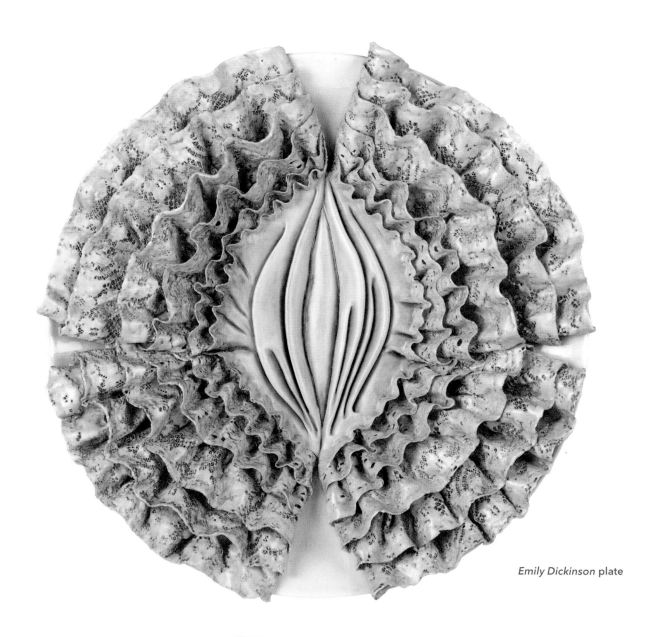

Emily Dickinson plate

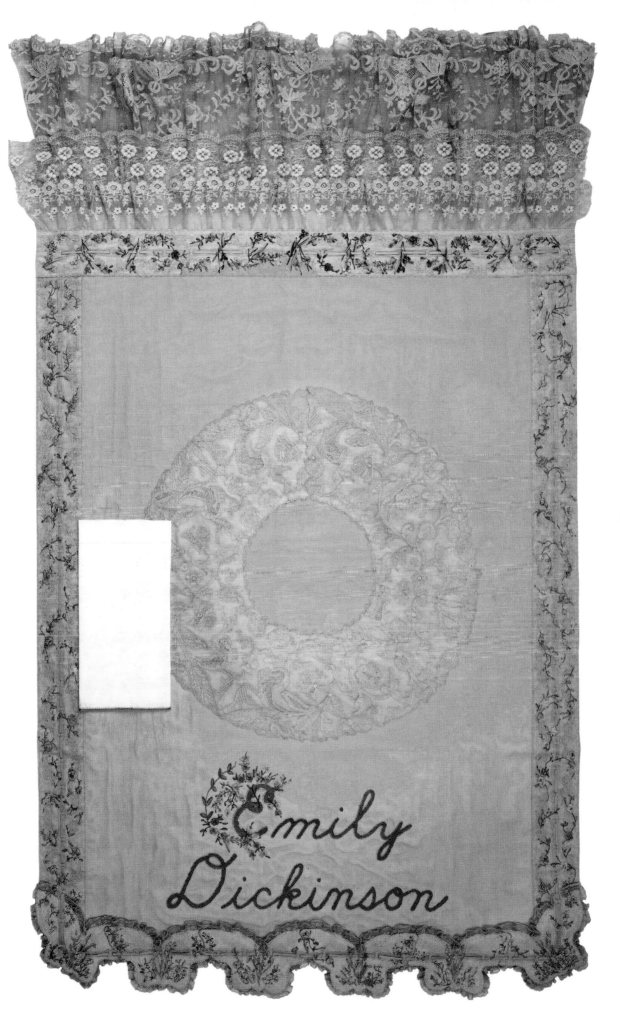

Emily Dickinson runner

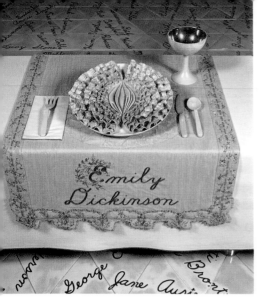

Emily Dickinson place setting

Poorly educated and with few opportunities for work, middle-class women were expected to demonstrate—through their leisure—the economic and social status of their husbands. The Victorian ideal extolled the submissive and dependent wife. Of course, working-class women *had* to earn money, but they were always paid less than men. These circumstances gave rise to conflicts that were expressed by women writers who, for the first time, articulated women's experiences from a female-centered point of view. Their names, along with women who fought to expand educational opportunities for women, are associated with the *EMILY DICKINSON* place setting.

Bettina von Arnim
1785–1859; GERMANY

Von Arnim, a writer of the German Romantic movement, belonged to a group of writers who worked toward the social reforms that led to the failed German Revolution of 1848, which was fueled by the American and French Revolutions. Her work depicted the squalid conditions of slum living and the limited options that forced many women into lives of prostitution. Von Arnim was also a feminist who lobbied for women's emancipation and openly questioned the sanctity of the institution of marriage.

Jane Austen
1775–1817; ENGLAND

The first major female novelist, Austen was the educated daughter of a clergyman. Although her writing was widely read during her lifetime, it was published anonymously. She was always sure to preserve a genteel demeanor, keeping a piece of needlework close by to cover her literary efforts if anyone came to call. In her work, however, she realistically described the circumscribed lives of her female characters. Marriage measured a woman's success and established her status; a bad marriage was considered better than no marriage at all. Austen herself preferred to focus on her work, considered some of the most well-crafted literature ever written and known for its luminous language.

Joanna Baillie
1762–1851; SCOTLAND

Baillie's first poems and plays, published anonymously, were well received, in part because they were assumed to have been written by a man. In 1799, a woman decided to produce her plays, insisting that their author must be female because the heroines were "clever, captivating, and rationally superior." Though her works continued to be popular after Baillie revealed her gender, some of the male critics changed their previously favorable opinion of her writing. The poet Lord Byron (1788–1824), who admired her work, defended her. In an 1817 letter, he wrote: "Voltaire was once asked why no woman has ever written even a tolerable tragedy. He replied by saying that 'a tragedy requires testicles'. If this be true, Baillie must have borrowed them."

Elizabeth Bekker
1738–1804; HOLLAND

Bekker is best known for her epistolary novels, particularly those written in collaboration with Agatha Deken (1741–1804). Though little is known about the relationship between these two women, in 1782 they wrote the first Dutch novel; a number of their works are considered classics of Dutch literature.

Charlotte Brontë
1816–1855; ENGLAND

After her mother and two eldest siblings died, Charlotte, her sisters Emily and Anne, and brother Branwell were left to the care of their father, an Anglican clergyman, and a strict, religious aunt. The children occupied themselves by reading and creating imaginary worlds, recorded in small notebooks. In 1846, Brontë and her sisters published their poems under the pseudonyms of Currer, Ellis, and Acton Bell. In 1847, Brontë (again under her pen name) published *Jane Eyre*, the first modern novel in which a woman openly expresses her feelings, which became an immediate success. In her second novel *Shirley*, the heroine longed to have a trade instead of the "vacant, weary, lonely life" of a woman of her class, even if it made her, according to society's standards, "coarse and masculine!" The writing of *Villette*, her next book, was interrupted by her own illness and then the deaths of her sisters and brother. She eventually married her father's curate and soon after, became pregnant, then died from pneumonia.

Emily Brontë
1818–1848; ENGLAND

Emily, like her sister Charlotte, was brought up in the isolated environment of their father's parish house where the lonely purple moors provided a stark backdrop. Her poems were discovered by Charlotte, who initiated their publication. In 1847, Brontë published *Wuthering Heights,* bequeathing to literature what some critics consider the greatest piece of romantic fiction ever written, along with the unforgettable character of Heathcliff. At the time of its publication, some skeptics insisted that the book was written by Emily's brother Branwell, because they could not believe that a young woman from so limited a background could have written such a passionate story. In 1848, she died of tuberculosis.

Frances Brooke
1723–1789; CANADA

At the age of twenty-four Brooke set out for London, modest inheritance in hand, with the intention of becoming a writer. She soon established herself as one of the first English women to earn her living by her pen, producing a number of French translations along

with poetry, essays, plays, and novels. In 1756, she married John Brooke, who left England for Canada, where he became a chaplain in the town of Quebec. Frances did not follow him there until 1763 and then she stayed for only five years. Shortly after her return to England, she published *The History of Emily Montague*, a four-volume work set in Canada and written as a fictional travelogue. The novel was not given serious consideration by literary critics until the 1920s when it began to be studied as the first major Canadian novel.

Elizabeth Barrett Browning
1806–1861; ENGLAND

Browning, the eldest of twelve children, was self-taught. By the age of twelve, she had already written an "epic" poem consisting of four books of rhyming couplets. In 1838, her first volume of mature poetry was published but, that same year, her health began to deteriorate and she became an invalid and a recluse. In 1844, she published another book of poetry, which made her one of the most popular writers in the country and inspired the poet Robert Browning (1812–1889) to write and tell her how much he loved her work. With his devotion and encouragement, she slowly threw off the cloak of illness and then ran away with and married Browning, with whom she had a child. Their union lasted until Elizabeth's death in 1861, which devastated him. Her *Sonnets for the Portuguese*, which were written to express her feelings and fears about her relationship with Browning, are often referred to as the greatest sonnets since Shakespeare. In her epic poem, "Aurora Leigh," she challenged the subjugation of women and discussed her own conflicts as a female poet.

Fanny Burney
1752–1840; ENGLAND

After the 1778 publication of her secretly written novel *Evelina, or A Young Lady's Entrance into the World*, Burney became famous. None of her subsequent works achieved the same level of success, and her popularity declined. In 1793, she married, after which she stopped writing novels though she continued to work on her journals. Burney's diaries span seventy-two years and are her most widely known works today.

Anne Clough
1820–1892; ENGLAND

In 1852, Clough played a prominent part in founding the North of England Council for Promoting the Higher Education of Women. An active suffragette, she was also instrumental in gaining admission for women to several colleges. In 1871, when women were first allowed to sit in on lectures at Cambridge, she administered the residence house for female students there. This soon became Newnham College, the first university for women in England. Clough became its initial president, a position she held until her death.

Elizabeth Druzbacka
1695–1765; POLAND

Elizabeth or Elzbieta Druzbacka, one of the finest Polish writers of the eighteenth century, was a poet whose subject matter ranged from religious hypocrisy to the need to broaden women's experience. Dubbed "The Slavic Sappho," even though her work had little to do with the writing of the legendary Greek poet, Druzbacka's work blazed a new trail for Polish literature.

Maria Edgeworth
1767–1849; IRELAND

Although Edgeworth was born in England, she lived most of her life in Ireland on her father's estate. He enlisted her, as one of the eldest of his twenty-two children, to write stories that would promote her siblings' education. These were published and became immediately popular. Five years later, she began to write novels. In all, she produced nearly fifty books, which earned her an important place in Irish literature. Her fiction, which depicts Irish customs and heritage, inspired her friend Sir Walter Scott (1771–1832) to write similar romances of Scotland. Like Austen, she produced her work amid the busy goings-on of her family's sitting room.

George Eliot
1819–1880; ENGLAND

Born Mary Ann Evans, Eliot tended house for her father until his death in 1849. Fortunately, he left her with a modest annuity that gave her independence. When she was thirty, she began writing for the prestigious *Westminster Review* (a progressive journal established in 1824) where she soon became assistant editor, a position that brought her into contact with the London literary circle. She became involved with her editor Henry Lewes, with whom she lived despite the fact that he was married, which scandalized many of her friends. She soon began publishing fiction under her male pseudonym and her second book, *Adam Bede*, became a huge success. In her novels, she often dealt with the pain felt by women who tried to realize their talents in the repressive atmosphere of Victorian England. For example, in *Daniel Deronda*, Eliot laments: "You may try, but you can never imagine what it is to have a man's force of genius in you, and yet to suffer the slavery of being a girl." Despite her sym-

209

Detail, *Emily Dickinson* runner back

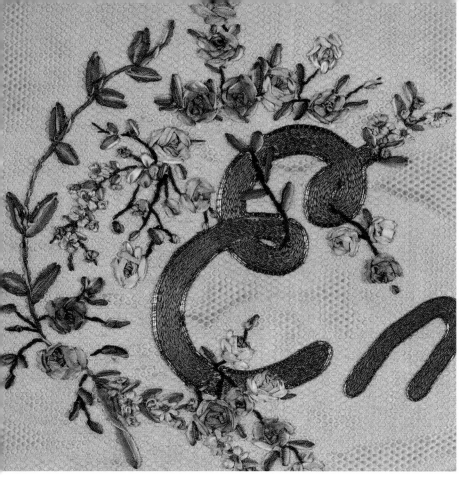

Emily Dickinson illuminated capital letter

pathetic portrayal of women, most of her heroines, while chafing under the restrictions imposed by their gender, did not openly rebel.

Margaret Fuller
1810–1850; UNITED STATES

According to Susan B. Anthony and Elizabeth Cady Stanton's 1881 book *History of Woman Suffrage*, Fuller "possessed more influence on the thought of American women than any woman previous to her time." The source of their admiration was Fuller's 1845 *Woman in the Nineteenth Century*, which profoundly influenced the women's rights movement that had its formal beginning three years later in Seneca Falls. Fuller received a rigorous classical education from her father Timothy, who was influenced by Mary Wollstonecraft's feminist ideas. In 1839, after his death, Fuller began holding a series of "Conversations" for women where they discussed politics, art, philosophy, literature, and science. She became involved in the transcendental movement and, with philosopher Ralph Waldo Emerson, founded the transcendentalist journal *The Dial*, which she edited for two years. She then moved to New York and served as literary and cultural critic for the *New York Tribune*. In 1846, she embarked for Europe, settling in Rome where she fell in love with one of the men involved in the Italian unification movement, with whom she had a child. On their way back to the United States in 1850, their ship struck a sandbar, and Fuller, her lover, and son drowned.

Anna Karsch
1722–1791; GERMANY

Karsch started to write poetry at an early age. She was subsequently "discovered" by a count who brought her to Berlin, where she was celebrated for a short time. Called the "German Sappho," she was soon forgotten and died in poverty.

Mary Lyon
1797–1849; UNITED STATES

A pioneer in women's education in the United States, Lyon's career began in 1814 when she started teaching at a summer school near her birthplace in western Massachusetts. Over the next twenty years, she taught in schools around New England. At that time, private female academies were springing up in the East, but the curriculum focused on such "ladylike" skills as needlework. Lyon became determined to create an institution of higher education for women. She spent four years raising funds, during which time her behavior was criticized as appalling for a "proper" woman. In the fall of 1837, Mount Holyoke Female Seminary (now College) opened its doors. Its success forced open the doors of university education to women.

Harriet Martineau
1802–1876; ENGLAND

In 1831, Martineau wrote *Illustrations of Political Economy*, a series of stories in which she tried to enable ordinary people to understand economics. The series' success funded a two-year tour of the United States. She based two books, *Society in America* (1837) and *Retrospect of Western Travel* (1838), upon her perceptions. The observational methods she developed while traveling were a forerunner of modern sociology. Though impressed with U.S. democracy, Martineau was disparaging of the contradiction between America's expressed values and the situation of women, asking: "Is it to be understood that the principles of the Declaration of Independence bear no relation to half of the human race?" Plagued by illness in her later years, she nonetheless pursued a journalistic career, writing more than 1,600 pieces for the London *Daily News*, "doing pretty well for a dying person," as she put it.

Hedwig Nordenflycht
1718–1763; SWEDEN

When Nordenflycht's father was on his deathbed, he insisted that his sixteen-year-old daughter marry a man she did not love. Three years later, that husband died, an event she commemorated in her early poems. In 1741, she married a former priest who had been her teacher. When he died, she published poems expressing her grief under the title *The Mourning Turtle-Dove*. She went on to publish a series of poems in the form of Yearbooks. Collected as *Womanly Thoughts of a Shepherdess of the North*, these were the first examples of a type of naturalistic writing that influenced subsequent Swedish authors. Nordenflycht continued to write and publish and also helped to form an important literary society known as the "Thought Builders."

Baba Petkova
1826–1894; BULGARIA

Petkova was a champion of education for women. In 1859, while Bulgaria was still under the rule of the Ottoman Empire, she had hundreds of girls attending her classes. Though the students and their parents supported her efforts, government officials attempted to stop her. Petkova was arrested and her home searched for (supposedly) seditious books. Forced to stand trial, she was released for lack of evidence and continued her campaign to educate women.

Christina Rossetti
1830–1894; ENGLAND

Rossetti was from an artistic family that included her brother, the Pre-Raphaelite painter Dante Gabriel Rosetti. She began writing as a child; during her lifetime, her poetry was more widely known than her brother's art, though that has since changed. Although some critics have categorized her as a religious poet, her work also provides a critique of the values of her era that might be attributed to her ambivalent position in relation to the male-dominated Pre-Raphaelite "brotherhood."

Susanna Rowson
1762–1824; UNITED STATES

Born in England, Rowson moved to the United States in 1793, joining a theatrical company in Philadelphia. After retiring from the stage three years later, she opened a school for girls in Boston—one of the best of its day—that she ran for twenty-five years. She is most remembered for her 1791 novel *Charlotte Temple*, the first best seller in the United States, which, according to the author's preface, was intended to prepare young women for survival in a dangerous world of false friends, seductive men, and hypocrites.

George Sand
1804–1876; FRANCE

Born Aurore Dupin, George Sand married in 1822 and had two children. But in 1831, she abandoned her family to pursue a literary career. A prolific writer, she remains best known for her novels, which established her as an important literary voice for her generation. Though she published under a male pseudonym like George Eliot, she went further, adopting male attire and behaviors and participating in a cultural life that was closed to women. She also openly engaged in love affairs, most famously with the composer Frederic Chopin (1810-1849), whom she supported and lived with for a number of years. Regarding her writing, critics have noted her deconstruction of gender stereotypes, her explorations of the female body, and her advocacy of sexual freedom and independence for women. She once wrote: "The world will know and understand me someday. But if that day does not arrive, it does not greatly matter. I shall have opened the way for other women."

Albertine Necker de Saussure
1766–1841; FRANCE

De Saussure was a cousin of the writer and revolutionary Germaine de Staël, with whom she collaborated and about whom she wrote. She also made a significant contribution to women's rights through her book *Progressive Education*, which argued for higher learning for women. An advocate for physical education for girls, de Saussure argued that physical activity would lead to strength for women instead of the continual ill health that resulted from their enforced idleness.

Bertha von Suttner
1843–1914; AUSTRIA

In 1876, Alfred Nobel, who had made a fortune in explosives, hired as his secretary Bertha Kinsky. She had been in the service of the von Suttner family and had become involved with Arthur, one of their sons. After going to work for Nobel, Bertha eloped with Arthur and—as the Baroness von Suttner—took up the cause of peace. Her first book, *Down with Weapons* (1889), raised European consciousness about the horrors of war. In 1892, Von Suttner invited Nobel to attend a Peace Congress she was organizing in the hopes of deterring him from more weapons production. Though he attended the congress (incognito) and contributed money, he continued making munitions; he also continued to support Von Suttner's peace efforts, to which she devoted the rest of her life. Before Nobel died, he established the Nobel Prizes, and in 1905 the Peace Prize was awarded to Bertha von Suttner.

Hermine Veres
1815–1895; HUNGARY

Because the schooling available to Veres was so limited, she wanted her daughter to become educated. In 1867, she made a public appeal for more adequate schools for women and was almost single-handedly responsible for opening higher education to them. She helped found the Society for the Education of Women and then, within two years, a women's school.

Emma Willard
1787–1870; UNITED STATES

Willard, a teacher, and her husband John housed his nephew while he was attending college. By studying his textbooks, she discovered the vast differences in education available to men and women. In 1814, she opened a school in her home to demonstrate that women could teach and girls could learn subjects thought suitable only for males. Five years later, she became the first American woman to take a public stand on the need for women's education when she wrote a groundbreaking pamphlet, "An Address to the Public Proposing a Plan for Improving Female Education." In 1821, Willard opened the Troy Female Seminary, later renamed the Emma Willard School, which she ran until 1838. Willard was the first person to provide scholarships for women; one of the first women to write geography, history, and astronomy textbooks; and the first female lobbyist in the United States.

Ethel Smyth

1858–1944

Smyth's French mother encouraged her interest in music, but her father disapproved of her ambitions, so she went on a hunger strike until he allowed her to go from England to Leipzig to study. By 1889 her compositions were being performed there to glowing reviews. Upon her return home, however, she had a difficult time establishing herself in the London musical scene. Nevertheless, she kept writing. Her Mass in D was one of the most ambitious pieces ever undertaken by a female composer, its production made possible by the support of two influential women. Though the audience was enthusiastic, the work was attacked by critics and ignored for thirty years.

Smyth became involved in the struggle for women's rights, writing "The March of Women," which was sung by thousands of suffragettes during demonstrations, in jail, or whenever their spirits faltered. In 1912, Smyth herself was imprisoned; she led the jailed suffragettes in a rousing rendition of her composition, conducting with her toothbrush. Soon afterward, while visiting the wife of an important politician in an effort to gain support, Smyth played some of her music. After hearing the "March," the woman said, "How can you, with your gift, touch a thing like politics with a pair of tongs?" "I do it because of my music," Smyth replied, "for owing to the circumstances of my career as a woman composer, I know more than most people about the dire workings of prejudice."

Ethel Smyth plate

Ethel Smyth runner

Literature was one of the first creative fields women were able to penetrate. But music was different: composing and conducting required substantial patronage and support, not to mention the need for a serious musical education. Even after this became possible, most, like Smyth, either encountered a solid wall of resistance or, sadly, remain largely unknown. Nevertheless, a number of women have attempted to participate in music, the most closed of the arts.

Elfrida Andree
1841–1929; SWEDEN

Because of her gender, Andree was not allowed to join the organ class at the Royal Academy of Stockholm. Instead, she studied on her own, receiving her diploma in 1857. She then faced a battle with the Swedish clergy who were hostile to the idea of a woman in the organ loft. With the help of her father Andreas, she engaged in a long struggle to become the organist at the Gothenburg Cathedral in the second largest city in Sweden, where she played from 1867 until her death, the first woman to hold such a position. During her tenure she gave more than eight hundred concerts and composed numerous works, including an orchestral symphony, a Swedish mass, and organ sonatas. In 1879, she was elected to the Swedish Academy of Music.

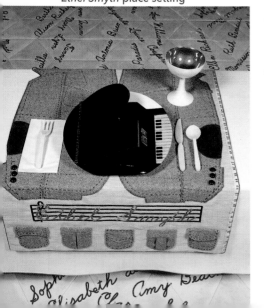

Ethel Smyth place setting

Amy Beach
1867–1944; UNITED STATES

A child prodigy, Beach made her piano debut with the Boston Symphony at age sixteen, after which she toured as a soloist. In 1896, the Boston orchestra premiered her Mass in E-flat, Opus 5, which prompted one of her musical colleagues to dub her "one of the boys." In 1893, she had received wider recognition when her *Festival Jubilate* was performed at the dedication of the Woman's Building at the Columbian Exposition in Chicago. Over the course of her career, she composed piano concertos, cantatas, string quartets, an opera, and more than a hundred choral works. After her death, her music endured a long period of neglect, which has been reversed through the efforts of singers and musicologists who have recognized that her use of vernacular melodies mark her as a pioneer in the development of an "American" music.

Antonia Padoani Bembo
1643–1715; ITALY

Bembo studied music with private tutors as well as the famous composer Francesco Cavalli (1602-1676). She wrote a number of works early in her career, one of the most successful of which was a trio for women's voices, penned to celebrate the birth of her first child. She had two more children with her husband Lorenzo Bembo (1637-1730), but they separated, which was highly unusual in that period. Antonia sued for divorce on the grounds of physical violence, infidelity, theft of her property, and negligence of family support. She lost the case and soon moved into a women's religious community, where she produced music for court circles. Between 1697 and 1707, her compositions were collected in a series of manuscript volumes.

Faustina Bordoni
1697–1758; ITALY

Called the "Songstress of Venice," Bordoni was considered one of the greatest opera singers of the eighteenth century. After hearing her perform in the Vienna Court Opera in 1724, George Frideric Handel (1685-1759) engaged her; in 1726, she performed in his opera company in London with another famous soprano, Francesca

Cuzzoni (1698-1770). The two divas became enmeshed in a rivalry that erupted in a scandalous skirmish during the middle of a performance. Bordoni went on to sing in a number of other Handel roles and then married Johann Adolph Hasse (1699-1783), court composer in Dresden, one of the musical centers of Europe. The couple moved there, and Bordoni concentrated on operatic roles created by her husband.

Lili Boulanger
1893–1918; FRANCE

Boulanger and her elder sister Nadia came from a famous musical family. By the age of three, she had showed enormous musical aptitude, and by sixteen she was an accomplished pianist, cellist, violinist, and harpist. In 1913, she became the first woman to win the Grand Prix de Rome for her cantata *Faust et Helene*. This allowed her to pursue her career in Italy, but failing health forced her home to Paris. She died at age twenty-five. During her brief career, she composed more than fifty works.

Nadia Boulanger
1887–1979; FRANCE

Although Boulanger became a composer and conductor—she entered the Paris Conservatory of Music when she was ten years old—it was as a teacher of composition that her primary impact was felt. In 1921, she became a professor at the American Conservatory of Music in Fontainebleau, France, eventually being named its director. Her students included such outstanding composers as Virgil Thompson (1896-1989), Aaron Copland (1900-1990), Elliott Carter (1908-2012), and Philip Glass (born 1937). Her own compositions included orchestral pieces, chamber music, and choral works. She was the first woman to conduct several major symphony orchestras, including those of New York, Boston, and Philadelphia.

Antonia Brico
1902–1989; UNITED STATES

In 1923, Brico graduated from college after a stint as the assistant to the director of the San Francisco Opera. She then studied at the Berlin State Academy of Music, becoming the first American to graduate from its master class in conducting. Her debut with the

Berlin Philharmonic made headlines, partly because in 1930 a female conductor was so unusual as to be considered newsworthy. Brico toured the continent as guest conductor of many major orchestras and made a triumphal New York debut in 1933. The next year she agreed to become the conductor of the new Women's Symphony Orchestra; this group evolved into the Brico Symphony Orchestra, which included men. It soon disbanded, and her career subsequently suffered a decline. As she explained: "At first I was a novelty . . . but then the jobs disappeared." In 1974, a documentary film about her life was widely seen, which led to many invitations to conduct.

Ethel Smyth illuminated capital letter

Marguerite-Antoinette Couperin
1705–1778; FRANCE

Couperin was a member of the famous family that dominated French music from the seventeenth through the nineteenth centuries. In 1730, her father, Francois Couperin (1668-1733), passed his position at the French court of Louis XV to Marguerite-Antoinette, who became the royal harpsichordist and principal soprano for the king.

Marguerite-Louis Couperin
1676-1720; FRANCE

Following in the musical tradition of her family, Marguerite-Louis became court musician to the king. In addition, she was the first woman to be appointed to the royal post of Ordinaire de la Musique de la Chambre du Roi (musician to the king) in 1723 under Louis XV.

Margarethe Dessoff
1874–1944; GERMANY

Dessoff traveled to the United States shortly after World War I. She soon became involved in music and in 1924 (with Angela Diller of the Diller-Qualille School of Music in New York) formed the Adesdi chorus, a moniker created from parts of the founders' names. This group was composed of fifty women who performed music that had been written specifically for the female voice. In 1929, Dessoff established the A Cappella Singers of New York, a mixed chorus. Together, these two groups came to be known as The Dessoff Choirs, their mission both to present

music which otherwise would not be heard and to provide an opportunity for talented amateurs to sing choral masterpieces. The Dessoff Choirs also helped to popularize early, medieval music, which was then almost completely unknown to American listeners.

Sophie Drinker
1888–1967; UNITED STATES

When I was doing the original *Dinner Party* research, I discovered Drinker's then out-of-print but groundbreaking book *Music and Women*, first published in 1948 and only recently reissued. In tracing women's role in music from early matriarchal societies to the modern period, she demonstrated that in many ancient cultures music was considered the province of women—part of their creative powers. There were even special rituals and songs written and performed by women for the important occasions in a community's life. The medieval Church's ban on women's voices led to, among other things, the castration of many young boys whose artificially controlled high voices replaced the natural voices of women.

Jeanne Louis Farrenc
1804–1875; FRANCE

Jeanne Louis (or Jeanne-Louise) Farrenc entered the prestigious Paris Conservatory of Music at age fifteen, studying composition with some of the most prominent composers of the time. She taught there for thirty years, the only woman to hold a permanent position at that institution. Farrenc wrote

symphonies, overtures, quintets, chamber music works, and piano pieces and was one of the first female composers to gain wide regard throughout Europe. With her husband, flautist Aristide Farrenc (1794–1865), she published a twenty-three-volume anthology of seventeenth– and eighteenth–century music. Although her musical output was rapidly forgotten, interest in her work has been revived through the recent publication of her piano music.

Carlotta Ferrari
1837–1907; ITALY

No opera producer would support the presentation of Ferrari's 1857 opera *Ugo* simply because it had been written by a woman; she had to personally pay for its production at the Milan Opera House. Fortunately, the opera was a popular success, which opened some doors for her. However, she was later arrested and forced to stand trial for the crime of being a female composer.

Elisabeth de la Guerre
1665–1729; FRANCE

De la Guerre, a child prodigy, began composing at an early age. She was soon taken to the court of Louis XIV and educated there, probably by the king's royal mistresses. Her performances as a singer, harpsichordist, and composer brought her great renown, and she was rewarded by the patronage of the king. She composed in all the standard genres of the time, including stage works, songs, cantatas,

Detail, *Ethel Smyth* **runner**

Jenny Lind
1820–1887; SWEDEN

Known as the "Swedish Nightingale," Lind was one of the most celebrated sopranos of all time. By the age of three, she could repeat any song she heard. At ten, she was singing children's parts on the Stockholm stage. Trained at the Royal Theater of Stockholm, she created a sensation throughout Europe and the United States on her highly successful concert tours, donating most of her vast earnings to charity.

Fanny Mendelssohn
1805–1847; GERMANY

Mendelssohn's musical talent was recognized by her parents, who provided both her and her brother Felix with training. However, as a female she faced many restrictions that her brother did not. By the time she was fourteen, her father began to remind her that her future role was to be a wife and mother. Consequently, her musical production was limited to pieces that could be performed at concerts in the family's home. In 1829, she married the artist William Hensel (1865-1925) who was supportive of her music. She soon reinstated family concerts where she conducted and accompanied a choir that performed the work of many composers, including her own. The success of these concerts encouraged Mendelssohn to compose longer works. It was only during the last year of her life that she began to publish her work—over the objections of her more famous composer brother. Much of her music remains unpublished, some in family archives that are closed to scholars.

Rose Mooney
1740–1798; IRELAND

Music was an important part of life in ancient Ireland, and professional harpists were the most revered performers. But by the eighteenth century, the tradition of Irish harpers was almost extinct. In an effort to change this, a festival was held in Belfast in 1792. Third prize went to Mooney, the only woman to compete and one of the very few female harpers of the time. Like a number of the participating musicians, she was blind.

harpsichord works, and operas, and her sonatas were among the first created in France.

Wanda Landowska
1879–1959; POLAND

Landowska's theories and techniques became the basis for contemporary harpsichord playing and have influenced innumerable modern keyboard composers. A musical prodigy, she began playing the piano at the age of four. After training at the Warsaw Conservatory and in Berlin, she moved to Paris, where her research in early music led to her interest in the harpsichord, an instrument that was thought to have been rendered obsolete by the piano.

In 1909 *Musique Ancienne*, her book on early music, was published. Later, she founded the School for Ancient Music and supervised the manufacture of replicas of ancient instruments, presenting many concerts that reintroduced these instruments to audiences in Europe. With the Nazi invasion of France in 1940, she lost her school, her extensive library, and all of her instruments. She and her companion Denise Restout made their way to New York where Landowska reestablished herself as a highly influential performer and teacher.

Maria Theresia von Paradis

1759–1824; AUSTRIA

Von Paradis lost her eyesight when she was young. Nevertheless, she performed as a singer and pianist in concerts as well as at Viennese salons and composed piano pieces, operas, and cantatas. To compensate for her lack of sight, she developed an innovative notation system involving the use of pegs and a pegboard. In 1808, she founded her own music school for young women, devoting the rest of her life to teaching.

Clara Schumann

1819–1896; GERMANY

By the age of nine, Clara, whose parents were both musicians, was playing public concerts; at the age of fourteen, she began composing, though her performing skills were so in demand that she found little time to write. While still a teenager, she fell in love with Robert Schumann, who would become one of the most famous composers of the nineteenth century. In 1840 they were wed, and the couple shared a rich musical interaction. However, the problem of maintaining two careers caused friction in their marriage, and Clara set aside her own music in deference to his. When she turned thirty-seven, Robert died, leaving her to support their eight children. Fortunately, music became both Schumann's solace and a source of income for her and her family.

Mary Lou Williams

1910–1981; UNITED STATES

Williams—considered by many to be jazz's finest pianist and one of its most brilliant composers—had perfect pitch and a highly developed musical memory by the time she was four. Her professional debut came in 1922 when she was twelve. During her twenties, she began writing and arranging for the big bands of the era. In 1942, she moved to New York; within a year, she was organizing bands and performing at many of the city's clubs. Williams influenced a generation of musicians through her original compositions, unusual arrangements, and radio show *The Mary Lou Williams Workshop*. Her home became an important center for the exchange of musical ideas, and she established the Bel Canto Foundation to aid down-and-out musicians. Later in life, Williams taught music at Duke University and composed sacred works. She also founded Mary Records, the first such company established by a woman.

Detail, *Ethel Smyth* runner back

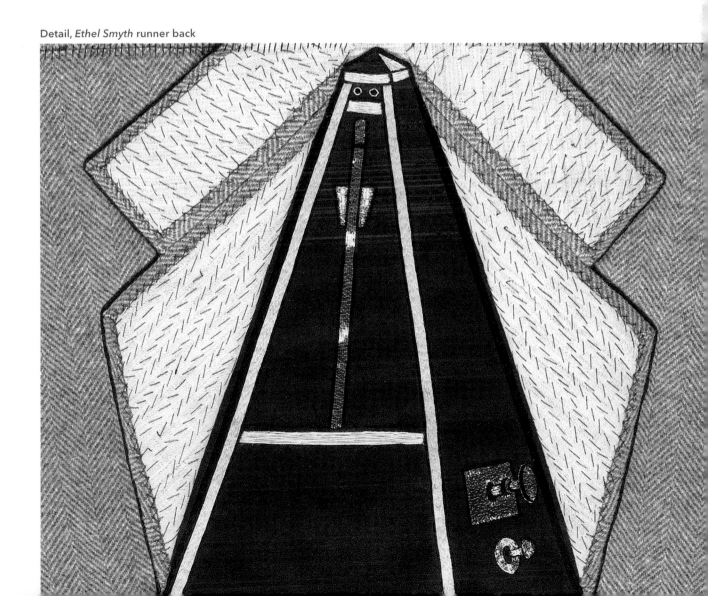

Margaret Sanger

1879–1966

Born into a large Irish-American working-class family, and in her work as a nurse in the slums, Margaret Sanger saw firsthand the ravages caused by a lack of reproductive rights. Determined to "do something to change the destiny of mothers whose miseries were as vast as the sky," she went to Europe and Asia to investigate the contraceptive research being done there. Upon her return to the United States, Sanger forced the taboo subjects of sexuality and birth control into the public forum through her magazine *The Woman Rebel*, ignoring the laws of the time that prohibited the dissemination of any information about sex and contraception.

From the time she opened her first birth control clinic in 1918, Sanger was repeatedly arrested for her actions. Convinced that the birth control movement had to be worldwide, she convened the International Birth Control Congress in 1925. The organization she formed was a forerunner of Planned Parenthood, of which she became president in 1953. Sanger believed passionately that once women were freed of involuntary childbearing, they would change the world. Although her dream of a more humane world order forged by women has not yet been realized, her contributions as a social reformer were vast, notwithstanding her support of the eugenics movement. Her life was a testament to her conviction that women should "look the world in the face with a go-to-hell look in the eyes; have an idea; speak and act in defiance of convention."

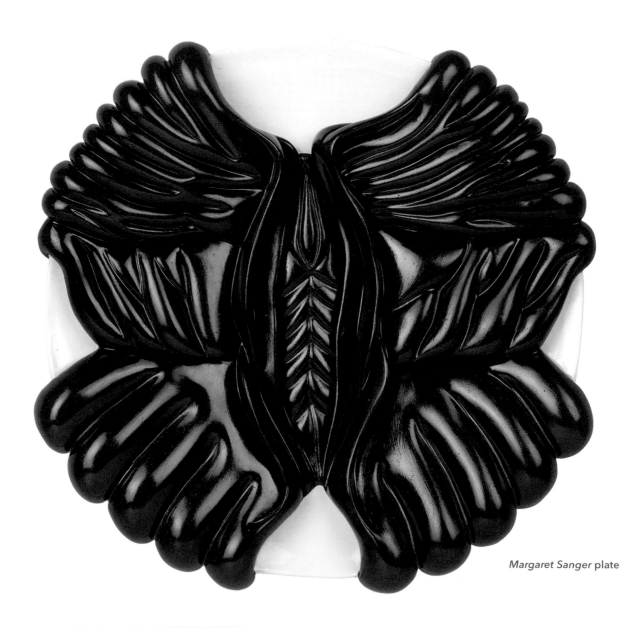

Margaret Sanger plate

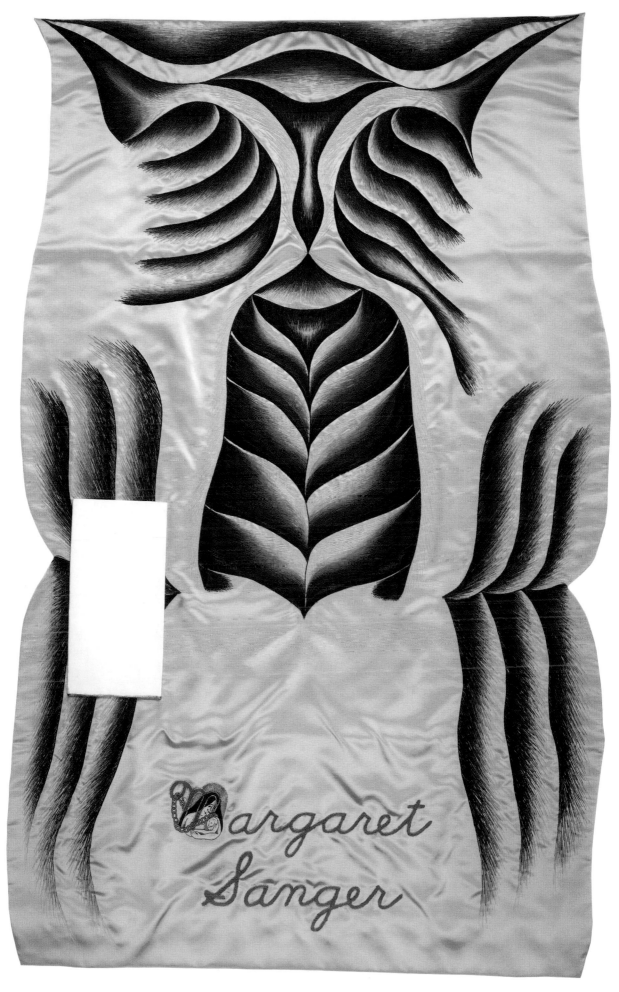

Margaret Sanger place setting

The resistance encountered by early advocates of contraception was intense, and considerable courage was required to stand up to the opposition of the Church, the state, and public opinion. Even though many of the women associated with *SANGER'S* place setting also worked for women's rights and reproductive freedom, few grasped her deeper insights about the connections between the fight to maintain control over women's bodies and larger issues of justice on the planet. Instead, most put their faith in national revolutions or specific reforms as a means of obtaining equal rights. Nevertheless, many of these women made important contributions.

Jane Addams
1860–1935; UNITED STATES

In 1889, Addams opened Hull House in Chicago, where she lived and worked until her death. It provided social services, English and vocational classes, and instruction in the arts. Shortly thereafter, Mary Rozet Smith arrived. From a wealthy family, she soon became Addams's life companion. From their experiences at the first social service agency in the United States, the Hull House residents and supporters forged a powerful reform movement, launching such organizations as the Immigrants' Protective League. Through their efforts, protective legislation for women and children was enacted in Illinois; in 1912, the Federal Children's Bureau was created, and four years later a federal child labor law was passed. Addams

lectured widely and wrote prolifically; in addition, she actively supported women's suffrage. She was a central figure in the international women's peace movement, and in 1931 she became the first American woman to win the Nobel Peace Prize.

Inesse Armand
1874–1920; RUSSIA

After opening a school for peasant children and joining a charitable group helping destitute women, Inesse or Inessa Armand began to question whether reform movements were sufficient to address the inequities of Russian society. In 1903, she joined the illegal Social Democratic Labour Party (a revolutionary party that later split into the radical Bolsheviks and the more moderate Mensheviks). Later arrested for distributing banned propaganda, she was sentenced to exile for several years in Siberia. Seven years later, she left her husband and five children to study with the Swedish feminist writer Ellen Key (1849–1926). She returned an ardent feminist. In 1917, Tsar Nicholas II abdicated and the Bolsheviks took over the country. Armand served as an executive member of the government, becoming director of Zhenotdel, an organization that fought for female equality in the Communist Party and the trade unions. In 1920, shortly before her death, she chaired the First International Conference of Communist Women.

Sylvia Ashton-Warner
1908–1984; NEW ZEALAND

Ashton-Warner was forced to become a teacher in order to earn a living, though she feared it would thwart her creativity as a writer. As it turned out, her work with Maori children led to an enrichment of both pursuits. Believing that children's natural impulses should be encouraged, she taught from primers that the children had written themselves, a revolutionary idea at the time but one that eventually brought her international recognition as a progressive teacher. Through her novels, she challenged the traditional dominance of literature by white males, thereby breaking new ground in New Zealand fiction.

Angelica Balabanoff
1878–1965; RUSSIA

A social reformer and revolutionary, Balabanoff joined the Social Democratic Labour Party in 1900 and worked closely with Lenin (1870–1924) after he and the other Bolsheviks split off from that party. After the Russian Revolution in 1917, she became the first secretary of the Comintern (founded in 1919 to work for the creation of an international Communist state). But she left the party and the country in despair, feeling that the Revolution's aims had been betrayed by the authoritarian dogmas of the Bolshevik regime. After meeting the activist Emma Goldman (1870–1924), Balabanoff embraced her vision of anarchism.

Catharine Beecher
1800–1878; UNITED STATES

The sister of Harriet Beecher Stowe, Catharine Beecher believed that women needed higher education to be adequately prepared for the task of educating their children. Through writing and the founding of several institutions, she advocated restoring value to women's traditional domestic activities, a position opposed by feminists, who argued that women needed to engage in the world. In 1843, Beecher published her influential *Treatise on Domestic Economy,* in which she explained every aspect of domestic life—from the building of a house to the setting of a table. Her book was the beginning of household automation and the servantless household; its widespread success probably lay in its ability to combine a convincing domestic ideology with practical advice.

Ruth Benedict
1887–1948; UNITED STATES

In 1923, Benedict, one of the first female anthropologists, received her doctorate from Columbia University, where she studied with Franz Boas (1858–1942), whose pioneering work changed the course of the profession. One of her students was Margaret Mead (1901–1978), with whom she had an intimate friendship. In 1934, Benedict published the best-selling *Patterns of Culture,* a landmark study of the relationship between culture and the development of human personality. During World War II, she worked for the Office of War Information, applying

anthropological methods to the study of contemporary cultures, including that of Japan. In 1946, she published *The Chrysanthemum and the Sword: Patterns of Japanese Culture*, which became a classic work and is still in print.

Yekaterina Breshkovskaya
1844–1934; RUSSIA

At the age of twenty-six, Breshkovskaya, who was dubbed the "Grandmother of the Russian Revolution," left her wealthy family to join the followers of anarchist Mikhail Bakunin (1814–1876). In 1874, she was arrested for her political activities on behalf of serfs, imprisoned in St. Petersburg, and then sent to Siberia. After her release in 1896, she helped to found the Social Revolutionists, a moderate political group who advocated confiscating all private land and distributing it to the peasants. Imprisoned again in 1907, she was released during the 1917 Revolution, but when the Bolsheviks came to power, she fled to Czechoslovakia to escape their authoritarian rule.

Rachel Carson
1907–1964; UNITED STATES

In 1952, Carson—marine biologist, naturalist, and writer—published her prize-winning study of the ocean, *The Sea Around Us*, which won the National Book Award for nonfiction and helped to make Carson famous. That same year, she resigned from her government job as editor in chief of all publications for the U.S. Fish and Wildlife Service to devote herself to writing. Her most famous book, *Silent Spring* published in 1962, was inspired by her concern for the survival of the human race and the dangers of pesticides like DDT. As she wrote: "The central problem of our age has become the contamination of man's total environment with substances of incredible potential for harm." She was attacked by business interests but defended her theories at Senate hearings, which led to stricter regulation of the use of toxic chemicals and helped to spark the environmental movement. Tragically, during the four years it took Carson to write the book, she was fighting cancer; there is considerable speculation that her illness might have been caused by exposure to the very carcinogens she had been studying.

Dorothea Dix
1802–1887; UNITED STATES

Dix's mission became to improve the facilities for and care of the mentally ill. To achieve this goal, she traveled thousands of miles to visit prisons, county jails, and almshouses, making careful records of the conditions she observed and then preparing documents to be presented to lawmakers to convince them of the need for radical change. Her work was directly responsible for the establishment of thirty-two mental hospitals, fifteen schools for the mentally challenged, a school for the blind, and training facilities for nurses which equipped them to work with the mentally ill. When the Civil War broke out, Dix volunteered and was made chief of nurses for the Union army. Serving without pay, she developed the Army Nursing Corps, mobilizing thousands of women and turning public buildings into hospitals. At the end of the war, she returned to her work on behalf of the mentally ill.

Vera Figner
1852–1943; RUSSIA

Figner, the daughter of prosperous parents, wanted to become a doctor. As training for women was impossible at this time in Russia, she went to school in Switzerland, where she met a number of political exiles. She returned home a confirmed revolutionary. In 1879, she joined the "People's Will," an underground radical group, eventually becoming its leader. She was part of the successful plot to assassinate Tsar Alexander II (1818–1881). Two years later, she was arrested, tried, and sentenced to death, later commuted to life imprisonment. She served over twenty years in solitary confinement. After being released she went to Europe, where she lectured, raised money for radical causes, and wrote about her prison experiences. In 1915, she returned to Russia, though she became disillusioned by the Bolshevik government not long after the Revolution. Her book *Memoirs of a Revolutionist* made her famous worldwide. Until her death, the Communist Secret Police watched her closely.

Elizabeth Gurley Flynn
1890–1964; UNITED STATES

The daughter of socialist parents, Flynn became an organizer for the Industrial Workers of the World (the "Wobblies"). Over the following few years, the "Rebel Girl," as she was called, organized garment workers, silk weavers, textile workers, miners, and restaurant workers. Although repeatedly arrested, she was never convicted. A founding member of the American Civil Liberties Union, Flynn joined the Communist Party in 1936, writing a feminist column for its journal the *Daily Worker*. During WWII, she played an important role in the campaigns for equal economic opportunity for women and the establishment of day care centers. She spent most of the 1950s in prison for her support of the Communist Party. Released in 1959, she became the first female chair of the American Communist Party, a position she held until her death at age seventy-four.

Elizabeth Fry
1780–1845; ENGLAND

Despite the fact that she was the mother of eleven children, in 1812, Fry, a Quaker, began visiting workhouses and prisons. Though she was appalled by the conditions, her family obligations prevented her from doing anything about it until four years later, when she decided to set up a prison school for the children of the female inmates. In addition, she provided materials so that the prisoners could make sewn goods for sale in order to buy food and clothing. In 1818, she was asked by the government to testify about prison conditions, the first woman to do so. Fry also set up societies to alleviate some of the suffering of the poor. Her work became well-known, particularly after the publication of her book *Observations, on the visiting, superintendence and government of female prisoners*, which called for more opportunities for women. She influenced the passage of a prison reform bill in 1821 and, through her work, instigated changes in prison policy in Scotland, Australia, France, Germany, and Holland.

Emma Goldman
1869-1940; RUSSIA/UNITED STATES

Born in Russia, Emma Goldman immigrated to the United States in 1885. Early on, she became involved in radical politics. Convinced that the social and political organization of modern society was unjust, she embraced anarchism for the vision it offered of absolute freedom. Throughout her career, she addressed the need for economic, social, and sexual emancipation for women. A fiery orator and gifted writer, she produced numerous influential essays and books along with more than two hundred thousand letters. She also served as publisher of the anarchist periodical *Mother Earth*. In 1919, Goldman was deported to Russia for subversive activities, but she was repelled by the Bolshevik dictatorship. She managed to obtain British citizenship and lived in Europe until the end of her life, all the while maintaining her commitment to a wide range of controversial causes.

Dolores Ibarruri
1895-1989; SPAIN

Ibarruri was born into a family of poor miners. After reading Karl Marx (1818-1883), she joined the Communist Party and began writing articles for the miners' newspaper under the pseudonym "Pasionaria" (passion flower). In 1930 she was elected to the Central Committee of the Spanish Communist Party. The following year, she became editor of the left-wing paper *Mundo Obrero*, using her position to campaign for women's rights. During the Spanish Civil War, she was the chief propagandist for the anti-Franco forces. At the end of the war, she fled to the Soviet Union, becoming secretary general of the Communist Party in 1944. She was awarded the Lenin Peace Prize in 1976.

Mary "Mother" Jones
1837-1930; UNITED STATES

Jones's husband George, an iron worker, died from a yellow fever epidemic, as did their four children. Forced to support herself, Jones established a successful dressmaking business in Chicago only to see it burn to the ground in the famous 1871 Great Chicago Fire. She then joined the Knights of Labor, a predecessor to the Industrial Workers of the World, which she helped to found. As a union organizer, she first gained prominence for organizing the wives and children of striking workers. Owners often used violence to intimidate strikers, but "Mother Jones" refused to be frightened or discouraged. An electrifying speaker, skillful organizer, and powerful leader, she devoted her life to fighting for the dignity of the worker. Though she was repeatedly arrested, she was never deterred, continuing to speak on union affairs until her death at ninety-three.

Rachel Katznelson
1885-1975; ISRAEL

Born in Russia, Katznelson immigrated to pre-state Israel in 1912. She cofounded the Women's Workers Council; its goals included expanded rights for women, an idea which was never completely realized by either the kibbutz movement or the larger culture. Best known for her 1932 book *The Plough Woman: Records of the Pioneer Women of Palestine*, which contained the first descriptions of working women's lives, Katznelson also established and edited the Hebrew monthly *Savor Hapocht* ("The Working Woman Speaks").

Helen Keller
1880-1968; UNITED STATES

When Keller was nineteen months old, she came down with a fever that left her blind, deaf, and unable to speak. At age seven, she was put under the care of Anne Sullivan of The Perkins Institute for the Blind in Boston. Sullivan taught Keller how to read and write and, finally, how to speak. In 1907, Keller graduated from Radcliffe with high honors, the first blind and deaf person to graduate from college. She became a famous speaker and author and, with Sullivan, traveled all over the world. She later wrote that her motivation for activism—she became a member of the American Socialist Party—was due in part to her concern about blindness and other disabilities; she also raised money for numerous organizations for the blind.

Aleksandra Kollantay
1872-1952; RUSSIA

In the Russian Revolution, there was a tendency among male radicals to dismiss the importance of women's issues. Kollantay (Kollontai) insisted that the Communist Party had to respond to women's special problems: the triple burden of work, child care, and housework that were the consequences of gender rather than class oppression. In 1903, Kollantay had become involved with the Russian Social Democratic Labour Party, which that same year incorporated equality of the sexes into its political program. In 1905, she fled Russia to avoid arrest. After the 1917 Revolution, she returned and was elected commissar of social welfare in the new government, helping to draw up legislation aimed at guaranteeing equal rights for women. Through her writings, Kollantay deepened and extended Marxist ideas regarding women's oppression, the family, and personal relations.

Nadezhda Krupskaya
1869-1939; RUSSIA

Krupskaya was a committed Marxist who along with Vladimir Lenin was exiled to Siberia in 1897 for involvement in radical political agitation. After they were released, they went to Europe where they worked toward political change in Russia. In 1917, they returned, and Lenin took over the Communist regime that came to power as a result of the Revolution. Krupskaya served as deputy people's commissar of education, beginning a lifelong involvement with Russian educational policies that in her view included adult education, the development of libraries, and the emancipation of women. Her contributions in these areas have been obscured by her disagreements with Joseph Stalin (1879-1953), who after Lenin's death succeeded him as leader of the Soviet Union.

Rosa Luxemburg
1871-1919; POLAND/GERMANY

Luxemburg, a Jew from the Pale of Settlement in eastern Europe, earned a doctorate in political science from the University of Zurich. During her time in Switzerland, she met other Russian socialist revolutionaries, including Leo Jogiches (1867-1919), who became her lover and with whom in 1893 she formed the Social Democratic Party of Poland, a Marxist political party. In 1912, she published her major theoretical work, *The Accumulation of Capital*, in which she tried to prove that capitalism was doomed and would inevitably collapse. During World War I, she was imprisoned for sedition. In 1919, she helped to organize a political uprising by the Spartacus League, a revolution-

222

ary left-wing faction of the German Social Democratic Party. Soon thereafter, she was assassinated. Jogiches was later murdered while trying to track down her killers. Luxemburg believed that women would achieve freedom only through the political revolution to which she devoted her life and the elimination of their economic bondage to the institution of the family.

Margaret Mead
1901–1978; UNITED STATES

Mead was born into a Quaker family of educators and studied anthropology at Barnard with Franz Boas and his assistant Ruth Benedict. By the time Mead received her PhD, she had begun doing fieldwork in Samoa, studying adolescent girls in relation to American teenagers. The result was the best-selling *Coming of Age in Samoa*. In 1931, Mead traveled to New Guinea to study gender roles. It was during this time that she made the discovery that "human nature is malleable," an astounding realization at a time when both science and society were arguing for a far more rigid construct of gender. During World War II, Mead wrote pamphlets for the Office of War Information and, after the war, published *Male and Female: A Study of the Sexes in a Changing World*, which made use of her research in the South Pacific and the East Indies to demonstrate that, though there are certain gender differences, they should not be considered restrictions, particularly on women. Through the publication of many books and articles along with her lectures, Mead became a larger-than-life character whose impact caused *Time* magazine to name her "Mother of the World" in 1969.

Golda Meir
1898–1978; ISRAEL

Meir (a name she chose, which in Hebrew means "to burn brightly") emigrated to Palestine in 1921 with her husband Morris Meyerson, where they joined the kibbutz movement. In 1928, she became executive secretary of the Woman's Labor Union, and from 1932 to 1934 she served in the United States as an emissary to the Pioneer Women's Organization (the largest women's organization in Israel). Upon her return to Palestine, she became part of the executive committee of Histadrut (Federation of Labor Unions) and then head of the Jewish Agency's Political Depart-

ment until the establishment of Israel in 1948. The following year, she was elected to the Knesset (the Israeli legislature). She was appointed minister of labor, and then, from 1956 to 1965, she served as Israel's foreign minister. In 1969, she became the first female prime minister of Israel, only the second woman in the world to hold such a high office. A formidable stateswoman, she was once described by David Ben Gurion, her predecessor in that office, as "the only man in his cabinet."

Louise Michel
1830–1905; FRANCE

In 1870, war broke out between France and Germany; the following year, the French government signed an armistice with Germany. This outraged the citizens of Paris, who mounted a revolt that came to be known as the Paris Commune, envisioned as a permanent world republic. Michel, an anarchist, was active in both fighting and caring for the wounded during the two months the Commune existed. After its fall, she was arrested, tried, and deported to New Caledonia, a French territory in the South Pacific. In 1880, she was allowed to return to Paris where she resumed her radical activities. In 1883, there was a large demonstration led by Michel. Arrested again, she was sentenced to six years of solitary confinement, though she was later pardoned. She spent the remainder of her life traveling and promoting anarchism. When she died, there were memorial services for her all over France.

Katti Moeler
1868–1945; NORWAY

In 1904, a branch of the International Council of Women (originally organized by Susan B. Anthony) was established in Norway, and by 1914 there was a wide array of women's organizations there. Katti Moeler or Møller fought for the legal protection of unwed mothers and their children, was involved in the establishment of Oslo's first family-planning center in 1924, and advocated for contraception and improved hygiene in maternity and infant wards. The efforts of early feminists like Moeler led to a change in social relations in Norway; in addition, it became the first country in the world to be led by a feminist (Gro Brundtland in 1981).

Margaret Sanger illuminated capital letter

Maria Montessori
1870–1952; ITALY

Montessori was the first woman in modern Italy to graduate with a degree in medicine. In 1906, she began to work with young children of working-class families, gradually developing her educational theories, which drew on the ideas of scholars in a number of fields, an early example of using an interdisciplinary approach. She soon attracted attention for her innovative work with children previously considered educationally hopeless. In 1912, her first book, *The Montessori Method*, was translated into English, and she became world-renowned. Montessori spent the last two decades of her life developing schools throughout the world, training thousands of teachers in the Montessori curriculum and methodology.

Federica Montseny
1905–1994; SPAIN

Raised by anarchist parents, Montseny was educated by her mother according to the pedagogical principles of Maria Montessori. At seventeen, she joined a clandestine anarchist labor union and soon convinced her parents to relaunch their anarchist journal of cultural criticism. An important speaker and anarchism's leading theorist, she published many articles as well as works of fiction that explored the deplorable status of women in Spain. In 1931, the Second Republic was established (the provisional government founded after the fall of the monarchy), and five years later Montseny was appointed minister of health and public assistance, using her

223

position to implement feminist reforms. In 1939, the left-wing government was overthrown, and Montseny fled to France where she continued to lead the exiled Spanish anarchist movement and publish the party's paper, remaining there until her death.

Emma Paterson
1848–1886; ENGLAND

A labor leader, Paterson organized three London unions, fought for protective legislation for women workers, and became the first woman inspector of working conditions for women's trades. She founded the Women's Protective and Provident League, later renamed the Women's Trade Union League. Through her efforts, more than thirty female unions were established. In 1875, she was one of the first female delegates to the Trade Union Congress at Glasgow and did much to overcome the prevailing prejudices of male delegates against female agitators.

Frances Perkins
1882–1965; UNITED STATES

As a young woman, Perkins became involved in social reform movements in New York, seeking to improve working conditions through legislation. She was part of the commission that investigated the 1911 Triangle Shirtwaist Factory Fire, a tragic event that helped change U.S. labor laws. In 1929, Perkins was appointed by then-governor Franklin Roosevelt (1882–1945) to the post of New York industrial commissioner with the charge of preventing recurrences of such tragedies. After Roosevelt became president, she was appointed secretary of labor, the first woman to hold a cabinet position in the United States. She became chair of the President's Committee on Economic Security and was instrumental in drafting almost all of the New Deal labor legislation, which banned child labor and established a minimum wage.

Sofia Perovskaya
1853–1881; RUSSIA

Arrested for subversive activities, Perovskaya, a teacher, was exiled to Siberia but managed to escape. Upon her return, she became a member of the People's Will Executive Committee (a radical political group) and participated in repeated attempts on the life of Alexander II (tsar from 1865–1881), including his assassination in 1881, which she organized. She became the first woman in Russia to be executed on political grounds.

Gabrielle Petit
1893–1916; BELGIUM

As soon as World War I broke out, Petit volunteered for the Belgian Red Cross. Later, she became a spy for the Allies and worked as a distributor of a clandestine newspaper and an underground mail service. In 1916, she was arrested by the Germans and executed. After the war, when her story became widely known, she was a national heroine.

Jeannette Rankin
1880–1973; UNITED STATES

In 1913, Rankin marched in the demonstration in Washington, DC, that brought thousands of suffragists to the nation's capital prior to the inauguration of Woodrow Wilson. The next year she led a successful drive for voting rights for women in her native state of Montana. In 1916, four years before the passage of the Nineteenth Amendment granting women the vote, she was elected to the U.S. House of Representatives (women could run for national office in those states that had granted female suffrage). An ardent pacifist, she voted against U.S. entry into World War I, which cost her the congressional seat. She spent the next years involved in women's issues and the peace movement. In 1940, she again ran for Congress and won; she was the sole member of the House to oppose America's declaration of war against Japan after the bombing of Pearl Harbor—an act that ended her political career. Undeterred, Rankin continued her peace work; in 1967 she led the Jeanette Rankin Brigade of five thousand women in a march on Washington to protest U.S. involvement in Vietnam.

Ellen Richards
1842–1911; UNITED STATES

Richards was admitted to the Massachusetts Institute of Technology (MIT) as a "special student," which she assumed was a form of financial aid. She would later find out that it was so that MIT could keep her name off the student roster and thus avoid acknowledging the admission of its first female student. She continued her graduate studies at MIT but was unable to obtain a doctorate in chemistry because the school was unwilling to grant its first degree in that field to a woman. In 1875, she married Robert Richards, head of the school's department of mining engineering; together they worked on the chemistry of ore analysis, which led to her being elected the first female member of the American Institute of Mining and Metallurgical Engineers. In 1876, Richards volunteered her services along with sufficient funds to establish a Women's Laboratory; it continued until women were allowed to join men in university classrooms. In 1882, while still teaching at MIT, she cofounded a college association of female professors that became the American Association of University Women. Later, she organized a summer conference to define standards for teacher training and certification in the new field of home economics, which Richards had founded. This led to the establishment of the American Home Economics Association in 1908, for which she served as president. She started the *Journal of Home Economics* shortly before she died.

Eleanor Roosevelt
1884–1962; UNITED STATES

Roosevelt transformed the role of first lady, using her position to develop and support many New Deal programs and to create a bridge between the presidency of her husband, Franklin Delano Roosevelt, and the voters through speaking tours throughout the country, a regular newspaper column, and weekly radio broadcasts. During WWII, she traveled internationally, conferring with world leaders on behalf of the United States. After her husband's death, she continued to be a world figure. From 1945 to 1952, she was a delegate to the UN Assembly, chairwoman of UNESCO's Commission on Human Rights, and America's roving ambassador of goodwill. She was an advocate of the rights of women, the poor, and the oppressed around the globe. Until the end of her life, she remained a powerful voice in the Democratic Party.

Augustina Saragossa
1786–1857; SPAIN

During the Spanish War of Independence (1808–1814), an army of 12,000 French soldiers besieged the Spanish city of Saragossa. Augustina, who

became known as the "Maid of Saragossa," threw herself into the fighting, rallying the troops who then repulsed the French army. History suggests that she was actually a soldier because she was later offered both military and civilian honors. Instead, she wanted to retain her rank of artillery captain, continue to bear arms, and wear her uniform. She was written about by the poets Byron (1788–1824) and Southey (1774–1803) and painted by Goya (1746–1828) and the Scottish painter Wilkie (1785–1841).

Hannah Senesh
1921–1944; HUNGARY

When Senesh was thirteen, she began a diary that became a primary source of information about Jewish life in Budapest during the rise of Nazism. By the time she was seventeen, she had decided to immigrate to Palestine, departing shortly after the outbreak of World War II. She joined a kibbutz where she authored her most passionate poetry and a semiautobiographical novel. In 1941, she joined the Haganah (the Jewish Self Defense Organization) and became the first woman to volunteer in the British Royal Air Force. She wanted to learn how to parachute behind enemy lines in order to rescue her mother; in addition, she intended to organize young people to immigrate to the pre-state of Israel. In June 1944, she landed in Yugoslavia and then crossed the border into Hungary. She was captured by the Germans and tortured, convicted of treason, and executed by a firing squad. After the war, her writings were translated into several languages, and a museum devoted to her memory was built at the kibbutz where she lived.

Marie Stopes
1880–1958; ENGLAND

Stopes earned a PhD in science from a German university and became Manchester University's first female lecturer in science. In 1918 she published the controversial *Married Love*, in which she argued for equality in marriage and women's right to sexual pleasure as well as the importance of birth control. After meeting Margaret Sanger, Stopes focused on starting a birth control campaign in England. In

1918, she wrote *Wise Parenthood*, a concise guide to contraception; she soon founded the Society for Constructive Birth Control and opened the first in a series of birth control clinics. Her reputation as one of the key figures in the struggle for women's reproductive rights has been sullied by her misguided advocacy of eugenics.

Henrietta Szold
1860–1945; UNITED STATES

In 1893, Szold helped organize Hebras Zion, the first Zionist organization in the United States. After a visit to Palestine in 1909, she became more deeply involved in Zionist activities, founding Hadassah, the Women's Zionist Organization, which under her leadership established the infrastructure for a modern medical system in Palestine. Szold spent most of the last twenty years of her life there, overseeing the creation of numerous health, educational, and social service organizations that would later become an integral part of the state of Israel. After she resigned from the presidency of Hadassah, she established and ran the Youth Aliyah, which rescued thousands of Jewish children from Nazi Germany.

Beatrice Webb
1858–1943; ENGLAND

As a young woman, Webb (born Potter) worked in her father's business, which led her to question the values of capitalism. After his death, she inherited enough money to become independent. In 1892, she married Sidney Webb, a leading figure in the Fabian Society, which believed that capitalism had created an unjust society. Together they wrote many books outlining their theories of social and labor reform and founded the London School of Economics, whose original intention was to be a more socialist-oriented institution than it ultimately became. Although she never seems to have developed a feminist consciousness, her autobiography *My Apprenticeship* provides considerable information about gender discrimination while chronicling one woman's journey toward a large social vision.

Vera Zasulich

1849–1919; RUSSIA

Zasulich became active in radical politics and conducted literacy classes for workers in St. Petersburg. In 1878, she shot and wounded the city's military governor after he ordered the flogging of a political prisoner who was one of her colleagues. She was found not guilty by a sympathetic jury and became something of a national heroine. In 1883, she cofounded the Liberation of Labour, the first Marxist group in Russia. She was later smuggled out of the country to Switzerland where she became active in radical movements, returning to Russia after the 1905 Revolution. Like many radical women of her generation, Zasulich became disenchanted with the autocratic Bolshevik regime.

Clara Zetkin
1857–1933; GERMANY

In 1878, Zetkin joined the Socialist Worker's Party, precursor of the modern Social Democratic Party. Because of the ban on socialist activities in Germany, in 1882 she went into exile in Paris, returning four years later and speaking at secret meetings of the Socialist Worker's Party. In 1889 she published *The Question of Women Workers and Women at the Present Time* and later became the founding editor of *Die Gleichheit* (Equality), which she turned into a militant journal of the international women's movement. In 1918, she cofounded the German Communist Party, and two years later she was elected to office on the Communist ticket, serving until 1933. With Hitler's rise to power, the Communist Party was banned, and she again went into exile, this time to the Soviet Union where she died.

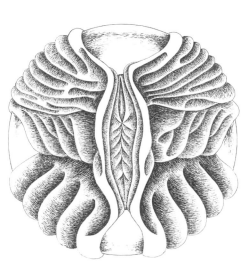

Natalie Barney

1876–1972

Born in Ohio to a wealthy family, Natalie Barney instinctively rebelled against the social expectations of her class, particularly the assumption that she would marry. As a child, she was taken on a European tour; in Belgium, she saw a cart pulled by a woman and a dog, both in harness, while the husband walked beside them complacently smoking his pipe, a sight Barney never forgot. When Barney was twenty-four, she fled her conventional surroundings for the bohemian life of Paris. Barney reveled in her sexuality, a courageous attitude at a time when homosexuality was viewed either as criminal perversity or sexual psychopathy.

In 1909, she moved into an elegant little house on the edge of the Latin Quarter, where she would live for most of her life. Every Friday night for many years women gathered at Barney's salon to hear concerts and to read poems and essays expressing their own experiences and affirming their sexual orientation. Barney's twelve published works, all but one written in French, reflect her brilliant wit and embody her unique philosophy of life, based upon her commitment to live as she chose. Her spirit is reflected in the epitaph she suggested for herself: "She was the friend of men and the lover of women, which, for people full of ardor and drive, is better than the other way around."

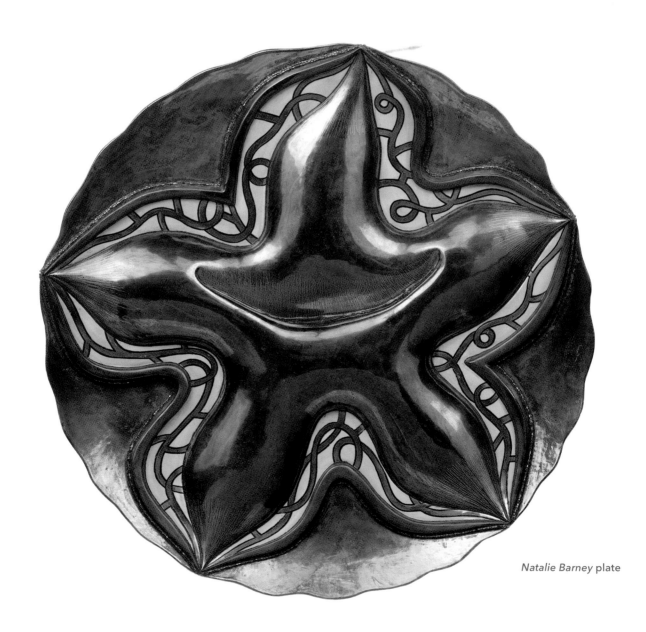

Natalie Barney **plate**

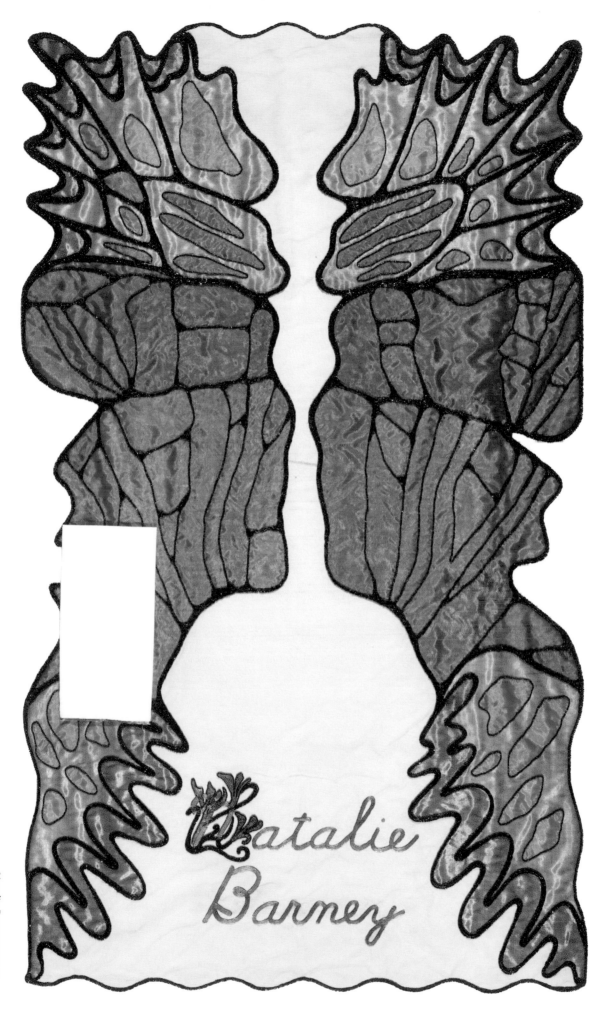

Natalie Barney runner

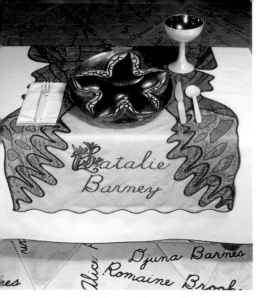

Natalie Barney place setting

Barney's salon grew out of a long tradition in which women had been able to exercise power and influence through their positions as *salonieres*. But her salon was unique in that the stature of the women who frequented it was in no way derived from the importance of the male visitors, nor were these women expected to "inspire but not write," as their predecessors had done. Nonetheless, revolutionary and feminist ideas had thrived in the early salons, and for that reason—in addition to feminists and lesbians—numerous *salonieres* are honored in relation to the *NATALIE BARNEY* place setting.

Djuna Barnes
1892–1982; UNITED STATES

Brought up in an unconventional household and educated at home by her father, a wealthy, dilettante artist, Barnes attended several New York art schools before working as a journalist. In 1915, she made her debut as a poet with *The Book of Repulsive Women*, which included her own drawings. This book was followed by three one-act plays, produced at the Provincetown Playhouse. In 1921, she went to Paris and immediately became involved in Natalie Barney's circle. At Barney's request, she produced *The Ladies Almanack*, a 1928 satire on the lesbian community that revolved around Barney. In 1936, Barnes published *Nightwood*, considered her masterpiece, an unrelenting examination of desire and pain, focused on the doomed relationships of five tormented characters. In 1940, ill health and financial insolvency forced Barnes to return to New York, where she lived as a recluse for the rest of her life.

Alice Pike Barney
1857–1931; UNITED STATES

Alice Pike Barney, Natalie's mother, was an accomplished painter, patron, and philanthropist. In 1903, she built and elaborately decorated Studio House, which functioned as her home and art studio and also as a cultural center in the nation's capital. Her salon brought together artists, celebrities, and the upper crust of Washington's society and, in the absence of a performance hall in the city, functioned as a performance space. In 1960, Natalie Barney gave her mother's house to the Smithsonian for specific use as an arts and cultural center. In 1995, the trustees of the Smithsonian decided to sell the house and all its furnishings, thereby depriving the country of one of the few preserved women artists' homes.

Anne Bonney
BORN 1697/8; IRELAND
Mary Read
D. 1720; ENGLAND

Historical knowledge about Bonney and Read is based primarily upon an account written by Captain Charles Johnson, probably a pseudonym for the author Daniel Defoe (1660–1731). When Anne Bonney (born Anne Cormac) was still in her teens, she married James Bonney, a renegade seaman. When she became involved with another man, Jack put her up for sale, an acceptable practice at the time. Anne ran away and joined a pirate ship's crew, apparently dressed as a man. She soon found herself attracted to an officer on the ship, who turned out to be Mary Read; she had spent most of her life disguised as a man and had already become a famous pirate. Entering into a shipboard romance, the two women proved to be courageous pirates and protected one another until their life of adventure ended in capture. Read died in prison, but Bonney, who was sentenced to hang, escaped and was never heard from again.

Romaine Brooks
1874–1970; UNITED STATES

In 1905, after inheriting a fortune, Brooks cut her hair, donned men's clothes, and moved to Paris. Freed by wealth to pursue art, she began painting portraits, for which she became renowned. In 1915, Brooks fell in love with Natalie Barney, with whom she would be involved for fifty years; they would remain emotionally connected despite Barney's affairs. Brooks's paintings focus almost exclusively on women in the overlapping worlds of high society, French arts and letters, and the homosexual elite of Paris, emphasizing the construction of gender and lesbian identity. Early on she had a number of exhibitions in Europe, but then she became increasingly reclusive; her work was rarely shown until 1971, when the National Gallery in Washington, DC, held a retrospective one year after her death. Although in 2000 the National Museum for Women in the Arts presented a similar show, a comprehensive assessment of her contribution to the development of a singular lesbian sensibility in art is still lacking.

Eleanor Butler
1739–1829
Sarah Ponsonby
1745–1831; IRELAND

From titled families, Butler and Ponsonby met at a girls' boarding school. In 1778, they attempted to elope but were apprehended and separated. Eventually, they finally wore down their families' resistance. The two women were given a stipend on the condition that they live far from home. They fled to Llangollen, Wales, where they shared a life of reading, writing, gardening, and walking, dressed similarly in men's waistcoats and women's skirts. There has been considerable debate about whether their union should be described as "lesbian," particularly because, until the beginning of the twentieth century, intimate, exclusive friendships between women were socially acceptable. The "Ladies of Llangollen," as they were known, became a popular subject for many writers over the years.

Sophie de Condorcet
1764–1822; FRANCE

There is a famous story about an encounter between Napoleon Bonaparte and Sophie de Condorcet at a reception in 1797. Knowing that her salon had been a gathering place for supporters of the French Revolution, he said to her: "Madame, I do not like women to busy themselves with pol-

itics." She replied: "General, you are right. But . . . [referring to the women who had lost their lives to the guillotine] . . . in a country where women have their heads cut off it is natural that they should wish to know why." Condorcet and her husband had both been imprisoned because of their radical politics. She had been released, but he had committed suicide while still in jail. Afterward, she struggled to make a living as a painter and died in obscurity.

Marie du Deffand
1697–1780; FRANCE

By age fifteen, Deffand knew that she did not want the same kind of stifling life as most of the noble women of her era. Unhappily married, she left her husband in 1722, shortly after she began a friendship with Voltaire. Her salon in Paris attracted major Enlightenment thinkers, scientists, and writers of the period. Later in life, she developed an intimate friendship with Harold Walpole (1717–1797), whose literary reputation rests upon his three thousand or more letters, many of which were exchanged with Deffand. In 1809, her correspondence was published in France in two volumes; the following year her letters to Walpole were published in London with a biographical sketch of Deffand.

Ninon de L'Enclos
1620–1705; FRANCE

After her mother died, Enclos entered a cloister in order to remain unmarried. After a short while, she went to Paris, where her drawing room became a center for the literary world. Because she took a succession of notable lovers, she has sometimes been characterized as a courtesan though this has never been proven. However, her independence and outspoken opposition to religion caused her to be imprisoned in a convent in 1656. Thanks to several prominent friends, she was released; in response, she wrote La Coquette Vengee (The Flirt Avenged), which defended the idea of living a good life without religion. Little of her literary output survives, but she lives on in a poem by the American writer Dorothy Parker (1893–1967), which is an ode to this flamboyant woman.

Stephanie de Genlis
1746–1830; FRANCE

When she was sixteen, Stephanie was married to the count of Genlis, from whom she later separated. In 1770, she became governess to the children of the duke of Orleans. As an aid to their education, she wrote a number of books on teaching that prefigure modern educational methods. Forced by the Revolution into exile in Switzerland, she was able to return to France in 1800. During this period, she supported herself primarily by writing, producing more than eighty books on a wide variety of subjects; most were translated into English almost as soon as they were published.

Marie Geoffrin
1669–1777; FRANCE

Geoffrin, the daughter of a valet, inherited an immense fortune upon her rich husband's death in 1750, allowing her to establish a celebrated salon that became a center for the writers of the Encyclopedie, a twenty-eight-volume "Encyclopedia" of Enlightenment thought edited primarily by Diderot (1713–1784). This project, which Geoffrin supported financially, introduced the controversial, liberal ideas of the Enlightenment into France, contributing to the intellectual ferment that caused the French Revolution. She also introduced many of the Encyclopedie authors to distinguished patrons (especially foreign ones), which contributed to the influence of French arts and letters.

Radclyffe Hall
1880–1943; ENGLAND

Marguerite Radclyffe Hall was the child of an enormously wealthy father who abandoned his pregnant wife. At age twenty-one, Hall inherited her father's fortune, began dressing in men's clothes, and left the stifling confines of her family home. Between 1906 and 1915, Hall published five volumes of poetry, most of them about the intense desire she felt for women. In 1915, she became lovers with the elegant Una Troubridge, with whom she lived until she died. With her support, Hall wrote a book on lesbianism—then labeled "inversion"—which was a completely taboo subject. When published in 1928, The Well of Loneliness caused a storm of controversy and became a cause célèbre in the literary world. Judged obscene in England, copies were

confiscated and burned by Scotland Yard. The book was later published all over the world, sold a million copies during Hall's lifetime, and has become idolized as a lesbian icon, primarily because Stephen Gordon, the mannish heroine of the book, was the first fully sexual lesbian character in literature. Recent feminist scholars have pointed out, however, that except for her advocacy of homosexual rights, Hall's politics were ugly: she renounced her initial support of female suffrage when the English suffrage movement became militant and was pro-fascist and anti-Semitic.

Louise Labe
1520/22–1566; FRANCE

At age sixteen, dressed as a man, Labe followed her soldier-lover into battle, demonstrating such military prowess that the army nicknamed her "La Capitaine Louise." She married a wealthy merchant in Lyon, and her home became the center of cultural life there. Always an independent thinker, she wrote a volume of verse dedicated to a local noblewoman that contained an appeal to women to strive for excellence in all areas in order to surpass men in achievement. Her love poems established her as one of the most celebrated female poets of her day.

Julie de Lespinasse
1732–1776; FRANCE

The saloniere Marie du Deffand invite Lespinasse to become her companion in the heady world of literary salons. Lespinasse assisted her from 1754 to 1764, until Deffand became jealous of the younger woman's popularity and dismissed her. Lespinasse then set up her own salon, which attracted the Parisian nobility throughout the reign of Louis XV until the Revolution, which she supported. Her passionate letters, published in 1809, reveal her significant literary gifts.

Mata Hari
1876–1917; HOLLAND

Margaretha Zelle established herself as an exotic dancer in Paris, changing her name to Mata Hari and claiming to be of Javanese descent. An intelligent, multilingual celebrity who performed throughout Europe (most notably at Natalie Barney's soirees), she was supposedly enlisted by the French government as a spy during World War I.

In 1917, she was accused of aiding the Germans, but at her trial, she claimed to have given worthless information to the military officers with whom she had become involved. While there was no solid evidence that she had actually been a spy, there was no one to refute the accusation either. She was found guilty and executed for treason. After her death, she became a legend and the subject of many books, films, and television series.

Catherine de Rambouillet
1588-1665; FRANCE

Married at twelve to another member of the nobility, Rambouillet was disgusted by the vulgarity and intrigue at the court of Henry IV (1553-1610) and established the first literary salon in France, held in a building called the Hotel de Rambouillet. She designed the house to receive visitors, devising suites of small rooms where guests could find greater privacy than was available in an ordinary abode. Her salon was responsible for a refinement of manners and the purification of the French language. The almost uniform excellence of seventeenth-century French memoirs and letters may be

traced largely to the development of conversation as a fine art at Rambouillet's gatherings.

Jeanne Recamier
1777-1849; FRANCE

The emperor Napoleon was enraged that Recamier's gatherings attracted important figures of early nineteenth-century Paris, including Germaine de Staël, one of his most vocal critics. On Napoleon's orders, Recamier was exiled for three years. After his downfall, she returned to Paris. The importance of her social position is suggested by the well-known portrait of her at the Louvre by Jacques-Louis David as well as another painting by the prominent artist Francois Gerard. In 1859 her correspondence was published, with additional material and scholarship about her appearing over the course of the next fifty years.

Madeleine de Sable
1599-1678; FRANCE

In addition to hosting a salon, Sable was a gifted writer. She introduced and made fashionable the practice of condensing life experiences into witty aphorisms, for example: "To be too dis-

satisfied with ourselves is a weakness. To be too satisfied with ourselves is a stupidity."

Marie Salle
1707-1756; FRANCE

Salle—one of the first women to dance professionally and the first to choreograph the ballets in which she appeared—performed with a touring company in France for eleven years before returning to London. She became famous for her footwork and her ability to portray character. Salle rejected the cumbersome costumes of the time, adopting instead a simple muslin dress draped in classical Greek mode, slippers without heels, and hair hanging free, a style considered shocking at the time but later adopted by many dancers.

Lou Andreas Salome
1861-1937; FRANCE

Born in Russia and from a privileged background, Salome was intellectually precocious even as a child. One of the first female psychotherapists, she wrote fifteen novels, a memoir, more than one hundred essays, and a controversial study of Nietzche, as well as books on Freud, Rilke, and the playwright Ibsen (1828-1906). Although she is known primarily as the inspirer of Nietzche (whose advances she rejected), the confidante of Freud, and the lover of Rilke, she struggled all her life to maintain her independence. Like many other women, her personal achievements have been obscured by the famous men with whom she was associated.

Madeleine de Scudery
1607-1701; FRANCE

De Scudery's essays, romances, and novels created a vivid picture of the social life of the period, and she was one of the most eminent literary women of the seventeenth century. In addition, she maintained a salon where discussions included the intellectual equality between the sexes. It was through such discourse that women kept alive feminist ideas.

Marie de Sevigne
1626-1696; FRANCE

Sevigne is best known for the 3,500 letters she wrote, 1,500 of which were sent to her daughter over a period of thirty years. Her correspondence pro-

Natalie Barney illuminated capital letter

Detail, *Natalie Barney* **runner back**

vides a vivid picture of contemporary customs and life at the court of Louis XIV (1638–1715). She also recorded the development of French salons, which provided one of the few alternatives to the dreariness of formal court society.

Gertrude Stein
1874–1946; UNITED STATES

Stein followed her brother Leo to Paris, where he had become an art collector. Their home, known as the "Salon," was popular with artists and writers. In 1910, Alice Toklas moved in with Gertrude and Leo; three years later Leo moved out, his relationship with his sister so strained that they would have little contact from then on. Toklas became Stein's reader, typist, critic, and lifelong partner. Stein produced more than four hundred pieces of work and many memorable phrases; she had her first taste of fame when *The Autobiography of Alice B. Toklas*, published in 1933, became a best seller in the United States and turned her into a celebrity. After the German occupation of Paris in 1940, Stein and Toklas, both Jewish, fled to the countryside where they

were protected by the villagers. In 1944, they were able to go back to their apartment where—amazingly—their art collection had remained untouched by the Nazis. Stein is often credited with having created a literature comparable to the avant-garde trends in the visual arts. However, lesbian feminist literary critics have recently begun to deconstruct Stein's use of language, demonstrating that she might be better seen as a feminist writer whose goal was to replace the worn-out conventions of the language of patriarchy.

Claudine de Tencin
1682–1749; FRANCE

Tencin was brought up at a convent and in response to her parents' wishes took the veil. But in 1714, she left the order and went to the court of Louis XIV, where she became the mistress of the prime minister. She established a famous literary salon, the first to which distinguished foreign visitors were invited. Tencin encouraged freedom of expression even though criticism of the monarchy could result in arrest. Like many other salonists, she supported the French Revolution. Tencin was also

a writer of considerable merit, penning an autobiographical novel as well as a number of fictional works that have been praised for their simplicity and charm.

Cristina Trivulzio
1808–1871; ITALY

From an aristocratic background, Trivulzio became involved in Italian politics; when the government noticed her activities, she fled the country. She was ordered to return or surrender her property and income. She refused, staying in Paris and painting fans and portraits for a living. In 1849, Trivulzio traveled to the Orient, buying land in Turkey at a time when many European women were traveling to the East. These journeys offered them independence along with the opportunity to study the social condition of women in other parts of the world. Trivulzio, who became interested in harem life, used her observations as a platform to argue for female emancipation.

Renee Vivien
1877–1909; FRANCE

Born Pauline Tarn, Vivien took a new name when she moved to Paris to symbolize her rebirth. She had an intense relationship with Natalie Barney, nourished by their shared desire for the recreation of a Sapphic tradition in literature. The two traveled to the isle of Lesbos in an attempt to revive a colony of women devoted to the arts. Vivien, who translated the ancient poet's extant work into modern French, also produced more than twenty volumes of poetry in French, little of which has been translated into English. Her poetry often attempted to rework biblical stories or fairy tales, inflecting them with lesbian themes. She died young from a body weakened from self-starvation.

231

Virginia Woolf

1882–1941

Virginia Woolf's father was so overbearing that she once commented that had he not died, she might have written no books. She was also sexually abused by her half brother, which contributed to the first of the mental breakdowns that tormented her throughout her life. In 1904 she moved to Bloomsbury, the center of London's bohemian intellectual world. Her writing developed against the background of the English suffrage fight, but although she was involved in the women's movement, she preferred to address herself to feminist issues through her work. In 1912 she married the political theorist Leonard Woolf, despite a preoccupying concern whether a woman's intellectual and creative needs could be satisfied within the framework of married life.

In 1915, *The Voyage Out*, Woolf's first novel, was published, and she went on to produce a formidable body of novels and essays, including *A Room of One's Own* (1929) and *Three Guineas* (1938), laying the groundwork for a new approach to literature, which employed innovative literary techniques to reveal women's experiences. According to Woolf, the subjugation of women was the key to the social and psychological disorders of Western civilization. She believed that if "masculine" and "feminine" traits became wedded on the personal, social, and intellectual levels, the world would be greatly humanized. But her values and goals seemed increasingly hopeless in the face of rising fascism, which she described as patriarchy "gone mad." In 1941, after another attack of madness, she drowned herself.

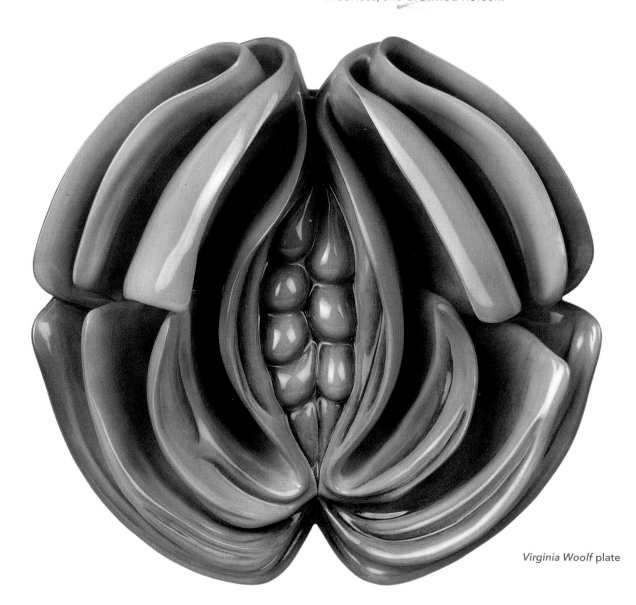

Virginia Woolf **plate**

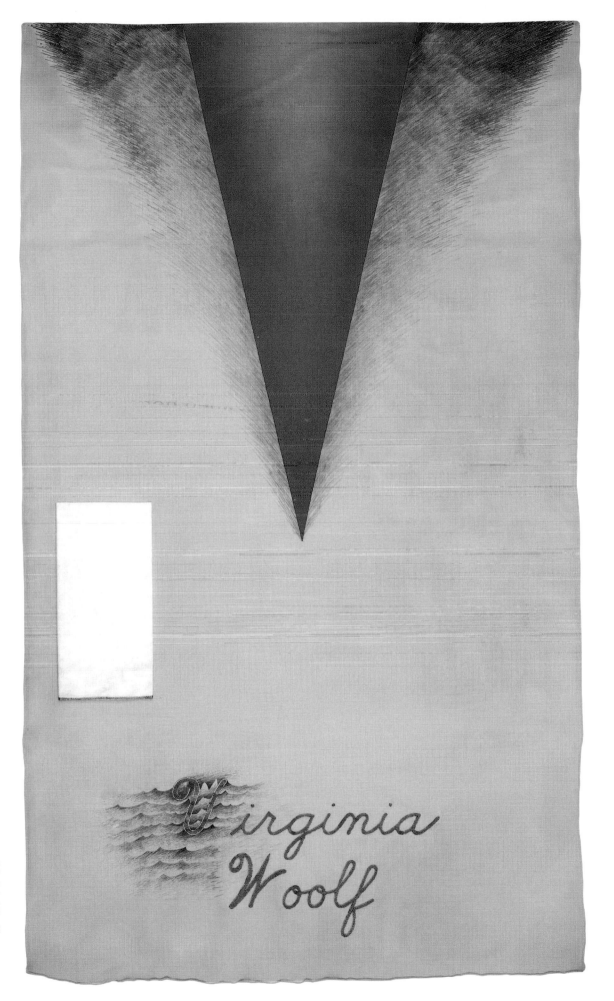

Virginia Woolf

Virginia Woolf place setting

Once women gained access to education, they began writing about their experiences. However, because men had long dominated literature, it was difficult for women to forge their own language forms. Woolf's work—like the beacon emanating from the lighthouse in her most famous book *To the Lighthouse* (1927)—opened a path toward a new woman-centered literary language. Associated with her place setting are the names of other writers, many of whom believed in a distinctly female point of view. Additionally, the names of writers and thinkers who have influenced contemporary thought are positioned in relation to some of their more explicitly feminist sisters.

Hannah Arendt
1906-1975; UNITED STATES
While Arendt she was a student at the University of Marburg in Germany, she had a brief but passionate affair with the philosopher Martin Heidegger (1889-1976), who was a Gentile. This love affair, which ended badly for Arendt, led her to explore her German-Jewish identity. When Hitler came to power, she escaped to Paris, where she worked in Jewish relief organizations. In 1941, she managed to reach the United States, and ten years later she produced her first major work, *The Origins of Totalitarianism*, which made her an international celebrity. In 1963, she published *Eichmann in Jerusalem*, about the Nazi war criminal who had been hunted down by Israeli security forces and brought to trial,

the most controversial book of her career because she portrayed him as a bureaucrat rather than an ideologue. For her, he exemplified the "banality of evil," a phrase that radically altered the discourse on that subject.

Simone de Beauvoir
1908-1986; FRANCE
After World War II, Beauvoir and Jean-Paul Sartre (1905-1980), her lifelong companion, became the leading exponents of the Existentialist movement, which to Beauvoir meant that "you are what you do," a philosophy that had a profound effect in both Europe and the United States. Beauvoir played a central role in the intellectual debates of her times as a writer of essays, novels, plays, memoirs, travel diaries, and newspaper articles, and as the editor of *Le Temps Moderne* ("Modern Times"), a monthly review and the most prominent French forum for radical political and philosophical debate. Her work posits that the personal, professional, and intellectual are interwoven, thereby challenging the notion of an objective reality long before contemporary scholarship made this concept popular. In 1949, she published *The Second Sex*, which put forth the then-revolutionary idea that "women are not born, but made," an early expression of the recent feminist theory about gender being a social construct. The book, considered one of the hundred most important of the twentieth century, is widely acknowledged as the founding text of modern feminism.

Willa Cather
1873-1947; UNITED STATES
When Cather was nine, her family homesteaded in Nebraska, where she developed a fierce passion for the landscape. After graduating from the University of Nebraska, she published a poetry collection and a book of short stories before moving to New York in 1906, where she worked as the managing editor of *McClure's* magazine. In 1912 she resigned in order to devote herself to literature, writing poetry, short stories, essays, and novels and creating some of the most memorable characterizations of frontier women in American literature. While Cather's lesbianism was never explicit in her work, she lived with her female companion Edith Lewis for forty years.

Colette
1873-1954; FRANCE
Colette's career began when her first husband Willy locked her in her room, forced her to write, and published her work under his name. The *Claudine* novels became a huge success, but tired of her husband's infidelities and his exploitation of her talents, she divorced him in 1906, though she had to sue to regain title to her work. In 1912 she married Henri de Jouvenel des Ursins, a newspaper editor for whom she wrote short stories and theater chronicles. Her relationship with his son formed the basis of her 1920 novel *Cheri* about the end of an affair between an aging woman and a pampered young man. The most startling aspect of the book is that Colette upends convention, making the young man the object of the female gaze. All told, she wrote more than fifty novels and dozens of short stories in which her main themes were the joys and pains of love and the difficulties of reconciling women's struggles for self-realization with the demands of passion and the constraints of a male-dominated world. When she died, she was accorded a state funeral.

Helen Diner
1874-1948; GERMANY
Diner was a member of an elite group of scholars, the "Arthurians," each of whom took a name from one of the members of King Arthur's Round Table. (Arthur, a legendary British king, made his knights sit at a round table to emphasize their equality; Diner named herself "Sir Galahad.") The group was dedicated to contributing to an unknown area of human knowledge, and Diner set out to compose a history of the feminine. Using the pseudonym Bertha Eckstein-Diener, she produced *Mothers and Amazons*, the first feminine history of culture. Her book was based upon Carl Jung's theories about female archetypes along with those of the Swiss anthropologist Johann Jakob Bachofen (1815-1887), who argued in *Myth, Religion and Mother Right* (1967) that early societies were matriarchal, a thesis that is still being debated by scholars.

Isak Dinesen
1885–1962; DENMARK

Born into a well-to-do family, Dinesen made her debut as a writer with the publication of several short stories in 1907. She married her Swedish cousin Baron Bror von Blixen in 1914 and accompanied him to Kenya where they ran a coffee plantation. After the marriage fell apart, Dinesen ran the plantation herself until the collapse of the coffee market. She had fallen in love with a bush pilot and hunter named Denys Finch Hatton, but after his 1931 death in a plane crash she returned to Denmark and began writing in earnest. Her years in Africa were depicted in *Out of Africa,* published in 1937 and made into an Oscar-winning film in 1985. Though she was Danish, Dinesen wrote her numerous works in English and translated them into her native tongue.

Lorraine Hansberry
1930–1965; UNITED STATES

When Hansberry was eight, her parents bought a house in a white neighborhood of Chicago where they were met one night by an angry mob, an experience that led to a civil rights lawsuit. In 1953, she married Robert Nemiroff, a white political activist. They were divorced in 1964, five years after her play *A Raisin in the Sun* became the first drama by a black woman to be produced on Broadway and the first work by a black playwright to receive the New York Drama Critics Circle Award. Unfortunately, her second play was not as successful, and on the day it closed, Hansberry died of cancer, cutting short a promising career. Her *Young, Gifted and Black*, adapted from her writings, was produced off-Broadway in 1969, helping to secure a literary legacy that expressed black consciousness long before it was acceptable. Shortly before her death, Hansberry began to claim her lesbianism, and in the 1980s feminist scholars started to examine her work for both its feminist vision and undercurrents of lesbian identity.

Mary Esther Harding
1888–1971; UNITED STATES

Harding, a Jungian psychologist known for her work with women and families, was a forerunner of contemporary feminist therapists who have tried to develop a female-centered psychology. *The Way of All Women,* published in 1933, was acclaimed as one of the best books on female psychology. Her next work was *Women's Mysteries,* a classic study of the feminine principle in myths, dreams, and religious symbolism and an exploration of the relationship between goddess worship and the powers women possessed in early civilizations.

Karen Horney
1885–1952; UNITED STATES

By the time Horney received her medical degree in 1913, she had married Oskar Horney. She taught at the Institute for Psychoanalysis in Berlin until she left her husband and moved to the United States in 1930, taking her three daughters with her. By 1941, Horney had become dean of the American Institute for Psychoanalysis, an organization she founded because of her opposition to Freud's theory of penis envy. In Horney's view, women did not envy men's physiology but, rather, their privileged position in society. She suggested that men may actually suffer from "womb envy" and are driven to succeed as compensation for not being able to directly extend themselves through childbearing. Her theories provided a new way of thinking about women. She is often called the most important woman in the history of psychology and is one of the few women whose theories are included in textbooks.

Selma Lagerlof
1858–1940; SWEDEN

In 1890, Lagerlof won a literary contest with excerpts from *The Story of Gosta Berling*, published the following year. Soon she received financial support from the royal family and the Swedish Academy, which allowed her to write full-time. By then, she had met the writer Sophie Elkann (1853–1921), who became her lifelong companion. Although she published a number of other works, none matched the success of her first book, though in 1909 she became the first woman to be awarded the Nobel Prize for Literature as well as the first woman appointed as a member of the Swedish Academy. As World War II approached, Lagerlof helped German Jews, intellectuals, and artists escape the clutches of the Nazis.

Suzanne Langer
1895–1985; UNITED STATES

Langer received her doctorate in philosophy from Harvard in 1926, entering a male-dominated field to teach at a number of prominent universities. In 1942, she published *Philosophy in a New Key*, which sold over 500,000 copies and made her a leading figure in the philosophy of art. She spent the last years of her life working on *Mind: An Essay on Human Feeling*, a three-volume compendium published over a period of fifteen years that was a culmination of her thinking about philosophy, art, and the human need for meaningful symbols.

Doris Lessing
1919–2013; ENGLAND

Born in Persia (now Iran) to British parents and reared in Rhodesia (now Zimbabwe), Lessing dropped out of school when she was fourteen, though she made herself into a self-educated intellectual. She married at nineteen and had two children but, feeling trapped, abandoned her family. By 1949, Lessing had moved to London and published her first novel *The Grass Is Singing*, in which she examined male/female interactions against the background of the destructive relationships between white South African colonizers and the native inhabitants. In the *Golden Notebook,* considered one of the major works of twentieth-century literature, Lessing documented the conflicts of a modern emancipated woman, which made her internationally renowned. The five-volume *Children of Violence* series, published over a seventeen-year period, chronicled a woman's search for self-definition in a world that is increasingly surreal. Over the years, Lessing's worldview became steadily more pessimistic. She often stated that she did not believe the human race would survive much longer, which she expressed in *Shikasta*, her multivolume science fiction series. In 2007, she was awarded the Nobel Prize for Literature.

Edna St. Vincent Millay
1892–1950; UNITED STATES

After graduating from Vassar, Millay moved to New York City, where she engaged in numerous love affairs. She was determined to love whomever she wished, expressing her bisexuality in

both her life and her work. In 1920, she published a book of poetry titled *A Few Figs from Thistles,* in which she explored the subject of female sexuality, emphasizing women's right to sexual pleasure. Three years later, she became the first woman to win a Pulitzer Prize in Poetry for *The Harp Weaver and Other Poems.* That same year, she married Eugene Jan Boissevain, who managed her literary career. She wrote prolifically, publishing thirty books in all. At her best, Millay was hailed as the voice of her generation, and in 1938 she was voted one of the ten most famous women in America. She has since fallen out of fashion among critics and scholars.

Gabriela Mistral
1889–1957; CHILE

Because of her experiences with the village schools of Chile, in 1922 Mistral, the pen name of Lucila Godoy Alcayaga, was invited to Mexico by the minister of education to collaborate on the reorganization of that country's rural school system. She then became Chile's delegate to the United Nations and was appointed to the UN Subcommission on the Status of Women. During this time, Mistral wrote poetry along with hundreds of articles published throughout the Spanish-speaking world. Considered the founder of the modern poetry movement in Chile, she was awarded the Nobel Prize for Literature in 1945. When she died, the Chilean government declared three days of national mourning, and hundreds of thousands of people came to pay their respects.

Anaïs Nin
1903–1977; UNITED STATES

Nin came to be known primarily as a patron, helping such struggling writers as Henry Miller (1891–1990) and Lawrence Durrell (1912–1990). But she led a double life; while writing surrealistic novels and playing multiple roles—wife, lover, protector, enigma—she confided her real self only to her diary, begun when she was eleven, consisting of more than 150 manuscript volumes. There, she recorded the painstaking process of a woman emerging from what used to be called the female role (now described as the construct of femininity) into a more authentic self. Despite the efforts of many men to take away her diary (including Otto Rank, her psychoanalyst, who believed it to be a symbol of her neurosis),

Nin continued to record her isolated voyage. Until the 1960s her journey remained invisible to all but a few close friends. Finally, at the end of that decade, Nin's diaries began to be published, but only because of the perceived significance of the famous male writers she had known. When the first diary sold out almost instantly, the publishers were shocked. To Nin, the audience response was surprising, then deeply gratifying, particularly when her work was hailed as the expression of a pioneer in the development of a female sensibility in literature.

Emilia Pardo-Bazán
1852–1921; SPAIN

In 1879, Pardo-Bazán published the first of nineteen novels. She also wrote literary criticism and hundreds of short stories that were noted for their narrative complexity and feminist themes. In 1906, she became the first woman to chair a department of literature. She was later named advisor to Spain's ministry of education and appointed professor of romance literature at the Central University of Madrid. However, the faculty protested her appointment, and the male students boycotted her classes. Nevertheless, she became known as one of the most important women writers of her generation.

Dorothy Richardson
1872–1957; ENGLAND

As a young woman, Richardson moved to London and mingled with the Bloomsbury group. In 1917, she married the artist Alan Odel, a bohemian figure many years her junior. Although Richardson published essays, poems, short stories, and journalistic sketches, her reputation rests upon *Pilgrimage,* a twelve-volume semiautobiographical novel, written over a twenty-year period. This epic work is an account of a woman's search for self-discovery and independence in a male-dominated world. Though critics consider her writing to be the first "stream of consciousness" literature, prefiguring the work of both Virginia Woolf and James Joyce (1882–1941), Richardson referred to her style as "interior monologues." As she made clear, her literary intention was to create "feminine prose," or a "feminine equivalent to the current masculine realism."

Nelly Sachs
1891–1970; GERMANY

In 1921 Sachs published a book of stories, but most of her early work was lost when she and her elderly mother fled Germany in 1940, the only members of their family to escape the Holocaust. Thanks to the writer Selma Lagerlof (with whom Sachs had corresponded for many years), they were able to emigrate to Sweden where Sachs made a modest living by translating Swedish poetry into German. After the war, she wrote dramas, short stories, and poetry. Though crafted in a modern style, her poetry intoned the prophetic language of the Old Testament to convey the horrors of the Holocaust, which earned her the Nobel Prize in Literature in 1966, the first Jewish woman to be so honored.

Vita Sackville-West
1892–1962; ENGLAND

In 1913, Sackville-West married the diplomat and critic Harold Nicholson. Despite both of them having numerous homosexual affairs, their marriage endured for almost fifty years, a relationship chronicled by their son Nigel Nicholson in *Portrait of a Marriage* (1973), which was based upon Sackville-West's unpublished memoirs. She and Virginia Woolf became romantically involved; the latter's 1928 comic novel *Orlando* is dedicated to Sackville-West. The notoriety of Sackville-West's personal life and her relationship with Woolf has obscured the fact that she herself was a gifted and successful writer as well as a keen gardener.

Olive Schreiner
1855–1920; SOUTH AFRICA

Schreiner, whose parents were missionaries, was raised in an isolated area of South Africa. After working as a governess and attending medical school in England, she turned to writing. In 1883, she published *Story of an African Farm,* which became a great success. That same year, she met the sexologist Havelock Ellis (1859–1939), with whom she corresponded for thirty-six years. (In 1992, their letters were published.) In 1889, she returned to South Africa and then married Samuel Cronwright, who took her surname and gave up his career to support her work. In 1911, Schreiner published *Women and Labor,* considered a key feminist work. *From Man to Man,* a novel about sisterhood and motherhood, was published posthumously.

Edith Sitwell
1887–1964; ENGLAND

Sitwell's two younger brothers, Osbert and Scheverell, became well-known literary figures, and the three siblings were frequent collaborators. Edith published a number of works, both poetry and prose. She devoted herself to "the avant-garde in literature and the eccentric in lifestyle." Like her friend Gertrude Stein, she was interested in the sound of words, once delivering a reading from behind a screen to ensure that the personality of the poet would not impinge on the sound. Throughout her life, Sitwell was the subject of virulent personal attacks by literary critics, both for her work and her unusual style of dress.

Agnes Smedley
1894–1950; UNITED STATES

Smedley grew up in poverty, and at fourteen she was forced to work as a domestic servant after her father abandoned the family. After working as a teacher and attending college, she moved to New York and began writing for a number of publications. In 1920, she set up Berlin's first birth control clinic. She also visited Russia but was disillusioned by the lack of freedom there. Eight years later, she traveled to China and the following year published the autobiographical novel *Daughter of Earth*. She wrote a number of other books about the country, including *Battle Hymn of China*, considered one of the best works of war reporting to come out of World War II. Smedley summed up her philosophy, saying: "I have had but one loyalty and one faith and that was to the liberation of the poor and oppressed."

Alfonsina Storni
1892–1938; ARGENTINA

After earning a diploma in education, Storni began teaching. An affair with a married man caused her to flee to Buenos Aires, where her son was born. With the publication of her poems and other works, Storni established herself as one of the first Latin American women to write from a female point of view. In 1935, she developed breast cancer, and three years later, despite surgery, it spread to her throat. Deciding not to go through any more operations, she committed suicide by walking into the ocean, leaving behind a poignant poem titled "Voy a Dormir" ("I Am Going to Sleep").

Sigrid Undset
1882–1949; NORWAY

After Undset's separation from her husband, a Norwegian painter with whom she had two children, she created her best known novels, which provide powerful descriptions of Scandinavian life during the Middle Ages. In 1928, she received the Nobel Prize for Literature. In 1940, when Norway was occupied by the Germans, Undset joined the Resistance. As an outspoken critic of the Nazis, she was forced to flee first to Sweden, then to the United States where she embarked upon a lecture tour. After the war, she returned to Norway.

Simone Weil
1909–1943; FRANCE

Weil's experiences in 1936 as a volunteer in the Spanish Civil War led to her deepening disillusionment with political ideologies. In 1938, the philosophy student from an agnostic Jewish family converted to Christianity, occasionally dressing in the clothes of a poor monk. During the war, she and her family had to flee from the Nazis (despite her conversion, she was still a Jew by Nazi standards). During the war, she permitted herself to eat no more than the rations allowed her countrymen. Finally she refused to eat at all, as if, by denying her own body, she could deny the suffering of the world. She supposedly died of voluntary starvation, a symbol for many European intellectuals of her moral integrity. Although she published little during her lifetime, the posthumous publication of her books and essays made her a cult figure in many intellectual circles.

Rebecca West
1892–1983; IRELAND/ENGLAND

Born Cecily Fairfield, West began to use the name Rebecca West in 1911, when she started writing for the London left-wing press and then for the feminist paper *Freewoman*. A fiery suffragette and socialist, by the time she reached her thirties, she was a world-famous political analyst and distinguished novelist. At nineteen, she had begun a turbulent love affair with the author H. G. Wells (1866–1946), with whom she had a son. They broke up in 1923, and seven years later she settled into a happy marriage with banker Henry Maxwell Anderson. Her literary career spanned seventy years, and her astute reportage of the Nuremberg

Trials was published as *A Train of Power* (1955). By the end of her life, she was considered England's foremost woman of letters.

Edith Wharton
1862–1937; UNITED STATES

In 1885, Wharton (born Jones), one of the major figures in modern American literary history, married Edward Wharton, a Boston banker twelve years her senior. The conflicts she experienced between her desire to write and the social expectations of an upper-class woman brought on a nervous collapse. She divorced Wharton in 1912 and went to France, where she lived for the remainder of her life. Her first novel was published when she was forty, and from then on, she averaged more than a book a year—novels, short stories, poetry, and nonfiction. She is known for her harsh observations about society's upper classes, the confinement of marriage, and women's desire for and right to sexual and economic freedom. In a letter she wrote: "I believe . . . [one must] . . . make one's center of life inside one's self . . . to decorate one's inner house so richly that one is content there . . ."

Adela Zamudia-Ribero
1854–1928; BOLIVIA

Zamudia-Ribero (Zamudio-Ribero) was one of the first writers to speak out against the oppression of women in Bolivia. Her work is suffused with an awareness of the social injustice experienced by them as well as by indigenous people. Unfortunately, Zamudia-Ribero's work remains untranslated, but she is known for her arguments for better education and more job opportunities for women, along with the right to vote (which women did not achieve until 1952).

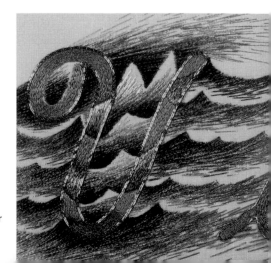

Virginia Woolf illuminated capital letter

Georgia O'Keeffe

1887–1986

Georgia O'Keeffe studied at the Art Institute in Chicago and then at the Art Students League in New York, but she was dissatisfied with curriculums that emphasized imitative realism. Exposed to the ideas of the American painter Arthur Wesley Dow (1857-1922), who encouraged artists to express their own ideas through the harmonious arrangement of line, color, and tonal contrasts, she decided to apply his theories, creating a series of abstract charcoal drawings that she sent to a friend in New York. She took them to the gallery called "291," founded by Alfred Stieglitz (1864-1946), who looked at the drawings intently and said, "Finally, a woman on paper." Stieglitz provided her with a level of support, but he also positioned her as a singular figure, disconnected from the struggles of other women.

His interest brought her to New York and made her part of the art scene centered on him. In 1924 O'Keeffe and Stieglitz were married; when he died, she moved permanently to New Mexico, where she had spent part of each year since 1929, attracted by the stark landscape that she painted again and again. Without Stieglitz there was no one to promote her work and her reputation declined, but in the 1960s, there was renewed interest in her work although her style had not dramatically changed. In 1997, the Georgia O'Keeffe Museum opened in Santa Fe, one of the few institutions in the world devoted to the work of a single woman artist.

238

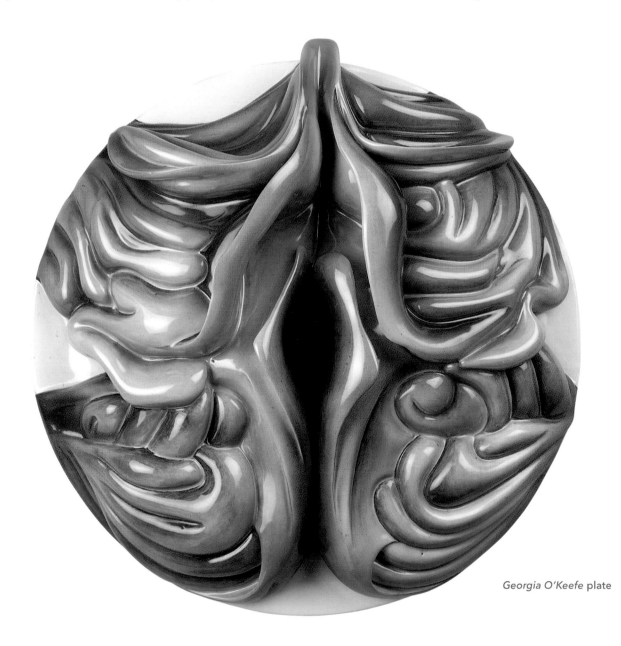

Georgia O'Keefe plate

239

Georgia O'Keefe runner

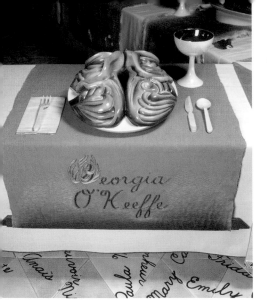

Georgia O'Keefe place setting

"Why have there been no great women artists?" is a question that is still too often asked. The more cogent question is why there are so many significant women artists who remain unknown or under-recognized. Surrounding the place setting for *GEORGIA O'KEEFFE* are the names of other women in the arts who broke through the many formidable barriers to women's full creative expression.

Dorothy Arzner
1897–1979; UNITED STATES

After Arzner's death her work was forgotten, even though she made Paramount's first talking picture, created the first boom mike, and launched the careers of a number of famous actresses. Feminist film historians rediscovered her oeuvre after her death, recognizing that Arzner had established the largest body of work by any woman director employed by the studio system. Moreover, she often revised scripts in order to emphasize the complexity of women's lives. Within the Hollywood community it was well known that she lived with her partner Marion Morgan, a choreographer and dancer; they were together for forty years.

Marie Bashkirtsev
1860–1884; RUSSIA

Bashkirtsev (Bashkirtseff) enrolled in a women's art class at the Academie Julien, one of the first schools to accept women, which also allowed them to work from the nude, a major step in providing the type of training necessary for acceptance as an artist. She was regarded as a woman of precocious talent and became well known, exhibiting at the Paris Salon (an essential venue for art world success). Bashkirtsev was aware of the difficulties women artists faced, and her own serious attitude toward her career permeated the diary she kept, which was published posthumously. Unfortunately, she died young of tuberculosis, leaving behind a small but substantial body of art along with the remarkable testimony of her journal, which bears witness to the struggles faced by one young woman trying to realize her dreams of becoming an artist.

Sarah Bernhardt
1844–1923; FRANCE

Bernhardt made her acting debut at the *Comedie Francaise*, the state theater of France, and by 1879 her position as a great actress was established. She broke with the theater, became the leader of her own company, and toured Europe and North America. Known as the "Divine Sarah," she became a legendary figure who was also an accomplished painter, sculptor, and writer. A million people lined the streets of Paris to watch her funeral procession.

Rosa Bonheur
1822–1899; FRANCE

After Bonheur, the daughter of an artist who trained her, decided to concentrate on animal painting, she began to frequent Paris markets and slaughterhouses with her sketchbook, obtaining police permission in order to wear masculine clothing, which was more practical than nineteenth-century female dress. She made her debut as a painter in 1841, soon becoming the most prominent woman artist in Europe and North America. Bonheur worked constantly, making extensive preparations and numerous studies, then executing a piece slowly; she would sometimes wait two years for the oils to dry before applying another layer of paint. Sales of her monumental canvases made her financially successful. She purchased a large estate, which she filled with exotic animals. In this private paradise, she lived and worked, first with Natalie Micas as her companion of forty years and then, until the end of her life, with Anna Klumpke, who was also an artist.

Julia Cameron
1815–1879; ENGLAND

While women played a prominent role in the early history of photography, few women photographers are cited in the literature. Among the pioneers was Julia Margaret Cameron; she received her first camera, from her daughter, when she was forty-eight. She transformed an old henhouse on her property into a studio, using a coal house as her darkroom. Almost three thousand of her images have survived. Among the most impressive is a series of portraits that are exquisitely contrived tableaux created with a large-format camera. She also produced a number of religious, symbolic, and allegorical photographs.

Emily Carr
1871–1945; CANADA

After Carr's family emigrated from England to British Columbia. she became an art teacher, saving her salary in order to expand her studio art training in Britain and France. When she returned to Canada, she focused on rendering the Pacific Northwest landscape and recording the native cultures there. Between 1907 and 1913, she undertook an extensive project to create watercolors and oils of totem poles in their village settings, carefully rendering their forms in her documentary sketches and paintings. These were done at a time when the "Indian problem" was a heated issue. Unable to gain any support from the provincial government or private patrons, Carr ceased painting in 1913, turning to writing instead; she produced seven volumes of autobiographical tales along with journals and letters. In 1927, she returned to art. Her later works depict the raw Canadian wilderness, anthropomorphizing the untouched forest in feminine terms. Though now one of the most celebrated figures in Canadian history, Carr did not have a one-woman exhibition until she was sixty-three, and she only exhibited five times during her lifetime. At one point, she wrote: "How completely alone I've had to face the world, no booster, no artistic backing, no relatives interested, no bother taken by papers . . . just me and an empty flat and the pictures."

Mary Cassatt
1844–1926; UNITED STATES

Women of Cassatt's generation bene-fited from the changes that had been achieved by the feminist revolution, including access to art training. Cassatt studied at the Pennsylvania Academy of Fine Arts, and she and her friends were outspoken supporters of equal rights for women. Her sister Lydia fol-lowed her to Paris in the 1870s, taking care of the household duties in order to free Cassatt to paint. In 1877, she was invited by Edgar Degas (1834–1917) to exhibit with the Impressionists. In time, she focused on either portraits or the theme of mother and child. Not long after she began this work, a number of artists started creating lim-ited edition prints in an effort to reach a wider audience. Cassatt made a series of aquatints that are considered among the finest prints ever created. She then received a commission for the 1893 Woman's Building at the Chi-cago World's Fair. Unfortunately, the sixty-five-foot mural, entitled *Modern Woman*, has been lost, greatly dimin-ishing the understanding of Cassatt's work, specifically her early exploration of feminist themes. Nevertheless, she achieved recognition and financial success during her lifetime and has sustained her place in art history.

Imogen Cunningham
1883–1976; UNITED STATES

Cunningham caused a scandal with her photographs of her nude hus-band posed in the landscape, an early example of the "female gaze" as an alternative to the masculine viewpoint that dominates visual art (these images were censored for many years). During the time she was raising her children, she turned to subject matter in her own backyard; her enlarged, sharp focus close-ups of flower and plant forms are considered to be some of her finest work. In 1932—with Edward Weston (1886–1958) and Ansel Adams (1902–1984)—Cunningham founded the influential Group f/64, named for the small aperture setting necessary for the sharply focused photographs all three artists preferred. About that same time, Cunningham began to pho-tograph migrant workers for a research project on disenfranchised Americans. She also experimented with dou-ble exposures and photomontages.

When Cunningham died at the age of ninety-three, she had just completed a collection called "After Ninety," a cele-bration of aging.

Sonia Delaunay
1885–1979; FRANCE

Together with her husband, artist Rob-ert Delaunay (1885–1941), Sonia devel-oped a painting style called Orphism, which involved overlapping planes of bright, contrasting colors. However, Delaunay developed her own vision, and her radical exercises in luminosity and refractivity remain unparalleled. In addition to painting, she is known for her fabric, textile, and clothing designs. She and Robert became involved in a number of public art projects, collab-orating on large-scale murals for the Paris Exposition of 1937. After Robert's death four years later, Delaunay contin-ued to work as a painter and designer, living to see a number of retrospec-tives of her work. In 1964, she became the first woman ever to have an exhibi-tion at the Louvre Museum.

Maya Deren
1917–1961; UNITED STATES

After college, Deren became an assistant to Katherine Dunham, an influential pioneer of black dance, and toured with her troupe. Later, Deren used some of her inheritance to buy a used 16mm camera. In 1943, she mar-ried Alexander Hammid (1907–2004), a Czech emigre filmmaker with whom she made her best-known work, *Meshes in the Afternoon*, the first American avant-garde film. Deren also founded the Creative Film Foundation and published numerous articles that helped to popularize independent film. In 1947, she received a Guggenheim Fellowship to go to Haiti, where she filmed the dances and rituals of voo-doo, the African ancestral religion. For many years, her book on this subject was the definitive text. Unfortunately, her career was cut short by an early death. In 1986, the American Film Institute established the Maya Deren Award for independent film and video artists.

Isadora Duncan
1878–1927; UNITED STATES

In 1895, Duncan and her family moved to the East Coast from San Francisco so that she could pursue a career in dance. Barefoot, dressed in a flowing white tunic with her hair loose, Duncan introduced a form of movement that revolutionized the dance world. Known as the founder of modern dance, she searched for a spiritual, rather than a physical, center of motion, looking back to an earlier time when dance was considered a sacred art. Unfortu-nately, her life was marred by tragedy, and she herself was strangled to death when her long scarf became entan-gled in the spokes of her sports car.

Eleanora Duse
1858–1924; ITALY

Duse first performed with her actor parents when she was four years old. By the time she formed her own company in 1886, she was famous for her interpretations of Shakespearean roles and nineteenth-century French drama. In addition to Duse's acclaim as an actress, she became known for her tempestuous love affairs with both men and women; her partners included Gabriele d'Annunzio (1863–1938), whose plays she personally financed, promoted, and produced. Duse, who became plagued by ill-ness, continued to tour. While in the United States, she collapsed on the stage while taking a bow, dying shortly thereafter.

Edith Evans
1888–1976; ENGLAND

While working as a milliner in London, Evans joined a drama class. She made her professional acting debut in 1912 in Shakespeare's *Much Ado About Nothing*. Later she joined the Old Vic theater company (one of the oldest theaters in London). Over the course of her long and memorable career, Evans created a number of definitive charac-ters and appeared on Broadway and in films. On November 20, 1950, Evans performed at the reopening of the Old Vic Theater, which had been destroyed during the German attack on London in World War II.

Natalia Goncharova
1881–1962; RUSSIA

In 1908 Goncharova, an artist whose work had begun to receive critical attention, exhibited a series of mod-ernist figure paintings that resulted in the authorities taking her to court on a charge of indecency. Although she was acquitted, her work was then

241

frequently lampooned in the popular press. In 1914, she was invited by ballet impresario Sergei Diaghilev (1872-1929) to create stage designs for one of his productions, and she began to work regularly for the Ballets Russes, which he founded. In 1915, she and her artist companion Mikhail Larionov (1881-1964) left Russia, joining Diaghilev in Switzerland; she followed Diaghilev to Spain to do additional stage designs, a trip that proved to have a significant influence on her subsequent paintings. However, after she left Russia, she rarely exhibited, and when she did, the galleries tended to promote her stage design work rather than her paintings. It is only recently that her role in the development of Russian modernism has been acknowledged, but her overall body of art remains insufficiently recognized.

Martha Graham
1894-1991; UNITED STATES

When Graham was fourteen, she attended a recital by Ruth St. Denis (1879-1968), the first dancer to successfully combine theatrical and dance traditions. In 1916, Graham joined the troop. After seven years, she moved to New York, launching her own company in 1929. Her focus was the development of a new style of dance through which to explore and express the emotions. Her most forceful and vivid creations were her portrayals of heroic women, both real and legendary. Graham's career spanned seventy-five years, during which time she produced some of the greatest masterpieces of American modern dance and influenced generations of dancers the world over.

Eileen Gray
1879-1976; IRELAND

Gray studied at the Slade School of Art in London. After stumbling upon a lacquer repair shop, she began studying lacquer techniques for use in furniture design. In 1922, she opened a design gallery to highlight her furniture and interior designs, thereafter expanding her practice to architecture. In 1937, she exhibited one of her architectural plans at the Paris Exposition. But as a woman, Gray was denied access to the supportive networks from which her male contemporaries benefited. During World War II, she was interred by the French as an enemy alien, her

house was looted, and much of her work was destroyed. By the end of the war she was largely forgotten, even though her work inspired both art deco and modernist design. In 1968, her work was rediscovered, and she is now hailed as a visionary and one of the most important furniture designers and architects of the twentieth century.

Sophia Haydn
1868-1953; UNITED STATES

Plans for the Woman's Building at the 1893 World's Fair were administered by a Board of Lady Managers, which was considered radical at the time. In an effort to draw attention to women's progress in entering previously all-male professions, they established an architectural competition, open only to women, for the building's design. Haydn, the first female to graduate in architecture from MIT, could not find a job in her field because of her gender, so she taught drawing at a Boston school. She won the competition, though she was paid only a small sum—far less than what was paid to the architects of the other buildings at the fair. Though the 80,000-square-foot Italian Renaissance-style structure received an award, male critics dismissed it as being too feminine. Haydn never built another building.

Katharine Hepburn
1907-2003; UNITED STATES

Hepburn graduated from Bryn Mawr College in 1928, the same year she debuted as an actress on Broadway; she was soon signed by RKO. Though she was headstrong, her talent was undeniable. In 1933, she won the first of her four Oscars, and by 1938 she was a big star. But within a few years, her career declined, although she did appear in The Philadelphia Story, a play written especially for her. Hepburn bought the rights and turned it into a successful movie, which revived her career. In 1942, she starred in a movie with Spencer Tracy (1900-1967), who despite being married to another woman became her companion for the rest of his life. During his long illness, Hepburn stopped working in order to nurse him, but after his death she returned to acting in films and on stage, becoming a near-legendary figure.

Barbara Hepworth
1903-1975; ENGLAND

Hepworth won a scholarship to the Leeds School of Art, where she studied sculpture alongside Henry Moore (1898-1986); she is sometimes erroneously described as his disciple rather than his colleague. Although her career spanned fifty years, recognition is usually given only to the work she created prior to World War II, when she began carving stone. In 1927, she made her first image of a mother and child, a theme that occupied her between 1932 and 1937. It is this work that first caused her to pierce her sculptures in 1931, a year before Moore, who has generally received the credit for this development, considered an important artistic breakthrough. Hepworth always saw her abstract shapes as related to the earth, to the human figure in the landscape, and to her own experience as a woman. She believed, "There is a whole range of formal perception belonging to the feminine experience."

Hannah Hoch
1889-1978; GERMANY

The Dada movement arose out of World War I, when a number of artists and intellectuals viewed the violence as evidence of the failure of the social order. The German Dadaists were more politically motivated than other groups. Hoch was one of the few women associated with this movement, though her contributions have until recently been marginalized in favor of a focus on her male colleagues. Hoch worked in photomontage, a technique she helped develop, often utilizing discarded materials as well as those traditionally associated with women—lace, buttons, and bits of fabric—to make strong, ironic images examining issues of gender and race. By the mid-1920s, Hoch's association with the German Dadaists ended, though she continued to work in a style that navigated between fine art and mass media. Although she was forbidden to exhibit during the Nazi years, she remained in Germany throughout World War II.

Harriet Hosmer
1830-1908; UNITED STATES

As a young woman, Hosmer began studying sculpture, working in a private art studio in her family's Massachusetts home. Unusual for a woman of her

time, her education included anatomy lessons and the study of the life model. In 1852, she went to Rome, gaining expertise in modeling and carving and studying ancient sculpture firsthand. She then set up her own studio, where in future years she was to employ up to twenty-four assistants. Generally, the subject matter of her work was women, and she gained an international reputation with her idealized, classical works of historic figures. In later years, she supported women's suffrage and became closely identified with the American women's rights movement. She was also the inspirational leader of a group of women artists who gathered around her in Rome.

Frida Kahlo
1907–1954; MEXICO

When Kahlo was a child, she contracted polio, and at age fifteen she almost died in a horrendous traffic accident that required repeated surgeries and left her in constant pain. Her haunting self-portraits are replete with multiple layers of meaning—personal, political, and historical. In 1929, Kahlo married the muralist Diego Rivera (1886-1957), whose work influenced hers, though she followed an independent road, consciously emulating the style of retablos, tiny votive offerings she also collected. During the 1940s, Kahlo enjoyed considerable success, and her work was exhibited internationally. But over the next decade, as her health deteriorated, her subject matter changed. The strange still lives that she created almost seemed to chronicle her own physical disintegration. After she died, she became an iconic figure, an aesthetic influence to generations of artists and the subject of considerable writing as well as a popular film.

Ida Kaminska
1899–1980; POLAND

Kaminska, the daughter of celebrated Yiddish actors, founded the Warsaw Jewish Art Theater and then her own Ida Kaminska Theatre, where she starred in productions that she adapted and directed. She spent WWII performing in the Soviet Union, returning to Poland at the end of the war to found and tour with the Jewish State Theater, which received both official recognition and financial aid from the government. However, recurring anti-Semitism

forced her to abandon Poland for the United States in 1968. The height of her film career was her appearance in the Czech film *The Shop on Main Street* (1965), for which she was nominated for an Academy Award. Disappointed by her failure to establish a Yiddish repertory theater in the United States, she moved to Israel, where she spent the remainder of her life.

Gertrude Kasebier
1852–1934; UNITED STATES

Kasebier had to wait until her three children were grown to begin "mak[ing] likenesses that are biographies." In 1897, she opened a portrait studio in New York, creating a series of memorable photographs of famous artists and writers that relied solely upon available light and natural settings, both departures from the usual Victorian studio-portrait techniques. From the late 1890s through the 1920s, Kasebier was the preeminent woman among an international group of portrait photographers. She also created allegorical photos about womanhood, motherhood, and family life that inspired many later photographers.

Kathe Kollwitz
1867–1945; GERMANY

Kollwitz settled with her husband in a working-class area of Berlin, where he set up his medical practice. In 1897 her first suite of images (lithographs and etchings) was exhibited to both acclaim and controversy. The work—which dealt with the miserable conditions of cottage industry weavers who rose up against their bosses and were slaughtered—was considered subversive. During the next fifteen years, Kollwitz created some of her most memorable art, experimenting with increasingly sophisticated graphic techniques to express her outrage at the suffering she saw around her. One of her sons was killed in WW I, which cast a pall over her life even though she was able to convert her grief into deeply moving images. In 1919, she was appointed the first woman professor at the Prussian Academy of Art, but because her work was deeply critical of the Nazis, she was expelled in 1933. Kollwitz then began to focus on sculpture. In 1942, her husband died and the following year, she was evacuated from her home to escape the Allied bombing of Berlin, when much of her work

was destroyed. By the time she died, reproductions of her images could be found in millions of homes throughout Germany, where there are now several museums dedicated to her work and the powerful social conscience it expresses.

Dorothea Lange
1895–1965; UNITED STATES

In 1918, Lange opened a portrait studio in San Francisco, embarking upon a fourteen-year career of commercial work. In 1920, she married the painter Maynard Dixon (1875-1946), with whom she had two sons and later divorced. In the wake of the Depression, Lange turned from portraiture to documentary photography with strong social content. In 1934, she exhibited this work, which was seen by Paul Taylor, a labor economist at the University of California who appreciated her images. They soon married and began to collaborate. She was hired by the Federal Art Project to photograph the rural poor. Some of her most famous images are from this period. These eloquent pictures served to arouse national sympathy for the plight of migrant workers. Although continuing health problems reduced her productivity during the last two decades of her life, her keen visual intelligence remained present in her work until the end. She died while preparing her retrospective at the Museum of Modern Art, which she did not live to see.

Marie Laurencin
1883–1956; FRANCE

Laurencin, who studied art privately, became friendly with the painter Georges Braque (1882-1963), developer of Cubism along with Pablo Picasso (1881-1973). In 1907, Braque introduced Laurencin to the circle of artists who regularly gathered in Picasso's studio. She became involved with the poet Guillaume Apollinaire (1880-1918), with whom she lived for five years. Included in several Cubist exhibitions, Laurencin's paintings contain many portraits of women and children, painted in soft pastel tones. She also did design work, stage and costume design, and book illustration—often considered to be female work—which only heightened the perceptions of Laurencin's work as being quintessentially feminine.

Mary Louise McLaughlin
1847–1939; UNITED STATES

McLaughlin, who studied at the McMicken School of Design in Ohio, organized an exhibit of Cincinnati women's china painting for the 1876 Centennial Exhibition in Philadelphia. McLaughlin became fascinated by the European underglaze slip decoration that she saw there, which was then little known in the United States. In 1877, she published the first American manual on china painting written by a woman for women, single-handedly inspiring a movement in which women virtually took over the field. She also founded the Cincinnati Pottery Club, the first women's ceramics organization in the country. In 1880, she produced a book on underglaze decoration, based upon her own experiments. Nine years later, she decided to produce porcelain pieces, the first person in the country to master this difficult craft, which resulted in some of her finest work. Only recently has a biography been written about this pioneering woman who had wanted to be a painter but turned to crafts because her gender stood in her way.

244

Paula Modersohn-Becker
1876–1907; GERMANY

After her art training, Modersohn-Becker settled in a German village and became absorbed in creating a series of somewhat romanticized images of peasant women nursing their babies. In 1901, she married another artist, landscape painter Otto Modersohn. Her diaries reveal the conflicts she felt between being a woman and an artist seeking a professional career. She also created powerful, earthy, sensual images of women as well as self-portraits and then still lives. At one point, she separated from her husband in order to pursue her work, but he convinced her to return. She became pregnant; three weeks after the birth of her daughter, at the age of thirty-one, Modersohn-Becker died of heart failure, leaving almost four hundred paintings and studies along with one thousand drawings.

Julia Morgan
1872–1957; UNITED STATES

Morgan was the first woman to receive a degree in civil engineering from the University of California as well as the first female architect to graduate from the Ecole des Beaux Arts (although she was forced to wait two years before the school opened its doors to women). Returning to San Francisco in 1902, she worked for an architectural office before starting her own firm two years later. After the 1906 earthquake, she received a number of commissions to help rebuild the city. By the time the powerful publisher William Randolph Hearst (1836–1951) hired her in 1919, she had already built 450 different types of structures. Morgan's buildings—whether brown shingle residences or Renaissance-style edifices—reflected her elegant sense of design, her concern with interior and exterior space, and her respect for materials and principles of construction. She and Hearst entered into a twenty-five-year collaboration, one result of which was the magnificent Hearst Castle in San Simeon. A decline in Hearst's finances slowed the pace of the work, which was never completed. However, Morgan remained active as an architect until the early fifties, when she closed her office.

Berthe Morisot
1841–1895; FRANCE

Born into a wealthy, progressive family, Morisot was also fortunate because she received a serious art education that included studying with the realist painter Jean Baptiste Corot (1796–1875), a family friend. She developed a close professional relationship with another family friend, the artist Edouard Manet (1832–1883); she influenced him to take up plein-air painting (work done outside the studio, an approach preferred by the Impressionists, who came to view Manet as their leader). In 1864, Morisot had work accepted into the Paris Salon, and ten years later she was invited to participate in a historic exhibition outside the Salon that would come to be viewed as the first Impressionist exhibit. That same year, she married Eugene Manet, the younger brother of Edouard. Unlike most other nineteenth-century women artists, her marriage did not end her career, and she continued to exhibit with the Impressionists. Her work was different from that of her male peers

in the perspective she brought to the representation of women and children in the home, and she produced some of the few portraits of pregnant women in nineteenth-century art. Nevertheless, after her death British and American art history texts dramatically minimized her contributions, dismissing her as a student of Manet's and failing to acknowledge her crucial support of Impressionist exhibitions. Recently, her role as a major woman artist of the modern period has begun to be reassessed by feminist art historians.

Gabriele Munter
1877–1962; GERMANY

Munter is another woman artist whose work has been overshadowed by an association with a male artist, in her case, Wassily Kandinsky (1866–1944). In 1902, the two painters began a relationship that lasted until 1915. During this period, Munter produced a considerable body of art and also helped to form the Blue Rider group, a changing roster of German Expressionist artists who exhibited together. Nevertheless, until recently she had been consigned to the role of Kandinsky's muse, an unfair assessment particularly because she deliberately remained childless, refusing to subordinate her own goals as an artist to the demands of motherhood. Her early work included self-portraits, portraits of members of the Blue Rider group, and a series of images of women. After WWII, Munter focused on landscapes, still lives, and interior scenes.

Louise Nevelson
1899–1988; UNITED STATES

At age twenty, Nevelson married the much older Charles, a wealthy ship owner. During the 1920s, she lived comfortably while taking a variety of art classes in New York. She began her professional art career in the 1930s and soon gravitated to sculpture. She held her first solo show in 1941 but struggled to be accepted into the New York art world, which only occurred when she was sixty years old. Between 1954 and 1960, she developed her signature style: monumental assemblages comprised of scavenged materials, structured with multiple compartments and united by a single color. In 1970, she began to create public works, the first for Princeton University. Eight years later, the Louise Nevelson Plaza in lower Manhattan—a site with seven welded steel pieces—was dedicated.

In 1967, she had expressed the hope that she might someday have sufficient funds to build a museum for her work. Unfortunately, she was never able to realize this goal, and her work has already begun to be eclipsed by the historic erasure that has subsumed so many women artists.

Elizabeth Ney
1833–1907; GERMANY

Elizabeth or Elizabet Ney, the daughter of a stone carver, was the first woman to attend the Munich Art Academy. She then became a student of important sculptor Daniel Rauch (1777–1857). Because of him, Ney obtained a series of commissions to sculpt some of the well-known men of the period. In 1871 Ney, along with her physician-husband Edmund Montgomery and family, emigrated to the United States, eventually settling in Texas. After a twenty-year hiatus in her artistic production, she set up a studio in Austin. She had a difficult time getting work, but finally, through the Daughters of the Republic of Texas, she received a few commissions and in 1893 she was hired to create a statue for the Columbian Exposition in Chicago, which helped to revive her career. At the end of her life, she was able to choose her own subjects, which allowed her to expand her personal expression. Thanks to her husband and a few friends, Ney's Austin residence has been preserved as a studio/home museum, one of the few such sites in the country devoted to a woman artist. Unfortunately, the site is inadequately funded and administered.

Anna Pavlova
1885–1931; RUSSIA

Although a sickly child, by the time Pavlova graduated from the Imperial Ballet School after seven years of study, she was recognized as an exceptionally gifted dancer. By 1905, she had achieved solo ballerina status, and two years later she began touring Europe, either on her own or with the Ballets Russes. In 1910, she appeared at the Metropolitan Opera House in New York, subsequently settling in London, then organizing her own dance company. While Isadora Duncan was revolutionizing dance, Pavlova remained committed to sharing the classical traditions, bringing ballet to the millions who were attracted to one of the century's greatest ballerinas.

Augusta Savage
1892–1962; UNITED STATES

In 1921, after an unsuccessful effort to earn a living through portrait commissions in Florida, Savage came to New York, leaving behind a husband (whom she later divorced) and their daughter, who was raised by Savage's parents. She was part of the "great migration" of African Americans who moved to northern cities in search of better paying jobs, enrolling at Cooper Union art school in hopes of becoming a professional artist. Savage soon found a place as part of the Harlem Renaissance and began to receive a few commissions to model portrait busts of African-American leaders. During the Depression years, she opened the Savage Studio of Arts and Crafts in a basement apartment to teach art to black children. In 1937, when the Harlem Community Art Center opened (part of the Federal Art Project), Savage became its first director. She took a leave of absence to complete her most famous work, *The Harp*, for the 1939–1940 New York World's Fair, a commissioned piece intended to symbolize the contributions of African Americans to music. Unfortunately, funds to cast the work in bronze could not be raised, and at the conclusion of the fair the plaster work was destroyed. At the end of the 1930s Savage left Harlem and lived as a recluse for the remainder of her life.

Sophie Taeuber-Arp
1889–1943; SWITZERLAND

Reading contemporary biographies of the artist Jean Arp (1886–1996), one would have no idea he shared a life of artistic collaboration with his wife Sophie Taeuber, "in duo," as they described it. They met in 1915; Taeuber was teaching applied arts in Zurich where Arp moved to avoid being drafted into the German army. He referred to their meeting as "the main event in my life." By the following year the two artists were a couple as well as founding members of the Dada movement. Taeuber had already embraced the values of the Dada movement, rejecting painting in favor of working in fabric and thread; she taught Arp how to embroider. Over the years, Taeuber worked in an astonishing array of media—weaving, embroidery, stained glass, collage, wood reliefs, stage decor, and furniture design—and some of her pictures anticipated by twenty years later abstract designs of

Georgia O'Keefe illuminated capital letter

other artists. Their collaborations continued for decades until a freak accident caused Taeuber's death in 1943. Arp was so devastated that he retired for a period to a Dominican monastery. When he emerged, he tore up many of her drawings and turned them into collages in homage to the woman who had taught him so much.

Suzanne Valadon
1865–1938; FRANCE

With no formal training as an artist—she was unable to afford the tuition at the art academies, many of which charged higher fees for women—Valadon began to draw while working as an artist's model in 1893. Edgar Degas (1834–1917), the Impressionist painter, bought many of her sketches and taught her an etching technique, which she perfected over the next twenty years. Valadon has become one of the best-documented French women artists of the twentieth century, in part because her bold, unconventional images of women have aroused considerable interest among feminist art historians. Also unusual are her self-portraits, unself-conscious images that bring considerable honesty to her views of her own body, particularly as she aged. In addition, Valadon's paintings of her husband disrupted the conventional representation of the male nude; one of these works, *Adam and Eve*, was censored until she covered Adam's genitals with painted vines. Despite her international reputation, unusual for women artists from working-class origins, she was treated as a minor figure for decades, seemingly of interest only because she was the mother of Maurice Utrillo (1883–1955), an alcoholic painter whom she both trained and protected.

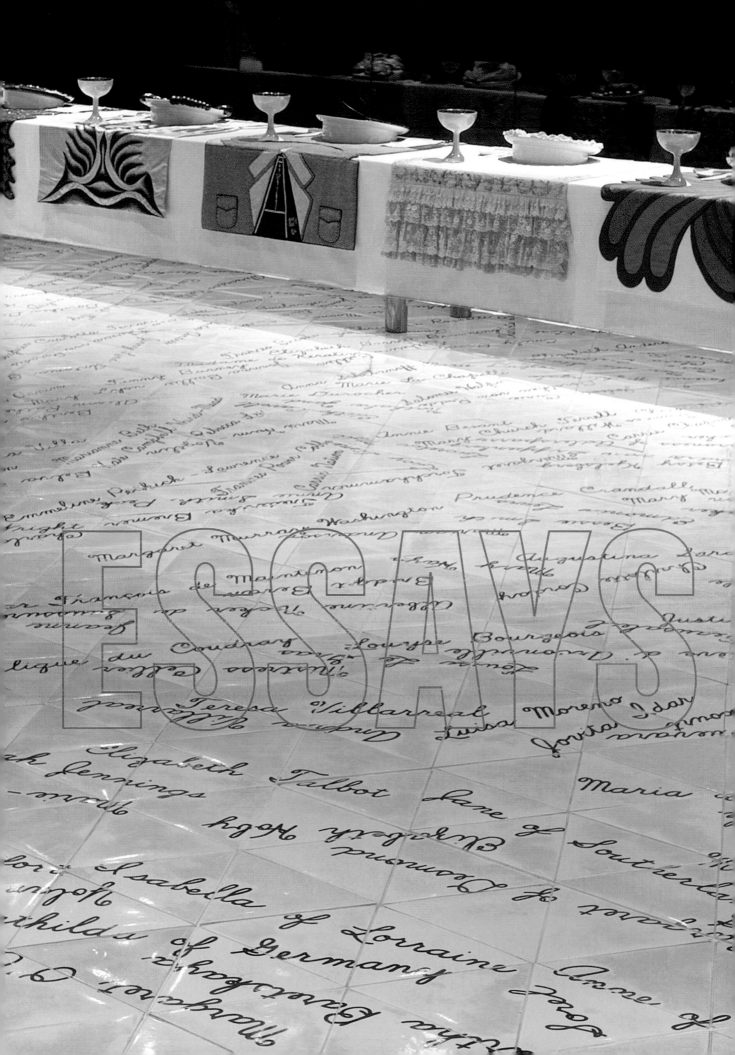

FROM JUDY COHEN TO JUDY CHICAGO

JUDY CHICAGO

I was born in 1939 to a secular Jewish family in Chicago. My father, Arthur Cohen, the youngest of nine children, was descended from twenty-three generations of rabbis. It was his rabbi father's expectation that he would be the one to carry on the family tradition. But even as a child, he would have none of it, though my grandfather threatened him with a beating when he refused to go to *cheder* (religious school). As a young man, he eschewed all things Jewish in favor of Marxism and labor organizing in the postal union he belonged to. Despite not finishing college, he was widely read and a brilliant man who led raucous political discussions in our living room that were unusual in the 1940s because women were always included.

My father worked nights at the post office, so he was usually at home when I woke up from my afternoon naps. I can still remember sitting in his lap while he played games with me that were intended to train me in logic, communication, and values. One of my favorite games involved our housekeeper, Oradie Blue, who was African American. My father would start out by describing an imaginary trip in which we were walking down the street with Oradie. We soon encountered such folks as Norman Black, Mary Green, and Helen White along with others whose last names were also a hue. In combination with the melange of races and ethnicities that filled our house for my parents' frequent record parties in support of one or another political cause, this game taught me that people's worth had nothing to do with the color of their skin.

My mother, May Levinson Cohen, had been a Martha Graham–type dancer when she was young and had retained an interest in the arts. I started drawing when I was three, and at four my nursery school teacher told my mother that I was talented. She soon borrowed a friend's Art Institute of Chicago membership card, and by the time I was five, I was enrolled in Saturday classes. These were held in the museum auditorium, which could accommodate dozens of children. Every week I lost myself in the rendering of models and still lifes, after which I would walk up the museum's large center staircase to the galleries and wander around for hours. By the time I was eight, my mother had managed to scrape together enough money to send me to the Junior School, where I was trained in the fundamentals of art.

Although I adored my father, the arts were not important to him—apart from a passionate interest in music, particularly jazz. His concerns were politics, history, and trying to change the world, a goal with which I was inculcated from my earliest days. As a result of Cold War–era McCarthyism, my father's political beliefs caused him trouble, and when I was six years old, the FBI visited our house. After that, it was just a matter of time before he was drummed out of the post office and the union-organizing job he loved. All of this precipitated a slow decline, accompanied by depression, health issues, and money woes. When I was thirteen, he died, leaving me grief-stricken and confused. My primary solace was my art; in both grade school and high school, I was the "school artist." I retreated into it, spending many hours alone in my room drawing or working on school projects.

I do not recall any ambiguity about my ambitions; I always knew that I would become an artist. From the beginning, I was intent on being part of art history, though I had no idea how difficult that would be, especially for a woman. I must admit that I was unaware that the art I so admired at the Art Institute had been created almost entirely by men. I was too busy tracing Toulouse-Lautrec's use of reds to move the viewer's eye around the canvas; studying Seurat's pointillist color system in the museum's grand *A Sunday on La Grande Jatte–1884* (1884-86); and staring at Monet's fascinating paintings of haystacks in changing light. My lack of awareness was also the result of being raised in an environment that was suffused with the idea of equality—for everyone.

started high school in 1953, at the end of the Korean War. While there, I had an experience that profoundly shaped my life. During that period, Communists and Marxists were customarily depicted as incarnations of evil, notably in a paper given out at school called the *Weekly Reader*. What was I to make of cartoons of hideous, bloated "Communists" bayoneting handsome, blonde, blue-eyed American soldiers? How could this vile image be reconciled with what I had gleaned from my father, a man of immense integrity whose life had been devoted to worthwhile goals?

Even though I was young, I was forced to make a decision about whether I would believe my own experiences or accept the prevailing point of view of the society. Somehow I was able to figure out that because an idea is widely held, that does not make it true, an insight that helped me hold on to my own vision—not only when I was a child but later, as I encountered many obstacles in the pursuit of my dreams. High school was a blur, made more difficult by the fact that my mother—for some never-explained reason—provided little solace for the grief that suffused me and my younger brother, Ben.

Many years later, he would move to Japan where he found his way to a successful career as a potter only to have his life cut short at forty-seven by ALS (amyotrophic lateral sclerosis or "Lou Gehrig's disease"), a fatal neurological illness that also claimed one of my paternal uncles when I was still a little girl. In fact, death shadowed my childhood, claiming an aunt who slipped on an

icy Chicago street and suffered a heart attack; a cousin who fell into an open manhole when he was disembarking from the ship that had carried him safely home from the war; and, eight months after my father's death, the husband of his closest sister (my aunt Enid) was shot in a holdup at the bar he owned. Then during my teens, my best friend and her family were killed in a collision with a train at an unmarked railroad crossing.

Perhaps it was my early awareness of mortality that accounts for the fact that at some point, my art life became more real than my day-to-day existence. It was the only thing I could both count on and never lose; as long as I was alive, I could draw. Many years later, when the art historian Gail Levin was writing my biography, *Becoming Judy Chicago*, she would often call and recount one or another story told to her by someone she had interviewed who had vivid memories of my interactions with them, which I could never remember. But I could always tell her what I was working on at the time.

Other than my classes at the Art Institute, the primary recollection from my teens is sitting down to nightly dinners with my mother and brother where my father's absence weighed on us as though there were a ghostly apparition at the table. At that time I had a marvelous teacher at the Junior School named Emmanuel "Manny" Jacobson, who taught figure drawing there for forty years. His favorite text was Kimon Nicolaides's *The Natural Way to Draw*, a series of exercises designed to assist art students in developing their own creativity.

"Mr. Jacobson," as all his students referred to him, believed that until young people were in high school they should be nurtured. Only then should their work be critiqued. I studied with him for many years, then lost contact with him until 1981 when *The Dinner Party* was exhibited in Chicago, and I gave him a private tour. At the end, he patted my hand and said in the soft, gravelly voice I remembered so well: "I always knew you would do something important," a perception that he had never shared with me before. Instead, he had done what he did best; nurture my creativity and then, in my teens, provide me with helpful, and always supportive, criticism.

By the time I graduated from high school, I'd had enough of Chicago and the painful memories it represented. I planned to go to Los Angeles and attend UCLA, which was reputed to have a good art department. That summer, a good friend of my mother's took me for a walk. She insisted that I forgo college and get a job to help support my mother and brother, who was soon to enter high school. Although she succeeded in making me feel guilty about my aspirations, I knew that no matter how difficult it had been for my mother to support two children on the paltry salary of a medical secretary, she expected both her children to go to college. In fact, she later moved to Los Angeles so that my brother could avail himself of the high-quality education that was then available from the California university system.

Besides, I knew that I had a destiny, something that I mentioned to a few companions during my last summer at the Indiana Dunes where some of my mother's friends had cabins to which we were often invited. I remember the kids looking askance at my declaration, clearly doubting my certainty. Of course, I had no idea that I would soon encounter similar doubts in the minds of, first, my male professors and then, more detrimentally, those who controlled the burgeoning L.A. art scene.

In the fall of 1957 I relocated to California where I could hardly believe the temperate climate, low-lying buildings, orange groves, and big, blue sky. My college days were not easy; though tuition was far less than it is today, I could only count on $50 a month from my mother, which was all that she could spare. I survived through a combination of scholarships, part-time jobs, and, once I was in graduate school, a teaching assistantship in

sculpture, an almost unheard of perk in 1963 when few women were able to acquire such a post (not that I realized it at the time). It was while I was an undergraduate majoring in art and minoring in the humanities (and earning Phi Beta Kappa in the process) that I first encountered sexism when male students were called on in class while I was ignored. My solution was to wave my hand around until I embarrassed the professor into acknowledging my questions.

By the time I started graduate school, I was married to Jerry Gerowitz. I was also starting to exhibit under my maiden name. I soon learned that there were many artists named Cohen, and I therefore switched to Gerowitz. At the end of my first year as a graduate student, Jerry was killed in an automobile accident, and I was again reminded of how impermanent life could be, a realization that added urgency to my decision to be an artist. I moved out of our Topanga Canyon house into a small apartment in a Santa Monica complex that was owned by Frank Gehry, then a quirky architect who was doing strange experiments with unusual materials. I turned the back outbuilding into a studio and, once more, retreated into my art-making life, this time with an intensified determination to make myself into a successful artist.

Quite coincidentally, Frank's sister, Doreen, started dating Rolf Nelson, who owned a gallery on La Cienega Boulevard where the contemporary art scene was beginning to heat up. Rolf included me in several group shows and started calling me "Judy Chicago" because of my strong Midwestern accent. He urged me to change my name, which I wouldn't do, at least not then. Instead, I listed my phone number under that nickname, something that many L.A. artists were prone to at the time (Ed Ruscha was "Eddy Russia" and Larry Bell was "Ben Luxe").

I also started hanging out at a bar called Barney's Beanery, which was memorialized in 1965 by Ed Kienholz in a life-size sculptural tableau. Kienholz was a cofounder (with influential curator Walter Hopps) of the Ferus Gallery, which featured a stable of male artists whose work became associated with "Finish Fetish," a style that owed a lot to Southern California car and surf culture and featured high-tech materials like plastics, resins, and coated glass. I was introduced to Barney's by Billy Al Bengston, one of the Ferus boys—a hand-

JUDY **CHICAGO**, *Rainbow Pickett*, 1964 (recreated 2004). Latex paint on canvas-covered plywood, 126 × 126 × 110 in. (320 × 320 × 279.4 cm). Collection of David and Diane Waldman.

some and dashing fellow who had come to teach at UCLA for a year. He was the first "real" artist I ever met.

In contrast, my painting professors seemed dull and uninspired. I already had had a series of run-ins with them concerning my color sense and my imagery, which they hated. Earth tones were all the rage in the art department, and my hues tended towards the pastel. As to my imagery, it was full of content, its biomorphic forms expressing ideas about birth, death, and sexuality that were clearly not in step with either Abstract Expressionism (brought to UCLA by Hans Hofmann) or the figurative tradition of Rico Lebrun, whose influence at the school was strong. My response was to immerse myself in sculpture where the teacher, Oliver Andrews, was far more supportive, so much so that he gave me the teaching assistantship as an incentive to change my painting major to a dual focus on painting and sculpture.

By the time of my graduate exhibition, I was showing regularly at Rolf's, and my work was starting to attract the attention of critics like John Coplans, who was then running *Artforum*, a maga-

zine that had recently relocated from the Bay Area and was busy promoting the Ferus boys along with emerging artists. I was one of the few women who were part of the scene though my position was always marginal. John never tired of telling me that I couldn't be a woman and an artist too, which presented me with an unsolvable predicament. But since he was writing about my work, I figured that I shouldn't complain.

Since there was a minimal collecting community at that time, sales were not the focus of most of the artists I knew. Instead, they proclaimed the importance of "being taken seriously," a status to which I aspired despite my gender, which was obviously a hindrance, at least in their eyes, and apparently also for Walter Hopps, who used to visit studios in Pasadena, where I moved after graduate school. By then I was making large-scale sculptures, notably a piece titled *Rainbow Pickett* (whose title is a reference to the soul singer Wilson Pickett to whom I often listened while I worked).

I shared the studio with two other artists, the sculptor Lloyd Hamrol (whom I later married and divorced) and Llyn Foulkes, who sealed off his quarters with a lock to ensure that we would

never see what he was working on. Walter visited monthly, and after I finished *Rainbow Pickett,* I attempted to show it to him, but he walked right by it, choosing to comment upon a piece by Lloyd that he'd seen several times. I was devastated and fled to my living quarters where I broke down in tears, a common occurrence especially after interacting with the Ferus boys at Barney's. They were tough—or appeared to be—jousting verbally and putting each other down with the epithet "cunt." Their disdain for women was palpable in most of their interactions.

My reaction was to try and pretend to be as tough as they were, but later, when I got home, I'd tell myself that if I wanted to be part of the art world, I would have to find the strength to deal with them as they were the only game in town or at least the game I wanted to play. As I would later say, all I wanted was to be accepted as an artist among artists, but I was always an outsider, a position made very evident by Walter many years later when we had breakfast in Washington DC, where he had taken a job.

By then, I had published my first book, *Through the Flower: My Struggle as a Woman Artist,* which chronicles my early days in Los Angeles. I related the experience with Walter and *Rainbow Pickett,* though I didn't mention him by name. He had clearly either read it or been told about the mention because he tried to excuse his behavior by saying: "But Judy, you have to understand; in those days, women in the art scene were either artists' wives or groupies. What was I to do with the fact that you were making art that was stronger than that of many of the male artists? It was as though I was seeing a woman pull up her skirt and roll down her stockings; I *had* to avert my eyes," words that I remember as clearly as if they were said yesterday.

And even if I had some success during those years, one success did not lead to another as it seemed to do for my male peers. It's as if they were on a train that rolled along with minimum effort from them, whereas I never seemed to get beyond first base (if I can mix my metaphors). Still, I kept working, creating a large body of paintings and sculptures, many of which were large in scale. By the end of my first decade of professional practice, I had a lot of art I could not sell and not enough money to store it. So I destroyed a good deal of my early production, keeping

only a representative selection with the hope that someday, someone might be interested in it. Among the works I destroyed was *Rainbow Pickett,* even though it had been included in the *Primary Structures* show at the Jewish Museum in New York, the first major minimalist exhibition.

In addition to struggling against the overriding machismo of the L.A. art scene, I also suffered from a lack of understanding about how to get ahead in my career. None of the male artists ever offered me advice even though they were certainly supportive of one another. As a result, I didn't know that when one is included in a big New York show, one is supposed to get on a plane and fly to New York in order to attend the opening. Thus I missed the prominent critic Clement Greenberg extolling my piece to Walter, of all people, who certainly never bothered to mention those comments to me.

The intractability of this mind-set combined with the frustration of constantly being reminded of my gender by the men in the art world led me to make a radical change in my approach to art. To symbolize this, I formally changed my name to Judy Chicago as a way of declaring my intention to confront the issue of being a woman, a task that was definitely aided by the eruption of the women's movement at the end of the 1960s. While others were marching in demonstrations and engaging in political actions, I focused on the art world. My first step was to look for a teaching job outside of L.A., where I could experiment with a new type of art education, one that addressed women's needs, my own included.

A great deal has been written (including my own books) about the first feminist art program at Fresno State College and my stint at CalArts (which produced *Womanhouse*). Consequently, all I will say here is that working with young women and helping them to become artists without doing what I had been forced to do in order to be taken seriously—that is, move away from my own content as a woman—allowed me to reconnect with my early creative impulses. Figuring out how to fuse these with the complex visual language that I had developed in the first decade of my career was one of my personal reasons for taking a teaching job.

During this period, I also tried to address a significant lack in terms of my career, that is, the absence of support, something that continues

Judy Chicago (lower left) working with *Birth Project* administrator Mary Ross Taylor (second from left) and needleworkers, Houston, 1981.

to challenge many women artists. I decided that it was essential to create an alternative support structure for myself and other women, one that would provide exhibition spaces along with the promotion that is essential to an artist's visibility. Consequently, in addition to my studio work, I spent time organizing a women's art community by helping to curate exhibitions, establish galleries and an art magazine, plus (with the designer Sheila Levrant de Bretteville and Arlene Raven, the late art historian whom I still miss) set up the Feminist Studio Workshop and the Woman's Building, which went on to provide training and support for women for twenty years.

In 1974 I returned to uninterrupted studio work because I needed to bring all of my energies to bear on *The Dinner Party* which occupied me until after its premiere in 1979 at the San Francisco Museum of Modern Art. Soon afterwards, I moved to Benicia, a small town in Northern California east of Berkeley, on the Carquinez Strait. At that time, it was pretty run down, with a lot of cheap, empty space, which always attracts artists (it has since been gentrified). At first, I resided in a small apartment where I finished the drawings for *Embroidering Our Heritage*, the second of a two-volume set of books about *The Dinner Party*. Once that was done, I began work on a series of images on the subject of birth and creation that soon blossomed into a major project combining painting and needlework.

I am frequently asked how I attract the many people who have volunteered to work with me. As *The Dinner Party* traveled around the world, I received hundreds of letters from women who wanted to know if I intended to do another collaborative undertaking and expressing their desire to participate; many of these were from needleworkers. I am also queried as to whether I paid these people. I only wish I could have done so. For some reason, people assume that I have been made wealthy from my art, but sadly, for many years, I lived a hand-to-mouth existence, scraping by on a combination of book advances and royalties, lectures, and the occasional art sale.

However, my volunteers have been compensated in other ways. Working on *The Dinner Party*, as Jane Gerhard points out, they received an education in women's history; became personally empowered; and received deep satisfaction from the same source I did, that is, from contributing to a major work of art about women's history that continues to enlighten viewers. Plus I gave many of the core staff drawings, paintings, and test plates that are now extremely valuable.

The rewards for *Birth Project* workers were different. Many of the women were mothers whose birth experiences had transformed them, and they felt strongly about a project whose aim was to illuminate and honor this most female of acts. Also, a number of the stitchers wanted needlework to be seen as art, and the idea that *Birth Project*

work would be exhibited in museums and galleries thrilled them. Lastly, a great many women just wanted the experience of working with me.

This project took five years and was structured differently from *The Dinner Party* in terms of both its creation and distribution. First, instead of working in my studio, everyone worked in their own homes, and I traveled around to meet with them. This taught me a lot about ordinary women's lives and the many pressures and conflicting expectations that constrict them. Secondly, as has been well documented by now, *The Dinner Party* encountered considerable resistance in terms of museum exhibitions, and the installation ended up being shown in a combination of traditional and alternative venues, its tour fueled by an unprecedented grassroots movement that Jane's book chronicles.

But I felt deeply discouraged by the museum opposition and was determined to avoid a repeat performance in terms of the *Birth Project*. Instead of a single monumental work, there were eighty-five separate needlework components. These were accompanied by preparatory materials and documentation panels crediting all the participants. In addition, there was information about the birth process (sorely lacking in most people's educations) and the variety of needle and textile techniques employed in the project. Each of what we deemed "exhibition units" was provided with installation instructions, brads for the panels, and even white gloves for hanging the works. As a result, there were over one hundred *Birth Project* shows in museums, galleries, and alternative spaces.

Again, I was concerned about the disposition of the art, which was donated by me and the needleworkers to Through the Flower, the small non-profit art organization that had been set up at the end of *The Dinner Party* as a support framework for my large collaborative projects. We gave up ownership in the work because we wanted women's experiences to be better reflected in our art institutions. The startling lack of images of birth in museums was one of the reasons I took up the subject. As I often quipped, "if men had babies, there would be thousands of images of the crowning" (the moment the baby's head appears).

In an effort to counter this absence, Through the Flower established a Permanent Placement Program that entailed gifting *Birth Project* work to various institutions. Over the years, when describing this effort, I have commented that we did not take into account museum basements where—I was afraid—too many of the pieces had disappeared. Recently, under the able guidance of Dr. Viki Thompson Wylder, an authority on my work (having written her PhD dissertation on *The Dinner Party* and the *Birth Project*), we undertook a follow-up. What she discovered was heartening; not only were a number of the pieces in permanent installations, some had caused profound transformations in the institutions that housed them.

For instance, she spoke to Eugene Jenneman, the executive director of the Dennos Museum Center at Northwestern Michigan College. When they first received the four pieces gifted to them by Through the Flower, their museum didn't yet exist (which we hadn't realized). The works were initially presented in a building on campus and showcased as an example of the type of exhibition opportunities that could be available to the community if they had a museum, which was subsequently built, thanks in part to our art.

Another example is the Hartford Seminary in Connecticut. It owns a beautiful painted and needlework piece that is on permanent display in the Women's Center in their building, which was designed by the architect Richard Meier. In order to frame it properly, they consulted someone from the conservation department of the nearby Wadsworth Atheneum. According to Miriam Winter, professor of liturgy, worship, spirituality, and feminist studies, the image is important to the seminary's mission because it "testifies to the feminine aspect of the divine." She described its effect as "shaping a way of being in the world" that speaks to many groups of various faiths and both genders who meet there for prayer groups, rituals, and classes.

In Denver, Planned Parenthood of the Rocky Mountains moved from one location to another five years ago. They built a special display area in the new space to house the *Birth Project* work, which is protected by a large sheet of plexiglas. Midwifery is favored by their community, and the image celebrates and sparks discussion of this ancient method of childbirth. Angela Wells, the vice president of administration, commented, "The more you look, the more you see and understand."

I have to admit that Viki's findings forced me to reevaluate my earlier dismissal of Through the Flower's placement program. For some reason, I

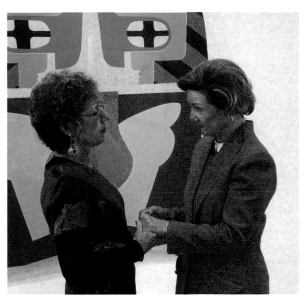

Judy Chicago and Queen Sonja of Norway during a private tour of Chicago's exhibition at Oslo Kunstforening, May 2013.

had assumed that it had been ineffective. But I have often not paid attention to the impact of my work, probably because I was so focused on the art world acceptance that eluded me for so long. In 2013 I had an exhibition in Oslo, where I gave a tour to the queen of Norway, who had expressed her admiration for *The Dinner Party* on Norwegian national television (which apparently caused a steady stream of visitors from that country to the Brooklyn Museum).

It was a thrill to accompany her, and even more exciting that she bought a drawing. Nevertheless, at the opening I brushed aside something that Elizabeth Sackler, who had traveled to Norway for the exhibition, said to me. "Judy, you have to talk to this woman who has been telling me that seeing *The Dinner Party* changed her life." I basically blew her off, stating that I would soon walk through the three rooms of the gallery and at least seventeen people would tell me the same thing, but, I complained, none of them would buy a work.

Sometime later, I was telling this story to Mary Kershaw, the director of the New Mexico Museum of Art, which at that time was preparing an exhibition of my post–*Dinner* Party work. Mary chided me, remarking that there are very few artists in the world whose work elicits such profound audience responses, and, she said, I should appreciate the importance of my art, which really took me aback.

Since then, I've been thinking about what

Mary said, as well as Viki's discoveries about what happened with the *Birth Project*. It is true that I have not been rewarded in the conventional ways that artists are, that is, by sufficient sales to allow me not to have to worry about money. This did not trouble me when I was young, but it has become increasingly challenging now that I am older. I continue to feel frustrated by the ongoing resistance in the art world to acknowledging the widespread audience that I have built and the influence I have had, manifested by the fact that I am in so few major museum collections. Still, I have finally started to recognize that I should take comfort in the many ways my art has reached out and touched people's hearts.

The same response held true for my next major collaboration, *Holocaust Project: From Darkness into Light*, created between 1985 and 1993 with the photographer Donald Woodman, with whom I fell madly in love and married just a few months after we met. By then I was living in Santa Fe, having started to travel there while I was still finishing the *Birth Project* in order to create a major series of paintings, drawings, cast paper, weavings, and bronzes entitled *PowerPlay*. This project examined the gender construct of masculinity before the establishment of either gender studies or queer theory, both of which eventually created a context in which this series could finally be understood.

PowerPlay marked the moment when I began to lift my gaze from the female experience to examine a wider horizon, first, male behavior and some men's unfortunate abuse of power and then, in the *Holocaust Project*, the most grotesque manifestation of oppressive power in history; the Nazi murder of Jews and Gypsies and the hideous exploitation of millions of people deemed to be the "lower races." This, the most daunting of undertakings, occupied us for eight years and eventually traveled for ten years to both art museums and Jewish institutions. Like my earlier projects, there was a distinct difference between audience response (which was overwhelmingly positive) and art world reactions, which ranged from the brutal to the indifferent.

I went on to do one more major collaborative project, *Resolutions: A Stitch in Time*, a somewhat playful series recasting traditional proverbs for the future. This last project was extremely enjoyable because I worked with some of the best

of the needleworkers with whom I'd collaborated over the years, which allowed me to explore more fully the merging of painting and stitching that I'd initiated in the *Birth Project*. Begun in 1994, *Resolutions* took six years; it premiered at the American Craft Museum (now the Museum of Arts and Design), New York, and traveled to eight venues. Once again, there was a rift between critical and popular responses with a *New York Times* review so vitriolic that it stimulated a write-in campaign that included an enema bottle for the suggested cleansing of the reviewer's distemper.

By this time, both my audience and I were used to negative critical reactions, and viewers mainly disregarded critics' judgments, though these definitely influenced my opportunities (or lack thereof) in the art community. Still, I kept working on a series of projects including a number of more personal endeavors. In 2003 I began to concentrate on glass as a medium, which continues to engage me because of its range of aesthetic options and challenges and the fact that my ideas often require collaborative effort, which I still enjoy.

Earlier, I told the story of *Rainbow Pickett*, which in 2004 was rebuilt for *A Minimal Future*, a survey of minimal art at the Museum of Contemporary Art, Los Angeles. Imagine my surprise and delight to arrive at the opening and find the piece featured on a fifty-foot banner hanging outside the museum. It was also reproduced in many of the articles about the show. Slowly art world attitudes towards my work began to change. Then, in 2011, thanks to *Pacific Standard Time*, a Getty Museum-funded initiative, involving institutions from Santa Barbara to San Diego, celebrating Southern California art from 1945 to 1980 (a period in which I spent twenty years in L.A.), my early work was recognized. It appeared as though I had finally achieved my goal of being "an artist among artists"

(and one of the few women to be featured in multiple museum exhibitions).

At the Getty opening, I saw all the guys who had made my early days so difficult. They seemed to evidence considerable warmth towards me, or at least that's what Donald observed. And the evening *was* fun as we exchanged greetings and hugs; but my pleasure was short-lived. The heading of an interview with Billy Al Bengston a few pages away from my own in *LA Weekly* featured the heading, "You Have to Have Balls to Make Art." Despite the persistence of Bengston's decidedly backward opinion, *Pacific Standard Time* seems to have had an amazing effect on my career, which suddenly flourished after so many years of rejection, hostility, and struggle. In addition to a celebration of my work during 2014, Europe suddenly became hospitable, and a number of shows were planned including a traveling retrospective.

I guess it all boils down to the fact that if one lives long enough, one never knows what might happen, and of course, it proves the wisdom of that old adage about never giving up. In fact, that's what I tell young artists: believe in your own vision and keep working no matter how difficult it may be. As for me, I am trying to accept what I have accomplished: a prodigious body of art, the publication of fourteen books, and the crafting of an art education archive that was acquired by Penn State University, where it is being used by scholars and students alike. Many years ago, I read an interview with the painter Agnes Martin. In evaluating her career, she said: "Well done, Agnes," which I thought was both charming and remarkable, thinking how wonderful it would be to feel that way. In my own life, I know that I have worked hard to fulfill my father's mandate to make a contribution, and I hope that he would have been proud of me and what I've done.

AN ART HISTORY SIT-IN: THE DINNER PARTY IN ITS ARTISTIC CONTEXT

FRANCES BORZELLO

Imagine the astonishment felt by cinema audiences in 1977 seeing the mothership appear at the end of *Close Encounters of the Third Kind* and you understand something of the impact of *The Dinner Party's* appearance at the San Francisco Museum of Modern Art in 1979. This huge and colorful celebration of women—some famous, but many more entombed in the past—represented on a triangular banquet table by vulval ceramic plates lightly disguised in butterfly-inspired designs, appeared to have landed fully formed on the gallery floor, a new kind of art with no links to existing isms and movements. But however extraordinary, nothing comes from nowhere, and it is the purpose of this essay to situate this controversial installation in the art of its day.

To begin with, those who had followed Chicago's work since the sixties could have seen it coming. Though not, of course, on this scale or with such outspoken subject matter. Chicago cut her artistic teeth in the 1960s as a member of that most macho of Southern Californian groups, Finish Fetish, accepting not just its aesthetic standards but also internalizing its attitudes on women. She found the artistic side of things straightforward, exploring new technologies like plastics and synthetic resins and learning to spray paint in an auto body school, necessary skills for achieving the glossily smooth colors, abstract forms, and hard surfaces the group favored.

However, swallowing the movement's attitudes toward women was not so simple. Like many female artists of the time, she tried to be one of the boys, but right from the start something "other," as we would say today, kept forcing its way into her work. This intruder was her (mostly repressed and unrecognized) need to deal with subjects close to her heart as a woman, subjects for which her peers had no respect. Occasionally this "other" got through her internal censor: *Bigamy Hood* and *Birth Hood*, decorated car hoods from 1965 based on paintings which had been criticized as embarrassingly female by her art school teacher some years earlier, are revealing examples of female concerns encased in a male art form.

Recognition came quickly. Her first solo show was at the Rolf Nelson Gallery in Los Angeles in 1965. One of the sculptures, *Rainbow Pickett*, six graded lengths of gorgeously colored canvas-covered lengths of wood propped up against the gallery wall, went on to be included in the important exhibition *Primary Structures: Younger American and British Sculptors* at the Jewish Museum in New York in 1966. *Ten Part Cylinders*, a monumental rearrangeable fiberglass sculpture, was shown in *American Sculpture of the Sixties* at the Los Angeles County Museum of Art the following year. Critics responded favorably, although their awareness of her gender sometimes skewed their perception of the work.

As the sixties wore on, she became increasingly absorbed with solving the problem of reconciling the expectations of the masculine art world and her desire to make art out of her female self—that is, her sexuality, her new husband, and the feelings she realized she was keeping out of her work. A group of rounded and dome-shaped acrylic sculptures from the last years of the decade reflect this concern. In 1969 came the circular shapes of her *Pasadena Lifesaver* paintings and the first of her *Atmospheres*, a series of large-scale smoke pieces intended to create a more diffuse, more female kind of environmental art through the use of colored smoke, produced by fireworks and flares, that would blur and feminize a landscape.

By the end of the decade, Chicago had lost her artistic innocence. Her acceptance of the gender blindness of the art world died and took with it her belief that artists were judged solely on their talent. Angry and bewildered, she was rescued by the developing feminist movement, which provided a theory to explain, generalize, and dignify what had been happening to her both artistically and personally. A meeting at the start of the seventies with the writer Anaïs Nin, who went on to

JUDY CHICAGO, *Birth Hood*, 1965/2011. Sprayed automotive lacquer on 1965 Corvair car hood, 42.9 × 42.9 × 4.3 in. (109 × 109 × 10.9 cm). Collection of the artist..

become her mentor, was important in helping her take her feelings and experiences seriously; Nin's uncomplicated acceptance of female sexuality was comforting to Chicago and inspirational in terms of subject matter.

Within months, Chicago had found her path, and a series of events marks her progress along it. In 1970 the magazine *Artforum* carried a photo of Chicago, wearing boxing gloves, shorts, and boots, and a sweatshirt reading "Judy Chicago," in a corner of a boxing ring, as an announcement for a show of her work at California State University, Fullerton. This marked the change from her married name, Gerowitz, a symbol of male dominance, to Chicago, a neutral statement of her place of birth. In 1970 she set up the Feminist Art Program at Fresno State College, the first such program in the United States. In 1971 she took it to California Institute of the Arts where she teamed up with the artist Miriam Schapiro. In 1973, alongside her co-planners Arlene Raven and Sheila Levrant de Bretteville, she watched a dream come true with

the opening of the Woman's Building, a center for feminist art, education, organizations, and businesses and home of the Feminist Studio Workshop, where she taught for a year. In 1975 Chicago chronicled this life-changing journey in her autobiography *Through the Flower*, in which for the first time she publicly explained the bubbles, curves, and circles of her sixties work as female content struggling to get into her art wherever it could.

As an educator, her teaching style was nothing like what she herself had experienced, which followed the traditional pattern of an expert imparting knowledge to the students. Instead, in a tribute to the father she adored, she employed the "circle methodology" he had used in discussions when she was a child: although she was the guide, everyone contributed, so that all shared in the route to knowledge. It was not until she started working with her enthusiastic group of women that she fully understood the artistic and personal confusions of the previous decade and her first openly feminist works appeared.

JUDY CHICAGO, *Pasadena Lifesavers, Red Series #3*, 1970. Acrylic lacquer on acrylic, 60 × 60 in. (152.4 × 152.4 cm). Courtesy Locks Gallery Philadelphia.

Locating a female subject matter and then finding the form to express it became her mission. Her search for subjects that expressed a female point of view, hitherto unknown to art history, and her own growing confidence and conviction of the rightness of this cause, led her to refine her teaching strategy and adopt the consciousness-raising practices so typical of seventies feminism. Inside the safety of the studio, her students revealed their most intimate experiences and feelings, which, after many group discussions, became the basis of the art they made, a visual expression of the feminist catchphrase, "the personal is political."

Womanhouse in 1972 was the legendary outcome of this process, a series of installations in an abandoned house that dealt with female roles and role models, society's expectations of women, and explorations of female sexuality, all matters of concern to women that artists continue to investigate today. With its pail overflowing with bloody pads that contrast with the clinical white interior,

Chicago's installation, *Menstruation Bathroom*, was a visualization of the secret bodily recurrence of female life and an early instance of the outspokenness, which would disturb so many visitors to *The Dinner Party*.

These four teaching years from 1970 to 1974 were the crucible from which *The Dinner Party* would emerge. During the whole period of seeking a feminist art through discussion, pushing, and collaboration with her students, she continued to forward her own private work. The *Female Rejection Drawings* of 1970 are graphically detailed circular abstractions that suggest the most intimate female sexuality. Readable as the female body clenching against an intruder or (Chicago's intention) as the body's withdrawal into itself following rejection, they display an almost painful viscerality unknown in previous art. In the *Great Ladies* series that followed, Chicago found a metaphor, the butterfly, through which she could express the complications of female lives which struggle to unfurl their wings

JUDY CHICAGO, *Boxing Ring*, announcement in *Artforum* for an exhibition at Jack Glenn Gallery, 1971. Photo by Jerry McMillan.

As the *Great Ladies* were emerging from the chrysalis, Chicago entered into a particularly productive phase. In 1974 she gave up teaching in order to concentrate on a work that celebrated the women who had come to light in her research. Modest at first, the concept expanded until it emerged, six years, four hundred workers, and thousands of dollars later, as *The Dinner Party*. This celebration of thirty-nine women placed around a three-sided banquet table, with another 999 named on tiles on the floor beneath the table, was the culmination of two decades of artistic experience and concern with gender equality.

Stunned, emotional, horrified, and enthusiastic responses greeted its opening at the San Francisco Museum of Modern Art in 1979. The installation's banners, wall panels, imposing triangular format and ceramic plates that, it was whispered, were more like vulvas than the butterflies many of them were said to resemble, made an overwhelming claim for women's history, for women's wonderfulness, for women's right to a place at the center of life and art. Its timing was brilliant. In the previous few years feminist ideas had come out of their ghetto into the wider media, and women, sensing the new ideas in the air, were primed to be receptive to this huge artwork whose subjects' lives are told through embroidered runners and complex, colorfully gleaming ceramic plates.

Although for years it was usual to describe *The Dinner Party* as a one-off, resembling nothing but itself, it showed all the stylistic marks of the Southern California art world where Chicago had learned her craft. The smooth finish, the fusion of color and medium, of painting and sculpture, the interest in craft and commercial techniques, and an aesthetic of abstraction with a figurative element were classic Finish Fetish characteristics embedded in the installation. Her choice of the freestanding form relates to the numerous object-based Finish Fetish works, and the theatricality of the glowing presentation in a darkened space ties in with the Southern California interest in sculpting with light, which took in everything from the magical drama of James Turrell's spaces to her own evanescent Atmospheres.

The fusion of color and medium which she explored in the sixties is arguably the aesthetic that has held Chicago in thrall for the whole of her artistic life. It permeates the *The Dinner Party*, from the white tiles on the floor, which carry the names of notable women of the past, to the bold and gleaming colors of the dinner plates.

Technology has also kept its grip on her. Her drive to master the technologies involved in *The Dinner Party* had its source in her spray-painting workshop of the Finish Fetish years. Temperamentally unable to leave it to technicians to achieve the effects she wanted, she set out to learn how to paint and make the dinner plates that symbolize the women she celebrated. In the end, the technical demands of the raised plates required the services of an experienced ceramicist but not before Chicago was satisfied that she understood the problems and possibilities of the medium, a hands-on approach to technical matters which remains a trademark of her activity to this day. Needlework was the only skill she kept her hands away from, saved by the expertise of Susan Hill, who managed the embroiderers. But even here she learned fast: as she examined the first stitched versions of her ideas, her growing awareness of the medium's strengths fed back into her designs.

The reason it took some years for the Finish Fetish elements to be acknowledged was that they were rendered almost unrecognizable by the work's feminist slant. Where the California artists had looked to the new materials and commercial finishes of surfboards and automobiles to bring

freshness to their art, Chicago looked back to female crafts belittled by the art establishment to tell *The Dinner Party's* story. Her adoption of commercial techniques (substituting painted ceramic plates for painted car hoods) was an echo and a transformation of the macho world of the Finish Fetishists. Like them, she brought new materials into art, but her choices were loaded with deeper messages than the pleasure of the sun-and-technology–soaked L.A. lifestyle. The runner for *Dinner Party* attendee Mary Wollstonecraft was stitched in stump work, an English embroidery technique intended to keep female hands from getting into trouble, and the decoration of the plates elevated the lowly female job of china painting from craft to art.

The streamlined styling and perfect finish of the slickly designed commercial objects of Southern California inspired Finish Fetish and its successor Los Angeles Pop. References to the surrounding scene are constantly implied but never stated outright: the works are presented as abstraction. In contrast, *The Dinner Party* was committed to clarity of meaning and used a symbolism as unmistakable as the subject it stood in for. By foregrounding subject matter, *The Dinner Party* upset the figurative-abstraction balance of not just the Finish Fetish movement but of most art of the period, including Pop. Pop Art's presentation of the objects of everyday life was objective and value-free and lacked the defiant special pleading of *The Dinner Party*. No wonder so many critics were upset.

If Finish Fetish was a stylistic influence, then feminism supplied the content. Today, feminist art is an art history ism like Impressionism or Abstract Expressionism, and like any art movement has been analyzed, classified, and catalogued by scholars. But at its start in the late sixties, such self-awareness had no place in the feminist agenda.

At the heart of feminist art was a kind of crazy courage in overturning received ideas about women and art, which affected the thinkers as well as the artists. It was a time of great excitement as conventional ideas fell like toy soldiers before the feminist charge. Clichés were investigated, like the belief that talent automatically rose to the

surface like cream—smashed forever in in Linda Nochlin's 1971 *ARTnews* essay, "Why Have There Been No Great Women Artists?" which showed how the exclusion of women from art schools left them at the mercy of second-rate training. In 1975, the groundbreaking exhibition *Women Artists 1550-1950*, co-organized by Nochlin, at the Los Angeles County Museum of Art presented the latest research on women artists and became a foundation stone of the history of women artists we have today.

Scholars investigated the effect of women's lives on their art. To the unavailability of professional training before the end of the nineteenth century could be added women's internalization of society's horror at any self-willed demands by women to express themselves, and their acceptance that, unlike oil painting, which was "dirty" and required space and equipment, the proper outlets for female creativity were crafts such as drawing, embroidery, cut paper, and watercolor, "clean" activities, which could be daintily practiced and cleared away when the table was needed for family use. The images of women in art came under the unimpressed eyes of male scholars, who adopted a simplistic division between saintly women, passive, pure or motherly, and wicked women whose beauty seduced men into bad behavior, like the Renaissance images of a bewildered Adam lured into biting the apple by a wily Eve.

It was an exciting time, and discoveries were leaped on with delight. Chicago and Shapiro added to the clamor with an article entitled "Female Imagery" in *Womanspace Journal*, summer 1973, which argued that much art by women displayed a central space, unconscious evidence of their gender. It was written at the height of Chicago's search for a specific female imagery, and like all good theories it infuriated as many as it fascinated, including Georgia O'Keeffe whose work had been cited by the admiring couple as an example of gender-inflected art. She hated the idea.

The feminist artists of the day bore these discoveries in mind as they fulfilled their messianic desire to correct the male bias of the art world. The desire to avenge the situation of women of the past is woven through *The Dinner Party*. Chicago's understanding of the way women had always put themselves second, and her conviction that tact

and modesty had handicapped women's artistic expression, encouraged her outspokenness. Her realization that women had often worked at a small scale encouraged her to work big, as men had done for centuries, defiantly taking up as much space as was necessary to make her point. Her knowledge of how female talent had been diverted into crafts drove her to bring those crafts into a fine art setting.

The Dinner Party has been controversial from the moment of its opening at the San Francisco Museum in 1979. Its technical confidence and conviction spoke directly to viewers who found in it visual confirmation of the unease about female inequality that had been growing in them since the sixties. But it had its doubters, too. The hundreds of letters thanking Chicago and the extensive press coverage were undercut by the scandal surrounding its vulval plates and by the prudes and critics who gave it the cold shoulder.

Timing had a lot to do with this. By the end of the 1970s, feminist art had begun to attract the attention of academic critics. The labels were quick to appear, and it was Chicago's misfortune to fall into the category marked "essentialist," shorthand for the idea that women's inequality could be explained by their biology. A favored critical term of the eighties, the label did the work no favors. For one reason, it ignored the context of seventies feminism, which had all the fervor of a new religion. The artists who saw themselves as redressing the unfair male-female balance did so without benefit of the sophisticated analyses of feminism that were to follow. The second reason was that Cunt Art, as it was sometimes called, was everywhere in the seventies as women artists—sometimes literally—revealed all. The Cuban-born Ana Mendieta performed *Untitled (Rape Scene)* in 1973, a response to a brutal rape on the campus of the University of Iowa where she was studying. For one hour in her apartment, she bent forward naked from the waist with blood running down her legs. Incensed by the impossibly perfect glamor of female film stars, Valie Export, her name, like Chicago's, an antipatriarchal invention, walked round a Munich cinema in 1969 with the crotch of her trousers undone to display her pubic hair and labia. Her "Action: Genital Panic" was a challenging act akin to Chicago's *Menstruation Bathroom*. Though Chicago never performed in the nude, she specified that the two performers in the *Cock and Cunt* playlet she wrote in 1971 to satirize the stereoptypical roles of the sexes should wear leotards to which were attached a giant plastic vulva and a giant plastic phallus. As with these works, the vulval butterflies of *The Dinner Party* were not, as some critics labeled them, a reactionary limiting of women to their biology but a transformation of women's biology to symbolize their difference and their strength.

Unaware of the critiques of feminism that were appearing as *The Dinner Party* neared completion, fired with the rightness of her cause, immersed in the technical challenges of the work, Chicago had pushed ahead with her dream of putting women back into visible history. The single-mindedness and compulsion to express her own ideas in her own way that she displayed remain a core trait of her makeup: like a miner with a headlamp, she advanced toward her goal. That goal was no less than wrenching art out of the hands of the men who controlled it. In her own words, she wanted to "challenge the traditional hierarchies of art, introduce subject matter into the prevailing abstract visual language, critique and demonstrate the limits of the patriarchal narrative of the history of western civilization, and introduce women into the cultural dialogue." And that was not all. She hoped that by acknowledging the input of the hundreds who helped her, she could dent the image of the heroic male artist working all alone while in fact surrounded by a silent network of support.

The essentialist critique was an important theory that attempted to deal with the increased complexity of feminist ideas that emerged after the first enthusiasm of the seventies. Its demand for an analysis of women's position that took account of ethnicity, class, and economics as well as gender was necessary. But its application to the seventies brand of feminism encapsulated in *The Dinner Party* missed the point of the work and of seventies feminism. Chicago's butterfly vulva was a symbol for all the women who had been rubbished by patriarchy. It was not the reason for the women's failure to make a bigger mark on history.

The Dinner Party's drive to put women back into the frame, its sympathetic analysis of women's history, and the directness of its formal choices (craft, size, drama, and bold imagery) make it an unrivalled symbol of a period when artists believed that art could speak for women everywhere.

Although a precise account of *The Dinner Party's* links to the mainstream awaits the devotion of a doctoral student, it is possible in its absence and helped by hindsight to see several aspects which relate it to the wider art world of its day. But rather than try to squeeze *The Dinner Party* into shoes that do not properly fit, I merely want to suggest the affinities that fix it in the late 1970s.

The seventies is a decade which art historians have trouble summing up. Its art shoots off in all directions, and the word plurality crops up time and again in attempts to pin down its artistic identity. While business continued as usual for traditional forms of painting and sculpture, artists of an adventurous turn of mind built on the possibilities opened up by the previous decade's Pop and hard-edged abstract movements and the increasing demands for equality by those outside the white male establishment. The Marxist ideas that inspired so many seventies thinkers to challenge the status quo took artistic form in questioning conventional divisions between art and craft, between gallery and alternative exhibition spaces, between traditional materials and new technologies, between the age-old categories of landscape, history, and still life and contemporary political subjects, between painting and sculpture and the new hybrids of installation and performance.

One way of understanding the decade is to explain it as a takeover by sculpture. It infiltrated painting with oddly shaped canvases and three-dimensional elements and escaped the plinth to turn up as earthworks in the desert or as installations on gallery floors. By 1970, the incorporation of new materials, which had begun when Duchamp sent a urinal to a New York show in 1917, had expanded to include just about anything the artists fancied, from plastics, through neon, to the garbage Arman used to fill up a Paris gallery in 1960. In the last year of the decade, one culmination of this freedom took the form of Judy Chicago's *Dinner Party*, an installation on a grand scale overflowing with allusions to women as consumers and consumed, a sort of daring female sit-in of the *Last Supper*, the most important meal in art history.

Since it is impossible to make art that is out of its time, it is no surprise that many of *The Dinner Party's* techniques, materials, and attitudes interested artists outside the feminist and Southern California circles. Feminists had found the license to use fabrics helpful in creating new female voices. Miriam Schapiro's femmages of the 1970s are a female version of collage combining acrylic paint and a variety of fabrics; Betye Saar used everything from racist advertisements to embroidered materials to overturn the stereotype of the African-American woman in the assemblages she began in the late 1960s. But not all artists work in the same way, and the male artists had other ideas. Robert Morris and Joseph Beuys were big hitters who both used felt, although in different ways and for different reasons. Working within a personal mythology of being wrapped in felt and rubbed with fat by Tartars after his plane was shot down in the Second World War, Beuys incorporated these stuffs in installations in the 1960s, culminating in the Felt Suit, a type of self-portrait multiple of 1970. From 1967, Morris exploited the strong but fluid qualities of industrial felt to create his huge and strangely sinister sculptures.

It was a decade, too, when many voices were heard for the first time inside gallery walls. The feminists may have shouted the loudest as they explored ways to speak through their art, but black, gay, outsider, ethnic, and political artists also made work that attempted to loosen the white male stranglehold on the making, showing, and judging of art. These new voices of the seventies introduced the idea that art could have a relevance to society. After decades of critical respect for modernism where meaning resided in color and form, the clamor of the newcomers inspired many artists to consider subject matter once again. There are several accounts by artists trained when abstraction was at its height who took courage from these developments to try a modern kind of realism. Eric Fischl, who turned to the figure in the 1970s, believes that an art that ignores the body reduces our capacity to understand and feel.

But in my view, *The Dinner Party's* most extraordinary, and counterintuitive, link to the mainstream is via minimalism, the controversial avant-garde movement exemplified by the hard materials, geometric shapes, and mathematical grids and measurements of Donald Judd and Carl Andre. Counterintuitive because of all the contemporary movements, this was the one that turned its back on any meaning outside itself, asking the viewer to appreciate the aesthetic beauty of the hard surface

and the careful spaces between the sculpture's elements. Counterintuitive because many feminists saw minimalism as a masculine art, austere and overly intellectual. And counterintuitive because in its bright colors, its passion, and its extraordinary butterfly vaginas that strain to rise from their plates, *The Dinner Party* has elements of the baroque, a style of art no minimalist would ever tolerate.

And yet the precisely measured triangular form of *The Dinner Party*, thirty-nine feet on each of its three sides, relates to the geometry of minimalism. The repetition of the thirty-nine place settings echoes the seriality of so much work by minimalist artists. The 999 identical tiles on the floor are sisters of Andre's flat floor pieces. The difference is that in the classic postmodernist tradition, Andre's tiles are themselves the art whereas in the new politicized art of Chicago, the tiles are a means to celebrate the women whose names they carry. Unlike Andre, she uses minimalism, her favored form in the sixties, to celebrate a subject outside art.

Chicago was not the only feminist whose form owed much to minimal sculpture. In 1976 at London's Institute of Contemporary Arts, Mary Kelly exhibited three of the six "Documents" from her extended project *Post-Partum Document*. This large-scale work visualizes and analyzes the relationship of Kelly and her son over a period of four years through a uniformly sized series of drawings, charts, objects, and explanations, including a set of framed handwritten descriptions of her son's food intake alongside his washed

nappy liners. The work applied a reading of the psychoanalyst-philosopher Jacques Lacan to the developing child's separation from the mother and for a time was hailed by some academic critics as the intellectual arm of feminist art (good) as opposed to the "essentialist" *Dinner Party* arm (bad). The kindness of time has put them both under the heading of "feminist art, history of," and our awareness of context and of the prevailing attitudes of different decades has returned ideas of the correctness or otherwise of art's message to spectators who are now free to rate it as they wish.

For all its strangeness, *The Dinner Party* fits right into the art of its time. However, its stylistic links with the mainstream should not disguise the novelty of its language and the ambition of its intent. *The Dinner Party* is one of the purest expressions of the dream of feminist artists of the seventies to find a new vocabulary through which to express their new subjects. Theatrical, immersive, and novel, its confidence and outspokenness were warmly welcomed at a time when women were desperate for public endorsement of their beliefs and feelings. What no one foresaw was that its power to move, surprise, and shock would not fade. It is a tribute to its form and the directness of its imagery, and also, sadly, to the continuing relevance of the issues it addresses, that thirty-five years later it continues to speak to those who see it.

FROM CONTROVERSY TO CANONIZATION: THE DINNER PARTY'S JOURNEY TO BROOKLYN

JANE F. GERHARD

Judy Chicago's installation *The Dinner Party*, the most monumental work of the feminist art movement of the 1970s, has been celebrated and denounced since its debut in 1979. Few works of American art have ever inspired such a reaction or sustained attention from the media and audiences. Its journey to "the museum" and its status as canonical art were achieved under unconventional circumstances. After years of wild popularity coupled with persistent marginalization by much of the art elite, *The Dinner Party*'s undeniable historical significance finally helped it win a place in the museum world. Chicago wrote in 1975 of wanting to make a work of such importance that it "will enter the cultural pool and never be erased from history."[1] With the 2007 opening of its permanent installation at the Brooklyn Museum, as part of the Elizabeth A. Sackler Center for Feminist Art, there was no denying that *The Dinner Party* was here to stay.

ORIGINS IN THE FEMINIST ART MOVEMENT

The environment for female artists was not good as Chicago began the first Feminist Art Program (FAP) at Fresno State College in 1970. While a great many women were making art in the early 1970s, they were nearly excluded from the art market and exhibition venues. On any given day, art made by women comprised a mere 1 percent of what was on display at the Los Angeles County Museum of Art (LACMA), and the percentage was no better at New York's premier museums.[2] Art schools admitted more women than men into their programs but graduated very few women artists whose work was shown in galleries and museums. Few college art programs or art schools could boast a single female artist on their faculties. Neither did the work of women artists find a place in art publications. In 1970, 88 percent of

the reviews in *Artforum* discussed men's work, as did 92 percent of *Art in America*'s reviews. In 1972, the National Endowment for the Arts gave 100 percent of its grants to men. Female artists earned two-thirds of what their male peers earned.[3] Such obstacles, coupled with an ascendant women's movement, led groups of women on both coasts to organize.

The first shot fired against the established art world came in 1969 in New York City, when female artists, informed by antiracist and antiwar protests, organized to challenge the lack of diversity in the Whitney Museum of American Art's Annual Exhibition of American Painting (only eight women were among the 143 artists shown) and, more broadly, in exhibitions and staffing of all the city's museums. In 1970, when the Whitney Annual once again opened a show comprised of works almost exclusively by white men, African-American feminist artist Faith Ringgold organized Women, Students, and Artists for Black Art Liberation (WSABAL).[4] In 1971 Women in the Arts (WIA) formed and drafted an open letter to the Museum of Modern Art, the Brooklyn Museum, the Metropolitan Museum of Art, the Solomon R. Guggenheim Museum, the Whitney Museum, and the New York Culture Center, demanding an exhibition of five hundred works by women artists.[5] When, for the third straight year, feminists picketed the Whitney Annual, a group of women extended their activism to print, launching the *Feminist Art Journal* in 1972 in the hope of giving feminist reviews of women's work a national audience. After years of protest, the agitation began to pay off. The *Women Choose Women* exhibition, the first and largest woman-only art event, opened at the New York Culture Center in January 1973, showcasing the work of 109 contemporary female artists.[6]

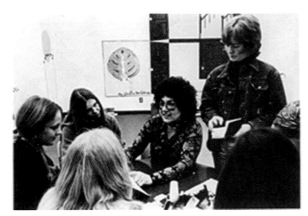

Judy Chicago with students, including Faith Wilding (on Judy's right) and Suzanne Lacy (standing), Fresno Feminist Art Program, c. 1970–71

West Coast activism followed a similar pattern but had distinctive features. Chicago's Feminist Art Program at Fresno in 1970 announced the start of what would become a surge of feminist art and activism. The following year, the Los Angeles County Museum of Art (LACMA) mounted a large and much anticipated exhibition, *Art and Technology*, which did not include a single artwork by a woman, triggering a local reaction that soon extended beyond Southern California.[7] Concerned women organized themselves into the Los Angeles Council of Women Artists.[8] The council's mission quickly expanded to address the broader pattern of discrimination in the museum's hiring practices, selection of artworks by women for the collection, and awarding of prizes. Coming together to protest LACMA's sexism, women from around the area met each other, many for the first time.[9] Young West Coast feminists incorporated a populist element in their art activism. Deeply influenced by the Chicano and black arts movements, they viewed art, particularly community art, as a powerful vehicle for enlightenment, and as such, important to social transformation.[10]

Like others in her generational cohort, Chicago was no stranger to a hostile art world. Yet neither her students nor faculty colleagues acknowledged the gendered hurdles to success. Chicago determined that the FAP at Fresno and later CalArts would better prepare women artists to face the male-controlled art scene. Her plan involved applying radical feminist theory to art education. She pioneered a circle methodology that shared elements of consciousness-raising, one of the basic structures of the women's liberation movement, but

also differed from it in fundamental ways. In most feminist groups, consciousness-raising through education and insight led to personal empowerment; in Chicago's classrooms, the artist always harnessed personal insight to the search for art content.[11] Chicago made the FAP women-only, separating the students from "male-dominated" spaces like mixed classes and mixed studios. For many other all-women's groups in the 1970s, separatism operated as a powerful strategy to enhance women's exploration of their weaknesses and their strengths.[12] The FAP engaged in innovative self-education as well. Chicago directed her students to generate their own women's studies curriculum through open-ended research. They logged hours in local and university libraries seeking out female role models in art history, mythology, and literature, and they read widely in contemporary feminist theory. Lastly and crucially, Chicago's program gave students, in the words of Faith Wilding, "encouragement to make art out of their own experience as women," thus paving the way for a new feminist expression.[13]

In addition to her teaching and producing her own art, Chicago made an effort to network with other female artists. In the spring of 1971 Chicago and artist/educator Miriam Schapiro launched a visiting tour of forty women artists' studios in Southern California to see work, which, for the most part, had never appeared in traditional venues. The two were shocked to learn that most of these artists had no formal studio but worked out of their homes.[14] The tour confirmed for Chicago what she had supposed about the difficulties faced by women artists. Yet she and Schapiro came to see that these home studios, rather than being deficient, represented an alternative model of art making. These were "authentic creative atmosphere(s)" where "art was indistinguishable from life" and where the artist did not require "the male trappings of scale, space, whiteness, and loneliness" to work.[15] Chicago and Schapiro argued that women's art required new ways of seeing that could appreciate the circumstances of its production and its connections to communities as well as "the strength, the power, and the creative energy of our femaleness."[16] The feminist art movement required nothing short of a reboot of the art world: new women-centered spaces to show women's art to women's communities.

Womanhouse, an art installation built by CalArts FAP students, brought all these factors together in an innovative and provocative way. Produced in an abandoned house just off the CalArts campus on a residential street in Hollywood, *Womanhouse* became the most notable work to come from the FAP and was an early example of site-specific art.[17] The students, along with Chicago, Schapiro, and two other local artists, designed each room of the house to be an exposé on domesticity. Visitors who entered the old Victorian mansion by the wide front steps walked into a space where the female body was tangibly conflated with the roles and duties of the home. They encountered art infused with a feminist critique of caretaking in the kitchen, female sexual erasure in the bedroom, the commodification of femininity in the bathroom, and the monotony of housework in the closet. Performance pieces ran nightly, including Chicago's *Cock and Cunt* play, Wilding's one-woman piece *Waiting*, and the group-authored *Birth Trilogy*.[18] The house opened to the public on January 30, 1972, and was torn down four weeks later.

Womanhouse grabbed an impressive amount of media attention. *Time* magazine, in an article called "Bad-Dream House," estimated that four thousand viewers came on opening day.[19] During the following month, more than ten thousand visitors went through. A *Los Angeles Times* reviewer called it a "Lair of Female Creativity."[20] Another warned, "the house at 533 N. Mariposa Avenue may be hazardous to the ego of Male Chauvinist Pigs."[21] Frankly feminist reviewers and audiences unpacked the layers of feminist signification in the process and product of *Womanhouse*, noting that the women artists were utilized a unique vocabulary that had not previously been displayed in art. Journalist Gloria Steinem recalled that walking through *Womanhouse* was "where I discovered female symbolism in my own culture for the first time."[22]

In 1973 Chicago resigned her position at CalArts in search of greater autonomy. She, along with art historian Arlene Raven and designer Sheila Levrant de Bretteville, opened an unaffiliated alternative art school called the Feminist Studio Workshop (FSW), which offered art education to the wider women's community. In the fall of 1973 the FSW moved into the newly established

Woman's Building in Los Angeles, which soon became an important center for the diverse communities of women that made up the Southern California feminist movement. The Woman's Building included art groups such as Womanspace and FSW, political groups like the L.A. chapter of the National Organization for Women and the Women's Liberation Union, and cultural groups like the Associated Feminist Press, publisher of five feminist journals (*Sister*, *Momma*, *Womanspace Journal*, *Lesbian Tide*, and *Women and Film*). The Woman's Building also housed the Center for Feminist Art Historical Studies, which included the region's first slide library of local women's art; the Sisterhood Bookstore, a store that offered consumers hard-to-find feminist books and journals; and a café for socializing.[23] Within a few months, three additional gallery spaces besides Womanspace took up residence: Gallery 707 and Grandview Galleries 1 and 2, owned and operated by a collective of forty women artists. With five shows running a month, the Woman's Building was soon a significant part of L.A.'s art scene.[24]

The Woman's Building embodied one of the principal philosophical underpinnings of the feminist art movement: the creation of mutually supportive communities of women artists. According to art historian Laura Meyer, "In opposition to the popular mythology of the lone (usual male) creative genius, the leaders of the feminist art movement contended that broad-based community support was a necessary condition of creative productivity and set out to build the kind of support systems—both material and psychological—that women artists historically had lacked."[25] The Woman's Building became a beacon.[26] News of it spread through feminist networks, making Southern California a mecca for women artists.[27]

By 1974, only a year into the FSW, Chicago left, wanting to devote all her energies to her new work. She had something big in mind. In letters and in her personal journal, Chicago explained that this new piece would represent a suppressed tradition of female power in Western civilization. Using the model of "great men," Chicago imagined a last supper of great women, each a person of influence in her society, whose struggle and accomplishment could inspire contemporary women. Little did she know that in a matter of years she would be overseeing one of the decade's largest cultural

feminist art organizations, involving a total of four hundred people over a four-year period.

THE DINNER PARTY

As Chicago began her new project, feminism itself continued to evolve. A new cultural orientation emerged (as an expression and extension of feminist radicalism), which focused on establishing alternative woman-centered institutions; support for a range of women's musical, artistic, and athletic activities; and new feminist lifestyles.[28] Cultural feminists hope to use new and autonomous male-free spaces like the Woman's Building to enable women to come together and build a women's community. They viewed "women's culture" and "woman-centered values" as supporting feminist political activism, not replacing it.[29] Chicago's art harmonized with this new emphasis.

In preparation for her new work, Chicago studied china painting for two years. In her account of the making of The Dinner Party, she recalls her fascination with the community of women drawn to it. The fact that so many of the china painters had gone to art school when they were young and only took up china painting after marrying and having children meant, for Chicago, that china painting was as much a testimony to women's limits as to their talents. Untouched by the feminism percolating around the students of Womanhouse, the china painters still embodied a kind of sisterhood, a female world that lovingly passed the techniques of china painting from mother to daughter. These networks appealed to Chicago and helped her articulate her interest in traditions that preserved gendered knowledge.[30]

As Chicago studied china painting, she also continued to develop her ideas about "female art," specifically the "central core" imagery that frequently appeared in women's creative expressions. In a 1973 interview, Chicago explained that much of the art made by women, including her own, shared "a central focus (or void), spheres, domes, circles, boxes, ovals, overlapping flower forms, and webs."[31] One such example was her Through the Flower (1973), a large painting of a bloom with red-orange petals that opened up to a radiant blue-green center. She connected history to these abstract central core images in two series also done in 1973 called Great Ladies and Reincarnation

Triptych. In these, Chicago enclosed the images of radiant central cores in bands of handwritten text that identified female monarchs and intellectuals, respectively. These informed her evolving ideas about the china plates she wanted to make for The Dinner Party.[32]

The debate over female aesthetics reflected a large issue in the women's movement of the 1970s and in twentieth-century feminism more broadly: what status should be granted to women's bodily differences from men? According to Chicago and others, women as social actors experience the world differently than men do because of their female bodies. That lived difference requires recognition and validation. For others, gender, as a system of predetermined distinctions, ought to be dismantled, not reified. The feminist art movement—or the broader political woman's movement for that matter—never reached a consensus about the status of women's difference, and the question remains open today. Both positions offered viable tactics and coexisted, if uneasily, in the 1970s. Many feminists saw no contradiction between celebrating women's art as unique while also picketing museums for discriminating against women artists. Striving for equality and celebrating difference shaped cultural feminism. In The Dinner Party, Chicago would mobilize both strategies.[33] The plates suggested the power and beauty of women's bodily difference, while the runners beneath them represented the changing and often crushing social realities of women's lives.

Through public talks and the publication in 1975 of her first memoir, Through the Flower, Chicago found a steady stream of people interested in working with her. Three of them proved central to the success of The Dinner Party. Diane Gelon, a graduate student in art history at UCLA, first met Chicago at the opening of the Woman's Building in 1973. Two years later, Gelon started working on the project two days a week and later dropped out of graduate school to become Chicago's full-time assistant. Eventually, she managed the daily administration of the project.[34] Leonard Skuro, a graduate student in ceramics at UCLA and for a few months the only man in the studio, helped Chicago with the difficult process of making carved plates. The third crucial person for the project was artist Susan Hill. Relatively early in her tenure, Hill suggested using runners

JUDY CHICAGO, *Through the Flower*, 1973. Sprayed acrylic on canvas, 60 × 60 in. (152.4 × 152.4 cm). Collection Dr. Elizabeth A. Sackler.

for plate settings in place of an embroidered tablecloth. Hill became the head of needlework and supervised "the loft" in Chicago's studio where teams of people worked on runners.[35] Others arrived and lent their expertise and time: Ann Isolde headed up historical research; Ken Gilliam, industrial design; and Helene Simich, graphics. Kathleen Schneider, Karen Valentine, Robin Hill, and Terry Bleacher worked in the loft, and Judy Keyes helped Chicago in ceramics. After 1977, Chicago paid these core staff members a modest stipend.

Chicago poured all the money she had into the Dinner Party studio and had barely enough remaining funds to keep herself in clay and thread.[36] She strategized continually over how to keep the project afloat, agonizing that "I'm living on pennies. I don't even know if I can pay the rent next month."[37] Gelon took over the time-consuming task of searching for and applying for outside funding.[38] They won nearly 50 percent of the grants they applied for.[39] By 1978,

a steady stream of small donations was arriving from women who had read about the studio and *The Dinner Party* in local and national newspapers and magazines as well as in local feminist newspapers and journals, with checks ranging from $1 to $100.[40] Fund-raising helped promote interest in seeing *The Dinner Party*, engaging potential audiences well in advance of the scheduled opening.

Yet Chicago needed more than money to complete *The Dinner Party*. In the spring of 1977, she and the core staff recognized the magnitude of the task they had undertaken. After a dramatic evening rap session, they determined to bring in more people. Since Chicago could not pay workers for their time, the announcements calling for volunteers emphasized that workers would experience firsthand the benefits of feminism while working on a major work of feminist art with a nationally known artist.[41] A steady stream of volunteers, almost entirely women, came to Santa Monica to work on the project. Between 1977 and 1979, fifteen to thirty people worked daily in the studio.[42]

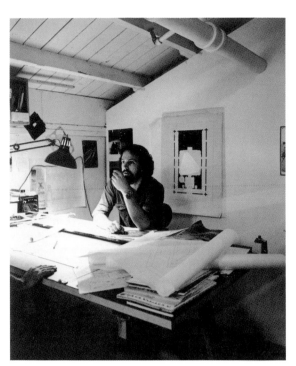

Industrial designer Ken Gilliam, who devised the specialized tools and equipment, structural underpinnings, and original lighting system for *The Dinner Party*.

experts in women's history, art history, or feminism. These gatherings enacted the goals of feminist education: to enhance everyone's involvement by soliciting ideas and feedback, to address group dynamics in the studio in an honest and direct manner, to explore the significance of women's lives and women's history, and to connect the work at the studio to the larger efforts to bring women's history to light. For many of the women and the few men who joined Chicago, working at the studio proved to be an intense and transformative experience. For some, it was their primary or only encounter with feminism. For others, it was an extension of their budding feminist awareness. Everyone made sacrifices to be there.[47]

In the winter of 1978, as the opening loomed, the team at the studio worked at a frenzied pace. Graphics team members painted names on the Heritage Floor tiles, needleworkers put down their last stitches, and Chicago and Keyes fired the remaining plates. No one had seen it assembled in its entirety until four days before its public debut. Hill experienced it "like a blow to the gut." She and the others who had given so much to the project "were stunned."[48] They celebrated by going out to dance.[49]

When *The Dinner Party* opened on March 14, 1979, supporters, fans, and friends of the artist and workers crowded into the San Francisco Museum of Modern Art. No one was happier than director Henry Hopkins, who had lent his enthusiastic support for the project since its inception. To commemorate the opening, two artists, former FAP students Suzanne Lacy and *Dinner Party* studio team member Linda Preuss, invited women around the world to hold dinner parties in honor of local and global women's history. The events, called "The International Dinner Party," involved participants in two hundred cities around the world.[50] Throughout the weekend, poetry readings, panels, and workshops ran at a nearby Holiday Inn in rooms overflowing with people. Chicago lectured to a sold-out crowd on Friday, March 16. Thousands of people lined up around the block to see the exhibit. For much of its run in San Francisco, people waited for three, four, and even five hours to see *The Dinner Party*. Over 90,000 people came during the twelve-week exhibition, breaking the museum's previous attendance records.

Volunteers came from as far away as Cleveland and Washington DC, but the majority lived in Southern California. Some found their way to the studio after hearing Chicago lecture, others from reading her memoir or from coming across news of the project in the feminist or art press.[43]

Once at the studio, their practice of feminism began immediately. During orientation, volunteers received a suggested reading list in feminist theory that included Simone de Beauvoir's *The Second Sex*, Robin Morgan's *Sisterhood Is Powerful*, and Virginia Woolf's *A Room of One's Own*.[44] They learned that everyone at the studio participated in historical research.[45] Needleworkers did research on the woman whose runner they stitched, and Heritage Floor workers combed local libraries for information about historically important yet overlooked women.[46] Volunteers also participated in two kinds of studio groups: formal consciousness-raising in groups of eight to twelve, done in the tradition of other feminist groups, and Thursday night "rap sessions." The Thursday night group met around two huge ceramic worktables pushed together for sharing family-style potluck dinners, conversation, and hearing monthly lectures by

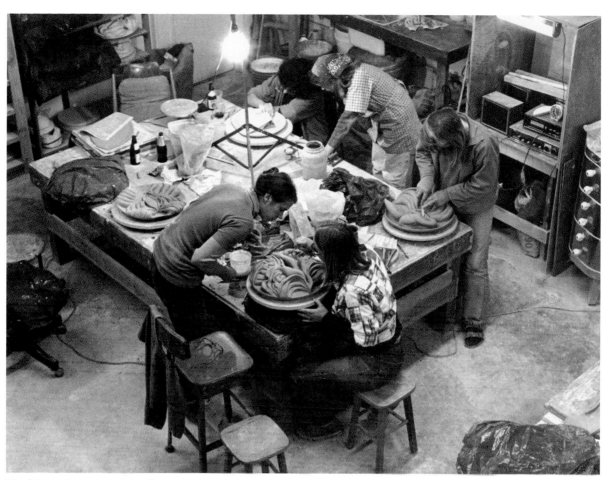

The Dinner Party ceramic studio.

While waiting to enter the gallery, visitors spent time looking at short video clips and a set of acknowledgment panels covered with photographs detailing the production of *The Dinner Party*. These images of blue-jean-clad women, with sleeves rolled up, holding needles or hunched over the jigger machine, seated around a table covered with books or a potluck dinner, invoked the literal community of women that had gathered for more than three years at Chicago's Santa Monica studio. These images underscored the extent to which volunteer labor mattered to Chicago and revealed how much it influenced what the viewer would soon see. Each person who worked at the studio—for two days or for two years—had her or his name listed on the photo documentation panels. In this way, Chicago broke with the tradition of apprentices whose work commonly went unnoted and unrecorded. These snapshots also oriented audiences to the range of technical skills employed to bring *The Dinner Party* to completion, ideally readying them to see with new appreciation the art, not just the craft, of the needleworker and the china painter.

During the long wait times, the lines sometimes became spontaneous temporary feminist communities. Jean A. Rosenfeld, from Carmichael, California, described her experience of being in line for three hours: "I began chatting with the woman behind me—and the chatting became sharing—personal and political and useful talk. And then as we rounded the corner to the final waiting hall a small group of people began to sing. They sang quietly and beautifully and were surprised by the applause. Then the singing spread to the people around them—and then everyone was singing. All the people waiting gathered into the final hallway and sang. Several hundred people singing in harmony—church songs, Hebrew songs, children's rounds, '60s songs, spirituals. It was glorious."[51]

"Festival of 1000 Women," Frankfurt, Germany, 1986, held to support the exhibition of *The Dinner Party* in Frankfurt, 1987.

The anticipation of seeing the piece contributed to the sense of excitement for those who waited in line. Many who had only moments before pressed eagerly forward slowed to a crawl as they stepped into the dim gallery, positioned themselves on the viewing side of the guardrail, and started forward in the snaking line to look at the first wing of goddesses and the shimmering floor and the golden stream of names. *The Dinner Party* catalogue, available for less than a dollar, or, after 1980, an audiotape narrated by Chicago, provided details about what they were seeing, connecting the names on the floor to the "guests" with places at the table. Director Hopkins commented on the current between the audiences and the art. He told the *San Francisco Examiner*, "*The Dinner Party*'s appeal to me became even stronger as I watched during the twelve weeks the power it held. It remained in pristine condition; no one tried to touch it. The audience found it a real experience. That's art."[52]

THE TOUR AND THE SEARCH FOR PERMANENT HOUSING

Despite the crowds and the enthusiasm on display in San Francisco, most of the formal gatekeepers of the institutional art world did not embrace *The Dinner Party*. That spring, the two museums next scheduled to show *The Dinner Party* pulled out of their agreements, leaving Chicago and Gelon scrambling to find alternative spaces. Like the piece's unique production, its remarkable American tour—made up of two museums (SFMOMA and Brooklyn) and five community shows (in Houston, Boston, Chicago, Cleveland, and Atlanta) between 1979 and 1982—became noteworthy precisely for its unconventionality and the doggedness with which its success was achieved.[53] Ironically, the very elements that made museums uneasy about showing *The Dinner Party*—its size, its content, and its controversies—set the stage for it to become an infamous icon of the feminist art movement.

The unconventionality of the tour broached critical questions about the connection between

art and audiences first raised by the feminist art movement in the early 1970s. When museums declined *The Dinner Party*, interested groups came together to organize a viewing. Community shows of *The Dinner Party* required a tremendous effort to pull off. Organizers had to reproduce the material support routinely offered by a museum: creating a climate-controlled, well-lit gallery with guards and docents, paying support and installation staff, and funding publicity and insurance. Lacking these things, groups had to work from the ground up to build alternative museum spaces to show the art they wanted to see, extending the grassroots feminist art movement geographically beyond the hubs of L.A. and New York and sustaining that effort into the 1980s. Volunteers secured local television, radio, and print coverage; convinced public relations groups to donate their expertise; organized fund-raising campaigns and assembled contact lists; held events like cocktail parties, screenings, and lectures; approached corporations for donations; and wrote grants to city and state arts and cultural councils.[54] Each community show brought in impressive numbers of viewers, and each made a profit that was kept and distributed. Chicago earned no more than a small honorarium for an opening night lecture.[55] Community groups organized educational and cultural events to go along with the exhibition. Seminars and lectures in local women's history, concerts of women's music, women-only dances, and other feminist events enabled local communities to mix and mingle. In the tradition of the feminist art movement, the community groups built temporary woman-centered art galleries where feminist artists and audiences could meet face-to-face.

An unexpected consequence of the collapse of the American museum tour, then, was that *The Dinner Party* built its reputation as a significant cultural event based on its popularity, not the blessings of the formal art world. Funders and ticket buyers, volunteers and organizers, and people who bought books sent enthusiastic letters to their newspapers and told their friends to go see *The Dinner Party*. These were the people who made it into the first feminist art blockbuster, not reviewers, museum curators, or boards of directors. *The Dinner Party*'s success, despite its near across-the-board rejection by elite cultural institutions, can be attributed to its translation of feminism—specifically, women's right

to a heroic past—into an engaging message that spoke to a range of people, not only to women and men who already saw themselves as feminists. *The Dinner Party* did not map out a course of action for social change but instead inspired viewers to think about women in new ways.

In addition to the American tour, *The Dinner Party* was shown in Europe and the UK for eight years and also farther afield. It opened to enthusiastic reviews at the Fringe Festival in Edinburgh and was seen at The Warehouse in London and a contemporary art museum, Frankfurt's Schirn Kunsthalle, where the opening coincided with a gala women's festival at the city's newly renovated opera house. Huge crowds at the three Canadian museums that showed *The Dinner Party* earned the venues significant and unexpected profits. The final museum show in the tour took place at the Royal Exhibition Building in Melbourne in 1988. Local women raised funds and organized viewings in all but two of the venues; the only museums to initiate showings were SFMOMA and the Musée d'art contemporain de Montréal. All told, *The Dinner Party* was shown fourteen times in six countries. Over a million people came to see it.[56]

After such extensive touring, *The Dinner Party* showed signs of wear and tear. Chicago's supporters turned their attention in earnest to locating or building a permanent home for the work. But before long, Chicago and *The Dinner Party* were once again at the center of a controversy, this time triggered by the "culture wars" around U.S. government funding for the arts. The wave of hostility against *The Dinner Party* in the summer and fall of 1990 resulted in its almost complete disappearance from the art scene.

In the spring of 1990, Pat Mathis, a longtime Chicago supporter and board member of the University of the District of Columbia (UDC) in Washington DC, approached Chicago about establishing a permanent installation for *The Dinner Party*.[57] Chicago eagerly agreed to give *The Dinner Party* to the underfunded, working-class, predominantly African-American university as part of its newly proposed multicultural arts center. Parties on both sides expressed their enthusiasm for what appeared to be a money-making proposition for UDC and, for the artist, a much-valued context for *The Dinner Party* that would highlight the common plight of the disadvantaged. The university's board

approved $80,000 to move, clean, and install *The Dinner Party* and agreed to raise $1.2 million to remodel and build a new entrance for the aged and deteriorated Carnegie Library.[58] A city bond ensured that all building funds would come from outside of the university's operating budget.[59] Fund-raising was underway to repay the university for the pledged $80,000, and a single donor had pledged $225,000 on the condition of the acceptance of *The Dinner Party*, a gift that represented the largest single donation in the university's history. Mervyn Dymally, a Democrat from Washington DC and an enthusiastic supporter of the multicultural arts center, introduced legislation that matched every dollar the university raised with five from the federal government.[60] These arrangements made *The Dinner Party* exhibit self-financing, a fact that critics overlooked in the ensuing controversy.[61]

On July 18, 1990, grumblings about the gift appeared in the politically conservative *Washington Times*. The paper reported that *The Dinner Party* had been "banned in several art galleries around the country because it depicts women's genitalia on plates and has been criticized by some critics as obscene."[62] More damaging, the article linked cutbacks in football and continuing education classes as well as unpaid staff salaries to *The Dinner Party*. The paper then reported that members of Congress had "sharply rebuked the D.C. Council" for its approval of funds to exhibit "a dramatic piece of sexual sculpture," calling the decision "mismanagement" and "questioning the 'sanity' of officials."[63] The story appeared in the national press linked to growing controversy about the role of federal funds for art that some Americans found offensive. Local DC politics became nationally relevant. Representative Dana Rohrabacher, California Republican and leader in the congressional fight against federally funded art, questioned "the values and taste" of UDC officials while Representative Stan Parris, a Virginia Republican and ally of conservative Republican senator Jesse Helms, cast aspersions on the city's "poor" fiscal planning.[64]

On July 26, 1990, the controversy went live on C-SPAN when the House of Representatives debated the UDC's budget as part of a larger DC appropriations bill. The eighty-seven-minute debate centered on an amendment offered by Representative Parris to subtract $1.6 million from the UDC's budget request. Robert Dornan, Republican from California, could barely contain his distain. "This thing is a nightmare. This is not art, it's pornography, 3-D ceramic pornography." Robert Walker, Republican from Pennsylvania, called the UDC administration irresponsible for not paying their professors so they could buy art.[65] Three supporters of home rule rose in turn to refute the amendment proposing to slash money from the UDC's budget. While their arguments centered on home rule for the District of Columbia, they also defended the university's judgment, its fiscal competency, and its taste in art. Nevertheless, by the end of the debate, a majority of representatives supported the amendment to cut $1.6 million from the UDC's budget request, and the District's budget moved to the Senate for approval.[66]

The overheated debate showed no signs of abating. The Christian Television Network and TV evangelist Pat Robertson's *700 Club* picked up the UDC story and urged listeners to keep the pressure on Congress to block any funds that would aid the university's display of *The Dinner Party*. Conservative African-American religious leaders jumped into the fray, calling the piece blasphemous and devilish.[67] *ABC Evening News* aired part of the House debate on its nightly program as another front in the ongoing culture wars.[68] When fall classes resumed at UDC, students weighed in, sadly misinformed about the terms of the gift, which they understood to be coming out of the UDC operating budget. Two hundred students occupied two UDC administrative buildings in protest against the administration's allotting of its meager resources.[69] Within days, students from other nearby university and college campuses arrived to offer their support. The school remained shut down for over a week.[70] Chicago requested a meeting with the protesters, but the trustees refused, fearing it might inflame the controversy.[71] The next day, Chicago withdrew her gift in a show of support for the protesting students, and Representative Parris issued a statement calling for restoration of $1.6 million to the DC budget.[72]

The Dinner Party stayed crated in a facility in Northern California for the next twelve years, with the exception of a single exhibition at the Armand Hammer Museum of Art in Los Angeles in 1996.[73] Initiated by Henry Hopkins and curated by Amelia Jones, the show and catalogue, *Sexual Politics*,

contextualized *The Dinner Party* in twenty years of feminist art activism.[74] The reassessment of the feminist art movement and its impact on art in America had begun.[75]

The search resumed for a permanent home for *The Dinner Party*. In 1998 Elizabeth A. Sackler, longtime supporter of Chicago, boldly envisioned a museum for feminist art in which *The Dinner Party* would be a part.[76] In 2002 she acquired and donated *The Dinner Party* to the Brooklyn Museum along with funds to create a new gallery devoted to feminist art.[77] To make it possible, the museum launched a $63 million capital campaign to rebuild its front entrance and to convert an 8,300-square-foot storage area into the Elizabeth A. Sackler Center for Feminist Art.[78] To celebrate the gift, the museum displayed *The Dinner Party* in 2002. History seemed to embrace it with open arms. Time had recast the controversies, clearing the way for the canonization of the feminist art movement and *The Dinner Party* as one of its iconic works. Roberta Smith in the *New York Times* called it "almost as much a part of American culture as Norman Rockwell, Walt Disney, W.P.A. murals and the AIDS quilt." This exemplar of the "*Our Bodies, Ourselves* phase" of 1970s feminist activism, she wrote, "keeps getting better with age."[79] Chicago keenly understood the significance of permanency to ending the historic erasure of women's accomplishments. It mattered to her and to everyone who worked with her on her monument to women's history that *The Dinner Party* would be on display at the Brooklyn Museum for anyone to see. She told a reporter from the *New York Times*, simply, "The girls . . . are very happy to have a home."[80]

NOTES

1. Personal Journal, December 11, 1975, reprinted in Judy Chicago, *The Dinner Party* (New York: Doubleday, 1979), 29.
2. Los Angeles Council of Women Artists, 1976, reprinted in Faith Wilding, *By Our Own Hands* (Los Angeles: Double X, 1977), 21; Hilary Robinson, ed., *Feminism-Art-Theory: An Anthology 1968–2000* (Malden, MA: Blackwell Publishers, 2001), 56–57 and chapter two.
3. Joanna Gardner-Huggett, "The Women Artists' Cooperative Space as a Site for Social Change: Artemisia Gallery, Chicago (1973–1970)," in *Entering the Picture: Judy Chicago, The Fresno Feminist Art Program and the Collective Visions of Women Artists*, ed. Jill Fields (New York: Routledge, 2012), 174.
4. Valerie Smith, "Abundant Evidence: Black Women Artists of the 1960s and 1970s," in *Entering the Picture*, ed. Fields, 123.
5. Mary D. Garrard, "Feminist Politics: Networks and Organizations" in *The Power of Feminist Art: The American Movement of the 1970s, History and Impact*, ed. Norma Broude and Mary Garrad (New York: Harry N. Abrams, Inc., 1994), 90–91.
6. Gloria Orenstein, "Review Essay: Art History," *Signs* 1, no. 2 (Winter 1975): 518.
7. Wilding, *By Our Own Hands*, 21.
8. Ibid., 1.
9. Ibid., 18.
10. Lise Vogel, "Fine Arts and Feminism: The Awakening Consciousness," *Feminist Studies* 2 (1974): 3–37; Kellie Jones, "Black West, Thoughts on Art in Los Angeles," in *New Thoughts on the Black Arts Movement*, ed. Lisa Gail Collins and Margo Natalie Crawford (New Brunswick, NJ: Rutgers University Press, 2006), 43–74.
11. Judy Chicago, *Through the Flower: My Struggle as a Woman Artist* (New York: Penguin 1975), 74.
12. Estelle Freedman, "Separatism as Strategy: Female Institution Building and American Feminism, 1870–1930," *Feminist Studies* 5, no. 3 (Fall 1979): 512–29; Chicago, *Through the Flower*, 72.
13. Wilding, *By Our Own Hands*, 11.
14. Judy Chicago and Miriam Schapiro, "The Liberation of the Female Artist," undated. Judy Chicago Papers, Schlesinger Library (JCPSL), carton 6, file 1.
15. Ibid.
16. Ibid.
17. First described by Peter Frank in "Site Sculpture," *Art News* (October 1975); Lucy Lippard, "Art Outdoors, In and Out of the Public Domain," *Studio International* (March-April 1977).
18. Judy Chicago, "Cock and Cunt" (1970) and Faith Wilding, "Waiting" (1971), reprinted in Chicago, *Through the Flower*, 208–13, 213–17; "The Birth Trilogy," Performance section, *Womanhouse* Catalogue, http://womanhouse.refugia.net. Accessed August 9, 2010.
19. Sandra Burton, "Bad-Dream House," *Time* (March 20, 1972, Special Issue: The American Woman), 77.
20. William Wilson, "Lair of Female Creativity," *Los Angeles Times*, February 21, 1972, JCPSL, carton 11, file 37.
21. Marilyn Wachman, "Warning: 533 N. Mariposa Ave., may be hazardous to the ego of Male Chauvinist Pigs," *California Apparel News*, February 11, 1972, 10, JCPSL, carton 11, file 27.
22. Gloria Steinem, foreword to Eve Ensler, *The Vagina Monologues* (New York: Villard, 1998), xiv.
23. Laura Meyer, "The Woman's Building and Los Angeles's Leading Role in the Feminist art movement," in *From Site to Vision: The Woman's Building in Contemporary Culture*, ed. Sondra Hale and Terry Wolverton (ebook, 2007), 77.
24. Suzanne Lacy, "The L.A. Woman's Building," *Art in America* 62, no. 3 (May-June 1974); reprinted in Suzanne Lacy, *The Pink Glass Swan: Selected Feminist Essays on Art* (New York: Norton, 1995), 84–88.
25. Laura Meyer, "The Woman's Building and Los Angeles's Leading Role in the Feminist Art Movement," 72–73.
26. Lacy, "The L.A. Woman's Building," 86; Terry Wolverton, *Insurgent Muse: Life and Art at the Woman's Building* (San Francisco: City Lights Book, 2002).
27. Personal interview, Ann Isolde, Los Angeles, January 2010; personal interview, Juliet Myers, Santa Fe, June 2009; personal interview, Jan DuBois, Santa Fe, June 2009.
28. Linda Alcott, "Cultural Feminism versus Post-Structuralism: The Identity Crisis in Feminist Theory," *Signs* 13, no. 3 (Spring 1988): 405–36; Alice Echols, *Daring to Be Bad: Radical Feminism in America, 1967–1975* (Minneapolis: University of Minnesota Press, 1989); Jane Gerhard, *Desiring Revolution: Second Wave Feminism and the Rewriting of American Sexual Thought, 1920–1983* (New York: Columbia University Press, 2001); Verta Taylor and Leila Rupp, "Women's Culture and Lesbian Feminist Activism: A Reconsideration of Cultural Feminism," *Signs* 19, no. 1 (Autumn 1993): 32–61.
29. Suzanne Staggenborg, "Beyond Culture versus Politics: A Case Study of a Local Women's Movement," *Gender and Society* 15, no. 4 (August 2001): 507–30.
30. Laura Meyer, "From Finish Fetish to Feminism," in *Sexual Politics: Judy Chicago's The Dinner Party in Feminist Art History*, ed. Amelia Jones (Berkeley: University of California Press, 1996), 61.
31. Shirley Kassman Rickert, "Thoughts on Feminist Art," *Strait* 2, no. 8 (February 7–21, 1973): 17.
32. Chicago, *The Dinner Party*, 27.
33. Jane Gerhard, *The Dinner Party: Judy Chicago and the Power of Popular Feminism, 1970–2007* (University of Georgia Press, 2013), 83.
34. Diane Gelon, interview with the author, January 30, 2010.
35. Chicago, *The Dinner Party*, 27.
36. Judy Chicago, personal correspondence with author, August 31, 2011.
37. Chicago, *The Dinner Party*, 35.
38. JCPSL, carton 16, files 1–16.
39. Diane Gelon, JCPSL, carton 19, file 3.
40. JCPSL, carton 19, file 22.
41. Flyer 1978, JCPSL, carton 15, file 12.
42. Susan Hill, interview with author, January 12, 2010.
43. Dinner Party Worker information sheets, 1977, JCPSL, carton 18, file 31.
44. Workshop Correspondence, JCPSL, carton 18, file 28.
45. Susan Hill, JCPSL, carton 19, file 3.
46. Chicago, *The Dinner Party*, 237.
47. Gerhard, *The Dinner Party*, 109–49.
48. Susan Hill, e-mail correspondence with author, July 15, 2009.
49. Susan Hill, millennium runners, JCPSL, carton 85, file 4.

50. Suzanne Lacy, e-mail correspondence with author, February 9, 2011.

51. Jean A. Rosenfeld to Judy Chicago, July 2, 1979. JCPSL, carton 10, file 1.

52. Mildred Hamilton, "The Dinner Party Left without a Second Sitting," *San Francisco Sunday Examiner and Chronicle*, July 1, 1979, 6.

53. Gerhard, *The Dinner Party*, 180–211.

54. BWAA fund-raising, no date, JCPSL, carton 19, file 16.

55. Judy Chicago, interview with author, September 17, 2011.

56. Judy Chicago, *The Dinner Party: From Creation to Preservation* (New York: Merrell, 2007), 276–77.

57. Judy Chicago, "The Struggle for Preservation," in *The Dinner Party: From Creation to Preservation*, 281; Lucy Lippard, "Uninvited Guests: How Washington Lost 'The Dinner Party,'" *Art in America* 79 (December 1991): 39.

58. Lippard, "Uninvited Guests: How Washington Lost 'The Dinner Party,'" 41.

59. Alice Thorson, "Hungry Conservatives Crash The Dinner Party," *New Art Examiner* 18 (October 1990): 56.

60. Lippard, "Uninvited Guests: How Washington Lost 'The Dinner Party,'" 41.

61. Terms of the Gift, Elsye Grinstein, president, TTF, JCPSL, carton 22, file 15.

62. Jonetta Rose Barras, "UDC's $1.6 million 'Dinner': Feminist Artwork Causes some Indigestion," *Washington Times*, July 18, 1990, 1.

63. Barras, "D.C. Council's 'sanity' questioned as Hill learns of 'Dinner Party,'" *Washington Times*, July 19, 1990, 1.

64. Lippard, "Uninvited Guests: How Washington Lost 'The Dinner Party,'" 43.

65. C-SPAN, July 26, 1990, Through the Flower, Belen, NM.

66. John Smith, "Congress Shoots an Arrow into UDC's Art," *Washington Times*, July 27, 1990, 1.

67. Lippard, "Uninvited Guests: How Washington Lost 'The Dinner Party,'" 45.

68. Smith, "Congress Shoots an Arrow into UDC's Art," 1.

69. Keith Harrison and Gabriel Escobar, "UDC Students Take Over Two Buildings," *Washington Post*, September 27, 1990, 1.

70. Jonetta Rose Barras and Michael Cromwell, "UDC Staff, Protesters seem to be at Impasse," *Washington Times*, October 1, 1990.

71. Lippard, "Uninvited Guests: How Washington Lost 'The Dinner Party,'" 47.

72. Carlos Sanchez and Ruben Castaneda, "Chairman Negotiating Resignation; Gift of 'The Dinner Party' Revoked," *Washington Post*, October 3, 1990, D1.

73. Richard Mahler, "The Battle of Chicago," *Los Angeles Times*, October 12, 1990, F1–2.

74. Henry Hopkins, foreword to *Sexual Politics*, 10; Jennie Klein, "Sexual/Textual Politics: The Battle over Art of the 70s," *New Art Examiner* (October 1996): 30.

75. Norma Broude and Mary Garrad, *Power of Feminist Art* (New York: Harry Abrams, 1996); Helena Reckitt, ed., and Peggy Phelan, collaborator, *Art and Feminism* (London: Phaidon Press, 2001).

76. Gail Levin, *Becoming Judy Chicago: A Biography of the Artist* (New York: Harmony Books, 2007), 392.

77. Levin, *Becoming Judy Chicago*, 394.

78. Carol Vogel, "A Brooklyn Home for Feminist Art," *New York Times*, December 5, 2003.

79. Roberta Smith, "For a Paean to Heroic Women, a Place at History's Table," *New York Times,* September 20, 2001.

80. Robin Pogrebin, "Ms. Chicago, Party for 39? Your Table's Ready in Brooklyn," *New York Times*, February 1, 2007.

Some core staff of *The Dinner Party* photographed at the work's inaugural exhibition, San Francisco Museum of Modern Art, 1979. In the background a photo mural shows Judy Chicago's 39th birthday party in July 1978 at her Santa Monica studio. From left to right, back row: Shannon Hogan, Mary McNally, Neil Olson, Judy Chicago; second row down: L. A. Hassing (formerly Linda Ann Olson), Kate Amend, Juliet Myers, Helene Simich, Sharon Kagan, Leonard Skuro; third row down: Thea Litsios, Elaine Ireland, Kathleen Schneider, Judye Keyes, Susan Hill, Diane Gelon, Anita Johnson; front row (seated on floor): Anne Isolde, Terry Blecher, Peter Bunzick.

ACKNOWLEDGMENTS

There are many people to thank for this, the fifth book about *The Dinner Party*. It is a very different publication from my earlier ones thanks to the vision of Christopher Lyon, Executive Editor of The Monacelli Press. I have written two essays, and the historical material is mine (ably edited by my longtime editor Mindy Werner, who tackled what would have been an incredibly daunting task for anyone else), but other voices are heard, notably historian Jane F. Gerhard and art historian Frances Borzello.

Jane's book—*The Dinner Party: Judy Chicago and the Power of Popular Feminism* (University of Georgia Press, 2013)—chronicles the story of *The Dinner Party*, both its creation and the unprecedented grass-roots–organized exhibition tour that took it around the world to an audience of one million people—amazing even to me. She also corrects some glaring historical distortions for which I am grateful. Frances's groundbreaking essay places *The Dinner Party* in a contemporary art-historical context, something that is long overdue.

Still, her text could only have been written now, six years years after *The Dinner Party* opened in its permanent housing at the Brooklyn Museum in the Elizabeth A. Sackler Center for Feminist Art in 2007. It remains the world's only center for feminist art (regrettably). This period of time has demonstrated its ongoing viability and relevance, exemplified by the fact that over twenty percent of visitors to the museum are there specifically to see *The Dinner Party*.

I particularly appreciate the efforts of Catherine Morris, the immensely able curator of the Sackler Center, who organized *Chicago in L.A., Judy Chicago's Early Work, 1962-1974* at the Brooklyn Museum. This show—part of the 2014 series of exhibitions and events celebrating my seventy-fifth birthday—begins to clarify how *The Dinner Party* grew out of my earlier work, which has only recently begun to be visible, in large part thanks to *Pacific Standard Time*, the 2011–12 initiative documenting Southern California art from 1945 to 1980, a period that includes the twenty years I worked as an artist in Los Angeles.

As I state in my introductory essay, I wanted from the beginning of my career to be seen as an artist among artists, a goal that eluded me because of the many difficulties faced by women artists. By acquiring and donating *The Dinner Party*, and providing the Center as its framework, Elizabeth Sackler has taken a giant step towards an overdue change. I thank Arnold Lehman and the Brooklyn Museum for supporting Elizabeth's efforts and for the museum's cooperation in providing additional photography of the piece for this book. It was always frustrating to my dear husband, photographer Donald Woodman, that we had neither the funds nor the time for him to create a complete record of *The Dinner Party*. As I often say, every artist should have the good fortune to be married to a photographer as talented as Donald. His photos, combined with those provided by the museum, have made for a more thorough documentation.

Thanks are also due to our assistant, Chris Hensley, to the able designer Gina Rossi, Michael Vagnetti, the production manager, Ashley Benning, the copyeditor, and to all others who helped with this book. I hope that its publication marks the moment when *The Dinner Party* finally moves out of my hands and into its place in art history, which was my objective from the moment I began to uncover women's unknown heritage.

I would be remiss in not thanking the countless people who worked on *The Dinner Party* (who are acknowledged on the Sackler Center website), along with all those who helped care for it until permanent housing could be achieved. Some of the key studio people have contributed their own recollections to the e-book version of this book so that their voices could be heard. And I owe a very belated thank you to Russ Roberts, of Art Services Melrose in L. A., who designed and fabricated all the Plexiglas elements, thereby contributing a great deal to the visual presentation of the piece.

It's been a long voyage from my Santa Monica studio (where the piece was created) to the Brooklyn Museum. Along the way, I have done my best to make sure that everyone's contributions were not overlooked. My deepest appreciation goes to Diane Gelon (or simply "Gelon," as she is often called), without whom neither the artist nor the art would have survived. Over the years, many folks have told me that seeing *The Dinner Party* changed their lives. When Gelon came to work with me in the mid-1970s, she changed mine.

INDEX OF NAMES

Fedele, Cassandra. *See* Fidelis, Cassandra

Felicie, Jacobe (Jacoba), 120

Fell, Margaret. *See* Fox, Margaret Fell

Ferdinand of Aragon, 139-40

Ferrari, Carlotta, 215

Fertile Goddess, 28, 30

Fibors, 109

Fickert, Augusta (Auguste), 192

Fidelis, Cassandra, 133

Fiennes, Celia, 179

Figner, Vera, 221

Figueredo, Candelaria, 167

Figueredo, Eulalia, 167

Fionnghuala. *See* O'Donnel, Finola

Fischl, Eric, 272

Fisher, Catharine, 139

Flavia Julia Helena, 82

Flynn, Elizabeth Gurley, 221

Fontana, Lavinia, 146

Fonte, Moderato. *See* Pozzo, Modesta

Forchhammer, Henriette "Henni," 192

Fortuna, 45

Foscarini, Ludovico, 128

Foulkes, Llyn, 251

Fox, George, 161

Fox, Margaret Fell, 161

Fragonard, Jean-Honoré, 147

Francesca of Salerno, 104

Francis I (France), 141

Francis II (Austria), 205

Francis of Assisi, 114

Francis Stephen of Lorraine, 142

Franco, Francisco, 222

Fraser, Antonia, 153

Frea. *See* Frija

Fredegund, 92, 93

Frederick (Sicily), 104

Frederick I (Denmark), 138

Frederick the Great (Prussia), 152, 175

Frederick Wilhelm II (Prussia), 152

Freud, Sigmund, 230, 235

Frey, 30, 31

Freya, 30

Frig, 30

Friia. *See* Frija

Frija, 30

Fry, Elizabeth, 221

Fulbert, 115-16

Fuller, Margaret, 210

Fuller, Timothy, 210

Furies, 40

G

Gaia, 26, 31, 45, 57, 72

Gaia Cyrilla, 57

Gaius, 82

Galindo, Beatrix, 128

Galizia, Fede, 146-47

Galla, 84

Galla Placidia, 84

Gallienus, 88

Galswintha, 92, 93

Gambara, Veronica, 133

Gamble, James, 184

Gandhi, Mahatma, 190

Garcia, Maria del Refugio, 167

Garrett, Elizabeth. *See* Garrett Anderson, Elizabeth

Garrett Anderson, Elizabeth, 191, 200

Gebjon, 26

Gefion. *See* Gebjon

Gehry, Doreen, 250

Gehry, Frank, 250

Gelon, Diane, 259, 261

Genevieve, 88

Gentileschi, Artemisia, 145, 146

Gentileschi, Orazio, 144

Geoffrin, Marie, 229

George III (Germany), 170

Gerard, Francois, 230

Gerard, Marguerite, 147

Gerhard, Jane, 252

Germain, Sophie, 173

Germanicus, 82

Gerowitz, Jerry, 250

Gertrude of Hackeborn, 115, 116

Gertrude of Nivelles, 100

Gertrude the Great, 115, 116

Geshur, 61

Geta, 84

Gibson, Althea, 204

Giliani, Alessandra, 134

Gilliam, Ken, 259

Gilman, Charlotte Perkins, 192

Gisela (abbess), 100

Gisela of Kerzenbroeck, 100

Gisle. *See* Gisela of Kerzenbroeck

Glass, Philip, 214

Glover, Goody, 120

Gloyd, Charles, 194

Gluck, Christoph Willibald, 142

Goddard, Mary, 161

Godgifu. *See* Godiva, Lady

Godiva, Lady, 109

Godwin, William, 179

Godwin of Wessex, 109

Goethe, Johann Wolfgang von, 152

Goldman, Emma, 220, 222

Goldsmith, Oliver, 146

Goldstein, Vida, 192

Goncharova, Natalia, 241

Gonzaga, Elizabetta, 134

Gonzaga, Francesco, 130

Gordon, Jean. *See* Jane of Sutherland

Gorgons, 52

Gormflaith. *See* Gormlaith

Gormlaith, 100

Gottsched, Luise, 154

Gouges, Olympe de, 179

Goya, Francisco, 225

Gozzadini, Bettisia, 104

Graham, Martha, 242, 248

Granderson, Lily Ann. *See* Granson, Milla

Granson, Milla, 185

Grant, Ulysses S., 197

Gray, Eileen, 242

Greenberg, Clement, 251

Greene, Catherine, 161

Gregory I (pope), 84. *See also* Saint Gregory

Gregory VII (pope), 108

Gregory of Nyssa, 84

Grimke, Angelina, 185, 196

Grimke, Sarah, 185, 196

Grunthler, Andreas, 134

Guda, 100

Guest, Charlotte, 204

Guest, John, 204

Guglielma. *See* Guillemine

Guillemine, 120

Guithelon, 88

Gustave II (Sweden), 138

Guta. *See* Guda

Guthrie, Kenneth Sylvan, 69

Guyon, Jeanne Marie, 154

Gwyn, Nell, 147

H

Hades, 40, 45

Hadrian, 85

Halkett, Anne, 173

Hall, Radclyffe, 229

Halpir, Salone, 202

Hals, Frans, 147

Halwisa. *See* Hawisa

Haman, 60

Hamilton, Charles, 179

Hamilton, Elizabeth, 179

Hammid, Alexander, 241

Hammurabi, 32

Hamrol, Lloyd, 251

Handel, George Frideric, 214

Hannah, Adams, 160

Hannahanna, 35

Hannahannas. *See* Hannahanna

Hansberry, Lorraine, 235

Hansteen, Aasta, 192

Harding, Mary Esther, 235

Harlind, 100

Harlinde. *See* Harlind

Harper, Frances, 185

Harrison, Jane, 204

Hashop, 56

Hasse, Johann Adolph, 214

Hasselaer, Kenau, 139

Hastings, Selina, 161

Hathor, 35, 36

Hatshepsut, 21, 54, 56

Hatton, Denys Finch, 235

Hatzerlin, Clara, 128

Hätzerlin, Clara. *See* Hatzerlin, Clara

Hawisa, 109

Hawise. *See* Hawisa

Haydn, Franz Joseph, 142

Haydn, Sophia, 242

Hays, Mary (England), 179

Hays, Mary (United States). *See* Pitcher, Molly

Hearst, William Randolph, 244

Heath, Sophia, 204

Hecate, 40

Hector, 49

Hecuba, 49

Hedwig, 115

Heidegger, Martin, 234

Heim-Voegtlin, Marie, 204

Hel, 40

Helen of Troy, 48, 49, 52

Helena, 64

Helms, Jesse, 263

Heloise, 115-16

Hemingway, Ernest, 184

Henie, Sonja, 204

Henry I (Germany), 94

Henry I (Poland), 115

Henry II (England), 106

Henry III (England), 103

Henry III (HRE), 108, 111

Henry IV (England), 111

Henry IV (France), 132, 134, 230

Henry IV (HRE), 104, 108

Henry IV (Spain), 139

Henry VI (England), 122

Henry VII (England), 126

Henry VIII (England), 129, 136, 138

Hensel, William, 216

Hepburn, Katharine, 242

Hepworth, Barbara, 242

Hera, 30

Herbert, Henry, 143

Hercules, 52

Herlind. *See* Harlind

Herodotus, 72

Herrad of Lansberg, 116

Herschel, Caroline, 171, 172, 175

Herschel, William, 170

Hersend, 116

Hersilia, 49

Heschem II (Spain), 111

Hesiod, 49

Hestia, 49

Hestiaea, 76

Hiera, 52

Higeburc. *See* Hygeburg

Hilda of Whitby, 100

Hildegarde of Bingen, 112, 114, 115, 116

Hill, Robin, 259, 260

Hill, Susan, 259, 269

Hipparchia, 69

Hippo, 69

Hippolyta. *See* Hippolyte

Hippolyte, 52

Hippomenes, 48

Hitler, Adolf, 223, 234

Hjalmgunnar, 72

Hoby, Elizabeth, 139

Hoby, Thomas, 139

Hoch, Hannah, 242

Hoffmann, Hans, 250

Holofernes, 58

Holst, Amelia (Amalia), 192

Homer, 48, 49, 52, 62, 64, 65

Hopkins, Henry, 260, 261, 263

Hopps, Walter, 250, 251

Horney, Karen, 235

Horney, Oskar, 235